Yale Publications in the History of Art

Walter Cahn, Editor

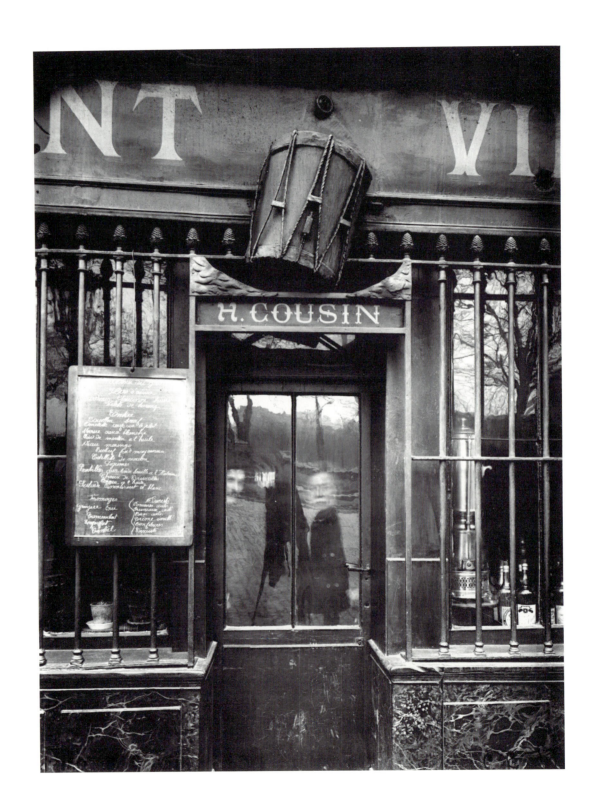

ATGET'S SEVEN ALBUMS

Molly Nesbit

Yale University Press

New Haven and London

Published with the assistance of the Getty Grant Program

Citations from the Atget Archive appear by permission of The Museum of Modern Art.

Excerpt from "The Waste Land" in *Collected Poems 1909–1962* by T. S. Eliot, copyright 1936 by Harcourt Brace Jovanovich, Inc., and Faber and Faber Ltd, copyright © 1964, 1963 by T. S. Eliot, reprinted by permission of the publisher.

Designed by Sylvia Steiner.
Set in Sabon and Gill Sans Condensed type by Tseng Information Systems, Inc.
Printed in the United States of America.

Library of Congress Cataloging-in-Publication Data
Nesbit, Molly, 1952–
Atget's seven albums / Molly Nesbit.
p. cm. — (Yale publications in the history of art)
"Published with the assistance of the Getty Grant Program."
Includes bibliographical references and index.
ISBN 0-300-03580-2 (cloth)
 0-300-05916-7 (pbk.)
1. Photography, Documentary—France—Paris—History—20th century. 2. Atget, Eugène, 1856–1927—Criticism and interpretation. 3. Paris (France)—Social conditions. I. Atget, Eugène, 1856–1927.
II. Title. III. Series.
TR820.5.N47 1992
770'.92—dc20 91–26835 CIP

The paper in this book meets the guidelines for permanence and durability of the Committee on Production Guidelines for Book Longevity of the Council on Library Resources.

10 9 8 7 6 5 4 3 2

Frontispiece: "Au Tambour." 1908. AVP 5522. Caisse nationale des Monuments historiques et des Sites, Paris.

to my mother

What are the roots that clutch, what branches grow

Out of this stony rubbish? Son of man,

You cannot say, or guess, for you know only

A heap of broken images, where the sun beats,

And the dead tree gives no shelter, the cricket no relief,

And the dry stone no sound of water. Only

There is shadow under this red rock,

(Come in under the shadow of this red rock),

And I will show you something different from either

Your shadow at morning striding behind you

Or your shadow at evening rising to meet you;

—T. S. Eliot, *The Waste Land*

Contents

AVANT L'ECLIPSE

L'ECLIPSE

Note to the reader

In all citations of Eugène Atget's writing I have retained the eccentricities, abbreviations, and oversights of the original. All translations are mine, unless otherwise indicated.

Unless otherwise specified, all photographs are by Atget and if by Atget are approximately 18 × 24 cm. albumen-silver prints. The idiosyncracies of his captions have been respected.

Key to the negative numbers:

AVP:	L'Art dans le Vieux Paris
Env:	Environs
PDd:	Paysages-Documents divers
Pp:	Paris pittoresque
Top:	Topographie

Acknowledgments

This book owes much to the generosity of many. First of all, to Robert Herbert, who directed the thesis from which it began to take shape, and to Donald Crafton, Alan Trachtenberg, Eugenia Parry Janis, Joel Snyder, Adrian Rifkin, and Rosalind Krauss, who have read and criticized the argument at various stages. The first steps of my research benefited immeasurably from the advice and friendship of Maria Morris Hambourg; my work proceeds, even in its deviations, from the example set by hers. I am equally grateful for the generosity of the French community of curators and scholars of photography, especially to Bernard Marbot, Jean-Pierre Séguin, Michel Melot, Laure Beaumont-Maillet, and Jacqueline Sanson of the Bibliothèque Nationale, Françoise Reynaud of the Musée Carnavalet, Marie de Thézy of the Bibliothèque historique de la Ville de Paris, Françoise Heilbrun and Philippe Néagu of the Musée d'Orsay, Catherine Prade of the Musée Bricard, Renée Kariotakis of the Ecole Boulle, Roxanne Debuisson, André Jammes, Jean Leroy, Gérard Lévy, Harry Lunn, Alain Paviot, Alain Pougetoux, André Rouillé, and the late Hugues Texier and François Braunschweig. In London, Mark Haworth Booth and David Wright guided me through the archives of the Victoria and Albert Museum. Among the many others who have helped me to think more clearly about this material, I should like to thank Susanna Barrows, Marie Desmartin, Alain Faure, David Freedberg, Kevin Hubbard, Pepe Karmel, Andrew Lincoln, Elizabeth Anne McCauley, Michael Marrinan, Barbara Michaels, Annette Michelson, Michael Orwicz, Francesco Passanti, Christopher Phillips, Kenneth Silver, Nancy Troy, and Anne Wagner. The Department of Photography at the Museum of Modern Art, New York, especially John Szarkowski, Peter Galassi, Susan Kismaric, Sarah McNaer, and Catharine Evans, has showed me every hospitality.

Without the financial support of the Kress Foundation, the Georges Lurcy Foundation, the American Association of University Women, Barnard College, and particularly the J. Paul Getty Trust, whose generosity has made the complete publication of the albums possible, this book would never have seen the light of day. My thanks to them and to my editors at Yale University Press, whose patience and confidence in the project have been instrumental.

One last acknowledgment, and perhaps the most important one. Over the years, this study has been enriched and sharpened during long Parisian conversations with Leila Kinney and Adrian Rifkin. It now shows all the signs of intersection with their thinking as well as my general debt to them both, the kind of debt inadequately conveyed by references and impossible to reimburse.

1. "L'Eclipse—Avril 1912." Pp 335. International Museum of Photography at the George Eastman House, Rochester, New York. Formerly Man Ray Collection.

Prologue

Once, in 1926, Atget had a brush with an avant-garde. He was sixty-nine years old. The Surrealists, a group of much younger, but even so, extraordinarily brazen men, had approached him, wanting to use one of his photographs on the cover of their magazine, *La Révolution Surréaliste*. Such a brush is commonplace in the history of art; more often than not it spirals into myth. Here it only made for friction and a few short sparks.

Atget called his picture "L'Eclipse—Avril 1912" (fig. 1); *La Révolution Surréaliste* would call it "Dernières Conversions" (fig. 2). *C'est tout.* We know nothing of what transpired except that in the end money spoke, the picture was sold, and the Surrealists had their way with the caption. All the details but one are hazy. That one was the last of them, the anticlimax, the matter of the credit. Atget chafed and abruptly told Man Ray, "Don't put my name on it." Then he said, pointedly, as if it were sufficient cause, "These are simply documents I make."[1]

He had drawn the line. The incident made such an impression upon Man Ray that he never forgot it.

Nº 7 — Deuxième année 15 Juin 1926

LA RÉVOLUTION SURRÉALISTE

FINE ARTS

LES DERNIÈRES CONVERSIONS

SOMMAIRE

L'enclume des forces : Antonin Artaud
Le surréalisme et la peinture : André Breton.

RÊVES
Marcel Noll, Michel Leiris.

POÈMES :
Robert Desnos, Philippe Soupault, Paul Eluard,
Antonin Artaud, Michel Leiris.

TEXTES SURRÉALISTES :
Louis Aragon, Arp.
A la fenêtre : Paul Eluard.
Derniers efforts et mort du prévôt :
Pierre de Massot.

La dernière nuit du condamné à mort :
Benjamin Péret.
Le Pont de la mort : René Crevel.

CHRONIQUES :
L'opportunisme impuissant : Marcel Fourrier.
Liberté, liberté chérie : Maxime Alexandre.
Protestation : L. Aragon, A. Breton.
Georgia : Louis Aragon.
Correspondance. Notes.

ILLUSTRATIONS :
Arp, Giorgio de Chirico, Georges Malkine,
André Masson, Picasso, Man Ray, Pierre Roy,
Dédé Sunbeam, Yves Tanguy, etc.

ADMINISTRATION : 42, Rue Fontaine, PARIS (IXᵉ)

ABONNEMENT,
les 12 Numéros :
France : 55 francs
Étranger : 75 francs

Dépositaire général : Librairie GALLIMARD
15, Boulevard Raspail, 15
PARIS (VIIᵉ)

LE NUMÉRO :
France : 5 francs
Étranger : 7 francs

2. "Dernières Conversions," *La Révolution Surréaliste*, no. 7 (15 June 1926). Avery Architectural and Fine Arts Library, Columbia University.

The line belonged to Atget, though it was not his exclusively. Others in France were always drawing similar lines to express difference, if not distaste. Theirs was a culture that prized hierarchy, division, clarity of position, even after modern times had undermined the classical order and its grid. The grid might be gone, but lines of difference still counted. In Atget's case the line was more than the work of a single stubbornness, more than that of an elitism stuck tight to an ego; it was the symptom of another order of things that had butted up against modern art. "These are simply documents I make." The line marked a break, a misrecognition, a misunderstanding, a fault in the order of knowledge, a rupture of some indeterminate, though seeming long standing, a difference of no small consequence. But it is impossible to understand the nature of this separation from one such line alone. So, in the interest of moving Atget's line beyond Surrealist anecdote to a general level where it might be posed again, properly, as part of a problem, we shall take another line, a similar line, this one from Zola.

It will be a line from *Paris*, the novel Zola published in 1898 as part of the trilogy he called *Trois Villes* (the others were *Lourdes* and *Rome*). *Paris* took the city through the eyes of a doubting but not especially clever priest, the Abbé Pierre Froment.

The abbé saw Paris in a kind of double vision, irremediably divided into two populations, two great districts, two classes. The cruelty of that division plagued the abbé and he spent most of the novel in a state of moral torture, agitated, trying to find an appropriate course of action, searching the panorama of the city for a sign, an answer or a confirmation, as if those things were actually waiting for him there. In the opening passage of the novel he stood at the top of Montmartre, Sacré Coeur at his back, and looked.

After two months of bitter cold, ice and snow, the city was steeped in a mournful, quivering thaw. From the far-spreading, leaden-hued heavens a thick mist fell like a mourning shroud. All the eastern portion of the city, the abodes of misery and toil, seemed submerged beneath ruddy steam, amid which the panting of workshops and factories could be divined; while westwards, towards the districts of wealth and enjoyment, the fog broke and lightened, becoming but a fine and motionless veil of vapour. The curved line of the horizon could scarcely be divined, the expanse of houses, which nothing bounded, appeared like a chaos of stone, studded with stagnant pools, which filled the hollows with pale steam; whilst against them the summits of the edifices, the housetops of the loftier streets, showed black like soot. It was a Paris of mystery, shrouded by clouds, buried as it were beneath the ashes of some disaster, already half-sunken in the suffering and the shame of that which its immensity concealed.[2]

The panorama revealed only as much of Paris as the abbé himself could see, the crude divisions, and even those obscurely known. Later in the novel, as Pierre reconciled with his anarchist brother Guillaume, left the priesthood, discovered the value of manual labor and earthly love, and at last saw the glimmer of a more just future, the panorama changed. It turned from grey to gold. Pierre now looked over the panorama from the windows of his brother's Montmartre workshop. From the perspective of labor, the future was clear. And so the novel ended:

The declining sun was once more veiling the immensity of Paris with golden dust. But this was no longer the city of the sower, a chaos of roofs and edifices suggesting brown land

turned up by some huge plough, whilst the sun-rays streamed over it like golden seed, falling upon every side. Nor was it the city whose divisions had one day seemed so plain to Pierre: eastward, the districts of toil, misty with the grey smoke of factories; southward, the districts of study, serene and quiet; westward, the districts of wealth, bright and open; and in the centre the districts of trade, with dark and busy streets. It now seemed as if one and the same crop had sprung up on every side, imparting harmony to everything, and making the entire expanse one sole, boundless field, rich with the same fruitfulness. There was corn, corn everywhere, an infinity of corn, whose golden wave rolled from one end of the horizon to the other. Yes, the declining sun steeped all Paris in equal splendor, and it was truly the crop, the harvest, after the sowing!

"Look! just look," repeated Marie, "there is not a nook without its sheaf; the humblest roofs are fruitful, and every blade is full-eared wherever one may look. It is as if there were now but one and the same soil, reconciled and fraternal. Ah! Jean, my little Jean, look! see how beautiful it is!"

Pierre, who was quivering, had drawn close beside her. And Mère-Grand and Bertheroy smiled upon that promise of a future which they would not see, whilst beside Guillaume, whom the sight filled with emotion, were his three big sons, the three young giants, looking quite grave, they who ever laboured and were ever hopeful. Then Marie, with a fine gesture of enthusiasm, stretched out her arms and raised her child aloft, as if offering it in gift to the huge city.

"See, Jean! see, little one," she cried, "it's you who'll reap it all, who'll store the whole crop in the barn!"

And Paris flared—Paris, which the divine sun had sown with light, and where in glory waved the great future harvest of Truth and of Justice.[3]

This vision of a unified golden utopian city, a classless city with country values, was only a vision. Zola knew, and the novel was careful to register this. Paris was not yet one.

Once again the sun had played a major role. But for both Zola and the Surrealists it was only the means to an end, an auxiliary image that helped represent an unknown, a social difference that could not be written off, that had to be expressed. Difference kept coming back to Paris, as Paris, marking Paris, changing lines. Was it the time of day? the angle of the light? It seemed to be objective, even as it shifted cases, natures, states. It could be baldly stated in a joke about a religious conversion or a novelist's metaphorical description; it could be carried implicitly in the tone of a retort or in an angle or a scrap of slang. Or in a photographic calculation. Atget's photographs were notable for their take on these differences. Yet Atget had his own view of the sun. Not Man Ray's, not Zola's. His lines would fall on nonaesthetic ground. His prospects were not theirs.

It is more than ironic that Atget's place in history was secured by the very same Surrealist circles he had not so delicately skirted in 1926 and that his work is generally seen now in light of modern art. In light, it should be said immediately, of a false problem. All the moon has fallen lost. Whether it is possible to recover Atget's optic of difference and all the standards and distinctions by which his work can be judged is of course debatable, but the basic lines, the differences, can be deduced. They will open up a negative space. That negative is not all void, it so happens, but rather a stage for

the appearance of knowledge, a stage with its own drama of *savoir*, its own notion of *sublime*, its own construction of ignorance and night. A stage where epistemological structures wear inelegant everyday clothes. How to think from the forms of the photographs and the lines of difference into this negative space—that is our problem. For now let us take what is virtually a philosopher's question back to the historical particulars, back to the split between Atget and the young Surrealists, back to their specific differences, which were above all else cultural. It is as good a place as any to begin.

Atget had come to the attention of the Surrealists in the first place by sheer, banal coincidence: he lived down the street from Man Ray on the rue Campagne première. He was known to them and everybody else as the old neighborhood photographer who took his pictures around to nearby studios to see if anyone wanted to buy them for use as studies.[4] The somnambulist poet Robert Desnos remembered that artists would also come to Atget, stopping by his studio: "Artists in search of documents came to buy prints from him for a few sous. He was a supplier who aroused a certain degree of curiosity, and nothing more."[5] Desnos himself had climbed those stairs and after Atget's death in 1927, he wrote an essay about the old photographer that tried to chart as well as honor his cultural remove. The essay was a part of his column in the Belgian paper *Le Soir*, under the rubric "Les spectacles de la rue." It drew this picture of Atget.

He was an older man with the face of a tired actor. He had evolved over a legendary number of documents: glass plate negatives, prints, album [sic], books . . . But what documents! With the marvelling lens of dream and surprise, for thirty-odd years Atget photographed all of Paris. These are not the albums of an artist then bequeathed to libraries . . . No, these are the visions of a poet handed down to poets.

Without ever giving anything up to the picturesque or anecdotal (a word which needs discussion someday, it is so randomly used), Eugène Atget fixed life itself.

His work divides itself up into a host of series containing several tens of thousands of prints: bourgeois rooms, workers' rooms, homes of the rich (including that of Mlle Sorel), fairground stands, grocery storefronts, hairdressers' shops, street scenes, stairs, junk dealers' reserves, etc., he saw it all with an eye that merits the epithets sensitive and modern.[6]

He was so unlike them. He had spent his life amassing a stock of documents, unfathomable documents that caught a side of the city missing from the usual bourgeois image: Atget's documents put forward a popular Paris, without the high life, without the reveries of an ancien régime, without the bourgeoisie.[7] His Paris was a mass of common detail. Starched lace curtains, a basket of cauliflowers, a prostitute with yellow hair.

To Desnos, Man Ray, and their friends, Atget and his pictures seemed to belong to that Paris. They admired his pictures for their qualitative cultural difference; they could tell that those photographs stemmed from another, immensely sensitive, stubbornly popular culture, alien and at the same time half-familiar, strange and desirable, *pensé* and *impensé*. To have known this was one thing, to explain it quite another. Their account of that popular culture, and their account of Atget as well, could only be made from their own position—not exactly inside popular culture (their clothes were a little too fine) and not quite outside it either (they like *le peuple* relished the taste of the movies, the

fantastic ground of the Buttes Chaumont, and a particularly seamy café in the passage de l'Opéra). They wrote about it all as Surrealism; they saw it from the threshold of their class. Sometimes they tried to make the popular over in their own image. Waldemar George thought that Atget had in effect written the *Paysan de Paris* before Aragon had even put pen to paper.[8] But Atget was not, like the young Aragon, seeking out the low life of the passage de l'Opéra in order to rectify philosophical error; nor did his image of the city rise from the real of ruby lips. Atget's work slipped away from those recently converted to peasantry. And George knew it, admitting that "this work is free from the fluctuations of dominant fashion," their mode, and the tamer bourgeois modes; it escaped from fashion "just like a Chaplin film, just like a painting by the Douanier Rousseau."[9] Atget's pictures reminded them that there was another version of modern life, a version that echoed from below. A version that unsettled when it did not echo *them*.

After Atget's death on the 4th of August, 1927, his oldest friend, André Calmettes, took charge of his estate and his photographs. He sold half of what remained to the Monuments historiques; the other half had no obvious destination. In the end they were bought the following June by a young American photographer named Berenice Abbott who had been among those of Man Ray's crowd to mount the stairs, to remark upon Atget's sign "Documents pour artistes," enter and look and buy a few prints.[10] Abbott saw to it that Atget became the grandfather figure for the new generation of modernist photographers; she included his work in the Salon Indépendant de la Photographie; she kept it in the minds of Desnos and other writers and saw that the press took

note of Atget's accomplishment; she asked Calmettes to write a short biography of Atget so that posterity would have a sketch at least of the man's life (and so Calmettes told them about Atget's early half-successful career as an actor, his brief flirtation with painting, and his years of commercial photography).[11] Finally, and most importantly, Abbott brought about the publication of a book of Atget's photographs, *Atget: Photographe de Paris,* in 1930. The book catapulted Atget's work into the upper reaches of modernist culture. Its preface was written by Pierre MacOrlan, a poet and raconteur of the Butte Montmartre who specialized in sagas of working-class love, music halls, and foggy quais.[12] MacOrlan's preface is the longest and probably the best assessment of Atget's work to be written by someone who knew him, though never all that well.

MacOrlan made Atget's work into a paradigm of the photographic image of the city. Photography cast the city in certain terms, MacOrlan claimed: "Photography uses light in order to study shadow. It discloses the people of the shadow. It is a solar art in the service of the night."[13] The photograph, by its very nature, to follow the argument, hit up against class, the working class of the tenebrous night. That class was not a full-formed proletariat however but a labor aristocracy which MacOrlan identified with "le petit commerce." Look at Atget's photographs, MacOrlan instructed his reader, and you will see that the small shopkeeper and the worker on the street are given pride of place.

> There one meets the elite *populaire,* those who give the street its history, its anguish and its triumphs. Because only the visions inspired by the collective feeling are humanly true, to make an exact picture it would take a man like Atget coming into being in each of

the world's great cities, a conscientious man nearly free of vanity.

> Atget did not seek the complications, full of charming surprises, of the night and early morning, he never missed a shot on the off chance of moving beyond the field he had mastered. Above all else his work is honest. It puts forward a reportage of exceptional quality, and oftentimes it shows a purely plastic awe. No one knew Paris better, from the long-lost Fort-Monjol to the friendly grass of a children's park. He knew how to see the nuance that gave each thing its value.

> Atget died elderly and just maybe inwardly discouraged but I think not. Once by chance I met le père Atget. He was at that moment selling some pictures of boutiques and prostitutes to serve as documents for artists. This old man of the theatre was impenetrable. In the first place because no one sought to understand either him or the profound value of his work. Atget was a man of the street, an artisan poet of the Paris crossroads. He did not announce his work by a song, but one saw his upright silhouette, a little stooped, carrying a camera on tripod, there between the greengrocer, the chair caner and the goatherd and his Pan pipe.[14]

Le père Atget, MacOrlan called him, to place Atget absolutely in the popular Paris that had so seduced and mystified the Surrealists. Pierre MacOrlan, *fils de la Butte,* succeeded better than anyone else in erasing some of that white-collar distance between the man of letters and the poet of the streets. And yet MacOrlan knew that those distances were indelible, that they would have to be left as they were. He went as far as he could go; he gave those distances a direction and a name. He had had the grace to introduce Atget into the history of modernism as an Other.

Abbott herself also wrote about Atget. She wrote in English, beginning in her diary; by the time she had written her big book on Atget in 1964, she had given his work an American reputation and an explanation that would satisfy the questions being asked of photography by Americans. The seeds of this explanation were present from the first in the diary passage, which she then copied into her first article on Atget, published in the American magazine *Creative Art* in 1929. Abbott understood some things about the culture of his photographs. She knew that "Atget was not 'aesthetic.'" But she argued his case through the most aesthetic and glamorous of comparisons: "Photographing, recording life, dominating his subjects," she claimed, "was as essential to him as writing to James Joyce or flying to Charles Lindbergh." [15] Later she would insist upon Atget's ability to see objectively, *photographically,* which for her meant not in an artsy way. Abbott turned Atget's cultural difference into a photographic one. She did not quite understand, as her French friends had, how important it was that Atget's work belonged to another class. [16]

The difference of this class was perhaps to be gauged in MacOrlan's blacks and whites (although Atget made albumen prints, which took the contrasts to sepias and creams), perhaps in the emergence of details that could be tagged with a social i.d. The *élite populaire* might tentatively be identified from these things but once that first step had been taken, the full movement from form to knowledge became increasingly tortuous, not to say impossible. This was true not only of Atget's photographs but in general. Whether or not one wanted to locate truth or an authentic reality in the working class, a mass of difficulty had been erected by that class's culture: the *populaire* had no

stable public face; it hovered between utter insularity and an apparently uncritical acceptance of the bourgeois mass media; sometimes it could come across as kaleidoscopic, at others it seemed vaporous. [17] It existed, certainly, but it did not *necessarily* or *consistently* take form. More often than not it trafficked in forms of formlessness. Hence its great attraction for the Surrealists. Hence their reading of Atget's photographs; through them they thought they could see popular culture, an electric otherness, forms that predicted the eclipse of the bourgeoisie.

It stands to reason that the relation here between form and knowledge cannot be told through the interpretation of symbols: Atget's photographs made other connections to the shady real of the *populaire*. For example, the eclipse on the cover of *La Révolution Surréaliste*. It showed a crowd on the place Bastille, armed with special viewing devices, watching the eclipse of the sun on April 17, 1912. Atget knew better than to try to train his camera on the sun. He took instead the folly of the crowd, a chorus of eyes trained on a spot. In the process he scooped up the image of a small boy who, tired of the sun, had looked over at the photographer and thumbed his nose, probably hoping to ruin the picture by sticking his fingers in it. Two of Atget's pictures of the crowd survived those fingers: the one just described, taken during the eclipse, and another, taken moments before (fig. 3). Both are broad, ribald pictures. The social classes have come together for the eclipse, a lady stands with apprentices, young gentlemen line up with tradesmen, suits rub against smocks, hats stand up with caps. The signs of class ring clear. Nowadays the photograph calls to mind another crowd, the one Eisenstein filmed gathering on the Odessa Steps to cheer the battleship *Potemkin*. On the place Bastille that day, there was however no revolu-

tionary drama to record, only jesting, jostling, anticipation, frowns.

Before the eclipse, Atget took a different crowd. This crowd swayed in more confusion, some in the official position already, papers held high, others turned to look quizzically at Atget. One man turned and then turned away; the photograph got him two-faced. Front and center stood another boy, this one holding a *feuilleton*, like a newsie would, except that there was only one copy. The *feuilleton*, an episode of Buffalo Bill, belonged to the boy; it was his sign of culture; it answered the billboards blazing forth the praises of Oxo and Marie's Foie Gras. To him food came after cowboys. (The boy was still holding Buffalo Bill tight as he looked at the eclipse.) Details like that one swirled through both images, doing the work of giving the diversity and the unevenness of culture in 1912. The crowd was definitely not a passive, lumpen, unified mass, not a machine, not patiently fulfilling the images of it that had lately been concocted by the social theorists and novelists, and not dying to be turned into an abstraction or a cliché. The crowd resisted a single interpretation of its business by an intellectual or by anyone else. Buffalo Bill was prominent perhaps, but tight-lipped. He could not have claimed to speak for the others. And Atget did not ask that of him. The *populaire* was simply shown as part of the crowd, equally slippery, uncentered, diverse.

The eclipse pictures elbowed their way toward the comic and then withdrew into the puzzlement of deadpan; slapstick was never Atget's mode. It follows that *funny* is not a word that comes up much in the writing on Atget's work; *melancholy* on the contrary runs rampant, especially since Walter Benjamin's review of the 1930 monograph. "They [the photographs] are not lonely but voiceless; the city in

3. "Avant l'Eclipse—17 avril 1912—Place de la Bastille."
Pp 334. Bibliothèque historique de la Ville de Paris.

these pictures is swept clean like a house which has not yet found its new tenant. These are the sort of effects with which Surrealist photography established a healthy alienation between environment and man, opening the field for politically educated sight, in the face of which all intimacies fall in favor of the illumination of details." Later in the essay he wrote the famous words "Not for nothing were pictures of Atget compared with those of the scene of a crime."[18] Politics like photography works by processes of representation, by form. Its constructions of difference are relevant here but first we need to look more closely at the kind of picture Atget made. For even in pictures which targeted single working-class figures, like the early one of the lampshade vendor on the rue Lepic (fig. 4) or the late one of the prostitute sunk naked in her bed (fig. 5), class consciousness was unclear, gestures posed outside clichés, bodies escaped design. Popular culture was represented most obliquely, by an uneasy glance and the pale stupor of a bottom, cupids' frozen dance, lampshade geometry, and the fearless gesture of a child, represented by forms which had turned on, or was it only into, the image. They had been given their connection to the real by the document.

More than once Atget explained to Man Ray that these photographs were only documents, documents for artists.[19] It seems that whenever he worked up an explanation for Man Ray or his young American friends, the word document came up. Calmettes used it too to describe the photographs. It expressed much, if one understood what a document was. It also expressed yet another order of cultural difference. For the document functioned in a part of visual culture that had few aspirations to greatness or avant-garde revolution; it issued from the depths of bourgeois culture; it was the aesthetic Other.

Any study of Atget's work has to come to terms with its various degrees of baseness, both bourgeois and *populaire*. Here they will emerge as a matter of albums, though it will take a few chapters to see why. We do better to commence elsewhere, with an assertion and an assumption. The assertion is unambiguous, reiterated by Atget himself, recorded by those who knew him, and read out of the pictures by those who did not. Atget's claim for his pictures can be taken at face value: the photographs are documents, in the first and the last instance. The assumption does ask for more evidence, although it would do well to state it plainly now: fundamentally Atget was content with his cultural lot. Atget's assertion that his pictures were documents was hardly naive; he knew of the existence of other possibilities, like pictorialist photography, but kept his distance from them, just as he had shrugged off the kind of highbrow cultural dissent practiced by the Surrealists.[20] Those who knew Atget well have all spoken about this tenaciousness, his tendency to dispute, his strong opinions, his temper. His concierge, who was in addition one of the best friends of Atget's mistress, could not overemphasize the point.[21] In 1928, Calmettes, his best and oldest friend, put it succinctly, "In art, in hygiene, he was absolute. He had his own ideas on everything and he imposed them with an unspeakable violence. He applied this intransigence of taste, of vision, of processes to photography and from it came marvels."[22] It is therefore important to understand why Atget persistently kept to his documents and kept his pictures moving along a specific layer of the cultural zone, not the public exhibition of Salon painters and galleries but the field of the archive and the printed page. This is not the familiar parnassian ground of art history, but then neither is the document.

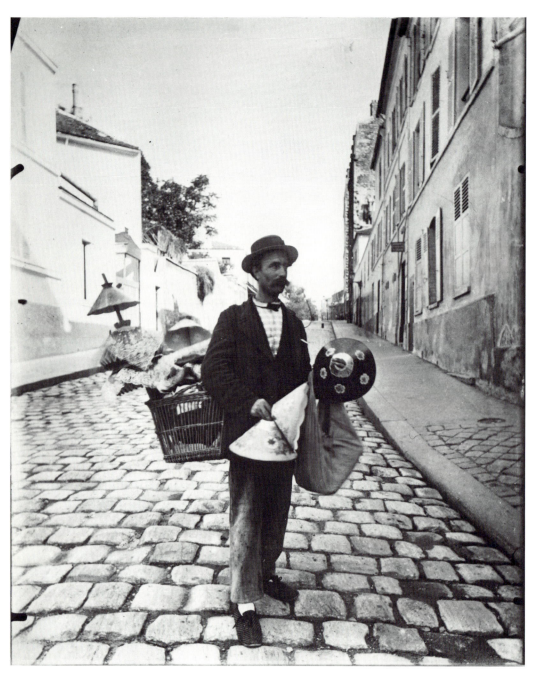

4. [untitled]. Pp 3196. 1899. International Museum of
Photography at the George Eastman House, Rochester,
New York. Formerly Man Ray Collection.

5. "Femme." Pp 62. 1921. International Museum of
Photography at the George Eastman House, Rochester,
New York. Formerly Man Ray Collection.

AVANT L'ECLIPSE

The Document

During Atget's lifetime, French photography was a medium of few words. What language was used to discuss photography lacked nuance; terminology was usually borrowed from elsewhere. Such an impoverished language did not encourage much of a discussion, let alone a full-fledged discourse, and there was little. Earlier, in middle of the nineteenth century, it had been otherwise, but the lively, mid-century debates over the status of photography (was it art? was it industry?) had subsided, leaving the questions largely unresolved. In their wake, a hush had fallen. Photographs were looked upon quietly, approvingly, lethargically and, much of the time, automatically.

This situation was dramatized in 1908 when *Camera Work*, Alfred Stieglitz's magazine, polled a group of French artists and critics to get their view of the artistic potential of photography. George Besson, the young art critic who conducted the survey, came back with an article full of bad news. He was obliged to explain that in these Parisian circles, photography had a dismal reputation, that these men hadn't the slightest idea of the work being done in artistic photography, and that "photography for them is a source of scientific precision; an ideal method of quick reproduction; which, when it develops pretentions to art, gives in certain hands special proof of an absolute ignorance of the first rudiments of art, and of a mind and education truly lamentable."[1] The situation for artistic photography was unthinkably dark.

Besson had known that his would be a difficult assignment. Therefore, to ensure responses based upon a firsthand knowledge of the facts, he had taken a group of pictures with him, some issues of *Camera Work*, and some photographs by Steichen, Demachy, and Puyo, then the foremost pictorial photographers working in France. Besson had hoped that he could show

these people something else in photography. And yet not trusting to the photographs alone, he had directed their attention to the pictures by handing them two questions:

1. Do you believe that by means of photography, works of art can be produced?
2. Do you approve of interpretation by means of photography, and the intervention of the photographer by the different means at his disposal, to realize, according to his taste and in his own personal style, his emotions?[2]

These were not random questions; Besson was prompting and prodding his distinguished sample, offering them a few of the standard pictorialist terms to help when they formulated their replies. He was giving them every opportunity to place photography in the symbolist camp.

Besson's sample included fifteen prominent liberal aesthetes, like Rodin, Frantz Jourdain, and Gustave Geoffroy, men who worked in the fine arts, the decorative arts, and architecture and whose interests were represented by the new Salon d'Automne. The group took an interest in the photographs he showed them, photographs like Steichen's portrait of Rodin (fig. 6).[3] And sometimes used the pictorialist standards, interpretative photography and pure photography. Frantz Jourdain, who had been responsible for including a photography section one year at the Salon d'Automne, had a typical reaction. He told the tale of that photography section. It had included work by the Photo-Club of Paris, Demachy and Puyo for example, as well as some reproductions of Cézanne paintings sent along by Vollard. But, Jourdain complained, the *professional* photographers had deluged them with entries spoiled by excessive retouching and soupy tones. They had ruined things for the others; subsequent Salons had no

photography section. Steichen's portraits, he thought, were in another, Salon-quality class. Nevertheless, as the interview continued, Jourdain gave the matter one last, fatal twist. He declared that, in the hands of an artist, photography could conceivably rise to the level of art, but it would never produce the *great* art of a Monet or a Carrière and he ended the interview saying that art photography would be most useful in the schoolroom. On the way to this devastating conclusion he remarked that pure photography should rightfully be compared to the ordinary newspaper report, different from it only in that it possessed the photographer's personal style. In other words he used two terms that Besson had *not* set out, to wit, a greater art and a lowlier document; Jourdain cited them, placing pictorialist photography on the tepid middle ground between the two—good but not remarkable. This was not at all what *Camera Work* had wanted him to say.

The fourteen other Frenchmen politely did much the same, putting Besson's terms together with their own spotty sense of photography. Most of them allowed that it was possible to consider the photograph as something like decorative art. Though not all. The conservative marine painter Charles Cottet felt that in the hands of an artist the photograph would only provide the basis for a loftier design; it could never be an end in itself. Matisse, the *fauve* of the Salon d'Automne and the most radical of these liberals, damned the photograph altogether. He explained to Besson:

Photography can provide the most precious documents existing and no one can contest its value from that point of view. If it is practiced by a man of taste, the photograph will have an appearance of art. But I believe that it is not of any importance in what style they have been produced; photographs will always be im-

6. Edouard Steichen, "Rodin—Le Penseur," *Camera Work*, no. 11 (July 1905), p. 35. Epstean Collection, Rare Book and Manuscript Library, Columbia University, New York.

pressive because they show us nature, and all artists will find in them a world of sensations. The photographer must therefore intervene as little as possible, so as not to cause photography to lose the objective charm which it naturally possesses, notwithstanding its defects. By trying to add to it he may give the result the appearance of an echo of a different process. Photography should register and give us documents.[4]

It was much like Baudelaire's famous condemnation of photography in his Salon of 1859, though Baudelaire had gone on at much greater length to say that photography was not to be

used to explore the *imaginaire,* and that photography should know its place: photography's place was the archive and photographers should work like clerks to make exact records of things that might otherwise disappear.[5] Photographs were documents, said Matisse and Baudelaire; photographs, like documents, had a job to perform. For an artist, the document could only be a submissive, nonaesthetic picture; not a style, it was an entire class of images. To call a picture a document was not however to call it a photograph. Fernande Olivier applied the term to Negro statues (her words), tapestries, decorative designs, and fashion prints. She was

describing the studios of Picasso and his friends, noting that they contained the artists' sources of inspiration, everything from masterpieces, like Matisse's little Cézanne, to documents, like the Grebo mask.[6] Documents provided artists with raw material. The material issued from a varied but essentially low visual culture, sometimes ornamental (tapestries), sometimes foreign (Negro statues), or simply prosaic (fashion prints). Most photographs were swept into this last, prosaic corner. Optical dust.

When photographers discussed the photographic document, they passed over it quickly, speaking of it in a general way as a supremely useful picture, much like one would speak of the doorman or the maid.[7] That level of generality was the key feature of the document. It gave an idea of the document that seems unbelievably open-ended, lacking intellectual rigor, flexible to the point of vagueness or rampant imbecility. Yet the document was in large part defined by this very openness. The best definition of the document, given on the occasion of the Fifth International Congress of Photography held in Brussels in 1910, was composed of nothing but neutral, rubbery options:

> A documentary image should be able to be used for studies of diverse kinds, ergo the necessity of including the maximum possible detail. Any image can at any time serve scientific investigation. Nothing is to be disdained: the beauty of the photograph is secondary here, it is enough that the image be very clear, full of detail and carefully treated so as to resist for as long as possible the ravages of time. [8]

To put a somewhat finer point on it, a document was a study sheet. Its beauty *was* secondary; use *did* come first. This meant that the document

had no prescribed form; in absolute terms we could say that it was a detailed blank. And, by extension, that it was an impersonal, expository picture, the zero degree of the image, taking shape as its job became clear. As Albert Londe, the photographer who worked with Doctor Charcot, explained, the photograph was a good document because it was true, exact, rigorous; it could be applied to art as well as to science, providing a "document vu" to accompany the "document écrit." [9] It would tell the truth about, say, a leaf, a doorway, an animal in motion, an earlobe, or an hysteric. So an architectural photograph would be called a document, as would a chronophotograph, a police i.d., or an X ray. They had one thing in common: all of them were pictures that went to work.

The document was a fundamentally practical picture that lay at the bottom of visual culture as a base line, a point of departure, an objective pole. The document lived out its time quietly in the basement, many floors below the storied academic hierarchy, well below genre, well below still life, way below landscape. It was not considered worthy of discussion and it never generated any kind of theory. Yet in the late nineteenth century the document was fast becoming something more than a preparatory step for buildings, paintings, and ornamental details. Whether drawn or photographed, the document was playing an increasingly important role in the elaboration of scientific and historical proof. It became a standard way of expressing knowledge; it became a means to knowledge; and it put together pictorial forms of knowledge, though they were not yet taken up as aesthetic forms and exploited for their own sake. That would come later. No pictorialist photographer, or anyone aspiring to the status of artist in the strictest bourgeois sense

of that word would have called their pictures documents. By the late 1920s, when avant-garde culture had turned to extremely technical forms in order to make its art modern, the document enjoyed a new cultural prestige but it still had to be given an avant-garde frame, a transformation on the order of the "Dernières Conversions." [10] While Atget was working, the work of art and the document were like night is to day and not to be confused.

The document's relation to knowledge was neither natural nor trivial. It held knowledge that in turn would be used to produce more knowledge, usually in a more advanced state. So a document of Vieux Paris would inform an antiquarian's account of a seventeenth-century political event; a document of a lampshade salesman might inform a genre painting meant for Salon exhibition. And yet the document was not the source of power; it was not representing its own noble order; rather it spoke from the position of the peasant who harvested for the lord, or the worker who produced for the capitalist. It could allow the classes to collaborate, but mainly toward the formation of certain areas of bourgeois knowledge. Or better, it fed a battery of those knowledges, some of them the traditional disciplines, some new disciplines, some the nebulous leisure-time activities where thinking and pleasure were confounded. The relation of these knowledges to one another was not charted nor were they set out in some hierarchical order; rather they jostled one another, overstepped their bounds, started and stopped wherever. That is to say, these knowledges were generally discontinuous. Any supplier of documents knew this automatically. Knowledge existed not as a corpus but as a congeries of what the French would call *connaissances*.

Document, knowledge, archive, discontinuity, dispersion, *connaissance,* and its summation, the transcendent *savoir,* these are terms

familiar to any reader of Foucault.[11] The terms have been used here to consider the state of knowledge at its lowest and its preliminary levels, and the means by which thought was made visible there. Knowledges emerged and converged in Atget's photographs in a way that reveals much about the relations between knowledges and much about the nuts and bolts of modern visual culture. However, and this is extremely important, Atget's pictures were not completely identified with these knowledges. Most of the time his photographs were breathing down the *outsides* of one kind of *connaissance* or another, their forms addressing the knowledge yet to come, their relation to power unsteady, ambivalent. And that was hardly the end of it. We have already seen the eclipse and the pale nude; we already know that there was always the possibility of an added wrinkle: the documents might serve *connaissance* well but they were capable of slipping away into a counter *bassesse*, into the bubbling, desublimated, negative space of the *populaire*. How then, faced with unfamiliar materials and unsettled knowledge, can we come to know anything from these pictures called documents? That is not a question that can be answered immediately, nor can it be answered in general terms. The knowledge we shall study has already been weighed, understood, used for leading a life, misbegotten, misremembered, or lost in transit; knowledge after it had already entered history, knowledge in thick and thin. And so we turn to the situation in which Atget's documents were conceived and seen.

Obviously a document could not function very well at the general level of its definition, its details acquired their full significance only when the blankness was charged with duty. A document could not exist alone: it needed a viewer and a job. For a document was actually defined

by an exchange, which is to say, by a viewer reading a certain kind of technical information from the picture and by the picture's ability to display just that technical sign. Both were needed for the document to become a document. Now in fact, it was the many different technical uses for pictures that produced the different discontinuous families of documents, each of them with their own characteristics. But one can say, even so, that all documents contained technical signs, that these technical signs were lodged in the very appearance of the picture, and that they were engaged with an equally technical, but altogether human, and occasionally compassionate eye.

Atget's pictures, complete with their technical signs, moved back and forth in a crowd of professional looks. They worked behind the scenes and then, duty done, could expect to be buried in a file. When Atget called his pictures documents he was explaining that they circulated in the closed channels of painters' cartons, decorators' folios, and libraries' files, where individual pictures counted for little and the quality of the file was measured by its scope. Unlike Matisse and Baudelaire, he saw a dignity in this kind of picture. This puts Atget's ideas against the grain of so many others that it bears stopping to consider how to put this technicality together with our preconceptions about culture. We might first try calling the entire complex of documents and looks an archive, though not exactly following Foucault, who used the term abstractly to describe "the general system of the formation and transformation of statements," the general order of words and things.[12] A philosophical notion of the archive will not do as a defining concept when discussing knowledge after it has entered history, if only because it brushes over the specific little

archives, from Atget's own personal archive (part of it now institutionalized as the Atget Archive at the Museum of Modern Art) to the files kept by his clients, like the Bibliothèque Nationale or the painter Edouard Detaille. A general idea of the archive, like the general idea of the document, deflects us from the qualitative differences between the specific archives. And it discourages an examination of their essential incompatibility. For each of these archives hoped to establish its own special relation to a kind of knowledge, and sometimes to more than one kind. Each exercised its own power over its own strand of knowledge. In practice, the same documents could take on different roles in different archives; indeed the organizing principles of archives varied a good deal. The specific little archives did not come together like the French state, centralized, indexed, subject to a single authority, like panopticons or spider webs. It would have been impossible, as we shall see, for Atget to have developed a general, let alone a monolithic idea of the Archive, just as it would have been impossible for him to have developed a single idea of his own Oeuvre or his own Style. Those were ideas for philosophers. The heterogeneity of his culture of documents overrode such abstractions and rendered them obsolete.

A technical look took command. It was hardly an idle glance and never an aesthetic gaze. This look zeroed in on the archive and then on the document; it took the picture apart surgically and brought away what it needed. Any pleasure was practical; this culture was a culture of work. A far cry away from the Matissian armchair. Yet we can begin to understand more about the technical look by appealing to one of Matisse's great early champions, Roger Fry. Of course Fry was not, any more than Matisse had been, overly concerned with

the kind of look that gravitated toward the document; he used it mainly as a foil to the subject at hand in an essay called "The Artist's Vision" and published in 1919, an essay that has become something of a classic of formalist criticism. To explain his idea of artist's vision, creative vision he called it, the highest order of vision, Fry set up four orders of sight, ranging (in ascending order) from practical to curious to aesthetic to creative. Creative vision looked for significant form alone: "In such a creative vision the objects as such tend to disappear, to lose their separate unities, and to take their places as so many bits in the whole mosaic of vision. The texture of the whole field of vision becomes so close that the coherence of the separate patches of tone and colour within each object is no stronger than the coherence with every other tone and colour throughout the field."[13] It was the kind of vision that knew no history, no time or space; it lived in its own world. The artist's work was a function of this vision, said Fry. It asked for a viewer possessed of aesthetic vision, someone who understood this general, timeless language of form. Curiosity vision went one step down to a disinterested exploration of the object. The upper three orders were very different from practical vision, which cared very much about the fine, one might go so far as to say technical distinctions between objects.

Now practical vision, according to Fry, was the kind one used while shopping. It was virtually instinctive but based on experience: "We have learned the meaning-for-life of appearances so well that we understand them, as it were, in shorthand. The subtlest differences of appearance that have a utility value still continue to be appreciated, while large and important visual characters, provided they are useless for life, will pass unnoticed. With all the ingenuity and resource which manufacturers put into their

business, they can scarcely prevent the ordinary eye from seizing on the minute visual characteristics that distinguish margarine from butter. Some of us can tell Canadian cheddar at a glance, and no one was ever taken in by sham suede gloves."[14] This was the summum of practicality, as far as Fry was concerned, but then he did not extend his idea of visual culture to the world of work. His hierarchy of vision was anchored to a leisure-oriented tradition of culture, and because of this his hierarchy seems tender, not to say childlike, though it has never quite fallen down.

And yet his idea of practical vision can be pried away from its soft gloves and used to think about the working look. In the practical vision of the workplace, small distinctions and identifying marks—sham and Canadian, cut and dried, French and classical—mattered enormously, just as enormously as butter. An architect would use Atget's picture of the doorway of St. Nicolas du Chardonnet, for example (fig. 7), to look for the particular lines of style, the details of the construction, the play of proportions, and so forth, all of this knowledge to be applied to the business of architecture. The technical look took this from the document. Atget's photograph was not unique; it belonged to a line of similar pictures of that church door, beginning with Charles Lebrun's original design and including César Daly's engraving, one of the *motifs historiques* he collected into a portfolio in 1869 (fig. 8). In fact Atget was only repeating the motif in 1900, though he did not have the equipment necessary to take in the pediment and, by exposing the shot for the overdoor, he ended up with a document that featured a very bright street. And yet his photograph exhibited the requisite forms of the architectural document: the apparatus was kept parallel to the subject; the subject filled the

frame; no irrelevant detail poked in; maximum clarity was achieved; light fell as obliquely as possible from one side; the shadows gave maximum relief. The limits so tightened the genre that "art" photographers refused to associate themselves with it, claiming the work void of any independent thinking, or worse, any idea at all.[15] Atget kept out of the debate and obeyed the conventions as best he could, knowing the acceptable margins for deviance—for instance, when it was permissible to drop a pediment.[16] As a result, Atget's doorway exhibited the highly conventional, literally significant form of the architectural photograph, its technical signs comparable to the measured lines of the mechanical drawing. The document contained everything necessary to make itself practical for the architect. Patches did not blend together; the object was not lost. Practical vision assumed another, and often extremely specific order of representation in the image.

Without saying so, Waldemar George was describing this order of representation when he saw in Atget's work "raw, frank, and direct writing"; and he was describing this life's work of documents when he called it "a diverse and multiform repertoire of the Parisian flora, fauna, and architecture."[17] He understood that this repertoire did not have a single raison d'être of its own but was instead obsessively analytic: "Adget [sic] disdains panoramic views, grand syntheses, and synoptic tableaus. His preferred method is analysis, a magical analysis which transgresses the limits of perception, of visual knowledge."[18] A repertoire of raw analysis that required another repertoire of looks, clients' looks. Along with Atget's studio effects, Berenice Abbott bought a little black book, with *Répertoire* stamped across its cover. In French *répertoire* also means address book.

7. "Portes. Boulevard Sᵗ Germain. Paris. Sᵗ Nicolas du Chardonnet." AVP 3992. 1900. Bibliothèque Nationale, Paris.

8. César Daly, "Style Louis XIV. Eglise Sᵗ Nicolas-du-Chardonnet, à Paris—Porte Latérale," *Motifs historiques d'architecture et de sculpture d'ornement* (Paris: A. Morel, 1869), vol. 2, pl. 2. Bibliothèque Nationale, Paris.

The *Répertoire*

We are able to see the connections between the document and the client's look better after opening the *répertoire*. The book was unpretentious: it had a series of tabs with the letters of the alphabet dividing its pages up into sections; it had about one hundred pages, though some have been torn away, probably by Atget himself; and it had pages and pages of entries, names and addresses, some crossed out, some annotated, some cross-referenced, some cryptic, all of this written in no particular order it would seem. A count of all the names would come to 460.[19] The *répertoire* was very evidently the address book Atget used for his business. It tells us what kind of clients Atget had and wanted, in other words, what kind of audience his pictures were to have. It teaches us that Atget took his photographs around to a network of painters, illustrators, engravers, architects, decorators, sculptors, set designers, amateurs of Vieux Paris, libraries of many kinds, and publishers. It confirms Brassaï's account of the Atget he met in 1925, a chance encounter with a man on the job: Atget had come to the apartment of the picture dealer Zborowski (he dealt from his home) to see about placing his documents there (picture dealers could also sell documents for artists). Brassaï looked at the photographs too and asked a few questions. "I also learned," he wrote later, "that Atget considered himself not as an artistic photographer, but as a documenter capable of providing artists and decorators working for the theatre or films with any view of the city, any quartier, any street. Braque and Picasso were among his 'customers' and he had also supplied Utrillo with the material for his 'Rues de Paris.' Whenever he finished printing a set of photos, Atget picked up the attaché case stuffed with albums and went off on his rounds."[20]

Still, the *répertoire* does not tell everything about Atget's commerce. It does not breathe a word about any sales to Braque, Picasso, or Utrillo. It clearly does not record every client Atget ever had.[21] Neither Zborowski's nor Man Ray's name, for instance, was ever written in. There is equal reticence about Atget's early career and about his sales to the public libraries of Paris. The *répertoire* is but a partial record. And yet it immediately restates the abstract questions about form and knowledge, putting them back into a daily grind of pictures taken, pictures sold, aspirations, disappointments, negative numbers, and schemes; it gives those questions a density, a duration, a weight, and a singularity. The *répertoire* makes it possible to articulate the abstract questions differently and to deny them enunciation. One would not, after all, ask philosophers' questions of oneself on a daily basis, nor would they sound out, full-grown interpolations complete with their own quotation marks, from every photograph, every sale. Those questions were asked and answered intuitively over periods of years, probably without ever needing to be voiced or consciously thought. The problems posed by Atget's work went their way as he went his. They were always cloaked in detail. The *répertoire* gives us the nature of the detail very well. We move from the abstract not just to the particular, but to the exceedingly particular.

From the beginning to the end of his career as a photographer, Atget sold his pictures for public as well as private reference. In the 1890s, when he began, the briskest business was done in portraits and tourist views, but he commenced in a vastly more restricted area: sometime before 1892 he had located himself in Paris on the rue de la Pitié (now the rue Larrey, just down the hill from the rue Mouffetard) and was photographing for artists. Two art magazines reported this in their February issues, recom-

mending his "landscapes, animals, flowers, monuments, documents, foreground studies for artists, reproductions of paintings, will travel. Collection is not for general sale."[22] The second of these articles was overcome by irony as it reported on Atget's work, photographic piecework, it said, for Salon painters, but piecework it was: "Already he [Atget] has given aid and protection to a pile of Van Beers; he has gone to take a view of the rue de la Paix for M. Grandjean (the painted photograph was exhibited at the Volney); he has gotten himself all the way to Boulogne-sur-Mer to take 'naturally posed groups' of sailors for a certain Maronniez of the rue Faidherbe. But M. Atget sees big; he wants to see it all, take it all, sell it all. Hey, critics, pay attention, don't move, it's time to begin, the Salon is being prepared."[23] Sometime afterward he set up in the small city of Clermont, in the department of the Oise, near Beauvais.[24] In the late 1890s, probably 1897 or 1898, Atget moved back to Paris and expanded his repertoire to include views of Paris and the surrounding area, a decision most likely inspired by the creation in 1897 of a municipal commission to look after the historic sections of the city. This historic Paris, or Vieux Paris, would occupy most of his time from then on. His friend André Calmettes considered this decision to mark the true beginning of Atget's photographic career.[25]

With his sale on the 2nd of October, 1899, to the Musée Carnavalet, the city's history museum, Atget left an elaborate calling card (fig. 9) which drew the many aspects of his business into a flamboyant cartouche: the cartouche held a filmy view onto a monument, a foreground full of garden trees, a camera trained on two posed models, one of them holding a picture which was definitely not a photograph; the ensemble set a studio tone.[26] It set out Atget's business in much the same way as the art magazines had done in 1892, leaving many possibili-

9. Atget's carte de visite. 189?. Musée Carnavalet, Paris.

ties open. Even after 1900, when his business with the public collections solidified and he began to sell in volume to them, Atget did not concentrate all his energies on one single market. He never abandoned his work for artists: in a business letter written in 1902 he summed up his clients for his Vieux Paris collection as "les Bibliothèques–les Artistes–les Editeurs"; a sign advertising "Documents pour artistes" still hung on his door at the end of his career. Yet by 1902 he had designed a more austere printed calling card (fig. 10), with a sales pitch narrowed to appeal to the Vieux Paris market: he labeled himself "Auteur-éditeur d'un 'Receuil photographique du Vieux Paris' (monuments et aspects)."[27] Contemporary to the austere card is a makeshift handwritten one penned on the back of a postcard (figs. 11 and 12): "Documents photographiques," wrote Atget and gave his Montparnasse address. The postcard showed a widow and child mourning the events of 1871; the print was made by Emile Bayard and the photograph of it looks to be an early Atget.[28] Another such card, this one "Avant la Guerre," also became a carte de visite and identified Atget's wares as "Documents artistiques."[29] The discrepancies in the cards need not detain us: Atget's collection of documents always had several dimensions and Atget sold it where he could.

The records are best when it comes to the sales to public collections, since those places kept fairly good acquisitions records of their own and unlike Atget's ledgers, they survive intact. Atget regularly sold to the Bibliothèque historique de la Ville de Paris, the Bibliothèque Nationale, the Bibliothèque at the Ecole des Beaux-Arts, the Musée Carnavalet, the Musée du Sculpture Comparée, the Ecole Boulle, and the Bibliothèque at the Union Centrale des Arts Décoratifs, also called the Bibliothèque du Musée des Arts Décoratifs (see appendix 2

10. Atget's carte de visite. 1902. Commission du Vieux
Paris, Paris.

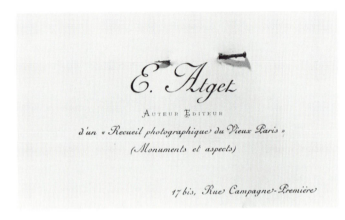

11. Atget's carte de visite, verso. Undated. Galerie
Octant, Paris.

12. Atget's carte de visite, recto. Undated. Galerie
Octant, Paris.

for a complete list of those sales). Between 1902 and 1904 he persuaded the Board of Education in South Kensington to buy 386 photographs. At some point before the war he sold 294 to the Bibliothèque de l'Arsenal. Just before the war Jacques Doucet bought 1,641 for his newly organized Bibliothèque Doucet.[30] With the exception of the Doucet and the Union Centrale, all of these libraries were run with government monies. Taking these facts into the calculations, the total number of photographs Atget sold to the French state amounts to 16,748 at the very least.[31] Atget was not blind to the fact that the state had been one of the mainstays of his commerce. In a series of letters beginning on November 12, 1920, to Paul Léon, director of the Beaux-Arts section of the ministry, asking if the Commission des Monuments historiques wanted to buy 2,621 of his negatives and a set of prints from them (the Neurdein's monopoly having blocked other kinds of sales there), Atget wrote, "Having been encouraged by the different state agencies, I prefer that the state be the one to profit from the ensemble of the collection."[32]

The state had not however been the steadiest of customers. Atget began to sell to it in 1898 in lots that varied in size, most of them titled *Vieux Paris* and *Environs*. The prints could arrive mounted on cardboard or, if destined for the library's loose-leaf folios, they might be mounted on the appropriate size and kind of paper or they might be delivered in paper albums. His business prospered at the Bibliothèque historique, but elsewhere Atget's sales declined after 1905. At the Musée Carnavalet and the Bibliothèque Nationale there was a sudden drop after 1905 and 1907, respectively, alleviated by new sales to both institutions only in 1910. At the Musée de Sculpture Comparée, Atget had a sporadic commerce, selling 30 prints in 1898, 300 in 1901, 109 in 1904; in 1906 an annual pattern developed: sales grew from 128 in 1906 to 175 in 1908, then dropped off to 99 in 1909 and 32 in 1910. The peak year at the Union Centrale and the Ecole des Beaux-Arts was 1906; over the next five years transactions dwindled to nothing. Sales to libraries perked up again just before the war. These shifts do not reflect Atget's fairly steady rate of production: they bear witness to tactical change. The *répertoire* indicates that Atget was switching his business from state to other, private sectors. After the war, Atget maintained a demure commerce with all but the Bibliothèque historique and the Ecole des Beaux-Arts. But the *répertoire* shows that then, too, he was turning his attention to other sides of his business.

The only access to Atget's private clienteles and the history of his dealings with them is by way of the *répertoire*. The *répertoire* has its drawbacks: initially it is hesitant, withholding for a time, then in a rush forthcoming, and finally restrained. The names listed there include both potential and actual clients, a good and useful record of where Atget wanted to sell but no account of where he actually did. Jules Bricard, *serrurier*, was a bona fide client. His name was listed in four places, on pages 5, 6, 18, and 50: on pages 5 and 50 just his name was inscribed; on page 6 we read "Bricard 39 Rue Richelieu (après midi 2h–Grilles et Heurtoir) Vu toute la collection–4645 Inclus–excepté Grille St Sulpice 7 janvier 1903–(23.x)" crossed out; on page 18 "Jules Bricard (Heurtoirs et Escaliers) le matin" stayed untouched.[33] Seventy Atget photographs dating from 1900 to 1911 can now be counted in Bricard's collection.[34] Jansen, *ameublements*, a more ambiguous case, was equally bona fide, albeit his name was entered only once, on page 37, "Mr Jansen–ameublement Demander Mr Brivois (Dessinateur)," and crossed out. But forty-four Atget photographs dating from 1899 to 1910 are still to be found in the folios kept by the Jansen designers.[35]

The *répertoire* did not pretend to collect all of Atget's clients any more than it kept track of all the visits to them. On several pages other *répertoires* are cross-referenced, sometimes by category:

page 4 Voir – Ferronerie, Tapissiers etc. etc. dans le livre précédent Marbriers – Sculpteurs s/ Bois – Ornemanistes – Ameublement

page 10 Voir Cinéma – adresse dans le petit livre

page 36 Voir les Joailliers – Bijoutiers – Brodeurs – Graveurs s/ verre – (avec Ferronerie)

page 61 Voir Fondeurs – Val Dosnes – Durene – etc., Fageret 742

And sometimes by name:

page 17 Cancalon _____ page __13
 Clairin _____ " 15
 Chaperon _____ page __21

page 49 Jambon __ page – 7

page 85 Ronsin et Cie – page 23

Within the extant *répertoire* scars of Atget's revisions are evident. Between pages 26 and 27, pages 52 and 55, and pages 93 and 94 a page has been torn out; between 56 and 61, two pages. None of this is very mysterious. The surviving *répertoire* went through several phases, its status changing as Atget cut out and tested his markets. First it functioned as an auxiliary, finally it was promoted to the rank of principal

address book. The *répertoire* becomes a reveal-
ing document of Atget's business but only when
professions can be assigned to the names, and
dates to the addresses. The facts will take shape
as particulars and the particulars will enable one
to sketch the broad lines of Atget's commerce
from the 1890s to the end.

Initially Atget used the alphabetical order in-
herent in *répertoires*. Centered and writ large on
the appropriate pages he listed

page 1 Arts Décoratifs (Bibliothèque)

page 5 Bibliothèque Ville de Paris Rue
 Sevigné

page 17 Carnavalet (Musée
 Cancalon _____ page __13
 Clairin _____ " 15
 Chaperon _____ page __21

page 19 Cancalon

page 20 Cuviller (6 quai d'Orléans)

page 21 Cavalier Col

page 35 Ecole des Beaux Arts

page 45 Mr Hartmann
 Vieux Paris 3956 Inclus son associé
 – a lui fourni
 les petits métiers de
 3211. à 3243 inclus 2ᵉ série

 Petits métiers 3243" 3 8bre – 60.00
 Vieux Paris – du No 3957 à 4172.
 Inclus –
 164 Ep – (Vendu 41 Ep – 20x50ᶜ)
 – 15 Mars 1901 –

page 49 Jambon____page – 7

page 67 Nationale Bibliothèque Mr Bouchot
 Conservateur

page 75 Perrin Père et Fils 8 R des Ecoles
 Pardinel 5 Rue Bonaparte
 Vieux Paris – Jusqu'au No 4431
 Inclus

page 85 Mr Riat – Bibliothèque Nationale
 18 Ep Versailles – plus 6 livré (fin
 Octobre 1901)
 Ronsin et Cie – page 23

Entries like these obeyed a system. The four-
digit numbers referred to Atget's negative
numbers, which were presented to his clients
according to subject (Ep is Atget's abbreviation
for *épreuve*, meaning print). Prices, details of
sales, and dates were rarely given in the address
book; in this the early entries were extraordi-
nary (for a list of clients and their professions
see appendix 3). Not every name was correctly
spelled (all transcriptions of Atget's writing
given here preserve its eccentricities).

Atget began his business with the large
libraries between 1898 and 1900. Since the
Musée de Sculpture Comparée did not figure
into the *répertoire* in any way, we may assume
that the *répertoire* was begun sometime during
1900, before his large sale there in 1901. When
Atget realized the size and pace of this library
business, he drew a horizontal line through all
these entries and adopted a different system
for keeping track of them. A system which has
been lost. A few private clients also appear in
this early group, architects (Cuvillier and Périn)
and Vieux Paris amateurs (Hartmann, Pardi-
nel, and Riat); entries for three set designers
(Cancalon, Chaperon, Jambon) and a painter
(Clairin) refer to another book. For one reason
or another, these were also crossed out with one

slash and moved elsewhere (Cancalon, Cavalier Coll, and Jambon reappear in later phases of this *répertoire*). The exceptions are "Arts Dec (Bibliothèque)" (an oversight?), Hartmann, Pardinel, and the short list of names on page 17, still valid perhaps and not fitting well anywhere else. They would eventually be x-ed out.

Also still valid was the first list of illustrators appearing on page 15, filed mysteriously in with the Bs. It is short and seems more like an idea than a working list, datable by Rudaux's address, which changed in 1901:

Illustrateurs
Zo
Garrat
George Conrad
Antony Troncet
Barrère
Henri Rudaux – Rue Clauzel 10

The Salon artists with whom Atget did business in the 1890s were left behind in this phase of the *répertoire*.[36]

The *répertoire* lay relatively dormant and quite empty for the next three years. A few names were added and short, dated notes made, none of them recording business on a grand scale but interesting now for their relative expansiveness:

page 5 Boileau architect (142 R du Bac)
 Vu la 1 et 2ᵉ série des Portes
 Vu la 3ᵉ série Portes and la 1ᵉʳᵉ série
 (architecture) Xᵇʳᵉ (6.x)

page 6 Bricard 39 R Richelieu (après midi
 2h – Grilles et Heurtoir) Vu toute
 la collection – 4645 Inclus –
 excepté Grille St Sulpice 7 janvier
 1903 – (23.x)

page 7 Beaulieu – 7 R Crevaux Les Portes
 Heurtoirs etc. Reste à lui faire voir
 l'année – 1902 – Vu jusqu'au [?]
 de la 3ᵉ Série (Janvier 1903

page 17 Clairin 62 Rue de Rome matin vers
 10h Part Detaille 1 x 1 x 25. Vu la 1ᵉ
 Série de Versailles 15 janvier 1903

page 37 Flandrin 15 quai Bourbon – Flandrin
 Vu la 1ᵉʳᵉ et 2ᵉ série des Portes
 (Décembre 1902)

page 95 Sigwalt 20 Rue Toqueville le matin
 montré la 1ᵉ série et la 3ᵉ
 Portes – fontaines etc – 17 avril 1902
 – (5 x 00 –) (montré la 2ᵉᵐᵉ série
 Portes 2 Xᵇʳᵉ 1902 – (10x).

A more workable list of illustrators was set down quite summarily on page 13:

Parys R Notre Dame des champs 83
Bombled Rue Cauchois 15
Damblans Rue Caulaincourt 55
Enjolras Rue Laugier 21
Jean Geoffroy. Rue Soufflot 15
Hernandez Fb St Honoré 235
Rochegrosse Bd Berthier 61
Sabatier R St George 52
Vogel – (Leloir – Mardi)

At this stage the *répertoire* contains the germ of Atget's Vieux Paris, building industry, and illustrator clientele, none well developed. The other books recorded Salon artists, set designers, institutional clients, and the early sales to publishers; this is exactly the group Atget himself named to the South Kensington Board of Education in 1902, when he summarized his business as "les Bibliothèques–les Artistes–les Editeurs."

In 1905, when he reorganized, weeding and expanding this base, the *répertoire* that survives came into its own.

Around 1905, but not before, Atget began to fill the *répertoire* page by page using any remaining space, starting with page one, and jettisoning any alphabetical order.[37] The remaining few dates supplied by Atget fall into this new chronological scheme and none of the data available in the Bottin or the archival documents for his clients contradicts it. The new round of names was probably culled from the other address books to make a working miscellany of clients attached to the building industry. The "livre précédent" (preceding book) cited by Atget on page 4, where one could see the names for "Ferronerie, Tapisseriers etc. etc." and "Marbriers–Sculpteurs s/ Bois–Ornemanistes–Ameublement" (Marbleworkers–Wood Sculptors–Ornamental Workers–Furniture) probably held the unrefined lists: eventually one finds all of these types in the *répertoire*, though never listed in rows the way the illustrators are. On page 5 Atget made another kind of distillation, probably about this time but certainly before the death of Victorien Sardou in 1908. It collects the names of noteworthy clients, most of whom will be entered in the *répertoire* in more detail more than once.

Mareuse	Devèche	Amable
Jambon	Bergeote	Parent (archᵗᵉ)
Grasset	Rateau	Flameng
Cancalon	Gegoudez	Vogel
Clairin	Roescher	Goelzer
Sardou	Detaille	
Chaperon	Loichemolle	
Ronsin	Lalique	
Guiffrey	D'albret	
Flandrin	Fortuny	
Paul Gervais	Guillemant	

Lehec	Destailleur
Kolukosski	Gaston Bideaux
André Michel	Valet
Vian	Sergent (architecte
Vinant	Bercia Tourette
Huvé	Ternisien Dantant
Risler (arch^te)	Bakés
Girault	Leloir
Cruchet	Lemeune
Lafon (architecte)	Forgeron
Jules Bricard	Jusseaume

Atget was in league with men at the top of their professions: Edouard Detaille was president of the Société des Artistes Français as well as a member of the Commission municipale du Vieux Paris; Victorien Sardou was a celebrated playwright (*Tosca* is his) and respected too as a member of the same Commission municipale; René Sergent built residences for the Comte de Camondo, the Duveen brothers, Jay Gould, J. P. Morgan, and others like them; Lucien Jusseaume was principal set designer for the Théâtre de l'Odéon and the Opéra-Comique.[38] The record of others, like Eugène Grasset, master of the poster, André Michel, curator at the Louvre, and Charles Girault, architect of the Petit Palais, could be cited but the point has been made. Men like these were the pillars of Atget's commerce.

Somewhere in the neighborhood of pages 10 and 11, transcription stopped and commerce began: the *répertoire* shows Atget getting tips on prospective customers, ruling out the dead ends, correcting addresses, skipping to the pages showing indexes of names by trade, improving upon them, then jumping back into the miscellaneous melee (fig. 13). On pages 21 and 22 he incorporated the set designers, eventually, circa 1908, listing them separately on page 33.

The list of illustrators on page 13 was kept active and a new page entitled "Dessinateurs et Peintres et Dessinateurs industriels" was begun on page 26. The page devoted to "Décorateurs—appartements," page 34, sums up the mixed bag of peintre-décorateurs, ébenistes, menuisiers, etc. from the building industry; one wonders why Atget even ventured the heading. Someone gave him the names of some American architectural magazines for page 36; on page 40 he made a grand list of private libraries, mostly de Rothschild. On page 42 the *répertoire* reverted back to the normal jumble.

It continued along in this manner until page 48, when Atget picked out the active names from pages 1 to 34 and consolidated them on that and following pages, referring once to the inventory of "Décorateurs en théâtre" on page 33.[39] Since page 32 is dated "15 déc. 1909" and an addendum on page 44 records a "6 déc. 1911" visit, this process of tailoring probably took place around 1911. At this time also the illustrators lists show signs of his attention: Lanos's address on page 13 was corrected and a string of new names was added to page 15, sometimes telling who referred Atget to the illustrator in question (*part* meaning *de la part de*):

Lanos – Rue Bonaparte 15
 le matin de de [*sic*] 10h à midi

———————————

Machiati – Malteste 33 Bd de Clichy –

———————————

Parys – 93 Rue de Vaugirard)
A Troncey
Conrad George
Zo
Wely
Barrère

Henri Rudaux – Rue Clauzel 10
Guillonnet – Bd de Clichy 60
Markete Rue St Didier 50
Orazi Rue de L'Orient 8 (Part Garcia
Tinayre Rue du Four 15 (Part Vogel)
Tofani Bd des Batignolles 82

Between 1912 and 1914 a new list of "Décorateurs en théâtre" appeared on page 67. By page 70 we find postwar addresses and sections labeled for "Editeurs," "Editeurs, Hommes de Lettres–Suite," "Artistes etc.–(suite)." For the next eighteen pages, the *répertoire* gives solid evidence that through the 1920s Atget remained very much in the same kind of business he had had before the war.

Atget worked sometimes on commission, but generally on spec.[40] Typically he addressed sectors of clients. These sectors defined themselves for Atget. The painters most often referred Atget to other painters; the members of the building industry referred almost exclusively to each other; with the set designers and the Vieux Paris amateurs the same clubhouse attitudes held. This would have encouraged Atget to think along the lines of the various professions and to map out his documents according to their functions. As he did his business, Atget was led to think in categories. These were the categories of practical vision.

All this meant that Atget produced documents in kind. The variations in his market caused some fluctuation in the way Atget ran his business but in essence the work was standardized, the documents were regular. He was always working for the same kinds of clients, with their same requirements for documents. His documents were their documents too.

13. Atget's *répertoire*, pp. 26 and 27. Museum of
Modern Art, New York. The Abbott-Levy Collection.
Partial gift of Shirley C. Burden.

The Artists

André Calmettes said that Atget's traffic with artists was saved one fine day by a painter named Luc-Olivier Merson.[41] It must have been a fine day in the 1890s, when Atget was putting together his documents for artists on the rue de la Pitié. Atget would traffic steadily with artists for the remainder of his life, even as his business divided and diversified. He kept up his early stocks of documents for Salon painters, in mid-career he developed a series of city pictures for cartoonists and illustrators, and after the war extended both lines of work. A group of nudes was commissioned from him in 1921 by a Cubist painter, André Dignimont, who was preparing a book on Parisian prostitutes and asked Atget to go out photographing them, their houses, and their clients. Atget had arrived to show him photographs of Versailles; very nice, Dignimont had remarked, but I need something else.

We may take this as a characteristic moment in Atget's conversations with artists. His pictures had to keep up their end if the dialogue were to forge ahead; a good subject like the garden of Louis XIV was not always enough. The documents for artists were plunged into long, evolving exchanges with painters' needs; they were forever bending themselves to the visual situations demanded of them; they accommodated a host of technical requests. For Dignimont's project Atget went back out to Versailles, this time to the brothels; and he went up to the chipped, working-class area around the port of La Villette, the place where most goods bound to and from Paris were unloaded and prostitutes clustered on the side streets, *faisant leur quart*. The nudes went together with a series that included views of prostitutes stationed on the sidewalk (fig. 14). Up at La Villette, on the corner of the rue Fleury and the boulevard de la Chapelle, he was stopped by the police: Atget pulled out a card that gave him permission to photograph at the Ecole des

14. "La Villette, rue Asselin, fille publique faisant le quart devant sa porte, 19ᵉ. 7 mars 1921." AVP 6218. Museum of Modern Art, New York. The Abbott-Levy Collection. Partial gift of Shirley C. Burden.

Beaux-Arts or was it the Louvre; it met with sarcasm. "Old man," said the policeman, "I know your fine arts."[42]

Atget's other work for artists was more respectable. He appears to have helped the military painter Edouard Detaille by supplying him with figure studies and decors. Some of this work may have been specially commissioned: Atget's *répertoire* notes the name of Detaille's model Verecchia on page 42, a page that dates to 1910 or 1911. Those photographs have not survived so that one might see their dialogue with Detaille's last paintings (Detaille would die in 1912). Detaille however appears to have bought as well from Atget's regular stock, plants, *petits métiers,* and a mill in the Somme (fig. 15). The mill was one of Atget's earliest documents from the 1890s; when Detaille bought it, no one knows. But it appeared, modified by artistic license, in at least two of his paintings. Maybe Detaille liked the way its stair elevated the action above the troops and projected it beyond the frame: in both paintings we are shown the lookout looking out (figs. 16 and 17). In both the mill has been converted to the business of war. The first painting, *En observation dans un moulin*, was an undated study for another project and, like a good study, it narrowed its focus to work on one aspect, here the integration of the troops with the mill. The axes of the mill's stair and arms provided the heavy foil for the unseen but nevertheless gripping lines of sight. Much the same kind of thing happened in the other painting, *Les renseignements à l'Etat Major* (1903), though its comparative finish enhanced the secondary anecdote, added to the confusion of gazes, and probed the facial expressions of the assembly to capture the degrees of gravity. Detaille took battle seriously. Atget's mill did not suggest battle, of course; it was angled and framed so as to show the splay of the stair and its brace. The document was a willfully

incomplete composition that wanted filling; it could only suggest an appropriate place to begin, a decor. The decor could lie anywhere in the document: the surfaces of buildings, the hollows in the scene, the play of light across wood or stone. These details would be caught by the painter's eye, considered, and if accepted, they would be transformed in the course of painting, much the way cotton would be spun into cloth. Decor was not to predict action, but to lie waiting for it, a hollow surface and nothing more. Detaille would give this mill two different wars; he was exploiting the forms of the photograph, extracting their value, and converting them to paint.[43] In this he adhered to one of painting's customary labor practices. The photograph helped to hold the world of appearances still for a while, so that the painter could look longer, trying to fathom the connections between volumes and tones, dwelling upon the details of things as long as necessary. The painter had to compensate for the way in which lenses made a perspective and for the way emulsions rendered tones, but none of this made the photographic study worthless. Far from it.

There would always be a gap between the document and its use. The document being available to any number of possibilities would begin the exchange but it would be unable to control the outcome. The painters would do as they pleased. Copying was not normally part of their pleasure. Atget's documents for artists could then serve various kinds of artists painting in quite disparate styles, realists, Cubists, eccentrics like Utrillo. Jean-Emile Laboureur, an artist who cast his lot with the modern style, followed much the same procedure as Detaille, the uneven scanning, appropriating the lines or details of a photograph that seemed relevant, giving the photograph no real say, cutting it off. In 1920 Laboureur took the decor toward the

depiction of modern life in his engraving "La fille au litre," which is based on a photograph of Atget's in his collection, "M^d de Vin Rue Boyer 262" (figs. 18 and 19).[44] The bar was given a *fille* stopping off to take a drink, market basket in one hand, bottle in another. Suffice it to say that her look out was not comparable to the one Laboureur used on Atget's photograph. Whatever he saw there, he found little of immediate practical application. Evidently he did not care much for the spatial set of the document. He plucked details: the curve of the zinc, the row of bottles, the squared-off corner of the mirror. They were then softened, sharpened, or largely forgotten in the rush to make the space bow out into a stylish Cubistic corrugation; the bar got its pleats, but the points of view were not rigorously shuffled; the decor dissolved haphazardly around the decidedly solid body of the *fille*.

Atget's documents for artists were integrated into this elastic and seemingly arbitrary process of looking and studying. The painter stared at the study both to learn something from it and to muse upon it, trying to see beyond the image to another picture, a greater aesthetic truth. There was a constant dialogue between the points the photographer found salient, like the undulation of the bar or the slope of the brace, and the points the painter would ponder and reform. Though in the end give succumbed to take. The document for artists had its conventions. They went together with the distinct role the document played in the actual process of painting.

The photographic document was made to fit into the place of the painted *étude*, an early stage in the making of an easel painting, falling between painted sketch and finished painting, the moment when detailed study from nature was warranted. When Ernest Hareux in his *Cours complète de peinture à l'huile* (1901) instructed his students on the value of this kind

15. [untitled]. 189?. PDd 54. J. Paul Getty Museum,
Malibu. Formerly Edouard Detaille Collection.

16. Edouard Detaille, *En observation dans un moulin*.
Musée de l'Armée, Paris.

17. Edouard Detaille, *Les renseignements à l'Etat Major,
1805*. 1903. Musée de l'Armée, Paris.

18. "Md de Vin Rue Boyer." 1911. Pp 262. Gilman Paper Co., New York.

19. Jean-Emile Laboureur, "La fille au litre." Second state. 1920. Bibliothèque Nationale, Paris.

of study, he explained, "The study is only the document, the notation of an effect of the ensemble, a tone, a value. Sometimes it is like a model for the execution of the canvas in the studio, a model that calls to mind the precise form of the object when one is no longer face to face with nature. In a word, the study is the dictionary ready to supply information about that which has slipped from mind."[45] *Etudes*, the painter's documents, were made for specific projects, but they were also made on spec and stockpiled; collections of them, drawings, paintings, prints, and photographs, were filed away in boxes and tacked on studio walls, ready for a lifetime of use. The visual world was studied in its parts, the parts, that is, that figured into the established genres. The document became the painter's means for taking the genres apart, an instrument, we might say, of decomposition. Essentially this boiled down to two kinds of pictures, studies of figures and studies of ground.

Figure studies covered both anatomy and clothed figure types, occupational types told through identifying costume and ritual gesture. Some of this typing had come down from the old physiognomic tradition, some of it was physiognomy modernized, some of it struck out into new zones of gesture and social ambiguity. Certain types had weathered the collapse of the hierarchy of genres and the homogenization of big city life pretty much intact. The *petits métiers* were one such group; the *parisienne* was another. Atget's series of *petits métiers*, done between 1898 and 1900, worked well as artists' models. Compare, for example, the sample *étude* provided by Camille Bellanger in his *L'art du peintre* (1911) to Atget's "Cremière" (figs. 20 and 21).[46] Bellanger's market woman struck a pose of informal interrogation, appropriate enough to her trade, but it spilled forth from an hourglass figure, suggesting infinitely more.

20. Camille Bellanger, "Marchande," *L'art du peintre* (Paris: Garnier frères, 1911), vol. 3, p. 31. Bibliothèque Nationale, Paris.

21. "Cremière." 1900. Pp 3282. Bibliothèque Nationale, Paris.

Atget's woman was shown in a less dramatic movement, her gesture with the bowl a bit hesitant, not making the full offer; she was not an hourglass. Her body went through the motions of a sale; the thoughts registered on her face had drifted somewhere else. But faces counted for little in this business of figure studies. Even the figure was never copied in its entirety. Jacques Beltrand turned Atget's scissors grinder into a line drawing, lifted from his surroundings and reversed left to right (figs. 22 and 23). Another artist named D. O. Widhopff pushed an Atget market scene into the middle distance, where the figures were just a source of atmosphere, haggling and rushing, behind the solitary young man who, so the story went, envied them their activity.[47] Atget's early series of *petits métiers* and crowd scenes found their way into all manner of image, from Salon paintings to cheap book illustrations.[48]

Landscape painters had their own figures. Flowers, trees, and plants. These painters wanted to see the different species in different seasons to get the sylvan body right, to see the lay of the leaves, the spread of the branches, the forks and joins at the trunk. They wrote about what for many of them became lifelong study and published models and manuals. By the end of the century they had produced a substantial body of literature. Ernest Hareux wrote such a manual, so did Karl Robert and Armand Cassagne, all of them providing their reader with illustrations (figs. 24–27).[49] Photographs could supplement studies like these or generate others. Atget fashioned landscape documents for just those fates.[50] His water lilies (fig. 28) made a brilliant foreground, lilies central, pads focused, the water cut sharply. His willow trees (fig. 29) held their ground, haggard, hale, and split with age. His chestnut tree trunk (fig. 30) made two

22. "Remouleur." 1899. Pp 3212. Bibliothèque historique de la Ville de Paris.

studies at once, so the caption said: there was the sturdy study of the trunk, its scales of bark and line of ivy; there was the *effet,* or study of light and air, read in the translucent run of dark and dapple. *Effets* were more commonly done as far distance studies and often capitalized on deep water reflections, as in Atget's document of the Marne (fig. 31) where the light and shadow have cut into all substance, turning everything to air. The landscape in pieces could take on a spectacular grandeur. Impressionist landscape painting stopped there, as if study alone were beautiful and profound enough.[51] As a result, Atget's photographs shared a superficial resemblance to that painting, but their relation to modernism was tangential and can only be argued by recourse to the document.

Most of the time Atget's documents did not even so much as dialogue with modernists. Albert Guillaume took Atget's pictures of Cécile Sorel's apartment and used them to back up a dumb dirty joke about one Mademoiselle Zizi Panpan (a name that translates, not so roughly, as Miss Make-Love) (figs. 32 and 33). When Guillaume was interviewed by *Lectures pour Tous* in 1913, he was asked to describe his working procedure. Guillaume explained that his eye was like a camera, registering the images passing before it, and never bothered to mention that his eye also relied upon photographs.[52] This was the kind of fate Atget could expect for his documents, thankless. Nonetheless they were always prepared for a larger project. They were meant to refer beyond themselves, to be taken up repeatedly, to have several futures, and to exist as a point of detail on the way to one of them. They were meant to be incomplete.

The painters' treatises said as much about such studies. Hareux discussed one of his illustrations depicting the stone bank of a stream as a prologue as yet empty of action. But, he explained, the painter's imagination populated the stony shore: "When we stopped before it, struck by the picturesqueness of the form and drawn to the vigor of the effect, we thought only of painting this terrain, but little by little, in assembling the study, we imagined figures and animals passing over the land, several subjects for paintings presented themselves to the mind and ultimately they were realized." Action, be it figural or animal, followed as an inevitable, if for the moment invisible, consequence. For studies of streets, Hareux insisted that figures and traffic be included; if not, "one would only make cheerless, lifeless landscapes, like those we have crossed in wartime where the inhabitants had fled the approaching enemy."[53] Wider studies of streets and stretches of landscape, most of Atget's photographs, as it happens, were properly classed as backgrounds or decor. For an artist they read literally as scenes waiting for action. The fact that Walter Benjamin, reviewing the first Atget monograph in 1931, did not see Atget's pictures as *études* but instead felt them to be vacant like scenes of a crime (or by some translations, action) reinforces the point.[54] The photographs in their capacity as documents asked for a narrative, dramatic action, a relation to a larger whole; they anticipated a look that would pirate; they also expected a look that would supplement. Each kind of document however worked off a different profile of possibilities; the nature of the supplement varied with the genre. This much can be said of all documents for artists: they anticipated a look that would see ahead to fully brushed and well-populated landscapes, characters, narrative action, and punch lines, the horizon of expectations in the artists' practical vision. Space in those documents left room for a look; more than that, it signified absence.

23. Jacques Beltrand, illustration for Tristan Klingsor and Jacques Beltrand, *Petits métiers des rues de Paris* (Paris: J. Beltrand, 1904), p. 81. Bibliothèque Nationale, Paris.

25. Karl Robert, "Etude des saules," *Leçons pratiques de dessin au fusain appliquées aux modèles du cours de paysage de A. Allongé* (Paris: Goupil, 1876), pl. 15. Bibliothèque Nationale, Paris.

24. Ernest Hareux, "Les Nénuphars," *Cours complète de peinture à l'huile (l'art, la science, le métier du peintre)* (Paris: Laurens, 1901), vol. 1, p. 57. Bibliothèque Nationale, Paris.

26. Armand Cassagne, "Pied d'un chêne," *Guide de la nature chez soi (suite aux modèles à silhouette)* (Paris: Fouraut, 1886), fig. 212. Bibliothèque Nationale, Paris.

27. Armand Cassagne, "Pavillon carré au bord de l'eau, vu sur angle," fig. 202. Bibliothèque Nationale, Paris.

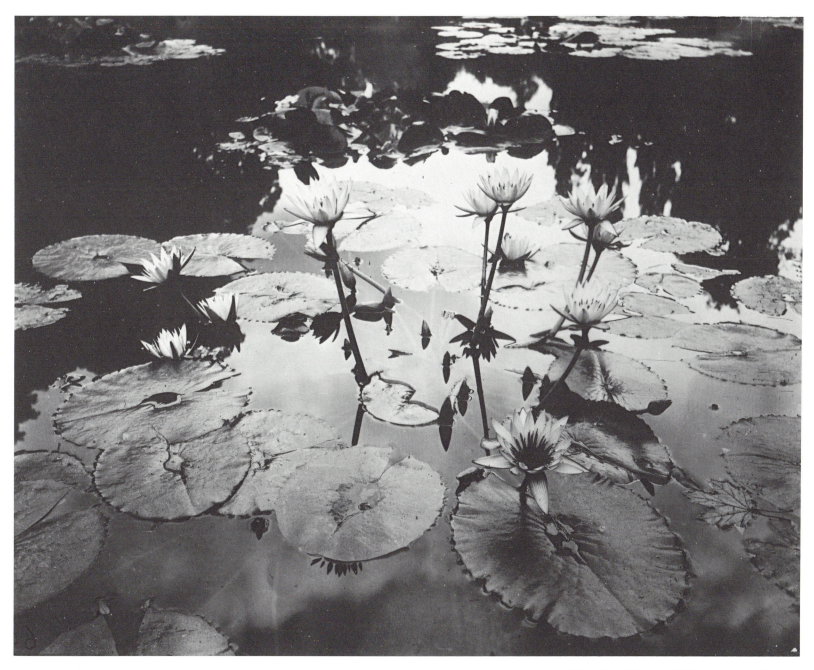

28. "Nymphaea." Ca. 1910. PDd 697. Museum of
Modern Art, New York. The Abbott-Levy Collection.
Partial gift of Shirley C. Burden.

29. "Saules." 1925. PDd 1245. Museum of Modern Art, New York. The Abbott-Levy Collection. Partial gift of Shirley C. Burden.

30. "Trianon, marronnier, effet de soleil." Ca. 1910. PDd
743. Museum of Modern Art, New York. The Abbott-
Levy Collection. Partial gift of Shirley C. Burden.

31. "La Marne à la Varenne." Ca. 1927. PDd 1289.
Museum of Modern Art, New York. The Abbott-Levy
Collection. Partial gift of Shirley C. Burden.

32. "Intérieur de M^elle Sorel, de la Comédie Française,
99 avenue des Champs Elysées." 1910. PDd 754. Musée
Carnavalet, Paris.

33. Albert Guillaume, "Souverain Mépris," *Le Rire*,
no. 594 (20 June 1914). Bibliothèque Nationale, Paris.

The Set Designers

Set designers made decors for a living too. Atget was in a rather good position to exploit this market, as he had first attempted a career in the theater as an actor. In 1879, at the age of twenty-two, he had entered the national conservatory in Paris to study acting, and though he was dropped from the program two years later, he had obtained enough to begin a career, though it was not exalted.[55] He appears to have toured the provinces and the suburbs for a good fifteen years, playing what were called third roles, traitors, villains, and character parts. This gave him a rather good understanding of staging, though he probably did not strut and fret his own hour in front of extremely elaborate sets. He had however made some good connections from his years at the conservatory, like his best friend André Calmettes, who was known as a director, eventually of the Théâtre de Strasbourg, and Victorien Sardou, whose productions made optimum use of the set designers' art. Perhaps they helped Atget to put together his clientele, which included the leading set designers of Paris. Not much is known of his dealings with this group, though the *répertoire* contained two separate lists of their names, both from the period before the war.[56] The second read as follows:

Décorateurs

Bertin Rue du 34 Rue du Plateau 34
De Cassina et Roger R. de l'Hermitage 53 [Bis]
Chapuis R. de La Condamine 12
Duverger Rude Mercadet 201
Paquereau Rue Charles Friedel 10
Monviau 63 Rue Desnouelles (Cᵉ Rue
du Vaugirard
352

Amable –
Jusseaume –
Jambon –

Maréchal – R. des Alouettes 33 et 35 –
Maréchal Olivier, Avenue Gambetta 243.
Numa et Chazot, 50 Bᵈ de la Villette
Chambourlouron et Mignard Rue Vic d'azir.
Simas, 64, R. David d'angers.
 métro: Nation Danube Direction Pré St
Gervais.[57]

None of the annotations he made for these designers was ever very telling with regard to what he actually offered them for sale. Earlier, Atget made a bid for the film market, trying such studios as Gaumont and Pathé frères, though it is not known what transpired.[58] According to Brassaï, Atget was still working in both these sectors in 1925.

The special needs of theatrical set designers were not far removed from those of history painters like Detaille. Gigantic, sumptuous, veristic scenery being the order of the day, set designers had to become "perspective experts, archaeologists, costume designers, ornament workers, landscapists, portraitists, architects, painters and draughtsmen, to be able to create at will, with color's awkward help, the most marvelous countrysides, sumptuous palaces, forests or seas; to change point of view continually, to pass from outdoors to indoors, from day to night, from fair skies to storms, in a perpetual kaleidoscope of white canvas and painted canvas."[59] To meet these demands, they kept large libraries of documents—sketches, photographs, and postcards. In 1902 the Vicomte d'Avenel described the entourage of documents chez Atget's client Marcel Jambon: "All around him piled up in crates are innumerable nature studies of the most diverse subjects: mountains and monuments, sunsets and sides of raw meat. To compose historic or mythological scenes the painter turns for inspiration to the world's frescoes and miniatures: at the Opéra Comique, in *Orpheus*, the home of happy shadows, a masterpiece of grace and taste, was borrowed from Puvis de Chavannes's *Sacred Wood* and from Botticelli's *Spring*."[60] Nothing escaped the set designer's gaze; it too needed the fine points. But the set designer did not specialize in a single genre as the painter tended to do; sets followed the direction of the theater. And so the set designer's visual needs were voracious, ranging, boundless; the archive of the set designer had to be an encyclopedia where all points might be starting points.

When Gustave Coquiot wrote his *Nouveau manuel complet du peintre-décorateur de théâtre* in 1910, he included a section on documents and cited Atget's client Lucien Jusseaume as the model to follow; it would not be too much to say that Atget's photographs were probably contributing to his definition of a document. To illustrate his text Coquiot used his own drawings of suitable documents, but the parallels with Atget's kind of photography are apparent. Set designers wanted decor, like an empty street (fig. 34), a courtyard, a landscape or a Dutch master painting minus its dramatis personae. All of this would, Coquiot explained, be submitted to the eye of the designer, who would extract the necessary: "He will carry in his head the singular ability to seize the characteristic aspect of whatever he sees wherever it may be. In a museum he will see the essential 'aspects' of the painting, sculpture, and architecture; in front of nature he will instantly imagine the 'decor to be made'; and if he fears that his memory might later betray him, then he will note down those precise lines, those picturesque silhouettes that bring out the style."[61]

One can see from the photographs Atget sold to another designer, Mariano Fortuny, that these documents too were at the same time empty and full (fig. 35).[62] Like the painter, the designer mounted an archive of potential motifs from which to work up a scene, but single

35. "St Gervais et Protais." 1899. AVP 3791. Museo
Fortuny, Venice. Formerly Mariano Fortuny Collection.

34. Gustave Coquiot, "Un décor architectural. (Maison
du XVᵉ siècle, au Mont-Saint-Michel.)," *Nouveau
manuel complet du peintre-décorateur de théâtre* (Paris:
Roret, 1910), p. 103. Bibliothèque Nationale, Paris.

motifs were only part of his problem, which
was first of all to produce a theatrical space.
The space in the photograph of the alley flank-
ing St. Gervais and Protais would be turned,
enlarged, and adjusted to fit the stage. It might
be reproduced in some combination of wood,
plaster, and canvas to fake a solid stone wall
or it might simply be painted on a huge sheet
of canvas to look like one. It would be given
another lighting scheme probably (Fortuny was
famous for his lighting effects) and it would be-
come larger than life. More to the point, the
decor would redistribute the planes of space in
the document in order to make its own perspec-
tive. It would separate out the levels of space,
foreground, middle ground, far distance, in the
photograph, allocating them to flat, generally
illusionistic planes, wings of scenery, or a great
perspective backdrop. The wings and backdrops
would rise and fall in combination. Conceivably
the foreground motif of one document could
end up on stage with the far distance of another.
Very few of the set designers' archives have sur-
faced, which makes it difficult to know just how
Atget worked his photographs in relation to
their needs. We might hypothesize documents
ever more attentive to the preparation of wings
and backdrops, separating the perspectives
of the document into planes useful to the de-
signer. That would help account for the strains
in some of these spaces, the gaping foregrounds
backed up by tentative, intervening screens of
buildings or foliage, the uneven grading of the
distances. How much of this was conventional?
We might compare the series of photographs
done by the Séeberger frères for an American
agency that supplied Hollywood movie studios
with Atget's decors of the 1920s.[63] The Sée-
berger frères began work on the project in 1923
and continued until 1931, when this view of the
Dome was made (fig. 36). It took advantage of

36. Séeberger frères. "Le Dome." 1931. Caisse nationale
des Monuments historiques et des Sites, Paris.

a partition that cut through the line of tables
like a curtain, or a backdrop, to make three
kinds of space, a foreground set with tables and
carafe, a middle ground perspective that cut
straight down the rows of tables, and a wall
of faraway buildings (though they were in fact
only on the other side of the boulevard Mont-
parnasse). A little too complex and ready to
please, this document, but it was sheer decor. As
was Atget's view of the Moulin Rouge, which
he made in 1926 (fig. 37), though it launched
straight into the mist of the middle distance and
stayed there, a curtain for the stage.

Set designers also worked on the furnishings
of the space, the curtains, the tables, the chairs,
and the props, and that entailed another kind
of study, the study really of architectural style.
This involved a knowledge of motifs and tech-
niques that is better taken up in the context of
the building industry, but it should be remem-
bered that this work was done by set designers
too. Apparently it was not uncommon for set
designers to combine their profession with that
of the interior designer; the professional ap-
pellation, *peintre-décorateur*, was the same
for both and conceivably always covered those
working both ends simultaneously, stage and
home. For Atget this was relevant only in that
he could also sell to them the kind of work he
directed toward the building industry.

37. "Moulin Rouge." 1926. Pp 109. Museum of Modern
Art, New York. The Abbott-Levy Collection. Partial gift
of Shirley C. Burden.

The Building Industry

The various professions and trades of the building industry formed one of the largest groups in Atget's clientele. He was dealing with those who worked on both the inside and the outside of the building, men who understood their occupation very specifically as a skill with a particular kind of material. A complete list of the occupations of these clients of Atget's gives an initial idea of how segmented this industry was.

ameublements
architecte
architecte-décorateur
artiste-paysagiste
artiste-décorateur
ciseleur
cheminées en bois
décorateur
décorateur en appartement
dessinateur
dessinateur industriel
doreur sur bois
doreur-miroitier
ébeniste
fabricant de bronzes
fabricant de meubles
facteur d'orgues
ferronerier
fondeur
ingénieur-constructeur
marbrier
marbrier-sculpteur
menuisier
ornemeniste
passementier
peintre-décorateur
peintre verrier
sculpteur-décorateur
sculpteur-ornemaniste
sculpteur sur bois
serrurier
tapissier
tapissier-décorateur

Yet oddly these clients shared certain requirements for documents, for all were moving toward the same basic end, the total work of architecture, which in France meant the revelation of style.

Most of these clients had set out to make their fortune on reproductions, imitations, and freer interpretations of the great French styles of the past. Much more than an aesthetic quality, style had become the object of industrial profit and immense national pride, at once a means of access to past history and the measure of people's civilization. For those inside and outside the building industry, their idea of style resounded with a great state ideology: style reflected not only a French tradition but France itself. During the Second Empire, Hippolyte Taine had phrased these ideas well; by 1900 they were common parlance.[64] As ideology the stylistic reflection was both fulsome and practical: it, or was it France? was meant to conquer the international market in buildings and furnishings. For all of these reasons, style was heavy with significance. Those who made it were mindful of the burden.

It is no exaggeration to say that the definition of a modern French style thoroughly preoccupied the building industry. And yet there was no agreement as to what modern meant. Since the Louis styles had been a proven success, many in the industry felt that they should be maintained as a modern style. "These styles are our glory, success, and joy, let us continue to do them well," declared Atget's client Edouard Poteau and his work supported his point (fig. 38).[65] There had long been opposition to this idea, opposition as old as the nineteenth century was long, but the perennial attempts to designate a modern style had never quite succeeded, this having the net effect of preventing the consensus necessary for a properly Tainian ethos.

No consensus, no one style. What, it was frequently asked, did this say about the state of French civilization? Toward 1910 the stalemate broke, though owing neither to embarrassment nor to a sense of duty to Taine; the real incentive had come from the successes of the Germans. The French industry finally came to realize that it could not hope to dominate the international market if it did *not* go obviously modern. Certain sectors of the building industry, the architects and decorators more than the *ébenistes* and craftsmen, grandly announced a new search for a national form; the department stores joined in and put together their own ateliers. Added impulse came from both the state and the marketplace. Consequently decoration was more than ever a field ripe for exploitation; in fact decoration was the most visible aesthetic issue of the day. Yet for all this no single modern style could reasonably be proclaimed. The drive toward modern style only succeeded in bringing about a stylistic mix, most of it modish—variations on the classical tradition, experimental geometric design (1912 saw a Maison Cubiste), the accommodation Le Corbusier and others sought between industrial and Latin forms, and a lukewarm style based on exceedingly simple natural models. After the war, the last of these prevailed and a swarm of deco rosettes settled in.[66] Meanwhile, off in the background, business in Louis reproductions was humming, though it was now attracting comparatively little notice.

Despite the controversies and the lobbying, the classical character of French style was never in question; classical was, after all, synonymous with national; both the ancients and the moderns would lay claim to it. The lines through which style was identified were always in the same place, in the ornamental frame of panels, balconies, and entrances; they could be factored down to typical motifs, propor-

38. Edouard Poteau, "Salon Louis XVI," Exposition Internationale, Liège, 1905. Bibliothèque Nationale, Paris.

tions, arabesques, and cornice patterns. None of this required much professional expertise. The more popular treatises on the subject had brought this act of reading down to a formula that had become part of the general culture. Roger-Milès in his book, *Comment discerner les styles*, taught his reader style by grouping the canonical shapes and motifs of a given style on a single page; the definition of style solidified in the act of comparison, particularly as one moved from page to page, matching one style against another (figs. 39 and 40). For example: the stern qualities of Louis XIII, with rusticated entrances and solidly rectilinear panels, were read against other styles, like that of Louis XV, where the decisive lines were disguised in arabesques encrusted with *rocaille*, scrollwork, and gilt. Doorways and panels provided the best samples for the analysis of style but any section would do: here too studying was dissection. With the standard parts isolated and identified, analysis could begin; synthesis was conceivable. The men of the building industry proceeded in the same way as the general public; their analysis of style and their synthesis of it was done with an eye toward the reception of their work by the same public that read Roger-Milès. At some point Poteau's Louis XVI interior would have been subjected to this standardized public scrutiny, broken down into its component parts, its style appraised, identified, and admired for its assurance, its distillation of the essential Louis into modules of fauteuil and window frame, its classical tone. In such an interior everyone could see that the national identity was legible, safe.

As modern styles appeared, they too were presented and read in these terms. Louis Süe, whose name appeared in Atget's *répertoire* sometime after 1919, did a salon for a M. Ch.

39. Roger-Milès, "A l'époque Louis XIII, l'architecture civile chercha souvent l'élégance dans la simplicité," *Comment discerner les styles du huitième au dix-neuvième siècle* (Paris: E. Rouveyre, 1896–97), vol. 2, pl. 100. Private collection, New York.

40. Roger-Milès, "Documents caractéristiques de décoration à la fin de la Régence et pendant la première moitié du règne de Louis XV. Le *style rocaille* n'a pas encore imposé son système outré d'asymétrie," pl. 68. Private collection, New York.

Stern (fig. 41) which was published in 1921 in Süe and his partner André Mare's deluxe revue *Architectures*. The salon was introduced as a style to be discerned: it held its oval mirror in a squared-off wall and gave it repeated bouquets of carved roses. Additional clues were provided for the visually obtuse: Jacques Villon, who had drawn the salon for the revue, polished his architectural drawing off with a Cubist couple submerged in their ultrasophisticated small talk; their Cubism was the salon's subtext, though it never was translated very well into a building style. From Poteau to Süe, whether ancient or modern, style was subject to many interpretations but the procedures for identifying its existence remained stable.

Despite the range of styles produced, the industry's requirements for documents did not vary much: everyone used the same standardized parts to set their problem; everyone at some point studied the past in order to design for the present. In order to be useful, a document would have to zero in on those parts, the building blocks from which style was known, produced, revealed. From the parts of a *rocaille* panel to a Louis XV reproduction or a frame for Stern's mirror. In the process of production style held little transcendence or mystique. It was only the product of *connaissance*, only a specialized knowledge with its conventional practices, only something to be made. That stylistic ideals came sometimes from 1711 and sometimes from 1912 was a detail. In spite of Taine's efforts to elevate style to the status of *savoir*, it was never truly that; at best style was a structuring principle, the willing creature of nationalists, and a rhetorical substitute for the name of France. We can now see that in this period the idea was in fact losing even its fragile claim to *savoir* and that the high pitch of the debate was the symptom of its impending decline,

41. Louis Süe, "Cheminée et Glace, Salon de M. Ch. Stern," *Architectures*, vol. 1 (1921), pl. 93. Engraved by Jacques Villon. Bibliothèque Nationale, Paris.

and that in a few decades it would not be much more than an identifying label, a category, an attribute, a discourse drained of power. At the time however style could only be taken with extreme seriousness.

Like it or not, Atget's documents were sailing into a fray. They provided each faction with evidence of style, archives of style. The building industry was unusually well supplied with archives. Atget's business shows how well. Atget sold to professionals and craftsmen at all levels of the industrial hierarchy, the architects and decorators and those artisans specializing in woodwork, metalwork, and stone carving; in 1913 he investigated the possibilities at Printemps, whose atelier Primavera was founded that year.[67] He generally sold to the largest and most profitable of these firms, since the size of their profits allowed for the establishment of bigger house libraries. He might deal directly with the head of the shop or with the chief architect of a firm, or he might deal with their nameless subordinates, the draughtsmen, but his clients were not obscure. Many of them were members of the committees formed to organize the French section for the international decorative arts trade fairs that were held almost annually at the turn of the century. A good number belonged to the Union Centrale des Arts Décoratifs, an organization of businessmen formed in 1863 that was extremely influential in the reform movements in the building industry. The Union Centrale had been responsible for the foundation of the Musée des Arts Décoratifs in 1877, which found its permanent home in the Louvre in 1905, the French answer to the English South Kensington (now the Victoria and Albert) Museum.

The industry saw to it that its members had access to its own general libraries and archives.

The most significant of them was the Union Centrale's library with its immense picture archive organized into huge loose-leaf folios by building and object type, facades, doorways, staircases, door knockers, vases, panels, nothing about a building or a garden was too large or too small. Figure, animal, and botanical studies were included; the styles of the past were made available, so was nature. Atget sold 1,737 documents to the library between 1900 and 1926. A group of plant studies appeared in the first sale but as the museum was already well supplied with that kind of material, subsequently Atget sold it views and details of historic monuments, the part of the collection that still had gaps. Somewhere Atget got the idea that he could sell a similar line of work to the library's South Kensington counterpart. Between 1902 and 1905 he carried on his trade with that institution by letter, selling them 572 photographs altogether. The letters, bursting with sales pitch, did not mince words. In the first, written on November 19, 1902, Atget laid out his goods in series:

A Monsieur le Conservateur du Musée,

Je puis mettre à votre disposition un superbe Receuil de photographies sur le Vieux Paris et ses Environs dont voici le Detail.

Le Vieux Paris.
1- Les Hotels particuliers
2- Les Maisons historiques ou curieuses
3- Aspects et Vieilles rues
4- { Les quais, les ponts, les Ports,
 Les Marchés, Squares et Jardins.
5- Fontaines et Puits
6- Les Portes Artistiques (Boiseries)
7- Heurtoirs et Mascarons
8- Escaliers (bois et fer forgé
 (maison particulière)

9- Les Enseignes – Boutiques
 et Cabarets

1000 clichés (à suivre

10- Types et petits métiers de la Rue
 (200 clichés)

Les Petits Environs de Paris

Environs immédiats
Gentilly – Aulnay – Montmorency
Bicetre – Sceaux – Pontoise
Robinson – St Denis – Meudon
 etc et

etc etc – et Versailles
 coins de Parc
en tout 400 clichés (à suivre

En préparation Les Grands Environs
 de Paris[68]

Atget presented his documents to the archive in series that could be described as ongoing lines of work. In the course of a sale he used certain hooks—place names, architectural types, media, repeated underlining. The views of the city did not seem especially well suited to this market, yet if the buildings depicted were important examples of their kind and period, those views too could find a place in these archives. But the groups of ornamental details were the key to his success; accordingly Atget weighted his list, just as he weighted his production.

These libraries were far from the only ones to provide the industry with references. The library of the Ecole Boulle, established in 1886 for the training of apprentices in the woodworking trades, also bought from Atget between 1902 and 1910 (although the group of photographs suggests earlier sales too) and filed his work away, in much the same way as at the Union Centrale, with flower studies by Aubry and architectural views by Baldus.[69] Like the Musée des Arts Décoratifs, the Ecole Boulle found the doors and the early plant studies worthy of purchase, though as time went on it took primarily the architectural documents; when in 1902 Atget summarized his sales there he said that it had bought his recent series, "L'Art ancien dans les rues et Paris."[70] The Ecole des Beaux-Arts, where architects trained, also maintained a picture archive which contained reproductions of works of art and architecture. Atget sold it some sixteen hundred photos of historic monuments between 1900 and 1913, photos to be counted more as documents for budding architects than decors for painters.[71] The couturier Jacques Doucet put together much the same kind of picture collection in 1914 with the idea of donating it and his library to the Sorbonne; in 1918 it became the Sorbonne's Bibliothèque d'Art et d'Archéologie. Affluent businessmen, bankers like the Rothschilds and J. P. Morgan, were also keenly interested in the decorative arts and Atget got wind of this around 1910, hoping that their libraries might buy his work and extend his market, but his expectations appear to have come to naught.[72]

Doucet's library had a grander destiny than most, but his colleagues had also mounted study collections for their private use and for use by their employees. The architect Victor Cuvillier bought at least 196 photographs of facades and doorways mainly to help him in his work restoring châteaux; he is listed but once in the *répertoire* on a page dating before 1901; his pictures date from 1897 to 1903–04, suggesting that he and Atget had more than a single transaction. The photographs were kept as loose prints by Pierre, his son, also an architect, who numbered them.[73] One was the Lebrun doorway at St. Nicolas de Chardonnet.[74] For an architect, as for others in the industry, the useful photograph was determined by pictorial convention that prepared style for dissection: the procedures for dissection were more technical than those taught by Roger-Milès: frontality, symmetry, and respect for proportion were the mainstays: exactitude here was the only truth. These procedures had a long history, crossing architectural drawing, engraving, and photography and for all this, becoming increasingly authoritative.[75] The standardization was increasingly ideological. And yet slight deviations were acceptable. Atget sold work that was constantly deviating slightly. The deviations could have the advantage of turning the professional eye toward the irregularities in the handling of the material— its curves, folds, texture, bunching, and gathering. The document could represent style so that it could be read in the main, framing lines and typical flourishes, the schemes that a technical drawing rendered best; at the same time the photograph could show how style had been embedded in substance.

Atget took the near view of the paneling at the Hôtel Roquelaure (fig. 42) in 1905. It used a stock detail, the lower section of a panel, and nestled it into the frame of the photograph, centered, focused. The viewer was brought close enough to the panel to understand its woodenness, the textures in the fillips with which hawks' heads have been carved, the care taken with the texture of the raspberries, the surface of the paint, the warp of the panel, the daily life of the style. The lens pushed all of this off a single plane; it caused the panel to warp more than it should; the silhouettes of the arabesques were not quite true; but somehow the lens held the panel in centrifugal suspense. The panel had not been completely turned into a picture.

In the best of all possible worlds, of course, the craftsmen would study from the original panel and their ateliers could hold collections of panels et al., which were considered documents too.[76] Georges Hoentschel, *décorations, ameublements,* member of the Union Centrale and chosen to design its pavilion for the 1900 World's Fair, brought together a magnificent collection of such objects which was completely catalogued and published in 1908, just prior to its sale to J. P. Morgan, who in his turn would donate it to the Metropolitan Museum in New York.[77] The collection centered around the Louis XV style, "the small monuments to the art of the foundries and carvers of the eighteenth century, mantelpiece and furniture trim, andirons, locks and bolts, plaques and handles, rings, frames and masks, ornaments for clocks and boxes, fragments doubtless, documents more than works in their entirety, but perfect examples of a level of craft that one will never ever surpass."[78] The preface to the catalogue recounted the display and explained its raison d'être:

Such debris, a matter of indifference to the common man with a little curiosity, hardly questioned by the archaeologist, assumes an exceptional importance in the eyes of an artist possessing the knowledge of the old artisanal techniques and who has divined their compositional processes; a piece of debris can

42. "Hôtel Roquelaure." 1905. AVP 5322. From the folio
Panneaux Sculptés 241, vol. 2. Bibliothèque des Arts
Décoratifs, Paris, Collection Maciet.

reveal an entire ensemble. With this detail from a panel, that example of a trophy, this sketch of a ceiling or wainscotting, Georges Hoentschel was able to create an entire decorative scheme, inspired by, reconstituting, and transforming the summary indication, bringing it to life. Worked, questioned, like confidants and witnesses, the debris reveals not only a past art but a contemporary one as well.[79]

For example, this unidentified, worn panel, style Louis XV (fig. 43). For the same ends Hoentschel bought steadily from Atget until he retired; then Atget dealt with his successors, Leys, Baudon, and their employee, Goelzer.

Hoentschel's picture archive has not survived, but we have that of another of Atget's decorator clients, the great patron of the Salon d'Automne, M. Jansen.[80] Jansen's folios were organized much like those at the Union Centrale, sometimes by style, sometimes by material, sometimes by object type. Atget provided Jansen with doorways, panels, fountains, shop fronts, door knockers, and stairways. His pictures were filed away as *Jardins et constructions* (t. I et II), *Intérieurs Louis XI, Intérieurs Louis XVI* (t. II), *Fer Forgé* (t. I et II), where they competed with pencil sketches, engravings, and more recent magazine clippings (fig. 44). Each kind of image reinforced the other; the drawings of stairway designs reduced the balustrade to permutations of straight lines and curves; the photograph gave the essence an appearance complicated by light, shade, and a position in space. All of this became practical knowledge. Jules Bricard, a *serrurier* who kept a set of Atget's door knocker photographs in his documentation room, used them to produce bronze replicas (figs. 45 and 46), like that of the lion's head knocker from the national mint.

As the document exchanged its forms with the designer, the matter of style became increasingly tangible. We can no longer ignore the divisions of labor that stratified these readers even as they sat side by side in the library of the Union Centrale. Neither could Atget. He expanded the lines of work he offered South Kensington into collections designed for specific trades. Often he would organize the work into albums that divided the problem of style by material: the metal *grille*, balcony, and stairway, for example, or the wooden door. On the cover of one stairway album he noted the name of a *maître serrurier* of the seventeenth century, Robert Davesne; in 1901 or thereabouts he made a trip to Switzerland, perhaps on commission, to photograph the public fountains.[81] He also developed a series of close-ups of paneling, door knockers, balconies, and old signs; in 1908 he made enlargements of details from his own photographs in order to have a larger group to show. After the war, he called such groups *Motifs Décoratifs*. His documents were more and more insinuated into the work of the building industry, preclassifying themselves, opening themselves up to closer and closer study, and collaboration.

Atget's pictures often found themselves embroiled in the building industry's most traditional and conservative business. But Atget's documents also provided more general lessons and inspiration for the other modern styles. His documents were nonpartisan; they themselves did not get mixed up in the debates over the styles; they stood back and furnished all sides with lines. Atget sold flower and landscape motifs to designers like Eugène Grasset and his student Verneuil and after the war to men like Jean Dunand, Jacques Gruber, and Serrière. The use value of these documents was similar to that of their architectural counterparts: they

44. "Hôtel Jumilhac rue de l'Abbé Grégoire." 1904. AVP
4956. From the Jansen folio *Fer Forgé*, vol. 1. Collection
Jansen, Paris.

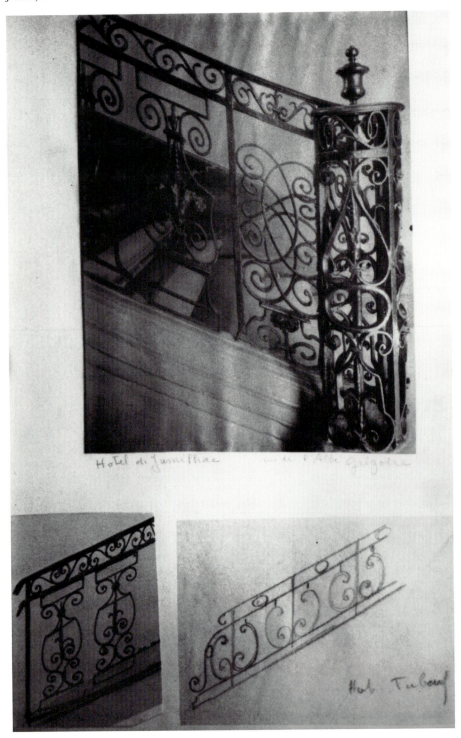

too would be absorbed into a grander scheme, though not so stringently imitated; their main lines were less regulated by the stylistic procedure, their influence not so easily traced in the final product, the line of style drawn from them would become increasingly summary and extreme. Grasset demonstrated the role of the document, albeit drawn, in his book, *La plante et ses applications ornementales* (1897–1901). Each motif was drawn in two steps, first a faithful representation of the flower or plant or tree, then a leap into its art nouveau version, though art nouveau was never quite such a direct effect. Grasset never mentioned photographs in his book but they could be used at the very beginning of this process.[82] The folios covering plants at the Musée des Arts Décoratifs mixed drawn botanical studies, like the ones in Grasset's first step, with photographic ones by the likes of Aubry and Braun. There sit the early studies Atget made of the apple tree (figs. 47 and 48), waiting for someone to put them together with Grasset's lesson: lines, the two-dimensional, pictorial configurations, could be extracted from that bloom and branch, abstracted and applied to wallpapers, clocks, and broad-shouldered water pitchers (figs. 49 and 50). In the decorators' passage through the screen of the picture, motifs and stylistic lines were seized. They were not, it should be said, the same as the motifs that landscape painters drew from their study of the same image.

Atget seems to have made both kinds of documents for the building industry from the beginning to the end of his career. In 1920 he sold off an important part of his negatives of historic monuments, including some of the work on styles, to the Caisse nationale des Monuments historiques et des Sites. He dealt with the director of the section of the ministry responsible for Monuments historiques, Paul Léon,

N

45. "La Monnaie—ancien Hôtel de Nevers—quai de Conti." 1900. AVP 4142. From the Bricard album *Heurtoirs*. Musée Bricard, Paris.

46. "Marteaux de Portes," *Marque des produits. Maison Sterlin Bricard Succ^rs. Fabricants de Serrurerie, 39 Rue de Richelieu, Paris. 1910*, pl. 103. Musée Bricard, Paris.

47. "Pommier." Ca. 1900. PDd 55. From the folio *Plantes 422*, vol. 58. Bibliothèque des Arts Décoratifs, Paris, Collection Maciet.

to whom he explained that he was currently
working on a new collection, *L'Art décoratif
dans le Vieux Paris et L'Art dans les Environs:
Seine, Seine-et-Oise, Seine-et-Marne,* and asked
for authorization to photograph church interi-
ors in those places.[83] Only the authorization
to photograph at the Musée Cluny has sur-
vived, dated March 4, 1921.[84] In other words,
in the 1920s Atget kept this wing of his business
open and active, very active. He worked up a
group of nature studies, repeating the motifs of
branch, leaf, vine, and bud. The pear branches
(fig. 51) were taken for the kind of essential
curve that Jansen's assistants deduced from
staircases, now bent through the space of the
photograph, dark, off center, the thrust of the
composition. Here the pear buds were swept
into place like so much rococo overlay, but
Atget would make other documents that moved
closer to examine the pile. He took some nas-
turtiums (fig. 52) as they fell into the sunlight,
their leaves round, star-veined, concave, float-
ing. He was still working within the tradition of
the nature study; his nasturtiums separated into
sensible forms much like Aubry's cut poppies
did (fig. 53). He continued to push the devia-
tions and the standards together. When Atget
photographed the stone carving at the Musée
Cluny (fig. 54), he knew from twenty years of
experience how to offer it up to his client. And
so he pushed close to the stone, here a section
of curly vines, and made sure to include the full
range of relief, the snail's perch, the striations
of the leaves, and the ripeness of the grapes.
The picture too was ripe, full of the motif, com-
pletely conscious of its material business. It got
much closer to the decoration than the genre
required. It anticipated the dissecting, techni-
cal look that would appreciate the viscosity of
style in a way that few others could. It kept the
dialogue with the stone carver moving.

48. "Pommier." Ca. 1900. PDd 97. From the folio
Plantes 422, vol. 58. Bibliothèque des Arts Décoratifs,
Paris, Collection Maciet.

49. Verneuil, "Pommier," from Eugène Grasset, *La plante et ses applications ornementales* (Paris: Lévy, 1897–1901), vol. 2, pl. 31. Victoria and Albert Museum, London.

50. Verneuil, "Pommier," in Grasset, *La plante*, vol. 2, pl. 32. Victoria and Albert Museum, London.

51. "Poirier en fleurs." Ca. 1922. PDd 1178. Museum of
Modern Art, New York. The Abbott-Levy Collection.
Partial gift of Shirley C. Burden.

52. "Capucines." Ca. 1921. PDd 1090. Museum of
Modern Art, New York. The Abbott-Levy Collection.
Partial gift of Shirley C. Burden.

53. Charles Aubry, "no. 25." Ecole Boulle, Paris.

54. "Porte (Hôtel de Cluny)." 1920. AVP 6199. From the folio *Panneaux Sculptés 238*, vol. 1. Bibliothèque des Arts Décoratifs, Paris, Collection Maciet.

The Amateurs of Vieux Paris

Atget's Vieux Paris clients, the antiquarians who tended the large topographical files of the city libraries and the rich amateurs who tended their own, also liked ornamental details but saw them differently. The line of style was relatively unimportant to them; they only looked to see where the historical players had tread; if they could, they would have looked for fingerprints. Failing that, they searched out a historical imaginary in the architecture of the city, patiently gathered up fragments, and labeled them in anticipation of some unstated project, posterity's project surely. In this context, style was just a piece of information; in the words of one of their main spokesmen, "[With] the architecture calling up the pomp of the preceding epochs, in front of picturesque and curious houses he will dream of a vanished bourgeoisie."[85] The role of the document was to give the dream its detail. These documents were always grounded by the terse captions written underneath them; address was required, ownership if it involved an elite. They were in this way clearcut, a definite part of the dream work, and in the same stroke, cut short.

The Commission des Monuments historiques had established the archetypes for pictorial documentation in all media. In 1851 it had sent out a group of photographers to document the historic architecture of the land; it was called the Mission Héliographique and was manned by some of the best photographers of the day, Edouard Baldus, Hippolyte Bayard, Gustave Le Gray, Henri Le Secq, Mestral. Monuments historiques had subsequently contracted with other photographers, in Atget's day, they were the Neurdein frères, Mieusement, Durand, and Robert. In 1919 the Ministère de l'Instruction publique et des Beaux-Arts was reorganized and for the first time since 1905 a director of the Beaux-Arts section was named; this put Monuments historiques under a new régime. It was

at that juncture that Atget wrote Paul Léon, the new director, offering him both the negatives and the prints from his Vieux Paris collection.

Paris, 12 nov. 1920

Monsieur,

J'ai receuilli, pendant plus de vingt ans, par mon travail et mon initiative individuelle, dans toutes les vieilles rues du Vieux Paris, des clichés photographiques, format 18 × 24, documents artistiques sur la belle architecture civile du XVIe au 19e Scle: Les vieux hôtels, maisons historiques ou curieuses, les belles façades, belles portes, belles boiseries, les Heurtoirs, les vieilles fontaines, les escaliers de style (bois et fer forgé); les intérieurs de toutes les églises de Paris (Ensembles et détails artistiques: Notre Dame, St Gervais et Protais, St Séverin, St Julien le Pauvre, St Etienne du Mont, St Roch, St Nicolas du Chardonnet, etc etc.

Cette énorme collection, artistique et documentaire est aujourd'hui terminée. Je puis dire que je possède tout le Vieux Paris.

Marchant vers l'âge, c'est à dire vers 70ans, n'ayant après moi, ni héritier, ni successeur, je suis inquiet et tourmenté sur l'avenir de cette belle collection de clichés qui peut tomber dans des mains n'en connaissant pas la valeur et, finalement disparaître, sans profit pour personne. Je serais très heureux, Monsieur le Directeur, s'il vous était possible de vous intéresser à cette collection. Naturellement, vous ne pouvez prendre en considération ma demande sans avoir, soit une référence, soit des renseignements sur ma collection et sur ma personne. Comme renseignements: J'ai vendu toute ma collection: épreuves 18 × 24, au Musée de Sculpture Comparée, Musée du Trocadéro. J'ai vendu tout le côté pittoresque, vieilles rues, vieux coins, à Mr Courboin, conservateur du cabinet des estampes à la Biblque Nationale, j'ai

vendu toute la collection, architecture et pittoresque à la grande Biblque de Londres, Board of Education et, des fragments de la collection à la biblque des Bx Arts, à la biblque des arts décoratifs et, à Mr André Michel, conservateur au Louvre. Enfin, je tiens à votre disposition, Monsieur le Directeur, sur un simple mot de vous, mes références sur le Vieux Paris et, toutes les explications qu'il vous plaira de me demander.

Je vous prie, Monsieur le Directeur, de recevoir mes très respectueuses salutations.

E. ATGET[86]

The letter permits a glimpse into the kinds of exchanges Atget had with antiquarians. It shows Atget tailoring his pitch to their expectations for encyclopedic coverage and lost artifacts: he showed himself to be adept with the jargon, words like *pittoresque* and *disparue;* his documents, he warned, could suffer the same kind of fate, disappearing without a trace, if the Commission were not to buy them. Léon, a man deeply committed to the preservation of the architectural past, responded favorably and Atget wrote him two more letters negotiating the sale, which amounted to 2,621 prints and negatives.[87] Though Atget did not then stop making photographs of Vieux Paris; even after the sale his collection was not depleted and it swelled up again. At Atget's death seven years later, André Calmettes would sell two thousand more negatives and photographs to the same Léon.

Vieux Paris photography had become one of Atget's specialities around 1897, just at the time when the Commission municipale du Vieux Paris was founded. Interest in Vieux Paris had been revived at the end of the century with the decision to go ahead with the subway. The idea of digging up Paris immediately panicked the city's antiquarians, who remembered all too well the devastation that had accompanied the

Baron Haussmann's urban renewal during the Second Empire, and they called for the protection and documentation of the old city. Atget answered this call but not on his own. Calmettes remembered the role of Victorien Sardou in pointing Atget in the right direction at the right time; Detaille probably had a role as well. Both of them were members of the new Commission municipale. Though Atget had other personal connections: Detaille's student Georges Cain had become a curator at the Musée Carnavalet and Cain was a friend of André Calmettes. André Calmettes himself was an armchair amateur of Vieux Paris (he once wrote to Cain, "I am your avid reader").[88] All of this combined put Atget in a good position to cater to the amateurs of Vieux Paris. He approached them individually, as they banded together in societies, as they received official recognition in the creation of the Commission municipale du Vieux Paris, and as they spurred the city libraries to replenish their topography collections. In other words, he saw to their individual and institutional needs for documents.

The Commission municipale had a special committee responsible for the "conservation of views, or aspects, with the help of both photography and the various artistic methods in such a way as to ensure the memory of those parts of the city slated for demolition or those having a picturesque quality."[89] It ordered visual documents: "painting, gouache, watercolor, drawing, photography will serve to preserve in images: old houses at the point of demolition, the quais of the Seine during their transformation, the work beneath the public thoroughfares, the architectural ornament decorating the dwellings of the past few centuries, the old streets and crossings, in a word, everything across the city that can conjure up the memory of the past or call to mind vanished epochs."[90] The image was part of their

program for documentation, conservation, and surveillance. Collectively these pictures were to structure memory. Yet not just any memory, only those that had been certified, formalized, and selected. The Commission took it upon itself to speak for memory, demanded particular pictures of fragments, and so produced the odd, dispersed, composite Paris of the archives, where the city of light was preserved as a broken shell; modernity, that gay Paris went unfiled, repressed.[91] Official documents had to be severely judged. Here Atget's documents had an extremely critical reception.

The Commission municipale took care to specify exactly what it wanted from a particular document when it gave its orders for photographs:

Rue de Montmorency, n° 5 (old hôtel called de Montmorency, XVIIIth century).—In the courtyard, on the right, a large and important triangular pediment crowns the entire third floor and commands three windows. The center of this pediment is decorated by a sculpted motif in the style of Louis XV, made up of two oval escutcheons flanked by two genii or cupids surrounded in turn by palms, flowers, and attributes of the garden. The door in the middle of this facade, on the ground floor, which has a key made with a curious rococo motif, is itself topped by a beautiful wrought-iron balcony that rests on two consoles of very interesting design. This facade could be easily reproduced from the vantage point of the facing window on the other side of the courtyard.[92]

The Commission wanted technically perfect architectural photographs of the Hôtel de Montmorency; it knew which details it wanted and which point of view (a picture taken from the window across the courtyard would yield the image least bothered by parallax distor-

tion). The photographs of hotels and ornament published in their minutes were the sharp conformist ones. In November 1901, it was decided that all work commissioned became city property and that it would be filed at the Carnavalet. In 1902 the specifications for these prints were set down: one print on platinum paper, one on albumen paper, and the negative (format 18 × 24 cm.) would be bought for the single price of twenty-five francs. In 1910 the print specifications changed to "papier chloroplatine demi-brillant inalterables." The Commission divided its business among an approved group of photographers: Barry, Berthat frères, Emonts, Godefroy, Gossin, and the Union Photographique Française.[93] Atget's name was never on their list.

The work of the Commission was seconded by the smaller societies that sprang up in defense of individual *arrondissements*. These Vieux Paris societies had their visual criteria just as clearly in mind, though straightened, frontal views were less important to them than clean, tidy images of the past, meaning that the present was swept, whenever possible, out of sight. On the pages of *La Cité*, the journal of the society that took responsibility for the third and fourth arrondissements, Atget's pictures were clipped to documentary perfection (figs. 55 and 56). In 1915 the approved view of the Hôtel Chalons-Luxembourg excised the details to the left and right of the door frame, namely the shop fronts and most of the little boys. In 1913 the journal published a drawing by Auguste Callet after Atget's photograph of the Hôtel des Ambassadeurs d'Hollande that eliminated similar undesirable elements.[94] A predictable demand for this architectural and temporal purity was responsible for this kind of editing. Atget knew about the demand but did not always accede to it. His Vieux Paris pictures could seem lazy, unbridled, frequently on the verge of shifting

55. "Hôtel Chalons Luxembourg. Rue Geoffroy Lasnier. 1898. 4^{ème} arron." AVP 3528. Bibliothèque historique de la Ville de Paris.

56. "Hôtel de Chalons-Luxembourg," *La Cité* (1915), p. 242. Bibliothèque Nationale, Paris.

genres from the architectural photograph to the larger view; he often allowed signs of modern life to slip in. The Vieux Parisiens were obliged to look past them; if they wanted to publish one of these pictures, they had to edit modernity out.

The small Vieux Paris societies do not appear to have formed collections on their own; presumably they drew upon the personal holdings of their members. Individually Vieux Parisiens pursued documentation the way other amateurs chased butterflies. One of the most intrepid, Georges Hartmann, amateur, member of the Commission municipale du Vieux Paris, and an Atget client, amassed 120,000 engravings, tracings, lithographs, drawings, watercolors, and photographs. His picture file was divided up into categories, on a scale rivaling the public collections and every bit as regimented as theirs: "All these Parisian documents are classified chronologically by arrondissement, quarter, monument, house and old hôtel, and street; then a suite of cartons is reserved for the métiers, street cries, customs of Paris, for portraits of Parisians, for historic or merely interesting events which took place in Paris."[95] Hartmann's collection was lent to exhibitions at the Bibliothèque historique and served as a ready source of illustrations for his own and others' historical writing. Paul Blondel was another of Atget's clients; at his death in 1924 his files, notable for their quantity of postcards, went to join those of the Bibliothèque Nationale.

Photographic documentation for public record was begun by the Commission, which sent material to both the Musée Carnavalet and later, after 1907, the Bibliothèque historique de la Ville de Paris. Most of the large libraries in Paris were inspired by this to open their topography files and refurbish them. It was through *these* more liberal channels that Atget moved his Vieux Paris work. He sold quantities

of photographs to the topography files of the Bibliothèque Nationale, the Bibliothèque de l'Arsenal, the Musée de Sculpture Comparée, the Bibliothèque historique de la Ville de Paris, and the Musée Carnavalet, and he was known in the trade as a photographer of Vieux Paris, "phot. archéologue" as someone, not Atget, wrote inside the front cover of one of his albums at the Bibliothèque Nationale.[96] The libraries were not as strict with the image as the Commission du Vieux Paris and the antiquarian journals. Their topography collections gathered up a variety of documents into files organized by place name. Marcel Poëte, chief curator of the Bibliothèque historique, had to initiate such a picture collection, though not completely from scratch, when the library was separated from the Musée Carnavalet in 1898. In 1906 Poëte revitalized the Service des Travaux historiques, together with its picture file, which included the work of Charles Marville. Poëte described the library's file as a fund of source material for an unspecified urban history. Visual standards for this history were unmentioned and probably minimal.[97]

But then library files were fairly accommodating systems. On occasion the libraries also sought pictures for their *moeurs* files, an anthropological counterpart to the topography files, although none of them pursued this ancillary file with much diligence. The *moeurs* files today are filled mainly by the *physiologies* of the nineteenth century; Gavarni and Daumier prints were entered there, as were sheets torn from illustrated magazines; in 1900 these files were not very active, though Atget's *petits métiers* series was bought for them. However, Atget mainly furnished the libraries with the architectural fragments and topographical views that would leave a Vieux Paris on record, as his letter to Léon said. Almost any historical fact would be admissible in the library files, almost any

picture, so long as its detail was in focus, for in the end the libraries had the same concern for fact as the amateurs of Vieux Paris. All of them skimmed over the internal, pictorial work of the photograph as they looked for their piece of information. The looser set of the topography file, like the fastidious optic of the Vieux Parisien, was strangely nonvisual.

Atget's relations with the Musée Carnavalet and the Bibliothèque historique were good. From 1898 and 1899 respectively, he sold continuously to them both, at the Carnavalet dealing with Georges Cain, at the Bibliothèque historique with Marcel Poëte and his assistant Edmond Beaurepaire.[98] Both institutions held substantial collections of the topographical work of Charles Marville, who beginning around 1858 had been commissioned by the city to document, as asked, the parts of the city destined for demolition, the newly furbished parks, and the new improvements to the streets, like kiosks, *pissoirs*, and lamps. In 1899 the photographer Emonts was asked to make prints from the negatives. Atget certainly knew the Marville model.[99] He also knew the genre to which it belonged.

Vieux Parisiens wanted the topography as well as the architecture of Vieux Paris documented but they did not have as technical a model to propose for street scenes as they had for architectural details.[100] The topographical document was perforce derived from travelers' views made in the previous century, views commonly called *pittoresque*. We could also cite the precedents of Charles Marville's photographs. We could remark that views down dark city streets form a kind of late nineteenth-century genre visible in all manner of printmaking throughout Europe—for example, the Alinaris' Florence, Henry Dixon's London, Martial's Paris, Whistler's Venice. All were contributing to the definition of a picturesque document.

57. Charles Marville, "No. 110 Rue Estienne (de la rue Boucher)." 1865–68. Musée Carnavalet, Paris.

The picturesque view had initially been determined by its peculiar visual qualities: in English aesthetic theory *picturesque* was used to describe certain formal properties, the rough, the crumbling, the craggy, usually wild landscape or antique ruin. In common French, *pittoresque* could take in all kinds of nuance; it was among other things the word meaning "pictorial"; by 1900 it was used so indiscriminately to describe scenic beauty or charm that it existed primarily as a cliché of praise.[101] The topographical document was not too concerned with those anglo-banalities; it concentrated instead on the empirical matter, the location of the site and the age of its features. It took the *pittoresque* into the nonvisual, for it was not so much interested in how it looked as in what it was. A ruin and a shame. History was extracted from appearances. History took precedence.

The document was a receptacle for contradiction. There were family resemblances between topographical documents, family forms that look sometimes like stylistic traits. But even gorgeousness would turn nonvisual. How to make a nonvisual analysis of such documents as, for instance, Marville's view of the rue Estienne (fig. 57) and Atget's of St. Etienne du Mont (fig. 58)? Both let a narrow space run through the center of the picture; both have set up the monument at the end to block the run, though one is a vulgar building whose side has been painted up with an advertisement for sewing machines and the other is a lofty *monument historique*. Both exhibited the narrowness of these streets; the accessories of modern life, the carts and newspapers, lined the street, which was dark—narrow streets never caught much sun. That darkness made their point, the historical-nonvisual point: the old streets of Paris were designed for foot traffic and small vehicles; they were datable by their space. Darkness and narrowness were valuable only insofar

58. "St Etienne du Mont rue de la Montagne Sainte
Geneviève Vᵉ arr. 1898." AVP 3555. Musée
Carnavalet, Paris.

59. "Rue Rataud Vᵉ arrᵗ. 1909." Top 458. Musée
Carnavalet, Paris.

as they were signs of age. Any grace in the per-
spective, any orchestration of the composition
so that the dark met light was additional, not
essential, information. Authenticity arrived
with the tangential fact.

The Bibliothèque historique seems to have
commissioned Atget to do a large topographic
survey of Paris in 1906, a survey which would
have extended the scope of Marville's. Over the
next decade Atget made a special series of some
seventeen hundred documents for that sur-
vey. He appears to have moved systematically
through the city's *quartiers*, using the guide-
book *Guide pratique à travers le Vieux Paris*
written by the Marquis de Rochegude in order
to round out the captions.[102] His view down
the rue Rataud (fig. 59), made in 1909, con-
tinued the description of the narrow and dark,
making the most of the gleam off the wet paving
stones and the distant tree silhouetted against
the winter sky. In essence it continued the line
of topographical work he had done before iso-
lating it into a series of its own. The series took
other kinds of spaces into account, courtyards,
for instance, like this one at 34 rue des Bourdon-
nais (fig. 60), taken in 1908, where a long view
of a staircase pivoted around a filigreed shadow.
It made a complete description of a space and
a partial one of the unseen levels. One day a
historian would pierce the detail to pick up a
tangent. The series matured in this way, with
Atget making variations, sets, and offshoots,
like a survey of the statuary and garden spaces
in the Tuileries (fig. 61).

Then in 1912 came a dispute, which took
place by letter. Poëte questioned some of the
prints Atget had just delivered, claiming that
the quality of the printing was not up to stan-
dard. "Trop mauvais état" (condition too poor)
were his precise words.[103] Atget's defense of his
work was even more precise:

60. "Cour Rue des Bourdonnais 34." 1908. Top 275.
Musée Carnavalet, Paris.

61. "Tuileries—Coureuse par Coustou—1912 1e arr."
Tuileries set 241. Bibliothèque historique de la Ville
de Paris.

62. "Tuileries—Coté de la Concorde." Tuileries set 317.
Bibliothèque historique de la Ville de Paris.

14 juin 1912

Monsieur,

 Je suis très étonné de votre lettre. J'ai montré
à Mr Beaurepaire, les photos, Topographie des
Tuileries et, pour compléter le mandat quelques
photos, Topographie du Vieux Paris. J'ai mon-
tré ces photos à Mr Beaurepaire, devant témoin,
qui les a acceptées, toujours devant témoin. Je
lui ai même demandé s'il était nécessaire que
je vous attende, il m'a répondu que "étant très
occupé à votre exposition, il était impossible de
vous voir et qu'il ferait lui même la démarche. Il
a plu à Mr Beaurepaire, à la suite de notre petite
discussion et, par esprit de rancune de soulever
une nouvelle difficulté, à son aise, je ne le suivrai
pas sur ce terrain. Je vous envoi le mandat recti-
fié. Je regrette infiniment, Monsieur, les petites
discussions, étant donné l'immense production,
faite par moi, par amour du Vieux Paris, plutôt
que pour le bénéfice que cela me rapporte, il me
semble, à mon avis, que ce labeur, méritait un
peu plus d'indulgence.

 Je vous prie, Monsieur, de recevoir mes très
respecteuses salutations.

E Atget[104]

At no point was the actual construction of the
pictures debated in the letters; neither party
pointed to particular photographs. As for the
"new difficulty," we can only speculate that
Atget and Beaurepaire were not on the best of
terms and that Poëte cast a more forgiving eye
toward the photograph than did his subordi-
nate. The troublemakers here were Tuileries
pictures, some of them statues, some experi-
mental efforts to capture the dissipation of the
space into enormous, formless basins and *allées*
(figs. 62 and 63).[105] The spread of the space was
given, for example, from the vantage of the lion

63. "Tuileries—Coté place de la Concorde—1912."
Tuileries set 320. Bibliothèque historique de la Ville
de Paris.

whose job it was to guard the corner of the garden from the place de la Concorde, the lion standing for the old-fashioned way of marking space symbolically. The space was also given as it appeared from the westernmost *bassin,* as a straight but melting perspective down to the Arc du Carrousel. For the librarians the significance of the detail and the arrangement of the space were not so much at issue as the unidentified quality of these prints, which amounted to nothing more complicated than the clarity of the detail. Theoretically blankness was possible, but only if it sustained its detail. Atget's details had not been sharp enough to be considered historical, that is to say, to provoke the nonvisual response. He withdrew the prints in question, reprinted some of them (fig. 62) but not all of them (fig. 63), the group was deemed acceptable, and after a brief hiatus, his work for the library resumed.[106] Atget came out ahead. The topography file however was thrown into question in 1912, though the reasons why remain mysterious. After 1912, work continued to come into the file from the Commission du Vieux Paris as well as from Atget and other free-lance photographers, but none of it was catalogued. Possibly Beaurepaire's duties changed. Whatever, no one was supervising the topography file. The file closed down with the advent of the war and was not reopened afterward. With it Atget lost one of his best customers.

Afterward the librarians at the Bibliothèque historique occasionally passed work his way. When Poëte needed an Atget print for his other Vieux Paris work, he knew where to go. In 1916, for instance, Poëte was making a report for the Commission municipale du Vieux Paris on the Hôtel Chancellerie d'Orléans, which had been remodeled by the Banque de France. In his library files he found an Atget photograph that showed the previous state of the facade; the

photograph was entered as part of his evidence; subsequently the report was published and so the Commission bought another print of the photograph from Atget and the rights to reproduce it as an illustration, all for ten francs.[107]

After 1912, Atget's topographical work took a new turn. His special series for the Bibliothèque historique surveyed with much less system and ground to a halt in 1919. He reintegrated that project into his other Vieux Paris work and began to work up some new groups entitled "Coins pittoresques" and "Cours pittoresques."[108] After the war his Vieux Paris work turned increasingly in that direction; it seemed to make sense to sell off the bulk of the older work to Monuments historiques. Atget himself called the old and the new work *pittoresque,* though it did not literally mean pictorial here. *Pittoresque* stood for the screen that the Vieux Parisiens drew over those topographical details they did not want to see. Atget worked the contradiction in the Vieux Paris document, the detail that pulled the screen. The *pittoresque* was part of the procedure for not seeing poverty; it veiled, it blinded, it blithely cauterized; nonvisuality was the dreamer's protection.

Georges Cain, the curator at the Musée Carnavalet and himself a painter, said as much when he gave the following advice to those amateur photographers wanting to make their own collection of Vieux Paris views:

It is essential to find the picturesque viewpoint, the colored foreground that will situate the deeper space from there to the horizon, the unforeseen artistic document that will distinguish our print from the usual banality. Women, with their innate taste, have the ingenuity and daring to gather together picturesque images; the most talented even know how to use the grey and pallid "bad days," precious for just that reason when repro-

ducing certain melancholy, poor or dramatic sites, which gain by resting vague and a little mysterious—such as the banks of the Bièvre, the rue Croulebarbe, the ruelle des Gobelins, several old streets in the Marais, on the île Saint-Louis and on the île de la Cité, the quais of the canal Saint-Martin . . . where the picturesque silhouettes are extremely striking, but dishonored and devalued by all kinds of things.[109]

The Bièvre had acquired full *pittoresque* status during the last years of the nineteenth century through considerable effort. It was a small river passing alongside the Gobelins tapestry works, flowing eventually into the Seine. The Gobelins and the tanneries of the thirteenth had been using it as their dump for centuries and the river for as long had been discolored, foamy, and condemned repeatedly as nothing but an open sewer. During the 1880s the parts closest to the Seine were covered over; in 1898 the project for burying the rest was begun. Huysmans published a short essay on the river in 1886 because he saw it as a casualty and also because "nature is only interesting when despondent and frail."[110] In 1890 the essay was written into a book, illustrated by A. P. Martial, that went through three more editions before the war. In the longer version the putrid realist landscape was converted into the grander realist metaphor of the fallen woman.

Behind the image lay the fact that the Bièvre was a damaged, working-class river patronized by the antiquarians as a matter of conscience because of its ties to the historic Gobelins. Its thin, polluted stream reappeared in Vieux Paris publications; pretty and sinister views of it dotted postcard series, magazine articles, and illustrated books.[111] In these pictures one normally looked along the riverside to register the

64. "Passage Moret Ruelle des Gobelins." 1900. AVP 3889. Musée Carnavalet, Paris.

patterns of roof, quai, sunlight, and molder-ing scum. In such a place the *pittoresque* image was not easy to come by; even the image of the fallen woman had to be dislodged and replaced by something more refined. Cain wrote of a small green corner of the Gobelins as the place to make a picture: "They are old hovels; but by contrast, this island is very green and there will be, I think, pretty things to photograph. See the concierge. The photographs should be taken in the morning."[112] Take, for an instance of pret-tier *pittoresque* things, Atget's picture of a tree spreading its slim branches against the river (fig. 64). Blight, poverty, and decay were con-tested by that tree. It was a detail that screened. In the eyes of an antiquarian such a picture was perfect. Its point of view was virtually repeated in Docteur Capitan's (he was a member of the Commission municipale) drawing for the cover of Jeanne Capitan's *Notules sur la Bièvre* (1909) (fig. 65). "What Parisian," Capitan began, "with the soul of an archaeologist and a piteous heart has not, inspired by Huysmans, been tempted to give his alms of commiseration to the poor Bièvre?"[113] Commiseration was as far as it went.

Georges Cain made a speciality of books that took walking tours through the old city, stop-ping to remark upon the famous site, and then imagining the dramas that had once taken place there, his form of historical fiction.[114] The tour stopped, a scene involving counts and count-esses, kings and queens, took over the work of the narrative; then always the crystal ball clouded over and Cain resumed his walk. The *pittoresque* documents were the equivalent of his narrative fades: they were part of a program to take the city through a fine veil of aesthetic effects and aristocratic or distinguished bour-geois episode; the working class would not be allowed to trouble any of these scenes. André Calmettes belonged to the public that welcomed

65. Docteur Capitan, cover for Jeanne Capitan, *Notules sur la Bièvre* (Paris: Champion, 1909). Bibliothèque Nationale, Paris.

this view of the city. He wrote once to Cain about an old house at 68 boulevard Auguste Blanqui, near the quartier Croulebarbe and the Maison Blanche (near the Bièvre), and rhapsodized in picturesque language: "If it has no history, what a shame! It's Théophile Gautier's palace of poverty; it is extraordinary, overcome by grasses, and what grasses! the roof caved in, the grilles patched with boards, a certain pretty air withal and inhabited! yes inhabited!"[115] Charles Jouas, the illustrator and Atget client, drew vignettes for the Vieux Paris literature that put this genteel picturesque into visual form; for a while he cornered the market on illustrating Huysmans.[116] For a 1920 edition of *Trois églises* Jouas went straight down an extremely narrow street looking toward St. Merri, whose side was obscured by the wooden beams bracing the aged buildings; under the braces came a good woman carrying her market basket; the entire scene was dark and timeless (fig. 66). Atget was surrounded by dreamers.

Atget kept the *pittoresque* documents going after the war, regularly selling paperbound albums of such documents to the Musée Carnavalet. They gave the obligatory references, the nonvisual tip of the hat to the dreamer; they danced their details in and out of the tales spun by the amateurs of Vieux Paris. And at the same time they could take the nonvisual brief and expose the contradictions. With an aggressive shape or a vertical cut, as in the document of the rue de Bièvre (fig. 67), or with a flagrant temporal contrast between a particularly antique courtyard on the rue de Valence filled to bursting with gaudy motorized vehicles (fig. 68). Each in its way critiqued the very idea of not seeing the new Paris of momentary light, fast cars, and delivery carts, the very idea of not seeing differences in degree and differences in nature.

66. Charles Jouas, untitled illustration for J.-K. Huysmans, *Trois églises. La symbolique de Notre Dame. Saint Merry. Saint Germain l'Auxerrois* (Paris: René Rieffer, 1920), p. 113. Bibliothèque Nationale, Paris.

67. "Coin de la rue de Bièvre." 1924. AVP 6468. Musée
Carnavalet, Paris.

68. "7, rue de Valence." 1922. AVP 6379. Musée
Carnavalet, Paris.

The Publishers

Toward 1900 Atget sold documents which went
beyond the archive, appearing instead as illus-
trations in books, Georges Riat's *Paris*, Fernand
Bournon's *Paris Atlas*, and Charles Simond's
Paris de 1800 à 1900. Riat's book (fig. 69) was
representative of the attitude all of them took
toward the photograph. The text did not com-
ment directly on the images, all of the elements
floated relatively free of each other, superficially
linked by their common subject, the Luxem-
bourg gardens and palace, and the design of
the page. The publishers took the documents
as documents and printed them without com-
ment, expecting that the reader would weave
the images together with the drift of the text
and apply the appropriate gaze. Initially Atget
did not much mine this market. He did how-
ever think about the possibilities of turning his
documents into postcards.[117]

The *petits métiers* series, together with its at-
tendant street scenes, had been quite a success.
Artists had bought it and continued to work
with it for all kinds of images from Salon paint-
ing (fig. 70) to cheap illustration; the Biblio-
thèque historique, the Bibliothèque Nationale,
and the Musée Carnavalet had been attracted
to the series, cataloguing it with their *moeurs*
documents; Simond had published one (fig. 71),
mistitling it "Devant Guignol, aux Champs-
Elysées. D'après une photographie instantanée
de M. Atget" (it was in fact the Luxembourg).[118]
F. Berkeley Smith published them through-
out his two books, *The Real Latin Quarter*
and *How Paris Amuses Itself*, without cred-
iting Atget at all. Sometime in 1903 or 1904
Atget decided to give them yet another life by
turning them into a series of eighty postcards
called *Les p'tits métiers de Paris*.[119] Each pic-
ture was cropped and given a caption, here
"Guignols parisiens—Un peu de musique pour

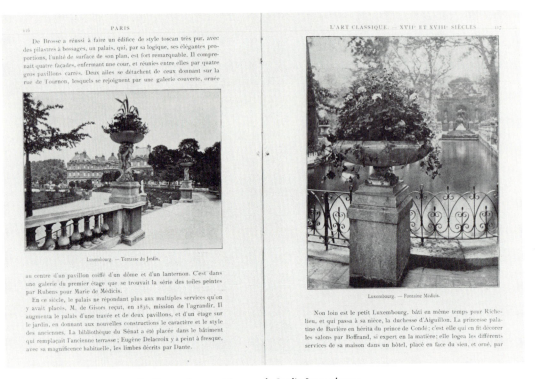

69. "Luxembourg. –Terrasse du Jardin Luxembourg. –
Fontaine Médicis," from Georges Riat, *Paris* (Paris:
Renouard, 1900), pp. 116–17. Private collection,
New York.

prendre patience" (Parisian puppet theaters—a little music for having patience) (fig. 72). The pictures could now be seen as unadulterated photographs, not hidden behind the lines of someone else's drawing or caption; they could be known as Atgets. Atget did not publish the postcards himself. He made his arrangements with V. Porcher, 67 rue des Archives. The venture did not yield; certainly there were other postcards in this and in the Vieux Paris genre, other possibilities, but Atget did not pursue matters further.

Then, just before the outbreak of the Great War, the *répertoire* shows him researching the growing market among the editors of books and magazines.

In 1916, during the war, when he responded to Marcel Poëte's letter requesting a photograph for the purposes of publication in the *Procès-verbaux* of the Commission municipale du Vieux Paris, Atget showed himself to have measured this market. "Unfortunately I cannot

70. Henry Morisset, *A Guignol*, Salon Nationale des Beaux-Arts, 1909, no. 876. Postcard reproduction. Private collection, New York.

71. "Devant Guignol, aux Champs-Elysées, D'après une photographie instantanée de M. Atget," from Charles Simond, *La vie parisienne à travers le dix-neuvième siècle: Paris de 1800 à 1900 d'après les estampes et les mémoires* (Paris: Plon, Nourrit, 1901), vol. 3, p. 247. Rare Book and Manuscript Library, Columbia University, New York.

72. "39. Guignol parisiens—Un peu de musique pour prendre patience. 3684," *Les p'tits métiers parisiens.* Ca. 1904. Private collection, Paris.

relinquish my negative. But I could do as I do for the publishers: Larousse, Hachette, Armand Colin and others, and sell you a print together with the reproduction rights." [120]

The needs of book and magazine publishers cannot be fixed with the same specificity as for Atget's other clients. [121] They took work to illustrate particular projects, sometimes gathering the images themselves, though it seems that many of Atget's published photographs were brought along by the author, Riat, for example, or found in the library files by an enterprising picture researcher. Mostly these publishers picked up on the documents as documents only, study sheets for certain points, not illustrations to summarize a section or broadly set the scene. André Hallays's article in *Lectures pour Tous*, "Le Charme de l'Ile St Louis" (1914), represented the charm with Atget's documents, charm to be endangered by the widening of the rue des Deux Ponts. None of the sites pictured would be at all affected, but little matter. They were bits of history made artistic by the magazine layout, which superimposed and vignetted Atget's pictures (fig. 73) and gave all credit for the beauty of the image to the motif.

Atget seems to have worked on developing this market at two separate points. First in 1910, when a list of American architectural magazines appears in the *répertoire*, surely on the suggestion of an American architect, perhaps Ogden Codman. [122] Then just before and immediately after the war. Atget was moderately successful here: his pictures were reproduced as the illustrations of J. Mayor's article "Possessions austro-allemands à Paris—l'Hôtel de Matignon" in *La Renaissance de l'Art Français* in 1919; two of his early Versailles views appeared in F. Bournon and A. Dauzat's *Paris et ses environs* in 1925. [123] Yet this market where

73. Illustration for André Hallays, "Le Charme de l'Ile Saint-Louis," *Lectures pour Tous* (15 March 1914), p. 1064. Bibliothèque Nationale, Paris.

documents could double as illustrations had historical import. By selling his work directly to publishers, Atget was attempting to bridge the distance between the old-style production for files and the new opportunities for publication on the page which had been created by better halftone reproduction, the page that would revolutionize photographic practice. His pictures were caught in this move and his practice was hinged to keep both fields open.

The historical transformation in photography in this period was twofold. It restructured the way the work was distributed, providing a new exhibition space, establishing a new public use for photographs, and creating a regular mass audience. The photographs themselves could suffer a qualitative change, witnessing instead of documenting, less tied now to the older conventions for conveying archive-quality truth. Soon the photograph would be used to relay the news and to advertise the latest household appliances. The document could now behave as if knowledge lay inside or behind it—it no longer needed the support of intermediaries. The field in which photographs were made and taken toward knowledge was being restructured beneath his very feet but Atget did not look too far into the future of photography, as was perhaps appropriate, since he was no longer so young; photography's future would certainly not be his. He concentrated his energies on photography's present. He did not really change his ways for the printed page; he merely gave the page documents. Yet his documents had new possibilities presented to them. The document was still functioning, relaying a kind of information, still essentially a nineteenth-century document, but it had been moved into place on the cusp and it found itself face to face with an unprofessional, general viewer.

The Commodity

Let us take stock. Atget's photographic practice was flexible enough to stretch in several directions at once without stopping, in proportions that were always susceptible to change. This stretch would be an interesting enough problem on its own but it was not particularly exceptional. Many nineteenth-century photographers, Marville, Baldus, Le Secq, Quinet, Blanquart-Evard, Nadar, had practices with several specialities and most photographers readily accepted the commercial basis of their work.[124] However, Atget brought those specialities together in ways that others did not. In the nineteenth century, when he started out, photography was thought to be perfectly suited to the production of images for great encyclopedic files. Visual dictionaries and facsimile museums were envisioned, and even Baudelaire could speak positively about photography's social service. This amounted to an idea of the archive and it provided the nineteenth-century photographer with a job to do, a job that preceded, structured, and survived Atget's photography. Documents could be confused with the archives themselves. Baudelaire confused them.

Baudelaire's assessment of photography's place remains a good, if prejudiced, summary of nineteenth-century archival practice. Both document and archive, as well as the "progress" of industrial (read capitalist) culture, were to his mind the sworn enemies of poetry (read art) and as he warmed to his subject, he grew vicious.

Poetry and progress are like two ambitious men who hate one another with an instinctive hatred, and when they meet upon the same road, one of them has to give place. If photography is allowed to supplement art in some of its functions, it will soon have supplanted or corrupted it altogether, thanks to the stupidity of the multitude which is its natural ally. It is time, then, for it to return to its true duty, which is to be the servant of the sciences and arts—but the very humble servant, like printing or shorthand, which have neither created nor supplemented literature. Let it hasten to enrich the tourist's album and restore to his eye the precision which his memory may lack; let it adorn the naturalist's library, and enlarge microscopic animals; let it even provide information to corroborate the astronomer's hypotheses; in short, let it be the secretary and clerk of whoever needs an absolute factual exactitude in his profession—up to that point nothing could be better. Let it rescue from oblivion those tumbling ruins, those books, prints and manuscripts which time is devouring, precious things whose form is dissolving and which demand a place in the archives of our memory—it will be thanked and applauded. But if it be allowed to encroach upon the domain of the impalpable and the imaginary, upon anything whose value depends solely upon the addition of something of a man's soul, then it will be so much the worse for us![125]

In actual fact, the applications of photography *were* many and servile, though not perhaps to the discredit of photography.[126] The photograph was not so much passive as active; documents had to display technical signs ready for a dialogue between the look and the form, ready for the world that lay beyond the four walls of its frame. It was, as we can see from Atget's case, very much a world of work, aesthetic, artisanal, historical, but always hard pictorial work, much of it inglorious. Behind the scenes, these pictures did their job and then were filed or thrown away.

The *répertoire* set out a space of operations that became more visible and at the same time more complex as Atget extended himself and his practice. It was in many ways an outer space. For Atget brought his documents to the different professions, each with its own sense of how to use its eyes, each with its own register of form and its own procedures for making form tell. All of the professions took the document into the very early stages of their work. Atget therefore always found himself at the dawn of the knowledges, before they had actually broken forth into discourse, while they were still cogitating, recollecting, pulling thought together, preparing a weave, and he operated in this half-light between the knowledges, in a space which was by and large outside them all. For him, the space of the operation and the archive were not coterminous.

His work moved over this space in different directions; it spoke in different voices, responding to a range of professionals looking to produce one form or another of bourgeois culture. Now when light broke over this bourgeois culture, it did not uncover a single temple or a model republic, only a culture rotating clumsily on a class axis, not a culture that we can in any way call unified, unconflicted, or responsible to an agreed-upon set of ideals; its axis was mythical and in this period especially subject to constant redefinition; its map of the *connaissances* was soft, the borders between them forever being readjusted, as if the knowledges were distant wonders, something like the colonies. Nothing on either side of the threshold of *connaissance* was hard and fast. To be on the outside was not the beggarly position, only the one that stayed low and marginal, content to be surrounded by the chaos, the *hétérotopie*.

This preference for liminal chaos characterized Atget's work.[127] We are in the presence of an especially baroque instance of discursive formation flitting along the outsides of knowledges and powers and incorporating them in various ways: through details, lines, screens, and *disponibilité* or, to use another vocabulary, through exclusions, declarations of truth, and the strategic movement of a statement. Atget responded *avant la lettre* to the criteria Foucault put forward as part of his analysis of such formations, criteria opposed to those traditionally maintained by the history of ideas: ergo, there was the criterion of event as opposed to creation, series as opposed to unity, regularity as opposed to originality, conditions of possibility as opposed to meaning.[128] Atget's work did not travel nicely in a single-file discursive formation; multiplicity was fundamental to its operation, as fundamental as its chosen space. It could not however have existed without the *connaissances*. The discursive formations of the document were engaged by bourgeois culture, took its cues from it, were called in by it, were in dialogue with its needs. To put it very simply, the document dialogued across the threshold of the given *connaissance*. Though voluble, it was never self-sufficient.

Mikhaïl Bakhtin saw language to be defined like this, in use, principally by the way in which it had already been spoken. To his mind, there were no neutral words, no utterance that could be claimed by one speaker alone; language was always social, words fell into dialogues, and language was constructed by the interruption of different voices. That construction was characterized by what he came to call heteroglossia; those kinds of literature that offer sanctuary to the lone voice, lyric poetry for instance, did so by making a concerted secession from this magnetic field of speech.[129] A secession that was virtually impossible. The word once expropriated and spoken again, quotation marks or no, returned to a social space where it would see more action. The dynamic never stopped. The social space, as we have seen, was not exactly a place of free exchange; as it divided into spheres, classes, and counties, the word would encounter barriers.

Documents and words would never be quite the same, though they exhibited similar behaviors. The technical sign by which the document was recognized did not break up easily into signifiers and signifieds, at least not according to a rule whereby the form is all signifier, leaving the signified in the mind: to the eye of the decorator, for instance, form was everything. And yet, minimally, the technical sign worked like an element of language; otherwise it would be difficult to account for the fact that Atget's documents were noticeably locked in heavy conversation with their viewers. Though not always smooth or well-tempered conversation. Witness the malentendu with Poëte, the grumpy exchange with Man Ray. Commercial work had its own unpredictable twists and hard-boiled repartee; it required additional fluency in the *non-dit*. Just because it fell into the space of regular work did not mean that it came unnuanced and clear; that idea of transparency in ordinary practical communication is a cliché invented in order to give all the nuance to literature and art. Documents too could be guarded, opaque, and as patterned as sonnets.

The divergence of the documents in their space of operations could be described as a commerce. Atget certainly knew that archives made for markets; by the same token he knew that his documents were commodities. His photographs moved in these circumstances; they actively participated in the business of the archive; their commercial nature was not imposed upon them nor was it something that happened to them later. Their commodity forms were intrinsic. His photographs were commodity pictures.

The commodity is, first of all, an external object, a thing which through its qualities satisfies human needs of whatever kind. The nature of these needs, whether they arise, for example, from the stomach, or the imagination, makes no difference. Nor does it matter here how the thing satisfies man's need, whether directly as a means of subsistence, i.e. an object of consumption, or indirectly as a means of production.

Every useful thing, for example, iron, paper, etc., may be looked at from the two points of view of quality and quantity. Every useful thing is a whole composed of many properties; it can therefore be useful in various ways. The discovery of these ways and hence of the manifold uses of things is the work of history. So also is the invention of socially recognized standards of measurement for the quantities of these useful objects. The diversity of the measures for commodities arises in part from the diverse nature of the objects to be measured, and in part from convention.[130]

This is Marx's definition, which more than probably informed Atget's ideas about markets and goods; in any case, Atget's documents fit it. There were definable markets for documents; they were, like cheese and gloves, bought and sold; they were counted as business assets and they were expected to work indefinitely, indefinitely satisfying man's need through their play between sign, knowledge, and vision.[131] They were expected to function efficiently and so defray the cost of their purchase. It is clear that

all of Atget's work arose from and was directed back toward these circumstances. The technical, that is to say, the commodity forms did not ever leave his photographs.

Atget's pictures exhibited their use values as technical signs. On that basis they acquired exchange values and existed henceforth as classic commodities, depending on the exchange value to negotiate the way through the marketplace (usually 1 franc, 1 franc 25 if Atget had to take the train to the motif). Their identity was founded on the mediation between these two kinds of values. Atget's labor was counted into this ratio of values as a use value: it was reified, abstracted into value, and thereby fetishized. Use value was not only an important criterion for the production of a commodity, it was also the value that came back into the foreground *after* the sale had taken place, during the process of consumption. Use made consumption productive, just as it contributed to the dialectical motion between production and consumption.[132] Cultural commodities did not always want to display their use, but not all cultural knowledge was produced by poets seeking detached, ideal states of existence; Atget certainly was not looking to live life as a Des Esseintes.[133]

Atget held his documents out before the archive for practical, commercial, and unknown reasons. In that distance he worked out the uses and use values of his documents, the approaches to the *connaissances*. The hiatus suited him and he gave it a concrete form—in numbers. Before Atget's pictures ever reached their final destination in someone else's archive, they had already been subjected to his own file. Photographers who supplied archives with large quantities of photographs had to develop their own systematic classification with some kind of index. So, accordingly, Atget divided his production into

five main series, each with its own numerical sequence: *Vieux Paris* (parts of it came to be called *L'Art dans le Vieux Paris* and it is now generally known by that name), *Environs de Paris, Topographie du Vieux Paris, Paris pittoresque*, and *Paysages–Documents divers*. The negative number of the photograph attached it to its parent series. *Vieux Paris* began in 1897 and occupied his attentions ever after; its more architectural photographs were called *L'Art dans le Vieux Paris*. Together with its sister series, the *Environs*, Atget aimed straight at the historic monument. The *Topographie* series was begun in 1906 and its seventeen hundred pictures made a patient tour of the old streets for their general, not just monumental, aspect, and took into account the impending disruptions in the urban fabric, demolitions and the like. The *Paris pittoresque* began in 1897 with the collection of *petits métiers* and scenes of crowded streets; it lay dormant after 1900 until 1910, when it became the location for Atget's meditation on modern life in Paris. The *Paysages–Documents divers* series cannot be precisely dated, but it probably covered the work being promoted in 1892 and its early numbers may date from then. The *Topographie* series ended in 1919. The others were continued throughout Atget's career.[134] The series, then, were continuous and defined their own broad subjects. Atget used them to organize some ten thousand pictures.[135]

The five great series were never sufficient unto themselves. Atget was forever organizing smaller series for the purposes of presenting his documents to prospective clients. His business letters were forever describing series: "Je vous ferai parvenir une nouvelle Serie sur les Vieux Paris. Les Escaliers. Les Heurtoirs. les Boiseries.

Portes des XVI–XVII. et XVIIIᵉ Sᶜˡᵉ," he wrote to the South Kensington Board of Education on December 27, 1902.[136] In the *Vieux Paris, Environs*, and *Topographie* work, which is to say the large-scale series, Atget worked out annual subseries, bringing out a new collection each year. He also worked up shorter sequences of photographs, best called sets, like the group of fifty photographs taken of Rouen sometime around 1908, and the group of sixty pictures taken at Sceaux in 1925.[137] These shorter, smaller, more manageable groups would be shown to prospective clients in paper albums.

Man Ray said that the pictures were shown in "book," and if one bought a print, it was taken out, to be replaced in the album by another copy. Levy remembered the same thing, in addition to the fact that Atget didn't like to sell him more than he could print.[138] The architect Walter Destailleur bought entire albums from Atget with titles like "La Monnaie Quai Conti. 11 Construite en 1771 par l'architecte Antoine" and "Vieux Paris," and some whose title pages had been left blank.[139] The manila paperbound albums were Atget's system for storing and classifying his prints. Atget used them to show his work to clients and to deliver his orders. Among his studio effects, Berenice Abbott found 121 of them, full of prints.[140] The paper albums that remained in his studio exhibit the signs of constant use and reuse. Their pages, which were made by folding a large sheet in half twice, have more often than not been turned inside out to exploit the fresh side; the outer sides of each were cut by four, very practical slits into which the corners of a document could be inserted, or removed. The captions, which were almost always written in pencil, were eminently erasable; Atget had no scruples about erasing when he needed the new page.[141] The albums now

bear the light and heavy marks of Atget's re-
visions. Often the covers are three or four deep
with new pasted layers, each layer standing
for a former, buried identity. Some are titled in
ink, some are given printed covers. They were
embedded in the ebb and flow and supply and
demand of Atget's career.

The albums were Atget's vehicle for directing
his photographs out of the studio and into the
world; they took the negative numbers and gave
them a context; they pointed the documents
toward the *connaissances;* their editing became
a critical part of Atget's activity as a photog-
rapher.[142] Sometimes Atget found archives that
would take his paper albums and leave them in-
tact. The Musée Carnavalet kept a 1904 album
on the church interior of St. Gervais Protais in
its topography file and after 1910 it bought only
paper albums from Atget (fig. 74).[143] Atget had
some title pages printed up, which gave these
albums a more finished look, but he did not use
them systematically.[144] He grouped his pictures
under general titles so as not to overdetermine
their use values, and so that he could show the
same album to different archives. The capacity
of the work for divergence was however best ex-
pressed in the individual documents themselves.

It was not at all uncommon for Atget to in-
stall more than one technical sign in a given
document. As the signs accumulated within the
frame, a slight confusion arose and a strain of
functional ambiguities grew up. The ambigui-
ties did not take anything away from the value
of the pictures as commodities; ambiguous, the
documents shimmered with possibilities. The
technical signs acquired a glow. Fairly early on,
Atget figured out that he could work more than
one technical sign into a given document, let-
ting the document go off, or circulate, in two
or more directions, authorizing a functional

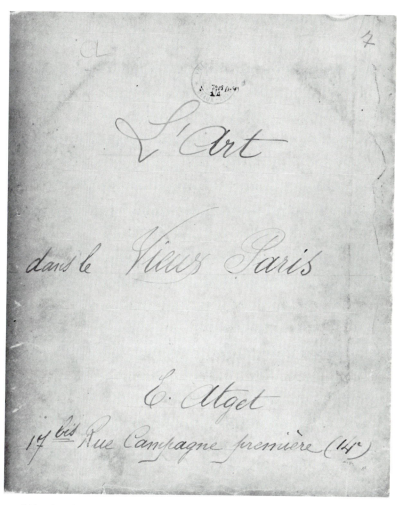

74. *L'Art dans le Vieux Paris,* paper album. 1912. Musée
Carnavalet, Paris.

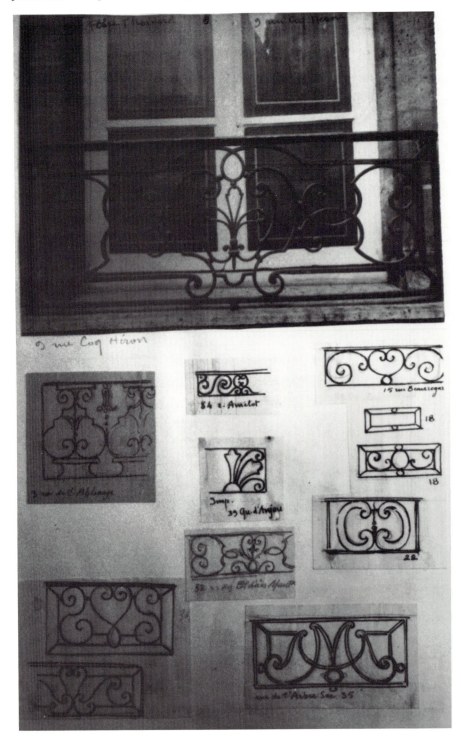

ambiguity perfectly legible to those, like himself, versed in more than one kind of technical looking. The hypothetical viewers, presumably not so well versed, would see what they wanted, dispensing with the extraneous, not strictly technical, elements in the image, noting perhaps a certain superfluity at the periphery of their professional vision, some excess. In fact the document necessarily set up spaces around and between its technical signs, ruptures that were tucked into the picture as a skip in the space, a mysterious syncopation or a break, a pictorial silence. This double function and its surrounding excess were the generating principles of most Atget photographs. They produced an often-beautiful doubling of the signs and the illusion of an open text. We have not however stumbled through the back door of the archive onto art. The double function did all this while leaving the required objectivities intact. The text was not so open as all that. It was still very much a document.

Often the effects of this double function on the picture were negligible: the different technical signs resided in the same pictorial form. The document of the Thoinard balcony (figs. 75 and 76), for instance, contained the line of style and provided the focus for the historical information written into the caption (corrected by a watchful librarian). But there were other documents where the functions sat in different parts of the picture; they pulled at its field by producing two different centers of interest; they could cause separations and gray areas where no work per se was being done. *Au Dragon* (fig. 77) took a picture of the sign and the space; it could have been bought for the architectural detail of the dragon; it could have suited a topographer's interest in the passage that opened up underneath. It was a correct combination of

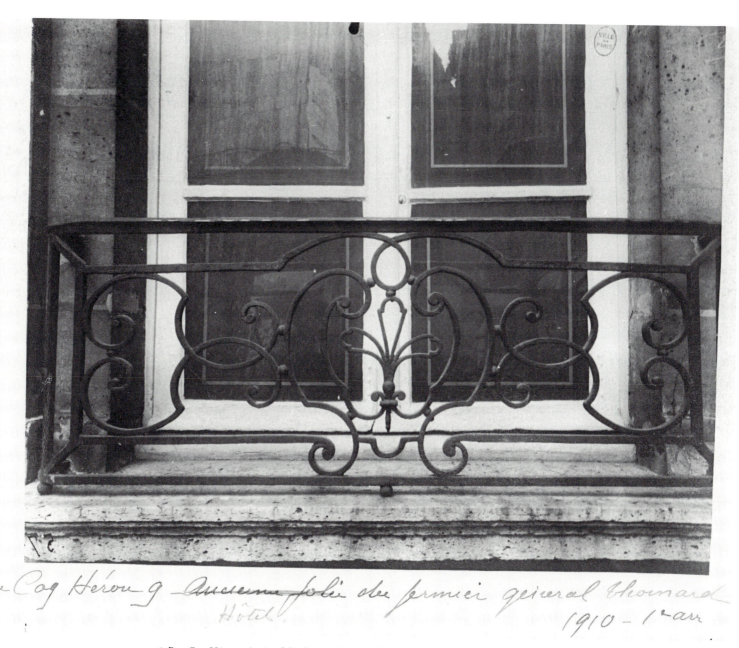

76. Rue Coq Héron 9 Ancien folie du premier général
Thoinard 1910—1ᵉ arr. [corrected by someone else to
read "Hôtel"]. AVP 5729. Bibliothèque historique de la
Ville de Paris.

77. "Au Dragon." 1899. AVP 3766. Caisse nationale des
Monuments historiques et des Sites, Paris.

types, a two-tiered document, supplemented by
a completely extraneous bicycle, which would
have fallen like scales from the eyes with the
technical look.

This is what Atget's commodity pictures
looked like. Their use value then, and this is
a crucial point, was located in the very fiber
of their appearance (which also stood behind
its exchange value). This rule of appearance
does not however hold true for all commodity
pictures; Atget's were crude compared to the
visual workings of others. No other image was
conscripted to speak for his commodities, no
demonstrations of success with mustaches, no
ace of club trademarks, no intervening allegory
(fig. 78). Atget's commodity spoke for itself. If
compared to the most celebrated kind of com-
modity of his day, namely Picasso's Cubism
(fig. 79), Atget's work seemed positively arti-
sanal. Picasso too, remember, played the market
(through Kahnweiler), making small, wicked
pictures for the homes of enlightened and trust-
ing clients. But his collage only hinted at its own
usefulness: it brought its own wallpaper to the
drawing room wall and implied by means of its
allusions to music that it could fit into the soci-
ety of the room. Looking at the collage was not
done according to any time-honored formula—
its forms jumped around, declaring their own
novelty; their appearance confused the collage's
claims to uselessness; it was not supposed to
make conventional sense. Its commodity forms
could not have been more different from Atget's
but then, they were playing a fast, boulevard art
market and Atget was not.

Atget's way of describing his activity was
to call himself an author, or more exactly, an
auteur-éditeur, author-publisher. The calling
cards he had printed up show that he arrived
at this epithet by 1902.[145] Initially he had been

78. *Le Rire*, no. 396 (3 September 1910). Bibliothèque Nationale, Paris.

79. Pablo Picasso, untitled collage. Autumn 1912. McNay Art Museum, San Antonio, Texas. Bequest of Marion Koogler McNay.

happy enough to call himself a photographer. In the 1890s, when he was out in the Oise, Atget had a stamp made so that he could brand his prints (fig. 80). "Documents Artistiques," it read, "E. Atget, photographer (Clermont, Oise)." When he moved to Paris, sometime in 1897, and began his Vieux Paris business, he used the stamp but scraped the bottom two lines off. A receipt left at the Carnavalet on October 9, 1899, showed it truncated so; by September 1901, he left a receipt with the top line scraped away. He was ready to make a new carte de visite, new stationery, and eventually printed title pages (fig. 81). By 1902 he had become an *auteur-éditeur.*

Extending Atget's idea of the author is easier said than done. In a first extension, Atget's activity might be compared to that of an enterprising man of letters, say, the calculating side of a Baudelaire, a writer looking to profit from the boom in printed matter. His and Baudelaire's markets did not match however and not only because there was a distance of some fifty years between the two; Atget's practice falls back into low relief when challenged by a description of Baudelaire's sense of the market, this one worked out by Walter Benjamin in a set of notes:

> Baudelaire's conduct in the literary market: Baudelaire was, through his deep experience of the nature of the commodity, enabled or forced to acknowledge the market as an objective (cf. his advice to young *littérateurs*). Through his dealings with editorial offices he stood in uninterrupted contact with the market. His strategies: defamation (Musset), counterfeiting (*contrefaçon*) (Hugo). Baudelaire was perhaps the first to conceive of an originality appropriate to the market,

which was at the time just for that reason more original than any other. (*créer un poncif*—to invent a cliché, trivial piece of work.) Such *création* included a certain intolerance. Baudelaire wished to create a place for his poems and to this end had to displace (*verdränger*) others. He devalued certain poetic freedoms of the romantics by means of his classical management of the Alexandrine, and the classical poetic by means of those *caesura* and blanks within the classical verse itself which were peculiar to him. In short, his poems contain certain specific precautions for the eradication of their competitors.[146]

What idea of the author then was Atget so anxious to conjure up? He seems to declare a nonarchival kind of ambition with this word, a move toward publication, the great twentieth-century space for photography. But he was also setting himself up to monopolize the accessions records of the libraries, where there was a column for the author's name and a column for the publisher's; Atget would have had his name there twice. This was hardly the end of it. The title *auteur-éditeur* was dense: not only did it describe the transitional nature of Atget's photographic practice but it also made reference to Atget's rights to that practice, his *droit d'auteur,* or copyright. He would be hovering on the outside of bourgeois culture, but rightfully so. In 1902 *auteur* was already a complicated enough word; now it reverberates, and some of its connotations are wholly inappropriate to our problem. Before we can tell the story of the albums, the *auteur* must be retrieved. *Auteur* was not a synonym for artist.

80. Atget's stamp. 1890s. Ecole Boulle, Paris.

L'ART

DANS LE

VIEUX PARIS

E. ATGET

AUTEUR-ÉDITEUR

17ᵇⁱˢ, Rue Campagne-Première, 17ᵇⁱˢ

PARIS

81. Title page, *L'Art dans le Vieux Paris*. Ca. 1909.
Museum of Modern Art, New York. The Abbott-Levy
Collection. Partial gift of Shirley C. Burden.

The Author

Between 1902 and now, the French definition of the author has gone vague: the author is a general case, an orphan; some say corpse. It is a definition too diffuse to be useful; worse, it has stripped the author of distinction. As if in flight from such a fate, lately French authors have become authors by doing other things besides write; they may make music, television appearances, psychoanalysis, maps. Whatever the result, it is literally diffused, scattered across an immense accumulation of spectacle, the "magazine covers, illustrations, ads, slick and pulp fiction, comics, Tin Pan Alley music, tap dancing, Hollywood movies, etc.," Greenberg's kitsch.[147] Those who go looking for authors must devise the means by which to recognize not only the worker but the work; at some point, perhaps by night, culture was camouflaged.

The situation of positive unclarity regarding the author has given rise to a growing body of criticism, full of dire pronouncements about the plight of culture, author death, and postmodern conditions; apocalypse weighs on the wind.[148] It might seem peculiar to be proposing that all of this, apocalypse too, be projected backward but, in fact, the conditions of bourgeois culture have not changed all that much in the past two hundred years; Baudelaire's complaints were continually repeated: bourgeois culture was always a little too crude to be believed. *Y compris* bourgeois photography and bourgeois writing. Mallarmé wrote a variation on the subject in 1895 which took a different, perhaps more useful tack. In the course of it the author mysteriously disappeared behind the word:

> The pure work involves the disappearance of the poet's voice, ceding the initiative to the words mobilized by the clash of their disparity; they illuminate one another in reciprocal reflections like a virtual trail of

sparks on gem stones, replacing the breathing perceptible in the old lyric inspiration or the personal, enthusiastic direction of the phrase.[149]

The idea does and does not illuminate Atget's photograph of the cabaret *Au Tambour* (fig. 82). In it Atget took a picture of himself as something more than the man on the street: with a ripple effect in the glass, he worked out a dark, winter's-day reflection on himself in which his body disappeared into his shadow and then attached itself to another man's head.[150] The photograph was an answer of a sort to the question about what an author was. But it was partial and insufficient, full of insider's bias, just like Mallarmé's *pensée*. Authorship in modern culture cannot be gauged from the absences and shadows and charges of crudeness alone. We shall be obliged to step away. Fortunately a more reliable standard exists: we find it in the law.

Authors of all kinds have for a long time been flatly equated in the law, though the equation was not made using the familiar terms of creativity, genius, and ancient lyric breath; it was instead (and still is) an equation of rights. The legal definition of the author was plain to the point of ugliness. The author was given rights to a cultural space over which they could range and work; all authors shared the same cultural space; they were defined by their presence there as well as by their rights to it. Through the law, then, we can gauge the author and the work, though the law does not rush forward, waving ready answers: the same law that defined the author was responsible for much of the confusion about what authors were and are. French copyright law dates from the Revolution; the landmark law on author's rights was enacted in 1793; it governed *droits d'auteur* until 1957, when it was revised. In 1985 it was revised again.

Chapter and verse of the law went as follows. The law of 1793 gave authors privileges that ordinary men did not enjoy: "Authors of every kind of writing, composers of music, painters and draughtsmen who have their paintings and drawings engraved, will enjoy the exclusive and lifetime right to sell, to have sold and to distribute their work in the territory of the Republic, and to cede the same in toto or in part."[151] In other words, authors retained property rights over the fruits of their labor even after their work was sold to somebody else. That was the essence of the privilege. The rights themselves could be ceded or sold but this took a separate operation and was not assumed to be the natural part of any deal. The *droits d'auteur* were applied to any work done in the designated media, writing, music composition, painting, drawing, and engraving, basically those media that could be worked up into forms of high culture, like poems, sonatinas, and red chalk sketches. The law did not even try to draw lines between good and bad work in these media and it did not presume to erect criteria for aesthetic quality. Slipshod failures and drawn reproductions were covered by the same rights as the masterpiece: a hack and a Mallarmé would both be called authors; an engraver of Salon paintings had just as much claim to the title as an Ingres.[152] The cultural field is broad, said the law. It covered kitsch, avant-garde, low-, high-, and middle-brow work with equal justice. Authors were not necessarily artists.

The law did not divide culture into states. It set out a single field where standards were blurred, where the different hierarchies of the arts wobbled, rotated, and eroded, irrelevant. Others in academies and newspaper columns and university lectures could and did quibble, insisting on other definitions of culture with genres, standards, traditions, and rules. The law let these storms erupt around it. It held like

82. "Au Tambour." 1908. AVP 5522. Caisse nationale des Monuments historiques et des Sites, Paris.

bedrock, content with its basic distinctions. Its distinctions entered the Napoleonic Code and as the nineteenth century progressed, they acquired more nuance in the courts. But historically the law of 1793 set a breathtaking precedent that was not to be undone. Its definitions of culture survived all the others: the collapse of the hierarchy of genres and the slow death of the Salon made no difference to it; neither did the rise of the mass-produced, printed forms of culture. The law had already leveled the academic distinctions; in its very practical, authoritative terms, culture was flat.

In the law, the term author did not and does not carry with it a mark of supreme distinction, nor did it designate a particular profession, like poet. It was only meant to distinguish a particular kind of labor from another, the cultural from the industrial, gist from germ. According to the law, a privileged, cultural form of labor was identified by a quantity and a quality. It took shape only in the certified media. Its privilege was justified by the presence of a human intelligence, imagination, and labor that were imprinted and legible in the work, meaning that such work was seen, crudely, to contain the reflection of the author's personality.[153] Material and reflected personality were linked; they became inseparable. They became the two traits of culture. In the nineteenth century only one exception was made to this marriage between matter and spirit—drawing, divided in two because technical drawing had been impossibly compromised. The compromises had been produced by industry and they resulted in the technical drawing's fall from grace. The compromises also pointed to something clear in the broad and blurry cultural field: they were the black marks that showed where the edge of culture lay.

It was painfully simple. The technical drawing fell from culture because it had participated in the manufacture of industrial objects. In this case, drawing, the material, was *not* felt to reflect the personality of the draughtsman; the bond between matter and spirit had been broken, though this was largely a matter of opinion and never proved. In fact these sentiments had been motivated by the basest instincts: industry did not want authors in its ranks; it wanted perfect control over the property rights during every phase of production, from technical drawing to finished commodity. In 1806, the silk manufacturers of Lyon obtained this control from Napoleon and drawing was legally split in two. This had the effect of exiling the technical drawing from the cultural field and exempting its maker from *droits d'auteur*, its status thereafter defined by another set of laws protecting industrial design.[154] Still, for our purposes, the episode is instructive. Clearly the authorial media were not naturally, as it were, cultural; one saw what one wanted in them; one had refused to see a self-reflecting author in the technical drawing. Later in the century, in 1891, the courts refused to see the author in the poster; no matter if there was an established artist involved.[155] And so, in France manufactured goods, designs and objects alike, were not officially allowed to embody the personality of their makers or the signs of abstract human labor: they were not to display any evidence of the commodity's fetishism.[156] Manufactured goods were to be magically simple, not self-centered, not meant to serve the spiritual needs of the community the way books and pictures did. They served material needs. In essence the law of 1806 recorded and encoded the limits of modern culture.

Modern culture existed as an economic distinction, in effect a protected market that functioned within the regular economy. Authored work was always understood to be circulating in the market, generally in printed form.

This had already been an element of the 1793 law, which had been necessary in the first place because the market for culture needed to be policed. Yet after 1793 authors were unlike other laborers: the law had given them some rights to their work; even as it moved through the economy, their work remained their property. The law played a critical, though largely unsung, role in the definition of modern culture. Daily it stood by to arbitrate and to provide a practical definition of what an author was and where cultural work was to be done. It conceived of the cultural field as a marketplace. With time its conception grew stronger. For the duration of the nineteenth century, its terms remained sacrosanct. In a series of modifications in 1844, 1854, and 1866, the author's heirs won the rights to the work for fifty years after the author's death but the rights and regulations for authors themselves did not, in their essentials, change.[157] In theory and in practice, in all sectors of daily life, the cultural was always being distinguished from its Other, which was the industrial.

The copyright law regulated the market economy for culture at the same time that it set it apart from the regular economy. The law did nothing more than negotiate the dialectical movement between the two economies with a maximum of simplicity and efficiency; it was functional but servile, something of a butler. Though it furnished the apparatus so that culture could work, it had drawbacks: for example, it could not be expected to accommodate uninvited guests. These began to arrive over the course of the same nineteenth century, new technologies and new materials for word, sound, and image; before long the photograph, the phonograph, and the cinematograph all became candidates for copyright. They tested the limits of the law in yet another way. For to give these producers the status of authors involved granting the new technologies (the technologies we

have come to associate with mass culture) the status of the materials of aristocratic culture (the culture we have come to call high). The law, for all its apparent elasticity, could not handle such a request overnight.[158] Curiously, the problem lay not with the low order of culture but with the nature of the labor involved, a labor integrally connected to machines. Printing presses were one thing, cameras quite another, and no small obstacle; they kept the French law from granting the technological authors their rights until 1957, long after the law had been modified to take in architecture and sculpture (1902), a good seventy years behind the law of other industrialized nations.[159] But to account for the technologies, the law could not be modified; it had to be rewritten.

Before 1957, in their effort to gain these privileges, those who made photographs, records, and movies were obliged to devise justifications for the value of their materials, their medium, and for their rights to use the title author. They and their advocates argued with the law and produced their own voluminous definitions.[160] Their definitions of the author followed a pattern. Generally it was maintained that a human factor overrode the mechanical process; upon close inspection, a human mark, the trace of a cultural act, was discerned. Alphonse Lamartine wrote one such apologia. Initially Lamartine had, much like Baudelaire, condemned the photograph as abject, a plagiarism of nature, a picture without soul. After seeing the work of Adam Salomon, he changed his mind. Subsequently he wrote a retraction, explaining that the photograph needed to be seen as the result of the particular photographer's labor. Then he went one better: the photographer worked principally with nature, to wit, the sun, Lamartine claimed, and left the machine out of it entirely.[161] Hippolyte Taine made a more pragmatic contribution to the debate: "Photo-

graphic work," he wrote, "is property; it belongs to the producer under the same title that gives the engraving to the engraver, and, in the two cases, the property should be protected."[162] For all the rhetoric, which culminated in the pictorialists' claims for photography as a fine art, the objective was simply to occupy a place in culture; photographers would have been content with low-lying regions, the wetlands of the field. Listen to the photographer Bulloz in 1890 arguing for his rights by deferring to painters like Cabanel (fig. 83): "All that we are claiming is that a photograph can take on the character of a personal creation. There is no question here of sentiment; photographers are not demanding to be assimilated to the ranks of the master painters; none of them would dream of asking the law to declare them the equal of Baudry or Cabanel."[163] These terms were neither academic nor gratuitous: if they succeeded, they could have real social, legal, and market value. The photographers provoked the fierce debate over the author, basically the same debate that is with us still.

The positive, defining justifications of the photographers and their kind, not to mention the volume of photographs, records, and movies they made, were read, considered, and critiqued. In the response we find another, defensive discourse on the author, a relatively negative discourse that worried. It worried over the decline of the author and the old hierarchies of the arts; it disliked the new forms of labor; it wrongly pinned the trouble on the use of the machine, seeing it as a barrier that prevented the imprint of a human being's spirit on a certified, authorial material; it mourned a mirror stage of cultural work in which the self appeared and could reflect; it saw a dark future with no guaranteed Ideal-I. The debate lengthened, still other positions were developed and these have become the authoritative ones, the essays of Mal-

83. Alexandre Cabanel, *Naissance de Vénus*. 1863.
Musée d'Orsay, Paris.

larmé and Benjamin, and later, Foucault and Barthes.[164] Their discourse had little effect upon the disposition of the law, which continued on with its duties, maintained the cultural distinctions such as they already were, and upheld its brute definition of cultural work. But while all this talk was going on, the new technologies had imposed themselves and other, newer technologies, like television, arrived. Things had finally gone far enough to warrant a revision of the law. A truce was reached. The older culture by technology was legalized in 1957.

The 1957 law expanded the definition of the author to include those who worked in dance and pantomime, cinema and photography, translation, and maps. Industrial design and advertising were denied admission. The field of culture had grown vast however. The text of the law had grown longer too:

The disposition of the present law protects the rights of authors and covers all work of the mind, whatever the kind, the form of expression, the merit or the destination. The following are considered work of the mind: books, brochures and other literary, artistic, and scientific writing; lectures, speeches, oaths, pleas and other work of this nature; drama and musical theater; choreography and pantomime when the work is recorded in writing or otherwise; musical compositions with or without words; cinema and work obtained by an analogous process; drawing, painting, architecture, sculpture, engraving, lithography; artistic and documentary photography and work obtained by an analogous process; the applied arts; illustrations, maps; plans, sketches and models related to geography, topography, architecture or the sciences. The authors of translations, adaptations, transformations or arrangements of works of the mind enjoy protection under

this law, without prejudice to the rights of the author of the original work. The same follows for those authors of anthologies or collections of diverse work who by the choice and arrangement of the material do the work of intellectual creation.

Titles were protected as well as works, and even the name of the author was covered: "The author enjoys this right with respect to his name, his quality, and his work. . . . This right is attached to his person."[165] Authorship still covered all levels of culture, high and low, but it had now spread to many media and to the separate signifiers of authorial work, like the title of the piece or the name of the author. The author's name alone could signal the body of his work so effectively that even in a detached state, a name was covered by *droits*.

After 1957 authorship was identified by more than a happy combination of a medium and a person: it could designate a rather immaterial position, a reputation and a generalized cluster of forms, stereotypes, trademarks. It was not so clear where one should be looking to find the reflection of the author's self. Authorship had become patently defined now by the reproduction of the work; it had taken on many of the characteristics of overtly commercial, brand name products; in many cases there was no single original. The law tried to cover all possible situations; it made special provision for collaborative work, such as cinema, where there was no single author. It signaled the breakdown of the clear distinction between culture and industry. The 1985 law, which took video and computer technology into account, went further in the same direction.

Now the 1957 law ushered in a new level of *ennui* for those wanting to understand what an author was. It had cut into the mass media, pulling Hollywood film and news photography in and leaving advertising out, making the legal distinction between culture, the culture industry, and industry even more arbitrary than before. It made it more difficult to conceive of a single mass culture in the way Greenberg, for one, had. The new law's definition of the author did not adequately explain what constituted creative work or what separated it from the run of the mill. It did not explain the privileged economic dynamic of the cultural field. It did not explain that this field was actually industry's inner sanctum. It did not explain that cultural forms can be industrially produced. It did not help us to make a clear distinction between the cultural subject and the industrial subject. The law however is not supposed to explain itself— that work takes place elsewhere. Explanations were not slow in coming but they were seldom adequate. The author question kept coming up. Michel Foucault was led to ask it once again in 1969 as part of his archaeology of *savoir*.

Foucault did not call in the new law to supply answers to his essay question "What Is An Author?"; oddly, he did not even mention it. He was more concerned to see what culture had made of the author and to understand why most intellectuals had come to call the author a dead letter. Foucault therefore undertook to measure the disappearance of the author, though much of what he measured was actually the difference between the old law and the new. The sum of these differences, according to Foucault, amounted to this:

> We can conclude that, unlike a proper name, which moves from the interior of a discourse to the real person outside who produced it, the name of the author remains at the contour of texts—separating one from the other, defining their form, and characterizing their mode of existence. It points to the existence of certain groups of discourse and refers to the status of this discourse within a society and culture. The author's name is not a function

of a man's civil status, nor is it fictional; it is situated in the breach, among the discontinuities, which gives rise to new groups of discourse and their singular mode of existence. Consequently, we can say that in our culture, the name of an author is a variable that accompanies only certain texts to the exclusion of others: a private letter may have signatory, but it does not have an author; a contract can have an underwriter but not an author; and, similarly, an anonymous poster attached to a wall may have a writer, but he cannot be an author. In this sense, the function of an author is to characterize the existence, circulation, and operation of certain discourses within a society.[166]

Foucault's essay turned on some of the law's new points, notably the name of the author and its separate existence, its ability to designate what Foucault called an author-function. But when he separated the authors from the writers, he was not technically correct: one remained an author so long as one did not abandon one's rights; certain kinds of employment, underwriting and some kinds of journalism, for example, involved such an abdication. And when Foucault described the circulation and operation of discourses, he did not feel it important to explain that this took place within a market economy even though this economic condition, as we have seen, defined the author in the first place. But the economy as a determination was not agreeable to Foucault. His author had existed in a disembodied, nonreflecting, dispersed state, not in the world. For Foucault the author existed as one of the founding fictions of literature, as part of its link to a transcendent position above ordinary knowledge; even if one rejected this cliché of traditional intellectual history, there was still an author-function which operated. As he worked to generalize the author-function, he summarized his findings:

The "author-function" is tied to the legal and institutional systems that circumscribe, determine, and articulate the realm of discourses; it does not operate in a uniform manner in all discourses, at all times, and in any given culture; it is not defined by the spontaneous attribution of a text to its creator, but through a series of precise and complex procedures; it does not refer, purely and simply, to an actual individual insofar as it simultaneously gives rise to a variety of egos and to a series of subjective positions that individuals of any class may come to occupy.[167]

This led him to posit an author disconnected from the commonplace procedures of everyday life, an author as philosophical object. Yet authors functioned in other ways. In his inaugural address to the Collège de France the following year, Foucault refined his idea:

> Of course, it would be ridiculous to deny the existence of individuals who write, and invent. But I think that, for some time, at least, the individual who sits down to write a text, at the edge of which lurks a possible oeuvre, resumes the function of the author. What he writes and does not write, what he sketches for the work, and what he drops as simple mundane remarks, all this interplay of differences is prescribed by the author-function, such as he receives it from his historical time, or as he in turn modifies it. For he may well overturn the traditional image of the author: it is from his new position, as an author, that he will fashion—from all he might have said, from all he says daily, at any time—the still shaky profile of his oeuvre.[168]

The new position of the author was not unfortunately given a specificity, a case in point, perhaps because Foucault could not rid the idea of the author of its taint. Whatever, the result left the author's practical relation to *savoir* in abeyance.

Barthes had written a similarly elegiac essay, "The Death of the Author," in 1967. But the occasion for Barthes's essay was more unusual. It was written for an American magazine, *Aspen,* nos. 5 + 6, edited by Brian O'Doherty and dedicated to Stéphane Mallarmé.[169] *Aspen* 5 + 6 was something of a Franco-American cultural effort: Alain Robbe-Grillet, Marcel Duchamp, Michel Butor, Susan Sontag, George Kubler, John Cage, Morton Feldman, Merce Cunningham, Robert Rauschenberg, Tony Smith, Robert Morris, Sol Lewitt, Mel Bochner, and Dan Graham were among the contributors. (There was also work by Hans Richter, Laszlo Moholy-Nagy, Richard Huelsenbeck, and Samuel Beckett.) Yet for all the great authorial names, the magazine moved toward a denial of old-style authorship. In many ways it chipped away at the traditional separation that had been legislated between the high culture and industry. If anything, it behaved like low culture, where the kind of omission posited by Mallarmé and the kind of subordination to the mechanics of the statement described by Foucault were unremarkable and commonplace.

Aspen 5 + 6 was kept in a white box. Barthes's essay was one of twenty-eight pieces, a pamphlet stuck between movies, records, diagrams, cardboard cutouts, and advertisements. The box encapsulated the spreading field of modern culture in a way that remains quite advanced. For example, Marcel Duchamp was asked to record his essay on the creative act at 33 rpm; his voice was unmistakably his own, his breathing perceptible: "What I have in mind is that art may be bad, good or indifferent, but, whatever adjective is used, we must call it art, and bad art is still art in the same way as a bad emotion is still an emotion. Therefore, when I refer to 'art coefficient', it will be understood that I refer not

only to great art, but I am trying to describe the subjective mechanism which produces art in a raw state—*à l'état brut*—bad, good or indifferent."[170] There was nothing mysterious here; Duchamp signed his name, lent his voice, and subordinated his idea to French common sense, the working definition of art as a quantity not a quality, the letter of the law. His text kept motley company, much of it technologically based. Brian O'Doherty's *Structural Play #3* used a reduced, virtually technical drawing to make cultural meaning: in the play A and B were moved impersonally about a grid, dialoguing in the diagram. The same standardized geometry went to make Tony Smith's *Maze*—a diagram, a photograph, and a group of black cardboard pieces, more like a kit ready to be assembled than an aesthetic *ding an sich*. One man's mark was now inseparable from another's. The box's sheaf of advertisements collected a Bolex brochure for home movie equipment together with subscription blanks for *Artforum* and *Aspen*. The subjectivity of the author was progressively siphoned off. Dan Graham wrote a "Poem, March 1966" which proposed a scheme, literally a word count, to be set into final form by the editor of the given magazine. Sol Lewitt introduced his "Serial Project #1, 1966" by describing the work of a serial artist:

> The aim of the artist would not be to instruct the viewer but to give him information. Whether the viewer understands this information is incidental to the artist; he cannot foresee the understanding of all his viewers. He would follow his predetermined premise to its conclusion avoiding subjectivity. Chance, taste, or unconsciously remembered forms would play no part in the outcome. The serial artist does not attempt to produce a beautiful or mysterious object but functions merely as a clerk cataloguing the results of his premise.

With its technical drawings, advertisements, and author-producers, its technological look referring to a technologically oriented social order and not to some sign of modernist purity, with its desire for scientific objectivity and its recognition of the real conditions for cultural production, the box broke relentlessly with tradition. It did not confine itself to the cultural field; furthermore, it put the new means and the economic realities of art side by side. It exposed modern form as a complex of machinery, marketing, impersonality, rationality, power, and scientific truth; it took these materials over and tried to work with them; it beautified and on occasion mimicked the practices of the non-cultural zones. It asserted its own position as a cultural product that was tentatively engaged with a larger, uncultured but technologically sophisticated world. The box showed how authors, including modernists, could do critical work. In that respect it was a model box. Barthes, for his part, was out of step. Faced with these particular new cultural conditions, he backed off, away from any new science of the text or language game. He would only advance the idea of an authorless literature; for him, assimilation to the forms of industry or kitsch was unthinkable; impersonality was death.

And so the great modern texts on the author split away from the law as if to disregard its terms, to escape. They remained, in spite of themselves, oriented toward the high-culture artist and traditional, self-reflecting art; they tended to assume a desire for upward mobility. They were full of nostalgia for the days when spirit and material were obviously married. And they did not fail to repress the commerce. In part this stemmed from the fact that the series of agreements between culture and industry had an unwritten proviso that prohibited any real analysis by legitimate culture of its links to the industrial complex: culture was to leave

industry alone; culture was to be theorized in the abstract, detached from the working definition that the law provides, detached too from objective knowledge. Now this was also one of the keys to its ideality. When the ideal could no longer be maintained, the discourse on the author turned morbid.

The law had helped to generate and to consolidate the positive and the negative discourses on the author, from the lectures to the boxes, though it did not alone produce them and it could not control them. Yet neither the law nor the philosophers ever had the last word on the author. And none of them had defined *auteur* by himself. They were met by legions of streetwise, downwardly mobile low-culture suppliers and rising entrepreneurial modernists, authors who took other positions in relation to bourgeois culture and bourgeois knowledge. Foucault's idea of the author-function takes on a different resonance in this context; perhaps, if he had allowed the low orders of knowledge and production into his model, he would have worked out a definition of the author that separated from the specter of transcendence. Outside his idea and outside Barthes's, such a definition was certainly in the making by, among others, commercial photographers. What, we may now rephrase our question, did *they* think the author was?

In the nineteenth century a fair number of photographers worked illegally as authors, hoping to force better definitions out of the courts.[171] When, in the 1860s, the first cases in which the *droits d'auteur* of photographers were proposed, contested, and tried, the courts came up with a loophole in the law that gave the subsequent courts the right to decide on a case-by-case basis what kind of production was in question, whether the particular photograph was art or industry, whether the photographer was an author working with a medium or an

ordinary citizen working a machine. When the courts did apply the 1793 law to the photograph, they did so with the rationale that photographs were drawings of a kind.[172] But the court was unable to divide art from industrial photography as drawing had been divided, because all photographs appeared to them to function according to the same code of representation. All photographs seemed to reproduce external appearances, like the authorial drawing, and not, like the technical drawing, to measure internal structures of things. Photography could not therefore be covered, as the technical drawing was, by patent law. Nor, because of the role of the machine, was it clearly copyrightable. The photograph fell hopelessly between the cracks in the existing law into a no-man's-land; *technically it was neither culture nor industry*. It was impossible to claim legal rights to a photograph without an argument. So, when the case arose, the court expected a justification that cited a reflection of the author's personality or personal skill; with enough of one or the other, the photograph could be considered as a protected drawing. Using this logic, by 1900 most of the important court decisions gave the photographer his *droits d'auteur*. They were still not automatic, it must be said, since the law itself had not been revised, but the photographer might have *droits:* to call oneself an *auteur* meant that one would actively lay claim to them.[173] The title could designate a photographic practice like pictorialism with all the cultural ambitions of painting; it could just as well be used as a cover to gain economic privilege for more technical pictures that served the material needs of production.

Atget can be counted among the streetwise. By 1902 he had taken to calling himself an author or, more precisely, an *auteur-éditeur*. As a title it was neither common nor descriptive. One understood by it that the *auteur* half

is meant to refer to the *droits* to which he felt entitled and, more immediately to the point, which he expected to be observed by those who bought his photographs. Atget was more than ready to publish these photographs on his own, hence the *éditeur* half, though this functioned as a sign of his professional desire more than anything else. His work rarely saw print; his dreams of publishing remained dreams. *Auteur-éditeur* was really a practical epithet. He used it to announce himself on his calling cards, his stationery, and sometimes on the credit line of his paper albums. But the epithet is not to be taken as a sign of purely artistic ambition. At the same time that he claimed the authorial privilege for himself, Atget used one of the lowest of all photographic forms available to him, a form that was for all intents and purposes industrial, the photographic document. Atget did not inflate the value of his photographs when he referred to them as simply documents he made; the word document brought them straight down. The document was the photographic equivalent of the technical drawing.

In fact Atget's photographs functioned rather like technical drawings did in the manufacturing process: they were a step, a preliminary diagram that would help produce another commodity and nothing more. It would be altogether possible to use these photographs as evidence for an argument that photography was rightfully subject to patent, not copyright, law because the picture was bound by a relation to a product.[174] Sometimes Atget's photographs would contribute to the reproduction of a Louis style, sometimes to a caricature of *la vie parisienne,* sometimes to a historical article on *Vieux Paris*. In all of these cases, the document was consumed, absorbed into the labor process, and contained, so to speak, in the client's own product, almost always a cultural good. But the technical signs in the document were nothing if

not standard and impersonal. "Au Tambour" contained the same technical signs, for example, as "A l'homme armé" (fig. 84). There were the signs for architects and metalworkers, who looked carefully at the way the building facade and its grillwork fit: the forms of the picture that look like an architectural drawing.[175] There were also other technical signs for the eye of the antiquarians, who cared more for the old metal sign and wanted therefore to see the sign as a specimen for their histories. These two different kinds of technical signs produced the functions for such photographs, constituted their use value, and gave them the ability to enter the market as a commodity. But this made the documents themselves neither cultural nor industrial. At most, one could have claimed that they belonged with the lowest forms of culture.

Atget grew to enjoy this contradiction of his own making, the authorial document. Not the contradiction between art and work, for art was not at issue, the contradiction reset form and subject. The first part of this study has prepared the contradiction, the second follows from it. The contradiction became a source of power. At "Au Tambour," the contradiction took over. The multiple functions were let loose in his usual way; the technical signs bumped against one another; plenty of intermediate space was left open. Into one such space, the pane, Atget worked his shadow. The pane was not crucial to any of the technical signs. It ought to have been kept neutral in order to preserve the pictorial integrity of the facade, but what transpired on or behind this pane of glass was immaterial to the professional viewer.[176] By working his shadow into the free space between the technical signs, Atget dampened the perfection of his document without undermining its different usefulnesses. He knowingly made a grade B document. This enabled him to insert himself among the signs,

84. "A l'homme armé." 1900. AVP 4079. Caisse
nationale des Monuments historiques et des Sites, Paris.

to make his authorial presence if not his per-
sonality felt, and to show his true position as
an *auteur:* he did not identify himself with the
technical signs of the image; the document was
fetishized in the intermediate spaces that bound
the signs together and held the functional ambi-
guity in place. It was in the binding and grafting
of the signs that Atget emerged as an author.[177]

As if this were not sufficient, the shadow
fetish took another tack. It appeared in a pane
that was half mirror, half not, in the place where
one saw through the looking glass. There we
find one body in the process of changing magi-
cally into another, the photographer's head
swallowed up and replaced by an apparition.
This constructed another photographer, not
exactly Atget, in the pane and made that *other*
man, that shadow with a moustache, appear to
take the picture. It was a bit like signing Rrose
Sélavy's name to a French window (fig. 85).
Yet Atget had no pretension to avant-gardism;
there was no dada slap, no minimalist dirge;
his materials were those of any documentary
photographer without nostalgia for the old-
style authorship of the easel painter or poet; his
combinations were made with the same techni-
cal signs used by his peers. For him, authorship
involved lyric impersonality and a credit line.
He would not have thought that he was disap-
pearing or behaving like a clerk. The technical
sign was part of his signature, part of his elo-
quence. Perhaps he was cheating a little when
he called himself an author; he had neither won
the right nor did he have the right kind of work
to back up the claim in court. But for Atget
the law existed to be exploited. And so with-
out ceremony Atget bent the law and trafficked
between the cultural and the industrial zones;
he hustled his work back and forth across the
border, playing to any market he could.

The cultural and industrial zones of copy-
right and patent gave a fairly strict definition

85. Marcel Duchamp, *Fresh Widow*. 1920. Museum of
Modern Art, New York. Katherine S. Dreier Bequest.

of culture. That definition did not structure Atget's work, which was technically neither. The space of Atget's operations was composed of a crisscross of outer spaces, at the beginning of others' labor, before the archive, in and out of legally defined culture, on the gray ground of the marketplace, wherever that was. The outside was not a pure blackness, not an abstraction to be conjured up when all other images failed. The outside had its own kinds of solidity, materials, and potential. Atget understood its subtleties and benefits well. From the outside he would deal with the *connaissances*. His documents would subordinate culture to knowledge; others could do with this knowledge what they liked. *The forms of the document were not the reflecting authorial material posited by the law; his forms were but the means to knowledge.* The documents spoke louder than Atget's epithet. They remained unambiguously outside art.

Atget became increasingly interested in the idea of opening up his space of operations, of playing to other kinds of visibility than those afforded by the archives. He would not have called himself an *éditeur* if he had not wanted it to mean something. Publication gave the photographer access to the public sphere and a way of addressing the general public. However, public address and publication were not necessarily available to a photographer; to a large extent these things depended upon the scale of the photographer's operation.[178] Those who had the most public success were the companies like the Neurdeins, who had bargained for an exclusive contract with the Commission des Monuments historiques and published their stark, stately views extensively in others' books, in their own, and in their postcards. Bigger firms with more capital at their disposal could afford many publishing projects and more risk; they were the ones to define the appearance of the published photograph. In 1900 Atget was aiming for this

kind of influential, highly visible practice but somewhat naively, since he remained a one-man shop, a small businessman, and something of a marginal, largely through his own doing. He avoided photo clubs, societies, and trade unions (and undercut union prices).[179] He never listed himself in the Bottin. Other decisions took him farther away from typical photographic practice. He tampered with the accepted rules for professional-quality photographic form, printing cracked negatives, allowing a vignette on the frame, shooting the reflections in the window-panes. And yet despite the obvious drawbacks to his work ever winning great acceptance in print, he kept alive his dreams of publishing.

The first of them, the postcard series, came to no particular good. Then, around 1909, Atget began seriously to consider the idea of a book. He made a maquette of one called *L'Art dans le Vieux Paris*. Captions and title page were set in type and the ensemble was bound between a pair of cardboard covers trimmed in leather. The venture never passed the maquette stage but the Bibliothèque Nationale became interested in that format.[180] Of their own initiative they had already bound the *petits métiers* (acq. 6100) into a large loose-leaf folio that was neither edited nor captioned by Atget (and included a page of someone else's photographs *chez la couturière*). This may have given Atget the idea to propose a more elaborate body of work on modern life to the Bibliothèque Nationale. The origin of the idea is not important. The fact remains. Between 1911 and 1915 Atget sold them a group of six albums, each carefully bound and captioned under his supervision: *Intérieurs parisiens début du XXᵉ siècle artistiques, pittoresques et bourgeois; La Voiture à Paris; Métiers, boutiques et étalages de Paris; Enseignes et vieilles boutiques de Paris; Zoniers. Vues et types de la zone militaire de Paris; Fortifications de Paris*.[181] The albums were catalogued into

the O. series for costumes and *moeurs* (with the exception of the *Fortifications*, catalogued as topography, and the *Voitures*, set into the section of arts of wood, where other carriage pictures had already been catalogued) but were separate from the big folios which gathered all kinds of images together according to subject. Atget's albums were treated like library books. With them, Atget's name entered the card catalogue, as an author. With them, his work could reach not only a public but posterity.

The Bibliothèque Nationale was the repository for all work published in France; technically any work published in the country was to come there automatically under the *dépôt légal*, though photographs had been excused from this, *faute de place*.[182] When Atget first sold to the Bibliothèque Nationale, it was stipulated in the *registres* that his work had not been placed on the open market, nor officially published. With the sale of his albums, Atget turned the tables and worked one of his better coups. Although the albums were technically unpublished, they entered history in the same place they would have if they had been. "In the clear light of habitual memory, images of the past fade little by little, obliterate themselves, no trace any longer remains, we shall never recover it. Or rather we could never recover its memory, if a few words (like 'director of the Postal Ministry') had not carefully been locked up into oblivion, just as one deposits a copy of a book at the Bibliothèque Nationale, which without this would risk becoming unobtainable," as Proust put it.[183] Atget's albums are to this day a matter of public record. They permitted his work to separate from the archive and make another kind of sense. A sense for a public.

The print room of the Bibliothèque Nationale, it would appear, accommodated quite a broad public with mixed expectations; though it had another reputation. In 1906 the director of

the print room, Henri Bouchot, felt obliged to argue strenuously against its reputation as a rendezvous for idle connoisseurs, so strenuously that one suspects that its reputation was probably deserved: "Has it not been insinuated in high places that the Cabinet des Estampes, being a department *de luxe*, should content itself with its lot? A place of luxury! the collection on any given year providing the readers with 60,000 volumes, the least of which are folios, and receiving a majority of workers in the arts, of practitioners of all kinds, of artists, of humble laborers, a hundred of them for every ten idle *flâneurs* or simple curiosity seekers!"[184] The Bibliothèque Nationale's public as a whole certainly was more like the one Bouchot wanted to claim for the print room, tireless scholars, "these poor readers, the traditional rats, soured by a life of disappointments and failures, led astray by impossible dreams, full of bitterness, jealousy, and anger, hard, exacting, willful, and often ignorant; one of these poor souls is enough to poison an entire session."[185] For this public nobody could identify exactly Atget could not expect a single technical look, instead he had to work toward another idea of his viewer. In his experience the library was at the very least a place devoted to bourgeois culture and the majority of its public was equally bourgeois. He knew what it meant to work for the topography file there; there was no reason for the public of the *moeurs* file to be so very different. Bouchot died in late 1906; Atget worked out a plan for albums with his successor, François Courboin.

The six albums were another one of those places where Atget drew the line. An eclipse. Their tone had been set by a seventh, which was chronologically the first, the album that was a misbegotten book, the only one *not* made for the print room of the Bibliothèque Nationale: *L'Art dans le Vieux Paris*.

L'ECLIPSE

The First Album

The antiquarian sense of a man, a city, or a nation has always a very limited field. Many things are not noticed at all; the others are seen in isolation, as through a microscope. There is no measure: equal importance is given to everything, and therefore too much to anything. For the things of the past are never viewed in their true perspective or receive their just value; but value and perspective change with the individual or the nation that is looking back on its past.

—Nietzsche

The daily grind. Atget came face to face with the antiquarian sense of Paris every time he photographed Vieux Paris; he knew its perspectives and its blind spots well. In 1909 he saw a Vieux Paris publication wipe a cart out of the foreground of one of his photographs (figs. 86 and 87). Mostly he photographed within the limits. His projected book, *L'Art dans le Vieux Paris*, was in many ways a reproduction of the antiquarian city. Not a sonorous authorial monologue, not a clarion call, not a moment of release. The album hovered around the old markets, offering itself to the Vieux Parisiens we have already met. But with it Atget tried to look as though he was *not* operating from outside their *connaissance*. The documents were now to behave as if they were the end product of knowledge. The document masquerading as the last word. The author putting himself forward as an authority.

Antiquarian sense may now seem isolated, immaterial, and rather unimportant but it held sway over Vieux Paris and any representation of the old city had to contend with the antiquarian vision of the past. The antiquarians' was not an isolated power, nor were they a gentle group, nor were they amateurs really. Now it can be said: the best of them were little men of the state, convened in the Commission

86. "Fontaine Rue de Grenelle. 1898 7^{eme} arron." AVP ?
Bibliothèque historique de la Ville de Paris.

87. "Fontaine Bouchardon, Rue de Grenelle," from
Fernand Bournon, *La voie publique et son décor* (Paris:
Renouard, 1909), pl. 49. Bibliothèque Nationale, Paris.

municipale de Vieux Paris and endowed with
a budget. Duly constituted, their activities had
a definite value for the state. They were actu-
ally producing history for it, giving the object
of their devotion the suitable cast and color, the
detail and the fog of a state ideology. Whether
it was due to their excess of ideology or to their
unbridled zeal, Atget's relations with them were
neither constant nor easy. By the time he made
L'Art dans le Vieux Paris, the strains between
them were apparent.

Only on the surface of it did *L'Art dans le
Vieux Paris* cohere: it collected sixty of Atget's
photographs from the series of the same name,
dating from 1900 to 1909 (see appendix 1,
table 1). It made a fair sample of those 1,758
pictures, which included facades, doorways,
stairways, and ornamental details from the an-
cien régime. Some of the motifs were famous
and well published; some were obscure, held
back in dim hallways; some had already been
lost forever in the time that had lapsed between
the taking of the photograph and the assembling
of the maquette. All of them had been success-
ful images for Atget, going into collection after
collection of library files and decorators' ar-
chives. The book put these documents into a
linear sequence and had them speak to a histori-
cal problem, the architecture of the Bourbon
past. Its first thirty-four pages moved the viewer
quickly through twenty-three sites in a generally
numerical-chronological (not topographical)
order. Half-open *porte cochères*, grand and
vacant staircases, wanton fountains, fierce door
knockers, the odd vase; rather than advancing
toward a purpose, the images merely accumu-
lated. Then, without warning, an arrangement
was struck. The second part of the book was
given over to three monuments, the Hôtel Bou-
cherat, the Eglise St. Sulpice, and the Hôtel
Lauzun, with two photographs capriciously
sandwiched in between the Hôtel Boucherat

and St. Sulpice. These three chapters, if it is possible to call them that, took time with the interiors of those buildings, moving more carefully through an inventory of motifs—hounds' heads, Virgin Marys, arabesques, grotesqui, Marie-Antoinette's pipe organ. The book collected all of this with some solemnity. There was no preface.

The maquette was put together at some point during 1909 or 1910.[1] It did not entail any new photographing but it meant writing captions, working with printer's galleys, overseeing the pasting and binding of the maquette, and giving the documents a public presentation.[2] A document in the book was not worth two in the archive; these documents if anything became even more technical, as they were under added pressure to behave as if the process of making meaning were virtually complete. The link between form and knowledge here was not fragile, but it was, as always, contingent, here upon the antiquarian sense of the city. Atget made a point of honoring those contingencies, incorporating some of them into the album itself, maybe as insurance against rough passage. The maquette opened to a printed title page and the photographs followed on cardboard mounts, recto and verso, with the typeset proofs for the captions pasted underneath. The captions went beyond Atget's usual short titles to offer a few lines of historical information, the date of construction, the famous inhabitants, and so forth, ending with a brief, in this context almost indiscreet comment on the beautiful style (of the decoration). The captions apparently were written by Atget with the Marquis de Rochegude's *Guide à travers le Vieux Paris* close by to help both with the factual flourishes and the antiquarian turns of phrase.[3] Atget, like the marquis before him, worked to maintain an interested sympathetic tone, refraining from the melodrama which all too frequently infected Vieux

Paris discourse.[4] He broke this tone only once, at the Luxembourg gardens, at a spot that had been bypassed by the marquis, to write not a lament but a vivid paragraph which made sure that his reader understood the view pictorially.

> Jardin du Luxembourg (6 Arrt)—Vase artistique, avec fleurs tombantes, du plus gracieux effet; au fond, le palais du Luxembourg baigné de lumière; le tout compose un délicieux et artistique paysage parisien (Luxembourg Garden [6 Arrt]—Artistic vase with hanging flowers making for a most graceful effect; in the distance, the Luxembourg palace bathed in light; the ensemble composes a delightful and artistic Parisian landscape).

The paragraph betrayed Atget's ambition for his documents of Vieux Paris—a prolongation of the ordinary dialogue, a turning of the viewer's look. Here he was asking the Vieux Parisien to look again at the image to see the *visual* properties of his document, to see how its knowledge was in fact subject to form. The caption was overwritten, florid, a bit immodest, and something of a slip of the tongue. Usually Atget's captions parroted the Vieux Paris travelogues and then trailed off to say what was beautiful about the building. All Atget was really saying in the Luxembourg caption was that pictures mattered. This was his way of improving upon Rochegude's guide, which was not illustrated and did not normally give the city's art its due. Though not straying far from the standard texts, Atget was extending the Vieux Parisien's perspective. *L'Art dans le Vieux Paris* could be taken as an abridged, illustrated, slightly revised edition of Rochegude.

By using Rochegude as his reference, Atget had attached his book to one of the most respected pieces of the existing literature, he was able to improve upon it without discrediting

(or crediting) it, and he produced a solidly antiquarian book. None of this was done out of idle speculation. The book was part of a fresh and conciliatory move toward what had become an increasingly problematic clientele. By 1909 Atget's library sales, which is to say the bulk of his Vieux Paris market, had fallen off. Other possibilities needed to present themselves and they were doing so but not all at once. The new Société d'Iconographie parisienne had published one of his views of the Hôtel Flesselles in 1908 in the first number of its revue, referring to it as "a rare and excellent image obligingly lent by M. Atget, the far-sighted photographer of countless lost monuments" (fig. 88).[5] And subsequently some of his work, like the cartless view of the Fontaine Bouchardon, was published in a series of books called *Les richesses d'art de la Ville de Paris*, written by some of the leading authorities on Vieux Paris, Fernand Bournon, Amédée Boinet, Jean Bayet, Robert Hénard, and G. Dupont-Ferrier.[6] *L'Art dans le Vieux Paris* was bidding for this new sector in the Vieux Paris market. It was a frank and open bid; the maquette obviously aimed to please. Nonetheless there were nuances to the bid and the book; on closer examination they darken and sour; we shall have to speak of added contingencies, of soiling and stain. The book was ingratiating and mistaken, enthusiastic and reticent; in the last instance it was seen to be ever so clumsy and not worth printing. It showed all the signs of trouble in Atget's documents of Vieux Paris well before his run-in two years later with Edmond Beaurepaire and Marcel Poëte. After the experience of his first album the author was made to understand that there were limits to his power.

In fact the album contained the history of those strains. *L'Art dans le Vieux Paris* summarized a first idea of authorship, a transitional idea that began by wrapping ten years of Atget's

88. "L'Hôtel Flesselles, rue de Sevigné, 52. Photographie prise au mois d'avril 1898," from Albert Vuafluart, "L'Hôtel Flesselles," *Société d'Iconographie parisienne. Bulletin*, vol. 1 (1908), p. 64. Bibliothèque Nationale, Paris.

history as a Vieux Paris photographer into an album. The album itself made no mention of this fact but it makes much more sense as a project when more of that history is retold.

A chronological digression: in 1898, the year Atget took up Vieux Paris photography in earnest, the new Commission municipale du Vieux Paris adopted the proposal of the third subcommission to create a special portfolio at the Carnavalet. It was to hold the documents of old *hôtel* decoration, specifically, "these delightful heads of young ladies that form the keystones of windows and doorways, these strange infinitely diverse, sculpted masks, these supports or consoles of balconies affecting the most diverse fantasies, these window frames of such light and delicate design; and now again the front entrances, the interior wood paneling, the stairways, the vaulting supports." Or, in the more bureaucratic language of the last paragraph, "all the parts deemed interesting and in general all of the sculpted, carved, wrought work in the old houses and *hôtels particuliers* of Paris, such as the window and doorway keystones, window and doorway frames, doors, balconies, consoles, masks, wooden or wrought-iron stairways, window supports, front entrances, interior wood paneling, etc."[7] The proposal noted the absence of such documentation in the museum's archives; the published literature, it felt, was better but far from complete. It selected a bibliography of good references that gave photographers like Atget a concrete model, if that were necessary, of what architectural photography should be.[8] The proposal, voted into a project without hesitation, handed a real, itemized opportunity to the attentive photographer. It was certainly no coincidence that Atget's *L'Art dans le Vieux Paris* series, albeit more of a Vieux Paris series initially, was begun that year, and that the only city museum to acquire a version of *L'Art dans le Vieux Paris* would

be the Carnavalet. The Carnavalet however acquired Atget's work on its own, not through the Commission's projected series (which never did materialize). Atget never succeeded in tapping into a regular business with the Commission municipale du Vieux Paris. In hindsight this fact becomes astounding.

Atget's work for the official Vieux Paris movement had been carried on through the museums and libraries, that is, through its *secondary* channels. His relation to the *primary* channels, governed by the Commission municipale and the little antiquarian societies which sprang forward to protect the national heritage of every arrondissement, was in retrospect remarkably tenuous. The Commission and most of the little societies were manned by *fonctionnaires*, full-time amateurs, and a hardy few from the professions. It should be noted that Atget himself never belonged to any of the societies and neither did most of his clients. Of those clients listed in the *répertoire*, 41 belonged (roughly 11.2 percent), most members of only one. Of these 41, 22 made a profession as government officials and/or amateurs of Vieux Paris, and 8 can be associated with the building industry, though considering the total number of those clients (186), this figure is low.[9] Those primary channels of the Vieux Paris movement were not however Atget's target: he was developing an unofficial, second-degree version of Vieux Paris, of which his *L'Art dans le Vieux Paris* series was one result. By virtue of their unofficial nature, the photographs from that series could be made to double function and did, their technical signs bending to serve both the Vieux Parisiens and the building industry. The advantages to this were not lost on Atget and the series never lost this particular flexibility. The two markets were however discontinuous and their needs were in several respects incompatible; Atget had to approach

each group separately, giving the one a city and the other its styles. The double function was not something that would have appealed much to a Vieux Parisien.

In 1902 Atget did however make an effort to sell his collection, expediently called a Vieux Paris collection, to the Commission municipale du Vieux Paris. In the minutes we read that "M. Lucien Lambeau announced that the third subcommission had been called upon by the Beaux-Arts Commission of the municipal council with reference to a petition by M. Atget proposing the acquisition of a photographic compendium of Vieux Paris." The letter was more detailed. It proposed a special arrangement whereby Atget would simply be patronized by the Commission rather than undertake work on assignment from it, as its regular photographers did. The Commission did not generally make exceptions like this and it was decided, for the very good reason, that the Carnavalet already owned the *recueil* in question, that it was not necessary to pursue things further with Monsieur Atget.[10] The matter was dropped there and Atget continued his work, as he had wanted, at arm's length from the Commission's activities, but without its patronage. It is likely that he had always worked at some remove from its agenda. If we can use the pictures in the maquette to represent his usual pattern of work, the consideration or concern expressed by the Commission for an endangered building bears little on when, or if, Atget took his photograph. Often he photographed places which were never presented as official problems, never seen to be in need of protective classification, documentation, or study. His movements across Vieux Paris were probably not random, but the explanation for them does not lie in the minutes of the Vieux Paris societies. Rather he operated in some unspecified, general relation to their interests. Neither master nor slave.

In December of 1908 Atget did the Commission a favor, showing that he was still in touch and of goodwill. The Commission had been looking for a photograph of the building on the corner of the rue Caumartin and the boulevard Madeleine, which had been vandalized; Atget supplied one taken in 1904, and the Commission reproduced his view in their minutes (fig. 89).[11] Meanwhile, in July of that year the Commission municipale had undertaken to create a new subcommission solely to "watch over the preservation of the old Parisian *hôtels*."[12] The reason given for the new watch was "a wind of destruction that one could compare to that which raged relentlessly during the transformations of the city in the middle of the nineteenth century. And it seems that some evil spirit might have thrown a curse over the most curious and picturesque of the city's houses, since it is precisely they who get no reprieve from the destroyers."[13] The subcommission was staffed by a Vieux Paris elite: Charles Normand, Adrien Mithouard, M. Miniot, André Laugier, Georges Cain, Marcel Poëte, Charles Sellier, Lucien Lambeau, and M. Selmersheim. The creation of this committee renewed the plan for the Carnavalet portfolio.

L'Art dans le Vieux Paris, of course, surveyed exactly this old *hôtel* terrain, documenting it before the wind swept in and grimly noting the demolitions that had already carried off some of its subjects. In and of themselves, the *hôtels* were guaranteed to succeed with the Commission and its faithful, in 1909 more than ever. The album however continued to make overtures, demonstrating how it could fall into step with the antiquarians again on the question of the law on Church and State, which in 1905 had separated the two once and for all. The effects of the 1905 law had been felt immediately by all the commissions for historic monuments since church properties now were to be maintained

89. "Maison située à l'angle de la rue Caumartin et du Boulevard de la Madeleine," Commission municipale du Vieux Paris. *Procès-verbaux* (12 December 1908), after p. 168. Bibliothèque Nationale, Paris.

without state monies unless they deserved classification for their historic importance. Little, unclassed churches suffered most, some being forced to sell their altarpieces and church furniture to pay the bills. By 1911 the situation warranted a nationwide campaign to save them, led by none other than Maurice Barrès.[14] In Paris the Commission municipale bent itself to the task of making definitive lists of all former convents, monasteries, and churches so that the slow process of classification could be begun. Much needed to be done. As of late 1907, even St. Sulpice remained "*à classer*."[15] Atget was maneuvering the second section of his album into this, the latest of Vieux Paris causes, dwelling first upon the Hôtel Boucherat, dismantled when it passed from sacred into secular hands, and then upon the unprotected St. Sulpice. This produced a book doubly geared toward the Vieux Paris movement in 1909. As if that were not enough, the overtures accelerated in the third and final chapter on the Hôtel Lauzun. The Hôtel Lauzun, as Atget's caption pointed out, was bought by the city in 1900 with the idea of converting it into a museum. The officials reasoned that this period piece ought to be conserved intact in memory of the aristocracy of the ancien régime but the plan failed to achieve the necessary financing and the building had to be returned to the baron Pichon in 1906.[16] Atget had made his photographs just before the Hôtel Lauzun was resold (and then restored). Yet, although the project had been abandoned, the Hôtel Lauzun was a fond, official memory. Atget's photographs flattered it. They seemed to be lit by the heavy glow of the gold; they lingered over the elaborately carved panels, the garlands, vases, rams' heads, and Pans. They celebrated the accomplishment of Lauzun the aristocrat, his hired artists, and their time. Regrettably they were unable to celebrate an accomplishment of the Commission du Vieux Paris.

Atget's efforts to make an official image of Vieux Paris should have pleased, yet the fact remains that no one was pleased enough to support the publication of the album as a book. There were flaws in the overtures. The most obvious problem with the album had nothing to do with the pictures but rather with those self-conscious, specially written captions. The mark of a true antiquarian was fanatical accuracy. The unfortunate album was plagued with errors. Factual errors. Marie-Antoinette's *parfumeur* sold his scents from the boutique La Petite Dunkerque on the quai Conti, not from the one on the quai Bourbon. The last picture in the Hôtel Boucherat shows number 50, not 60, rue de Turenne. The *grille* on the rue du Four comes from number 10. Jacques Donat, not Jacques Doucet, worked on the Eglise St. Louis-en-l'Ile. Anne d'Autriche, not Marie-Thérèse, figured in the history of the Hôtel Fieubet. At St. Nicholas du Chardonnet, Atget gave Lebrun's dates instead of the church's. The Hôtel Mascarani was only partly, not completely, destroyed.[17] The number of mistakes at such an important level of the album betrayed a certain disregard. A Vieux Parisien would know to quibble over them, quibbles that most likely contributed to the book's failure to reach publication. The photographs however were not blameless.

The photographs exhibited the technical signs of the architectural document as they had been evolving through the early years of Atget's practice. They were still solid signs, but they had been hammered and pulled, often producing images that were decidedly imperfect, technically loose, and busily double-functioning. This is not to say that Atget's architectural documents were careless. Take the "artistique paysage parisien" and the photograph of the Hôtel de la Monnaie that followed it (*L'Art*, nos. 23 and 24). Atget took the Hôtel's picture

after swinging his camera left, to get the entire doorway into the frame and to get as near to it as he could. Most other architectural photographers kept the frontal position as a given and received a regular balanced view for their trouble, quite within the acceptable codes. What Atget received was the advantage of the damp on the paving stones. The patch distracted, even detracted, from the door; it stood for a messy washing down that leaked into the epic of the mint; Atget should have waited for the patch to dry. Yet in the picture the damp was the foreground repoussoir, much like the shadow of the vase in the artistic Luxembourg landscape. (The point becomes more obvious if both pictures are turned upside down, which is how they appeared to Atget when he framed them in his view camera.) Both the shadow and the patch controlled the upper left corners of their respective frames; both pointed headlong into the picture. And, most critically, both compromised the timelessness and the sobriety of the document. They were extraneous and too visible. More than anything *L'Art dans le Vieux Paris* provided evidence, concrete evidence of Atget's defects, evidence of how habitually he had come to fidget within the regulation forms of the document, angling his perspectives more than necessary, not always aiming for perfect symmetry, making heavy contrast and uneven lighting his trademarks, allowing traces of later historical time to appear. Repeatedly we see doors left open, signs posted, horse manure in the streets.

Atget lost respectability with the Vieux Parisiens because of these kinds of details. He had not distinguished sufficiently between past achievement and modern debasement. No condemnation of the modern signboard, for instance, was made in the captions, no reference to the crashing incomprehension of the modern bourgeois culture that would sacrifice

its past in the name of progress and profit. No effort to suppress or retouch the details of common life like carts and brooms and invocations to wipe one's feet please before climbing the stairs. Atget's was an approach to the historic monument in the tradition of Victor Hugo, who had been one of the principals in the national Commission des Monuments historiques in the earlier nineteenth century, though by the twentieth, Hugo's view of the past was no longer canonical. And one can see why not in this passage from *Notre Dame de Paris:*

> These hybrid edifices are, we repeat, by no means the least interesting to the artist, the antiquary, and the historian. They let us realize to how great a degree architecture is a primitive matter, in that they demonstrate, as do the Cyclopean remains, the Pyramids of Egypt, the gigantic Hindu pagodas, that the greatest productions of architecture are not so much the work of individuals as of a community; are rather the offspring of a nation's labour than the outcome of individual genius; the deposit of a whole people; the heaped-up treasure of centuries; the residuum left by the successive evaporations of human society; in a word, a species of formations. Each wave of time leaves its coating of alluvium, each race deposits its layer on the monuments, each individual contributes his stone to it. Thus do the beavers work, thus the bees, thus man. Babel, that great symbol of architecture, is a bee-hive.[18]

In spite of Atget's courtly gestures, an undertone of Babel persisted in his album, growing loudest at exactly the wrong moment, the grande finale in the Hôtel Lauzun. The last detail of the Hôtel Lauzun showed half a painted lunette together with the carved border along its bottom edge. The format was a standard, but the photograph overflowed with error, especially when compared with the offi-

cially sanctioned photographs of like motifs (fig. 90). Light obscured the painting almost entirely, flooding the rocky glen, the running stream, the hounds, the attendant maid. All that remained was Diana's tiny face staring straight ahead, and the woman laughing in the medallion down below. The photograph manufactured impassivity for the goddess and matched it with a mortal joy. It pulled the faces together, much like Atget had done for the organ grinder and his singer (fig. 91). But the Lauzun picture was perhaps more extraordinary for the way in which it filled the inhuman architectural document with human experience. It was this kind of experience and detail of course that was cut from Vieux Paris documents when it came time to publish them.

Atget was content to inflect some but not all of the basic principles of the Vieux Paris movement: he did not contradict but neither did he mirror. When he bent the rules for good architectural photography, when for his album he used the old eccentric images meant for the archives, their details only fairly pure, rather isolated, pretty sharp, in effect he abandoned the pose of solidarity.[19] His was a delicate position on a spider's web of conjunctures where business opportunity, government service, and taste intersected; whether he meant to or not, he was forever stepping on the web. But there were still other factors that were being played into the album, factors that were unseen and unstated, but factors nonetheless that disrupted the movement between form and knowledge, factors that would send the little men of the state into pique.

The antiquarian sense of the past ran through to their own place in the present and it ran further, without comment, beyond their self-definitions. It was plain that the Vieux Paris societies wanted nothing more than to keep historical matters polite and apolitical. The charters of La Montagne Ste. Geneviève et ses

90. J. Barry, "Dessus de porte en bois sculpté et doré avec peinture sur toile, époque du XVIIIe siècle. (Maison située rue Saint-Antoine, no 46)," Commission municipale du Vieux Paris. *Procès-verbaux* (12 January 1905), after p. 13. Bibliothèque Nationale, Paris.

abords (1895), the Société historique du VIe Arrt (1899), La Cité (1902), the Centre de Paris (1913), and the venerable Société de l'histoire de Paris (1874) pointedly excluded any discussion of current political and religious questions, even before the disruptions of the Dreyfus Affair.[20] Hence, no acknowledgment that past, ancien régime models functioned in the present at the heart of the politics of the right (making it logical that Adrien Mithouard and Maurice Barrès should be so prominent in the preservation movement). Paris had changed considerably since the days of the Commune. There had been an about-face. By 1900 not only was the city's version of its own history situated deep in rightist politics, but it actually wanted to see Paris as part of the nation. In 1900 the newly elected city council held and, except for 1904 and 1906, continued to hold a majority of nationalists and conservatives until the war.[21] While the term nationalist embraced a good number of positions, culminating in the royalism of L'Action Française, the nationalist flank was united on the political and moral importance of the French cultural heritage. Past was made over into present. Barrès made the connections frequently through the idea of classicism.[22] The Vieux Paris agencies lumbered behind him but they got around to the same point.

Consider their performance at the Exposition Universelle of 1900, where they erected a counterfeit Vieux Paris. Lucien Lambeau prepared a pamphlet introducing the work of the Commission municipale to the world: "To learn about the past of a city what better lesson of show and tell than a walk through its monuments, its old streets, its antiquated houses! And the lesson takes on depth and meaning when the city in question is Paris! Its twisting streets, its odd houses, its old monuments, were they not often the witnesses, often the actors in the great city's living history where each line

91. "Joueur d'orgue 1898." Pp 3214, then 360.
International Museum of Photography at the George
Eastman House, Rochester, New York.

could serve as a chapter heading for the history of France! . . . Beneath her many aspects, is not Paris the most astonishing model to inspire genius, talent, work? . . . All this long line of marvels, is it not the sacred source from which spring the arts, sciences, letters, of which Paris is the true fatherland?"[23] With Paris at the head of every chapter of French history, the cardboard Vieux Paris became a most elevated expression of French nationalism. Yet it had to be simulated, even though the real one lay just outside the fairgrounds. Much the same can be said for the document of Vieux Paris, like the simulated city an authorized representation, and hardly a neutral one. Under the guise of objectivity, the Vieux Paris societies researched the classical aspect of the ancien régime, tracked down the town houses built by the urban nobility, and catalogued the contents of their churches. That is to say, they produced an ideology.

As a simple ideology, this classicism was cultivated in many areas of French society, overtly celebrated in the discourses of politicians and art historians, consumed in the official process of documenting Vieux Paris, produced as national style by the building industry.[24] History and historical art were used as exempla, selected moral lessons for the perfection of the French nation. Far from being unencumbered facts, styles represented relative powers and entire cultures, aspirations and myths. Atget would know these lessons from many sources, his decorator clients, his Vieux Paris connections, and his own political life. They would inevitably figure in a picture book about ancien régime Paris. But they did not figure as such in *L'Art dans le Vieux Paris*. Atget's captions gave the style but after that they fudged: the usual discourse on style commenced, was interrupted by Vieux Paris facts and then by a note about beauty, and then stopped. The book stopped short of French classicism, that is the one thing

the captions do make clear. Unlike the usual Vieux Paris text, the events of the aristocratic past were not paramount; unlike the usual treatise on style, there was no mention made of race or native characteristics. Rather, exercising his new-found authority, Atget stopped and played. In the Hôtel Boucherat and the Eglise St. Sulpice, where iconographical programs of church and state coexisted, Atget took the crossed flutes of Marie-Antoinette's pipe organ, locked away and under wraps in a St. Sulpice tower, and put them next to the crossed keys of St. Peter, which decorated a confessional booth (*L'Art*, nos. 47–49).[25] Crisscross. There is an explanation. Atget more or less towed his clients' line, but their line contradicted what we know of his own politics, which pointed directly very far left.

Atget hardly kept his politics secret. The Bibliothèque historique certainly knew of them in September 1911, when he donated numbers of *La Guerre Sociale*, the ultraleft, revolutionary socialist newspaper edited by Gustave Hervé, to the library's permanent collection. On the third of October 1911, he donated 110 more numbers of the paper, together with some issues of *L'Avant-Garde*, a newspaper published by the Communards. Later that month two more gifts are recorded, Urbain Gohier's book, *L'armée de Condé, la revanche des émigrés* (1898), and *L'armée jugée par les nationalistes* (circa 1900). The first was a dreyfusard's attack on the army, calling it an ancient bastion of the royalist aristocrats, enemies of the people, who had returned with the invading foreign armies in 1814; the second was an anthology of criticism of the army by the right, most of it written before the Affair had broken and the right had, on principle, rushed to the army's defense. On the fifth of January 1912, Atget gave 108 numbers of *La Guerre Sociale* and *La Bataille Syndicaliste*, the daily for the C.G.T.; on the third of February he gave more numbers of the latter.[26] These gifts

presented an antimilitarist, prosyndicalist position on the far left, a left working to undermine the governing power structure, its agents, its ideologies, its *classique*. And so, outside Atget's documents yet another chorus of voices could be heard; it would have been jarring and infuriating to the ear of a Barrès. Heteroglossia. Babel. The *populaire*. The people.

This left Atget put forward advocated pacifism in the event of wars between nation-states and promoted the idea of a general strike. In this sense, it was "antipatriotic" and revolutionary. Georges Sorel, political theorist for the syndicalists, explained it to those outside the movement in *Réflexions sur la violence:*

> Trade unionism in France finds itself engaged in antimilitary propaganda, the issue of state politics which clearly shows the enormous separation between it and parliamentary socialism. Many newspapers believe that it is really only a case of a humanitarian movement grown out of proportion, provoked by the articles of Hervé; that is a gross error. One should not think that this is a protest against the strictness of the discipline, or against the length of the military service or against the presence of high-ranking officers hostile to modern institutions; those reasons are the ones that have led many bourgeois to applaud the speeches made during the time of the Dreyfus Affair against the army, but they are not the reasons of the trade unionists.
>
> The army is the clearest, most tangible and most deeply rooted manifestation of the State. The trade unionists are not proposing to reform the State like the men of the eighteenth century did; they want to destroy it because they want to bring Marx's idea to fruition, namely that the socialist revolution should not end by simply replacing one governing minority with another. The trade unionists give their doctrine its color when they give it a

more ideological cast and declare themselves to be antipatriots—following in the steps of the *Communist Manifesto*.[27]

Revolution was to be the consequence of marxism, internationalism, and the Internationale. These positions were not only staked out on the terrain of theory; they were part of a practical politics. *La Guerre Sociale* phrased its position in equally strong language, describing itself this way:

> It aspires to become the organ: of "unified" socialists who deplore the fact that they see their party becoming more and more a part of the parliamentary and electoral process and who, from inside the party, struggle to pull it away from its reformism, from its respect for the law, from its talk of revolution that is nothing but talk.
>
> Of trade unionists who want to direct working-class organizations increasingly toward the paths of direct action and the violent general strike and to accentuate their already-existing federal, antipatriotic and antiparliamentary tendencies.
>
> Of libertarian communists who have had enough of vain theoretical discussion and purely individual action and who, in the sections of the A. I. A. or in any other grouping, try by means of ceaseless antimilitarist propaganda and energetic resistance to police brutality and intrigue to prepare the masses for the next insurrection, when a war, a general strike or any other unforeseen event will enable it to have some chance of success.
>
> *La Guerre Sociale* will therefore be an organ of revolutionary concentration, open to all who work outside the law for the expropriation of the capitalist bourgeoisie with a view toward the socialization of the means of production and exchange.
>
> More than that, it will speak of everything and about everybody one dares not speak of elsewhere.[28]

Its capacity for precisely this outspoken revolutionary language led to numerous tangles with the authorities. Which brings us to the timing of Atget's first donation.

Atget made that donation sometime shortly before September 8, 1911, when it was duly entered in the *registres*. On the 28th of July the police had raided the offices of *La Guerre Sociale*, creating havoc and arresting its editors, whom they held to be responsible for three articles by "Sans-Patrie" (the pseudonym of Hervé, who was at that time already in prison, writing from his cell): "Oraison funèbre du Colonel Moll," "Atilla au Maroc," and "Vers la Conquête de la Rue," printed during the preceding winter and each frankly seditious.[29] A special issue on July 28 printed the following appeal, to be repeated frequently on the front page of the next month's numbers, before the September trial:

To All Good Chaps

Our editors have been arrested; our offices robbed.

More than ever the GUERRE SOCIALE is being threatened by the police and the government, anxious to take their revenge and break our propaganda.

More than ever the good chaps must make every effort to help the militants across this difficult period.

More than ever we need money to guard against any eventuality and to aid those of us who have become the victims of the police.

Let the good chaps gather around their newspaper. Let each reach into his pocket.

With everyone's help, we are sure to win.[30]

Atget saw to it that back copies entered the Bibliothèque historique for safekeeping as historical documents. He was bringing the present, and worse, the historical time of the left, into the archive.

The Bibliothèque historique had in fact solicited documents of the "mouvement social." Marcel Poëte himself wrote an article in 1906 for the first number of the library's bulletin which said so. It was a liberal gesture toward the present, which Poëte wanted to be collected and filed so as to provide historical materials for the future. He explained that the library should prepare a catalogue of its holdings which treated the history of labor in Paris, "the trades, guilds, and organization of work in the city of Paris. In addition it would be useful on this occasion to bring out a critical bibliography of publications about working class life and the socialist movements in different historical moments—as well as a repertoire of manuscript sources contributing to the History of the People and the Commune of Paris. . . ."[31] The library was to take the work and culture of the people into its account as a separate category. In fact Poëte's programs there took it up less and less. There was the exhibition in 1907 called "La Vie populaire à Paris par le livre et l'illustration (XVᵉ à XXᵉ siècle)," but it saw the popular as a dated piece of history, part of a past, *pittoresque* Paris. It would, though, be possible for Atget to donate his radical newspapers to the Bibliothèque and to photograph the popular for its *moeurs* files. He did both.

Atget's newspapers entered into the part of the collection called *Actualités*, tended by Edmond Beaurepaire, the same Beaurepaire who was responsible for the photography collections. Atget continued to make donations of this kind for the next six months. Meanwhile he was making documents for the library that showed more and more of the modern life of the *bons bougres*. Not only did his *Paris pittoresque* series show them; they began to appear in places, categories, sections of the files which were not designated for them and where they did not belong, like the *Topographie* series (fig. 92). In 1912 he was surveying the *quartiers populaires* of the lower fifth and the thirteenth arrondissements for that series, exposing an old city hung with Oriental rugs, storing up raw materials (rushes for caning), and inhabited by people who stared from their windows. It was not *pittoresque* but poor, not part of the noble Bourbon past, not staid.[32] Le Corbusier would use this picture as a graphic example of tubercular ruin.[33] In June Beaurepaire finally was able to send a signal that liberties should not be taken in the library, though the point of dispute was, typically, not over the messages of the image but with the darkroom procedure, not over the views of poor Vieux Paris but over spots on photographs of the Tuileries. Those spots contained others; they were the condensation of a bad dream, bad because it was not a dream at all.

By this time *L'Art dans le Vieux Paris* had become a casualty of the same antiquarian view of the city. It had made its effort to conform, not dissenting, not offering a view of Vieux Paris from the other side of the barricade; it adopted the official voice as much as possible; it would not say classical, but it was polite. The book had succumbed to a swirl of pressures from without, left and right, pressures that hampered and weakened its presentation, left it without a clear thesis of its own, left it attached in faulty ways to the second string of a Vieux Paris ideal. The book lacked a conviction, no matter whose it was. It had been fatally snared by the ideological contradiction that lay dormant in much of Atget's work for the amateurs of Vieux Paris. That contradiction could not be brought forward in lieu of a thesis; it was obliged to hide itself. In the last analysis it would only be felt.[34] Henceforth Atget would use his authority very differently. The later albums have little in common with the first.

92. "Cour 41 Rue Broca—1912 (5ᵉ arr)." Top 1391.
Bibliothèque historique de la Ville de Paris.

The Second and Third Albums

In 1910 Atget began a body of work all about modernity, as if it too were a knowledge, which it was not. No single discipline could claim it as its sole province; it could not be identified with a traditional mode of inquiry, nor was it the raison d'être of a mode of production. Modernity identified a change. In comparison with the ancien régime, modernity was unruly. It moved; it was unstructured and open-ended, characterized by an untoward enthusiasm for scientific progress, and the rising prosperity that came with accumulated capital. Like capital, modernity seemed to have moods, appearing unpredictable, transient, capricious, futuristic, trusting overmuch to luck. Like copyright law, modernity made trouble: it exposed the lack of congruity between culture and knowledge.

Modernity, to put it bluntly, did not come, like knowledge, with a fixed set of procedures and technical signs by which it could be understood, nor did it come, like culture, as a set of specified materials. This put Atget's work on modernity in an awkward place: his documents did not already have a function to which they would be fitted: their object of knowledge was ill defined, as was the purpose to which they would finally be put. These documents had to make their own connections between object and purpose. They had to find form and knowledge in modernity. In this context the sight of everyday life could be terrible. So Atget simply began as if modernity were a knowledge, a false premise but a practical one. It allowed him to continue to subordinate culture to knowledge, to try to tame modernity with the document.

Ours is not a story of mountains climbed. Atget worked this problem without finding general answers. Modernity remained his sphinx. Though there was one positive result: the group of albums he made for the Bibliothèque Nationale. In these albums Atget did not attempt to describe modernity as if it were com-

pletely known to him, as if he were its authority; the first album had shown him the dangers of that pose. Now he worked on albums as the modest author of documents, the voice behind the scenes that prompted, proposing a first set of links in the chain of someone else's knowledge. He put the notion of full knowledge back in its customary position, back in the future of his pictures; their own profile would be low. The albums used this low profile to investigate the stratification of modernity. They began to fixate on the way in which the lows of modernity established themselves, their details, their identity, their difference. Atget gravitated toward the *populaire*, that terra incognita, the unthinkable other, or was it to be called the *impensé*? His play in and out of the gamut of *bassesse* was about to begin.

Atget's initial reaction was to take modernity apart in pieces, to examine a feature and posit typicality, reducing the feature to regular forms that could be studied. Modernity, then, was treated by Atget as if it were one of his usual objects. The first two sections of his response were type studies, one of modern household rooms, one of wheeled vehicles. Both were photographed according to the same procedure: the type was isolated and examined in its variations, sixty variations that became sets, each of which then became an album. The interiors were a set unto themselves; the vehicles became the first leg of the number series he would revamp, still calling it *Paris pittoresque*.

When the types were set into documents, a paradox was temporarily introduced. A type was not automatically a technical sign that could go to work. An initial functionlessness was being set into the document; a nothing had arrived to spoil everything. It must be said, however, that Atget's pictures always revolved anyway around functional ambiguity, an indeterminacy, a condition of possibility, a hesi-

tation that could look like nothing. Here the hesitation was a little longer than usual. Technical signs would be brought in to steady the type. This was not necessarily the most obvious step to take. Atget could have proceeded to use the photograph to simply mirror modern life without regard for its form; he could have caught it as it presented itself, like the budding news photographer did; his idea of the document would have taken off in a new direction. But Atget did not see modernity as a current of events; he did not ask his document to reverse itself and start to behave as a simple photographic or Tainian or indexical reflection of the appearances of the world; no, it continued to thread the world not through a mirror but through the eye of its peculiar needle, the technical sign. The needle metaphor is not much better than the mirror one (which won't do at all), for technical signs belonged to a world without metaphors; with apologies to them, let us hazard one other, more description than conceit: the technical sign was a knife: it formed, it directed, it cut.

The ability of the technical sign to cut out pieces of modernity and make them wait gave Atget's documents of modern life the quality of collage (is it obvious, it should be, that this quality should not be taken either as influence or analogy). Atget's document of a hat maker's bedroom (fig. 93) used a wide lens on the corner with the bed and the mantelpiece; neither was given center stage. The angle of the shot, together with the angle of the lens, tipped the corner up; from this space objects flowed down, a hat poked up from a candelabra; there was a workbasket bursting with artificial leaves and flowers, a cinched lampshade, patterns of marble, fringe, stripe, and cornice. Then there was the white circular face of the clock. The document decomposed these details disengaged from the life of the *modiste*. Collage used scissors for the same purpose, taking similar ele-

93. "Intérieur de M^{me} C. Modiste Place S^t André des arts." 1910. PDd 736. Bibliothèque Nationale, Paris.

ments, wallpaper, a sheet of music, a piece of the daily paper, literally clipped them from their usual place, and brought them to another plane where wine glasses projected a hyperspace of lines and guitars appeared in a botched silhouette. Then there was the white sound hole of the guitar. Both kinds of work took modernity as best they could but neither could dispel its strangeness. That strangeness was inherent. It fell to the technical sign to put it in perspective.

For Atget the technical sign had practical advantages: it ensured markets for this work as it went off in search of a suitable place for itself, a suitable role to play; and it gave him a familiar foothold from which to begin. As a general rule Atget would use two kinds of technical signs in these documents of modern life: the signs native to the architectural document and those belonging to the document for artists. There is every reason to think that initially in 1910 Atget conceived of his group of interiors as decors, the kind of backdrop he had been making for artists and set designers. He was working out a new section of the artist clientele, *humoristes*, or cartoonists, and it is more than likely that he was setting up the set and the series for them. At least at first, or was it second? The group of interiors actually started up in a preliminary way much earlier; it was then taken in hand and extended to make decors suitable for the *humoristes;* it was broken off and restarted, probably in an effort to round out the sample to sell it to the *moeurs* files of the libraries; and finally it was completed in preparation for the album *Intérieurs parisiens.* It was prey to more than the usual number of functions and they began to pile up uneasily. Somewhat miraculously they all came from the same rich emptiness. The development of emptiness was the precondition for Atget's work on modern life. For him emptiness was a means to knowledge—if knowledge had its strange side, so be it. Strangeness

could contribute to the movement of a thought. Emptiness was never nothingness.

To understand the bizarre eruptions and departures in the emptiness, we must turn back again to the nuts and bolts of the document trade and to Atget's labyrinth of negative numbers. The group of numbers to which the interiors belong started and stopped in an odd corner of the *Paysage–Documents divers* series (see appendix 1, table 2). Before number 720 it seemed to contain a miscellany and many gaps: three photographs taken chez Mme D, one dark wall of the concierge's(?) room of the château in Viarmes and three, possibly four pictures of Atget's rooms at 17[bis] rue Campagne première, where he lived with Valentine Compagnon after July 1899.[35] There was some precedent for this work in the number series; early in his career Atget had made a photograph of a farmhouse hearth at Abbeville (no. 604). At 690 he stuck a few more pictures into line. But after 720 the virtually unbroken sweep of numbers indicates a set planned and executed, and another order of things, an order for illustrators.

Atget worked up his lists of illustrators, including the *humoristes,* several times before the war. The majority of them illustrated short stories and drew cartoons for such weekly humor magazines as *Le Rire* (copies of which lined the shelves in Atget's salon). In the beginning the documents for these artists waited for humor and the gag, though the possibility of melodrama also existed. Atget's interiors were swept into the ludicrous, macabre, and blue sides of the bourgeois imaginary, becoming scenes of crimes for mysteries like Marcel Prévost's "Le Meutre de Mme Aubry (pièce de dossier)" (fig. 94): " 'My God! My God!' she cried. I would no longer even question her. I was sure. I pulled the trigger three times. She took the shots point-blank, between her breasts, and fell only with the third, rolling at the foot of

94. Serafino Macchiati, illustration for "Le Meutre de Mme Aubry (pièce de dossier)" by Marcel Prévost, *Notre Compagne (provinciales et parisiennes)* (Paris: Alphonse Lemerre, 1909), p. 47. Bibliothèque Nationale, Paris.

the bed, in blood. At that point I leaned on the mantel and waited." [36]

The lists of illustrators in the *répertoire* were annotated only once, for "Intérieurs" as luck would have it, with Bac, Lourdey, Gerbault, and Gottlob singled out as likely prospects.[37] Gottlob appears to have used the washstand of the *modiste* in the cartoon he drew for the June 14, 1909, issue of *Le Rire* (fig. 95); he turned it sideways and posed two figures there in front of the bamboo mirror, the rippled glass bottles, the washstand, and the rest. His picture however focused on the sexual action of the figures, this time just lusty: "The minister told me: 'Write a report on the water supply of Paris . . .' I am beginning my investigation!" The joke was, in kind, standard; most of the illustrators' humor turned on the organics of sex. Some of the interiors featured statues, naked, sleepy, flirtatious statues that seem to herald the kind of action the illustrators always lampooned. In the last view of the salon of the *petit artiste dramatique,* Atget uncovered the clock to let a cupid go. But these were peripheral elements in a larger decor.

Tailoring the set for illustrators probably started in earnest at number 720, with the rooms belonging to the department store employee. At number 726 Atget returned to the apartment of the *petite rentière* (a lady living on a small inheritance), this time to photograph the salon and to add another view of the bedroom, now rearranged and swollen up with a winter duvet. At number 729 he moved on to record the decorator's studio, salon, dining room, and bedroom. With number 734 he photographed his salon desk to represent his work area, though in fact it seems to have belonged to Valentine; a stack of *La Guerre Sociale* was prominently displayed and magnified by a glass blotter, its title quite visible in prints that have not faded. Sometime before June 1909 he photographed

95. Fernand Gottlob, "Le ministre m'a dit: 'Faites-moi un rapport sur le service des eaux à Paris . . .' Je commence mon enquête!" *Le Rire*, no. 332 (12 June 1909). Bibliothèque Nationale, Paris.

— Le ministre m'a dit : « Faites-moi un rapport sur le service des eaux à Paris... » Je commence mon enquête! Dessin de GOTTLOB.

the interior of the *modiste*. It seems likely that this set was being photographed slowly, as Atget gained entrée to these places. Equally, it seems likely that midway into the project, he was interrupted: number 744, the bedroom of the *ouvrière* (woman worker), contained an almanac dated 1910.

With the renewal of the set, the sample broadened. It looks as though at the halfway mark Atget determined to convert these pictures to a *moeurs* file use. He sought out examples from the extremities of his society. He surveyed the workers, caught another view of the decorator's studio, moved on to do the apartments of the financier and Cécile Sorel, moved back to the decorator's rooms and labeled them "d'un collectionneur," took in the quarters of the *négociant* (wholesale merchant) and *industriel* (industrialist). All of this probably occurred over the spring of 1910, judging from the vases of spring flowers, and this fits with the librarian's annotation on the title page of the album: "photographies exécutées dans le 1er semestre de 1910." The very end of the set shows him rounding out the upper reaches of the group; at the tail end he was filling in the bottom layers of the sample with two more views of the salon of the *petite artiste dramatique* and one view of a kitchen. It would seem that by then he was editing the album.

Atget sold the group of documents on the 6th of July 1910 to the Bibliothèque historique de la Ville de Paris, where the photographs were sold as usual, already mounted on blue cardboard, captioned in Atget's customary way, and ready to be filed individually as *moeurs*. The group cost the library sixty francs. The Carnavalet bought the same pictures the next month, but as a paper album with a typeset cover which it kept intact and for which it paid one hundred francs. On the 16th of January 1911, a bound version of the Carnavalet album entered the

Bibliothèque Nationale, the registers there calling it "Intérieurs parisiens 1910."[38] The typeset cover had been moved inside to become the title page and the price of the album had risen to 210 francs. The libraries paid more for albums; whether they were aware of it, they paid for the editing as well, though as far as they were concerned, they were buying *moeurs*. Atget must have persuaded them of the value of these pictures and albums: *moeurs* were not generally given as empty rooms.

But more than this, Atget would have had to do some work to make these *moeurs* files into good markets. Most of them had lain virtually dormant for years. The *moeurs* files of the libraries had been stocked mainly with mid-nineteenth-century prints by the likes of Gavarni, Daumier, Adam, Cham, Bertall, and others. Atget certainly knew the terms in which those artists had thought the subject through: they were figural, concerned with a full range of social types, occupations, and physiology; typical actions and gestures were spoofed or made sentimental; typicality was tied to class. The libraries probably hoped to make a postscript to these physiologies when they bought Atget's *moeurs* work, unusual work in 1910. But Atget did not model his pictures of modernity on the old physiologies, nor did he model his *Paris pittoresque* number series on them. *Moeurs* might rub off on the environment, but the physiologies and the files depended upon the human figure to establish cause.[39] Atget proposed *moeurs* without it. This was in the end acceptable to the libraries perhaps because the *moeurs* files were not a high priority and the standards for such documentation had become vague. Whatever the reason, their vagueness would have suited Atget's purposes very well.

The series carried all of its functions along, endowing emptiness with variation. Yet in Atget's mind the series also served to complete

and extend the line of work that he had been carrying forward in his Vieux Paris series. For the emptiness could also be read as an architectural document. Atget himself made the connection to his Vieux Paris work, and the registers of the Musée Carnavalet recorded it: "60 Vues du Vieux Paris: Intérieurs parisiens. nouvelle série (faisant suite au No. E. 7468)" (60 Views of Vieux Paris: Parisian Interiors. new series [the follow-up to No. E. 7468]). E. 7468 was a loose-leaf version of *L'Art dans le Vieux Paris*. Doubtless, this echoed some sales pitch of Atget's; his business letters liked to dwell upon new series, though the connection to Vieux Paris was a bit specious. The album did not treat Vieux Paris at all and the title page Atget had printed up made no reference to it:

INTERIEURS PARISIENS
DEBUT DU XXe SIECLE
ARTISTIQUES
PITTORESQUES & BOURGEOIS[40]

The extent of its relation to the Vieux Paris work was not great. At the Hôtel Matignon, a picture in the *L'Art dans le Vieux Paris* series (fig. 96), Atget took care to feature the material of the mantelpiece, even while inflecting it with reflection; in the *Intérieurs parisiens* the mantelpieces were cut differently; they were fragments that sank uneasily back into the decor as part of a general description of things in a space, usually a corner. The *Intérieurs* had taken the problem of decoration into modern times, documenting the styles as they appeared in dining room tables, mantelpieces, sofas, desks, and beds. As it happened, the styles were hovering around the same national-classical ideal that stood by Vieux Paris. Unlike the first album, *L'Art dans le Vieux Paris*, the *Intérieurs parisiens* gave that ideal a critique.

For the first time Atget had pitted one part of his practice against another, point for point for

point. This album organized the movement of the document and gave it a single, unambiguous direction. The *Intérieurs parisiens* smothered both the historicism of the antiquarians and the laughter of the *humoristes*. In their place something else was rising up—something with properties—melancholy, stubbornness, class, spleen—and a politics, which came in like a coup or a *coup de foudre*. Walter Benjamin would want this idea restated more emphatically: "With Atget, photographs become standard evidence for historical occurrences, and acquire a hidden political significance. They demand a specific kind of approach; free-floating contemplation is not appropriate to them. They stir the viewer; he feels challenged by them in a new way."[41] The remark is famous now, and prescient, but it was only a remark. Benjamin did not say how political significance was hidden in the pictures or how the photographs became political—by reflection? by indictment? This was all he said. But we could nod in agreement anyway, citing chapter and verse where Benjamin did not, citing the *Intérieurs parisiens*. Free-floating contemplation was not appropriate to them. The technical signs were moving toward a political idea, their point of departure being, not surprisingly, the concept of style.

In everyday life the styles of the decorative arts were a choice in the furnishing of a home. Styles were commonly understood as a higher order of brand name, usually copied off Matignon-type originals, and therefore somewhat debased. Léon Werth could not help but mention this when he wrote his introduction to the Salon d'Automne catalogue in 1910: "One sees the same furniture everywhere, in the ministries, in the bourgeois homes, in the workers' homes, in the brothels. The salon of *le grand 16* resembles the boss's office: the same armchairs, same consoles, same carpets, same Diane de

Falguières. An epoch without style? But it all holds together, goes together: stamped furniture from Saint-Antoine and paste jewels from the rue de la Paix."[42] In Atget's album we see Werth's point very well, the same Chardin boys, Renaissance sideboards, and Oriental vases. The poorer interiors were furnished with less fine examples, but the idea was the same. Style had become more like a color or a pattern with historical connotations, a *banalité* susceptible in the end to dust.

The pictures did not have to do much of a technical dance in order to indicate the styles: style in its sheer and unlabeled state escaped, as everybody knew, from any angle, any decor. Books counseling the bourgeoisie on the decoration of the home had tried to maintain order by educating their reader to the names of the styles (fig. 97).[43] Atget's album settled upon such things without comment. The hearths, beds, tables, and the rest repeated themselves, comparisons were inevitable, but there were too many competing objects of attention, too many small things like clocks, the Venus de Milo, potted plants, and sprays of thistles, too many styles. In practice the stylistic sameness amounted to stylistic confusion. Louis and Henris and modern extractions gathered together among an equally diverse range of terra cottas, heart-shaped pillows, salad baskets, and drapes. The modern room was a melting pot. Atget would sometimes move the furniture around to suit his picture better, but he did not try to edit the cacophony down. If anything he contributed to it, letting light cut into the decoration, not in even patterns of chiaroscuro, not to blend the tones; it was uneven, often anarchic, beyond the control of the photographer. The glow behind the bed of the department store employee, the gleam that cut around the black Venus de Milo, the splash of light and shadow on the *petite rentière*'s rug, the blotches

96. "Hôtel Matignon." 1905. AVP 5110. Caisse nationale
des Monuments historiques et des Sites, Paris.

97. "La salle à manger. — 1. Salle moderne sans buffet ni dressoir de style. — 2. Salle à manger art nouveau de style français. — 3. Salle à manger classique avec buffets, dressoir et sièges Henri II. — 4. Salle à manger modern-style. — 5. Salle à manger Henri II," *Pour bien tenir sa maison* (Paris: Lafitte, 1911), opp. p. 176. Doe Library, University of California, Berkeley.

in the bedroom of the *financier*, the gloom that spread in the corners, the glow of polish, and the gleam of glass set the modern room down into a more complicated physical world governed by a money economy. The room lost all of its abstraction, its connotations of national genius and individual taste. These pictures were made for eyes that sized up other people's homes, comparing the beauty of the decor, the number of square meters, and the amount of light (not to mention the ambiance, the neighborhood, and the number of windows and doors, which were taxed).[44] The album might have its basis in the technical signs but it nonetheless promoted a crude practical vision that saw an apartment as a sign of one's place in society. Atget turned the gaze further in this direction by asking it to read. The captions he wrote for this album were fascinating in this regard and in one other: they were full of lies.

The captions were short—the name of the inhabitant, their occupation, and their address. Decoration was being matched to modern life. Though in fact the captions rested at the level of the type, the generic level of occupation, and an unnumbered street address. But the captions did not abbreviate, they modified. There was no Mme C., hat maker, for instance, living on the place St. André des Arts, no Mr C, decorator, on the rue de Montparnasse. When the true identities involved can be recovered, the captions can be seen to have been approximating the truth: "Mr M, financier" is a Monot according to an Atget caption on a print at the Museum of Modern Art, probably René Charles Monot, *industriel*; the apartment belonging to the "Ouvrière" can be traced to Léon Morat, *horlogier* (clock maker), through the names on the lifesaving certificates on the wall. Pages 1, 2, 3, 25, 51, and 52 of the album depict Atget's own home. It is likely that pages 36 and 37 also were taken in Atget's apartment, since they sit next to the

others in the numbering, and it is unlikely that Atget would have made two special trips to Mr F's kitchen. There in these half-truths Atget classed himself as *artiste dramatique, ouvrier,* and in some way with the kitchen help.[45]

Atget's decision to call himself an *artiste dramatique* was based on a current truth: in 1910 it was still his official profession on the electoral lists; only in 1912 did he change it to read *éditeur.* This exempted him from occupational taxes: photographers as industrial artists paid forty francs a year if they worked alone, fifty if they did not; actors and publishers, since their labor could be classed as intellectual, paid nothing.[46] Still, there is no legal explanation for his insertion of himself in the album as a member of the working class. But there can be no mistake about it: the washstand belonged to his bedroom, with his open chamber pot, his old shoes, his photograph of Valentine Compagnon pinned to the wall. If pages 36 and 37 do represent corners of his kitchen, he has converted them too into working-class interiors, chez Mr F. His salon was, in his own words, *petit.* It was decorated with pictures datable to 1899, the year he moved in, and before: posters of *La Petite République Socialiste* (a leading socialist daily, vehemently pro-Dreyfus) and *La Lanterne* (whose republicanism gained popular approval in the 1880s as a result of its exposés of the Parisian police force) hung across the way from two of Atget's early photographs, the view of St. Etienne du Mont (fig. 58) and a landscape of the Bièvre (*Paysages–Documents divers,* no. 1181) that had been destroyed in 1891. There were bought portrait photographs, prints, photographic reproductions of old master paintings, like Jean-Baptiste Regnault's *Three Graces* in the Louvre, sketches, drawings, and bric-a-brac. The decoration never changed. It was just as much of a miscellany as everyone else's, except that there were political posters

hanging up. The statistics available on Atget's income and expenditures are not adequate to even hazard a guess about his real economic position in 1910. But they would not matter. Atget could and did identify himself with the working class. The document was no longer the sum total of its impersonal signs. The author had left his spark. The documents were to be the theater for an analysis of class.

Class had an order of appearance, it materialized in the things belonging to people, it was introduced as a parade of apartments (see appendix 1, table 3). The level of class was modulated and contrasted as the album progressed: the *petite rentière* and the department store employee occupied the same level of class, but afterward the album began to swing higher and lower between the grandest bourgeoisie and the modest working class. All of this was placed into a perspective, however, that stood generically with the have-nots, looking from *there* onto the pale, luminous interiors of the more prosperous. Ergo, there were no slums, as there would have been if this were surveyed from a bourgeois position: the low was not discredited, or pitied, or seen as unsuccessful. The underclass was shown to have its own idea of beauty, arrangement, and grace. The point of view of the album was given very simply at the beginning. The album started with the *petit* interior of the small-time actor and expanded from there; at the end it made a summary by returning to its *petit* point of departure before introducing the enormous interior of Cécile Sorel, the star of the Comédie-Française. The album represented the view from this perspective, a political perspective that had much in common with Atget's own political habits.[47] It was the logical consequence of the subscriptions to *La Guerre Sociale, La Petite Socialiste,* and *La Lanterne.*[48]

As the album expanded upon this perspective, it made pointed comparisons. On six occasions

the shift from one interior to another occurred on facing pages, the first an object lesson in light and dark (*Intérieurs parisiens,* pp. 18 and 19). The other comparisons followed in this vein, pitting modesty against affluence every time but one, when modesty succeeded modesty, *ouvrier* to *ouvrière.* Atget used his own interior in three of them. At the last, when he reintroduced his own "Petit intérieur" and used it to preface Cécile Sorel's, he made that interior participate in the most acute class comparison of the album.

The comparison was of course nothing but contrast. Atget shot down the length of his salon into the corner and worked out a reflection that cut a swathe of pictures and books across the image; a statuette raised her hand to Cupid. At Cécile Sorel's he took a section of the salon wall with its pretty Louis XV commode on its own pedestal, framed by a symmetrically perfect group of pictures, the largest of them a dark and lifeless prize. The differences in wealth were reified beyond dispute. There was Atget on the side of the disorderly have-not; there was Cécile Sorel on the other side of have. Here the captions did not lie. Other evidence tells us quite exactly that Atget paid 725 francs a quarter for his six-room (counting vestibule and water closet), 5e *étage* apartment in Montparnasse; Cécile Sorel paid 5500 for her suite of nineteen on the 3e *étage* of a building on the Champs-Elysées.[49] Class, the album asserted, was founded on real material differences, which could be expressed through the evidence of addresses, antimacassars, period styles, and available light.

The entire album fell out around the class difference, although Atget did not serve it up baldly. But the point was as unmistakable as a thunderclap: there were those who had wealth and those who did not. "In the industrialized countries of our day, nowhere does one find a

deeper rift than the one between those who are workers and those who are not," one sociologist duly noted.[50] The album in effect repeated the by-then classic marxist division of a capitalist society into "two great hostile camps, its two great classes directly facing each other: Bourgeoisie and Proletariat."[51] Hervé, when he wrote the *Histoire de la France et de l'Europe pour les grands* in 1910, a *La Guerre Sociale* book, explained that the camps had closed ranks in the following way:

At the beginning of the twentieth century, France, just like all of the other big European countries, is divided into two camps.

On one side of the barricade: the Great Bank composed of twenty or so banking houses belonging to archmillionaires and billionaires like the Rotchschild [*sic*], who lend their money to all debtor nations and to all commercial and industrial Companies that issue stock, and who, after having taken a fat commission, quickly sell off the foreign stocks and national bonds to the public of small-time savers through the agency of the great Credit Institutions (Société Générale, Crédit Lyonnais, Comptoir d'Escompte); big business, each branch of it with several large Houses and at the head of all of them are bosses' unions, sometimes called trusts (metallurgy, mining, shipbuilding, sugar-refinery trusts); the Department Stores, powerful companies who, whether through their branch stores in the provinces or through catalogue sales, ruin every little shopkeeper far and wide; the great landlords who hold, especially in the Parisian suburbs and in the West of France, vast properties run by their bailiffs, tenant farmers, and sharecroppers; finally the high-level state and military bureaucrats who administer revenues in the millions.

This *haute bourgeoisie* is master of all the newspapers with large circulations (*Petit Parisien*, *Petit Journal*, *Journal*, *Matin*) who make most of their money from the Great Bank's financial advertisements through which the Great Bank buys support or silence; and by means of these newspapers this *haute bourgeoisie* is master of public opinion and of the government representatives, senators and ministers whose careers it can easily break. These newspapers from one year to another openly attack the Socialist Party and the C.G.T. to prevent them from recruiting the sympathy of the mass of small rural property holders, small businessmen and shop owners.

On the other side of the barricade are those without property, factory workers, employees in stores, banks or offices, petty bureaucrats, agricultural day laborers, the mass of the poor and the disinherited who all come more or less under the influence of the Socialist Party and the C.G.T.

That which is called the social question is nothing else but the pitched battle between the owning class and the working class, between the rich and the poor.

Will it end in an accord between the two classes, as the partisans of private property, in general the wealthy class, would like? Or rather in the lawful or violent expropriation of that wealth, as the Socialist Party and the C.G.T. wish?

This is the serious problem that France, like all other countries, will have to resolve in the twentieth century.[52]

In essence *Intérieurs parisiens* represented this great face-off, this gulf, this *fossé*. It was presented in line with Hervé as a simple inequality, imbalance. The technical signs and crude practical vision were being directed toward this

particular idea, this construction of difference. Political theory could follow from a close look at furniture. From emptiness to class struggle. Those familiar with the kind of censures present in *L'Art dans le Vieux Paris* can only relish the fact that all of this was communicated by the architectural document, the kind of picture that ordinarily would have none of it.[53]

One last point, and not such a minor one. Atget was not interested in any and all differences, differences between individuals for example were not important to him, although they could easily have been. Atget's idea of putting together sixty views of ordinary, private apartments, identified by a few, unspecific facts and without any human presence, was altogether unusual in a public context. Normally portraits like these, of unpeopled rooms, were seen in private places, in family albums alongside other views of the home and family life, each of which had special personal significance. Homes of celebrities appeared in public places for the prying eyes of the fan as an extension of the genre. The very first two views in Atget's group of interiors showed his own salon and probably had a family use. They covered much the same ground as the picture of Georges Cain's salon, part of a family album titled *Etudes* (fig. 98) and photographed in order to display the mantelpieces, vases, swags of silk, and rows of art.[54] Atget's salon was photographed for the same kinds of objects. All of these things had family meanings, intelligible to intimates who filled such photographs to overflowing with memories, often confusing the things with the people. Bourgeois individuals liked to think that they had left the reflection of their personality on their *fauteuils*, wallpapers, and objets d'art (the point was seldom pushed in discussions of the working-class interior). As if they could live life as art, like old-style authors unrestricted to a medium, unable not to reflect their powerful

98. Untitled interior from Georges Cain's family album,
Etudes. Bibliothèque Nationale, Paris.

Ideal-I onto the world around them. It was an
idea that fascinated both Balzac and Proust.[55] It
was also a period cliché. Cécile Sorel explained
in her memoirs that her antique period rooms
taught her about herself and her former lives;
she fantasized a past among the French aris-
tocracy; one night she sensed the presence of
Louis XV in her bed.[56] Atget did not however
allow his album to engage in the psychospiri-
tual uses to which decoration was put and he
did not probe its capacity to portray the indi-
vidual. The individual was not allowed out in
the album. Cécile Sorel, already a public figure
famous for her Célimène, her Marie-Antoinette
nose, and her extravagance, was there as a rich
and famous actress, not as herself. The album
took what might in another context be consid-
ered a family photograph and presented it as a
document where nostalgia and delusion were
excluded by the technical sign. The individual
was submitted to knowledge. There were no ex-
ceptions.

The technical sign had given Atget the means
to be incisive. It, finally, was responsible for
producing the imbalance and compiling the
inequalities. It began in the second album to
put a function forward for these documents of
modernity.[57] The document could isolate the
places where modernity separated.

• • •

Atget continued to use the procedures he
had developed for the *Intérieurs parisiens* in his
next album, whose pictures were also made in
1910. It looked at modernity as a matter of carts
and carriages and was titled *La Voiture à Paris*.
La Voiture isolated the type and surveyed it,
though not in chapters, as had the *Intérieurs*.
This survey atomized its data. The viewer
simply got the carts and carriages in rapid,
jumbled succession. Evidently Atget shaped this

group while he photographed it, beginning the group, twice renumbering some earlier pictures to include with it (now nos. 9, 13, 59, and 60), and photographing to complete it. The album followed the order of the negative numbers, from 1 to 60 (see appendix 1, table 4).[58] Like the *Intérieurs*, *La Voiture* had a prehistory: it was sold first loose to the Bibliothèque historique, then as a paper album to the Carnavalet, and finally as a hardcover album to the Bibliothèque Nationale. In the final version its images were glued to the right side only of each page, a format that all the later albums would follow.[59]

Atget was pushing toward essentially the same separation between the carts as he had with the rooms, though with more urgency; *La Voiture* made its comparisons constantly. From a taxi to a laundry truck to the trailer of a basket maker at the Porte d'Ivry to a *calèche* (barouche) for hire to a private *cabriolet* to a *voiture de vidange* (a rotorooter) to a public bus seen twice (but not the same year) to a short cart for the transport of rocks. The associations were multiple, since the vehicles when they were not carrying the bourgeois themselves carried the stuff that made bourgeois life possible. Drivers were usually not hauling goods for their own consumption. Classes met, though not always face-to-face (servants would come to the door for the shirts and linens). The *voiture* did not facilitate a pure separation of one class from the other, but the album did its best to steer toward the low end of the subject.

In 1911 it was estimated that two-thirds of the conveyances transported people and only one-third hauled merchandise.[60] As part of cutting his sample, Atget neatly inverted the evidence.[61] Worse, many of the vehicles on the street in 1910 were completely neglected in the album, as a census of them taken that year showed:[62]

Known figures

	Animal	Automobile	Total
Public carriages	12,336	5,188	17,524
Public transport	698	2,425	3,123
Private carriages	6,523	8,017	14,540
Commercial carriages (two-wheeled)	46,709	—	46,709
Bicycles	267,422	—	267,422

Approximate figures

Handcarts	20,000
Fruit and vegetable sellers' carts	9,000
Four-wheeled carriages (carts and miscellaneous transports)	50,000

Bicycles and automobiles were not at all involved in Atget's sample; there was a decided lack of pretty or family carriages, the kind of transport most associated with bourgeois life in town. So much for mirrorical objectivity. Instead the album began with the lower orders of delivery trucks and migrants' trailers, interspersing the occasional taxi-cab but nonetheless remaining at the level of the working class of vehicle through most of its duration. Milk trucks, coal trucks, delivery trucks for Suze, paddy wagons, asphalt mixers, garbage trucks specializing in the kind of waste tactfully called mud. It paid special attention at one point to moving vans, distinguished from one another by the tenant's *terme,* the quarterly period by which rents were calculated and paid.[63] This

was the view of modern transportation. By any account it avoided much of what was considered modern.

Atget cut the *voiture* from its normal ties to modernity, from the promotional line of the "latest model" and from the concept of traffic. Time was cut off at the present. Motion was halted. Traffic had no place. Paris had a population of 2.7 million people in 1906, making one vehicle for every 41 inhabitants that year and one bicycle for every 16, these figures registering a 45 percent increase in the numbers counted in 1891.[64] The city's traffic was growing, mixed, public and private, automotive and horse-drawn, interspersed with streams of bicycles and pedestrians; the increased mobility provided by the expanding subway lines only multiplied the number of people out and about in the downtown districts. The traffic was stupendous and legendary, a trope in fact for all of modern life and modern change well before the end of the century (fig. 99).[65] In 1910, the very year Atget was photographing the *voiture*, the Italian futurist manifesto on "Futurist Painting: Technical Manifesto 1910" incorporated the trope into its theory of universal dynamism which had it that "all things move, all things run, all things are rapidly changing":

> The sixteen people around you in a rolling motor bus are in turn and at the same time one, ten, four, three; they are motionless and then change places; they come and go, bound into the street, and are suddenly swallowed up by sunshine, then come back and sit before you like persistent symbols of universal vibration. How often have we not seen upon the cheek of the person with whom we are talking the horse which passes at the end of the street.[66]

Atget spurned everybody else's trope. He did not want the roll in his motor bus any more

cabriolets se joignent les tapissières de courses, les voitures de bouchers, les haquets de Bercy, les camions des livreurs, les coupés de maîtres, les tapecus des berloquins, les guimbardes des laitiers, les omnibus, les tramways, les fiacres, les chemins de fer en pleine rue, et les vélocipédistes indisciplinés, si bien qu'on est très au-dessous de la vérité quand on estime à quarante mille le nombre des voitures qui circulent dans Paris, dont plus de la moitié prennent la voie du Boulevard?

On a noté cette circonstance, en désignant d'un mot expressif un point connu, le carrefour des écrasés : l'intersection de la rue et du boulevard Montmartre. Toutefois, c'est une réputation que ce carrefour tend à perdre, comme celui de l'Opéra. Sur les dix-neuf cent cinquante-neuf accidents annuels, il n'est représenté que pour un total

9

99. Pierre Vidal, untitled illustration for Georges Montorgueil, *La vie des boulevards—Madeleine—Bastille* (Paris: May et Motteroz, 1896), p. 65. Bibliothèque Nationale, Paris.

than he wanted to show what it was like to ride in one as a passenger. The album bore into the subject according to its own logic; the *voiture* was taken in isolation so that it appeared to be an object of serious study. And yet the album repeatedly collapsed into comedy.

René Clair would take the idea of a Paris without traffic, or rather, thanks to a freeze frame, traffic stopped dead in its tracks, as the basis for a film, *Paris qui dort*, in 1923 (fig. 100).[67] Paris as Sleeping Beauty. A mad scientist had turned a ray beam on Paris, stopping life short, except for a small group who had by accident escaped: one had been standing guard at the top of the Eiffel Tower; the others had been aloft in an airplane; all of them inadvertently had missed the force field of the ray. When they descended, they discovered an unnatural Paris. The fun began as the plot met the stillness, the emptiness, the silence. Paris would be rescued, but only after the comic potential of the stiff decor had been sufficiently mined. The laughter would end when life was restored. There was no reason why the document of a stopped cart could not have similar potential. In fact the *voitures*, like the rooms, had been designed for the humor business, tailor-made for illustrators: another in the list of details to study, "animals, carriages, utensils, trees, houses. The memory never provides enough," as one illustrator explained.[68]

The illustrators' jokes mined the emptiness in a different way than Clair's film had: their humor was made once the carriages began to move. Fabiano's carriage carried an exchange between an old businessman and his lady friend speaking of bad stock deals in *double entendre* (fig. 101); Maréchal showed two top-hatted revelers at the crack of dawn, mistaking the street sweepers for trotters going off to race at Vincennes (fig. 102). The names of both these illustrators appeared in the *répertoire*.[69] Atget

could reasonably have expected them to take an interest in these photographs (and it would not have been impossible for Maréchal to have worked on this particular joke using one of Atget's sweepers, as his cartoon was published in July and that part of Atget's series had been taken by then).[70] The photographs however made their own jokes in their own way. Their jokes depended on the lack of movement; they made fun of modernity. One of the street sweepers parked around Notre Dame made a devilish analogy between the cart wheel and the rose window. Another document showed a cart carrying the opposite river bank, the Pont de Grenelle, and the twin towers of the Trocadéro. The documents were unbelievably faithful to the detail of the horse's ass. But the horses were child's play compared to the hearses. Midway into the album Atget included two views of a hearse and two of a carriage meant to carry the bereaved. The bourgeois was being treated as just another load, coming along naturally after coal and before milk. The criminal got similar treatment but it was not nearly so harsh: the move from wine barrel to paddy wagon to the special bus service set up by the train company put the paddy wagon on a par with the bus, which fared worst of all in the comparison. The bourgeois was being set up for ridicule in the album, first as a load, then as an absence.

The penultimate group of photographs in the album, seven in all, took the pretty carriages in the Bois de Boulogne, in which the famous rituals of Tout-Paris (the kind of passenger Fabiano mocked) were carried out. The photographs took the carriages straight-faced, parked at a restaurant in the woods and alongside one of the *allées*. The first carriages were shown with their drivers in place; the rest were then even more obviously empty. Their emptiness would have been completely telling. For the Bois served as a place where beautiful women promenaded,

100. René Clair, *Paris qui dort,* 1923. Private collection, New York.

where society intersected, and where much of the illicit trysting of the upper classes was done. Even the boy Lartigue had a clue as to what was going on when precociously he stalked the beautiful women there and in admiration took their photograph (fig. 103).[71] A halt in this place signified a significant break in the dynamic of seeing and being seen. And emptiness signified a very specific kind of action not far away, a plot thickening discreetly and hilariously in the bushes. The technical forms walked in on bourgeois foible; they began to wink and smile. The author had produced a vaudeville gag.

The line in the Bois did not close the album. That privilege was given to two older photographs that Atget brought forward to end the set.[72] Both isolated outmoded forms of transport, a wood-wheeled *fiacre* and a superseded post-cart. Now this seems but ever so coincidentally Proustian. The first novel in Proust's *A la recherche du temps perdu*, published just a few years after the album, in 1913, ended with a long passage about the recent, and to his mind catastrophic, changes in the Bois de Boulogne. It was a November day; the trees and the women of the Bois combined:

> They recalled to me the happy days of my unquestioning youth, when I would hasten eagerly to the spots where masterpieces of female elegance would be incarnate for a few moments beneath the unconscious, accommodating boughs. But the beauty for which the firs and acacias of the Bois de Boulogne made me long, more disquieting in that respect than the chestnuts and lilacs of the Trianon which I was about to see, was not fixed somewhere outside myself in the relics of an historical period, in works of art, in a little temple of love at whose door was piled an oblation of autumn leaves ribbed with

— En tout cas, je n'ai jamais commis de mauvaises actions.
— Vous vous contentez d'en émettre, mon cher!

Dessin de FABIANO.

101. Fabiano, "Péchés par actions," *Le Rire*, no. 337 (17 July 1909). Bibliothèque Nationale, Paris.

102. Maréchal, "Quatre heures du matin rue Marbeuf," *Le Rire*, no. 388 (9 July 1910). Bibliothèque Nationale, Paris.

QUATRE HEURES DU MATIN RUE MARBEUF

— Nous v'là à Vincennes, à c'l'heure !
— Penses-tu, mon vieux?
— Mais si; r'garde donc les partants de la course au trot...

Dessin de MARÉCHAL.

gold. I reached the shore of the lake; I walked
on as far as the pigeon-shooting ground. The
idea of perfection which I had within me I
had bestowed, in that other time, upon the
height of a victoria, upon the raking thinness
of those horses, frenzied and light as wasps on
the wing, with bloodshot eyes like the cruel
steeds of Diomedes, which now, smitten by a
desire to see again what I had once loved, as
ardent as the desire that had driven me many
years before along the same paths, I wished
to see anew before my eyes at the moment
when Mme Swann's enormous coachman,
supervised by a groom no bigger than his
fist and as infantile as Saint George in the
picture, endeavoured to curb the ardour of the
quivering steel-tipped pinions with which
they thundered over the ground. Alas! there
was nothing now but motor-cars driven each
by a moustached mechanic, with a tall foot-
man towering by his side. . . . The places we
have known do not belong only to the world
of space on which we map them for our own
convenience. None of them was ever more
than a thin slice, held between the contigu-
ous impressions that composed our life at
that time; the memory of a particular image
is but regret for a particular moment; and
houses, roads, avenues are as fugitive, alas,
as the years.[73]

Into the *fête galante* rolled the car; times
changed. Already in 1900 there were some two
thousand automobiles in the greater Paris re-
gion; by 1914 that number had grown to twenty-
five thousand.[74] But Proust had exaggerated
their conquest of the Bois; even after the First
World War carriages continued to make their
rounds through the woods.[75] Time however
was Proust's subject and the automobile served
to make its rip and roar palpable, much as the

103. J. H. Lartigue, "Allée des Acacias 1911." Musée
d'Orsay, Paris.

madeleine had done. Atget would see the change too, but he expressed it otherwise. In his view of the Bois, the carriages were visible but not the gallant nods and errands. His joking staved off any morose contemplation of change. Change was introduced only at the last moment, in the final two photographs of the album. But significantly it was introduced just after the empty line of carriages in the Bois, after a set of pictures that depended upon the ability of the reader to see through the emptiness to absence. With absence established there, it could be used to introduce the idea of an outmoded *voiture*. Once the bourgeois load had acquired a sexuality, the *voiture* could have a past. The carriage would become an absence too, but any tragic overtones were drowned out by the preceding gale of laughter.

The album had had a duration of its own; time, like motion, had been suspended, left as a question for the viewer to raise. The captions for the last *fiacre* and post-cart broke the artificial calm. For the later viewer it is virtually impossible to blink at the future the way Atget did, difficult not to see the carriages along with Le Corbusier (fig. 104), signifying an obsolete and intractable past. Yet the album was insistent: the future was an element of the modern that Atget refused. He gave the *moeurs* of the *voiture* for 1910 and edited them into a sample that made his prejudices clear. Atget was asking that the old hierarchies of vehicular traffic with their *blagues*, their bumps, and grinds be considered before novelty intervened. *La Voiture* confined itself to the horse and carriage, known to be on their deathbed, though Atget never said so. His album gave them presence not absence, substance not memory, credence not death. Remember above all, it said, the fact of the hierarchy. And that no order stands above ridicule.

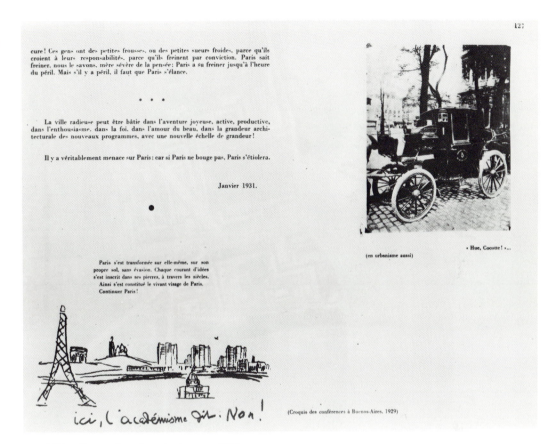

104. "'Hue, Cocotte!' . . . (en urbanisme aussi)," *Les plans Le Corbusier de Paris* (Paris: Minuit, 1956), p. 127. Bibliothèque Nationale, Paris.

The Third City

After these two albums, one motioning to Marx, the other looking forward to the Marx brothers, Atget's *moeurs* project moved into another phase. There it cut the umbilical cord to the bourgeoisie, to its modern, and to one of the bourgeoisie's favorite ideas, viz., that modernity was all that revolved around fashion, really the fashionable female body, really the *parisienne*.[76] The document turned against her. The *parisienne* was far more than a type; she stood for the city's women of whatever class so long as they were beautiful and a little bit tart; finally she came to stand for the city itself. The city was forever confused with these women; the tourists were confused by them. One of Joyce's Dubliners, the gaudy Ignatius Gallagher, summed up the wonders of the city by marveling, "There's no woman like the Parisienne—for style, for go." [77] Yet Atget could see a Paris, which is also to say a modernity, beyond sexuality. He allowed the image of the *parisienne* to flutter weirdly for a moment in three pictures taken of shops just off the grand boulevard (fig. 105), but only as a manikin, as if to remind the viewer just how far from the clichés this project had come. No go. The *parisienne*'s body disappeared from the project; the emptiness that had always characterized these documents deepened; they took on the color of grief, repression, loss, and then lack. This Paris was neither *vieux* nor particularly gay. Atget was isolating a third city, a city that wore neither its heart nor its mores on its sleeve, and perhaps because of this it seemed unsettled, contorted, plagued by a persistent, whistling *ostranenie*.

The process of isolating the third city was not particularly smooth, in part because the image of the third city had to be discovered. Atget built the third city from what can now be seen as his preliminary work on modernity—the interiors and the vehicles. Those first projects lay, in effect, like a plane inside his practice, in-

105. "Corsets." Pp 379. Art Institute of Chicago. Julien Levy Collection. Gift of Jean and Julien Levy, 1975. 1130.

side that web of exchanges and regular labors to which the first part of this book has been devoted; the next stage in his work on modernity took that web as a given; it never actually broke with it and sometimes participated in its designs, but mainly it did not. As a first step, the *moeurs* project was expanded from sets into a large number series. Ever frugal, even with his own series, Atget did not give the series a new name but instead revised an existing series, the *Paris pittoresque,* the one which had held the *petits métiers,* like the lampshade man and the *crèmière,* and which had also held the scenes of crowds, like the group watching the harpist and the puppets in the Luxembourg, a series which had lain inactive for almost a decade. The revision was drastic; with it came the focus on the third city and a different sense of the placement of the plane. The series twisted away from the old web of practice, rotating the plane like the dial on a padlock, moving this work out of the archive now, gearing it up for the more public sphere of the album. At that point the web was twisted away from its usual relation to knowledge and stretched. The entire series strained to communicate not only the modernity of the third city but also the articulation of difference there. But before any of this could happen, Atget had to bring modernity into the document somehow; increasingly he did so by setting out absence, seeing modernity as vacant hollow space.

In the new phase of his project Atget began to define modernity by cutting into the signs of his document, as if to trim them down, and he extended the principle of cutting to his sample, which he was to slice more and more sharply. The eighteenth-century *tableau de Paris* was shortened; the nineteenth-century *physiologies* were a dimming precedent; a panorama was never considered.[78] The emptiness that was now being hewn was almost progressive, un-

like the other emptinesses we have seen before. The emptiness was again the form that had to make the connection to knowledge, though the mechanics of the connection were never systematized and that problem would bother Atget for the remainder of the series. The technical links with which he was familiar could not be expected to control this space; there was no hypothetical panoptic structure at the bottom of this void. Instead a kind of chaos and a primordial air. But modernity was not simply a chaos; what was knowable went hand in hand with what was not, knowledge walked with the *impensé.* And so Atget worked to make the forms of the document speak to both these folds of the modern condition. The new emptiness was reduced, reduced in another key, and then another, and another. The document was being moved back to its original condition of blankness.

This blankness was not just substituted for the *parisienne*—no neat case of displacement here. It was the product of a series of acts of rejection. What kind of weight did Atget cast off, what ballast? First and foremost, the unsatisfactory myth that saw modernity as the life led along the grand boulevard, the line of wide streets that stretched from the Madeleine to the Bastille (and afterwards often found itself driving through the Bois). The grand boulevard was famous for its attractions: the nightlife, the banking, the *grand magasins,* the offices of the press, the theater district, were all located along its axis. In 1908 Léon Descaves tried to explain its quality to the hypothetically ignorant English reader:

> In the eyes of the provincial and the foreigner, all Parisian life seems to centre there—in its shop-windows, the terraces of its cafés, and the doors of its theatres, amid the rush of vehicles and the glare of those illuminated signs which, in the evening and from a distance, appear like the celestial bill-posting

foreseen by Villiers de l'Isle Adam in one of his *Contes Cruels.*

> And, after all, are not these crowded, dusty side-walks the spot where spring comes earliest, as if Paris communicated its excitement to the mounting sap and the bursting buds? Do not business activities, great reputations, journalism, gossip, all the sparks and flashes of the life of a great city, radiate from this focus? So be it. That little line of boulevards, arched in the middle and curving at the corners, forms, if you like, the lips of Paris—those facile, tireless lips, which never weary of too much talking and of laughing at all things. And the universal infatuation for this one feature of an immense, many-sided city can no more be explained than can the kindred phenomenon expressed in Sully Prudhomme's lines:
>
> "Toi qui fait les grandes amours,
> Petite ligne de la bouche!"[79]

The myth had developed out of the boulevard hype, the adverts that spoke of the faerie of the department store and its wealth of goods, the press that gossiped openly about the latest theater and the indiscretions of the stars, the entertainments being offered to the tourist, the citified pleasures of gaslights, electricity, and the magnetism of a crowd. The *parisienne,* for lack of any other solid symbolic structure, had been brought forward as the figure for this culture.[80] Her body became the trope; its beauty and lenience spoke for *moeurs;* it was, as we have already seen, material for the *humoristes.* Their fascination with her sexuality grew obsessive in the decade just before the First World War.

Albert Guillaume gives us the Parisienne in the latest fashion, with her cute sweet face peeking out from a heap of lace; always flanked by impeccable mama's boys dressed

106. Cardona, "Insinuation," *Le Rire*, no. 362 (8 January 1910). Bibliothèque Nationale, Paris.

107. Albert Guillaume, "C'était un tout petit épicier de Montrouge," *Le Rire*, no. 370 (5 March 1910). Bibliothèque Nationale, Paris.

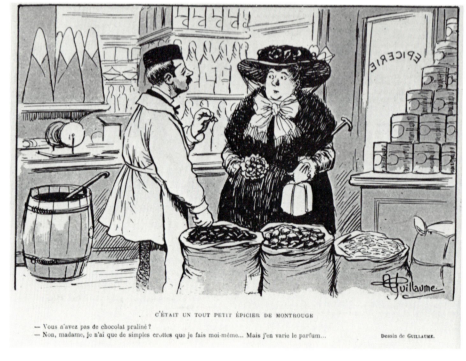

to the nines. In this combination she becomes ever more delicious, they ever more grotesque. Her adorable little mouth is always laughing wide, while they, trapped in their high starched collars, go stiff, too cowed to smile! With Ferdinand Bac, it's the supremely elegant mondaine who does everything in order to be taken for . . . does one still say horizontal? . . . and who does not wait around to become one. The "flirt" is her sole preoccupation; the flirtation, begun in the salon, finishes in the bachelor flat. The Parisienne who goes forward nose to the wind, her eyes "her soul's perdition" as the fine old ladies say, well padded . . . well—in many respects, say, that Parisienne, that's where one finds your friend Gerbault; one turns around to watch when she goes by and one says "Good heavens! . . ." The Boulevard has the monopoly on them and they are its brand name.[81]

Corporeal and ephemeral, the *parisienne* set the stage for many of the young Marcel Duchamp's cartoons; Albert Guillaume stuck just precisely this kind of scene in front of Cécile Sorel's fireplace before he proceeded to the joke about Mademoiselle Zizi Panpan. Others would move their characters through the scenes that form the main material of the *Paris pittoresque* number series, like shopwindows and market stands (figs. 106 and 107). All of them were translating *moeurs* into the bedroom farces of the standard social types, what the *humoristes* themselves called the *types éternels*.[82] Many of these *humoristes* were Atget's clients.

The abiding concerns of his illustrator clients appeared less and less in this series as it progressed, though the document for artists remained the basic unit. But the document paid less and less attention to the work of clearing a stage for the arrival of comic types. Atget abandoned his illustrators and their frivolous

boulevard to the breach and continued on his course. Still, Atget could not completely avoid this mythology even as he rejected it. His new series was always suffering from its exclusion of boulevard and *parisienne;* to the native French viewer, a man like Descaves, for example, their absence would be remarkable and glaring; it left a vacuum, a subnormal pressure in the pictures as visible as a footprint. Not for nothing have these pictures been compared to scenes of a crime. The bourgeoisie was too powerful *not* to be felt, even here, in a number series full of radical ambition. But it was felt as a cut. Atget was doing revolutionary dream-work now, displacing the bourgeoisie and its obsessively genital *idées fixes* and leaving the whole lot to hang, outside his document, in their own thin air.

Atget was himself no boulevardier (fig. 108). His was the city of small shops, vendors, ragpickers, cabarets, and circuses, a pair of boys selling roses at the edge of the city, a circus attraction in the morning light (figs. 109 and 110). They plotted an axis through the modern that for Atget replaced all the others. Atget did not depend upon the clichés or the maps that for others said Paris. His Paris was more than a map; the hollowness here was not a topographical form; the tracks were not meant to coalesce, beating a path to a zeitgeist. His axis for the modern struck out in another direction. This axis, which filled in what for lack of a better term we shall continue to call the third city, fell into line as the exclusions became evident. The exclusions were many and useful for marking off the limits of the third city. Atget had become extremely critical not only of others but of himself. He was rejecting his own early work on modernity.

As part of the first section of his *Paris pittoresque* series, begun around 1898 and ended around 1900, Atget had made pictures for the

108. Anonymous, portrait of Eugène Atget. Collection of Berenice Abbott.

109. "Md de Fleurs." 1912. Pp 369. Museum of Modern
Art, New York. The Abbott-Levy Collection. Partial gift
of Shirley C. Burden.

110. "Fête de Vaugirard, avenue de Breteuil, Cirque Manfreta—1913 (15ᵉ arr)." Pp 410. Bibliothèque historique de la Ville de Paris.

legend of tireless lips and city sights, supplying the Paris books of Simond and Riat with snapshots and picturesque views. *How Paris Amuses Itself* (1903), an American book on this order by F. Berkeley Smith, used Atget's early photographs of street carnivals to help illustrate and prove points like this one: "There are no people who enjoy their city more than do Parisians, or who use its thoroughfares so much as a place of pleasure." [83] And as proof Berkeley Smith illustrated most of his book with snapshot photographs or sketches made to emit the same quality of *instantanée*. Somewhat arbitrarily this *instantanée* had been deemed the code for relaying the vitality of the spectacle, the disparate emotions in the crowd, and the spontaneous nature of amusement in France. Play structured the very definition of the city and this was its best visual equivalent. Atget jettisoned the *instantanée* in the second *Paris pittoresque*. The crowds of people meandering along the boulevard and watching the puppets in the park never reappeared.

The *petits métiers* were the more curious exclusion. The new series would spend a good deal of time examining the work of the ragpicker but the figures of other laboring laborers were never central. Some of the older *petits métiers* pictures would be brought forward and renumbered, but only a few; the revised series did not want too much of them. Perhaps because the *petits métiers* belonged to the folklore of the boulevard. They were a national tradition by the turn of the century; their cries were printed up as folk poems; as their role in supplying the city's household needs diminished, the street peddler was turned into a poet and performer: "C'est dit, je pars, mais je ne veux plus jamais pour nos dîners que des choses dont nous aurons entendu le cri. C'est trop amusant," Albertine told her lover later on in *A la recherche du temps perdu*. [84] The poetry masked the

freedom of the enterprise, and the fact that the *petit métier* could advance to become the traveling salesman or the self-made man. In 1878 one dry goods store on the avenue de l'Opéra, actually named "Gagne-Petit," put a bas relief of a scissors grinder over its door. [85] Alternately the *petits métiers* could be cherished as one of the last remaining signs of *le peuple* before it had become dangerous, before it had gained consciousness of its class. For many contradictory reasons the *petits métiers* were idealized and mourned by the modern bourgeois. They were not, needless to say, to be confused with the *métiers*, that is, the trades, which were still vital and still belonged to labor as part of *its* aristocracy.

Enough. Atget's new series had little use for types, tropes, and myths like these, even though they had been, some of them, the substance of his old *Paris pittoresque*. The new *Paris pittoresque* tried to take the life of the lower class in another way, starting from scratch, without types and without the support of any other dictionary-like structure. Atget did not work with the kind of countermythology of the laboring classes elaborated by Steinlen's pictures and Zola's novels. As a general rule Atget's new series collected documents of modest places—the kiosk, the circus, the garbage dump. He was operating in certain neighborhoods more than others, favoring the area around the central market, Les Halles, the historic working-class neighborhood that moved along the spine of the Montagne Ste. Geneviève and the rue Mouffetard, the quais of the Seine and the Canal de l'Ourcq, and the *zone militaire*, a ring of ragged fortifications that lay just at the city limits, their military function somewhat of a formality ever since the Germans had scaled them in 1870. Nonetheless the place name did not replace the types: neither was assumed capable of categorizing *moeurs*. [86] Naming the places or the

dramatis personae would not reveal much about social relations, very simply because classes were not neatly segregated in the city. The places where the working classes lived were not necessarily the same as where they worked. The classes confronted each other all the time on the street, or when one paid rent to the other, or climbed into the other's cab, or strolled through the exhibits at a World's Fair. Their proximity however did not automatically produce a confusion; identity was not really vanishing. The lady and the cab driver knew their places, even if the lady was a parvenu. The difference between them and the distances they took from each other were just not very well served by a name. Atget's series had to find other ways to communicate.

If names could not organize *moeurs*, what about numbers? A rhetorical question. Atget's project was only nominally organized by the negative numbers of the *Paris pittoresque*. Nonetheless we can begin to see something more of the series by following them along for a while. The photographs that made up *La Voiture* began the series. [87] All the later albums but one, *Enseignes et vieilles boutiques de Paris*, were also derived from that number series, some five hundred photographs made between 1910 and 1914. The entire scope of the new *Paris pittoresque* number series was projected in 1910, as if Atget were trying to draw its dimensions at the outset. He began with three different starting positions, each of which opened up an area in the numbering. The series began in 1910 at number 1 with *voitures*, at 100 with ragpickers or *chiffonniers*, and at 200 with small shops and stalls, *métiers*. The *métiers'* number line became the trunk for the rest of the series. At some point Atget added a few *voitures* to reach number 73; he left the *zoniers* in the 100s intact for a while and then advanced several of them in 1912, working them into the series at

336. The *métiers* trunk, the only section with infinite room at the end, was extended and expanded to include a large group of bridges and quais, new *zoniers* and fortifications photographs and a group of traveling circuses (see appendix 4 for the complete list). In 1912 several of the *petits métiers* from the early series were advanced to participate in the new version, where they became numbers 353 through 364. But mostly Atget took new pictures. Their tendencies can be summarized in the views he took of bridges and quais.

The bridges and quais were photographed in units which overlapped and repeated; it is enough to say that they worked the distance between the Pont des Invalides and the Pont Sully, with a late interest in La Villette. The Seine, even in the center of Paris, was very much a working river. Atget concentrated on the evidence of work in the space. He even included the working painter, the kind that put the old bridge into a Vieux Paris–style picturesque view, and Atget's first bridge pictures showed such a painter, dwarfed always by the surrounds, here a large dark tree that floated like a caption or a cloud (fig. 111). The quais were not meant for the promenades of genteel folk: the river quais were not to be confused with the quai-streets that ran parallel to them; guidebooks explained that the quais below were beneath notice and that the quais above kept one at the appropriate spiritual distance: "The quai is too high and the river too far away. Between it and the passerby, no familiarity."[88] Down by the river was another world where barges purposefully glided in to unload and to load. On the quai de la Tournelle Atget found a cart and a parking sign for the barges (fig. 112). The quai de la Tournelle was not unusual in this regard; all along the Seine goods came into town; each port had its specialties; at the quai de Tournelle they were sand, stones, plaster, chalk, wood,

111. "Terre plein du Pont Neuf—1911 (1e arr)." Pp 273.
Bibliothèque historique de la Ville de Paris.

112. "Un coin du quai de la Tournelle—1911 (5ᵉ arr)."
Pp 245. Bibliothèque historique de la Ville de Paris.

and sugars.[89] The document worked with these details but not in a methodical way. At the Pont Marie, Atget spun the bridge across his photograph, anchoring it in the corners with the heads of three passersby and the painted white buttress featuring the measuring stick by which the level of the Seine could be exactly known (fig. 113), important information ever since the great flood of 1910. In the distance of that same view of the Pont Marie were *bateaux lavoirs* and *bains*, public washhouses and baths. A sample was being circumscribed in these pictures, all of them from 1911. By 1913, the project was slanted toward the hard labor on the quais. At the Port des Invalides Atget took the new over-decorated Pont Alexandre III showered in light; below the workers stopped loading rock for a moment to pose (fig. 114). They were the poses of laboring men at labor, pausing between loads that were going off to build a better Paris, like the bridge shimmering above. Atget pointed to a moment in the process of building the city and indeed building the image of the city, a moment which was analogous to the moment at which the document made its contribution to the production process, a moment where the labor was ephemeral, not yet inscribed in the product as a fetish or a wage relation. The document gave an image of capital before labor was fully transformed, before the gaiety of Paris congealed into spectacle, a moment when the third city showed raw.

Among his last pictures was a floating bar at the Port des Champs-Elysées, one in a series of short boats plastered with signs for aperitifs, chocolate, and life insurance, down below the Pont Alexandre III on the other side of the river, down next to the docks, where the arm of the big crane could still be seen alongside a mountain of sand (fig. 115). These were the bars for the people who worked on the waterfront. Nothing more than the boats was shown how-

ever; separated off from the laborer now and the rituals of custom, they alone had to summon *moeurs* and speak in the absence of any other voice. Dubonnet, Byrrh, Bière du Lion. The brand names were not saying much. The words were as thick as the surfaces. The surfaces like the silences were simply the boundaries of the emptiness, but they had been given critical duty. They had circumscribed a nonbourgeois low modernity, what can now be identified, though nebulously, as the *populaire*. For Atget the third city was a means to the *populaire*, the part of modernity that mattered the most to him.

The *populaire* was extremely problematic as a part of modernity. Knowledge of it did not ever come easily; mostly it existed as a lunar *impensé*. What this meant for the document is better seen, because literally seen, in the view across the barges taken at the great dock of La Villette (fig. 116). For Paris had some forty-two kilometers of waterway on the Seine and fourteen more of canals; all in all they handled thirteen million tons of goods in 1909. La Villette lay at the north on the canals, where they widened into a big basin, where the exchange of goods was monumental. One writer who saw it in 1910 tried to summarize this objectively:

> The incoming traffic above all involves the northern coal mines, Valois stone, colonial produce from Le Havre, industrial products from the Ardennes, Picardy grain; outgoing there are the *articles de Paris,* manufactured goods. On the well-stocked quais here and there one glimpses: "household articles, baby carriages, sewing machines, agricultural machinery, glass, conserves, rags, papers, bamboo and rattan from the Far East, fibers, palm fronds, wax, paste, oil, oats, flour, sugar, mineral water, fruit from tropical lands, phosphate, metal ingots, vegetables, dried fruit, noodles, liqueurs, honey, etc." Nine—insufficient—hangars have been built for the

shipping companies. One also finds several storehouses and shacks.[90]

Oranges, wax, sewing machines, and fancy dress goods could fasten onto sailor romance and exotic fantasy and turn picturesque very easily. And Atget, of course, took a defensive tack over the top of a barge whose goods were either gone or still untouched. The top was the thickest of surfaces, with its ropes and poles and mysterious holds, only for the experienced sailor; in the distance, leaning on the rail of a second barge there were two sailors, shadowy figures who offered no help. Their distance was not the far distance, however; the farthest distance was given to Paris, reduced to a group of small, enigmatic buildings disappearing into the mist. Paris had retreated. Though it was Atget who had retired it from active service in the document, just as he had seen to it that the sailors stood at the far edge. The things he showed were primarily traces; the photograph alluded to knowledge that it would scarcely show. It took the visible tip, a detail or a surface, and found other ways to indicate what was not there, what had been relegated to the distance, when not altogether cut. That was the thrust of the emptiness in the third city. The document communicated the existence of a knowledge in the *populaire* but only the existence. The *populaire* remained vaporous and enigmatic. The barge top did not, for example, portray a recognized battleground of class struggle, like the Mur des Fédérés in Père Lachaise, the place where the Communards were executed en masse, a place with a commemorative plaque, a place shown by Atget as a brute and now bloodless wall on a cheerless winter day, an official Vieux Paris image for an official history (fig. 117). The barge tops would not be written into history so easily; they lay outside it and its procedures, holding in their breath of *savoir*, holding the *populaire* to the

113. "Quai d'anjou, Pont Marie—1911 (4ᵉ arr)." Pp 315.
Bibliothèque historique de la Ville de Paris.

114. "Port des Invalides—1913 (7ᵉ arr)." Pp 477.
Bibliothèque historique de la Ville de Paris.

115. "Port des Champs-Elysées—1913—8ᵉ arr)." Pp
484. Bibliothèque historique de la Ville de Paris.

116. "Bassin de la Villette." Ca. 1914. Pp 521. Museum
of Modern Art, New York. The Abbott-Levy Collection.
Partial gift of Shirley C. Burden.

117. "Belleville. Emplacement du massacres des Otages
85 rue Haxo (20ᵉ)." 1901. AVP 4210. Musée
Carnavalet, Paris.

impensé. The *impensé* might possibly be postulated as a *savoir* or a low sublime but in any case it was not a *savoir* with disciplines like history, science, and the arts, nor did it *require* documents. As a result it seemed formless. Perhaps it was.

Denis Poulot, a mechanic turned manufacturer, wrote a book in 1869 that tried to account for the variations in attitude and values among the workers of Paris. The book was titled *Le sublime ou le travailleur comme il est en 1870, et ce qu'il peut être,* in honor of the most extreme position the laborer could take, the position of not working or working at his own rhythm, of politicking, of disorder, drunkenness, and disruption, of *sublimisme.*[91] This sublime was not his concept, nor was it Burke's; it came up from the working class itself, as Poulot explained, citing a song sung by the sublimes, for the sublime here was a worker:

> *Fils de Dieu,* créateur de la terre,
> Accomplissons chacun notre métier.
> Le gai travail est la sainte prière.
> Ce qui plaît à Dieu, c'est le *sublime* ouvrier.[92]

The workers had taken a pious song and sullied it, converting a godly sublime to an ungodly one. Poulot took its sublime as the figure by which to explain the social difference, a separation that for him was unnatural. *Sublimisme* was incomprehensible, he decided, because it was a *disease* of the working class; he kept trying to pin it down, describing its symptoms:

> Here it is: we were directing an establishment in Belleville (that *sublimiste* center par excellence); two *vrais sublimes,* former *grosses culottes,* tired barflies, had set themselves to looking for work; after three or four rounds of vitriol to get up their nerve, they came to find us.
> The one says to us:
> "You the boss of this outfit?

> —Oui, citoyen.
> —You hiring in there?
> —Right now we have no need of anybody."
> The other, with a familiar tone, says to us:
> "You want a shot?
> —Thank you, we take nothing between meals.
> —Come on, it will be a shot from the bottle.
> —It's no good, we're not thirsty."
> The first, vexed, yells to him:
> "Then offer them there a *gloria,* imbecile!
> —We repeat that we do not take anything, and if we wanted to, it would not be with drunken men."
> This response provoked an explosion of insults:
> "T'es t'un *mufe,* c'est pas toi qu'a ch . . . levé la colonne, espèce d'*aristo, bon à rien,* va donc, *rapointi de ferraille,* tu ne sais pas, *triple muselé,* que ce qui plaît à Dieu c'est le SUBLIME ouvrier?"[93]

Forty years later Atget gave this separation between the sublime and the spy as a negative space, a space which put up screens between the two cultures of Paris. He would show the viewer what they were missing; but the viewer would be kept on the surface, outside, at bay, denied any hope of that other *savoir.* The document would lie in wait in the library files, ready to do its dirty, dialectical work of denial.[94] But the document could not do this work by itself. *Moeurs* and its world of differences were not revealed by the image, by form alone, but by the contact between form and practical vision. These documents were just like all the others except that now they expected and appealed to the practical vision of a class. The technical agenda had been converted to a social one. The viewer had been constructed as fatally bourgeois; the document resembled nothing so much as an empty box.

To pull knowledge from an empty box requires superhuman skill. Not dialogue.

This summary is perhaps premature. For this play of practical vision would only gradually become evident in the later albums. All the same, one last question could be asked now, namely, how was this emptiness suited to the general *public?* The emptiness that rolled in to become the defining form of this third city, the emptiness that harbored the *populaire* was not a single effect. It was an overlapping emptiness wrought through a long and probably never too systematic series of excisions, like the first cut to produce decor, the cut whereby figures were taken to the margins if they were seen at all. The axis that made the third city was made by exclusion, progressive refinement, a process of purification oddly enough, a development that could look like an increasing abstraction. Some of this can be explained in photographic terms—as part of his work on the series Atget cropped. The cropping first took place as part of his reformulation of his early *Paris pittoresque* work. The first image of the fish stand on the corner of the rue Mouffetard and the rue Daubanton appeared in the files of the Bibliothèque historique with all of its ruffles and flaws (fig. 118); the ghost of the little girl who stood, turned, and left during the exposure (probably at Atget's request) was retouched out of the image when it was published by F. Berkeley Smith in *The Real Latin Quarter* the next year; the document became a vignette (fig. 119). For his postcard series Atget himself cropped the image down to make a close-up of the fish (fig. 120); for the new series, he returned to the corner, by then repainted, and photographed the stall again (fig. 121). It was now a picture of fish at the end of a day's trade, a picture of unwanted fish. Atget was cropping now while shooting, focusing down.

119. "Les Beaux Maquereaux," from F. Berkeley Smith, *The Real Latin Quarter* (New York: Funk and Wagnalls, 1901), p. 47. Private collection, New York.

118. "Une Marchande de Poissons Rue Mouffetard 1898." Pp ? Musée Carnavalet, Paris.

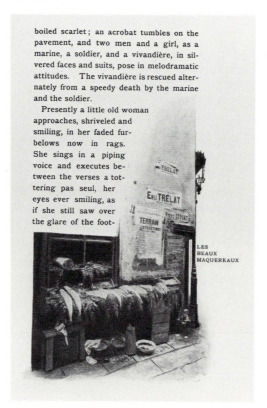

boiled scarlet; an acrobat tumbles on the pavement, and two men and a girl, as a marine, a soldier, and a vivandière, in silvered faces and suits, pose in melodramatic attitudes. The vivandière is rescued alternately from a speedy death by the marine and the soldier.

Presently a little old woman approaches, shriveled and smiling, in her faded furbelows now in rags. She sings in a piping voice and executes between the verses a tottering pas seul, her eyes ever smiling, as if she still saw over the glare of the foot-

LES
BEAUX
MAQUEREAUX

120. "Les p'tits métiers de Paris. Anciens quartiers de Paris. Poissonnerie en plein vent. 3756." Ca. 1904. Collection Debuisson, Paris.

Les p'tits métiers de Paris
Anciens quartiers de Paris
Poissonnerie en plein vent

121. "Un coin de la rue Daubanton—1911
(5ᵉ arr)." Pp 211. Bibliothèque historique
de la Ville de Paris.

In the last analysis, this cropping does not seem to have been too conscious of the conventions enforced on the published photograph. The series was not really gearing itself up for a later life as a string of vignettes. The pictures of working Paris published in books and magazines were still very much oriented toward the figure type; they might cut around the type now to make patterns with it or push the figures around using the new fashion for montage. The fish stall at Les Halles was featured in an article published in *Lectures pour Tous* in 1910 but only came to life through the character of the good woman who sold those fish with her cry (fig. 122). The montage was designed to put her forward, the fish were her attribute. No critique of the old symbolic structures was taking place. The same kind of operation was performed on the ragpicker by *Je Sais Tout* in February of 1914. An aerial view of the garbage being brought in for sale to a wholesaler was cut on the diagonal, the text reflected by a like wedge of image as if the two were equivalent (fig. 123). And yet the image could not have done without the figure of the ragpicker bringing in his harvest. Even the most modern of magazines needed the old figural types. It should be noted that this kind of layout, with its montaging and bird's-eye views, was becoming prevalent before the First World War. Commercial photographers and magazine designers were putting forward the forms for which avant-garde artists in the 1920s would become famous. But Atget was not interested in this tendency, not too interested in working in the way that magazines would like, not interested in the forms that would later look modernist, or in their anachronistic idea of the type.[95] His idea of the cut was homemade and functional. It was not the modernism of the cut that attracted him; it was the effect.

122. Anonymous, "Marchande des Halles," from "Quand Paris fait maigre . . . ," *Lectures pour Tous* (1910), p. 579. Bibliothèque Nationale, Paris.

123. Anonymous, "Chez le Marchand de demi-gros,"
from B. Tarride, "Rebuts du riche, trésors du pauvre,"
Je Sais Tout (February 1914), p. 220. Bibliothèque
Nationale, Paris.

Je sais tout

vitalité qui n'a rien à envier à nos œuvres sociales. Cette bienfaisante association, qui ne demande annuellement que 0 fr. 50 à ses adhérents, a des statuts fort sages. Voici les articles qui nous ont le plus frappé : Les tas d'ordures, divisés en districts, seront partagés entre les membres de la corporation. Il est interdit à chacun de toucher au tas d'un autre. Une allocation quotidienne de 0 fr. 60 est donnée aux malades, etc...

Les chiffonniers habitent des quartiers spéciaux (le plus souvent la zone militaire), des rues, des logements garnis tout à fait à eux.

Les chiffonniers eurent, comme leur intéressante industrie, les honneurs de la littérature. Ils connurent aussi la griserie de la rampe.

Vers 1847, un drame de Félix Pyat, délices des contemporains de Louis-Philippe, *Le Chiffonnier de Paris*, joué à la Porte-Saint-Martin, attira les sympathies de Paris à toute la gent chiffonnière. C'était une pièce touffue, animée d'un souffle très démocratique. Venue à son heure, elle obtint un succès retentissant. Frédérick Lemaître dut une de ses plus belles créations au rôle du « Père Jean », vieux chiffonnier, ivrogne repenti, sorte de Diogène parisien en qui s'incarnent les qualités du peuple.

Dans la réalité, certains types de chiffonniers sont devenus célèbres ; par exemple, le « Père Christophe » à qui les Parisiens de son temps vouèrent une estime spéciale et que la gravure, la peinture même ont immortalisé. On a fait de lui un

CHEZ LE MARCHAND DE DEMI-GROS

Le chiffonnier cède généralement sa récolte à un brocanteur, qui entasse les marchandises qu'on lui livre de toutes parts. Il fait des tris sérieux parmi ce « capharnaüm » et vend au marchand en gros ses lots bien classés.

220

OMBRES PORTEES

Phase One

Atget narrowed his idea of modernity to the *populaire*. Best to call it labor. So far, so good. However the document was not about to take labor up into itself as a value to be converted, or even better, *used* in the making of a *connaissance*. Neither was labor to be taken through the lens of the *pittoresque*. Labor was to be extricated from these things, to be shown as a difference having cultural properties of its own and an insularity. The difficulty of taking labor separately and on its own terms was not to be underestimated, in many ways it was as alien as the Orient.

Au Père Lunette (fig. 124) was a dive, and a very celebrated one, at the foot of the Montagne Sainte-Geneviève, near the river. In 1910 its clientele was still dominated by down-and-out locals of the kind described in 1883 by a pair of sporting *badauds*, A. de Champeaux and F. E. Adam, according to whom "père Lunettes' [*sic*] establishment, which could have served Zola as a model for his *assommoir* [is] an incredible, hideous, weird establishment, which has already made a millionaire out of more than one of its owners and never fears the neighboring competition of the Château Rouge on the rue Galande. Big money or small change picked from the pocket of the self-satisfied *flâneur*, it all falls into the cash register of the père Lunettes! What do you want? This good man can hardly worry about where it came from. Still, if I can give you one piece of advice, do not go in: at the very least you would be looked at askance."[1] The dive's essential character had not been affected by the renovation (the "airing" it was said) of the place Maubert in the 1880s, when the boulevard Saint Germain was extended eastward through the ancient maze of little streets between the Sorbonne and Notre Dame. The hideous and fantastic collection of regulars had remained inside, walled off from the new city, happy to sit and sing and drink and dis-

124. "Brocanteur, rue des Anglais." 1911. Pp 242. Bibliothèque Nationale, Paris.

cuss the world around them. The upper crust of that world took to visiting such places in the 1890s. Never mind the fact that the mère Lunette was knifed there in 1893, her husband's cabaret was a tourist attraction of sorts; the very next year a specialist in the *bas du pavé*, Guy Tomel, deemed it safe enough for those wishing to join, though only briefly and even then not symbolically, "*la compagnie des miséreux.*"[2]

Many were wishing to visit that company. Popular song had been developed into entertainment that could elicit pleasure in a mix of classes; the upper classes increasingly came to the places where they thought the "real" songs were sung and "real" danger could be sensed: all of that gave them added thrills. In places like Au Père Lunette, the lower classes came along much as they always had done. They were not much like the up-market versions of the phenomenon, say, the Folies-Bergères. All over Paris the cabaret and the dance and music halls were being transformed to accommodate everybody's pleasure all at once, though it was always possible to tell the rich from the poor, at least as far as the poor were concerned.[3] They took some advantage from the invasion as well as some distance.

It was to be expected that the czar's uncles, a pair of grand dukes, would want to be guided down to the bottom of Parisian nightlife when they visited the capital in 1905. The magazine *Je Sais Tout* covered their adventure, sending both a writer, Jean Lorrain, "un maître styliste," and an illustrator, D. O. Widhopff, one of Atget's clients, to cover the story. Not much had changed:

A clientele used to visitors from above always gives the clients a warm welcome; robbers frequent the place, making friendly ties with the newcomer, and for good reason; but the steady customers of the place keep their dis-

tance; you are disturbing their sloppy sleep or their drunken sleepwalking stupor.

Le Père Lunette is not a pleasure spot like the *Alca* or the *Octobre*, it is a refuge. The poor one meets there, collapsed on the benches, come to sleep; no one even comes to take their order. Wild faces rise from the tables where they have been sleeping on weary arms. Menacing looks focus on us, but with infinite lassitude: we are intruders, what right do we have to trouble the nightly torpor of these wild animals that society has banished from its midst? Finally, an old native of the place, an ancestral drunk answering to the name of Ninon, comes forward to sing, tracing with her foot a halting high-kick dance.

We leave Père Lunette with a heavy heart, leave the horrible sketches displayed like frescoes along the walls, no, pitiful caricatures, silhouettes evoking Paul de Cassagnac as a faithful dog, Ferry with an enema under his arm, Naquet standing on a heart and holding the enormous scissors of divorce, Zola dressed like a pilgrim from Lourdes, Freycinet as a white mouse, Littré as a monkey, Clovis Hugues as a hairy poet, Garibaldi and Andrieux, Clemenceau, Eiffel unscrewing his tower, Henri Maret, Déroulède, and *tutti quanti*; a macabre farandole headed up by a skeleton wearing the golden helmet of General Boulanger. We have already made it to the narrow alleyway which serves as an aisle, when the voice of Ninon starts up again:

Louise, her face calm
Beneath Rochefort's laugh,
Carries the standard of death
For the proletariat.

The hiccup of a drunk, jostled in the corridor, cuts into poverty's refrain; her hoarse voice whimpers on:

Here's the old boss's portrait,
Knowing that I didn't have a cent,
He let me go begging among you,
 Chez Père Lunette.

Remorse comes over us again and we return to put some change in the singer's clammy hand. The heavy sleep of the brutes, the deaf, groaning nightmares of the starving and the pariah, a complaint from an old lady beggar and musty smells of rags and vomit, a pretty thing to be showing a Grand Duke.[4]

In the end Widhopff did not draw the entire scene at the cabaret; instead the magazine took a photograph of its seamy, disrupted interior, showing the artist hell-bent on sketching it. With the photograph the readers could see the truth of the reportage inside the cabaret and glimpse its unhappiness, though the crowd stood around looking out, posed and amused by the process (fig. 125). Their culture was dense and in its own way cutting: they knew enough about Zola's pretensions to represent their interests, enough to make fun of him by dressing his image up as a Catholic pilgrim on his way to Lourdes (that was how the abbé Pierre Froment had begun the road that ended in *Paris*). They took themselves to be human, not an object for others' happiness or profit. "Their subjectivity" was moved forcefully to the fore in the looks and songs that greeted the *Je Sais Tout* crowd that came to play. They would not don the bourgeois forms in order to gain a higher order of so-called civilization; their civilization was good, macabre, and tough as nails. They knew their politics and let their opinions of republican politicians be known: the betrayal of the republicans Rochefort and Ferry was not unnoticed; they made a monkey out of Littré, the author of the dictionary; they pictured Eiffel unscrewing his tower as if it were nothing

125. Anonymous, "Chez Le Père Lunette," from Jean Lorrain, "La tournée des Grands-Ducs," *Je Sais Tout* (June 1905), p. 719. Bibliothèque Nationale, Paris.

more interesting than a bolt. There was a darkness that pervaded the caricatures and the songs and the innuendo and that darkness spoke for a deep, cynical resistance—it wasn't only that they wanted to go to sleep. The upper crust, the "I know it all" crust, took its distance as best it could from that part of the scene; the visitor turned the "they" to "it" whenever possible, setting up the locals more as objects than subjects: with objects they could see the humor, shrug off the anger. The ladies and gentlemen who visited the dive blindly made class difference into fun. When momentarily overcome by conscience at the sight of the poor souls who used the cabaret as lodging, they gave their entertainment alms.

Custom had set up an image of the cabaret and a scenario rich with possibilities: everybody took the Other as a cliché. Atget rejected this particular theater of the classes when he went to represent the life of the cabaret. The mistaken identities that were fabricated on both sides did not much interest him, nor did the substance of the folly and the song. He photographed Au Père Lunette from the outside only, as an extension of the old clothes shop next door where the *brocanteuse* sat back, gazing abstractly into the distance, rather as if she were looking straight through the *lunettes*. The cabaret was to be understood through the perspective of *brocante* and *brocanteuse*. She was no entertainer and she was not telling what she saw (was it Zola in pilgrim's costume? was it something in the dark?). Au Père Lunette remained inscrutable to the viewer of the document, who could not put on those glasses and could not see the custom within in the way a neighbor (as opposed to a grand duke) would. All we can understand about this closed bar is that it had an ordinary day-to-day, or night-to-night, existence and that it, like the other shops on the street, was wrapped in all kinds of vision. The document gave precedence to the vision of the *brocan-*

teuse. But if Atget could privilege one kind of vision over another, and if he could privilege the songless view of the cabaret, just a piece of the habitus, local not spicy, not touristic, not foreign, Atget kept the distance that popular culture had taken from bourgeois culture. Popular culture had a sense of privacy that verged on secrecy, as all bourgeois visitors reported. Atget did not try to detail the inside of that culture, only its outside. The viewer of his document was kept back from the life of the cabaret and deliberately removed from it. Atget respected its privacy. He was drawing the borders between the classes in increasingly subtle ways now. The line between them turned into a block for a host of very good reasons.

At the beginning of the 200 run in his new series Atget showed the higher class version of Au Père Lunette, the Montmartre cabarets on the outer boulevards, of which the Moulin Rouge is now the best known.[5] The dangerous entertainments of Montmartre, a traditional working-class neighborhood, had capitalized on the Père Lunettes of its district, turning them into the world-famous supper clubs and dance halls. Atget put the cabarets at a disadvantage by photographing them during the city's customary business hours, that is to say when their doors would normally be closed. Seen at half-strength, they appeared to satirize themselves, gesturing all out of proportion, roaring into dead space and closed doors. The gate to hell was shut; the grotesques dragged and flailed (fig. 126).[6] Without its audience, its barkers, the pimps, and the whores, the Montmartre cabaret looked like what it was, a caricature of popular culture drummed up by a set of not so working-class entrepreneurs. Atget made an effort to distinguish between these caricatures of popular culture and its own presentation of itself. Not monsters, eyeglasses. Not the spectacle, spectacles.

126. " 'Le brulant Alexandre' cabaret, 100 Boulevard de Clichy." 1911. Pp 207. Bibliothèque Nationale, Paris.

Could one move to some kind of knowledge of modern labor by looking at it? Atget started work on that question at the outside of the *populaire* in late 1910 and 1911. He sorted a heap of fragments into two parallel lines of inquiry. In one of these lines he took up the idea of *métier*, or trade, which meant that he started in at the upper echelon of labor—the small tradesperson and the artisan. For the parallel, he sank to the very bottom of the echelon and took up a study of the ragpicker. Out of each of these an album came into being: *Métiers, boutiques et étalages de Paris* in 1912 and *Zoniers. Vues et types de la zone militaire* in 1915. Between them lay a good deal of untouched material—the work being done in sweatshops, in ateliers, and in factories, the work of the proletariat. Atget apparently did not want to identify lower-class culture with the proletariat alone, any more than he would want to condense it into a single image. That culture would emerge slowly in the progression from document to document in these albums devoted respectively to shopping and garbage.

Shopping. In the *Métiers* album, this was done by showing displays of goods for sale. Its title, *Métiers, boutiques et étalages de Paris,* presented the album's business in reverse order: the album was actually organized around the idea of *étalage,* or shop display. The album, it should be noted, is no longer in its exact order; rebound some time ago, its pages were replaced and the original captions were lost (see appendix 1, table 5).[7] But the order of the photographs can be almost completely recovered, owing to an older library inventory of the album's contents, and anyway the exact sequence here was not crucial. The album was composed of two sections, a long sequence and then a recapitulation; the group of pictures brought together a host of *étalages* into a critical mass that linked all the displays by means of one great analogy.

The analogy has survived unperturbed.

The album collected sixty pictures, the majority from the 200 numbers of the *Paris pittoresque*, though for the sake of the album a few select pictures relevant to the project were pulled in from other number series.[8] Atget edited them into a topical, spotty order where short sequences ran quickly into one subject, say kiosks, and switched to another, like fruit and vegetable shops, only to pass quickly on to the markets around the rue Mouffetard, cutting in a Montmartre cabaret as a premonition of things to come. The album was laced with singleton photographs like this, reminders of previous sequences and forecasts of later ones. They helped to tie the group into a single sample, doing the yeoman's work of drawing the analogy out. At this pace Atget covered kiosks, the fruit and vegetable boutiques, the commercial landscape of the rue Mouffetard, the Montmartre cabarets, the place Maubert shops and its Marché des Carmes, the old clothes shops still surviving in the district of the defunct Marché du Temple (formerly "*La Bourse de la friperie*"),[9] Les Halles, and a pair of café interiors in the heart of Paris's eastern side. Late in the game the photographer's studio was slipped in. And then the last ten or so photographs recapitulated and concluded. This was all very well, however *étalage* was not a concept that one normally brought to bear on the kind of small commerce that spread its wares across the sidewalk: it was, rather, the hallmark of the *grand magasin,* the department store, the great bourgeois contribution to merchandising. The department store had been excluded from the album of course but *it* set up the analytical category Atget would use, and as an absent point of reference, it bit like acid. *Etalage* in Atget's album was the negative of the big magic white sales and notions counters, as their Other. The

Other manifested itself in arrays of *mangetouts* and limp fish.

Etalage was held responsible for commodity magnetism, though this was recent tradition. The decoration of a store and the display of its stock had only become important with the advent of the *magasin de nouveautés* in the nineteenth century and then, in 1869, the department store. Decoration grew ever more vital to the creation of a commercial environment, changing according to the commercial seasons, the seasons marked by sales. Indeed the movement of goods in the department store was symbolized by the frequent changes of display both inside the stores themselves and inside the store windows that gave onto the street. Many of the rules for retail were subjected to full-scale revision. The decorated windows of the *grand magasin* on the grand boulevard became part and parcel of the landscape there; boulevard crowds looked upon these displays in admiration and, we are told, idealized them; though not necessarily intending to buy, they automatically looked to shop.[10] It became customary for the working classes to stroll the city streets this way too, looking to shop, but the small shops in their neighborhoods, arrayed with commodities basic to the upkeep of their lives, never demanded the kind of homage paid to the businesses of the grand boulevard. Potatoes were not so magical. *Etalage* in the strict sense of the term did not exist in shops, in part for purely practical reasons.

It would have been financially impossible for a small capital business to change displays as often or to set them up as brilliantly as the department store. In 1911 a defender of the rights of the small businessman saw the department store to practice "the supreme art in the arrangement of the displays, in the combinations of light effects and color, in the fascination exercised on the female visitor by the profusion

of fabrics, by the spell of a thousand and one twinkling and reflecting objects, provoking the coquette, dazzling even the sober woman by the rendition of a sort of poetry in paste."[11] The seduction worked, sometimes too well. A lady kleptomaniac used it as her excuse: "Once plunged into the heady atmosphere of the department store . . . I felt myself little by little overcome by a disturbance that can only be compared to drunkenness, with the same dizziness and intoxication. I saw things as if through a cloud, every object provoked my desire and to me became extraordinarily attractive."[12] Magic, magic, magic and its victims. The accounts began to sound the same, no matter who was speaking. "It is a palace that rises up one day, causing the poor little shops on either side to collapse, taking possession of their site and their clientele, enlivening the whole neighborhood and assuming the proportions of a sumptuous city erected to the greater glory of female coquetry."[13] But always, always next to the fairyland sat those lower forms of life, the shop and the stall, together with their tradespeople, those who sold, and those who bought. They looked over at the fairyland with a jaundiced eye. Their ranks were mixed; of course, the small shopkeeper was not exactly working class, but nevertheless the left claimed his fight against the forces of capital. The last of the accounts just cited was in fact written from the left by Léon and Maurice Bonneff as part of their series *La classe ouvrière*, published by La Guerre Sociale. Not all of this rhetoric stands up to scrutiny. Small business was understood to be struggling for survival during these years, although the statistics show it remaining vital despite the threat from the big stores: small businesses employed 657,000 people in 1896 and 786,000 in 1906.[14] All the same, the tension between the two was palpable. Right at the outset Atget wrote the name of the Bon Marché into

two captions to remind the extremely stupid
viewer just what the determining absence of the
album was. The doll shop on the rue de Sèvres
and the newsstands in the park nearby all stood
cheek by jowl with the great Bon Marché, and
Atget twice called the little park by the name of
the store, even though this was not technically
true (it was called the Square Potain in honor
of a doctor at the Hôpital Necker just up the
street). The name of the store, having pointed to
absence, never came up again. Cut.

Etalage in shops? Only a foreigner like F.
Berkeley Smith would see the little shops as
"studies in decoration. If it happens to be a
problem in eggs, cheese, butter, and milk, all
these are arranged artistically with fresh grape-
leaves between the white rows of milk bottles
and under the cheese; often the leaves form a
nest for the white eggs (the fresh ones)—the
hard-boiled ones are dyed a bright crimson."[15]
"These are the department stores of the poor,"
a Frenchman once said, speaking in passing
of the *brocanteurs* on the place Maubert; the
smocks hung limply from a hundred hooks
and the shoes strung up like beads were well
beneath most notice.[16] Elegant boutiques kept
their displays inside and in the windows. The
kind of *étalage* Atget photographed spilling
over the sidewalk was considered inelegant and
was anyway altogether unsuited to the display
of valuable items. When the bourgeois took
time to consider the *étalage* of popular com-
merce, they were likely to find fault; some called
it straight out a public nuisance. In 1911 a group
of these civic-minded Parisians was working
hard to dismantle the lumpen and chaotic swell
of these displays; then the sidewalks would
again be passable; then there would be less
danger of germs landing on the goods.[17] They
published photographs of the offending bou-
tiques (fig. 127) in their magazine, *Les Amis de
Paris*, none of the boutiques too unsightly or too

127. Anonymous, "Rue Saint-Antoine (8h. du matin),"
Les Amis de Paris 1 (1911), p. 216. Bibliothèque
Nationale, Paris.

different from the kind of displays Atget photographed. *Les Amis de Paris* hoped to show the offense done to the pedestrian forced to walk along the curb or in the gutter to avoid the vegetables: there was something unnatural about a bourgeois stepping into the gutter, where in addition to the indignity "he falls prey to the bus." [18] Eventually, in two years time, the Préfet de la Seine responded and regulated the *étalage* in the *arreté* of May 31, 1913: "It should not take up more than one third of the sidewalk; the displays should not extend beyond 2 meters; the concession will not be permitted when there is less than 1m. 50 of sidewalk." And prohibited among other things (like the display of indecent books and pictures, like the butchering of meat and poultry, like the sale of drink), the sale of scrap metal, old clothes, and food susceptible to dust and dirt. The "proscriptions concerning public morals and hygiene" would try to abolish the mainstays of Atget's subject:

2. It is forbidden, in the interest of cleanliness and the good image of the public thoroughfare, to put old or used objects on display, such as: secondhand clothes, rags, scrap metal, etc.

3. It is formally forbidden to set down meat, fowl, game, fish, or other victuals, or any object generally susceptible to dirt or likely to inconvenience the passerby, whether it is placed on the ground, in baskets, or in cases.

4. Foodstuffs likely to be consumed without further cooking will not be put out for display or sold on public thoroughfares unless they have been well protected against dust and dirt.

5. No display of foodstuffs will be allowed at heights less than 0m. 60. [19]

Indeed the prefect abolished *étalage* altogether on certain streets, beginning on January 1, 1914:

it became most hazardous, it seems, in historically temperamental districts like the Mouffetard, the Latin Quarter, around the Bastille, and in Belleville. Atget's photographs did not concern themselves with the troubles of the pedestrian; neither did they care a wit for hygiene. They could not have foreseen the long arm of regulation descending onto the market. Instead they dwelt upon the unruly volume of lower-class commerce; they preserved its swell, its spoils, its superabundance, its germs, its good value.

Throughout the album Atget showed how necessities were put up for sale in different working-class districts, mainly in the Marais, the Temple, and the streets leading up the hill from the place Maubert to the rue Mouffetard. The necessities of food and clothing, supplemented by some cakes from the quai de la Rapée near the Bastille and some newspapers from the place St. Sulpice, both better neighborhoods, were localized. The Mouffetard being the most famous and ancient of these *quartiers populaires* had been the most often described. The Vieux Paris men had dutifully treated it, though with difficulty, for the market had no respect for its historic surrounds and the modern life there was a little too powerful to be imagined away. The Vieux Parisiens had to work hard to find an image that would overpower the scene. Georges Cain finally closed his eyes and took a deep breath, and then wrote the sensation up as part of an inventory of smells, "old rags, old lead and cauliflower." [20] In 1929 Léon Daudet, novelist and man of the Action Française, seized upon the word *villonienne* for the same purpose. Fortunately he found a little girl to compare to Mary Magdalen:

The rue Mouffetard, which runs from the place Contrescarpe to the rue Lacépède at the avenue des Gobelins, is, from the point of

view of filth, squalor, stench, not to mention age, color, and relief, one of the most remarkable streets of Paris. There in magmatic coagulation live ragpickers, secondhand dealers, prostitutes, pimps, coat-snatchers, beings without age, without sex, but not without scent, covered with rags in colors ranging anywhere from green to yellow, dogs of all breeds and rats of all kinds. The swarm is localized, a kind of villonian relic. The ravishing little church of Saint-Médard holds out its net at the bottom of this rottenness, from which all of a sudden comes a pretty Parisian girl—hair short and kiss-curled—a provocative face, a Mary Magdalen of the gutter. It is a street for hanging oneself, if not for reading one's breviary at day's end among the mewing of the cats and the curses and vomiting of the drunks. [21]

Cain and Daudet had clung to the Vieux Paris strategy of finding a sacred detail that would overwhelm the present with the past. They could not bring themselves to use any other practical vision to see the rue Mouffetard. Atget's pictures on the Mouffetard had nothing to do with the Vieux Paris brief; those descriptions were beside the point; in effect Atget took up the unsentimental practical vision they repressed and gave it to the viewer of his photographs. We are given to look at these pictures from the ungainly position of the shopper, and even more specifically, the working-class shopper.

The viewer of the album was plunged into the one commercial world that did not exist for the sole purpose of serving bourgeois need, though in the beginning it was not immediately clear what kind of shopper the viewer would become. The album opened with a general store and moved to show a newsboy framed by an avalanche of magazine covers, as if he were part

of the display too, like the dolls in the doll shop that Atget showed next. The viewer then turned to find a man deep in his booth making keys and then turned again to find a small square stall, unmanned, where one could buy ice cream. Then two kiosks, one a Morris column where the press and the poster made an *étalage* of their own. All of this was by way of introduction. The department store was named and removed: *étalage* sprang out of the opposition. The album then settled down to work. The viewer was brought to look close at shop after shop where food or junk or used clothing was sold. The pictures merged. The commerce grew modest, the shopper's look parsimonious. All became obvious. The look was that of someone verging on a purchase, a bag of *frites* or a bag of beans or an old coat. Only a shopper from the people would ever look so intently at these things. The apples, beans, fish, chestnuts, used furniture, old clothes, and old shoes were eaten, used, and worn by the working population living above these shops and stands. The goods were known to be related to this population. These goods were their goods, their necessities.

The shopper's look elided these displays. Under that scan the goods became fungible; connections were made between old shirts, leeks, a secondhand pillow, and a group of abandoned easel paintings sitting on the ground; homogeneity was implied. These things were analogous. Unbeknownst to Atget, this same homogeneity was being studied by a young French sociologist named Maurice Halbwachs, who was breaking with the convention of monographic case studies to describe the working class in a general way. His book, *La classe ouvrière et les niveaux de vie*, appeared in 1913. It took its definition of class from the way in which a group not only produced but consumed; class was being defined by needs and the ability to satisfy them. For Halbwachs class

was a more general condition, especially at the bottom of the social scale:

> One might think that the diversity of métiers and revenues separates the working class into many groups, therein determining the most diverse collective habits, with the result that the working class would itself be a very complex society that one could not define by means of several tendencies or relatively simple characterizations. But our entire study shows the contrary. If we had proposed to study the social needs and activities in their most advanced form, we should have made our observations in the uppermost reaches of society. But we wanted to study the classes: now there is, no doubt, no more homogeneous class than the working class, precisely because its social life is so reduced, less complicated, and also because the interval separating it from the other groups is so marked by that rapport.[22]

Atget's album came to a similar notion of class, though without benefit of sociological reflection. The album took its sample of labor in a broad sweep across all of the terrain of lower-class consumption, from the stands at Les Halles to the photographer's darkroom. Documents and lobsters were classed together in the same category. Labor had its own, sweeping form. Labor, it should be understood, was in this period neither generally nor strictly identified with an industrial proletariat. Working-class life was spread across a larger portion of the social territory, including the workers in all kinds of shops and trades and industries; it could even be understood to encroach upon the levels that we would be inclined to label the *petite bourgeoisie*.[23]

Atget sought access to the general, homogeneous culture of labor through the working-class shopper's look. Which brings us back to

the *brocanteuse-savante*. For just because one was being given the look of the working-class shopper to wear did not mean that one would know how to *use* it. The bourgeois viewer might well have trouble separating the apples from the oranges; this was one tree of knowledge he did not own. For him or for her, wearing the look of the working-class shopper was probably a bit exasperating, especially since the album insisted that the look be adopted. For the bourgeois that look would be something of a trial. Atget was setting up this screen of power-knowledge for the public of the Cabinet des Estampes of course (fig. 128), setting up the poor bourgeois to fail. They might have the comfortable chair but much of the album would be over their head.

At best they could take stock of the details. The *étalages* used these details to move toward a knowledge of working-class culture, which can be seen to fan out from them, though not systematically. This helps to explain the abundance of secondary incident, like the *sabots* in the shoemaker's display at the Marché des Carmes. The document showed how the *sabots* sat apart, awkwardly and absolutely woodenly in a row by themselves; significantly they had been classed beneath several lines of leather boots. The *sabots* were the heavy vestiges of popular life; they were worn by the rough, the very poor, and the peasant; they spelled out a distinction for working-class feet that was not quite stylistic. Some needed *sabots;* others could not wait to take them off. Details like these constantly abutted the *étalages* and pulled them from their isolation into a complex world. Like the political posters for René Viviani that sat above a shelf of carrots at the corner store on the rue Galande, or the black hand pointing to the ladies toilet at the Métro Bastille, or the advertisement of a contest sponsored by l'Eau de Melisse where a free Dion-Bouton automobile with Michelin tires could be won, an ad that

128. Anonymous, "Le Cabinet des Estampes (salle de travail)," from Henry Marcel et al., *La Bibliothèque Nationale* (Paris: Laurens, 1907), p. 37. Bibliothèque Nationale, Paris.

snuggled up unwittingly against a brasserie with the blasé name of Equivoque. The ad entered at the side, a qualifier that snapped the other figures into place, much like the bag of wood sitting off to one side of the bar on the rue Boyer, which said that the bar was one of those that sold fuel as well as drinks. A cultural coherence was being mapped as these details joined forces; there was a society behind the *étalage;* there was a language. The word appeared periodically as another detail and kind of interjection, for example, in the names chalked on the wall next to the radishes and lettuces at Les Halles, names written in big schooled script and followed by small drawings of a boot and a wheel which look to be the work of a child. On the side of the costume store on the rue des Cordiers, some gregarious soul had chalked "bonsoir." Good evening, good day, good morning. The shadow came forward to greet you. The words echoed through the displays, echoes equivalent to the *sabots,* the sack of wood, the carrots, and the black hand.

Now these details could only reinforce a knowledge that already existed in the mind of the viewer (in that sense these documents were similar to those Atget made for his various professional clients). Only a *savante* like the *brocanteuse* would know how to put the politics, the toilets, and the firewood together into something more than an analogy, into a way of life. Atget had had previous experience with this knowledge difference. Atget had a sideline occupation that derived from his days as an actor giving recitations in various public education programs around Paris.[24] This familiarized him with the problem that existed in bringing traditional bourgeois culture to the people, the reverse approach to the same knowledge difference of the album. The Universités populaires organized evening lectures on all sorts of subjects as part of an effort to raise a

class consciousness—"Just like the Union, a work of class, founded by the people and for the people," claimed a sympathetic paper called *L'Effort Social*.[25] The other extreme of the press did not hesitate to criticize such a cultural politics. Mithouard's review, *Occident*, warned that knowledge was rather carelessly disseminated in those quarters: "One would find it, in truth, in these popular universities, where one discusses with equal indifference Nietzsche and Wagner, the virtues of Karl Marx and the dogma of transformism, where one is imprudently given all the contradictions of contemporary thought and where the only positive discipline proposed is the discipline of revolt. Furthermore, upon close examination, French culture, historically considered, is the work of an aristocracy. . . . Unless it were to be renovated to a point where it would no longer be recognizable, the people as a class cannot collaborate with this culture; those from the people who bring something to it have had to first raise themselves up to the elite."[26] Revolt was not exactly on the agenda of the U.P. but certainly some form of bourgeois socialism was. For Atget to lecture to this audience implies some sympathy with that position but does not tell us very much more. There are no surviving accounts of what Atget actually said or even what passages he chose to recite. His lecture titles gave only authors and works— for example, "On ne badine pas avec l'amour— Alfred de Musset." But when he went to make his albums, he did not choose to represent the culture of labor by the subjects offered at the Universités populaires, nor did he assume a superiority, nor did he take the problem of class difference from the perspective of a bourgeois *savant*. He knew that for *le peuple* their own culture sufficed and that they had their own view of the theater of Musset, Molière, and Hugo. That view proceeded from an unwritten

coherence that the details in the album fanned out to cover as best they could.

Where might the details lead? The details did not put together the culture that some felt the working class ought to have, nor however did they put together a familiar representation of popular culture that would be recognizable and useful to those who used it as the raw material for a sociology or a song. In *Métiers, boutiques et étalages de Paris* the details were located in common sense and left there, a long analogy, unexplained, unmediated. The details did not appeal to the contingencies of the bourgeois *connaissances*. Indeed the movement of detail here was not at all conventional. Sociologists, for example, used detail to pin the social subject to a category; it was subordinate to the category and thus not in and of itself very powerful; it was not, as in Atget's documents, fungible and was not equipped to go off into a long analogy. Detail for Halbwachs was an index to the pattern of need. Halbwachs knew that foodstuffs had their price as well as their social value: dinner was a ritual on which much attention was lavished; special dinners were sources of pride and pleasure. The cultural twists and turns of the dinner itself or even the conversations about food were of less interest to Halbwachs however; the particular gave way to the general:

> The housewife does her own shopping. She meets others like herself in the stores and at home. As food occupies a large place in the thinking of workers, a larger place than in that of other men, among themselves they speak more about it. For that reason they are often up to date on what their neighbors and friends are eating, they are scandalized by their excesses, reproach them for their parsimony, pity their poverty and awareness of it. Yet, this information is often spotty and

contributes rather to the maintenance of a general group opinion about the appropriate kind of food; it is easy to send the gossip off on the wrong track, to slip away from malevolent inquiries.—Much more important is the family's own judgment of what food it itself consumes.[27]

The lacunae and judgments were not demonstrated by example. What was said about leeks and lobsters remained buried in the patterns of the generality; the sociologist did not exhume common sense. French sociology, it should be remembered, had not made much use of photographic, or even of pictorial, evidence; there was no reason for Atget to consider his work as a natural extension of a Halbwachs or a Durkheim or a Le Play; he would not have understood his work to be reforming; he would not have welcomed comparisons between himself and Jacob Riis; his photography did not rake muck. More to the point, the details in Atget's photographs were not presented in a way that would be useful to a sociologist or a social reformer; they were presented as the cryptic bits of an already respectable culture. *Mangetouts* and limp fish. Atget's equivalents.

It would have been more logical for Atget to liken these documents to songs. And yet his idea of popular culture was not being packaged like theirs. Take, for example, a song of Aristide Bruant's (whose legacy was parlayed by the cabaret that played off his name, the Brulant Alexandre). It was printed up as part of a collection Bruant published while at the height of his success in the 1890s. The song told outsiders about life in the quintessentially popular district of Paris, Montmartre, or as its hero pronounced it, "Montmertre":

> Malgré que j'soye un roturier,
> Le dernier des fils d'un Poirier
> D'la ru' Berthe,

Depuis les temps les plus anciens,
Nous habitons, moi-z-et les miens,
 A Montmertre.

The honest working man, a commoner named
Poirier (Peartree) whose roots extend into the
most classic working-class places, led a life of
cliché, which Bruant gave ironically:

L'an mil-huit-cent-soixante et dix,
Mon papa qu'adorait l'trois six
 Et la verte,
Est mort à quarante et sept ans,
C'qui fait qu'i r'pose d'puis longtemps,
 A Montmertre.

Deux ou trois ans après je fis
C'qui peut s'app'ler, pour un bon fils,
 Eun' rud' perte:
Un soir, su' l'boul'vard Rochechouart,
Ma pauv' maman se laissait choir,
 A Montmertre.

Je n'fus pas très heureux depuis,
J'ai ben souvent passé mes nuits
 Sans couverte,
Et ben souvent, quand j'avais faim,
J'ai pas toujours mangé du pain,
 A Montmertre.

Mais on était chouette, en c'temps-Là,
On n'sacrécoeurait pas sur la
 Butt' déserte,
Ej' faisais la cour à Nini,
Nini qui voulait fair' son nid,
 A Montmertre.

Un soir d'automne, à c'qui'i' paraît,
Pendant qu'la vieill' butte r'tirait
 Sa rob' verte,
Nous nous épousions, dans les foins,
Sans mair', sans noce et sans témoins,
 A Montmertre.

Depuis nous avons de marmots:
Des p'tit's jumell's, des p'tits jumeaux
 Qui f'ront, certe,
Des p'tits Poirier qui grandiront,
Qui produiront et qui mourront,
 A Montmertre.

Malgré que j'soye un roturier,
Le dernier des fils d'un Poirier
 D'la ru' Berthe,
Depuis les temps les plus anciens,
Nous habitons, moi-z-et les miens,
 A Montmertre.[28]

The working-class family occupied the entire
attention of the song, which followed the gen-
erations of Poiriers as they didn't marry, procre-
ated anyway, and died. The details of their lives
were sparse and threaded through bare, rhym-
ing sounds: *mertre, verte* absinthe, the *verte*
(green) grass of the matrimonial field, ma's
perte, certes, to give just one of the rhyming
chains. The sound pulled the details together
into a cycle: the working class would reproduce
itself internally, in *Montmertre*, without any
help from the outside.

In Atget's album such circularity was out of
the question. The details were similar but they
kept extending outward, like creeping vines. No
single one of them would do as a description
of this culture, hence the decoding of a single
document leads nowhere in particular. The de-
tails took their meaning from the sequence that
Atget constructed for them, the sequence that
was the analogy. By the time it has finished,
the details have upset the preconceptions of
what an *étalage* should be and laid an unmis-
takable line of difference across everyday life.
Furthermore they have broken one of the un-
written laws of the document business: they
have asked the viewer to experience the photo-
graph not as a fragment but as a totality, *as if
it were reality itself.* The documents here were

creeping toward a real that lay behind the tech-
nical sign, a real that anchored the details to a
material world. It was in part that real that has
often bedeviled the criticism of photographic
images, the real that attached itself to even the
most elaborate of pictorial signs, the real that
turned the sign, as Barthes once said, as if it
were milk.[29] The souring real was here too,
but the real had been carefully given a cultural
specificity: it was the working-class real, not the
bourgeois one; it was the real of common sense,
not the real of the unconscious; it was decidedly
not a transparent real. One of the repeating
details summed it all up in the empty picture
frame. Atget was developing a realism based on
an indescribable everyday void, the thick void
of ignorance.

This leaden realism returned a new version
of *métier* to modern times. The conclusion of
Atget's album made that very very clear. It was
probably not just sheer coincidence that the
album was made in 1912, the year when Atget
officially became an *auteur-éditeur*. The *auteur-
éditeur* however this time presented himself
in the middle of the album as an anonymous
photographer, whose studio showed the dif-
ferent sectors of the documents business in
the lettered pigeonholes for interiors, trees,
and some numbers in the 3000s, in the copy of
Rochegude's guidebook *A travers le Vieux Paris*
tucked away into the shelves, in the stack of
paper albums, the top one entitled "11^eme Série
Vieux. . . ." The pockets of work in the service
of artists and antiquarians described the extent
of his commerce, the paper album pointed to
the hardcover albums. The worktable at the left
was loaded with the paraphernalia for making
photographs and the corner is filled with repro-
ductions, a calendar girl, and Gervex's *Avant
l'opération* (1887).[30] Two other photographs of
the studio showing the shelves of negatives were
excluded from the album.[31] Documents were

the point, analogous to lobsters. The photographer's documents were goods like the others; in the eyes of some they were necessities, just like *brocante*. In this album photography was a *métier* and the photographer was an artisan, just like the ceramicist or the bookbinder.[32] The *auteur-éditeur* was presenting his work in a very particular and very low cultural context. But, then, the album was itself an *étalage*. Albums were, after all, Atget's way of displaying his work to clients. This one was no different except for the fact that the client now was sitting in a library.

The conclusion. The point of view of the lower-class shopper was taken to the facade of the art nouveau boutique and its luxe at once became grotesque, as did the cabaret facades, whose entertainment seemed all show, all bluff, all gratuitous, rather like the clichés strutting around Bruant's sentimental song. And then the album returned to the purer forms, the details from which its long analogy had been made. What could be shown in the end was only the extent of the analogy: the covers of books sold by the *bouquiniste* who sat soberly reading beneath the liberty column on the place Bastille, the front of the brothel. One could not really judge culture by its cover or by its appearance. Labor was not easily known, said the album in the end, and its culture was not to be summarized by a form. *Tant mieux*. The culture of labor had to be shown as open and closed, diastolic, present and absent, surface and substance, the substance never shown outright. We end up in the studio of the bookbinder, who sewed the documents into these albums that were makeshift books. The book was a vehicle. Just like the carts pulled up at the Marché des Patriarches, the book delivered its goods. Just like the flowers in the stall at St. Sulpice, the book was a bouquet.

• • •

Garbage. The other line in the labor parallel boiled these conclusions down to a case. There *métier* was reduced to the single one of the *chiffonnier*, or ragpicker, and the detail was all the same thing. Garbage. The album took the ragpicker's home ground, which was littered with the bits and pieces of rags and junk that had been collected together into a way of life. Rags, pots, old chairs, scrap wood, tar paper, tarpaulins, brooms, blankets, carts, baskets, graffiti, stuffed animals piled up in these photographs. The album collected them in no particular order. Yet it is clear from the way in which Atget set the exposure times for his negatives that we are meant to take these things, their sudden beauty, their manifold ugliness, and even their grime as positive goods. Atget exposed the entire image for the garbage. His lighting would make it shine. His exposure bleached out the sky, produced halations, obscured frail chimneys and trees, and exaggerated the horizon line, from which sibylline pandemonium hung.

Rags and refuse could not be allowed to go uncollected or unclassified. The bourgeois could always grasp them as part of a concept of ruin and decline. Atget would photograph ruins for that concept; in 1913 he documented the dismantling of a set of houses that had backed up into the complex of St. Severin and over the centuries had rotted beyond repair. They were disemboweled most rationally, the old timbers neatly piled against the bare walls that still wore their paint, their wainscoting, and their sheets of wallpaper as if nothing had gone amiss; above them rose a noble set of peaks, the peaks of the ruin and the spire of the church, whose ruin was being saved, paradoxically, by laying waste to the neighbors (fig. 129). All scraps were not equal. The rubble of the little shops that had had the bad luck to be built into St. Severin

meant one thing in one context and another thing in another. Rags and refuse in the form of cut paper could also be grasped as a concept called Cubism. That same year Cubist collage was also seizing upon the scraps of bourgeois commerce (fig. 130). But their bits of paper, like a lingerie label from Au Bon Marché, and a snippet from a newspaper ad from its rival, La Samaritaine, were used as good working signifiers of a culture, here that of the unblinking *parisienne* who took her image home in wrappers from the department stores. That image shattered as it came into contact with the materials of everyday life—with nondescript wallpaper, a fragment of newspaper column, a glass of wine drawn with the Cubist twist. The papers gave the sophisticated Cubist eye a rest and an ordinary real. The *parisienne* was there as jigsaw pieces, a bust from La Samaritaine, lingerie from Bon Marché, and her identifying "trou ici" (hole here) picked out of the newspaper by the ever vigilant artist. The jig came down to a dirty joke.[33] Of course for Atget scraps were not necessarily ruins nor were they compliant signifiers. In his album on the ragpicker the possibility of seduction existed but it disappeared into the scrap metal like a porcelain mirage (fig. 131). He gave the mores of the working class another structure, a structure of recession that took the scraps—we might also call them details—with it.

Rags and recession. Both described the condition of the ragpicker very well. Atget took the bits and pieces that characterized the existence of the ragpicker and let them crack open the split between the bourgeois image of the city and the popular experience of it; he had found the perfect figure for difference. In fact it was a compounded figure involving both the ragpicker and his space, the zone; it was also, conveniently, a figure that withdrew itself. The document's use of the scrap took the *populaire* in a way

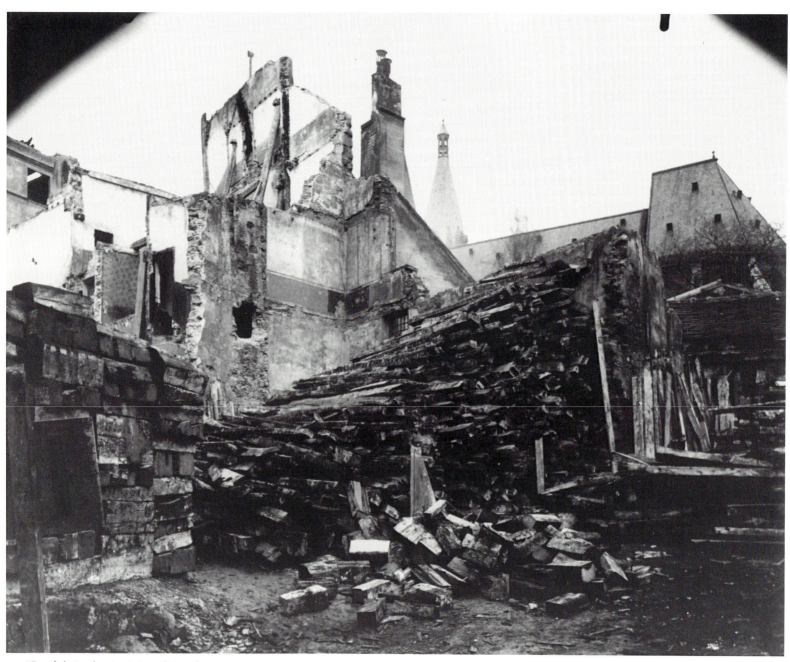

129. "Rue de la Parcheminerie Demolitions de mars
1913." Top 1421. Musée Carnavalet, Paris.

that the Cubist could not. Collage embraced the popular in order to ground the image in banality, the banality of the newspaper perhaps, or the banality of the scrapbooks that working-class women liked to make, collecting install-ments of the *feuilletons,* or serial novels, as they came out in the daily paper.[34] The vulgarity of a pasted culture suited the collage and was its pole of the real against which the fanciest fourth-dimensional variations could be drawn. Yet those same papers displayed Picasso's and Braque's ambivalence toward the boulevard art market; bourgeois women pasted too, but not with these things. The low order of wall-paper, newspaper, and label reminded the elite, the Gertrude Steins and Daniel-Henry Kahn-weilers, that another order of things lay beneath them. But reminded them of these things with nice lewd jokes like a *humoriste* would. Atget put the scraps of modern life into a completely different perspective, with another sense of the *trou,* a wandering, cavernous, widening *trou,* that would not be restored to order by a parlor laugh. His *trou* was told by the rag-picker's scrap.

For the ragpicker rags were rather like nature itself, something to be followed and harvested, though rags of course came not from the land but from the city. The ragpicker collected the "vomissement confus de l'énorme Paris" and kept what he could use for his home; cloth was stretched over a board to screen a wall; a stray gate was integrated; café awnings were cut into strips and used to block the wind; *bricolage* was commonplace. The refuse was weird and scenic but its effects were temporary distractions as far as the album was concerned: refuse here pointed to a specific form of labor that could no longer be called primitive accumulation.

The ragpicker was actually a good example of the independent worker in the old French style, the worker who did not give all of his

130. Pablo Picasso, *Au bon marché.* 1913. Collection Peter Ludwig, Aachen.

131. "Intérieur d'un chiffonnier Bᵈ Masséna. 1912
(13ᵉ arr) Porte d'Ivry." Pp 344 (112). Bibliothèque
Nationale, Paris.

labor to the factory or the workshop but presided over various cottage industries that took place inside the home and in the fields.[35] Labor was chosen and mixed according to the seasons and one's needs. The album was careful to show the assortment of *métiers* actually practiced by these people, sometimes showing the work process in the photograph itself. At other times it indicated through some detail of it, like the cart belonging to the *marchand de coco,* the caned chairs, and countless baskets piled up in stacks. These activities went along with the collection and sorting of garbage. But basically the ragpicker thrived on rags, that is to say, on the very stuff that the bourgeois rejected. The refuse was the immediate sign of the extreme difference between them.

That difference had already been the subject of much analysis and reverie. Marx had taken the ragpicker as the figure of the exploited working class, the ultimate figure for the degradation of the proletariat under capitalism: " 'By comparison savagery appears like a royal condition.' 'Prostitution of the non-owning class in all its forms.' Rag-and-bone men." [36] Baudelaire had taken the *chiffonnier* as a free spirit, whose freedom to philosophize was matched only by his freedom to drink. In "Le vin des chiffonniers" the ragpicker became a bard of phenomenal resilience, a *sublime* of the rag-and-bone. The poem opened with a long description of that worker cum poet:

Souvent, à la clarté rouge d'un réverbère
Dont le vent bat la flamme et tourmente
 le verre,
Au coeur d'un vieux faubourg, labyrinthe
 fangeux
Où l'humanité grouille en ferments orageux,

On voit un chiffonnier qui vient, hochant la
 tête,

Butant, et se cognant aux murs comme un
 poète,
Et, sans prendre souci des mouchards, ses
 sujets,
Epanche tout son coeur en glorieux projets.

Il prête des serments, dicte des lois sublimes,
Terrasse les méchants, relève les victimes,
Et sous le firmament comme un dais
 suspendu
S'enivre des splendeurs de sa propre vertu.

Oui, ces gens harcelés de chagrins de
 ménage,
Moulus par le travail et tourmentés par l'âge,
Ereintés et pliant sous un tas de débris,
Vomissement confus de l'énorme Paris,

Reviennent, parfumés d'une odeur de
 futailles,
Suivis de compagnons, blanchis dans les
 batailles,
Dont la moustache pend comme les vieux
 drapeaux.
Les bannières, les fleurs et les arcs
 triomphaux

Se dressent devant eux, solennelle magie!
Et dans l'étourdissante et lumineuse orgie
Des clairons, du soleil, des cris et du
 tambour,
Ils apportent la gloire au peuple ivre
 d'amour! [37]

By the 1860s the Paris lore would tag the *chiffonnier* as a latter-day Diogenes; Hugo had put the image in the discourse of one of his characters in *Les misérables,* the savvy republican student Grantaire, the ugly one with a libertine urge and Pyladian death.[38] It was a romantic figure, quite unlike Marx's. By the time Atget went to photograph the ragpicker, both versions were current though they existed in rather different textual traditions. But everyone took

the ragpicker as the ultimate figure of poverty, native poetry, and absolute cultural difference. It made some sense, then, that Atget would settle into a sustained study of this figure, just as it made sense that this would be the figure he would ultimately choose to represent labor. But, in keeping with his usual procedure, he did not take his cues from a text.

In 1912, the year of *Métiers, boutiques et étalages de Paris,* Atget took the group of photographs that had occupied the 100 space in the *Paris pittoresque* series and began to develop it further. The group had dealt with the *zone militaire.* It had been known since 1898 that the fortified zone would disappear: the state was negotiating to sell the entire zone to the city for the development of new housing and industry, which would raze and replace the long-outmoded fortifications of Louis-Philippe.[39] The negotiations were concluded in 1913 without much regard for those who had been living there already. Some of these held property rights dating to 1840, which is to say, *before* the land had been annexed for the fortifications, and they had started to develop the land on their own with light industry and small businesses; they organized themselves into a union and vigorously protested. The common *zonier,* and this included the ragpicker, did not have these rights and did not organize; ignored by the city planners, he continued to live his life in a perpetual present with a doubtful future. Eventually, in the 1920s, he would have to move. When Atget started his work in 1910 the *zone* was only in the process of being condemned. He sampled many of its aspects, the fortifications, bastions, customs houses, boulevards, embankments, and the *zone militaire* behind them, shantytowns, and a few outdoor cafés, known as *guinguettes,* so that the 100 numbers collected a mixed neighborhood of home and

bastion.[40] Atget integrated some of this work into the later sections of the *Paris pittoresque*, even to the extent of renumbering some of the negatives. He also divided the group into two separate projects. One of them would become the album he entitled *Zoniers. Vues et types de la zone militaire* (see appendix 1, table 6). The *Zoniers* title was ever so slightly misleading since the album was in fact devoted to the labor of the ragpicker.

Zoniers. Vues et types de la zone militaire began with some of the *zoniers* at the Porte d'Ivry whom Atget had photographed in 1910. Any kind of cabaret or *guinguette* was carefully avoided, no hint of the ragpicker's *vin*. But then, vice was not Atget's subject. Atget focused on the home, the ragpickers' home, which was also their workplace, the place where the day's refuse was brought for sorting. By 1913 the work of the ragpicker had been substantially transformed from what it was in Baudelaire's day. The ragpicker who roamed the city streets by night, a professional scavenger who rifled the garbage left outside on the curb and collected its valuable pieces into his *hotte* (a huge basket that was strapped to his back), that ragpicker had been rendered virtually extinct in 1883 by new city ordinances proclaimed by a prefect named Poubelle. Poubelle ordered regulation containers to be used for the garbage of every city dweller (the containers that would be given his name, now the generic word for the garbage can). This was less of an impediment to traditional ragpicking than the next stipulation, which came as the real blow: the cans were to be placed on the streets no more than fifteen minutes before their scheduled collection by the city. The *chiffonniers* managed to parlay the fifteen minutes into a grace period of an hour and won the right to empty the contents of the container onto a piece of canvas, the

better and faster to examine it, but the *métier* was still forced to accept no small amount of modification.[41] The *chiffonnier*, or *biffin*, as he was sometimes called, could no longer work by night.

In the aftermath of the ordinances the *métier* was reconfigured. The old hierarchy, the *chiffonnier de nuit* and the *chiffonnier gadouilleur* (those who specialized in greasy waste), expanded to include *chiffonniers placiers, chiffonniers coureurs, chiffonniers du tombereau,* and *ouvriers chiffonniers* (*chiffonniers* who worked for other *chiffonniers*).[42] The *placiers* paid the concierges for the right to sort through the garbage before it was put out for the official collection; this done, they brought the building's garbage out to the street; sometimes they had already brought it down from the upper stories. They were fairly prosperous: they used a cart to haul away their findings. The *coureurs,* on the other hand, ran from one neighborhood to another, working on the street during that free hour, which varied according to *quartier*. They stashed their findings in voluminous sacks; sometimes *coureurs* shared a handcart. Some *chiffonniers* were able to ride the city's dump wagons and work the debris there. By 1903, the year of an official government report on the *métier*, it was estimated that altogether between five and six thousand ragpickers were working in Paris.[43] They left home around five o'clock each morning, returned home around ten, and proceeded to sort rags from bones from metal from paper until mid-afternoon. At this time, they would take their sorted goods to the *maître chiffonnier*, the middleman who gave them money in return for these new-found raw materials. The *maître chiffonnier* ran a kind of atelier in which the sorting was refined, classed by the type of material and its market value. Normally he was aided by members of his family,

just like most ragpickers, and by a few wage laborers. As a *quantité importante* of a particular material was accumulated, it was sold to a wholesale merchant.

Atget never gave the step-by-step description of the collection, sorting, and selling of rags and bones; he surveyed the different levels of the profession as one would actually encounter them—out of chronological order. To document the ragpicker's work, Atget needed to photograph at several times and in several places. The different stages of the ragpicker's work were likely to be going on all at once around the city, each ragpicker on his own schedule, following Poubelle's hours as they opened up new fields of opportunity and closed others down. Atget was concerned to have all of the phases represented: among the corrections he made to his sample in 1913 was the incorporation of the larger establishments of the *maître chiffonnier*. He was not interested in preserving the picturesque clichés that still clung to the figure of the ragpicker. And he did not include an image of the ragpicker with the outmoded *hotte*, though he had made such a picture for the early *Paris pittoresque*.[44] His new work took him from one side of Paris to the other. In the *zone*, he could photograph the small stockpiles of scrap metal, the handcarts, the sacks bulging with rags, and the ragtag homes the ragpickers built from their findings; the odd assortment of urns and pots and pans, for instance, spread along the ground at the Porte de Montreuil showed the luck of a small-time ragpicker and his *batterie de cuisine*. To photograph the work of sorting and selling however Atget took his camera to the Porte d'Asnières, where the quantities of garbage hauled in were visible both in the wagons on the street and in the courtyards of the ragpicker. Here in the recessed courtyard of the Cité Tribert he could show the ragpicker up to his ankles and sometimes his knees with un-

sorted rags. Here he could show the office of a *maître chiffonnier* where strings hung down in anticipation of future bundles and the day's haul was neatly stacked. The other courtyards at the Cité Tribert could well belong to this *maître;* their sorting, in any case, was on the large scale of the second-round type done by *maîtres.* The working ragpicker stopped work for the photograph. Work had to be deduced from the setting; the worker was slightly disengaged from it; the formality of his pose put him at some remove from his work and from the viewer, unable to see how the work was done. The pose acted as a screen. Atget would (or could) only describe the *métier* up to this point; after that a discretion or hesitation set in. An ellipse formed in the document. The ellipse reenacted the differences the ragpickers themselves had already established. One would never know precisely what rags meant to them.

The gulf between the *chiffonnier* and the rest of the city was carefully preserved by both *chiffonnier* and bourgeois alike, as if by mutual agreement. The ragpickers used their work to hold themselves apart from the rest of the city. It was the perfect instrument, for the bourgeois had already rejected the essence of that labor, garbage being his instinctive expression of negation. And it was precisely this garbage that was the ragpicker's prize. The bourgeoisie could only look upon the ragpicker with some horror, which it expressed by progressively expelling the *chiffonniers* from the city, first from the area around the place Maubert, then from the rue Mouffetard, then from the thirteenth arrondissement out to the zone and the faubourgs, for reasons, it said, of Hygiene.[45] Throughout the Second Empire and the Third Republic, experts on cleanliness and disease condemned the filth in which the ragpickers lived and worked, as in the 1882 report written for the Préfecture

de Police stating that the Cité Doré, a housing project in the thirteenth and known as an enclave for *chiffonniers,* was fit for neither man nor beast: "An entire population swarms, there, in the obscure damp of a maze of ruins. In the face of such a heartrending spectacle one asks oneself why and how the institution of a Commission of slum dwelling and the Administration can tolerate the existence of such homes, not only because of the precipitous rate of mortality, but also because of the depth of the degeneracy."[46] The 1903 report addressed itself to this issue again.[47] By then, however, most of the ragpickers had bowed to the pressure of real estate developers and health experts and had moved their establishments out to the fortifications and beyond, joining the larger pattern of working-class migration toward the edges of the city. In 1900 Georges Renault, a litterateur determined to uncover the essential *chiffonnier,* found only a few of them still living inside the city limits, "mostly on the outskirts of the Butte-aux-Cailles and the Epinettes."[48] The ragpickers had literally withdrawn, forced out by gentrification to be sure, but they were also moving rather than change their way of life.

Rags had moral and cultural value for the ragpicker, a concept that baffled outsiders. As A. Coffignon complained:

> What has not been said or written about the ragpickers? Their mores have been more or less sincerely studied; their enclaves have been explored and described with more or less exactitude. The misfortune stems from the fact that most of the time one has been contented to make a superficial study, without looking into the causes for the state in which the ragpickers live, without analyzing the proportions of vice, poverty, laziness and alcoholism that make up the kind of independence they affect.[49]

The squalor and garbage were the stuff of independence, unaffected independence. And it had been so for a while. In the previous generation, the bohemian writer Privat d'Anglemont described the Cité Doré as a utopia:

> Seen from above, it is a meeting of Christians living in rabbit hutches. Seen up close, it is suspect, but all in all consoling. It is a city in a city, it is a people lost in the middle of another people. The city looks no more like the other Paris than Canton looks like Copenhagen. It is the capital of poverty gone astray in the middle of the country of luxury; it is the republic of St. Marin at the center of the Italian States; it is the land of happiness, of dream, of easy come, easy go, by chance set down in the heart of a despotic empire.[50]

Approve it or not, the difference Privat d'Anglemont ascribed to the ragpickers was theirs. The rags gave the ragpickers their independence from the modern industrial city, even though they could not exactly exist without it. Their harvest of its garbage provided them with the necessities of food, clothing, fuel, the materials for shelter, and this gave them a large measure of freedom from the constraints of a money economy, freedom too from bosses and the confinement of factory labor. The price of this freedom was their material poverty; most ragpickers earned between 1 franc and 1 franc 25 a day.[51] The ragpicker had essentially removed himself from the thick of the class struggle but his group remained a special corner of the working class and a refuge for those who had lost their regular employment. L. Paulian, a sympathetic social scientist, outlined the kind of mixed population he found in their cities in 1893; by his count, not only workers found asylum there but "the army man chased from his regiment, the notaire who *has had a bit*

of trouble, the inventor forever in search of a new discovery, the so-called man of letters, misunderstood but only because his abuse of absinthe makes it impossible to understand a word he says."[52] Fallen or born to this condition, the ragpicker existed in a disturbing combination of liberty and poverty, a combination Paulian could not condone:

> The ragpicker is above all an independent; he lives from day to day, and often quite badly, but he lives in complete liberty. He looks compassionately at the worker closed up in his atelier, beginning his day at a set time and finishing it at an equally set time. A similar existence would not suit the ragpicker. For him it is slavery. He prefers his poverty to this slavery. At least he is his own master, he works when and as he wants. If it pleases him to lie down, he will lie down without having to hear any remarks from a boss. He knows no master, or at least he pretends not to have ever known one, and he brags that he has resolved the problem of wage labor, when in reality he is, through his own error, the most exploited of all the proletariat.[53]

Such poverty, Paulian felt, could not be freedom; rags could not be freedom. But the ragpicker had not sold his virtue, had not succumbed to "prostitution of the non-owning class in all its forms," and had not turned to vice. The outsider and the scavenger performed a useful social service. From inside the city, it was difficult to interpret his position, to understand his attachment to a life lived in city debris. Bourgeois writers puzzled over that. Their negation had produced his freedom.

In bourgeois discourse this freedom of the *chiffonnier* came up constantly, partly because it seemed to depend upon a foreign idea of freedom and partly because it had produced a foreign culture, some said a tribal one, comparable to that of the American Indian. Georges Mény's book, appearing in a series sponsored by Catholic socialists, analyzed the extent of this separation between the *chiffonniers* and the rest of the city. It was a disturbing gap, which grew more disturbing upon inspection. The differences were more than political here—they were incomprehensible:

> Their mores are quite special. Too often one regards the ragpicker as a pauper, a fallen man. That is a total error. In the entire métier there are hardly three or four percent like that. It is more correct to consider the ragpicker as belonging to a separate race, exercising the profession from father to son, living more or less on the margins of civilized society, massed in certain neighborhoods understood to be their closed, exclusive fiefs. The ragpickers frequent only each other's society. Content with their way of life, they are quite ready to take as their enemies all those who would like to organize them toward improving their situation.
>
> "We do not meddle in the affairs of the bourgeois, let them settle their own affairs between themselves and leave us to settle ours," said one of these people to M. the abbé Aubert one day, this priest who left his university chair to live in the midst of the "biffins" and for whom all feel the deepest sympathy and whom they greet with joy when he passes through their city.
>
> These words reveal the depths of the ragpicker's nature. He is above all an independent. His life is poor, but he is free, and he wants to remain so. In 1884, Dr. George Martin, municipal counselor of the XIIIth arrondissement, had filed a petition by 294 ragpickers asking to be employed by the city of Paris, so as to escape the difficulties the Poubelle decrees caused their industry. They were all convened by M. Alphand, the director of public works, who offered them work as street sweepers at a salary of 3 fr. 20 for a ten-hour day. Only *eight*—and one of these hypothetically—accepted the proposition. The reason for the mass refusal was given to M. Lefebure by one of the petitioners: "We work freely and we do not want to be slaves, there are enough old men to do that job; we are asking to *work* at our independent métier."
>
> The ragpicker spurns any outside intervention in his affairs. He protests the reforms to clean up the neighborhood imposed on him by the committee of hygiene, because he will be less at home. Sometimes he prefers to emigrate elsewhere rather than submit. Never, when he has difficulties with a colleague, does he bring the case before the courts. For him there is a special justice system, of which the first sanction is a fine and the second a very conscientiously administered thrashing. Mostly he settles his accounts himself. Knife combats are not rare and the battle waged with their hooks by the two ragpickers on the rue de la Santé is, in the corporation, a natural occurrence. It is explained by the fact that the ragpickers live completely outside the rest of the world. And they cast off everything. Among them unmarried couples are the great majority.[54]

Through actions like these, the ragpicker had pulled himself off into a special corner of the proletariat, so special that his indifference to revolutionary politics was a constant source of astonishment.[55] But the ragpicker's refusal of the modern industrial economy was politics

enough, and his scorn of its forms of civiliza-tion was certainly not at odds with the more conventional feelings of class struggle. "If the bourgeois holds the ragpicker in contempt, the ragpicker returns the favor and does not bother to hide it," wrote Renault in his book on the *chiffonnier* and called this a simple incontro-vertible fact.[56] But class difference here did not fall into the familiar Marxist categories; the ragpicker belonged to the *impensé*.

When middle-class writers and govern-ment reporters did not find this group easy of access (most depended on a friendly *chiffonnier* guide), they wrote up cultural rather than class difference. "To be admitted into their society, one just has to become one with them, dress like them, speak their language and above all not recite piteous phrases," wrote Renault.[57] When the sociologist Joseph Durieu, a follower of Le Play, wrote his account of the *métier* in 1910, he was reduced to telling stories:

When I wanted to find a *chiffonnier coureur,* a runner, in Paris, I could not find a single one. The runner, in effect, is no longer to be found inside the fortifications, he has been relegated to the suburbs. For the rest, he is a kind of vagabond, an intermittent ragpicker, whom the *placiers* scornfully refer to as the *saqueur,* the jerk, and is always being more or less tracked by the police for working without a permit. Given the fierce isolation to which they are inclined, meeting one of these char-acters is fairly difficult, as I can testify, at my own expense:

One day, having spotted two ragpickers, a father and son, in the process of working on a pile of sludge in a field, I felt the time was right to approach them.

Carelessly I drew closer and casting an interested look at their business I gradually

got myself ready to start up a conversation. The younger of them, a twelve-year-old kid, did not let me have any time. "What does that one want?" he groaned in a loud voice while giving me a sidelong glance, "a cabbage stump for his lunch?" The father did not take up the thread and continued to excavate his heap of sludge as if he had not heard a thing: "That's what's funny—a pile of sludge," the kid went on, "for sure if he had there a photo-graph machine he could take a portrait to put on his mantel." The father still did not pick up. A little taken aback by the rather cool reception I decided to put my interview off for another day and philosophically beat a retreat.

The incident was nonetheless interesting for it showed the particular mentality of the rag-picker very well, something I never encoun-tered in any other métier; something like the hatred of the savage for the civilized man.[58]

To recuperate the *chiffonnier* into a system where bourgeois values reigned took no small effort. In 1913 an article on the *chiffonniers* in *Je Sais Tout* insisted upon the economic bril-liance of the ragpickers, their ability to turn a profit, and their good character: they were a sympathetic lot, said the article, if a little rough around the edges. A photograph (the mantel-piece genre the boy mocked?) showed just how sympathetic, how harmless (fig. 132). The *in-stantanée* caught everyone off guard, which made for a confused portrait, set into some re-lief by the presence of a dog montaged in at the border, presumably for decorative effect.[59] The ragpickers did not make themselves available to others' representations of them, as if they knew they would be turned into trivia or Diogenes. When posed, aware of the process of represen-tation, their attitude toward the photograph was rather different. Atget's photographs of

the ragpickers, all of them posed, showed their diffidence very plainly.

Since the ragpickers had withdrawn them-selves from bourgeois culture, it would follow that they would withdraw as well from some-thing as bourgeois as a photograph. They did, but not out of shyness. The ragpickers in the album looked calmly out, steadily meeting the photograph's perspective with their look. The look gave them victory. For these were by and large knowing looks, with a proper dose of suspicion, confidence, and sometimes a steady smile. Atget represented their symbolic con-trol of themselves; he did not have his camera dominate, the way the know-it-all photographer did or a Jacob Riis would. For it was precisely this power of theirs that interested him most, even if that power was expressed by a move-ment during the time of his exposure. Just like Atget's ellipse, the blurs sang difference. And not all of them were made by children, chickens, and dogs.

The steady looks and blurs gave the rag-pickers their own remove. They also thwarted practical vision. But seeing *moeurs* here was made still more difficult by the documents, which did not break the sample down into the study of single details, did not systematically zero in on the ragpicker or the rag. Instead the documents pushed both rag and ragpicker off into the deep of space. The documents tended to place much of the detail and many of the figures in the depths of the foreground and in the middle distance. This was in part the resi-due of a technical sign, the one for decor, but it stood these pictures well. The spaces were as carefully dug into the picture as Picasso's *trou ici:* at the Porte d'Ivry (*Zoniers,* p. 40) a cart-wheel took off from the lower right corner of the frame, leaned back into a clearing, a yard between two trailers, each of which was hung

132. Anonymous, "Familles de chiffonniers au vingtième
siècle," from Tarride, "Rebuts du riche, trésors du
pauvre," *Je Sais Tout*, February 1914, pp. 218–19.
Bibliothèque Nationale, Paris.

with lace curtains, each of which had an opening, each of which was silent like a tomb, and let the litter chatter, the half-erased numbers trail off. The perspective jogged back to yet another yard, more litter, this not so neatly swept, and a light that engulfed the thin trees and spilled over the horizon. The light softened this space and gave the dark passages in this no-man's-land a depth that seemed penetrable, but the perspective intervened and the depths tightened up. In other images, like that taken at the Cité Valmy (*Zoniers*, p. 45), the space revealed people standing here and there along the curb, like the broad woman in black standing midst all the carts, down the street from a reflecting puddle and a bag that swung gracefully in the wind. She stood with her elbow resting easily upon a pile of bound rags and looked straight into the photograph, which she seemed to regard as hers alone. All through the album the documents collaborated with her, with the others, and their completely nonbourgeois way of life; the documents were dragging and stalling instead of moving to knowledge.

Like its predecessors, this album had a finale, which began with the man on the avenue des Gobelins. The finale included photographs from other number series, *L'Art dans le Vieux Paris* and *Topographie de Paris*, photographs which showed the ragpickers' former home, the dark masonry alleys of the Cité Doré and the range of shacks and slope at the Butte aux Cailles. Both of these places were situated in the middle of the thirteenth arrondissement, nowhere close to the zone, but they were part of its history all the same. In the aftermath of 1848 and the demolitions brought by Haussmann in the central and working-class districts of Paris, both the Cité Doré and the Butte aux Cailles acquired their populations of *chiffonniers,* who lived there for a time until the pressures of urbanization forced

them slowly farther out into the *zone* and the suburbs.[60] In 1853, when Privat d'Anglemont wrote about the Cité Doré, some of them still lived in tents and shacks. The way of domestic life had changed very little for the *chiffonnier* in this slow march to the *zone:* Atget photographed the same kind of campground in 1913, though by then it had moved from the Cité Doré into the open spaces outside Paris, the Porte d'Ivry or wherever. The masonry buildings at the Cité Doré dated from the Doré housing project of the 1850s; they still held some ragpickers in 1903 but the center of the industry had moved on; Atget's photographs at the place in 1913 showed hardly any rubbish. The last sequence of the album was interrupted twice: once to remind the reader of the wooden shacks and straight dirt paths of the newer *zonier* settlements and then again to remind the reader of the existence of the *maître chiffonnier,* whose courtyard it was at the rue Amiral Mouchez. It was a reminder that life and work for the *chiffonniers* continued apace despite the move to the *zone.* Their modernity would survive demolitions and condemnations by boards of health. Their separation, their *écart,* would settle down elsewhere but it would not go away.

When Atget recorded the displacements of the ragpickers he was pointing out the difficulties created by the city for them and their independence. In 1914 there was talk in the city council of cutting their rights to the garbage on the street, which would destroy the *métier* of the *coureur* and attack once again the way of life his work permitted.[61] As it was, the ragpicker was drawing diminishing returns from his work: the government report of 1903 noted that the selling price of his particular harvest had tended to decline; to earn his old wages meant more work had to be done.[62] Atget might have been conscious of some of this; he knew

that the campground on the *zone* would soon be destroyed, forcing another move. The last three photographs flashed back to the Butte aux Cailles, the old *chiffonnier* nest that had been razed between 1900 and 1910. It seemed even more desolate than the *zone,* since the Butte was so steep as to permit only the most tenuous constructions, when they could get a foothold at all. The rest was bare and inhospitable. A few of the conveniences of the city had arrived, like gas lamps, but the roads were not paved and Atget picked a place to photograph where a line of manure had briefly hit the dirt; the Butte was far, very far, from elegant. The last photograph forecast its destruction: a tall new building painted in two colors and packed full of windows rose above the shacks, literally on their horizon. But the album did not take that past nostalgically; we have already been shown that the culture of the Butte had not been eradicated, it had simply moved. A remove that was as much chosen as it had been encouraged.

Even though the only picture of the *chiffonnier* actually gathering in his harvest on the streets of Paris was one taken around 1900, a description of these workers emerged: renegades, *sublimes* beyond Poulot's worst fears, workers with a culture they would not share. The description resulted from everyone's work on the forms of these documents—the ellipses would not matter so much if it weren't for the looks, the blurs, and the pandemonium the ragpicker called home. All of these contributed to cut the passage of form to knowledge, all of them were hostile to the gaze. Another modernity, dark but not degraded, slipped into view, a modernity that shadowed all that gaiety on the boulevard, picking up its trash: the shadow knew, it looked, it smiled, and then withdrew. Rags were freedom.

Phase Two

The lines along which Atget had elaborated his sense of labor set the axis of his series straight. The axis had cut into modernity, mounting evidence, documents, a Paris which was showing itself to be much more than the *pittoresque* Atget called it. It is entirely possible that he had come to take that word *pittoresque* ironically, retaining it because no better title arrived to claim its place. *Pittoresque,* that weak and never very telling adjective, was by no stretch of the imagination a description or even a definition of that series which in 1913 was making modernity stranger and stranger. Off the boulevard, that series was saying, modernity was hardly a single entity, hardly progressive, hardly industrial. Absorbed into the *populaire* it was barely knowable.

The lines, the axis, the series, modernity itself, had set up a new and a technical problem for the document. For these documents were coldly proceeding on the basis of an essential and permanent alienation from the viewer—and from bourgeois culture generally. They used form to come between the eye and the object, to block knowledge without dissolving it completely. Between the eye and the object a great occluded space had grown. And yet in the act of denying knowledge, the document found itself holding a space that was both a space of negation and of class, a space of appearances, ellipses, shadows, details, and perspectives, all running lustily away from the eye. The sharpest practical glance would not have altered a thing. The space of class would have quelled it with emptiness. In the last two albums the space of class was given an address. The first of the two, sold to the Bibliothèque Nationale in May 1913, examined the quintessential space of the *populaire,* the cabaret.

The cabaret. It seemed impossible in those days to separate the working class from it. Yet it would take Atget a few years to see how to

fold the cabaret into his project, in part because of the sheer amount of presumption and cliché that had already been there before. Left and right, all kinds of interests had mucked up the cabaret. The journalists tailing the Russian aristocrats into Père Lunette, the audience for Bruant's hymns to a fading *populaire,* the rhymes into which Baudelaire poured the rag-picker's wine, all belonged to a long effort to understand, check, and if possible control the supposedly irrational nature of the cabaret. In small doses irrationality was sheer pleasure, in larger amounts it could become ornery, destabilize, debilitate, spill.

Bourgeois writers of all stripes congregated around the cabaret. They tried to swaddle the cabaret in images, most of them unflattering and unrepentant clichés. Any critique of bourgeois culture would do well to shoot holes into their picture of the cabaret, and avant-garde artists and poets like Picasso and Apollinaire took full advantage, with the net result of swaddling the cabaret further, now in the finer bed linen of art. Atget bent himself to unwrapping it, though not to rescue the hypothetical baby, all authentic, pink, and innocently bundled in. There was no baby. Atget stripped the dreaded irrationality bare: it flitted across dark doorways, drifted under awnings, lay bemused, ghostly and serene, in the shadows, basking in the emptiness of the document. What look could subjugate this scene, what viewer? Atget cut new conditions into these pictures.

The stock images however were all around him, thick and furious and coming from all directions, especially from the reformers campaigning against alcoholism. Both left and right were concerned about the excessive drinking that took place in the cabaret, the right because it, rather conveniently, saw drunkenness as one of the causes of the Commune as well as an impediment to full productivity in the workplace,

and the left because it saw drunkenness as an impediment to rational revolution. When the cabaret appeared in the literature of temperance, no matter which side was writing, alcohol became the devil himself and the cabaret an earthly hell:

> Alcoholism, it is habit's demon jabbing, breaking down all resistance, turning energy to rust; it is the world of the bars where perverse pleasures dim the spirit and debase the character; alcoholism, it is weak flesh fortified by animal desire. . . . Alcohol mixes into all of our activities. The most modest of churches is flanked by a cabaret; a train stop is established somewhere and just as quickly a liquor shack springs up alongside, waiting for the Hôtel de la Gare that will come along and take its place. No building moderately well situated that does not have the characteristic sign. No factory, no town hall, no barracks, no theater, no courthouse, no marketplace or fairground without the indispensable accompaniment, a branch of Bacchus and Company! What is more, everything furnishes the pretext and occasion for taking a drink.[63]

Such a version of the cabaret constantly appeared in print. No constituency went unsolicited. J. Gauvin wrote a children's book in 1914 on *Les métiers* to introduce the worker to the reading child. All went well for the honest laborer until the last pages, when his enemy, alcohol, arrived.

> Unfortunately the worker has a terrible enemy: alcohol. One must pity the worker who goes into the cabaret or café for a rest; he'll soon have none, besides losing the money he earned working, his strength and health, then his intelligence and dignity; [*sic*]
> He has lowered himself to the level of an animal, and when he is loaded, no longer

knowing what to do, losing all self-control, he becomes nasty, he bullies and often mistreats his wife, a good woman wanting to remind him of his duties.

Bad luck to the man, whoever he may be, who loses his wits at the bottom of a glass![64]

One of the leading crusaders for temperance, Dr. Legrain, offered this adage to those campaigning in the schools: "The cabaret makes the drinker much more often than the alcoholic makes the cabaret."[65] *Humoristes* used the drunken worker as a type (fig. 133).

The cabaret had a long and complicated history that moved through these intemperate images: Louis Napoléon saw the cabaret as a hotbed of revolution and worked to suppress it; in the Third Republic, things grew better for cabaret society, though no longer was it the real meeting ground for political work as it had been in 1848; the left had come to depend upon other institutions.[66] The numbers of cabarets were nonetheless growing: in all of France they had risen by 66,000 in 20 years, from 416,691 in 1891 to 482,704 in 1911.[67] In Paris the number had climbed to 30,481 in 1909, this for a population of 2,661,000, as compared to 10,821 for New York with its population of 3,437,000 and 5,860 for London with its 4,536,000.[68] None of these figures was limited to the working-class cabaret but the cabaret was bound to an idea of the *populaire*, which was taken to be an irrational, alcoholic *populaire*. The two, cabaret and *populaire*, were synonymous. *Je Sais Tout* published a long article about absinthe and alcohol in 1907 where the author worried at length about the sanity of the average citizen who takes a drink; but in the last analysis he saw drunkenness as the province of poets and workers.[69] Mostly the drunks were taken to be workers who sat glumly before the enormous glasses (fig. 134), or harangued the air, or murdered,

— C'est que, ma voix, elle est bien éraillée !
— Ça ne fait rien, donnez-la moi : elle comptera tout de même.

Dessin de A. ROUBILLE.

133. A. Roubille, "La Voix du Peuple," *Le Rire*, no. 378 (30 avril 1910). Bibliothèque Nationale, Paris.

134. Anonymous, "Un français sur dix boit cent litres d'alcool par an," from "L'absinthe tueuse d'hommes et d'énergies," *Je Sais Tout* (February 1907), p. 52. Bibliothèque Nationale, Paris.

or passed out in front of their families, the paycheck spent as well. Above all else, publishing alcoholism meant imaging the worker, showing the size of his glass, the loss of his dignity, and the damage done to his heart, his eye, and his family. The three-volume medical guide to home remedies that Atget used, *Mon Docteur*, had a similar diagram, marking off the progressive damage done by alcohol to both face and liver.[70] The images of temperance, intemperance really, were ubiquitous.

In this campaign the left was not much different, though its motives for wanting a healthy productive working class were not of course the same. Writers like the Belgian socialist Emile Vendervelde and the brothers Bonneff argued with the facile identification of workers as drunks, taking care to point out that the drinking problem existed throughout French society; it was just that the rich drunks were less visible since they could be tucked into carriages and driven home, while the poor would have to walk, weaving across the streets, declaiming, muttering, disturbing the peace.[71] The public spectacle however concerned the left less than the workers' loss of reason.[72] They saw the working class ruining its revolutionary potential in the cabaret. They too saw the cabaret in class terms and, just like the right, silted and swaddled what they found.

Et tu bois cet alcool brûlant comme ta vie
Ta vie que tu bois comme une eau-de-vie

Tu marches vers Auteuil tu veux aller chez
 toi à pied
Dormir parmi tes fétiches d'Océanie et de
 Guinée
Ils sont des Christ d'une autre forme et d'une
 autre croyance
Ce sont les Christ inférieurs des obscures
 espérances

Adieu Adieu

Soleil cou coupé[73]

The poets used their license. Apollinaire published a volume of poems in 1913, entitled, defiantly, *Alcools*. It is possible to isolate a discourse of counterreformation in these poems: "Zone," the long poem with which *Alcools* begins, takes its point of departure from a Roman Catholic haze where the Eiffel Tower appears as a good shepherdess looming over a turbulent state of Catholicism, complete with a pope and a *tu* whose adulthood was being spent in motion, taking the profane route through love and through Paris, through the signs, prospectuses, industrial byways, the margins, though stopping just short of the *zone* itself. This was all part of Apollinaire's effort to situate the *populaire*.

Tu lis les prospectus les catalogues les
 affiches qui chantent tout haut
Voilà la poésie ce matin et pour la prose il y a
 les journaux
Il y a les livraisons à 25 centimes pleines
 d'aventures policières
Portraits des grands hommes et mille titres
 divers

J'ai vu ce matin une jolie rue dont j'ai oublié
 le nom
Neuve et propre du soleil elle était le clairon
Les directeurs les ouvriers et les belles
 sténo-dactylographes
Du lundi matin au samedi soir quatre fois
 par jour y passent
Le matin par trois fois la sirène y gémit
Une cloche rageuse y aboie vers midi
Les inscriptions des enseignes et des
 murailles
Les plaques les avis à la façon des perroquets
 criaillent

J'aime la grâce de cette rue industrielle
Située à Paris entre la rue Aumont-Thiéville
et l'avenue des Ternes[74]

Tu was in and out of babel, which became the antithesis of debased Catholicism. But for Apollinaire the *populaire*, complete with its culture of bars, babel, and streets, was a version of what was already called poetry and prose; ultimately it was not too different from *tu*; it was also graceful and parroting. The encounter between *tu* and the people ended in the sordid bars and the *grands restaurants*; it had to end *Adieu Adieu*, with a cut to utter darkness, eclipse. Yet Apollinaire had covered up any overwhelming difference with fast-talking poetical patter. Lyric personality was his mode; all through the poem he was really only talking to himself. His *moi* transcended the stepped space of class.

The avant-garde, mainly Cubist newspaper *Montjoie!* made other connections between the cabaret and the *populaire*, connections which bring us closer to Atget's. Drunkenness was subordinated to the modern and a note of antiquarianism sounded. In 1914 the paper took two illustrations that the Montmartrois illustrator André Warnod had made to accompany the definitive new book on the history of the sign, written by the young Charles Fegdal, the same Charles Fegdal who would in the 1920s develop his antiquarian expertise and his art criticism into a congenial hybrid, making him an avant-garde specialist in the modern *populaire*.[75] In his early book on signs however Fegdal behaved like a proper Vieux Parisien. *Montjoie!* did not find his text worth reprinting. But it took Warnod's illustrations and published them in its April issue, using one to accompany an article on bars and taverns by Jean Muller, the other to vignette the page on which appeared Blaise Cendrars and Sonia Delaunay's galley pages for the simultaneous poem about the trans-Siberian

railroad (fig. 135).[76] Originally Warnod's illustrations and Fegdal's book had been published by Figuière, the editor responsible for bringing out Apollinaire's *Méditations esthétiques* and Gleizes and Metzinger's *Du Cubisme*, probably the best reason for the appearance of old signs in a publication like *Montjoie!* But old signs most often appeared on cabarets, and this modernism had its own tart version of the cabaret to which the sign was supposed to refer.[77] Warnod's old sign was only interesting insofar as it touched upon their modern. Their modern was anthropologically considered; it was human feeling and primal urge caught in the rhythms of a machine culture. As Muller wrote: "The common bar, which opens wide onto the morning's brisk movements, the fever of the afternoon and the great evening din, is an extension of this street on the march and rounds out its diverse, tumultuous soul. The decoration on the walls does its part. When the train carrying us stops at the edge of this city, or in this rustic valley, our emotions, dreams, reason breathe the air of the station for an instant, which is enough to modify them ever so slightly or more. The merchant also, and the poet, and the soldier, and the prostitute, do not look vainly, even with a distracted eye, at the decoration of the bar, where they bring their appetites and their worries."[78]

Fegdal's book chose not to dwell on this aspect of its subject. Like most Vieux Parisiens he regarded the cabaret worth discussion only because of its old sign; the rest—the appetites, the revolutionary history, the drinking songs—fell outside his special perspective. If they had achieved the status of historical fact, they were dutifully mentioned, but only *if*. Fegdal could not take the old sign into the present, any more than he could incorporate the sign into a history of the cabaret; for him these things were separate.[79] We have come to yet another family of images that like the others twirled around the

135. *Montjoie!* (April 1914), p. 14. Bibliothèque
Nationale, Paris.

cabaret. Yet in Fegdal's book there was a point
when another view of the cabaret interrupted
his and made fun of it, though Fegdal was not
quick enough to banter. He had been inter-
rupted on his tour by the owner of one of these
cabarets, A l'Homme Armé. Fegdal reported the
encounter to his reader in painstaking detail:

> Now here is a very old and very beautiful
> wrought iron sign dating from 1432; it des-
> ignated, and still does, the cabaret *Homme
> armé*. It shows a warrior seated on a cannon;
> he has thrown his sword between his legs,
> he holds a glass in his hand; at his feet is an
> unopened bottle, while beside it, on a pile of
> cannon balls, lies an empty one.

which he interrupted with the owner and his
version:

> As I was amusing myself by examining the
> details in the breastplate of the armed man,
> the proprietor of the establishment came out
> to give me a postcard of his shop and the sign,
> of which he is quite proud.
> —A fine warrior, n'est-ce pas, monsieur? . . .
> And, since I was of the same opinion, he
> went on:
> — . . . It is so expressive! My armed man,
> does he not seem to say: Between the two
> shots I do not hesitate! the first shot . . . I sit
> on it! the second . . . I drink it, and that's the
> one I'd rather have!
> The explanation seemed rather picturesque
> to me; I wrote it down and then entered
> the *Homme armé* where the owner himself
> wanted to pour me a glass of white wine from
> his best cask: as he recorked the flask he even
> deigned to philosophize:
> —With the love of wine, monsieur, the love
> of peace enters in you. Ah! if all diplomats
> loved wine! If all warlike people resembled
> my *Homme armé!* . . . Would that they come
> here! . . .

" La Prose du Transsibérien "
Poème simultané de SONIA DELAUNAY
et BLAISE CENDRARS

He wound up as the good merchant who does not shy away from publicity:

—That they might come here! And, monsieur, if you know any diplomats . . . here is my address: 25, rue des Blancs-Manteaux; and then read this postcard: the place is famous . . .

I read, in effect, that during the Revolution, Ange Piton climbed upon the post at the corner of the cabaret and that he held forth there, or sang the satiric couplets that brought him fame and . . . prison.

Enough hustle and *blague*. Fegdal read about the satire and, seeing that the offender got a prison term, without regret he left, but not before taking one last look of his own at the sign: "On leaving I turned around for one last look at the sign, so decorative and so curious; I admired the columns, the capitals and the masks, the grilles beneath the span entwined with grapes, vines, and leaves." [80] The repartee of the *canons* had left him cold. Other amateurs of Vieux Paris were not nearly so stuffy.

The old signs of Paris were great favorites of the amateurs. The Commission du Vieux Paris watched out for them, the Musée Carnavalet collected them and eventually, on July 4, 1914, opened a permanent exhibition room devoted to the display of those which they had managed to save from demolition. [81] Countless books and articles were written to catalogue the signs, their religious emblems, and secular puns. There were even moments when the antiquarians found themselves retelling old jokes. For example, Edouard Fournier:

The rebus sign: *A l'Assurance* (un A sur une anse) [an A on a handle] goes back to the seventeenth century, even though Sauval may not have cited it; that of *Saint Jean-Baptiste* (singe en baptiste) [a monkey in baptiste], representing a monkey dressed in a ruffled

collar and cuffs, seems to us more bizarre than inspired. The rebuses of modern signs are for the most part reminiscences of things past, of which the most curious have not been preserved or put back in vogue. In every case one has not saved those which would no longer be comprehensible, because of changes in the language, like the *Gras scieurs* [fat sawyers], in which one was supposed to see the *Gracieux* [Three Graces]. But in the suburbs one still finds signs that have the same attraction for the *populaire* from the old districts of Paris, such as the following: aux *Contenis* (au comptant) [?—in cash], à *l'Epi scié* (à l'épicier) [at the sawed stalk, at the grocer], au *Verre galant* (au vert galant) [at the gallant glass, at the gallant of the green wood], au *Canon de la Bastille* (place de la Bastille) [at the shot of the Bastille, at the place de la Bastille], au *Canon de Bordeaux* [at the shot of Bordeaux], au *Grand I vert* (au grand hiver) [at the great green I, in the dead of winter], aux *Vieux par chemins* (aux vieux parchemins) [old by different routes, old parchment], etc.

"The sign of the *Epi scié*, or the *Epis sciés* (épiciers), says M. J. Poignant, this sign, which until 1855 shone above a dive on the boulevard du Temple, might have served in the eighteenth century to glorify the den of these honorable manufacturers." We have seen the rebus l'*épi scié* (l'épicier) in a book from the end of the sixteenth century. As for the famous sign of the *Femme sans tête* [witless woman], it fell to French gallantry to rescue its honor by attaching the impertinent caption *Tout en est bon* [all is well with it], not only to the decapitated woman but to the pig gilded from head to toe. Finally we have collected, in the district of Les Halles, at Paul Niquet's famous *consolation bar*, the design of his rebus sign, painted with a great deal of talent on the wall in a tasteful

carved frame: it shows a map of the world on which is written the word POLE, a nest with three little cheeping birds, a group of vessels raising their masts behind the quai of a port, the letter N with an apostrophe in a hedge, footprints, and a seated Moor, ax in hand. The very obscurity of the rebus was the great attraction of the sign, which must be translated simply by these five words: *Paul Niquet n'est pas mort* [Paul Niquet is not dead]. [82]

Fournier was writing the authoritative book on the sign, which would be published posthumously in 1884. The project was scholarly, tracing the signs back to their origins, explaining, for instance, the presence of wreaths and branches of leaves as more than bacchic decor:

For a long time during the Middle Ages cabarets had the same sign as in antiquity. This sign was nothing more than a green bough, a pine branch, an ivy crown, or any other bouquet of leaves, which one called *bouchon*, from the first formulations of the French language. The handful of straw and the laurel branch were used to show only *mauvais lieux* [shady operations]. What is more, cabaret and *mauvais lieu* were often one and the same. As the people speaking certain dialects said *bouchou*, instead of *bouchon*, many cabaret owners replaced the bough or tree branch by a head of cabbage [*chou*]. The cabaret itself took on the name *bouchon*, which is still used, but with the least favorable connotations; one also calls it *buffet*, which has been transformed into *buvette*. [83]

And explaining that in the fourteenth century signs became obligatory for cabarets. *Grilles* became obligatory later, making it logical to cast the entire apparatus in metal. *Grilles* made it clear that the boutique sold only wine to go; the *grilles* were to keep the drinkers outside (glasses were passed to them through the *grille*);

they also saw to it that the cabaret signs survived better than all the others. By the twentieth century the cabaret signs provided the sample by which the old sign was studied. All of this was history for Fournier, as was the tradition of drunkenness, a noble tradition, he noted, at the Petit More.[84]

Not many of his successors would recount their experience of the faubourgs in order to expound upon the sign. Edmond Beaurepaire, for one, did not. Beaurepaire devoted three articles to the sign, in which he seemed to derive a huge pleasure from relating the lore. He explained in great detail about a famous sign with many versions, most lost, although one that had been saved could be found in the Musée Cluny. It concerned an old sow who spun. "It was a small bas-relief in painted stone, in front of which, on the day of mid-Lent, boys from the neighboring shops, apprentices, serving girls and porters from the market came to go crazy, 'throwbacks to paganism,' if Jean Deslyons, a serious doctor from the Sorbonne, is to be believed. Sauval tells us just what this folly involved: the new apprentices and artisans from the market were forcibly brought to kiss this sow, care being taken to smash their noses against the stone, and then until nightfall there was nothing but dancing, shouting, masquerades, and bouts of drinking all through the neighborhood."[85] The illustrations to his articles followed the convention for showing the signs, detached as much as possible from their environs, as an emblem would be in an emblem book, sign, not cabaret (fig. 136). This was the usual procedure for pictures of old signs. It was used, for example, by Jean-Jules Dufour in the drawings he worked up in 1911 for a postcard series published by the Neurdein frères.[86] Science prevailed over the rowdy tales, old drinking songs, puns, and kissed pigs. The modern *populaire* was held at an even greater distance. The sign after all

marchand de vin, à l'angle des rues Saint-Sulpice (nº 1) et de Condé, devant lequel, dirai-je incidemment, fut arrêté Georges Cadoudal, je veux mentionner tout particulièrement la très belle enseigne en fer forgé qui se trouve au nº 33 de la rue Saint-Honoré : *A l'Enfant Jésus*.

Elle est unique à Paris, en ce sens que, seule, elle porte les trois lettres I. H. S., contraction du nom IHESUS. L'Enfant divin est représenté debout sur la lettre H du trigramme, entre deux ceps de vigne formant les montants du cadre et se réunissant dans la partie supérieure.

A la Grâce de Dieu.

Avant d'être l'enseigne d'un marchand de vin, cette enseigne fut celle d'une hôtellerie, située au même lieu.

Le *Journal* de Pierre de l'Estoile, parlant du Levantin Ismaël, qui vendit sur le pont au Change les premières lunettes d'ap-

136. Robert Hénard, illustrations for Edmond Beaurepaire, "Les enseignes de Paris," *Le Carnet* (December 1902), p. 331. Bibliothèque Nationale, Paris.

was everything. In this the amateurs sounded practically Saussurian.

But their meditation on the sign had to come back to face the present: the sign was being tarred by cabal, and it was dying at the hand of the poster.[87] Vieux Parisiens rallied round to save the sign. In 1902, Beaurepaire published his documentation. That same year the city of Paris, encouraged by the painter Edouard Detaille, actually organized a Concours d'Enseignes, hoping to revive the practice of handcrafted, solid, one-of-a-kind signs. It produced winners, among them Jean Gérôme's *Opticien* (fig. 137), which stuck close to the prototype of the traditional sign—one image, one pun, very few other words. The trompe l'oeil behind the spectacles and the optical dog did not however set a new precedent for advertising: "Sans succès," wrote Marcel Sembat in the preface to the Salon d'Automne catalogue in 1913.[88] Nonetheless these years were kind to the sign. In 1911 Dufour's series was published. In 1913 Fegdal's book. And in 1914 their room at the Carnavalet was opened to the public. All of this came together as a defense of the pure sign, the sign without its referent, without its people or its cabaret. The sign needed to be interpreted, its original meaning postulated and hermetically preserved, for it was no longer able to signify, or so the thinking of the amateurs went.

For Atget to take the cabaret into his project meant unwrapping the mesh of cliché, whether it had been produced by vigilantes, Cubists, or nearsighted historians with an unsuspected affinity for Saussure hardly mattered—a cliché was a cliché. This may have put him off at first; at any rate, the cabaret did not make much of an impact on his *Paris pittoresque* series. In the middle of it, a few cabaret interiors cropped up, modest neighborhood bars, like the two on the rue Boyer that had made their way into the *Métiers* album, and a *zoniers* bar on the boulevard

137. Jean Gérôme, *Enseigne murale—Peinture avec cadre à attributs.* 1902. From *Concours d'enseignes de la Ville de Paris 1902* (Paris: Guerinet, 1903), pl. 2. Bibliothèque Nationale, Paris.

138. "Epicerie, Md de Vin—Bd Masséna—1912 (13e arr)." Pp 366. Bibliothèque historique de la Ville de Paris.

Masséna, a combination bar and general store (fig. 138). To make the details of the cabaret interior speak, Atget tried pushing at the corners, at the rude place where the pile of casks gave way to counters and shelves, so that the cabaret's status as a store of wine, sugar, chocolate, and gramophones could be shown: a culture of drink, popular music, and sweets appeared; the corner had no strong center, no controlling detail, no guiding light. Its forms had no particular relation to the knowledge Atget sought; they broke well enough with the layers of cliché, but they did not show the edges of the cabaret well enough for Atget to propose the problem of its space. By this point in the series, the emptinesses were being cut out abstractly; the document was setting up its problems as perspectives of edges, edges of practices, cultures, and looks. Atget ended up employing the most literal edge of the cabaret. By the end of the series, the few cabarets that did appear, like the bar on the rue des Lyonnais (fig. 139), were simply shown from the outside, all surface, all curtain, all shell—a screen substitute for the goings-on behind. The waiter on the St. Raphael sign walked across the scene like a circus midget on parade to give the *cache-cache* a light touch. The cabaret was best told, Atget seems to have decided, by reverting to a picture of its street front. This meant that he did not need to make very many more pictures of cabarets, for he had a large supply of them already in his *L'Art dans le Vieux Paris* series. His album about the cabaret was made from those (see appendix 1, table 7).

This older body of work masqueraded as a collection devoted to the old sign. Hence the title of the album, *Enseignes et vieilles boutiques de Paris*, though it was not taken literally by the Bibliothèque Nationale when it was received in 1913. The librarians accepted the album and catalogued it as *moeurs*, attaching

139. "Boutique 12 Rue des Lyonnais—1914—5ᵉ arr—."
Pp 495. Bibliothèque historique de la Ville de Paris.

it to the O. series where it still sits, between the *Métiers* and the *Zoniers*. The Cabinet des Estampes had already bought a good number of these sign photographs over the years and had filed them separately into its Topography series. Whether it kept close enough track to know that it was buying many of the same photographs twice will never be known. The second time around however it took the work as *moeurs*. The Vieux Paris document had been made to signify in reverse.

The Vieux Paris document had put Atget on the outside of the cabaret right from the start and the photographs in the album, dated from 1899 to 1911, showed how. They were arranged in deadpan chronological order, except for the very last photograph, which dated from 1900. The album never let the viewer know that this was the key to its sequence, for the meaning of the album was not to be derived from dates and numbers (they were not the knowledge to which the form was pointing). Over the years the technical sign had been bent to the demands of its viewers, mostly amateurs of Vieux Paris, but it had not doubled over in complete submission; when it came to old signs, Atget could be obstinate. At the beginning of the project he treated the problem as one of making a portrait of the establishment, including the proprietor and his staff; the first pictures of the album showed the results, which were not technical enough; very quickly a modification was introduced, portraiture was pretty much abandoned, and the sign became omnipresent. In the years that followed, especially in 1902, Atget concentrated on the doorway over which the old sign presided; this was probably a professional response to the growing interest in the signs that would culminate in the competition and in Beaurepaire's articles. Beaurepaire's need for documentation and illustration probably had some impact on Atget's sense of his subject:

Beaurepaire's fellow amateur Robert Hénard drew the illustrations for the article after some of Atget's photographs and may well have used others as *aide-mémoires*.[89] The article actually reproduced an Atget photograph of the house Nicolas Flamel, though it was a fairly standard topographical view which did not much privilege the fragmentary inscription explaining the gratitude of the fifteenth-century laborers to Flamel for his charity.[90] The drawings after Atget's other photographs pulled those pictures back into the strict Vieux Paris line, cutting away the superfluous doorways, storefronts, and streets. Atget did not subsequently mend his ways, but in recognition of their wish to have the sign alone, in 1908 he rephotographed a number of these photographs, not the sites, to make uncomplicated details showing only the sign (one of these appeared in *L'Art dans le Vieux Paris*). In 1911 he made a new group of signs, sometimes rephotographing old locations. In 1913 the album collected all but the 1908 details, all but the pictures for purists.[91]

Atget took the picture of the sign to be a full description of the outside of the place, of its surfaces, both old and new. The area around the technical sign of the sign being a free space or a blind spot as far as the Vieux Parisiens were concerned, he began to work there, so well that in fact the center of the picture was never too clear; there were often two centers, the old sign and then, in the doorway, some cabaret innuendo. The more Atget worked this subject the better he understood the balance between these two, between correction and transgression, constraint and freedom, though the balance shifted and his photographs never fell into formula. The border of the technical sign was a live space where the smallest scrape or rustle could be heard. Two historical cultures were convened there, one ancient, one modern, both of them with a weakness for play. A drama unfolded

in the document, a theater of surface, a skit for two shadows. It became the description of the cabaret's edge. Theater gave difference.

The skit began once portraiture had been abandoned. The child Jesus guarded a cabaret that was dead empty, the door wide open gave away the simplicity of the place, a trap door to the basement, a pile of plates, a bench. The cabaret held a reflection of Paris in its front windows; it seemed to hold all of the city inside, signs and apartments and balconies rose from a vase of spoons. The emptiness was full, if one could only see it. One couldn't always: the emptiness could close. At the cabaret on the corner of the rue Charles V, two stern satyrs and two lace curtains dropped a veil across the place. Then at A l'Homme Armé a bright shadow appeared, standing shoulder to shoulder with a dapper but enigmatic waiter, a man wearing a smile that had drifted up into his moustache. The shadow did nothing but stand quietly, its face pale and no more legible, though for other reasons, than that of the waiter. Above, the soldier gave a tipsy toast. The scene changed. At the Petit Dunkerque, half a man sailed out of the photograph. The clipper ship above was diminished; the cabaret seemed haunted; no story tied anything together. The scene changed again, to a cabaret whose door opened onto a dense shadow, which cut off the brilliance of the *grille* and glass, exposing what lay behind. What lay behind was inscrutable, a few lamps, a checkered tile floor, a touch of brass. The scene changed again: the shadow was back, this time black as night and accompanied by a camera.

We have been brought to the sign of the good well near midday. The sun cut the shadow of the sign deep into the doorway of the cabaret; it touched the shadow of the cameraman and his camera, each occupying a panel in the door below. The shadows bled together, as if obeying some greater design; the paving stones of the street beamed all around them; inside the cabaret someone held a white towel, whose light broke the illusion. A towel, a dirty towel, insinuated itself into this world of shadow, a world beyond, an untold world that did not obligingly employ the language of the classics, of the Styx and the shades. The scene moved on to the Bon Coin, or good corner, under a pear, or, specifically, a *coing*, the pear used to make cognac. There the shadow set up shop again, this time allowing the inside to meet the outside on the surface of the glass. Inside and outside there were workers. Outside on the street was a man, a *petit métier*, wearing the traditional wooden carrier on his back: he stood in the light and brightly stepped in between the two shadows of the cameraman and his camera. At the point where all three touched, the reflection broke and through the door another figure emerged, another worker seated at table, head in one hand, a newspaper in the other. The cabaret was the good corner—that much was ancient and popular—under the protection of the *coing;* and it was the corner of the people with whom Atget, for Atget was the leading shadow, stood shoulder to shoulder. The culture he described in shadows came to the doorway in its own way, haphazardly, obscurely. At the Bon Coin there was no explaining the mysterious white paper that had been stuck to the glass. This culture was wordless sometimes; everything did not spring into patter or verse. The only constant seemed to be the shadow of the cameraman, a cast shadow, *une ombre portée,* that traveled through time and space across the surface of the cabaret. It gave the viewer to expect a theater on the surface. That was all, though it was this theater that was doing all the work of definition. At Au Lion d'Or the shadow did not stop by. Instead Atget sent a wave past the door, a fast pedestrian, too fast for the camera, too much for the lion. The lion had already caught a serpent, which undulated to the same beat as the blur; the blur slipped away.

Trick photography was about the last thing one would ever expect from Atget, but there it was. The tricks were never technically complex, nothing like the magic Georges Méliès would splice into his films, say, *L'homme à la tête en caoutchouc,* where a scientist took off his own head (Méliès's head as it happened) and made it grow to many times normal size (fig. 140).[92] No, Atget's tricks were almost childlike, since they involved setting up ghosts or reflections in the image, fooling around with its ability to register too much of a figure or not enough, stretching, a formalist would say, the limits of the medium; but not this time, we would have to answer, in order to declare an aesthetic or even a purely photographic vision. Atget was making choices that enabled him to play, rubber-headed, to his heart's content. The shadow returned. Intermittently. The cabarets (and the few odd shops) waited for him, about half the time in vain. The doorway had become a kind of *guignol* where figures met and danced. But mostly one figure and his faithful camera. The old actor had come back to play these shadows, a last black character in the string of traitors and villains that he had played on so many provincial and suburban stages. Atget transformed his black character into an *ombre chinoise,* a cutout silhouette projection that bobbed and strode on a luminous screen; as theater it was somewhere between puppet stage and cinema (fig. 141). But the *théâtre d'ombres* here took place on the door of the cabaret, the shadow was not very chinese, merely *autre,* deathly, funny. The two of them, the man and the camera, went through a routine, improvising, mimicking, and withdrawing. Sometimes the shadows sunk deeper into the murk; sometimes they dissolved into brilliant

reflections of the city. They merged and sur-
faced in no particular way, coming and going
mysteriously.

In its homely way, the shadow was prescient,
a good shadow that prefigured a bad one,
the one cast by the master criminal Fantômas
(fig. 142). Fantômas fit the bill of the dreaded
Other much better than Atget's shadow could.
First, because he menaced all of bourgeois Paris;
second, because he was being contained. He
was the invention of the bourgeoisie, its idea
of class difference in mass cultural form, so
that the dreaded Other could be exorcised and
adored. Fantômas was the fiction of two jour-
nalists, Marcel Allain and Pierre Souvestre, who
wrote up a best-selling set of novels about him
beginning in 1911. *Le cerceuil vide, Le faiseur
de reines, Le cadavre géant, Le voleur d'or,*
there were more than forty altogether; in 1913
Louis Feuillade put Fantômas on film. He was
the ultimate working-class criminal; unlisted,
untraceable, capable of a million disguises, a
thousand faces, when appearing as himself he
wore black from head to toe. In spite of the
best efforts of the valiant inspector Juve and his
friend, the journalist Fandor, Fantômas always
eluded his would-be captors. He never met his
Holmes. All the mystery remained in the man in
that he was a descendant of Poulot's *sublime,* an
ever-blacker *populaire* that would take another
form in the 1920s with the importation of black
American jazz.[93] Or in milder form with Chap-
lin's tramp. Atget's shadow did not aim to keep
company with them nor did it try to draw one
character by which the *populaire* could be fan-
tasized and in that superficial way known. His
shadow was as elusive as Fantômas but not as
dastardly; it was the common Other, multiple,
plotless, joking, and terrible. His shadow kept
the *populaire* alive in different characters and
fragments. At Au Franc Pinot Atget made a
popular print emerge right at the point where

140. Georges Méliès. *L'homme à la tête en caoutchouc.*
1902. Cinémathèque française, Paris.

141. Jean Kerhor, vignette for "L'infortuné voyageur,"
from Lemercier de Neuville, *Ombres chinoises* (Paris:
O. Bornemann, 1911), p. 45. Bibliothèque
Nationale, Paris.

142. Louis Feuillade, *Fantômas. Juve contre Fantômas.*
1913–14. British Film Institute, London.

his camera's lens would be. As if by sleight of hand, his had made a lithograph.

The glass on the cabaret door held up the secrets and games to the viewer. There was no pattern to this culture, no system to be revealed if only one could crack the code, no possibility of a dictionary of attributes (sorting through variations on the grape cluster), no neatly organized sets of binary opposites (the raw and the cooked), no consoling, swaddling image. Modern popular culture was not to be decoded like a rebus or solved like a crime—it was a magic act, a tour de force, a floating ghost. Paul Niquet lived. The shadow was not however a joke and only a joke: it showed the author sinking himself deeply into the life of the cabaret, fleeing the perceptual space of the viewer, moving beyond that perspective of surfaces into the untold world beyond, that world without pattern or fathom. This was the context for the head trick at Au Tambour.

The shadow had in the meantime come and gone, several times over, ceding its place to other shadows, other people, and other nothing. When it came back at Au Tambour, it was ripe for mischief, which it promptly made. It put Atget back into the cabaret, standing with those people and identified bodily with them. But the shadow had slipped underneath the head of the old man and, using his face as a mask, had turned him into the photographer. He looked out at the viewer, stood looking like that with a camera. The camera turned on the viewer and the picture switched. The document began to interrogate the viewer, who had all of a sudden become the object under scrutiny. The viewer was being photographed by an aggressive, white-haired shadow. The distance—the antagonism—between the viewer and the document could not have been given much better. The viewer was made to understand that his view, the camera's perspective, and the author's

view were not one and the same. Perfect identification was impossible. The head trick was the demonstration of how knowledge was split and denied. The document had grown ugly. And the author had become a shadow that stood on the far side of the camera, in the distance with the men in the cabaret; he was standing abstractly *inside* now on the inside of difference. The document protected the inside just as it protected him. *Soleil cou coupé.* But the album did not end there. The scene continued to change.

The 1911 pictures that rounded out the set returned the shadow to its first position, that of mimic and neighbor, though these last pictures were equally intent upon closed surfaces and grand voids. So at the sign of the golden grape, A la Grappe d'Or, the zinc, the bottles, the *serveuse* in a plaid blouse, and the street lamp outside melted into a cityscape of uncertainty; at another Lion d'Or Atget sent a last ghostly wave across the door; the scissors grinder on the corner of the rue des Nonnains d'Hyères rose from a round corner advertising corduroy. At Jean Bart, the hero took a step toward glory like the day he broke the blockade at Dunkerque, while in the pane below a folding screen or mirrors and windows took the city reflections like a set of pleats. The shadow of the camera made a mock step forward, a black parody of a white Bart, but this was a hiccup compared to its earlier shenanigans. The shadow's work was being done by other parts of the cabarets now, they boarded themselves up, closed forever in the case of the Orme St. Gervais, which had gone off to the Bastille. Or they sent off a gleam that turned back the eye with light. The last photograph of the album took the inscrutable place and placed it under the sign of the cross, not a Christian one particularly, though the cabaret was once upon a time making a pitch for itself as god-fearing.[94] Atget had the light make crosses on its *grille*, behind which

stood a woman and a child, not the standard cabaret characters, not happy topers, not lonely drinkers, not debauched.[95] They stood for respectability. Unknowable respectability. The outside of sublime.[96]

• • •

Nature. The *fortifs*, like the cabaret, were indissolubly bound to an idea of where working-class life was lived. The *fortifs* were their nature, their trysting ground (fig. 143), their countryside, their park, a ring of ragged wasteland, literally the outside of the city, pure exteriority, rampart, and wall. Atget took these documents as outsides of the outside and developed the surfaces of the space into full-scale perspectives, spaces bright now with emptiness, the emptiness of a shadowless day. Taken as landscapes they were brooding, sexless, and rough; the grass was patchy and unkempt, the brambles were sharp and thick, and the trees had grown as nature let them, spindly, verdant, and tough. The emptiness in these documents grew thicker exponentially. The opening photograph intimated as much, and the others reiterated. The perspectives taunted the viewer shamelessly, for *savoir* was still ostensibly within eyeshot, but these perspectives did not map anything like a Cartesian universe. On the contrary, their perspectives moved in more than one direction and their surfaces were repellent. The rough brightness of these landscapes deposited the viewer outside all respectable *savoir* and *connaissance* for good. This nature was hostile.

The photographs had been made in stages, beginning in 1910 and then again in 1913. The album was assembled in 1915 (see appendix 1, table 8). In 1915 France was well into the First World War, Atget and Valentine had lost Valentine's only son, Léon, to it the previous year, and fortifications were hardly, in anybody's

eyes, neutral territory. The cartoons of *Le Rire*
were not the only ones to sober up (fig. 144).
But the album kept the war outside itself; it was
made with the old prewar documents; its cap-
tions never mentioned battle; the *fortifs* were
the figures with which to express the remove of
the *populaire* from bourgeois perspective, from
bourgeois control, and from a bourgeois war.

Once the Germans reached Compiègne,
some eighty-four kilometers north of Paris,
in September 1914, the city prepared itself for
siege. The government withdrew, leaving Paris
under the command of General Gallieni, who
ordered the fortifications to be readied, even
though they were obsolete; they were to stand
as the second line of defense behind a series of
outlying forts. So, on September 6th an Ameri-
can in Paris, Herbert Adams Gibbons, wrote:

> Right at the Porte Maillot, before our eyes,
> we saw the elaborate preparations that we
> found afterwards to be practically the same
> at the other gates. I suppose the same work
> has been done at all the fifty-eight. The gate
> is closed and boarded up. Little holes for in-
> spection and rifle barrels have been cut every
> few inches. Outside the gate ditches have
> been dug for a distance of a hundred feet zig-
> zag across the road. In the intervening spaces
> rows of iron X spikes, whose presence is con-
> cealed by branches of trees, form another bar-
> rier. On the sides of the road trees, cut down
> whole, have been placed ready to be thrown
> across the road at the moment of alarm. In
> the mounds of dirt formed by the excavations
> from each trench and the displaced paving
> stones, posts have been planted. These are
> connected by a tangle of barbed wire.
>
> We walked along the fortifications through
> the Bois to the gate at the end of the Ave-
> nue du Bois de Boulogne. The trees that
> had grown up in profusion over the talus

143. Ricardo Florès, "Fiançailles," *Le Rire*, no. 310
(2 January 1909). Bibliothèque Nationale, Paris.

> have been cut down. At every angle, bags of
> cement are piled up to shelter the pickets. On
> the Avenue du Bois de Boulogne we found a
> taxi that took us around the fortifications as
> far as the Porte d'Orléans.
>
> At the Porte d'Orléans several stone houses
> opposite the gate have been blown up to pre-
> vent their possible use as a shelter for the
> enemy's sharpshooters and machine-guns.
> The little ticket office and waiting room for
> the Bourg-la-Reine steam tramway, that used
> to stand hard under the bastion wall at the
> left of the gate, has been demolished. The
> windows of the *octroi* bureau are bricked up.
> Barbed wire is lavished on the water-main
> that makes an unintentional bridge across
> the moat not far from the Porte d'Orléans

144. G. Delaw, "Les Territoriaux," *Le Rire Rouge*,
no. 10 (23 January 1915). Bibliothèque Nationale, Paris.

toward Gentilly, and a solid wall of masonry is being built where the main reaches the fortifications. *Meurtrières* are being left in this wall. On either side of the gate itself, bags of cement give a crenelated form to the top of the talus.[97]

The Germans were soon defeated at the Marne. Paris, now wrapped in her defenses, proceeded to wait through the war, suffering a few bombings in the early years, but mostly receiving the news and casualties. Edith Wharton, another American who was living in Paris then, wrote a progress report, dated February 1915. Daily life went on at a slower pace, cafés closed early, absinthe was banned, and little of the old gaiety was left:

Day by day the limping figures grow more numerous on the pavement, the pale bandaged heads more frequent in passing carriages. In the stalls at the theatres and concerts there are many uniforms; and their wearers usually have to wait till the hall is emptied before they hobble out on a supporting arm. Most of them are very young, and it is the expression of their faces which I should like to picture and interpret as being the very essence of what I have called the look of Paris. They are grave, these young faces: one hears a great deal of the gaiety in the trenches, but the wounded are not gay. Neither are they sad, however. They are calm, meditative, strangely purified and matured. It is as though their great experience had purged them of pettiness, meanness and frivolity, burning them down to the bare bones of character, the fundamental substance of the soul, and shaping that substance into something so strong and finely tempered that for a long time to come Paris will not care to wear any look unworthy of the look on their faces.[98]

Fortifications were seen as strictly military, not working-class, places in 1915 and any military presence could be seen as reference to war, even on a set of defenses designed in 1841. Soldiers ought to wear the appropriate look. Any other was off-color.

The war had been expected for years, even before Atget's pictures were taken, and it was likely always in the background of his project to photograph the *zone militaire*. But in the foregrounds of these perspectives Atget put *trees,* ever more insistently as the project continued, to the extent that some of these pictures were to be found in his albums of landscape documents.[99] Trees would shoulder knowledge here. The *fortifs* also held bastions, some ninety-four of them, of which the album showed exactly four.[100] Limiting their number kept them down, no more than a point of reference for the trees.[101] Nature seemed to take precedence over the course of human events. The trees were not supposed to be there; they had been allowed to grow up against the fortifications and when the war was declared, they were axed in case they should ever shield the enemy.[102] In the album they served to provide the continuity, like the shadow had before. The trees would come and go. They were essential to the perspective, which was a perspective of intense resistance. For the album presented its material as if the trees still stood. It was not quite the right color to be using in 1915.

The trees gave the blank bright space its detail and a tinge of pastoral, but they were not a lapse back to the good old days, forgetful green documents of better times. They stood against the bastions, stubbornly, quietly occupying a cultural position without symbolizing it. That position was pacifism. The war was being fought in 1915 despite all the crusading of *La Guerre Sociale, La Bataille Syndicaliste,* and the Second International. The working classes

had not struck against the world war; by the early months of the war, in 1914, Atget's revolutionary papers gave up that idea and converted themselves to more moderate, positively patriotic positions.[103] Gustave Hervé, a leader of the antimilitary polemic of *La Guerre Sociale,* fell into step with the hawks; as war broke, he at once bemoaned the demise of a unified left and at the same time supported the Union Sacrée with what he called "La Patriotisme Révolutionnaire." The contradictions went like this in July 1914:

But if the catastrophe comes about, in our aforementioned state of impotence, we socialists of all Europe, unable to prevent war through the concerted insurrection of a general strike, undertaken at the same time in all countries, we know only one duty—we the international socialists:—that is to defend the home of liberty that our fathers, the revolutionaries of 1789, 1792, 1848 and 1870 and the Commune created through the expense of great effort and bloodshed!

Between imperial Germany and republican France, not a moment of hesitation, our choice is made.

Vive la France, republican and socialist![104]

In December of that year, Hervé exhorted the nonmilitary to patriotic duty:

For the bosses patriotism consists in not profiting at the expense of the nation or of unhappy compatriots; for the functionaries, in giving without counting their hours, their thoughts, their intelligence and their heart to the nation; for the workers who are not able or are beyond the age to hold a rifle, to give a good pull in the harness so that the entire national collectivity might come out of the rude test victorious, and, for the journalists . . . to tell the truth to their best friends![105]

And then in 1915, the *coup de grâce:* he pronounced the death of the International:

> The worker's International? Where is it? Who does not see that the war has thrown it to the ground? What do we French socialists have in common now with the kaiser's socialists, who have not uttered a word of protest against the violation of Belgian neutrality? The proof that our worker's International is quite dead is that I, who pretend to be a good socialist, I feel myself to be a thousand times closer to a French reactionary fighting in our trenches than to a German socialist. It will revive perhaps. It will surely revive. In the meantime, it is dead. *De profundis!* [106]

Hervé's polemic notwithstanding, the campaign against the war continued throughout the conflict, albeit in a subdued form, relying on subtleties that emphasized pacifism over antipatriotism as the hope for the future. Atget stayed in Paris through the war, photographing a bit, and according to his concierge, staying indoors as much as possible, so as not to get himself in trouble. She would tell one of Atget's biographers that his paper was the *Bonnet Rouge,* a review started up in 1913, becoming a daily the next year and continuing publication until it was shut down in 1917.[107] According to her information, then, Atget had remained a man of the *first Guerre Sociale,* committed to pacifism, one of the few who did not swing into line when war was declared: that was the kind of resistance that got one in trouble. Pacifism was the tack the *Bonnet Rouge* settled upon, but it was a position for which it had to fight— literally, in the street, where its men brawled with the *camelots* of the *Action Française,* and officially, with the authorities, who saw to it that it did not survive the war.[108] Neither did the middle section of the *Paris pittoresque.*

Most of Atget's clients found their work disrupted by the outbreak of the war. His library sales ceased; the *répertoire* seems to have been shelved. The Bibliothèque historique bought photographs from someone named Lansiaux, who took pictures of the wartime city, but Atget did not adjust his idea of his work to fit the new opportunity. He continued to photograph sporadically in the environs into 1916 and started to work on a series of historic houses in the city itself. But he did not undertake new projects of any scope. Ergo, he had ample time, more time than ever before, to ponder and edit the last two Bibliothèque Nationale albums, the *Zoniers* and the *Fortifications.* They were sold respectively in May and November 1915.[109] The middle section of *Paris pittoresque* would not go down quietly. *Zoniers* gave its idea of freedom; the *Fortifications* stuck to a vision of trees.

Fortifications de Paris was one of Atget's most heavily edited sequences. As part of the *zone,* the *fortifs* were known to be on the drawing board of the city planners, who had since 1882 been working out ways to expropriate them; the delays had been due to discussions over the deeds to the property and to the bureaucratic nature of the negotiation, which had the city taking over land belonging to the state.[110] Only in 1919 would the expropriations actually begin, and then slowly.[111] All of this had made the *zone* newsworthy in the years just prior to the war, though no one was very interested in the beauty of the landscape. "Trampled, yellowed, dried out, sad," wrote Lucien Descaves about the fortifications in 1913 in an article for *Les Annales politiques et littéraires,* although for all this sad and yellow pathos, "they procure the illusion of fields and freshness for the poor."[112] None of this was of particular concern to the album. It proceeded with its perspectives, which pulled the viewer along from page to page, receding like waves on

the ebb. Every so often they were interrupted. Landscape gave way to customs house or bastion or railroad yard. But the album concentrated on the landscapes, the trees: they were, according to it, the essence of the *fortifs.*

More important than the interruptions by the official landscape was the balance of power within the perspectives themselves. The trees and hillsides did not go unchallenged: military walls and embankments swept into the perspectives, making it very evident that the perspective was nothing so much as a collection of incompatible surfaces, uneven surfaces which belonged to different kinds of interests. These perspectives juggled the surfaces so that their different identities, their characteristic markings and casings, could be distinguished; the surfaces did not congeal into one single image, a harbinger of Debord's spectacle (where a shifting, fickle capital congealed, rather too obligingly, into an image).[113] Rather, the surfaces jockeyed for attention, each of them a *plan,* as the French would say, or a distance, a wing in this nipped and bitten landscape: the surfaces, the wedges, and the baffles crossed in the landscape as they pulled back into the distance. For these surfaces, Atget did not provide any theater.

We have come to a land where even the surfaces suffer from ellipse, where culture would never be seen as more than a trace, a *sabot* stuck in the mud, a ragged path, a mysterious star of David, someone's cat, someone else's fire. *Moeurs* per se had flown the coop. There were variations to be observed in the perspectives, variations that could be seized momentarily as leading evidence: the Bièvre, for example, wound its foul way through some of the early views in the album and returned in the middle, bordered by dilapidated tanneries. Yet the album did not try to make a moral tale out of the Bièvre; it was treated just like the ditch water and the Seine, as nothing more than an

auxiliary to the dynamic of the surfaces. Much the same happened when the railroad yard of the Paris–Lyons–Marseilles line appeared. Its scenery was technologically animated but had much the same effect as the brick walls and pounded dirt of the other documents. Form was rendered obtuse, thick, blank.

These forms did not move toward knowledge, and they most certainly did not solicit a practical vision that would crack the form open. The viewer was no longer even a member of an audience. The viewer was standing in the position of the person who used these places for leisure, for these were the places where the Poiriers performed their own marriage rites and the king of the "Haricots blancs" proposed himself to a hypothetical queen of "Monte-en l'air." Louis Dausset, city councillor, also made mention of the socializing on the *fortifs* when he reported on the progress being made with the expropriations: "Right now, at least, the fortifications, however meager and bare the grass on the embankments, have several shady corners, and on summer nights and Sundays they host a crowd of workers keen for some rest and air: before them they see the open zone, a few trees, a horizon." [114] But the signs of pleasure were absent from the album: working-class romance in the bushes, picnics on the lawn, Sunday promenades, were not photographed. They might be off-camera standing in the wings, but they were gone. In their place was the mobile emptiness, identified now with the yellow outside of the outside. How could this, any better than a tree, speak for class difference? It could not, but its silence, a logical silence, was long and powerful, a block as eloquent as all the overlaps of emptiness combined. Its silence put the separation between the cultures of Paris very well. It stopped matters, stopped exchange, and sewed working-class culture into the pocket of itself.

The point of the document here was not to stop time, but to close off discourse. The document had become the no-man's-land of knowledge, an emptiness between a phantom *savoir* and a gaggle of *connaissances,* an intemperate zone.

Apparently the human implications of this album, its highly elliptical rendition of the *populaire*, its disregard for the military, and its final demarcation of absolute negative space, were lost on the librarians, who catalogued it as Topography. Nevertheless, the Cabinet des Estampes remained Atget's library of choice, the place where he had left his record and his authorial step. In 1917 he chose it as the place to leave another collection of political ephemera. This time it did not come free of charge. The collection would seem peculiar, especially considering the year: it consisted of two volumes containing about 250 clippings that chronicle the Dreyfus Affair from its inception in 1894 to 1902, the year of Zola's death. The narrative did not begin with Zola; it built from the crime, the passage of French military secrets to the Germans by the commandant Esterhazy, to the discovery of a *bordereau* incriminating his conspirator, the colonel Henry, to the framing of the innocent Captain Dreyfus, framed because he was the convenient Jew. Dreyfus was convicted and imprisoned before the truth leaked out, only to be twisted into a baroque series of exposés and cover-ups. Atget's collection followed the story as it came out in public. On the 13th of January, 1898, Zola seized the moral imperative and wrote his "J'accuse," charging the army with incompetence and treachery on the front pages of Clemenceau's *L'Aurore*.[115] He in turn was charged with libel and the affair continued its twisted path, now at a much higher pitch. It would succeed in splitting the political spectrum, a split that survived Dreyfus's pardon by the civil authorities in 1899 and his reinstatement in the army in 1906. Atget's

clippings documented the Affair in the regular press, listing its high points (Zola's "J'accuse") and going on to collect caricatures from left and right of everyone concerned (fig. 145). Sometimes Atget dated the prints and clippings and labeled them "Affaire Dreyfus," but mostly they were expected to signify on their own and to constitute a history on their own; no further explanations were provided, no moral.

The Dreyfus Affair was a distant memory in 1917 but the issues it had raised were not, at least not in Atget's mind; in the middle of the war, his idea was to revive the old doubts about the integrity of the army. As a gesture it was most definitely off-color: 1917 was not the time to be questioning the army's morals, the tide was turning in its favor but victory would take another year. But the clippings were put together most disingenuously, as if they had no ulterior point, no ideology of their own. They made sure to include the clipping of Zola driving his pigs (the cartoonist called them intellectuals) over the *zone* but the series ended with noble images of Zola, conventional portraiture (fig. 146). The clippings made their point in a different way than the documents in the *Fortifications* album, but they were both working toward the definition of moral points that would be permanently preserved in the collections of libraries. Both moral points were identified with the left; both derided the military. But the document, not the newspaper clipping, remained Atget's chief form of expression. Not caricature, but the wordless demonstration of visual difference, given through a forced point of view, a troubling detail, a mocking shadow, a brilliant void. Atget may have admired Zola's actions but he did not imitate his work. The documents in the albums proposed a form of realism that would not claim to have unmasked the real. Their version of the *populaire* would not lift babies toward the sun.

145. Anonymous, "Zola et ses 'Intellectuels.'" 1898.
From Atget's album of clippings, *L'Affaire Dreyfus*.
Bibliothèque Nationale, Paris.

146. L. Roussen, "Emile Zola." 1902. From Atget's
album of clippings, *L'Affaire Dreyfus*. Bibliothèque
Nationale, Paris.

Dust

And pictures? Up to now I have one idea only, which for the time being I ask you to keep absolutely secret, your wife, of course, excepted. They are old signboards and advertising displays, in which I include paintings on concession stands (e.g. Oktoberfest fairgrounds). I intend to go to the border of kitsch (or as many will think, *across* the border). In connection with this, nature photographs, especially single objects and parts of them. Etc. . . . [116]

Wassily Kandinsky was writing to Marc. It was early June of 1913 and they were preparing the second exhibition of the Blaue Reiter. While Atget had been working on his documents of modern life, a small crowd had been gathering around the same problem or, as Kandinsky said, border, the border that Atget turned to emptiness, that Kandinsky called kitsch. The crowd saw something desirable in these signboards and documents, something that could make the connection between the technical and the popular, something that might supply the deep structure that modern culture seemed desperately to need. The strangeness in modernity could be seen there in simple form and perhaps be grasped. In any case the strangeness in the *populaire* and the document was less off-putting than the strangeness in the theory of relativity. The crowd embraced the simpler strangeness like a comforting origin, a fairy tale to which it might repair. The more literate of them remembered their Rimbaud. In 1928, in an article for *Variétés*, Albert Valentin brought all of this to bear on Atget's documents. He had evidently seen the work at Abbott's, knew something of Calmettes's account of Atget's life, and knew that Calmettes had spoken of Atget's work as a search for the *pittoresque*. Valentin could not take the *pittoresque* explanation at face value:

for him Atget's documents and the *populaire* were one and the same.

But seen at closer range, these dead ends on the outskirts registered by his lens constitute the natural theater of violent death, of melodrama, and in this they are [so] indistinguishable that French film directors— Louis Feuillade and his disciples—at a time when they were skimping on studio costs, made this the decor of their serials. Atget was not so far-sighted, only obeyed his instinct, which never misled him and which took him to extremely strange sites where seemingly nothing aroused any interest. The petrified display that he returned to us moves us by an unwonted turn that is not the result of premeditation or a surprise. We become uneasy looking at this planet represented to us by Atget's ten thousand prints, and which is however very much ours. Our steps strike the tiles of an enormous wax museum and this character asleep on a bench, is it a visitor or a manikin? Everything has the air of moving into the beyond. Beyond this hotel room; beyond this furnished room messed up by love or by crime, or by both at once; beyond this inanimate merry-go-round; beyond this orthopedist's shopwindow; beyond the wax puppets of the tailor and the hairdresser; beyond this brothel door crowned by an outsized number; beyond this stall of the seller of toilet articles; beyond this inner courtyard unmoved by the street organ; beyond these abandoned work sites; beyond this spreading junk; beyond this sloping street where a laughable whore waits: the barge must come quickly, for in the shadows one can make out a pimp, a proprietor and several stooges of less importance. But on Atget's photographic paper, there are only several poor buildings and on the doorstep of one, a girl without hope. The rest is beyond, I tell you, in the

margins, in the filigree, in the mind, accessible to the least astute: it suffices to note, and if it is necessary to justify Atget, Rimbaud is there, with the well-known couplet: "J'aimais les peintures idiotes, dessus de portes, décors, toiles de saltimbanques, enseignes, enluminures populaires, la littérature démodée, livres érotiques sans orthographe, romans de nos aïeules, contes de fées, petits livres de l'enfance, opéras vieux, refrains niais, rythmes naïfs." Too bad for those who do not share this taste; too bad for those who turn away from the perfect uncanny mirror that Atget holds out to them: wanting to break it and make of it debris, they will only multiply the reflections and will be pursued by them.[117]

Form seemed to pass toward knowledge but on the way it had been trapped by an unavailable *au-delà*, an insoluble mystery, a trick mirror that shattered the image of the world and left it in a heap. It was the way in which the most ordinary forms did not make sense that stymied, excited, and pained men like Valentin; all they could do was stand by and watch while form fell victim to eclipse. Atget of course had provoked such a reading of his work. Valentin might well have summoned up one of Atget's late documents of the fairgrounds at the Fête du Trône (fig. 147), which continued the work of the *Paris pittoresque*. A detail of the stand where the giant and the midget performed presented the attraction like a shopwindow. The picture was a descendant of the documents in *Métiers, boutiques et étalages*. Its technical forms had been reduced and bent into sheer strangeness, keeping a few links to everyday life but proposing another context for them, a window onto another world, a black square, a place where giants and midgets lived together as friends. Still, Atget's project had never contented itself merely with the *frisson* of the beyond; it had

147. "Fête du Trône." 1925. Pp 68. Museum of Modern
Art, New York. The Abbott-Levy Collection. Partial gift
of Shirley C. Burden.

worked on identifying and delimiting its subject. Atget's approach to the *au-delà* was of a completely different order than that of Valentin.

Atget's late *Paris pittoresque* documents held two kinds of exoticism together, one technical, one cultural, both of them an *au-delà* for the avant-garde. It is unlikely however that Atget could ever have seen these younger artists as constituting a new kind of market or the public he had always sought to capture. They were thinly scattered, they did not fall into a coherent professional category, and they could not have articulated their needs very well. They could not have agreed upon the reasons why the *populaire* mesmerized them but mesmerize them it did. Listen to Léger.

The shop window spectacle has become a major worry in the retailer's activity. Frantic competition presides there: *the violent desire to be seen more than one's neighbor* animates our streets. Can you yourself doubt the extreme care that oversees this work?

In the company of my friend Maurice Raynal, I have witnessed this labor of ants. Not on the boulevards under the bright streetlights, but at the end of a badly lit arcade. The objects were modest (in the famous hierarchical sense of the word); *they were vests,* in a shirtmaker's small display window. This man, this artisan, had seventeen vests to arrange in his window; around them, again as many cufflinks and ties. Pocketwatch in hand, he passed about eleven minutes on each, we left tired after the sixth, we had been there for *an hour* in front of this man who, after having moved these objects one millimeter, went outside to see the effect; he went outside each time, so absorbed in his work that he never saw us. With the dexterity of a fitter, a focuser, he organized his spectacle, his brow tense, his eye stern; as if his entire future

life depended upon it. When I think of the unbridled and shameful work of certain artists, renowned painters, whose paintings sell at high prices, we profoundly admired this *worthy artisan,* forging with great trouble and conscientiousness his own work, which is worth much more than the other, which will disappear, and which in a few days he must renew with the same care and acuity. With those men, with these artisans, lies a concept of an incontestable art, strictly tied to the commercial purpose, a plastic fact belonging to a new order and equivalent to all existing artistic manifestations, whatever they may be.[118]

The *populaire* was the back door from which the avant-garde (and others too) could leave the upper reaches of intellectual culture. Atget's documents and displays of shirts could each of them become passages to a better modernity, or so the avant-garde hoped.

Louis Aragon used *Paysan de Paris* to go on this odyssey out the back door. His account gave off the odor of a guide to Vieux Paris seen now from the point of the migrant peasant rather than Marie-Antoinette; it was an updated version of Georges Cain, revised at the points when Cain would have taken a middle-aged tone. At those same points Aragon strode purposefully in the opposite direction. He dreamt the *sordide.* Nonetheless his dreams were populated by figures from all corners of his memory. In his view of the artisan's shopwindow, an umbrella and cane shop in the miserable passage de l'Opéra, an indoor gallery of shops that was soon to be swept away by the completion of the boulevard Haussmann, the artisan was absent, Aragon thought he saw letters of the alphabet, and he saw, but only saw, the siren call.

A cane shop separates the café called the *Petit Grillon* from the rooming-house entrance. Its

owner is an honorable tradesman who offers his shady clientele luxury items in great profusion and variety, grouped so that the bodies and heads alike show to their best advantage. A complete art of panoply is elaborated within this space: the bottom canes fan out, while the upper ones, placed criss-cross, favor a singular tropism which makes them bend their pommel-blooms toward the spectator: ivory roses, dog heads with gem eyes, a damascened twilight from Toledo—they are inlaid with sentimental wisps of foliage, cats, women, hooked beaks, and come in myriad materials ranging from twisted rattan to rhinoceros horn by way of the blond charm of cornelians. Several days after the conversation mock-reported above, I spent an entire evening in the *Petit Grillon* waiting for someone who thought better of joining me; conscious of cutting a peculiarly lonely figure, I would order a fresh drink every quarter hour to justify my presence, losing with each drink a fraction of my inventive powers; at length, having borne beyond endurance the cross of my vigil, I stepped exhausted into the darkened passage. Fancy my surprise when, attracted to the cane shop by a kind of mechanical drone which seems to emanate from its display window, I saw the window suffused as if under water with a glaucous light, whose source remained hidden from view. It brought to mind the phosphorescence of fish, which I had had the chance to observe when a child on the jetty of Port-Bail, in the Cotentin, but I was compelled to recognize that although canes may conceivably possess the luminous properties of sea creatures, no physical law seemed adequate to explain this preternatural light and especially the hollow noise filling the vault of the arcade. That noise I knew: it was the voice of seashells, which never fails to astound poets

and film stars. The entire ocean here in the passage de l'Opéra. The canes were gently swaying to and fro, like kelp. I hadn't yet recovered from this spell when I noticed a form swimming between the various strata of the display. She was slightly smaller than the average woman but in no way impressed one as dwarflike. Rather, her diminutiveness seemed the optical effect of distance, yet this apparition was directly inside the window. Her hair had come undone, her fingers occasionally grasped the canes. I would have taken her for a siren, in the most literal sense of the word, for it seemed to me that the lower portion of this charming specter, who was naked to the girdle which she wore at hip level, tapered into a dress of steel or scales or perhaps rose petals; but on drawing nearer to see her drifting through the waves of the atmosphere, I suddenly recognized this person despite her emaciated features and the faraway look imbuing them. It was as a member of the occupation forces humiliating the Rhineland, in the confused aftermath of war and buoyed by a wave of prostitution, that I met, on the banks of the Saar, the Lisel who had refused to follow her people in retreat during the disaster, and all night long on the Sofienstrasse would sing songs she had learned from her father, a master of the hunt by profession. What could she be doing here, among the canes? And she was still singing, to judge from the movement of her lips, for the pounding of the surf behind the window rose above her voice, up to the mirrored ceiling which obscured the moon and the menacing shadow of the cliffs beyond. "The ideal!" was all I could exclaim in my confusion. The siren turned a frightened face toward me and then held out her arms, whereupon the entire display convulsed. The canes which stood criss-crossed swiveled forward ninety degrees so that the upper portion of the X pressed its V against the window glass, completing the curtain drawn over the apparition. It was as if a battle scene had suddenly been fenced from view by a rank of lances. The light died along with the noise of the sea.[119]

Aragon played a peasant of great sophistication. His dream-work would be done after having left the café—dreams and wine were the consolation for having been stood up. But his dreams, if under the influence, were quite literary, a siren-prostitute singing in the canes, a window that was both an ocean and a Rhine, and an ideal that mocked his cry, his poor, instinctive reaction that was nothing more than a case of mistaken identity. Aragon's odyssey had brought him to the low life that he wanted to join, but it was a life told by bourgeois images and clichés. They moved through his dream like a vaudeville act, a spoof of Verne, a pantomime, a silent screen. Why would Atget have not thought of Aragon as a young Cain or an Apollinaire in prose? His own idea of the *populaire* in the shopwindow could be proposed without rhinemaids or first-person voice.

The younger men were not fully conscious of the fact that Atget had not given them the whole kit and caboodle of the *populaire*, though they sensed that he had understood it better than they had, which was probably true enough, and that he stood *with* the *populaire*, which was also true. All the same he too had stayed at the surface of that culture and like them he was trying to describe its strangeness and to seize the substance of its difference. Of course he did not share their approach. Atget proceeded toward the *au-delà* using documents and their conventions for obtaining *savoir*. He was still interested in the *measurement* of culture; difference itself was not being fetishized, nor was the delectation of the form the point. Aragon and company, on the contrary, were trying to assess popular culture by seeing it according to the conventions by which art was usually understood: they did not go outside their own habits of thought when they crossed the border that Kandinsky called kitsch: Léger made the materials of the shopwindow into the equal of art; Aragon gave it the attributes of art with a Venus and an Ideal-I; the *Révolution Surréaliste* saw the crowd on the place Bastille as a group of converts. None of them trusted practical vision to do the job alone. The difference between the practices of *culture* and *savoir*, the difference that was not supposed to stand out so plainly, separated Atget and the younger men like oil and water. That difference was at the root of all the friction between him and Man Ray that day in 1926.

There was no reason for artists not to adopt the practices of *savoir*. Duchamp often did just that. Atget's giant and midget document was in fact a work on the order of Duchamp's *Three Standard Stoppages*, where three meter-long strings were dropped on the ground and templates made of their new lengths; the templates became a new standard of measurement for Duchamp; he kept them in a box (fig. 148). Like the *Stoppages*, the giant and midget document began with a technical sign and gave it another set of standards that stopped short of respectable *connaissance*. Atget dropped the shop window onto the circus. As a result the circus spectacle was made to solicit the practical vision of the shopper. The performers became not only objects of knowledge but objects for sale.

The same year, which was 1925, Atget made a brutal picture of a shop window belonging to a second-rate clothing store called Aux Gobelins (fig. 149).[120] Like the rest of the crowd, he examined the image in the glass. This time there was no romance, no admiration. Atget took the dapper gentlemen, the postwar bourgeoisie, as

148. Marcel Duchamp, *Three Stoppages Etalon*.
1913–14. Museum of Modern Art, New York.

149. "Avenue des Gobelins." 1925. Pp 82.
Museum of Modern Art, New York.
The Abbott-Levy Collection. Partial gift
of Shirley C. Burden.

manikins, as if they *were* manikins, and then he smudged and punched their picture using an old trick we have seen before, the shadow. He broke the illusion of the shop window. Now this had been one of the projects of the young Duchamp, who had mulled it over in an early note for the *Large Glass*. His interrogation of the shop window asked the question about whether one could move outside high culture and then went straight to what he felt was really the point.

Speculations

Can one make works which are not works of "art"?

The question of shop windows ∴.
To undergo the interrogation of shop windows ∴.
The exigency of the shop window ∴.
The shop window proof of the existence of the outside world ∴.

When one undergoes the examination of the shop window, one also pronounces one's own sentence. In fact, one's choice is "round trip." From the demands of the shop windows, from the inevitable response to shop windows, my choice is determined. No obstinacy, ad absurdum, of hiding the coition through the glass pane with one or many objects of the shop window. The penalty consists in cutting the pane and in feeling regret as soon as possession is consummated. Q.E.D. [121]

Not a dream now, but a project, though Duchamp could not imagine the shopwindow without the specter of female sexuality, straight coitus rather than sirens but the result was much the same, more or less the *parisienne* we have met before. Atget's break through the glass also went for the bourgeois body, but he attacked the male member of the species, to wit, he sliced

down one of the most stalwart manikins in the group and extracted his eye. The document deposited the bourgeois look into a shadow, a stick-straight pole that seemed to generate all the action, from the reflected perspective of the city streets to the circle of manikins dressed for spring. The document literally turned on an axis of unbending bourgeois narcissism. For the bourgeois eye saw nothing from this shadow, a phallic shadow that returned the gaze of the man to himself. His was an insufficient, ultimately impotent look. Spectacles would not have helped. Bourgeois vision had already failed.

The scene was invaded at every level. By the bright rectangles of the price tags, for example, which made their own pictorial noise, and by other shadows, not the black shadow of the cameraman now but the bright ones of a boy alone and a mother holding her child. The manikins looked ill-equipped to walk out on this street, yet the document had put them in the position of walking awkwardly with the shadows. The difference and the strength of the *populaire* were still being measured. Its order was still a matter of shadows and opacity; knowledge of it was still more or less denied. Such a document had a place in Atget's work overall in the 1920s.

The war had not changed things all that much for Atget's photography: when peace was declared, he had gone back to work. The *répertoire* (fig. 150) was started up again and the fabric of the clienteles was rewoven with new names coming in to join the old. However the basic structure of Atget's business was not reorganized. He took the opportunity to clear out some of his old work, in late 1920 writing to Paul Léon to see about the sale of his Vieux Paris stock, negatives for which there was no longer great demand (most of the libraries already had bought prints from them). Subsequently

he would rephotograph some of the sites they depicted and make a shorter, more manageable list of Vieux Paris work with which to interest the libraries, the amateurs, and the publishers. [122] But clearly he also felt that it was time to ensure the preservation of his work. An inventory of another set of negatives from the *Paysages–Documents divers* series, the *Environs* series, and the *Paris pittoresque* series was written up for the Bibliothèque Nationale, probably in mid-1924. [123] The cover letter has been lost but the group complements the body of negatives sold to the Service des Beaux-arts in 1920, so nicely that it was probably calculated as a similar sale. If so, the Bibliothèque Nationale was unmoved by the offer.

The list Atget worked up did not mention albums but it indicated how he had come to think about the *Paris pittoresque*. He had siphoned off the quais and introduced the cabaret. His list had summarized the *Paris pittoresque* as he had defined it in his albums:

Paris Pittoresque. Fêtes, Foires, Cabarets
Petit metiers – Scènes de la rue, Chiffonniers

Zonniers et chiffonniers___	– 48
Boutiques___	74
Fêtes, Foires, Cabarets___	84
Petits métiers___	56
Ensemble	262 clichés

Yet the list as a whole showed that Atget was regrouping to meet the archives again; neither the printed page nor the album page was going to be his salvation in the 1920s. He had new letterhead printed up which contained the date 192_. He was intending to correspond with his clienteles, intending a new round of dialogue and document.

In the 1920s, the dialogue underwent a modification. The documents for archives now con-

150. Atget's *répertoire*, pp. 86 and 87. Museum of Modern Art, New York. The Abbott-Levy Collection. Partial gift of Shirley C. Burden.

tained the dialectical lesson of denial that Atget had put forward in his albums and yet the documents were nevertheless somehow contained by the greater rhythm of work for the archives and the *connaissances*. Atget's work for the Carnavalet during this period may be taken as typical. He sold them paper albums now on a more or less annual basis (six albums in seven years) that took the picturesque, Vieux Montmartre, courtyards, views of the Seine, topographical views around the city. There was as well a new series on the old *hôtels*. The projects now were conceived as short selections rather than great surveys, selections that did not disturb Georges Cain's idea of the *pittoresque*. They were suitably atmospheric; the detail at the edges was not allowed to disrupt the monuments; they were documents for gentle dreamers. Still, Atget had not washed all equivocation out of these documents of Vieux Paris. He titled one of the views for his last album *Vieux Paris Coins Pittoresques* for the street corner, leaving the Panthéon and St. Etienne du Mont unmentioned (fig. 151). The St. Raphael man scuttled off to the left. (The photograph has faded because it was badly developed, leaving a bizarre set of shadows flying around its edges.) The view of the Panthéon rose pale in the dawn, cut by the dark wings of the intervening buildings. The perspective jumped from plane to plane. The document was more decor than a good description of the space, a decor that took the Panthéon, the final resting place for the bones of the great men of France, as a distant, fading vision. Oblivion was a distinct possibility.

Atget still obliged. But the give-and-take in other sections of his practice was more pointed, even sharp. His work on the formal gardens, for instance, proceeded once again on the basis of the multiple functions, making for documents that combined the technical signs for topography and landscape, hybrids. Yet these technical

151. "Un coin de la rue de la Montagne Sᵗᵉ Geneviève."
1924. AVP 6479. Musée Carnavalet, Paris.

signs often worked at cross-purposes, interfering with one another's clarity, visibly undoing each other's ties to knowledge. Descriptions of the garden statues or the space were overrun by the details of the landscape. At the center of Atget's view taken at St. Cloud (fig. 152) sometime between 1915 and 1919 lay a group of tiny statues, one of them a copy of the Apollo Belvedere, though the photograph obscured this point and instead concentrated upon the effect, the landscape study of light and air. Space and statue were lost to this air, whose effect damaged the technicality of topography and identity. Damaging a technical sign was now one of Atget's specialities. Such a sign occupied a place in the old dialogue, but as a disappointment for the technical look, a simple denial of its needs.

This was the legacy of the seven albums. The denying document. The production of ignorance. Silence.

This legacy was meted out, reserved for certain occasions. After 1918 a sizable market opened up before the document of the classical garden. Versailles was now remembered as the palace of Louis XIV and the place where the peace treaty had been signed. A classicism was used to express the new national culture, the one that had won the war. Avant-garde artists like Picasso went classical for a time; Le Corbusier argued for the Latin roots of the airplane. More than ever, Versailles was à la mode. Atget had some of his pictures of Versailles published: Fernand Bournon, for instance, the same Bournon who had seen to the retouching of the Fontaine Bouchardon, used some of Atget's pictures for a book he did with Albert Dauzat in 1925, entitled *Paris et ses environs*.[124] Bournon did not however choose the newer, more synthetic and difficult work Atget was doing in the classical garden; rather, he took the earlier work Atget had made at Versailles some twenty years before, and used it, without crediting Atget, to

supply the small black-and-white details of the park that offset others' photographs—the half-and full-page color views of the palace itself and of the great perspective that ran through the center of the park.

Atget knew the rules for that new market; he knew that its classical needed to be centered and untrammeled; he knew where its politics lay. Though he had plenty of work pertaining to the classical, he did not try to muster up a book project to take advantage of this situation. He returned to the archives and took to documents that could not have made it into print. He gave the archives documents that were too full of technicalities, documents with too many signs, signs that overtook any clear exposition of a classical culture, that gave it as a ruin, or in unworkable light, or in miniature. These documents could not contribute to the survival of the classical past in reproduction or to a classical image of the state. Rather, they canceled that image of the classical, dissolving it in leaves or in air (fig. 153). The dialogue with the client was deliberately postponed.

There was always the pretext of dialogue. Atget's set of documents at Sceaux was made in 1925, a little over a year after the park there had come into public hands. At the point when it had, the Commission du Vieux Paris had reported on it, for it was Colbert's domain and all of Louis XIV's best artists and architects had worked there, from Le Brun to Le Nôtre. The report had included illustrations, uncredited photographs, and a detailed account of the ruin into which the place had fallen. Around the pond called the Octogone six statues remained, "most of them terribly damaged: a *Rape of Persephone*, a *Conquered Gaul* killing himself after having slit his wife's throat, a sturdy *Orestes and Pylades* group, an *Apollo* and a *Daphne*, an *Electra and Orestes*, an *Orator*. In several of these marbles all that survives is

the fleeting indication of a violent or a delicate movement: as in the *Apollo and Daphne*, where the thought rises up from an impotent, mutilated stone. They are no less compelling for this and it is to be hoped that they remain in situ, abandoned and green, stationed around the still water of the melancholy basin, which reflects their many misfortunes."[125] The illustration of Orestes and Pylades, the epitome of male friendship, Pylades supporting Orestes in his parricide (fig. 154), put the degradation of the statues into the customary frame. The picture was retouched so as to make the forms come forward more clearly and the scene was tactfully lugubrious but not overdrawn. Conventional objectivity, frontality, clarity were maintained. Atget's work at Sceaux fit into an album, the usual sixty pictures, which took the park at different times of year, looking at the way nature had eroded human achievement, destroying the classical line, the clear form, the *pensée*. His Orestes and Pylades were shown from behind, not because they were better seen or studied that way, but to show the characters from the past contemplating their own bitter fate (fig. 155). The classical past seemed to be surviving by a thread. In his documents the technical signs had been so bent and disregarded that they could not even lend ideological support. These gnarled, opinionated, technical signs kept the document in that space *before* knowledge, as if trying to hold it there indefinitely, away from the modern state.

Atget moved his documents toward closure in the 1920s, closure that would have various functions and various forms. Closure became Atget's last way of locating his positions, making distinctions, dividing points of view from one another, disputing with notions of universality, positing a class consciousness. Albert Valentin and Pierre MacOrlan tried to pin down the quantities, giving them names, the *fantastique*,

152. "Saint Cloud. Matin 6½ h., juillet." 1921. PDd
1065. Museum of Modern Art, New York. The Abbott-
Levy Collection. Partial gift of Shirley C. Burden.

153. "Saint Cloud. juin 1926." Saint Cloud set 1274.
Museum of Modern Art, New York. The Abbott-Levy
Collection. Partial gift of Shirley C. Burden.

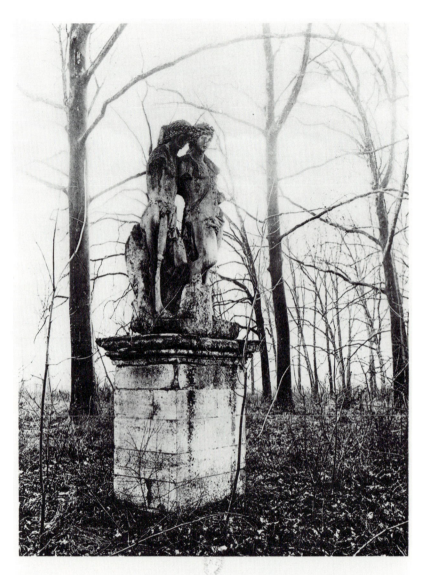

LE CHATEAU DE SCEAUX
Groupe d'Oreste et Pylade.

154. Anonymous, "Le Chateau de Sceaux. Groupe
d'Oreste et Pylade." From the Commission municipale
du Vieux Paris, *Procès-verbaux* (29 March 1924),
unpaged. Bibliothèque Nationale, Paris.

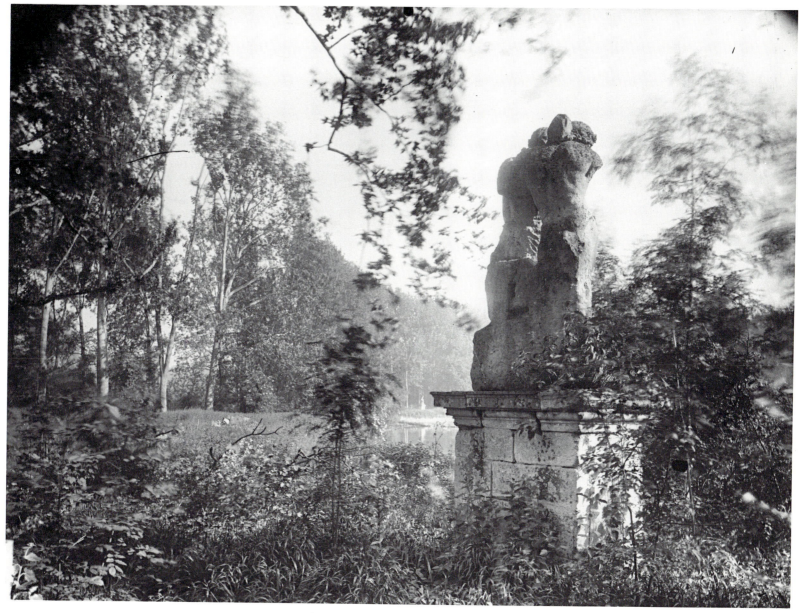

155. "Parc de Sceaux. Juin, 7h. matin." 1925. Sceaux set
65. Caisse nationale des Monuments historiques et des
Sites, Paris.

the *au-delà*. The line of demarcation itself is perhaps more interesting. It was where the author could express his power, his desire, and his contempt.

Atget expressed all of this repeatedly in the last section of the *Paris pittoresque*. In the 1920s that series had been continued, without benefit of a project comparable to the Bibliothèque Nationale albums to guide it. In 1921 Atget put the prostitutes that he had begun to photograph for Dignimont there and then worked hither and yon on shop fronts, docks, circuses, manikins, the details of the *populaire*. The separations he was building between it and bourgeois culture continued in the direction he had begun in his albums, but he worked the extremities of the *populaire* with an urgency that grew cynical. At the end of the series, he split the *populaire* open up and down the rue Mouffetard (fig. 156). His last pictures turned the shopwindow inside out, one of them putting rows of caps and work clothes out on the street, the signs of class ready to wear and already living with a blur of a girl. No other signs of class were allowed to interfere with the waves of caps. The caps dominated. Atget was finally going to give the people their image. It went together with another of Atget's last pictures, the working-class manikin, white-smocked, full-bodied, a headless Gilles or Pierrot (fig. 157). The players were diverse, the manikins macabre. But their theater was popular, their tale immaterial, the point was their *longue durée* even as Paris mechanized, modernized, *à l'américaine*. Atget gave Gilles without Watteau. An exclusive low, a pure low, a low that held itself away from knowledge and financial speculation. Just like the Orestes and Pylades. A low without a high.

Low culture, popular culture was, like death, not a concept to be absorbed and filed away. Atget's point was made. It was a point with a

politics, of course, but it was not made using the forms with which political culture was usually expressed, not with a social realism, not with an *art social*, not with a celebration of the worker's body or the *folklorique*.[126] The forms Atget used were those native to the document. In 1928 Walter Benjamin made himself a list in which he tried to work out what a document was. It was, he knew, different from the work of art, and so he proceeded to compare their properties.

I.	The artist makes a work.	The primitive expresses himself in documents.
II.	The artwork is only a document.	No document is as such a work of art.
III.	The artwork is a masterpiece.	The document serves to instruct.
IV.	On artworks, artists learn their craft.	Before documents, a public is educated.
V.	Artworks are remote from each other in their perfection.	All documents communicate through their subject matter.
VI.	In the artwork content and form are one: meaning.	In documents, the subject matter is dominant.
VII.	Meaning is the outcome of experience.	Subject matter is the outcome of dreams.
VIII.	In the artwork, subject matter is a ballast jettisoned during contemplation.	The more one loses oneself in a document, the denser the subject matter grows.
IX.	In the artwork the formal law is central.	Forms are merely dispersed in documents.
X.	The artwork is synthetic: an energy center.	The fertility of the document demands: analysis.
XI.	The impact of an artwork increases with viewing.	A document overpowers only through surprise.
XII.	The virility of works lies in assault.	The document's innocence gives it cover.
XIII.	The artist sets out to conquer meanings.	The primitive man barricades himself behind subject matter.[127]

Benjamin did not ask the elementary questions: how to speak about knowledge as distinct from culture? how to make the transition from the technical to the general? Instead he looked at the document through a negative dialectic. Documents were the property of primitives, Benjamin decided, they gave elementary form to knowledge, they were literal, they had their own relation to beauty. This seems inadequate as a formulation now. For one thing, the relations between form and knowledge at the level of the document, though primary, were hardly primitive. They depended upon intermediaries, contingencies that could be blocked or turned, that might or might not let knowledge in. The low that Atget enclosed in his documents was not at all primitive. It was a *savoir* of a kind; its surface could be seen. But it was a *savoir* that could never be known, an ungodly emptiness, a black square outside all measure, a disembodied eye, a cap as yet undoffed, a poor man's Gilles. Atget had seen to all of this. The *savoir* remained in the shadows. It grew stronger in eclipse.

156. "Rue Mouffetard." 1926. Pp 105. Museum of
Modern Art, New York. The Abbott-Levy Collection.
Partial gift of Shirley C. Burden.

157. "Avenue des Gobelins." 1927. Pp 158. International Museum of Photography at the George Eastman House, Rochester, New York.

Notes

Prologue

1. The incident that occurred when Atget met the Surrealists was recounted by Man Ray to Paul Hill and Tom Cooper, "Interview: Man Ray," *Camera* 74 (February 1975), pp. 39–40. *La Révolution Surréaliste* published three Atget photographs in no. 7 (15 June 1926), on the cover, p. 6, and p. 28, and another in no. 8 (1 December 1926), p. 20. None of them credits the photographer. At least the first three of these photographs belonged to Man Ray, whose collection of Atgets has gone to the International Museum of Photography at the George Eastman House. Both "Eclipse" and "Versailles" have annotations (not in Atget's hand) for the printer indicating that they in fact were the prints used to make the illustrations for *La Révolution Surréaliste*. The caption for "Versailles" is Atget's; the caption for "Dernières Conversions" is not written anywhere on the print itself, which retains Atget's "L'Eclipse—Avril 1912." The Man Ray collection arrived in a scrapbook with a cover decorated and annotated by Man Ray and dated 1926. It has been published together with an illustrated catalogue by Thomas Michael Gunther, "Man Ray and Co.: La fabrication d'un buste" in the special number of *Photographies: Colloque Atget. Actes du Colloque, Collège de France, 14–15 juin 1985* (March 1986), pp. 66–73. The Eastman House recatalogued this collection after Gunther's article went to press; their revisions include corrections to some of the titles and the addition of Atget's negative numbers. The best historical account of the development of Atget's reputation has been written by Maria Morris Hambourg, "Atget, Precursor of Modern Documentary Photography," in *Observations: Essays on Documentary Photography*, ed. David Featherstone (Carmel: Friends of Photography, 1984), pp. 24–39.

2. Emile Zola, *Paris*, trans. Ernest Alfred Vizetelly (New York: Macmillan, 1898), vol. 1, pp. 1–2.

3. Ibid., vol. 2, pp. 743–44. The same sight alarmed Léon Daudet, *Paris vécu* (1929; reprint, Paris: Gallimard, 1969), pp. 128ff.

4. P. Delarue-Nouvellière, in a letter to Jean Leroy, 13 May 1965, wrote that he never saw Atget sell his photographs in cafés but that Atget did tour the studios. At that time Delarue-Nouvellière lived at 54 rue Vercingétorix, an impasse inhabited by many painters and sculptors. "Atget passait de temps en temps avec une grosse serviette contenant de nombreuses photos: documents pour artistes. Je crois que, bien souvent, nous achetons surtout pour lui faire plaisir car il faisait un peu pitié"; quoted in Jean Leroy, *Atget: Magicien du Vieux Paris* (Joinville-le-Pont: Balbo, 1975), unpaged.

5. Robert Desnos, "Emile Adget [*sic*]," *Nouvelles Hébrides et autres textes, 1922–1930* (Paris: Gallimard, 1978), p. 436. See also "Bruxelles: Exposition de photographie (Galerie de l'Epoque)," *Cahiers d'Art* 3 (1928), p. 356: "Qui de nous ne se rappelle ce vieillard qui frappait à toutes les portes de Montmartre pour montrer et vendre aux artistes des épreuves de ses vues de Paris où tous les métiers, tous les quartiers, tous les types, pendant plus d'un demi-siècle, avaient été fixés sur ses plaques."

6. Robert Desnos, "Eugène Atget," *Le Soir*, 11 September 1928, p. 5. Ellipses are Desnos's.

7. See also Jean Gallotti, "La photographie est-elle un art?—Atget," *L'Art Vivant* (1 January 1929), p. 24: "Rien de conventionnel dans le choix de ses sujets. Emerveillée par la vie, il lui donne un amour pur. Un tronc d'arbre, une charrette, une rampe d'escalier, lui paraissent dignes d'admiration, aussi bien qu'un pommier en fleur, ou qu'une rivière ombragée; un tas d'ordures comme un boudoir."

8. Waldemar George, "Photographie vision du monde," *Photographie*, special number of *Arts et Métiers Graphiques* 16 (15 March 1930), p. 136. Middle-class intellectuals had been scrutinizing popular culture in this way for over a hundred years. See especially Peter Burke, *Popular Culture in Early Modern Europe* (London: Marice Temple Smith, 1978), and Susanna Barrows, *Distorting Mirrors: Visions of the Crowd in Late Nineteenth-Century France* (New Haven: Yale University Press, 1981).

9. George, "Photographie," p. 138.

10. "American Buys Famous Collection of Atget, Paris Photographer," *Chicago Tribune*, Paris edition, June 27, 1928, in Berenice Abbott's scrapbook, p. 39, now in the Atget Archive, MOMA. For the details of Abbott's work on behalf of Atget, see Hank O'Neal, *Berenice Abbott: American Photographer* (New York: McGraw-Hill, 1982), pp. 11ff. Abbott first saw Atget's work at Man Ray's studio in 1925; the next year she went to meet Atget himself. Her correspondence with Calmettes produced at least four letters from him, now in the Atget Archive at the Museum of Modern Art.

11. Maria Morris Hambourg has written the most complete biography of Atget, built in part upon the work of Jean Leroy. See her contribution to the Museum of Modern Art series of books, *The Work of Atget*, vol. 2, *The Art of Old Paris* (New York: MOMA, 1982), pp. 9–41, "A Biography of Eugène Atget"; and Leroy, *Atget*. Their work has been taken as the point of departure for the present study, which remains very much in their debt.

12. There was some talk of a preface by Paul Claudel, but it apparently came to naught. See "Bruxelles: Exposition de photographie," and Walter L. Davis, "Girl Wins Paris by Camera's Art," *Cleveland Plain Dealer*, 18 November 1928, Automobile and Feature Section. Another writer, Walter Hanks Shaw, in his article "What Americans Are Seeing in Paris," *Arts and Decoration* 30 (January 1929), p. 88, spoke of a folio of reproductions published by *Cahier d'Art* [*sic*], with a preface by André Salmon. This folio has not been located. Perhaps Shaw was referring, quite mistakenly, to a maquette of the MacOrlan book. Pierre MacOrlan was the pseudonym of Pierre Dumarchais. The manuscript copy of his preface is now in the collection of the Museum of Modern Art. Florent Fels, who had made a bid to buy the Atget estate from Calmettes, also claimed to know Atget, though his account of this "friendship" emerged late, not in the first article he wrote about the photographer, "Le premier salon indépendant de la photographie," *L'Art Vivant* (1 June 1928), p. 445, but in the second, "L'art photographique: Adjet [*sic*]," *L'Art Vivant* (February 1931), p. 28. The picture Fels gave of Atget showed a man looking to ally himself with avant-garde artists who could appreciate his work, like Dignimont, Gromaire, and André Derain. In this and other ways his picture does not jibe with every other reliable description of Atget's behavior, leading one to suspect some embroidery on Fels's part.

13. *Atget: Photographe de Paris* (Paris: Jonquières, 1930), preface by Pierre MacOrlan, p. 18. MacOrlan wrote elsewhere on photography and its connection to what he called the *fantastique social*: "La vie moderne: L'art littéraire d'imagination et la photographie," *Les Nouvelles Littéraires* (22 September 1928), p. 1; "La photographie et le fantastique sociale," *Les Annales Politiques et Littéraires*, no. 2321 (1 November 1928), pp. 413–14; "Photographie—éléments de fantastique social," *Le Crapouillot* (January 1929), pp. 3–5. He openly acknowledged its popular side when he wrote about the work of Atget. The practice of seeing the fantastic in popular culture has a long history; see Barrows, *Distorting Mirrors*.

14. MacOrlan, *Atget*, pp. 19–21.

15. Abbott diary, not dated, quoted by O'Neal, *Berenice Abbott*, p. 11. "Eugene Atget," *Creative Art* 5 (September 1929), p. 651.

16. And so there were two fairly different understandings of Atget, one French, one American. It is conceivable that Abbott always thought about Atget's work in English but it makes little difference to the fact that her view became the dominant English-language one. Abbott called Atget an artist in her 1929 article simply because he used his medium to perfection—though

not in an artsy way. She never deviated from this view. In her 1964 book, she wrote: "His Gallic eye scanned the city with objective appraisal, leavened with humor and sensitive awareness. The subjects that excited him were infinite in variety. All were photographic in nature and even the most picturesque subject never became merely pictorial, remotely 'arty,' or like a painting. With Atget photography stood on its own feet" (*The World of Atget* [New York: Horizon, 1964], p. xxiv). Thanks largely to Abbott, Atget became a hero to the formalists; he was, as Clement Greenberg once put it, their Complete Photographer (Greenberg, "Four Photographers," *New York Review of Books* 1 [23 January 1964], p. 8). Another symptomatic American translation of Atget can be found in Walker Evans's famous book review "The Re-appearance of Photography," *Hound and Horn* 5 (1931–32), pp. 125–28. The culmination of the American version came with the four-volume series of books put out by the Museum of Modern Art in New York: John Szarkowski and Maria Morris Hambourg, *The Work of Atget*: vol. 1, *Old France*; vol. 2, *The Art of Old Paris*; vol. 3, *The Ancien Regime*; vol. 4, *Modern Times* (New York: MOMA, 1981–85). The French view of Atget developed without recourse to cultural stereotypes or photographic essences and instead drew the connection either to the Douanier Rousseau, i.e., popular culture, or to the new objectivity of the medium. For the latter view, see the work of Leroy, *Atget*, and Romeo Martinez, "Eugène Atget in Our Time," *Camera* 45 (December 1966), pp. 56, 56–66; for its German version, see the work of Walter Benjamin.

17. Jacques Rancière's book, *La nuit des prolétaires: Archives du rêve ouvrier* (Paris: Fayard, 1981), takes this problem of imagery and political identity together, studying the worker-poets of the 1830s and 1840s. That book has been instrumental in developing the reflections which follow.

18. Walter Benjamin, "Short History of Photography," trans. Phil Patton, *Artforum* 15 (February 1977), pp. 50 and 51, respectively.

19. On the documents for artists explanation, see Man Ray, "Interview," p. 39, who took Atget at his word. Julien Levy, in his book, *Memoir of an Art Gallery* (New York: G. P. Putnam's, 1977), p. 95, recounts a similar explanation given by Atget: "Much has been written about what Atget thought he was doing, and I am of the opinion that words have been put in his mouth about ideas that were not his. He told me he was simply preserving carefully the vanishing world that he loved, and keeping an archive of important classified documents. He was a remarkably simple man, extremely modest. In truth, he was unaware of his achievement." But Levy felt that Atget's achievement could be summarized for him.

Ironically he finished his paragraph by virtually putting words in Atget's mouth: "He left 10,000 photographs in hundreds of series, but each individual picture was an essential pearl in the string that was his Paris. And he was making a new statement with every picture, transcending the document and creating poetry that outlived his Paris and will outlive us all."

20. Author's interview with Julien Levy, January 1978.

21. Ferdinand Reyher interviewed the concierge, M^me Cornet, a close friend of Valentine Compagnon, in 1947, while he was researching Atget. His notes for the project are now to be found in the Atget Archive at the Museum of Modern Art. On his project see Barbara L. Michaels, "Behind the Scenes of Photographic History: Reyher, Newhall, and Atget," *Afterimage* 15 (May 1988), pp. 14–17. Jean Leroy interviewed her daughter, M^me Demoulin, and one of Valentine Compagnon's other dear friends, M^me Lemaire, the *antiquaire* who lived at 15 rue Campagne première. Both made the same points about Atget's character. In the spring of 1978 I was able to speak several times with M^me Demoulin, who reiterated the description of Atget.

22. André Calmettes, undated letter to Berenice Abbott which has been dated by Maria Morris Hambourg to late 1928. The others are dated by Calmettes himself 1 January 1928, 28 October 1928, 13 April 1929.

Avant l'éclipse

1. George Besson, "Pictorial Photography: A Series of Interviews," *Camera Work*, no. 24 (October 1908), p. 13.

2. Ibid. These are typical pictorialist questions. See Ulrich Keller, "The Myth of Art Photography: A Sociological Analysis" and "The Myth of Art Photography: An Iconographic Analysis," *History of Photography* 8 and 9 (October 1984 and January 1985), pp. 249–75 and 1–38, respectively; Allan Sekula, "On the Invention of Photographic Meaning," in his book, *Photography Against the Grain* (Halifax: The Press of the Nova Scotia College of Art and Design, 1984), pp. 3–21.

3. The identity of the photographs Besson showed is not known, but it seems quite likely that the Rodin portrait was among them, given that it was considered one of the masterpieces of pictorialist photography, that Steichen had been living in Paris and was known to these men, and that the picture had appeared in a relatively recent *Camera Work*, no. 11 (July 1905).

4. Ibid., p. 22.

5. Charles Baudelaire, "Salon de 1859," *Oeuvres complètes* (Paris: Pléiade, 1961), vol. 2, pp. 1031–36.

6. Fernande Olivier, *Picasso et ses amis* (Paris: Stock, 1933), p. 229.

7. It is perhaps worth emphasizing that in France the word *document* did not carry with it any connotation of social documentary; in fact, there was no contemporary equivalent to the social documentary practice of American photographers like Lewis Hine and Jacob Riis.

8. A. Reyner, *Camera obscura*, quoted in *Cinquième congrès international de photographie, Bruxelles 1910. Compte rendu, procès-verbaux, rapports, notes et documents publiés par les soins de Ch. Puttemanas, L. P. Clerc et E. Wallon* (Brussels: Bruylant, 1912), p. 72. Frédéric Dillaye in his book *Principes et pratique d'art en photographie: Le paysage* (Paris: Gauthier-Villars, 1899), p. 2, gave a similar definition in order to distinguish the document from the artistic photograph: "Celui qui ne voit que le document, pur et simple, voudra des détails minutieux partout, prendra un objectif donnant le plus de netteté possible, le diaphragmera tant et plus pour augmenter encore cette netteté dans tous les plans. L'harmonie lui importe peu; la justesse de l'effet encore moins. Aussi choisira-t-il un révélateur rapide, énergique, susceptible de lui délimiter avec une précision absolue les détails les plus ténus de son motif. C'est à cela qu'il doit atteindre avant tout. C'est son but final."

9. Albert Londe, *La photographie moderne: Pratique et applications*, 2d ed. (Paris: Masson, 1896), p. 570; see chapter 11, "Photographie documentaire," pp. 545–71. Londe mentioned the new Musée des Photographies documentaires, located at the Cercle de la Librairie, boulevard Saint-Germain, being mounted by Léon Vidal. Apparently it never amounted to much more than a clippings file. By the First World War the collection had found its way to the Bibliothèque Nationale.

10. For a hostile pictorialist reaction to the document, see G. Vieuille, *La photographie artistique et les petits appareils* (Paris: Gauthier-Villars, 1915). The cultural potential of the document was recognized by many of the avant-garde by the late 1920s, notably the Surrealists. See Alain Mousseigne, "Surréalisme et photographie: Rôle et place de la photographie dans les revues du mouvement surréaliste, 1929–1939," in *L'art face à la crise, 1929–1939* (St. Etienne: CIEREC, 1980), pp. 153–81; and Molly Nesbit, "Photography and Modernity: Avant-Garde Photography from 1910 to 1930," chap. 6 of *Histoire de la photographie*, ed. Jean-Claude Lemagny and André Rouillé (Paris: Bordas, 1986), with an English edition published by Cambridge University Press in 1987. See also Philippe Soupault, "Etat de la photographie," *Photographie* (1931), unpaged; and Fels, "Le premier salon indépendant," p. 445, which ends with an axiom: "Une bonne photographie, c'est avant tout, un

bon document." The situation seems to have been similar in England, where before the war, the document did not have much of a reputation either, at least according to Clive Bell, *Art* (New York: Frederick Stokes, 1914), p. 18.

11. Michel Foucault, *L'archéologie du savoir* (Paris: Gallimard, 1969).

12. Ibid., p. 171: "Entre la *langue* qui définit le système de construction des phrases possibles, et le *corpus* qui recueille passivement les paroles prononcées, l'*archive* définit un niveau particulier: celui d'une pratique qui fait surgir une multiplicité d'énoncés comme autant d'événements réguliers, comme autant de choses offertes au traitement et à la manipulation. Elle n'a pas la lourdeur de la tradition; et elle ne constitue pas la bibliothèque sans temps ni lieu de toutes les bibliothèques; mais elle n'est pas non plus l'oubli accueillant qui ouvre à toute parole nouvelle le champ d'exercice de sa liberté; entre la tradition et l'oubli, elle fait apparaître les règles d'une pratique qui permet aux énoncés à la fois de subsister et de se modifier régulièrement. C'est *le système général de la formation et de la transformation des énoncés*." Some of the best analyses of the photographic archive work directly with Foucault's propositions. See especially Rosalind Krauss, "Photography's Discursive Spaces: Landscape/View," *Art Journal* 41 (Winter 1982), pp. 311–19; and Allan Sekula, "The Body and the Archive," *October*, no. 39 (Winter 1986), pp. 3–64, and "Photography between Labour and Capital," in *Mining Photographs and Other Pictures, 1948–1968: A Selection from the Negative Archives of Shedden Studio, Glace Bay, Cape Breton*, ed. Benjamin H. D. Buchloh and Robert Wilkie (Halifax: NSCAD, 1983), pp. 193–268. For more on the archive itself see *Traverses*, no. 36 (January 1986), which is devoted to the subject.

13. Roger Fry, "The Artist's Vision," reprinted in his book, *Vision and Design* (Oxford: Oxford University Press, 1981), p. 36.

14. Ibid., p. 33.

15. For the genre: Charles Chevalier, *Nouvelles instructions sur l'usage du daguerréotype* (Paris: l'auteur, 1841); Désiré van Monckhoven, *Traité générale de photographie comprenant tous les procédés connus jusqu'à ce jour, suivi de la théorie de la photographie et de son application aux sciences d'observation*, 4th ed. (Paris: Masson, 1863); Alphonse Liébert, *La photographie en Amérique*, 3d ed. (Paris: Leiber, 1878); Londe, *La photographie moderne*; Fleury-Hermagis and Rossignol, *Traité des excursions photographiques* (Paris: Rongier, 1889); G.-H. Niewenglowski, *Traité élémentaire de photographie pratique* (Paris: Garnier frères,

1905); Martin-Sabon, *La photographie des monuments* (Troyes: 1914). For the "art" dissenters: H. de La Blanchère, *L'art du photographe* (Paris: 1859), and L. P. Clerc, *La photographie pratique* (Paris: Mendel, 1902).

16. The pediment had been lost in Atget's photograph because his camera forced a choice: he could have either the complete ensemble or no parallax distortion, but not both. Significantly, the standards for documentation beat out the pediment.

17. George, "Photographie," pp. 136 and 134, respectively.

18. Ibid., p. 134.

19. I have determined the professions of Atget's clients by cross-checking his names, addresses, and annotations with the annual Didot-Bottin and the records of the Patentes, Cadastre and Listes électorales kept in the Archives de la Seine, Paris. On the basis of this research I have identified the categories of clients studied later in this chapter. There are literally 525 names in the address book, but in order to arrive at the number 460 I have counted the names of firms as one name and have not separately added the names of the employees of the firm with whom Atget actually dealt. The end pages of the address book give the addresses of his stepson's widow and his photo supply dealers. None of them is included in the count.

20. Brassaï, "My Memories of E. Atget, P. H. Emerson and Alfred Stieglitz," *Camera* 48 (January 1969), p. 4.

21. Those clients not listed in the *répertoire* include: Berenice Abbott, Milton Bancroft, Victor Barthelémy, Pierre Boucher, Robert Davesne, P. Delarue-Nouvellière, Robert Desnos, André Dignimont, Dunoyer de Segonzac, Florent Fels, Gilles, Grandjean, Jean-Emile Laboureur, Julien Levy, perhaps Pierre MacOrlan, Man Ray, Maronniez, Luc-Olivier Merson, Luc-Albert Moreau, Utrillo, Van Beers, and Zborowski. The "new facts" unveiled by Gerry Badger and John Szarkowski were a joke. Gerry Badger (review of *The Work of Atget*, vol. 1, *Old France*), *European Photography*, no. 12 (October 1982), pp. 35–36; and John Szarkowski, "The Life of Atget: New Facts," *European Photography*, no. 13 (January 1983), p. 32.

22. "Informations et nouvelles," *La Revue des Beaux-Arts*, no. 98 (6 February 1892), p. 30. Un modèle olympien, "Carnet de la curiosité—petit bleu de modèle," *Art et Critique*, no. 89 (13 February 1892), pp. 78–79.

23. Un modèle olympien, "Carnet," p. 79.

24. All that remains to document the episode is Atget's business stamp, which appears intact on several prints in the collection of the Ecole Boulle. See Commodity, this volume.

25. Calmettes, undated letter to Berenice Abbott.

26. Françoise Reynaud, "Richesses des collections publiques françaises," *Colloque Atget*, pp. 92–99.

27. Atget conducted his business with the Board of Education of South Kensington, which was buying for the Victoria and Albert Museum, by correspondence, beginning on November 19, 1902, and ending September 27, 1904. The entire correspondence is now to be found in the archives of the Victoria and Albert Museum. See also Mark Haworth-Booth, "Le fonds Atget du Victoria et Albert Museum," *Colloque Atget*, pp. 104–105. Abbott remembers the little sign, "Documents pour artistes," *The World of Atget*, p. ix.

28. The address is valid from July 1899 on, according to the receipts Atget left at that time when he did business at the Carnavalet.

29. It has been published in the *Argus Fildier, 1977* (Paris: Fildier, 1977), p. 8. The Bayard picture here is dated 1870; the postcard is numbered 100.

30. The photographs sold to the Bibliothèque de l'Arsenal are not credited to Atget, nor do the acquisitions records for his sale there exist. In the catalogue of Gaston Schéfer, *Catalogue des estampes, dessins et cartes composant le Cabinet des Estampes de la Bibliothèque de l'Arsenal* (Paris: Bureau de "l'Artiste," H. Leclerc, et Société pour l'étude de la gravure française, 1894–1929), for no. 248, the Atget photographs, one reads: "Paris. Monuments, rues, maisons, portes, jardins, etc. Photographies." They are mounted two to a page and seem to have been bound into an album by the library. The Atget photographs in question bear negative numbers ranging from 3044 to 3780 in the *L'Art dans le Vieux Paris* series and most of the pictures show topographical views of the city. The chief administrator of the library, Henri Martin, is listed in Atget's *répertoire* on pp. 37 and 39, identified as such on p. 39 and as the president of La Cité on p. 37 (La Cité was a Vieux Paris society). This would seem to indicate a prewar transaction. On Jacques Doucet and his library, see Gustave Babin, "La maison d'un amateur au vingtième siècle," *L'Illustration* (1912), pp. 475–82; Marie Dormoy, *La Bibliothèque d'Art et d'Archéologie, Fondation Jacques Doucet* (Paris: L. Giraud-Badin, 1930) and her *Jacques Doucet* (Paris: L. Giraud-Badin, 1930). Doucet and his librarian, Albert Vuaflart, are entered on pp. 17 and 39 of the *répertoire*. The highest negative numbers in that collection of Atget photographs are 1492 in the *Topographie*, 6121 in *L'Art dans le Vieux Paris*, and 438 in *Paris pittoresque*. All are dated 1913 by Atget on the mounts for the photographs sold to the Bibliothèque historique. Doucet gave his library to the state in 1918 for tax reasons; he began to build it in 1912. In 1912 he was already known as an amateur of Vieux Paris, and the same is true for Vuaflart,

who published an Atget photograph of the Hôtel Fles-selles in the 1908 bulletin of the Société d'iconographie parisienne, vol. 1, opposite p. 58. Atget most likely made a few small sales to Doucet the amateur and then after 1912 a few large ones to the library.

31. The count is undoubtedly a few thousand photographs low. I have counted only those lots that listed the numbers of photographs sold. I did not, in other words, extrapolate the number of photographs involved when only the price paid for them is given; nor did I count the number of photographs in albums if that number was not actually listed in the *registre*.

32. Atget letter to Léon, November 29, 1920. In the letter of November 12, he gave a list of references: "Musée de Sculpture Comparée; Musée du Trocadéro; M. Courboin, conservateur du cabinet des estampes à la Bibl^que Nationale; la grande Bibl^que de Londres; Board of Education; bibl^que des B^x Arts; bibl^que des arts décoratifs; M. André Michel, conservateur au Louvre." It resembles the list he gave the South Kensington Board of Education on November 19, 1902: M. Bouchot, conservateur du Cabinet des estampes de la bibliothèque Nationale; M. Caïn, conservateur du Musée Carnavalet. No Atget photographs have yet been found in the Louvre. André Michel did use some for his *Histoire de l'art*, 8 vols. (Paris: Colin, 1905–29); see vol. 8 (1921–22), pts. 1 and 2, and vol. 7 (1923), pt. 1.

33. "Bricard 39 Rue Richelieu (afternoon 2 o'clock–Grilles and Doorknocker) Saw the whole collection–4645 included–except for Grille St. Sulpice 7 January 1903–(23 francs)"; "Jules Bricard (Doorknockers and Stairways) mornings."

34. The collection has now gone to the Musée Bricard, Paris. It contains photographs from the *L'Art dans le Vieux Paris* series, ranging from 3880 to 5798.

35. The collection remains in the Jansen establishment on the rue Royale. It contains pictures from both the *L'Art dans le Vieux Paris* (3869–5729) and the *Environs* series (6919).

36. When Berenice Abbott asked André Calmettes about the identity of Atget's artist clients, he replied in a letter dated 13 April 1929 that the names of the artists were given in the "carnets" she had acquired, which implies that he thought she was in possession of the other *répertoires* too.

37. On p. 2, the entry for Sabattier could not have been written before 1905: the Bottin lists him elsewhere from 1900 through 1904.

38. For period sources on Detaille, see Louis Gillet, "Edouard Detaille: Peintre de la guerre moderne," *Lectures pour Tous* (September 1910), pp. 1082–92; *Bibliothèque de Feu Edouard Detaille. Vente 23–26 avril 1913* (Paris: Jules Meynial, 1913). On Sardou: Georges Mouly, *Les papiers de Victorien Sardou: Notes et souvenirs* (Paris: Albin Michel, 1934); *Bibliothèque de Feu M. Victorien Sardou*, 2 vols. (Paris: Librairie Henri Leclerc, 1909–10). On Sergent: R. Bétourné, *René Sergent: Architecte* (Paris: Madame René Sergent, 1931). On Jusseaume: Gustave Coquiot, *Nouveau manuel complet du peintre-décorateur de théâtre* (Paris: Roret, 1910).

39. Atget's own pagination stopped at page 44 and was probably done to aid this revision. The rest of the address book has since been given page numbers by someone else.

40. He said as much to Julien Levy, *Memoir*, p. 92: "He collected an archive of classified documents, at first to no particular end, he explained. Until the collection, over years, amounting to more than 4,000 careful photographs, became a record of aspects of a Paris that were to slowly vanish." Levy is using the total number of photographs in the Abbott-Levy collection now at the Museum of Modern Art, not counting the half of Atget's collection that had already been sold to Monuments historiques by the time Abbott had made her offer to Calmettes. Atget's total production numbered about eight thousand negatives.

41. Calmettes, undated letter to Berenice Abbott.

42. The exchange was given in Ferdinand Reyher's English rendition of Dignimont's version of the story as "You dirty old man, I know your beaux-arts." This seems rather too anglicized, though the insult was probably *dans le genre*. Reyher had the story secondhand from Dignimont, who had heard it from Atget. Atget was nearly arrested. Dignimont's story is known from several interviews with the artist: Beaumont Newhall's notes from his interview with Dignimont in 1952 are now on file at the International Museum of Photography at the George Eastman House, in Rochester; Reyher's notes from his interview in 1947 are now part of the Atget Archive, MOMA. Moreau's nude (*Paris pittoresque*, no. 14) was acquired from him by the photographer Marcel Bovis, who told me that he had only bought one Atget from the artist, but that Moreau had owned several of the nudes. Ilse Bing acquired several other photographs from Moreau. The permission card to photograph in the Louvre, valid only from 19 July–1 September 1921 is reproduced in Leroy, *Atget*, unpaged.

43. Jean Humbert has graciously pointed me toward this material. In addition to his book, *Edouard Detaille: L'héroïsme d'un siècle* (Paris: Copernic, 1979), see his

article, "*La Distribution des Drapeaux* d'Edouard Detaille, ou le centenaire d'un tableau détruit," *Revue de la Société des Amis du Musée de l'Armée*, no. 86 (1981), pp. 141–60. See also François Robichon's article on Detaille's work for the Hôtel de Ville, "A propos de trois esquisses d'Edouard Detaille," *Revue de la Société des Amis du Musée de l'Armée*, no. 85 (1981), pp. 89–101. Detaille had photographs made of the Barrière de La Villette in 1901, though he does not mention the name of the photographer. It could have been Atget, who made four photographs of La Villette that year.

44. The research done on the Laboureur collection by François Lepage is extremely useful. It was published in the catalogue of the sale of Laboureur's Atget photographs, "Exceptionnel ensemble de seize photographies d'Eugène Atget," Vente Nouveau Drouot, 24 April 1987. As Lepage points out, the same photograph was used again in 1921 for another print bearing the same title (Godefroy 217).

45. Ernest Hareux, *Cours complète de peinture à l'huile (l'art, la science, le métier du peintre)*, vol. 1 (Paris: Laurens, 1901), p. 88. Karl Robert, *Traité pratique de la peinture à l'huile (portrait et genre)*, 4th ed. (Paris: Laurens, 1910), p. 116. Albert Boime, *The Academy and French Painting in the Nineteenth Century* (London: Phaidon, 1971), especially chapter 8, "The Academic 'Etude': Generative Procedure." Jules Breton, *La peinture* (Paris: Librairie de l'art ancien et moderne, 1904), pp. 74–75, described the same process but gave it a mystical charge. Photographic studies had long been in general use by painters, so much so that the tax laws needed a special clause exempting those painters who made photographs for their own use from the photographers' *patente* tax. See Dalloz, "Patente," *Jurisprudence générale. Supplément au répertoire méthodique et alphabétique de législation*, vol. 12 (Paris: Bureau de la "Jurisprudence générale," 1893), p. 441. Rarely did photographers' manuals treat the genre; more often they simply and rather ambiguously advocated that painters learn how to make their own photographic documents. See Alexandre Ken, *Dissertations historiques, artistiques et scientifiques sur la photographie* (Paris: Librairie nouvelle, 1864), p. 241. For their part, painters' treatises touched upon this use of photography, but only to discourage it. Aaron Scharf, *Art and Photography*, 2d ed. (Harmondsworth: Penguin, 1974), and Van Deren Coke, *The Painter and the Photograph*, 2d ed. (Albuquerque: University of New Mexico Press, 1972), have shown in their research that most of the documents for artists that we know today were privately produced by the painters themselves or by others according to their specifications. Atget accepted these kinds of commissions for small packages of work. But he also produced documents for

another, generalized commerce in artist's studies, a commerce old enough to operate with conventions but never respectable and almost never discussed in print, Scharf and Coke included.

46. Camille Bellanger, *L'art du peintre* (Paris: Garnier frères, 1911), pt. 3, p. 35. See also Hareux, *Cours complète*, vol. 1, p. 84.

47. Widhopff's illustration accompanied the last installment of a story by Paul Margueritte, "Les Sources Vives," *Lectures pour Tous* (June 1913), p. 1084. He has used a photograph by Atget of the market at St. Médard in Paris, also in the collection of the Bibliothèque historique de la Ville de Paris, divers I, 36.

48. Albert Londe, *Album de chronophotographies documentaires à l'usage des artistes* (Paris: Mendel, 1903), laid out the transformation of the document in the eye and image of the artist. Kirk Varnedoe has studied the same point well and at length in his article "The Artifice of Candor: Impressionism and Photography Re-considered," *Art in America* 68 (January 1980), pp. 66–78. See also André Jammes and Eugenia Parry Janis, *The Art of French Calotype* (Princeton: Princeton University Press, 1983); Jean Sagne, *Delacroix et la photographie* (Paris: Herscher, 1982); Isabelle Jammes, *Blanquart-Evrard et les origines de l'édition photographique française. Catalogue raisonné des albums photographiques édités, 1851–1855*, Centre de recherches d'histoire et de philologie de la quatrième section de l'Ecole pratique des Hautes études, VI. Histoire et civilisation du livre, 12 (Geneva: Droz, 1981); Elizabeth Anne McCauley, *A. A. Disdéri and the Carte de Visite Portrait Photograph* (New Haven: Yale University Press, 1985); André Rouillé and Bernard Marbot, *Le corps et son image: Photographies du dix-neuvième siècle* (Paris: Contrejour, 1986).

49. Karl Robert, *Leçons pratiques de dessin au fusain appliquées aux modèles du cours de paysage de A. Allongé* (Paris: Goupil, 1876); Armand Cassagne, *Guide de la nature chez soi (suite aux modèles à silhouette)* (Paris: Fouraut, 1886); Ernest Hareux, *Cours complète*; Hector Allemand, *Causeries sur le paysage* (Lyon: Louis Perrin et Marinet, 1877), pp. 17–18, gives a good account of the visual work of looking at nature and making the study picture.

50. The Philadelphia painter Milton Bancroft filed four early Atget landscape studies into one of his scrapbooks, formerly in the collection of the Daniel Wolf Gallery, New York.

51. The *effet* was related to the *impression,* the *effet* holding fewer indications of the painter's subjectivity, the *impression* being the more personal study. See Alle-

mand, *Causeries*, pp. 9ff.; Boime, *The Academy*, pp. 18ff; and Richard Schiff, *Cézanne and the End of Impressionism* (Chicago: University of Chicago Press, 1984). Schiff has worked out a valuable analysis of nineteenth-century painting practice using the language of the period. His primary distinction, between making and finding, could be extended to show how finding in fact derives from the process of studying described above.

52. Albert Guillaume, "Comment on devient humoriste," *Lectures pour Tous* (December 1913), p. 604.

53. Hareux, *Cours complète*, vol. 1, pp. 39 and 101, respectively.

54. Walter Benjamin, "A Short History of Photography," trans. Stanley Mitchell, *Screen* (Spring 1972), pp. 5–26: "Not for nothing have Atget's photographs been compared with those of a scene of action" (p. 25). For "crime," see Phil Patton's translation of the same article in *Artforum* 15 (February 1977), pp. 46–51. The word in question is *Tatort,* which can be read both ways; given Benjamin's interest in detective stories and social injustice, "crime" is probably not too strong.

55. Maria Morris Hambourg, "A Biography of Eugène Atget," *The Work of Atget*, vol. 2, pp. 11ff.

56. *Répertoire*, pp. 33, 67.

57. *Répertoire*, p. 67.

58. *Répertoire*, pp. 11–12.

59. P. Calmettes, *Excursions à travers les métiers* (Paris: Juven, 1904), p. 144.

60. Vicomte Georges d'Avenel, *Le mécanisme de la vie moderne* (Paris: Colin, 1902), vol. 4, p. 204.

61. Gustave Coquiot, *Nouveau manuel complet du peintre-décorateur de théâtre* (Paris: Roret, 1910), pp. 101–02. See also Henriquez-Philippe, "Une exposition de maquettes de théâtre," *Les Annales Politiques et Littéraires*, no. 1562 (1 June 1913), pp. 470–71; Jules Claretie, "Les artistes décorateurs," on the same pages as the article by Henriquez-Philippe; Moutier, *Traité pratique et simplifié de la peinture à la détrempe appliquée aux décors de théâtre, et conseils pour l'application d'une scène* (Orléans: Jeanne d'Arc, 1911); Thiébault-Sisson, "Décor et décorateurs du théâtre," *L'Illustration* (24 February 1894), pp. 155–57.

62. Silvio Fuso and Sandro Mescola, *Mariano Fortuny Collezionista: Alinari, Atget, Bonfils, Laurent, Quinet, Sella* (Milan: Electa, 1983).

63. The agency was called International Kinema Research. On the Séebergers' work for them see the catalogue of their work made for the exhibition at the

Bibliothèque historique de la Ville de Paris, *Les parisiens au fil des jours (1900–1960). Séeberger frères* (16 November 1979–15 January 1980), p. 7.

64. Hippolyte Taine, *Philosophie de l'art* (Paris: Baillière, 1865). Hugues Rebell, "L'histoire de l'esprit français, 1850–1900: Taine, ou l'intelligence moderne," *La Plume* 13 (1902), p. 665, had this to say about the use and abuse of Taine: "Ce qu'il y a de vraiment caractéristique, c'est que l'université socialiste, révolutionnaire ou anarchiste réclame M. Taine avec non moins de force que le groupe nationaliste; et je ne sais pourquoi, les philosophes de la monarchie le mettent à côté de Maistre, qu'il ne pouvait souffrir. Il semble que M. Taine soit de ces hôtes aimables que tout le monde veut avoir sous son toit. C'est l'avocat de tous les parties; ou plutôt c'est l'adversaire de tous les causes; et si les bibliothèques municipales ont son *Ancien régime,* en revanche les bibliothèques religieuses possèdent sa *Révolution.*" Henry Havard, *Histoire et philosophie des styles (architecture, ameublement, décoration)*, 2 vols. (Paris: Schmid, 1899–1900), p. iii.

65. Edouard Poteau, *Exposition internationale de Milan 1906. Section française. Papiers peints, tapis, décoration, meubles: Classes 68 à 71* (Paris: Comité français des expositions à l'étranger, 1910), p. 18.

66. My understanding of this drive toward a modern style is greatly indebted to Nancy Troy, who kindly allowed me to read the manuscript of her book, *Modernism and the Decorative Arts in France: Art Nouveau to Le Corbusier* (New Haven: Yale University Press, 1991). For the industry as a whole, see Paule Garenc, *L'industrie du meuble en France* (Paris: Presses Universitaires de France, 1958); and Pierre Du Maroussem, *La question ouvrière*, 4 vols. (Paris: A. Rousseau, 1891–94). For art nouveau ideology, see Debora L. Silverman, *Art Nouveau in Fin-de-Siècle France: Politics, Psychology, and Style* (Berkeley: University of California Press, 1989). For a discussion of the way in which the classical and the national combined in the discourse on culture during the First World War, see Kenneth E. Silver, *Esprit de Corps: The Art of the Parisian Avant-Garde and the First World War, 1914–1925* (Princeton: Princeton University Press, 1989).

67. The grades of the building industry were set out in the *patentes* categories, which were something like tax brackets. See Armand Désiré and Edouard Dalloz, "Patente," *Jurisprudence générale. Supplément au répertoire méthodique et alphabétique de législation*, vol. 12 (Paris: Bureau de la "Jurisprudence générale," 1893). Atget's *répertoire*, p. 66, has an entry for the Printemps atelier; the page dates 1913–1914. *Atelier Primavera au Printemps* (Paris: Printemps, 1923) assessed the first ten years of the studio.

68. To the Curator of the Museum,

I am in a position to put at your disposal a superb compendium of photographs of Vieux Paris and its outlying regions, the details of which follow.

Le Vieux Paris.

1– Town houses
2– Historic or curious houses
3– Old Streets and Aspects
4– { The quais, bridges, Ports,
 Markets, Squares and Gardens.
5– Fountains and Wells
6– Artistic Doorways (Carved wood panels)
7– Doorknockers and Masks
8– Stairways (wood and wrought iron
 (private houses)
9– The Signs – Boutiques
 and Cabarets

 1000 images (to be continued

10– Types and Street trades
 (200 images)

The Smaller Outlying Districts of Paris

Immediately outlying districts
Gentilly – Aulnay – Montmorency
Bicetre – Sceaux – Pontoise
Robinson – St Denis – Meudon
 etc et
etc etc – et Versailles
 corners of the Park
in all 400 images (to be continued

In preparation The Greater Outlying Districts of Paris

69. The Ecole Boulle owns some of Atget's earliest pictures from the *Paysages Documents divers* series, ranging from nos. 12 through 1120, some bearing his Clermont (Oise) stamp, which would suggest a sale there before 1900.

70. See Atget's letter dated February 1902 to the Commission municipale du Vieux Paris, Archives de la Commission du Vieux Paris, Rotonde de la Villette.

71. Ecole Nationale Supérieure des Beaux-Arts, *La photographie comme modèle: Aperçu du fonds de photographies anciennes de l'Ecole des Beaux-Arts* (Paris: Ecole des Beaux-Arts, 1982).

72. See the *répertoire*, pp. 39, 40, and 61. The Rothschilds were founding members of the Union Centrale; Morgan was mounting his collection of objects and art.

73. The Cuvillier collection remains in the family. It includes work from the *L'Art dans le Vieux Paris* series (the nos. fall between 3017 and 4776) and the *Environs* series (6023, 6207).

74. For illustrations of the work of Atget clients working off the older styles, see Th. Lambert, *Nouveaux éléments d'architecture. 6ᵉ série. Hôtels privés* (Paris: Schmid, n.d.); and Gaston Lefol, *Hôtels particulièrs: Intérieurs. Décoration et ameublement. Vestibules, chambres, salons, salons à manger* (Paris: Massin, n.d.).

75. J. Guadet, *Eléments et théorie de l'architecture: Cours professé à l'Ecole nationale et spéciale des Beaux-Arts* (Paris: Aulanier, 1901–04), vol. 1, p. 35. See also Richard Chafee, "The Teaching of Architecture at the Ecole des Beaux-Arts," in *The Architecture of the Ecole des Beaux-Arts*, ed. Arthur Drexler (New York: MOMA, 1977), pp. 61–110.

76. See also Th. Chaussard, *Essai de vulgarisation de principes d'art décoratif et de dessin suivi d'un cours de botanique artistique* (Caudéran: Bissey, 1912), p. 15, for a discussion of documents for decorators.

77. See also J. Pierpont Morgan, Collector: European Decorative Arts from the Wadsworth Atheneum, ed. Linda Horvitz Roth (Hartford: Wadsworth Atheneum, 1987).

78. André Pératé and Gaston Brière, *Collections Georges Hoentschel* (Paris: Librairie centrale des beaux-arts, 1908), vol. 1, p. III, from the introduction by Pératé. Hoentschel kept them all safely in his *hôtel particulier* on boulevard Flandrin, its rooms hung, or rather, lined, or better, decorated with documents. Atget photographed one of these rooms, probably about the time Hoentschel (Atget spelled it Hetchel) determined to sell its contents to J. P. Morgan, which is to say around 1906 or 1907. This salon served as a living room and a study room; others were best called store rooms, but all of them displayed the collection. The Atget pictures were eventually numbered 530 through 533 and filed with his other interiors of professionals in the *Paris pittoresque* series.

79. Ibid., vol. 2, p. iv, from the introduction by Brière.

80. Jansen's folios are to be found in the design studio of the Jansen boutique at 6 rue Royale, Paris.

81. The Davesne reference is visible on an undercover of "Album No 1 Vieux Paris les Escaliers," MOMA, Atget Archive. The rest of the title of the undercover is only partially visible but it too was an *escalier* album.

82. Verneuil, the name used by Maurice Pillard, was listed in Atget's *répertoire* as a student of Grasset on p. 24. Grasset is listed by name only on p. 5. Eugène Grasset, *La plante et ses applications ornementales*

(Paris: Lévy, 1897–1901). See Charles Fry's introduction to *Art Nouveau Floral Ornament in Color by M. P. Verneuil* et al. (New York: Dover, 1976). Atget owned a copy of A. E. Brehm, *Les plantes* (Paris: n.d.), and it may have helped him work out the structure of the botanical photographs. The use of photographs in the applied arts was by no means new. See Philippe Burty, "Revue photographique," *Gazette des Beaux-Arts*, ser. 1, vol. 7 (1860), p. 252, on the flower pictures of Adolphe Braun and their use by "artistes industriels." Also Elizabeth Anne McCauley, "Photographs for Industry: The Career of Charles Aubry," *J. Paul Getty Museum Journal* 14 (1986), pp. 157–72.

83. Atget letter to Paul Léon, 29 November 1920.

84. In the collection of Atget's step-grandson, Valentin Compagnon.

85. Lucien Lambeau, "L'aménagement artistique et historique des cités," in the Commission municipale du Vieux Paris, *Procès-verbaux* (11 November 1905), p. 164.

86. Paris, Nov. 12, 1920
Sir,

For more than twenty years, out of my own individual initiative and work, I have gathered from all the old streets of Vieux Paris photographic images, 18 × 24 format, artistic documents of the beautiful secular architecture of 16th to the 19th cent.: The old hôtels, historic or curious houses, the beautiful façades, beautiful doors, beautiful woodwork, the Door knockers, the old fountains, the stairways *de style* (wood and wrought iron); the interiors of all the churches of Paris (Ensembles and artistic details: Notre Dame, Sᵗ Gervais et Protais, Sᵗ Séverin, Sᵗ Julien le Pauvre, Sᵗ Etienne du Mont, Sᵗ Roch, Sᵗ Nicolas du Chardonnet, etc etc.

This vast artistic and documentary collection is today complete. I might say that I possess all of Vieux Paris.

Moving toward the age, that is to say toward the age of 70, having neither heir nor business successor to follow, I am tormented and worried about the future of this beautiful collection of images which could fall into the hands of someone ignorant of its value and end up disappearing, to no one's benefit. I would be very happy, sir, if it were possible for you to be interested in this collection. Naturally you could not consider my request without having references regarding either my collection or myself. For your information: I have sold my entire collection, 18 × 24 prints, to the Musée de Sculpture Comparée, Musée du Trocadéro. I have sold the entire picturesque side of it, old streets, old corners, to Mʳ Courboin, curator of the cabinet des estampes at the Biblᑫᵘᵉ Nationale, I have sold the entire collec-

tion, architecture and picturesque to the great Library of London, Board of Education and fragments of the collection to the library of the Bˣ Arts, to the library of arts décoratifs and, to Mʳ André Michel, curator at the Louvre. Finally, I am, sir, at your disposition, and will, upon a word from you, send my references regarding Vieux Paris and any explanations it would please you to have.

87. Hélène Duchaussoy, "Archives photographiques du patrimoine au Fort de Saint-Cyr," *Colloque Atget*, p. 101, explains that Léon cited the law of 31 December 1913 on *monuments historiques* as part of his justification of the purchase. The law specified enabled the state to classify and protect buildings from modification even while they remained in private hands. See Léon's books *Les monuments historiques: Conservation, restauration* (Paris: Renouard, 1917) and *La vie des monuments français: Destruction, restauration* (Paris: Picard, 1951). On Léon's tenure at the ministry, see Jeanne Laurent, *Arts & pouvoirs en France de 1793 à 1981: Histoire d'une démission artistique*, 3d ed. (St. Etienne: CIEREC, 1983), pp. 112ff. Calmettes's correspondence with Léon has not survived. On the Commission des Monuments historiques and their Archives photographiques, see J.-J. Poulet-Allamagny and Philippe Néagu, "Caisse nationale des monuments historiques et des sites: Les Archives photographiques des Monuments historiques," *Monuments historiques de la France*, no. 110 (1980), pp. 53–67; Philippe Néagu et al., *La mission héliographique: Photographies de 1851* (Paris: Inspection générale des musées, 1980); Antonin Proust, *L'art sous la république* (Paris: Charpentier, 1892).

88. Cain's notes and drafts for his many books have been preserved: the Musée Carnavalet has a series of seven bound volumes entitled *Coins de Paris*, which contain the manuscripts of Cain's books bound together with miscellaneous photographs, some amateur and some professional, and other illustrative material. Certain of these pictures become the illustrations to the books. Only one Atget photograph appears in the entire series: it is "Hôtel r. Lhomond, 27," *L'Art dans le Vieux Paris* series no. 4444, and it was not published. Also included in these compendia are a number of letters from Cain's admirers; among these are two letters from Calmettes, one dated 1905. The citation is taken from the other letter. This might explain why four Atget negatives of Calmettes's apartment and garden at 29 rue St. Guillaume, taken in September 1922 and bearing the negative nos. 6399–6402, turned up at the Carnavalet. The pictures are dated in the paper album, "Référence 1922 Vieux Paris 6381–6432," at the Museum of Modern Art.

89. The description of the duties of the third *sous-commission* is found in the first group of minutes published by the Commission municipale du Vieux Paris, *Procès-verbaux* (28 January 1898), p. 4.

90. Commission municipale du Vieux Paris, "Notice rédigée par L. Lambeau destiné à être remise aux visiteurs de l'exposition spéciale," *Procès-verbaux* (19 July 1900), p. 129—"spéciale" meaning the Exposition Universelle held in Paris that year which saw a Vieux Paris fabricated on the fairgrounds under the auspices of the Commission du Vieux Paris.

91. A. P. Martial, *Paris intime* (1874), in his introduction to the portfolio wrote: "On peut dire que le sujet n'est pas suffisament étudié;—qu'il intéresserait tout autant qu'une restitution antique;—édifiant mieux l'avenir, et aurait certainement quelques chances d'éveiller sur l'époque actuelle et les pas qu'elle doit faire des idées plus nettes et précises. Conduit par cette évidence et pressentant que pour cette fin,—il n'est mince exemple—ni coin chétif:—voici quelques images—qui donneront une idée de ce que l'on rencontre sans beaucoup de peine; et la mesure de ce que l'on pourrait découvrir—de ce que l'on apporterait aux penseurs et aux déductions profitables; si les puissants objectifs de la science et de l'utile observation s'appliquaient sur Paris, au lieu de se tourner passionnément sur l'âge du Bronze, les spongiaires et les fossils." Henri Clouzot, "L'Haussmannisation de Paris," *Gazette des Beaux-Arts*, ser. 4, vol. 4 (1910), pp. 361–62: "Certes nous n'avons pas le fétichisme des ruines. Nous ne voyons nul inconvénient, si l'hygiène et la nécessité de la circulation l'exigent, à remplacer par une plaque commémorative telle bâtisse dont les souvenirs historiques font le seul intérêt. Mais il y a autre chose dans Paris. D'admirables façades de vieux hôtels, des jardins, des parcs, nous ont été légués par les âges précédents, et constituent un patrimoine de beauté que nous avons le devoir de conserver." Which is to say, a fetishism for ruins must accede to the needs of a modern city at the same time that beautiful history should be conserved. Yet it is not said how to distinguish the indispensable from the dispensable. There was more of an argument here than Clouzot let on. Gustave Coquiot satirized the amateur de Vieux Paris in his *Vagabondages à travers la peinture et les paysages les bêtes et les hommes* (Paris: Ollendorff, 1921), pp. 3–4. Speaking was his character Doucette (Doucet?): "—Oui, il faut être de son temps, bon Dieu! . . . Oui, il faut être fortement de son temps! . . . Moi, qui vous dis cela, j'ai gémi, aller, comme vous tous; j'ai fatigué de mes clameurs le ciel en voyant le pic et la pioche éventrer des murailles pourrissantes, des boiseries rongées; j'ai protesté avec les cris les plus déchirants contre l'assèchement de vieux ports croupis, contre la démolition de vieux

quartiers où s'épanouissent toutes les plus dévorantes maladies! . . . Ah! oui, cher Monsieur, je les ai défendus—et de toutes mes forces!—les beffrois centenaires, les tours décrépites et les murailles gallo-romaines et les remparts des Sarrazins! Et quand je sentais que j'allais faiblir, quand toute cette puanteur des pierres me remontait au nez, me suffoquait, quand je me disais que, moi aussi, j'en avais assez de toute cette pourriture des choses, vite je me précipitais dans un train pour Rome, et j'allais me retremper dans cette ville où, chaque jour, des caravanes vont admirer, renifler des déliquescences architecturales, des massacres de choses, des fientes du passé!" (ellipses in original).

92. On June 2, 1898, the third *sous-commission* proposed a uniform formula by which to ask for documents: "Elle contiendra l'indication sommaire du point ou de l'objet à reproduire," *Procès-verbaux* (2 June 1898), p. 34. The order for the Hôtel de Montmorency documents was made on January 19, 1899, and given in the *Procès-verbaux* (19 January 1899), p. 26.

93. *Procès-verbaux* (14 November 1901), pp. 160–61; (16 January 1902), pp. 23–24; and (9 November 1910), p. 91.

94. Auguste Callet, "Porte de l'Hôtel de Hollande," *La Cité* (1913), p. 277. The photograph in question is from the *L'Art dans le Vieux Paris* series, no. 4076. The Marais held out other possibilities, as was shown in the fuller description of its life given by Lucien Descaves, "Of Open Spaces," in the Académie Goncourt book *The Colour of Paris* (London: Chatto & Windus, 1908), pp. 55–56: "Here and there one catches a glimpse of a bas-relief, a gable, a carved door, a sculptured mask, a balcony, a fountain, or one sees aged figures seated in silence with a dog at their feet, or a cat on their knees; and this is enough to brighten the atmosphere of an oppressive afternoon in this crowded quarter, with its entire population rushing to catch trams, 'buses, cabs, or the *Métro*."

95. Charles Fegdal, "Un grand collectionneur d'iconographie parisienne," *L'Art Vivant* (March 1920), p. 698. Hartmann is listed in Atget's *répertoire* on p. 45. Other collectors did not buy in such quantity. Paul Blondel's collection, now in the Cabinet des Estampes et de la Photographie of the Bibliothèque Nationale, Paris, contains many postcards and only forty-five Atget photographs. Hartmann's collection now forms part of the collection of Yvan Christ. These documents sprang into service as required. Atget documented the Hôtel de la Reine Hortense just before its demolition on October 10, 1899. Hartmann acquired it as a worthy record, and years later the editor of *Le Vieux Montmartre* published it, a welcome illustration to J. Mauzin's "Ordonnances et visites de police à Montmartre au dix-huitième siècle" (1927), opp. p. 85.

96. *Enseignes et Vieilles Boutiques de Paris.* For a summary of Atget's sales to the libraries, see Françoise Reynaud, "Richesses des collections publiques françaises," *Colloque Atget*, pp. 93–99.

97. Marcel Poëte, "Leçon d'ouverture du cours d'introduction à l'histoire de Paris professé à la Bibliothèque de la Ville," *Revue Internationale de l'Enseignement* (1904), pp. 14–15. Marcel Poëte, "Les sources de l'histoire de Paris et les historiens de Paris," *Revue Politique et Littéraire* (18 November 1905), p. 13. A great project in urban history did eventually come out of the Bibliothèque historique in the 1920s, when Poëte published his *Une vie de cité: Paris de sa naissance à nos jours*, 3 vols. and album (Paris: Picard, 1924–31). Its relation to the collections of the Bibliothèque historique deserves further study, but no mention is made of this project in the publications of the bibliothèque before the war and the collection there seems to have been formed to serve a variety of historical needs. On the clarity factor in the historical document, see G.-H. Niewenglowski, *Les applications de la photographie* (Paris: Garnier frères, 1907), p. 21.

98. Atget actually sold in small lots to the Carnavalet, as the receipts from the early sales of 1899–1902 show; when entered in the registers these sales were grouped periodically under single acquisition numbers, for example acq. no. 5759. Here, as at the Bibliothèque Nationale, Atget had to arrange to be paid through a dealer; at the Carnavalet it was Danlos, for administrative reasons.

99. The nature of this series, called the *Topographie de Paris*, has been studied in depth by Maria Morris Hambourg in her thesis, "Eugène Atget, 1857–1927: The Structure of the Work" (Ph.D. diss., Columbia University, 1980). See also her essay "A Biography of Eugène Atget," in *The Work of Atget*, vol. 2, pp. 9–41, as well as her note to pl. 91, p. 186; and her essay "The Structure of the Work," in *The Work of Atget*, vol. 3, pp. 9–33. The work of Marville has recently been given excellent study by Marie de Thézy in her catalogue for the Bibliothèque historique, *Charles Marville: Photographe de Paris de 1851 à 1879* (1980), and in her essay "Marville et la naissance du Paris d'Haussmann," *Colloque Atget*, pp. 46–51. She and Roxanne Debuisson are currently at work on a catalogue raisonné for Marville. Maria Morris Hambourg has written well about the differences between Marville's project and Atget's in her essay "Charles Marville's Old Paris," for the Alliance Française catalogue, *Charles Marville: Photographs of Paris, 1852–1878* (1981).

100. Charles Magny, *La beauté de Paris: Conservation des aspects esthétiques* (Paris: Tignol, 1911), p. 2: "C'est la physionomie particulière de la Ville qui est en jeu, il s'agit, de son aspect esthétique, de la beauté de ses perspectives: d'ailleurs, les rues de Paris n'ont-elles pas un caractère propre et en quelque sorte une vie spéciale?" Anthony Sutcliffe's book, *The Autumn of Central Paris: The Defeat of Town Planning, 1850–1870* (London: Edward Arnold, 1970), is also relevant for its discussion of city government and urbanization in the center city. Jeanne Gaillard's book, *Paris la ville, 1852–1870* (Paris: Champion, 1977), is invaluable.

101. Christopher Hussey, *The Picturesque: Studies in a Point of View* (London: Frank Cass, 1927). Peter Conrad, "The City and the Picturesque," in his book *The Victorian Treasure House* (London: Collins, 1973), pp. 65–105. Roland Barthes, "Le guide bleu," in his *Mythologies* (Paris: Seuil, 1957), pp. 121–25. See also Eugenia Parry Janis, "Demolition Picturesque: Photographs of Paris in 1852 and 1853," in *Perspectives on Photography: Essays in Honor of Beaumont Newhall*, ed. Thomas F. Barrow and Peter Walch (Albuquerque: University of New Mexico Press, 1986), pp. 33–66.

102. Morris Hambourg, "Eugène Atget," p. 278.

103. Bibliothèque historique de la Ville de Paris, *Constitution d'un patrimoine parisien: La Bibliothèque historique depuis l'incendie de 1871* (1980), p. 47. Poëte's draft for his letter to Atget survives, and it reads:

13 juin 1912

Sur votre avant-dernière livraison de photographies, seize épreuves sont en trop mauvais état pour que je les accepte. Ci-joint votre mémoire rectifié en ces épreuves et que je vous [illegible] de vouloir bien approuver en le [illegible] aux endroits marqués. J'ajoute que dans votre dernière livraison, dans autres photographies également sur les Tuileries ne me donnent point satisfaction et sont à votre disposition. De cette dernière livraison de photographies sur les Tuileries seuls vous [illegible] ici [illegible], les autres ne l'ayant pas été, vous devrez les reprendre.

Recevez, Monsieur, l'assurance de mon [illegible] distingué.

M.P.

104. June 14, 1912

Sir,

I am astonished by your letter. I showed Mr. Beaurepaire the photos, Topography of the Tuileries, and to complete the bill, several photos, Topography of Vieux Paris. I showed these photographs, with witnesses present, to Mr. Beaurepaire, who accepted them, with witnesses still present. I even asked him if it was necessary for me to wait for you, he replied that "being very busy with your exhibition, it was impossible to see you and that he himself would take care of things. It pleased Mr. Beaurepaire, at the end of our little discussion and, out of rancor, to raise a new difficulty, at his own convenience. I shall not follow his lead. I send you the corrected bill. I deeply regret, sir, these small-minded discussions, especially given the immense work I have undertaken out of love for Vieux Paris, more than for any profit that it might bring, in my opinion it seems that this labor merits a little more indulgence.

Respectfully,

E Atget

105. Morris Hambourg has drawn different conclusions from this incident, perhaps because she did not try to account for the little 1s and little 2s (see note 106), in *The Work of Atget*, vol. 3, pp. 22–23. Her argument hinges on the idea that neither the park nor the assignment to document its every statue was very inspiring to Atget: "With these Atget's patience and imagination wore thin; constrained to record every sculpture, he framed and exposed his plates carelessly. When Poëte expressed dissatisfaction and refused some of these photographs, Atget's frustration became explicit. . . . But this was only the surface symptom of the real problem, which was that adopting other people's values in place of his own was finally impossible" (p. 23, my ellipsis). Yet these other values were going to form the basis of Atget's series after the war at St. Cloud, the series in which Morris Hambourg sees fact turning to ether, work into art, *self*-expression. In this instance, her account does not quite square with itself. The confrontation at the Bibliothèque historique was not aesthetic in nature; those qualities simply were not criteria for the judgment of topographical file documents.

106. The lots in question were acquisitioned as 42504 and 42535. Some of them have a small "1" and "2" written in the upper left corner on the back of the mount in Atget's hand, which would suggest a first and a second print. The 1s were probably the contested prints, the 2s their replacements. In some cases the "1" prints are spotty; in others, the prints are acceptable even now. Others with the "1" and "2" in the Tuileries group have no accession number, but this is true of a number of the pictures Atget made for the library after 1912, which seem to have been entered into the collections in a lackadaisical manner and, as mentioned, never filed. The work Atget went on to do for the library after 1912 was, Morris Hambourg has explained, less systematic and might respond to an agenda of Poëte's; on this, see her thesis, "Eugène Atget," pp. 295ff. There is unfortunately

a troublesome detail to report: Poëte's lack of interest. When Marcel Poëte published his book on the Tuileries, *Au jardin des Tuileries: L'art du jardin. La promenade publique* (Paris: Picard, 1924), he used no photographs to illustrate his subject, only prints; when he published his monumental *Une vie de cité: Paris de sa naissance à nos jours* beginning in 1924, with three volumes of text and an additional album of pictures, only one Atget photograph appeared (fig. 370 on p. 344 of the album), uncredited and retouched to eliminate a little boy. A print for the image could be found in the topography file (XXV, 142), "Fontaine Rue de Sèvres. 7ᵉ arron 1899."

107. See Morris Hambourg, "Eugène Atget," p. 199. The photograph, *L'Art dans le Vieux Paris* series, no. 5164, went into the archives of the Commission municipale at La Rotonde de la Villette, where it remains, along with a letter from Atget regarding the terms of the sale. The photograph was reproduced with the minutes of the July 8, 1916, meeting. The Bibliothèque historique acquired the picture in 1905 (acq. no. 38813); it is dated 1905 on the mount.

108. He reintegrated it by pulling out certain views of streets, hotels, and picturesque corners into paper albums of their own, now known through the interleaves of the paper albums at the Museum of Modern Art. See "No 5 Reférence 1923 Vieux Paris 6433–6492" and "Le Vieux Paris Les Fontaines, les Portes, Heurtoirs, les Escaliers 4 série 1902" (an undercover for a later album).

109. Georges Cain, *Nouvelles promenades dans Paris* (Paris: Flammarion, 1908), pp. 390–91, ellipsis mine. With enough of a haze, one could move into pictorialism, though Atget would not have approved. See, however, G. Vieuille, *La photographie artistique et les petits appareils* (Paris: Gauthier-Villars, 1915), pp. 79ff. Léon Daudet, *Paris vécu* (1929; reprint, Paris: Gallimard, 1969), pp. 24–25, using the picturesque as the controlling metaphor, described the Marais as a Rembrandt painting. Poverty, in other words, was a masterpiece.

110. J.-K. Huysmans, "La Bièvre," *Croquis parisiens* (Paris: Vanier, 1886), p. 81; there were later editions in 1890, 1898, 1901, and 1914, though the title varies. Adrien Mithouard, *La perdition de la Bièvre* (Paris: Bibliothèque de l'Occident, 1906). Jeanne Capitan, *Notules sur la Bièvre* (Paris: Champion, 1909). Anatole Béry, *La Bièvre* (Paris: Ficker, 1911). Elie Richard, *Paris qui meurt* (Paris: Figuière, 1923). Martial's print depended heavily upon a Marville photograph, no. 305, "Rivière de Bièvre."

111. *Receuil sur la Bièvre: Envoi de la Commission du Vieux Paris. Ex libris: L'Esprit.* The unique copy is in the collection of the Bibliothèque historique de la Ville de Paris.

112. Cain, *Nouvelles promenades*, p. 402.

113. Capitan, *Notules*, p. 8.

114. In addition to *Nouvelles promenades*, see his other books, especially *Coins de Paris* (Paris: Flammarion, 1905) and *Promenades dans Paris* (Paris: Flammarion, 1906).

115. Calmettes's letter to Cain in Cain's ms. albums *Coins de Paris*, vol. 1. The letter is undated but was probably written before the war when Calmettes lived at 16 rue de la Paix, the letter's return address.

116. Jouas illustrated *Le quartier Notre Dame* in 1905, *La cathédrale* in 1907 and 1920, *Trois églises* in 1920, and *Croquis parisiens* in 1928. See also his illustrations for Cain's book *La Seine au point de jour à Bercy* in 1927. Jouas lived in the cour de Rohan and liked to draw Paris from the rooftops; the views Atget made of the cour and its upper stories were probably made with Jouas in mind. Jouas is listed on pp. 9 and 72 of the *répertoire;* his name is given as a referee on pp. 74 and 76. On p. 72 Atget noted that his wife wanted flower documents.

117. On the back page of one of Atget's later paper albums, "Album no 11 Versailles Trianon du No 1202" (now in the Atget Archive), is written in very large script "Modele Cartes Postales." There is no further indication of the postcard project to which this might refer.

118. "In front of the Puppet Theater on the Champs-Elysées. From a snapshot by Mr. Atget." Charles Simond, *La vie parisienne à travers le dix-neuvième siècle: Paris de 1800 à 1900 d'après les estampes et les mémoires du temps* (Paris: Plon, 1901), vol. 3, p. 247.

119. The entire series has been published in "L'album de cartes postales—'les p'tits métiers de Paris' Eugène Atget, 1857–1927," *Guide pratique de la carte postale, numéro hors série du "Collectionneur français"* (1981), pp. 37–40. The postcard already reproduced as fig. 12 and its pendant, "Avant la guerre," indicate another, probably earlier series, but no other trace of it has yet surfaced.

120. Atget letter to Poëte, 2 August 1916, Archives de la Commission du Vieux Paris, Rotonde de la Villette.

121. Reyner, *Manuel pratique*, pp. v–vi. See also "La création et le lancement d'un magazine," *Je Sais Tout* (May 1905), pp. 491–97.

122. The magazines appear on p. 36: *American Architect, Architectural Record, Industrial Publication Co.* Codman's name is given on p. 12, which is to say ca. 1906. The name of the American Art Association of Paris is given on p. 19.

123. J. Mayor, "Possessions austro-allemands à Paris—l'Hôtel de Matignon," *La Renaissance de l'Art Français* 2 (1919), pp. 295–301. See *répertoire*, pp. 72, 76, 78, 80, for entries involving Mayor. F. Bournon and A. Dauzat, *Paris et ses environs* (Paris: Larousse, 1925), p. 200.

124. See, for another example, the case of the photographer Henri-Paul-Emile Godefroy, one of the photographers patronized by the Commission municipale du Vieux Paris (he was also a member of the commission). According to the entry for him in *Les archives biographiques contemporains* 1 (1905), p. 282, he was the "elève de Léon Coignet, il débuta de bonne heure aux Salons annuels avec des portraits, parmi lesquels on remarqua notamment ceux de MM. Thiébaud, ancien maire de Paris; Géraud, secrétaire général de la Cⁱᵉ des Chemins de Fer du Nord, etc. Obligé de quitter la carrière de l'art pictural, par des nécessités impérieuses, M. Godefroy se consacra à l'art industriel, dont il pratiqua presque toutes les branches: lithographie, décoration, etc. Il s'adonna, en même temps, à la photographie, qui le prit bientôt tout entier. Photographe des Ponts et Chaussées depuis 1875, M. Godefroy l'est devenu, depuis, de l'Assistance publique de Paris, du Génie Civil, des grandes Compagnies de Chemins de fer et de la commission du Vieux-Paris. Il a été aussi le photographe de MM. Menier et de La Martelière, pour leurs usines, et de nombreuses autres industries." Suffice it to say, this was not Atget's league. On the nineteenth-century case generally, see Elizabeth Anne McCauley, "Of Entrepreneurs, Opportunists and Fallen Women: Commercial Photography in Paris, 1848–1870," in *Perspectives on Photography*, pp. 67–97. See also Ulrich Keller's pair of extraordinary articles on the amateur, which is to say antiprofessional, culture of pictorialism, "The Myth of Art Photography: A Sociological Analysis" and "The Myth of Art Photography: An Iconographic Analysis." For a contemporary sense of the difference between amateur and professional, see A. Bigeon, *La photographie et le droit* (Paris: Mendel, 1894), pp. 136–38, which bears quoting in this context:

> Sont *amateurs*, et peuvent être réputés tels, ceux qui, indépendamment de leurs occupations ordinaires, soit comme passe-temps agréable, soit comme pure satisfaction d'amour-propre, paraissent avoir un goût marqué, une prédilection particulière pour certaine branche d'une science ou d'un art; ils la cultivent passionnément, avec une intention artistique bien exercée, sans qu'aucune idée de lucre ou de bénéfice vienne en ternir le sentiment désintéressé.
>
> Et, par le seul fait qu'ils n'envisageront que l'élément artistique; qu'ils ne jugeront les épreuves que sur le groupement des modèles, le choix des sujets, la perfection des lignes, la pureté des tons;

qu'ils ne verront dans une exposition qu'une occasion de développer leur goût esthétique; ils apporteront dans l'art photographique des améliorations et des modifications qui lui seront pour l'avenir d'une grande utilité.

Qu'importe si quelques-uns, flattés par les offres alléchantes de connaisseurs habiles et enthousiastes, tentés par des estimations respectables qui leur sont faites au sujet de leurs épreuves, cèdent quelques clichés ou quelques photocopies à un éditeur ou à un amateur! N'est-ce pas une récompense légitime de leur talent, une rétribution assez juste de leur temps et des frais que lui a nécessités la confection de l'oeuvre. Bien ridicule celui qui menacerait d'une patente ou qui qualifierait de trafic la vente d'un tableau de maître par son auteur, peut-être à court d'argent.

Tout autres sont les *professionnels*, faisant un usage permanent d'un métier spécial, d'une industrie déterminée, dans le seul but d'en retirer un profit commercial qui leur permet de faire face aux frais généraux, aux charges de leur profession et à la patente souvent forte à laquelle la loi les soumet. Artistes parfois, souvent même, je le veux bien; mais artistes dans le seul intérêt de leur commerce, ne recherchant la perfection des produits que pour l'augmentation de la vente. Une exposition ne sera pour eux qu'un lieu de travail une manière de publicité, et les médailles qu'ils acquerront seront considérées comme une plus-value de leurs fonds commercial, un moyen de répandre leur raison sociale et leur adresse, un appel à l'attention de la clientèle.

Once when pushed by Levy to call himself an artist, Atget protested, saying that he was not an artist, only "un amateur photographe," *Memoir*, p. 91. One wonders if Levy's memory has not betrayed him here, conflating "un amateur, un photographe," since Atget's work in every way resists any attempt to classify it with other photographers' amateur practice.

125. Baudelaire, "Salon de 1859," *Oeuvres complètes*, vol. 2, pp. 1035–36. English translation by Jonathan Mayne, *Art in Paris, 1845–1862: Salons and Other Exhibitions Reviewed by Charles Baudelaire* (London: Phaidon, 1965), p. 154.

126. See Alphonse Davanne, *Le progrès de la photographie* (Paris: Gauthier-Villars, 1877), pp. 1–2, for a discourse on the applications of photography to science and art.

127. It is probably not out of place to say that the argument building here runs outside the prevailing view of Atget's work. Virtually all of the writing on Atget to date takes his work whole, considering it as an oeuvre (coming with its own catalogue numbers, alias negative numbers, it is too accommodating). The oeuvre is considered to have an unstated but overriding unity, sometimes to be found in the man, sometimes in his sense of the photographic medium, sometimes in his project of photographing French culture, which is also for some reason seen whole. Clement Greenberg called Atget the Complete Photographer in his review "Four Photographers," p. 8. This completeness extends to the photographs: "He [Atget] was not after beautiful views; he was out to capture the identity of his subject, and the success with which he did so has to be called 'classical.'" The completeness, it should be noted, is expressed in traditional art historical terms; Atget's work is simply fitted to a preexisting argument for all great art. Greenberg's tactic is common to most writing on Atget and though as a tactic it is dubious, it has had the advantage of producing some particularly seamless and eloquent praise for Atget's work. The most gifted of these writers is John Szarkowski and essentially it is his work that has formed the current view of Atget's photographs. In his book, *Looking at Photographs* (New York: MOMA, 1973), p. 64, he began to formulate his position: "Other photographers had been concerned with describing specific facts (documentation), or with exploiting their individual sensibilities (self-expression). Atget encompassed and transcended both approaches when he set himself the task of understanding and interpreting in visual terms a complex, ancient, and living tradition. The pictures he made in the service of this concept are seductively and deceptively simple, wholly poised, reticent, dense with experience, mysterious, and true." The mystery of Atget's work appears to be sublime instead of classical now, but still complete (true) and quite beyond a rational explanation. In the first of the four volumes of the Museum of Modern Art Atget project (Szarkowski and Morris Hambourg, *The Work of Atget*, vol. 1, p. 12), Szarkowski explained himself more fully: "One might say that the mystery of Atget's work lies in the sense of plastic ease, fluidity, and responsiveness with which his personal perceptions seem to achieve perfect identity with objective fact. There is in his work no sense of the artist triumphing over intractable, antagonistic life; nor, in the best work, any sense of the poetic impulse being defeated by the lumpen materiality of the real world. It is rather as though the world itself were a finished work of art, coherent, surprising, and well constructed from any possible vantage point, and Atget's photographs of it no more than a natural and sweet-minded payment of homage." The exception to this general tendency is Rosalind Krauss's ground-breaking article "Photography's Discursive Spaces: Landscape/View," *Art Journal* 41 (Winter 1982), pp. 311–19. For an assessment of the state of the literature see Abigail Solomon-Godeau's review "Canon Fodder: Authoring Eugène Atget," *Print Collectors Newsletter* 16 (January 1986), pp. 221–27; and John Szarkowski's reply, 17 (May 1986), pp. 56–57.

128. Michel Foucault, *L'ordre du discours* (Paris: Gallimard, 1971), p. 56.

129. Mikhaïl Bakhtin, "Discourse in the Novel," in *The Dialogic Imagination: Four Essays by M. M. Bakhtin*, ed. Michael Holquist, trans. Caryl Emerson and Michael Holquist (Austin: University of Texas Press, 1981), pp. 293–94:

For any individual consciousness living in it, language is not an abstract system of normative forms but rather a concrete heteroglot conception of the world. All words have the "taste" of a profession, a genre, a tendency, a party, a particular work, a particular person, a generation, an age group, the day and hour. Each word tastes of the context and contexts in which it has lived its socially charged life; all words and forms are populated by intentions. Contextual overtones (generic, tendentious, individualistic) are inevitable in the word.

As a living, socio-ideological concrete thing, as heteroglot opinion, language, for the individual consciousness, lies on the borderline between oneself and the other. The word in language is half someone else's. It becomes "one's own" only when the speaker populates it with his own intention, his own accent, when he appropriates the word, adapting it to his own semantic and expressive intention. Prior to this moment of appropriation, the word does not exist in a neutral and impersonal language (it is not, after all, out of a dictionary that the speaker gets his words!), but rather it exists in other people's mouths, in other people's contexts, serving other people's intentions: it is from there that one must take the word, and make it one's own. And not all words for just anyone submit equally easily to this appropriation, to this seizure and transformation into private property: many words stubbornly resist, others remain alien, sound foreign in the mouth of the one who appropriated them and who now speaks them; they cannot be assimilated into his context and fall out of it; it is as if they put themselves in quotation marks against the will of the speaker. Language is not a neutral medium that passes freely and easily into the private property of the speaker's intentions; it is populated—overpopulated—with the intentions of others. Expropriating it, forcing it to submit to one's own intentions and accents, is a difficult and complicated process.

130. Karl Marx, *Capital*, trans. Ben Fowkes (London: Penguin and New Left Review, 1976), vol. 1, pp. 125–26.

131. Marx moves to a definition of the use value just after the passage cited earlier: "The usefulness of a thing makes it a use-value. But this usefulness does not dangle in mid-air. It is conditioned by the physical properties of the commodity, and has no existence apart from the latter. It is therefore the physical body of the commodity itself, for instance iron, corn, a diamond, which is the use-value or useful thing. This property of a commodity is independent of the amount of labour required to appropriate its useful qualities. When examining use-values, we always assume we are dealing with definite quantities, such as dozens of watches, yards of linen, or tons of iron. The use-values of commodities provide the material for a special branch of knowledge, namely the commercial knowledge of commodities. Use-values are only realized in use or in consumption. They consti- tute the material content of wealth, whatever its social form may be" (p. 126). It is not my intention to slight the next aspect of the commodity that Marx introduces in *Capital*, the exchange value, but exchange values are a function of the commodity in circulation and not, as Marx himself points out later in the chapter, inherent in the commodity (p. 152). They are the economic form of its value. Use values make such commercial trading (exchange) possible and they are often made visible be- cause of the exchange; they cannot be cut apart from the life of the world and idealized; but their forms are more intangible. The usefulness of the work is a matter of its visible form, its appearance in the case of pictorial work. Atget made his work useful, knowing that he would be able to sell it for the kinds of visual structures he had established in the photograph. The use values are not identical to the photographic medium; they are formed through the medium, qualities, technical signs, not undifferentiated material. For a further precision on the material status of the photograph, see the 1900 Cadastre records for the avenue de la Grande Armée at the Archives de la Seine, which explain that Bergeotte, *serrurier*, whose large workshop was lodged at no. 52, merged with the firm of Schwartz and Meurer in 1913. A clipping from *Petites affiches* (20–21 April 1913) has been placed in the file, and it describes the status and as- sets of Bergeotte's business. Also included is an engraved letter by Bergeotte announcing the merger. Bergeotte felt it necessary to state that the property of both com- panies, both of them Atget clients, would be considered as one. This included his documents: "La Société nou- velle disposera en conséquence de tous les documents, estampes, dessins, photographies, modèles faisant par- tie de mon ancien fonds, et que viendront compléter et enrichir ceux de l'ancienne société." The division of the commodity into use and exchange value, it might be added, was derived from Adam Smith, *The Wealth of Nations* (Harmondsworth: Penguin, 1976), pp. 131–32,

who added: "The things which have the greatest value in use have frequently little or no value in exchange; and, on the contrary, those which have the greatest value in exchange have frequently little or no value in use. Noth- ing is more useful than water: but it will purchase scarce anything; scarce anything can be had in exchange for it. A diamond, on the contrary, has scarce any value in use; but a very great quantity of other goods may frequently be had in exchange for it."

132. Karl Marx, *Grundrisse: Foundations of the Cri- tique of Political Economy*, trans. Martin Nicolaus (London: Penguin and New Left, 1973), pp. 90ff. See also the working out of use value here, pp. 260ff. For a more extended consideration of use value at the stage of consumption, see Michel De Certeau, *L'invention du quotidien*, vol. 1, *Arts de faire* (Paris: Union générale d'éditions, 1980).

133. See the brief but elegant comments on the desire for uselessness in bourgeois art objects by Allan McCul- lom, "Perfect Vehicles," in the New Museum catalogue, *Damaged Goods: Desire and the Economy of the Object* (1986), p. 10.

134. Anyone venturing into the network of Atget's nega- tive numbers is forever indebted, as am I, to the work of Maria Morris Hambourg. She graciously shared this work with me before having published it first in her Ph.D. dissertation, "Eugène Atget, 1857–1927: The Structure of the Work" (1980), and subsequently in a shorter version as her essay "The Structure of the Work," in *The Work of Atget*, vol. 3, pp. 9–33, which appends a synthetic chart. Morris Hambourg has been able to give dates for most of these numbers. Her work on the number series builds upon that of Barbara Michaels, published as "An Introduction to the Dating and Orga- nization of Eugène Atget's Photographs," *Art Bulletin* 61 (September 1979), pp. 460–68.

135. The total count of Atget's production is necessarily vague, since there is undoubtedly a lost part dating from the 1890s. The Museum of Modern Art collection totals five thousand prints. John Szarkowski estimates some ten thousand images in all in his essay "Atget and the Art of Photography," in Szarkowski and Morris Hambourg, *The Work of Atget*, vol. 1, p. 12.

136. "I will have a new Series on Vieux Paris sent to you. The Stairways. The Door knockers. the Wood Paneling. Doors from the XVIth–XVIIth. and XVIIIth c." Atget letter to the Board of Education, South Kensington, 27 December 1902.

137. Académie de Rouen, *Quand Atget photographiait Rouen: Photographies de la Bibliothèque municipale de Rouen*, présentées par Claire Fons (Rouen: CRDP, 1982), where the pictures are dated on internal evidence to the years 1903–08. A date of 1908 would make still more sense, given the sale of thirty-three of those pictures to the Musée de Sculpture Comparée at the Trocadéro in 1909.

138. Man Ray, *Self Portrait*, p. 39; Levy, *Memoir*, pp. 92–93; Brassaï, "Memories," p. 4.

139. Some of Destailleur's albums are in the collection of the Galerie Octant, Paris, where Alain Paviot has graciously given me the opportunity to study them.

140. "American Buys Famous Collection of Atget, Paris Photographer," *Chicago Tribune*, Paris ed., 27 June 1928, with the same lines repeated in a later story, "Miss Abbott Will Show Large Atget Photo Collection Here," *Chicago Tribune*, 27 October 1928. The paper albums are now part of the Atget Archive, MOMA.

141. For example, a paper album in the Atget Archive, MOMA: "Album no 1 Vieux Paris et Environs Balcons," which started in with balconies superseding an album of trees and never got very far, leaving the tree captions in place until more balconies could be added. The con- version here can be dated to after 1922. For another such example in the same archive: "Album no 3 Parc St Cloud du no 1234."

142. Albums figured into the *répertoire* entries only four times, none of them too revealing, except for Atget's habitual misspelling of the word *album*:

page 7 Crisson – Marbrier – Bd de Strasbourg 25 (Cheminées) – le voir de 6 à 7h soir ou laisser les albums (Demander Mr Bernard)
page 37 Galli – 20 Rue du Petit Musc le mardi de 6 à 8 heures (soir) pour ablum (conseiller municipal)
page 38 Arthur Meyer (part Leloir) pour ablum
page 72 Mr Blondel – Amateur Vieux Paris, 30 Rue Fontaine et 19 Rue La Bruyère, tous les jours à partir de 9 heures, le Dimanche excepté. (René Fournets de l'Opéra). Vendredi matin 10 Jan- vier à partir de 9 heures (ablums Vieux Paris).

Meyer, the editor of *Le Gaulois*, collected fine illustrated editions and had books specially illustrated in unique copies, but the sales catalogue of his collection contains no evidence that Atget ever did this kind of work for him. *Bibliothèque de Feu M. Arthur Meyer. Vente 3–6 juin 1924* (Paris: 1924).

143. The Carnavalet paper album for St. Gervais Pro- tais, acq. no. 6505 (11 September 1904). The entry of 16 October 1899 in the Bibliothèque historique registers is the first record of Atget's delivering his goods in paper

albums. The step from thinking in small deliveries to thinking in sets and then albums seems short, but a decade passed before Atget actually sold albums to be kept intact as albums. This happened at the Musée Carnavalet in 1910 and at the Bibliothèque Nationale in 1911.

144. Besides the title page for *L'Art dans le Vieux Paris*, there were two other printed title pages. They read:

Album No

DOCUMENTS
POUR
L'HISTOIRE DU VIEUX PARIS
MAISONS HISTORIQUES OU CURIEUSES
ANCIENS HOTELS
VIEILLES RUES – COINS PITTORESQUES

E. ATGET
AUTEUR–EDITEUR
17bis, Rue Campagne Première, 17bis
PARIS

And the second:

INTERIEURS PARISIENS
DEBUT DU XXe SIECLE
ARTISTIQUES
PITTORESQUES & BOURGEOIS

E. ATGET
AUTEUR–EDITEUR
17bis, Rue Campagne Première, 17bis
PARIS

145. For a sample of other photographers' business cards and brochures dating from the 1890s, see the Collection Delcourt, Cabinet des Estampes, Bibliothèque Nationale, box 60, "Photographes."

146. Walter Benjamin, "Central Park," trans. Lloyd Spencer and Mark Harrington, *New German Critique*, no. 34 (Winter 1985), p. 37.

147. Clement Greenberg, "Avant-Garde and Kitsch," *Art and Culture* (Boston: Beacon, 1961), p. 9. For a résumé of the author problem in 1985, see the catalogue for *Les immatériaux*, by Jean-François Lyotard et al. (Paris: CCI, 1985). The plate entitled "tous les auteurs" reads: "En raison de la multiplication des procédés de reproduction, de diffusion et de la complexité des techniques de création, l'identité de l'auteur est de plus en plus difficile à cerner et à définir. Paternité d'une oeuvre, indéfinissable?" (What with the multiplication of reproductive processes, of the means of distribution, and the complexity of the techniques of creation, the identity of the author is more and more difficult to grasp and define. The paternity of a work, then, indefinable?)

148. Roland Barthes, "The Death of the Author," in *Image–Music–Text*, ed. and trans. by Stephen Heath

(New York: Hill & Wang, 1977), pp. 142–48. The French version was first published in *Mantéia*, vol. 5 (1968). Michel Foucault, "Qu'est-ce qu'un auteur?" *Bulletin de la Société Française de la Philosophie*, vol. 64 (22 February 1969), pp. 73–104; in English, "What Is An Author?" in the collection *Language, Counter-Memory, Practice*, ed. Donald F. Bouchard, trans. Donald F. Bouchard and Sherry Simon (Ithaca: Cornell University Press, 1977), pp. 113–38. The French version was first published in 1969 and should be read in conjunction with *L'archéologie du savoir*. Brian O'Doherty and Barbara Novak showed me the relevance of *Aspen* 5 + 6 for this issue and to them I am grateful. Michel Melot has dealt with many of these authorial issues in his interrogation of originality, "La notion d'originalité et son importance dans la définition des objets d'art," in *Sociologie de l'art. Colloque international, Marseille, 13–14 juin 1985*, under the direction of Raymonde Moulin (Paris: La documentation française, 1986), pp. 191–202. As has Rosalind Krauss, *The Originality of the Avant-Garde and Other Modernist Myths* (Cambridge: MIT Press, 1985).

149. Stéphane Mallarmé, "Variations sur un sujet," *La Revue Blanche* (February–November 1895, September 1896); reprinted in his *Oeuvres complètes* (Paris: Pléiade, 1945), p. 366.

150. For it was a quintessential winter menu:

Menu du Jour
Hors d'Oeuvre
Sardines saucissons beurre
Filet de Hareng

Entrée
Bouillon boeuf
Omelette oeufs sur le plat
Morue sauce blanche
Pied de mouton à l'huile
Veau marengo
Rosbif froid mayonnaise
Côtelette de mouton

Légumes
Lentilles aux lards
Nouilles à l'Italienne
Choux de bruxelles
Poireaux à l'huile
Salade Pissonlis d'Havre

Fromages	Desserts
Gruyère Brie	Pommes cuites
Camembert	Pruneaux cuites
Roquefort	Poires cuites
Cantal	Crème Vanille
	Confitures
	Biscuits

151. The law of 19 July 1793, given in Georges Chabaud, *Le droit d'auteur des artistes & des fabricants: Législation–Jurisprudence–Projets de réforme* (Paris: Librairie des sciences politiques et sociales, Marcel Rivière, 1908), p. ii. Chabaud's appendix gives the texts of the laws from 1777 to 1902, and his book gives an instructive close reading of them. I have discussed the cultural implications of the 1985 law elsewhere: "What Was An Author?" *Yale French Studies*, no. 73 (1987), pp. 229–57.

152. Those interpreting the law would not mince words. See Eugène Pouillet, *Traité théorique et pratique de la propriété littéraire et artistique et du droit de représentation*, 3d ed. (Paris: Marchal et Billard, 1908), p. 97: "La loi récompense et protège toute composition due à un effort de l'esprit humain et se rapportant aux beaux-arts. Elle ne considère ni l'importance ni la beauté de l'oeuvre; elle n'envisage que le fait de la création; c'est pour cela qu'elle protège au même degré le tableau de Raphaël et l'image sortie des fabriques d'Epinal."

153. For a good summary of the evolution of this point of law, see *Dalloz: Encyclopédie juridique: Répertoire de droit civil*, ed. Pierre Raynard and Marguerite Vanel, vol. 6 (Paris: Dalloz, 1975), "Propriété littéraire et artistique." Charles Aussy thought the point important enough to argue in his book, *Du droit moral de l'auteur sur les oeuvres de littérature et d'art* (Auxerre: Pigelet, 1911), p. 5.

154. The law on design and patent was separated: the laws on design—18 March 1806, 14 July 1909, 12 March 1952; the laws on patent—5 July 1844 and 2 January 1968. See *Dalloz. Encyclopédie juridique. Répertoire de droit commercial* (Paris: Dalloz, 1986).

155. Pataille, *Annales de la propriété industrielle, artistique et littéraire* (1894), pp. 48–55.

156. Bernard Edelman, *Le droit saisi par la photographie: Eléments pour une théorie marxiste*, 2d ed. (Paris: Bourgois, 1980). Edelman does not distinguish between the privileged, special nature of this market and the regular market, but his book is an exemplary discussion of how the laws for photography and cinema reveal the property relations between people.

157. The laws of 3 August 1844, 8–19 April 1854, and 14 July 1866.

158. Or, for that matter, anyone else. See especially: Greenberg, *Art and Culture*; Walter Benjamin, "The Work of Art in the Age of Mechanical Reproduction," in *Illuminations*, ed. Hannah Arendt, trans. Harry Zohn (New York: Schocken, 1968), pp. 217–51; Thomas Crow, "Modernism and Mass Culture in the Visual Arts," in *Modernism and Modernity: The Vancouver Papers*, ed. Benjamin H. D. Buchloh, Serge Guilbaut,

and David Solkin (Halifax: The Press of the Nova Scotia College of Art and Design, 1984), pp. 215–64. On the evolution of the law, see *Dalloz* (1975). The full texts of the laws in question are given in the *Receuil Sirey*.

159. The institutions supporting the various cultural professions were at odds with one another in the ancien régime, and the law of 1793 records those differences; the late arrival of architecture and sculpture to copyright probably stemmed from them. For more on this subject see Pouillet, *Traité théorique et pratique de la propriété littéraire et artistique*. It should also be noted that the entrance of architecture and sculpture into this law in 1902 spoke worlds about the new legitimacy of that work by the end of the nineteenth century: they were part of the national culture, often represented a culture of the state, and consequently merited much more than simple legal protection. The law of 1902 was a symptom of the widening authority of the so-called industrial arts.

160. A number of these texts have been anthologized by André Rouillé in his book, *La photographie en France, 1839–1870. Textes et controverses: Une anthologie, 1816–1871* (Paris: Macula, 1989). For a discussion of the debates during the Paris World's Fair of 1855 over whether photography was art or industry, see his article "La photographie française à l'Exposition Universelle de 1855," *Le Mouvement Social*, no. 131 (April–June 1985), pp. 87–103.

161. Alphonse Lamartine, "Entretien XXXVI. La littérature des sens. La peinture. Léopold Robert," and "Entretien XXXVII. (2ᵉ partie)," in *Cours familier de littérature* (Paris: chez l'auteur, 1858), vol. 6, p. 411, and vol. 7, p. 43, respectively.

162. Quoted without reference by A. Bigeon, *La photographie et le droit* (Paris: Mendel, 1894), p. 18.

163. J.-E. Bulloz, *La propriété photographique et la loi française* (Paris: Gauthier-Villars, 1890), p. 3. See also M. E. Potu, *La protection des oeuvres photographiques: Extraits de la Revue Trimestrielle de Droit Civil* (Paris: Sirey, 1912), and Léon Vidal, *Absence d'un texte légal réglant les droits d'auteur afférents aux oeuvres des arts mécaniques de reproduction. Diversité d'opinions relatives à cette question. Solution qui semble la plus rationelle. (Extrait des Mémoires de l'Académie de Marseilles)* (N.p.: n.d.).

164. Walter Benjamin, "The Author as Producer," from *Understanding Brecht,* trans. Anna Bostock (London: New Left Books, 1977), pp. 85–103. See also Pierre Macherey, *Pour une théorie de la production littéraire* (Paris: Maspero, 1966), and Raymond Williams, *Marxism and Literature* (Oxford: Oxford University Press, 1977), both of which books deserve more notice than I can give them here.

165. The law of 11 March 1957, *Receuil Sirey*, 1957, p. 124.

166. Foucault, "Qu'est-ce qu'un auteur?" p. 83.

167. Ibid., p. 88.

168. Foucault, *L'ordre du discours*, pp. 30–31. My modification of the English translation by A. M. Sheridan Smith in *The Archaeology of Knowledge* (New York: Pantheon, 1972), p. 222.

169. The English translation of Barthes's essay was made by Richard Howard. Jérôme Serri organized an exhibition and catalogue which collected Barthes's work on the image, though the *Aspen* box was missing from the group. Pavillon des Arts, Paris, *Roland Barthes: Le texte et l'image* (1986). The box should be understood in the context of Brian O'Doherty's other work, an idea of which can be had from the exhibition of his drawings under the name of Patrick Ireland, National Museum of American Art, *Patrick Ireland: Drawings, 1965–1985*, essay by Lucy Lippard (1986).

170. "The Creative Act" was written in 1957 as a talk for a meeting of the American Federation of the Arts in Houston. The text has been reprinted in *Salt Seller: The Writings of Marcel Duchamp (Marchand du Sel)*, ed. Michel Sanouillet and Elmer Peterson (New York: Oxford University Press, 1973), pp. 138–40.

171. Elizabeth Anne McCauley is preparing a book-length study of the commercial studio during the Second Empire. Until its publication, one can only refer to her article "Of Entrepreneurs, Opportunists, and Fallen Women." See also Jean Sagne's book, *L'atelier du photographe, 1840–1940* (Paris: Presses de la Renaissance, 1984).

172. Potu, *La protection des oeuvres photographiques*, pp. 737, 764; A. Bigeon, *La photographie et le droit*, pp. 12–21.

173. Two court cases that did not allow the photographer to work as an author are worth citing: Viot vs. Laurent fils, Nancy, 14 March 1903, D.P. 2.296; and Tricaud vs. Raoult, Toulouse, 17 July 1911, D.P. 2.161.

174. See Pouillet, *Traité théorique et pratique de la propriété littéraire et artistique*, pp. 127ff., for a discussion of the difference between a photograph and a *dessin de fabrique;* see also Bigeon, *La photographie et le droit*, p. 3. See the Toulouse decision (1911) regarding the industrial character of the photographs in question.

175. Two of the paper albums collected in the Atget Archive of the Museum of Modern Art in New York group some of the sign pictures under a *fer forgé* rubric to make a selection of documents useful to metalworkers. They are titled "Album No 1 Vieux Paris et Environs Grilles, Lanternes Enseignes" (with one line crossing out the word "Enseignes") and "Album No 2 Enseignes et Vieilles Boutiques du Vieux Paris."

176. In point of fact, reflections off windows were not considered good form, and photographers' manuals warned against including them. See Georges Brunel, *Encyclopédie de l'amateur photographe, no. 2* (Paris: 189?), p. 93.

177. There was some disagreement over whether or not it was possible to insert the author's personality into a photograph. See Bigeon, *La photographie et le droit*, pp. 38–39; and C. Puyo, "La photographie pictoriale," *Cinquième congrès internationale de la photographie*, p. 443.

178. The big business in documents for reference or tourist views or portraits was managed by teams of photographers working under the direction of a Neurdein brother or a Nadar. In 1911 photographers in Paris were counted at 1,945 (there were at this time 19,177 professional artists), a number broken down into employers and workers—831 and 1,114, respectively (Ministère du Travail et de la Prévoyance Social, *Statistique générale de la France: Résultats statistiques 5 mars 1911* [Paris: 1915], vol. 2, pp. 6–8). Albert Reyner, *Manuel pratique du reporter photographe et de l'amateur d'instantanés* (Paris: Mendel, 1903), pp. 17–18, gave a critique of the banal views produced by the large studios. Marcel Duchamp, *Fresh Widow*, New York, 1920. Miniature French window, painted wood frame and eight panes of glass covered with black leather, 30½ × 17⅝", on wood sill, ¾ × 21 × 4". Collection, The Museum of Modern Art, New York. Katherine S. Dreier Bequest.

179. *Chambre syndicale française de la photographie, Cinquième congrès national, novembre 1912* (Paris: 1913), p. 92, established regulations for the cost of reproduction rights, recommending a price of at least ten francs per photograph. That Atget knew the union standard is shown in his letter to Poëte of 2 August 1916: "Le prix de l'épreuve, avec droit de reproduction est de 10.ˣ (Prix du Syndicat accepté par les éditeurs de revues et journaux)." The *répertoire* entries for publishers are annotated with five-franc prices for these rights (pp. 65, 75, and 76), with one exception. For *Art de France* Atget was prepared to charge ten francs (p. 76).

180. Unfortunately nothing in the *répertoire* tells what happened when Atget took the maquette to a printer or another publisher. It was absent from the *répertoire* because it was to be a book, and as such, out of his ordinary line of work. The six at the Bibliothèque Nationale were not entered either, because the library accounts were kept elsewhere. The *répertoire* only enables us to see the general practice of which they form a part, and it thereby accords them their status as very special, exceptional cases.

181. The formats and binding of the Bibliothèque Nationale albums did not match that of their forebear exactly, but a general correspondence to the maquette is apparent, especially in the first of them, *Intérieurs parisiens,* where the photographs are mounted on both recto and verso sides of a cardboard page and a title page has been set in type. Later albums were mounted on drawing paper on the recto side only, and no title page was printed for them. That Atget supervised the order and binding of these pages is proved by his lightly penciled page numbers usually half visible at the top edge, meant as a binder's guide and to be cut off when the pages were trimmed. In *Enseignes et vieilles boutiques* and *Zoniers,* the penciled lines on which Atget's handwritten captions rest extend off the page proper onto the binder's hinge, another piece of proof for Atget's control over the several stages of album production. The *répertoire* does contain information on typesetters: p. 37, "Dactylographe–Guérin–Rue St Severin 25."; and on a binder: unnumbered back page, "Berteaux (Relieur) Rue Clovis 4 ou 6 dans le milieu de la rue." Romeo Martinez interviewed André Michard, the apprentice of a printer who worked for Atget after the war and perhaps before, a printer in the boulevard Raspail (his name is not given) who printed the titles and captions for his "two works 'Paris' and 'L'Art dans le Vieux Paris'" ("Eugène Atget in Our Time," p. 66). "Paris" remains unknown; perhaps it was the Bibliothèque Nationale project misremembered.

182. Henri Lemaître, *Histoire du dépôt légal, 1ère partie (France)* (Paris: Picard, 1910). Eugène Morel, *Le dépôt légal: Etude et projet de loi (1917)* (Paris: Bossard, 1917).

183. Marcel Proust, *A la recherche du temps perdu: A l'ombre des jeunes filles en fleurs* (Paris: Pléiade, 1954), p. 643.

184. Henri Bouchot, "Le Département des Estampes," in Henry Marcel, Henri Bouchot, Ernest Babelon, Paul Marchal, and Camille Couderc, *La Bibliothèque Nationale* (Paris: Laurens, 1907), vol. 1, pp. 71–72. See Henri Bouchot, *Le Cabinet des estampes de la Bibliothèque Nationale: Guide du lecteur et du visiteur, catalogue général et raisonné des collections qui y sont conservées* (Paris: Dentu, ca. 1895) for its catalogue of the holdings of the various series. It would have been easy for Atget to see what the context for his albums would have been. See also Joseph Guibert, *Le Cabinet des estampes de la Bibliothèque Nationale: Histoire des collections suivie d'un guide du chercheur* (Paris: Le Garrec, 1926).

185. H. LaVoix, introduction to E. Poirée and G. Lamouroux, *Catalogue abrégé de la bibliothèque Sainte-Geneviève* (Paris: Didot, 1892), p. vii.

L'éclipse

Epigraph (p. 104): Friedrich Nietzsche, *The Use and Abuse of History,* trans. Adrian Collins (1874; reprint, New York: Bobbs-Merrill, 1949), p. 19.

1. In 1908 and 1909 Atget had worked up a set of details by photographing close-ups of his own photographs, and some of these watery images appear in the album (5505, 5511, 5630, 5636), making it impossible for the book to have been completed before the spring of 1909. In June 1910 the Musée Carnavalet purchased an expanded but unbound version of the book. *L'Art dans le Vieux Paris* was probably prepared in the interim.

2. The title of the Musée Carnavalet entry E. 7468 read: "67 Vues du Vieux Paris (série de 67 épreuves) Hôtels d'Ecquevilly, Lauzun, Mascarani, de Hollande, Séguier, Boisgelin, Eglise St Sulpice, Fontaines Cabarets et . . ." They paid Atget one hundred francs. Each print was mounted on white drawing paper, 34.9 × 26.8 cm., captioned by Atget in ink and signed in the lower right corner of the page. He dated each 1910 and only gave short titles, not the elaborate captions of the maquette. On the back of each page in the upper left corner, he wrote the negative number, by this time his practice whenever he sold prints mounted on cardboard to the Bibliothèque historique. This said, I have been able to find only some of these pages in the Carnavalet topography boxes. They are pages 5, 10, 11, 17, 18, 19, 26, 27, 28, 32, 33, 34, 37, 39, 40, 41, 44, 53, 54 (my numbers).

3. It is the reference book visible in Atget's 1911 photograph of his studio. Rochegude did not always suffice, but for the historical half of the captions it was Atget's basic source. Atget appropriated it just about wholesale for the Hôtel Fieubet: Atget—"Hôtel de Fieubet, 2, Quai des Célestins (4e Arrt)—Construit sur l'emplacement de l'hôtel royal de Saint-Paul, par Hardouin Mansart, pour Gaspard de Fieubet, Chancelier de la Reine Marie-Thérèse (1617); acheté en 1850 par M. Lavelette, publiciste qui le restaura: Aujourd'hui Collège Massillon"; Rochegude—"Quai des Célestins, No 2. Construit sur une partie de l'emplacement de l'hôtel royal St-Paul, par Hardouin Mansart, pour Gaspard de Fieubet, chancelier d'Anne d'Autriche (1671). Boula de Mareuil en 1780. Acheté en 1850 par M. de Lavalette, publiciste qui le restaura. Les Oratoriens en ont déshonoré les ailes: Collège Massillon." Atget seems to be using the second 1903 edition of the *Guide pratique à travers le Vieux Paris* (Paris: Hachette), p. 218. Other editions were printed in 1903, 1905, and 1907; after a lapse, more appeared following the war. In 1910 the marquis prepared his magnum opus, the twenty-volume *Promenades dans toutes les rues de Paris par arrondissements* (Paris: Hachette). I have pinned Atget's captions in the maquette to the second edition of the *Guide pratique* on the basis of Atget's facts

and the marquis's subsequent revisions. The other major guides to Vieux Paris available to Atget were: Charles Normand, *Nouvel itinéraire: Guide artistique et archéologique de Paris,* 2 vols. (Paris: L'ami des monuments et des arts, 1889–1903); and Gustave Pessard, *Nouveau dictionnaire historique de Paris* (Paris: Rey, 1904, rev. ed., 1908).

4. For an example, see *Le Vieux Paris: Ses derniers vestiges dessinés d'après nature et gravés à l'eau-forte par J. Chauvet et E. Champollion, notices par L. V. Dufour, parisien* (Paris: Detaille, n.d.), p. 99: "Voulez vous voir des ruines en plein Paris—ruines d'autant plus tristes qu'elles sont systématiques—allez visiter les restes de l'hôtel Fieubet."

5. Albert Vuaflart, "L'Hôtel Flesselles," *Bulletin de la Société d'Iconographie parisienne,* vol. 1 (1908), p. 57. The same photograph that was retouched in Bournon's book appears untouched in Georges Riat, *Paris* (Paris: Renouard, 1900), p. 129.

6. See Fernand Bournon, *La voie publique et son décor* (Paris: Librairie Renouard, 1909); Jean Bayet, *Les édifices religieux dix-septième, dix-huitième, dix-neuvième siècles* (Paris: Librairie Renouard, 1910); Amédée Boinet, *Les édifices religieux Moyen Age–Renaissance* (Paris: Librairie Renouard, 1910); R. Hénard, *Les jardins et les squares* (Paris: Librairie Renouard, 1911); G. Dupont-Ferrier, *Les écoles, lycées, collèges, bibliothèques* (Paris: Librairie Renouard, 1913).

7. Commission municipale du Vieux Paris, *Procès-verbaux* (6 October 1898), pp. 26–29.

8. Ibid.: Albert Lenoir, *La statistique monumentale de Paris* (1867); *L'encyclopédie d'architecture* (journal of architecture); Eugène Rouyer, *L'art architectural en France* (1866); César Daly, *Les motifs historiques d'architecture et de sculpture d'ornement* (1869); Krafft and Ransonnette, *Les plans, coupes et élévations de plus belles maisons et hôtels de Paris; L'Art pour Tous* (revue); A. de Champeaux, *L'art décoratif dans le Vieux Paris* (1898).

9. These figures are based on the individual clients listed in Atget's *répertoire.* I am not counting the librarians and the members of their staff who can be members of these societies, because technically the institution itself was not a member and Atget was in fact selling his photographs to the institution, not to its staff. In any case, the libraries' needs are, as we have seen, different from those of the Vieux Paris societies. The names of the clients who were members of the Vieux Paris societies and their numerical distribution over the years in the different societies is given in detail in my thesis, "Atget's Seven Albums, in Practice" (Ph.D. diss., Yale University, 1983), as charts 12 and 13, pp. 278–83.

10. Commission municipale du Vieux Paris, *Procès-verbaux* (10 April 1902), p. 100. Atget's letter to the Conseil municipal was entered into the minutes of the 11 March 1902 meeting. Simply: "Petitions par M. le Président. De M. Atget proposant l'acquisition par la Ville d'un receuil photographique du Vieux Paris. Renvoyée à la 4ᵉ commission," *Bulletin Municipale de la Ville de Paris* 1 (1902), p. 1109. The letter itself is in the archives of the Commission du Vieux Paris at the Rotonde de la Villette, Paris.

11. The Commission municipale du Vieux Paris, *Procès-verbaux* (12 December 1908), reproduced the photograph. The minutes for 30 January 1909, p. 10, gave the circumstances surrounding its publication. It is likely that some member of the Commission checked the files of the BHVP and the Carnavalet. The Carnavalet already had the picture, the BHVP did not; the Barry gravure went to the BHVP. Atget had one more transaction with the Commission but not until 1916, this time selling them the old view of the Chancellerie d'Orléans at the request of Poëte.

12. Commission municipale du Vieux Paris, *Procès-verbaux* (7 November 1908), p. 139.

13. Ibid. (4 July 1908), p. 107.

14. Paul Léon, *La vie des monuments français: Destruction, restauration* (Paris: Picard, 1951), pp. 144ff. Maurice Barrès, *Pour nos églises* (Paris: Société des Trente, 1912).

15. Commission municipale du Vieux Paris, *Procès-verbaux* (16 November 1907), p. 291. The lists were composed during 1906 and 1907.

16. Exposition Universelle de Paris 1900, *Commission municipale du Vieux Paris, 1897–1900* (Paris: 1900), p. 23. Report written by Lucien Lambeau.

17. Ironically one can make the corrections for most of this by using Rochegude's *Guide pratique*. Atget got the captions right for the picture of 50 rue de Turenne on the cardboard mount of the Bibliothèque historique print (XI, 87) and for the cabaret on the rue du Four (XXIV, 19).

18. Victor Hugo, *Notre Dame de Paris* (Paris: 1831; reprint, Seuil, 1963), p. 279. English translation by Jessie Haynes, *Notre-Dame de Paris* (New York: Heritage Press, 1955), pp. 69–70. Hugo continued in this vein: "Les grand édifices, comme les grandes montagnes sont l'ouvrage des siècles. Souvent l'art se transforme qu'ils pendent encore, *pendent opera interrupta;* ils se continuent paisiblement selon l'art transformé. L'art nouveau prend le monument où il le trouve, s'y incruste, se l'assimile, le développe à sa fantaisie, et l'achève s'il peut. La chose s'accomplit sans trouble, sans effort, sans

réaction, suivant une loi naturelle et tranquille. C'est une greffe qui survient, une sève qui circule, une végétation qui reprend. Certes, il y a matière à bien gros livres, et souvent histoire universelle de l'humanité, dans ces soudures successives de plusieurs arts à plusieurs hauteurs sur le même monument. L'homme, l'artiste, l'individu, s'effacent sur ces grandes masses sans nom d'auteur; l'intelligence humaine s'y résume et s'y totalise. Le temps est l'architecte, le peuple est le maçon."

19. These conventions sometimes go under the name of denotation but even Roland Barthes did not argue for absolute denotation in the photographic image. See his essays "The Photographic Message" and "The Rhetoric of the Image," in his *Image–Music–Text*, ed. and trans. Stephen Heath (London: Fontana, 1977), pp. 15–31 and 32–51, respectively. Historians are confronted with similar expectations for denotation. In 1900 working historians understood quite well that the variables in their working methods shaped their conclusions. See, for example, Albert Sorel, *Vues sur l'histoire* (Paris: Plon, 1898), pp. 13–14, echoing Nietzsche, *The Use and Abuse of History*, pp. 37–38. Nietzsche bears quoting in this context: "Might not an illusion lurk in the highest interpretation of the word 'objectivity'? We understand by it a certain standpoint in the historian who sees the procession of motive and consequence too clearly for it to have an effect on his own personality. We think of the aesthetic phenomenon of the detachment from all personal concern with which the painter sees the picture and forgets himself, in a stormy landscape, amid thunder and lightning, or on a rough sea; and we require the same artistic vision and absorption in his object from the historian. But it is only a superstition to say that the picture given to such a man by the object really shows the truth of things. Unless it be that objects are expected in such moments to paint or photograph themselves by their own activity on a purely passive medium! But this would be a myth and a bad one at that. One forgets that this moment is actually the powerful and spontaneous moment of creation in the artist, of 'composition' in its highest form, of which the result will be an artistically, but not a historically true picture. To think objectively, in this sense of history is the work of the dramatist: to think one thing with another, and weave the elements into a single whole, with the presumption that the unity of plan must be put into the objects if it is not already there. So man veils and subdues the past, and expresses his impulse to art—but not his impulse to truth or justice. Objectivity and justice have nothing to do with each other." See also John Tagg, "The Currency of the Photograph," *Screen Education* 28 (Autumn 1978), pp. 45–67.

20. *La Montagne-Sainte Geneviève* 1 (1895), pp. 3–8; *Bulletin de la Société historique du sixième arrondissement* 1 (1898), p. 10; *Bulletin de la Société historique du huitième arrondissement* 1 (1899), p. 13; *La Cité* 1 (1902), pp. 13–16; *Centre de Paris* 1 (1913), pp. 13–18; *Bulletin de la Société de l'histoire de Paris* 1 (1874), p. 1. A pearl of wisdom: "In one way or another forgetfulness, especially of classes and class conflict, is a common theme of bourgeois culture, a theme which can be related to the concept of art as a transcendent form of activity" (Adrian Rifkin, "Cultural Movement and the Paris Commune," *Art History* 2 [June 1979], p. 207).

21. *L'oeuvre de la nouvelle majorité à l'Hôtel de Ville: Un bilan victorieux, 1900–1904* (Paris: Bureau de "La Patrie Française," 1904) put national politics into a tract praising the new city government: "Tour à tour l'affaire Dreyfus, la condamnation de Zola à la suite de ses attaques contre l'armée, l'infame verdict de la Haute-Cour exilant Déroulède et d'autres bons Français à la suite d'un procès inique avaient surexité au plus haut point l'opinion publique au cours de l'année 1899. Tous ces faits prouvaient surabondamment l'existence au sein de notre pays, d'une coalition internationale qui avait pour but de détruire nos plus chères traditions en particulier l'idée de patrie, et de saper les forces vives de nos institutions, à commencer par l'armée." See also: René Rémond, *La droite en France*, 3d ed. (Paris: Auber, 1968), vol. 1, p. 165; Madeleine Réberioux, *La république radicale? 1898–1914* (Paris: Seuil, 1975); Eugen Weber, *The Nationalist Revival in France, 1905–1914* (Berkeley: University of California Press, 1959).

22. Maurice Barrès, *Scènes et doctrines du nationalisme* (Paris: Juven, 1902), pp. 12–13: "Ainsi je possède mes points fixes, mes réperages dans le passé et dans le posterité. Si je les relie, j'obtiens une des grandes lignes du classicisme français. Comment ne serais-je point prêt à tous les sacrifices pour la protection de ce classicisme qui fait mon épine dorsale? . . . Précisons davantage. Combien j'aime cette phrase d'un peintre qui disait: 'Corot, c'est un homme qui sait s'asseoir.' Il me faut s'asseoir au point exact que réclament mes yeux tels que me les firent les siècles, au point d'où toutes choses se disposent à la mesure d'un Français. L'ensemble de ces rapports justes et vrais entre des objets donnés et un homme déterminé, le Français, c'est la verité et la justice françaises; trouver ces rapports, c'est la raison française. Et le nationalisme net, ce n'est rien autre que de savoir l'existence de ce point, de le chercher et, l'ayant atteint, de nous y tenir pour prendre de là notre art, notre politique et toutes nos activités." I do not mean to oversimplify the use of the word *classique,* which will take on many nuances, even medieval, during the prewar period. See the journals edited by Mithouard (*L'Occident*) and Charles Maurras (*L'Action Française*), especially: Mithouard, "Le

classique occidental," *L'Occident* 1 (1902), pp. 179–87; L. Dumont-Wilden, "La muse française," *L'Occident* 15 (1908), pp. 203–11; Maurice Pujo, "La réaction classique," *L'Action Française* 18 (1905), pp. 200–15. As regards classicizing in the visual arts, there were two periods of unusual activity, one around 1905, the other on the eve of the war. See André Véra's article, "Le nouveau style," *L'Art Décoratif* 27 (January 1912), pp. 21–32, illustrated with the work of the Maison Cubiste artists. Véra explained their genealogy like this: "Cette inclination pour un art qui doit être fondé sur la raison et qui doit mettre notre intelligence dans une fête continuelle, nous porte naturellement à affectionner le XVIIᵉ siècle. Ne donne-t-il pas, en effet, par ses ouvrages, une complète satisfaction à la tendance momentanément rationaliste de notre goût? Mais à pénétrer les oeuvres de Corneille, de Descartes, de Pascal, de Bossuet, de Molière, de Racine et de La Bruyère aussi bien que celles de Mansart, de Poussin et de Le Nôtre, nous constatons que le règne de Louis XIV fut rendu certainement unique dans l'histoire des arts par le développement des qualités mêmes que maintenant nous recherchons. Dans le moment où nous approchons ainsi de ces formes artistiques, qui se trouvent être non seulement l'apanage de notre race, mais encore la gloire de notre pays, naît en nous un prompt sentiment de fierté national. . . . Certes, il n'y a aucune incohérence, aucune incompatibilité à se pouvoir du nécessaire dans deux époques différentes: nous recherchons des qualités de clarté, d'ordre et d'harmonie que nous trouvons complètes au XVIIᵉ siècle, et d'autre part, nous voulons renouer avec la tradition que nous voyons arrêtée vers 1848" (pp. 31–32). Kenneth Silver's masterful article "Purism: Straightening Up after the Great War," *Artforum* 15 (March 1977), pp. 56–63, takes up the subject for the postwar period. His book *Esprit de Corps: The Art of the Parisian Avant-Garde and the First World War, 1914–1925* (Princeton: Princeton University Press, 1989) develops it at length. For accounts of the classical period of 1905 see: Maurice Denis, *Théories, 1890–1910: Du symbolisme et de Gauguin vers un nouvel ordre classique* (Paris: L'Occident, 1912); Ellen Oppler, *Fauvism Re-examined* (New York: Garland, 1976); Theodore Reff, "Cézanne and Poussin," *Journal of the Warburg and Courtauld Institutes* 23 (1960), pp. 150–74. For an attack on the neotraditionalists see Georges Batault, "Le problème de la culture et la crise du français," *Mercure de France* 92 (1911), pp. 52–81; and Louis Lumet, "Notes sur l'art industriel," *La Revue Socialiste* 35 (June 1902), pp. 690–97. Lumet reminded his readers of the aristocratic nature of ancien régime style: "Le style du dix-huitième siècle était l'expression exacte de la royauté française et non de la Nation. Il correspondait à l'élégance de la Cour et des gentilshommes,

résultant de la civilization d'une caste, et, s'appropriant à elle, seulement. La ligne du meuble s'affinait avec les manières royales et elle était parvenue à son extrême raffinement. Cependant, en dehors de ce style officiel qui ne pénétrait point la masse, des styles se créaient parmi le peuple, inspirés par des besoins communs et qui n'avaient avec lui que de lointains rapports" (p. 694).

23. *Exposition Universelle de 1900, Ville de Paris. Commission municipale du Vieux Paris, 1897–1900* (n.p.: n.p., n.d.), pp. 10–12. The 1894 proposals for the Vieux Paris exhibit appealed to national pride with much less metaphor. Charles Normand and Lucien Leblanc, *Projet de reconstitution de Paris à travers les âges: Exposition Universelle de 1900 à Paris* (Paris: 1894), pp. 4 and 6: "On sait d'ailleurs que chacun, dans notre pays, à quelque classe qu'il appartienne, sent son intérêt aiguillonné par tout ce qui a trait à notre passé; chacun aime à entendre raconter qui a trait à notre passé; chacun aime à entendre raconter avec détails les faits et gestes de notre histoire, à savoir comment vivaient nos pères, et à comprendre les beautés disparues de l'antique capitale. . . . Dans ces conditions, notre dessein ne peut être que favorablement accueilli par le gouvernement de la République, car il est essentiellement français et son exécution rappelera *de visu* aux visiteurs étrangers les souvenirs glorieux de notre histoire." On the invention of tradition in Western Europe during this period see *The Invention of Tradition*, ed. Eric Hobsbawm and Terence Ranger (Cambridge: Cambridge University Press, 1983).

24. "La société policée, instruite, aimant les arts, de la second moitié du XVIIᵉ siècle, gravite autour du Roi-Soleil. La majesté royale dicte le ton à la Cour et à la Ville. Le style Louis XIV va symboliser cet état social." This passage was preceded by another: "En moins d'un siècle un style français est né, qui de Louis XIV à Louis XVI reflétera le génie de la race, et dont le néo-classicisme, à son tour, inspirera le monde entier." Both are from P. Planat and E. Rümler, *Le style Louis XIV* (Paris: Librairie de Construction Moderne, ca. 1912), preface, unpaged.

25. It seems extremely odd that Atget would not have tried to publish a book on Versailles. In 1912 Pierre de Nolhac, the curator there, wrote a preface to a volume on the château, remarking on the demand for this kind of picture book: *Versailles* (Paris: Les grands palais de France, n.d.). Atget had made some three hundred photographs of Versailles, mostly of the gardens, between 1901 and 1906, during the years of the first boom in post-Affair classicism. Versailles was at the heart of that classicism, according to Maurice Denis in *Théories*, pp. 258–59: "On connaît l'engouement de la nouvelle génération pour le XVIIᵉ siècle, pour l'Italie, pour Ingres: Versailles est à la mode, Poussin porté aux nues;

Bach fait salle comble; le romantisme est ridiculisé. En littérature, en politique, les jeunes gens ont la passion de l'ordre. Le retour à la tradition et à la discipline est aussi unanime que l'était dans notre jeunesse le culte de moi et l'esprit de révolte. Je citerai ce fait que dans le vocabulaire des critiques d'avant-garde, le mot 'classique' est le suprême éloge, et sert par conséquent à désigner les tendances 'avancées'." Versailles had more symbolic power than all of Vieux Paris put together, and Atget's pictures there at this time (and for that matter after World War I) need to be studied as representations of national symbols. I would venture to say here that Atget avoided these symbols to produce much the same kind of indirect critique for the formal garden that he made for Vieux Paris.

26. The dates in the register indicate the day when the gift was recorded and numbered, not the day it was given.

A. 1339 8 sept. 1911
 La Guerre Sociale (Journal)
 don Atget
A. 1455 3 oct. 1911
 Mouvement Social (L'Avant-Garde, La Guerre Social, boch.)
 110 pièces
 Don Atget 17ᵇⁱˢ rue Campagne première
42129 12 oct. 1911
 Gohier, L'Armée de Condé, la revanche des émigrés–St. Denis. In 16. 39p. br. Don de M. Atget
42130 12 oct. 1911
 L'Armée jugée par les Nationalistes. St. Denis s.d. In 16, 64 p. br. Don de M. Atget
A. 1523 5 jan. 1912
 108 nos divers "Guerre Sociale" et "Bataille Syndicaliste"
 Don Atget
A. 1540 3 févr. 1912
 "La Bataille Syndicaliste" mar–août 1911
 Don Atget

At the Bibliothèque historique, the *La Guerre Sociale* holdings begin at 16 September 1908 and continue until 1914. They were not annotated. Their holdings of *L'Avant-Garde* are: no. 51 (27 September 1870), no. 295 (31 January 1871), and nos. 384–486 (18 March–27 May 1871). Their holdings of *La Bataille Syndicaliste* begin with 152 (September 1911); note the discrepancy with Atget's don A. 1540. As for Atget's books: the Gohier book can now be found at the call no. "in 16–906129" and someone has inscribed "Atget" on the cover; *L'armée jugée* can be found at no. "in 16–701939." Both were priced at ten centimes; both are La Librairie ouvrière editions.

27. Georges Sorel, *Réflexions sur la violence* (Paris: M. Rivière, 1910), pp. 150–51. For a deprecation of French classical culture as it was reproduced in the schoolroom, see C. A. Laisant, "Qualité ou quantité," *La Bataille Syndicaliste* (26 November 1911).

28. "Ce qu'elle veut être, ce qu'elle sera," *La Guerre Sociale*, no. 1 (19 December 1906). See also Jean Jaurès, *La classe ouvrière*, présenté par Madeleine Réberioux (Paris: Maspero, 1976).

29. "La Guerre Sociale aux Assises," *La Guerre Sociale* (13 September 1911); Maria Verone, "La Guerre Sociale aux Assises," *La Bataille Syndicaliste* (7 September 1911). The offending articles were published on 14 December 1910, 17 May 1911, and 3 May 1911, respectively.

30. "Aux Bons Bougres," *La Guerre Sociale* (28 July 1911).

31. Marcel Poëte, "Le Service de la Bibliothèque et des Travaux historiques de la Ville de Paris. Exposé historique sur le service. Etat actuel," *Bulletin de la Bibliothèque et des Travaux historiques de la Ville de Paris* 1 (1906), p. xxiv.

32. Sometimes poverty overwhelmed the picturesque, and when this happened, the Vieux Parisien was at a loss: Should the historic building, now a tubercular slum, be razed or preserved? For a meditation on the problem and photographs of such buildings (which look scrubbed compared to Atget's), see A. C., "Un mauvais coin de Paris," *L'Illustration* (11 February 1911), pp. 85–86.

33. Le Corbusier, *Les plans Le Corbusier de Paris, 1956–1922* (Paris: Minuit, 1956), p. 124. The image was noticed and attributed by Yvan Christ in an unpublished paper, "Eugène Atget."

34. To this day *L'Art* remains a sample book with no particular future. Berenice Abbott retrieved it from Atget's studio after his death. Some business did come out of it: two copies have been found in private collections, one originally belonging to Emile Jammes, *médailleur*. Both copies differ slightly in sequence and text from the maquette and seem to represent later, special orders presumably commissioned during the normal course of Atget's documents business. The Jammes version is bound between black leather covers in quarto format with "ART / VIEUX PARIS / I" printed on the spine. The pages are cream-colored drawing paper. Atget mounted its photographs on the recto side of the page only and the captions are printed directly onto the page. The version is no longer a maquette but a privately printed edition. The captions differ from the Museum of Modern Art copy in capitalization and punctuation (they have been reset). The negative numbers are not given. Actual changes in the text occur as follows:

page 28	. . . Très jolie façade . . .
38	. . . Heurtoir, attributs . . .
42	Rue de Turenne, 50 . . .
45	. . . remarquables boiseries . . .
46–49	. . . [address omitted] . . .
52	. . . Acheté en 1900 par la Ville de Paris, pour en faire un musée, et revendu ensuite à la famille du Baron Pichon . . .
53ff.	. . . [address omitted]
4974	["Décoration intérieure" omitted] . . .
4978–4983	all read: Hôtel de Lauzun – Décoration intérieure XVIIᵉ siècle.

I have given the negative numbers for the last part of this list because the order of the Hôtel Lauzun pictures differs from the Museum of Modern Art maquette. The new order in the Jammes version is 4971, 4972, 4974, 4978, 4976, 4979, 4984, 4985, 4983. Inside the front leaf someone has written "604" in pencil. The other version is known to me only through conversation with Harry Lunn. The Musée Carnavalet bought a third version of the album in loose-leaf and methodically filed its pages into the topography boxes. Atget continued to use the extra printed title pages of *L'Art* to cover paper albums from the series.

35. Atget's move to 17ᵇⁱˢ from 8ᵇⁱˢ rue Campagne première can be seen from the *bons* he left that year at the Musée Carnavalet: The *bons* for May 20, June 26, and July 11, 1899, all list the 8ᵇⁱˢ address; on July 18, 1899, he gave the 17ᵇⁱˢ address.

36. Marcel Prévost, "Le Meutre de Mme. Aubry (pièce de dossier)," *Notre compagne (provinciales et parisiennes)* (Paris: Lemerre, 1909), p. 49. The illustrator was Atget's client Serafino Macchiati.

37. *Répertoire*, p. 26.

38. The Bibliothèque Nationale album is missing one of its pages, that which held the "Petite chambre d'une ouvrière, rue de Belleville" (*Paysages–Documents divers*, no. 743). Its photograph was taken however before this happened, and it is listed in the copy photograph file in the Cabinet des estampes as no. 54 B. 12610. As the order of the photographs in the Carnavalet album is in every other way the duplicate of that at the Bibliothèque Nationale, I have assumed that the other side of the missing page contains the next picture in the Carnavalet album, *Paysages–Documents divers*, no. 744.

39. "La Grisette," *Les français peints par eux-mêmes: Encyclopédie morale du dix-neuvième siècle* (Paris: Curmer, 1839), vol. 1, pp. 9–16.

40. Parisian Interiors / Early Twentieth Century / Artistic / Picturesque & Bourgeois.

41. Walter Benjamin, "The Work of Art in the Age of Mechanical Reproduction," p. 226. Benjamin began his reflections on the emptiness in Atget's work as part of his 1931 book review of *Atget Lichtbilder*, "A Short History of Photography," pp. 50–51: "More noticeably, however, almost all of these pictures are empty. The Porte d'Arcueil fortifications are empty, as are the regal steps, the courts, the terrace cafés, and as is appropriate, the Place du Tertre, all empty. They are not lonely but voiceless; the city in these pictures is swept clean like a house which has not yet found its new tenant. These are the sort of effects with which Surrealist photography established a healthy alienation between environment and man, opening the field for politically educated sight, in the face of which all intimacies fall in favor of the illumination of details. . . . Not for nothing were pictures of Atget compared with those of the scene of a crime. But is not every spot of our cities the scene of a crime? every passerby a perpetrator? Does not the photographer—descendant of augurers and haruspices—uncover guilt in his pictures?" It is not simply pedantic to note that Benjamin's notion of criminality can be tracked back into Recht's preface and ultimately to the *Intérieurs parisiens*. The 1930 monograph contained five photographs that also appeared in the *Intérieurs parisiens* album (pp. 25, 27, 29, 43, 45), and Recht talked about the evidence they contained, perhaps social, perhaps ironical, perhaps criminal (*Atget Lichtbilder*, pp. 14–15).

42. Léon Werth, "Préface," *Salon d'Automne, 1910* (Paris: 1910), p. 47. See also *Pour bien tenir sa maison* (Paris: Laffitte, 1911), pp. 16–17, on decorating with the styles. For the working-class version of this practice see: Henry Provensal, *L'habitation salubre et à bon marché* (Paris: Schmid, 1908), p. 78; and Fernand Roches, "Ameublements ouvriers," *L'Art Décoratif* 25 (January 1911), pp. 39–46.

43. *Pour bien tenir sa maison. Deuxième salon des industries du mobilier 1905* (Paris: n.d.) in its introduction gave a neat summary of the comparative method for the study of style. Disderi, *L'art de la photographie* (Paris: l'auteur, 1862), pp. 319–20, wrote of the role that photograph could play in establishing museums of documents, the purpose of which was to make comparisons between works of art.

44. Housing reformers measured the success of a dwelling by the quantities of both light and space: both could, they felt, positively affect the emotional and hygienic sides of home life and, in abundance, would encourage the development of large and happy families (Provensal, *L'habitation*; Eugène Protol, *Une révolution*

dans l'habitation [Paris: Sevin et Sarrat, 1909]). Atget, though no reformer, used these standards of measurement. The dankest slum conditions were not indexed in Atget's album, although those dwellings will be his subject later (P. Simon, *Statistique de l'habitation à Paris* [Paris: Librairie Polytechnique, Baudry, 1891]). *Pour bien tenir sa maison* included a section of statistics on rents according to *quartier* and the size of the apartment (Christophe Charle, "Situation sociale et position spatiale: Essai de géographie sociale du champ littéraire à la fin du dix-neuvième siècle," *Actes de la Recherche en Sciences Sociales,* no. 13 [February 1977], pp. 45–49).

45. Monod's apartment was called "Intérieur Monot" on the back of no. 750 of the print in the collection of the Museum of Modern Art in New York. Monod was listed as an *industriel* at 33 avenue Elisée Reclus in the electoral lists for 1909 (he was born in 1874). Morat's name can be read off the prints made by Richard Benson from negative no. 744, now in the collection of the Museum of Modern Art in New York. The diploma was given to him by "Les Intimes Sauveteurs." The electoral lists for 1909 put Léon Morat, *horlogier,* at 97 boulevard Soult (he was born in 1875). Atget's apartment has been identified for me by Atget's step-grandson, Valentin Compagnon, and by the daughter of his concierge, M^me Demoulin. Neither of them recognized any of the other interiors in the album. Reyher took down a description from the concierge, M^me Cornet, on p. 42 of his Paris notebook. On kitchens as working-class interiors see Henry Thierry and Lucien Graux, *L'habitation urbaine: Chambres de domestiques, cuisines et loges de concierges* (St. Denis: Bouillant, 1909). In the Carnavalet album, Atget miscaptioned the two pages where he reintroduced his own interior: he wrote under them that they belonged to the *collectionneur* M^r B. An alert reader would have recognized the mistake, which was more than a slipup, revealing as it did the possibility of false identities in the album. Atget did not make the same slip twice however in the Bibliothèque Nationale album, where perhaps he took more care with his presentation. The interleaves of the paper album at the Carnavalet revealed a first draft for the captions; at one time they read:

690 Petit intérieur d'un artiste dans le quartier Montparnasse
691 Intérieur d'un artiste dans le quartier Montparnasse
707 Intérieur d'une rentière B^d du Port-Royal
708 Intérieur d'une rentière B^d du Port-Royal
691 Intérieur

So initially the captions were even more typical and Atget put himself forward as a Montparnasse artist, though it would have been difficult to sustain this claim without a picture of a studio. In the Carnavalet album and the Bibliothèque Nationale album, he has changed from *artiste* to *artiste dramatique.*

46. Listes electorales, Archives de la Seine, 14th arrondissement. In the Archives de la Seine it is possible to glean the following pieces of information, which, added together, give the shifty image of Atget's official profession. Atget wrote his profession down on the electoral lists as follows: The records begin in 1902, by which time Atget had moved into the apartment at 17 bis, rue Campagne première. The electoral lists for the rue Campagne première address have gaps for the years 1900, 1901, 1903, 1904, 1921, 1922, 1923, 1924, 1926, and 1927. In 1902 Atget is listed as "artiste dramatique," and this continues until 1912, when he lists himself as "éditeur." The Cadastre records for 1900 list Atget but not his occupation. The Patente records of 1925 also list those who do not pay the *patente;* there Atget was listed as someone who does not pay, but no indication of his occupation appears. A notation for the electoral lists is given on the last page of Atget's *répertoire:* "(tous les ans)." On the question of *patente,* see also Dalloz, "Patente," *Jurisprudence générale. Supplément au répertoire méthodique et alphabétique de législation,* vol. 12 (Paris: Bureau de la "Jurisprudence générale," 1893), pp. 328–29.

47. For an interpretation of this as strictly personal, see Morris Hambourg, *The Work of Atget,* vol. 3, p. 21.

48. M^me Demoulin remembers that in the 1920s Atget read *Le Bonnet Rouge* and on Sundays the more moderate *Journal des Débats.* See Reyher notes with M^me Cornet, the concierge, who tried to say more when Reyher asked her the question about Atget's politics, p. 42: "Politics—might be somewhat right (?)." Her vagueness should not be misconstrued: what she knew was that Atget's opinions were strongly held, but it is unlikely that she knew what they were. Political discussions did not customarily involve women. All of the other evidence of Atget's political ideas points very definitely in the completely opposite direction, left.

49. The figures are taken from the 1900 Cadastre records.

50. Maurice Halbwachs, *La classe ouvrière et les niveaux de vie: Recherches sur la hiérarchie des besoins dans les sociétés industrielles contemporaines* (Paris: Félix Alcan, 1913), p. 124.

51. Karl Marx and Friedrich Engels, *The Communist Manifesto* (Harmondsworth: Penguin, 1967), p. 80.

52. Gustave Hervé, *Histoire de la France et de l'Europe pour les grands* (Paris: La Guerre Sociale, 1910), pp. 401–02.

53. Atget sharpened his subject from the beginning by arranging and rearranging the decor in the interiors. On p. 3, for example, he moved the armchair during the

exposure. On p. 41, he left off type photographing to show a peculiar corner where the sense of bourgeois proportion has run wild, a miniature commode is perched on the table and a large drape hangs over much of the foreground. Atget measured the interiors by his own standards. Evidence of his interference is designed to make this clear.

54. Called *Etudes* and mixed with studio views of family and friends, portraits, posed models, and interiors, none of them captioned, it is to be found under the call no. Na. 324, in 4, in the Cabinet des estampes of the Bibliothèque Nationale. Attributed by Jean Humbert, *Edouard Detaille,* p. 90.

55. For an example, Foemina, "Poèmes silencieux," *L'Illustration* (Noël 1909), unpaged. *Tout-Paris, 1910,* p. 737, gives Foemina's name as Mme. J. Vontade.

56. Cécile Sorel, *Les belles heures de ma vie* (Monaco: Rocher, 1946), pp. 127ff. See also Albert Flament, "Cécile Sorel," *Je Sais Tout* (15 March 1911), pp. 162–70, which published a picture of Cécile Sorel standing by her fireplace. J. H. Lartigue, *Mémoires sans mémoire* (Paris: Laffont, 1975), p. 146, said this about her in his boyhood journal entry for 24 April 1913: "Cécile Sorel est une jeune actrice, comme Eve Lavallière ou Mona Delsa, mais ni douce et gentille comme l'une, ni excentrique, avec la frange et les yeux entourés de noir, comme l'autre. Elle est un peu précieuse. Avec son nez 'à la Marie-Antoinette', elle ressemble beaucoup à certains oiseaux du Jardin d'Acclimatation, qui avancent, un peu fiers et très maniérés, sur des pattes marchant au ralenti."

57. After the album, the problem of the interior pretty much ended in Atget's work. The string of nos. 690–774 was cut short and the few more interiors he photographed before the war were special cases stuck into the newly opened *Paris pittoresque* number series. In 1912 three more views of the decorator's studio were added into the *Paris pittoresque* series as nos. 394, 395, and 396 and are captioned "Intérieur artiste" in a paper album in the collection of the Museum of Modern Art. The paper album was entitled "Intérieurs parisiens, C^cement du 20 S^cle Artistiques Pittoresques et Bourgeois Album No 2." It also included nos. 6797–6800 from the *Environs* series. The Bibliothèque historique owns a print of no. 6797, which Atget has dated 1914 and captioned "Ancienne Chateau de Villiers 61^bis Rue de Villiers—Neuilly s/ Seine—Pavillon de la musique du Duc d'Aumont." The Musée Carnavalet owns four of Atget's negatives, numbered 6399–6402, which depict Calmettes's home. John Szarkowski has speculated that the 394ff. pictures were taken because the stairway in the studio of M^r C had been remodeled (*The Work of Atget,* vol. 4, p. 173). M^r C does appear to have been a family friend: a print of 395 turned up in the collection of Valentin Compagnon.

58. The album has been restored and is no longer on its original pages but the original order has been maintained and the captions have been saved. There are two paper albums at the Museum of Modern Art in New York, entitled "La Voiture à Paris." "Album No 1 La Voiture à Paris 1910" reworked the order of the Bibliothèque Nationale album, drawing on the entire set of seventy-three photographs so that it went 1–13, 70, 71, 72, 67, 18–24, 65, 38–47, 59, 58, 50, 29, 52–55, 31, 32, 73, 35, 36, 48, 66, 62, and 64 (negative nos.). The photographs omitted from the paper album were: 14–17, 25–28, 30, 33, 34, 37, 49, 51, 56, 57, 60, 61, 63, 68, and 69. "Album No 2 1910 La Voiture à Paris" is incomplete, and many of those lower right corners, which listed the negative number, are missing; but it seemed to store the omissions to which it appended *Paris pittoresque*, no. 253, "Un coin du Marché des Patriarches."

59. The individual photographs entered the collections of the Bibliothèque historique on November 10 in that year as "60 photographies représentant des voitures parisiennes." They entered the Musée Carnavalet on March 21, 1911, as a paper album, "Suite de 60 épreuves, les Voitures." The finished hardcover album entered the registers of the Bibliothèque Nationale on July 23, 1911, entitled "Les Voitures à traction animale. Paris en 1910." Between the sale to the Carnavalet and that to the Bibliothèque Nationale, Atget substituted a new "voiture pour le transport des grosses pierres" at no. 13. The rejected one had been pulled from the early part of *Paris pittoresque*, but it was not returned there; it was moved to the middle part of the series as no. 62 in a string of other transfers from the early part, tacked on to form the tail end of the group.

60. Vicomte Georges d'Avenel, *Le mécanisme de la vie moderne*, 2d ed. (Paris: Colin, 1911), vol. 5, pp. 140–41. The figures he quoted, and felt justified in quoting, were derived from Alfred Martin, *Etude historique et statistique sur les moyens de transport dans Paris* (Paris: Imprimerie nationale, 1894), p. 200.

61. *Moeurs* surveys were made with carriages, but not frequently, even at mid-century, and always depended upon the activity of human figures for their sense. Victor Adam did one then. See also *Paris en voitures*, a series of colored postcards bound into a volume at the Bibliothèque historique de la Ville de Paris. A group of prints and photographs was assembled on a page of *Je Sais Tout* to show "Comment on voyageait dans Paris au siècle dernier" (15 February 1912), p. 118. The narrowness of Atget's survey can be measured by comparing these others with his.

62. Georges Mareschal, *Les voitures de place: Etude de la réglementation parisienne de la circulation. Thèse pour le doctorat, Université de Dijon* (Dijon: L. Marchal, 1912), p. 10.

63. *Terme* signified the three-month interval by which leases and rent were calculated in Paris. Behind this *terme* however there was a scenario. As Parisians experienced a general shortage in housing and a steady increase in rents, the population, especially those at the lower end of the scale, was often forced to shift. See Lucien Descaves, "Les rues débordent," *Je Sais Tout* (15 September 1910), pp. 165–74. The *petit terme* (short-term) tenant was taking his few but by no means shabby possessions in an open cart, presumably to other temporary quarters. The *grand terme* move, handled by an "Association Ouvrière" took up a long van. For Atget *terme* seemed to indicate the size of one's household effects.

64. Eugène Hénard, *Etudes sur les transformations de Paris*, fasc. 7—*Les voitures et les passants; Carrefours libres et carrefours à giration* (Paris: Libraries–Imprimeries réunies, 1906), p. 247. See also fasc. 6—*La circulation dans les villes modernes: L'automobilisme et les voies rayonnantes de Paris* (1905).

65. Georges Montorgueil, *La vie des boulevards: Madeleine–Bastille* (Paris: May et Motteroz, 1896).

66. Umberto Boccioni, Carlo Carrà, Luigi Russolo, Giacomo Balla, and Gino Severini, "Futurist Painting: Technical Manifesto, 1910," in *Futurist Manifestos*, ed. Umbro Apollonio, trans. Robert Brain et al. (New York: Viking, 1973), pp. 27–28. Before his conversion to modernist writing André Billy wrote *Paris vieux et neuf: La rive droite* (Paris: Rey, 1909), in which the *banalités* of modern traffic were given virtually a futurist confusion. See especially pp. 77ff.

67. Annette Michelson first made the connection between the film and Atget's photographs in her article " 'Man with the Movie Camera': From Magician to Epistemologist," *Artforum* 10 (March 1972), pp. 60–72.

68. Louis Morin, *Le dessin humoristique* (Paris: Laurens, 1913), p. 36.

69. Fabiano's name appeared on p. 45; Maréchal's on pp. 23, 33, and 67.

70. See the "prix d'été" signs in the background of *Paris pittoresque*, no. 49.

71. J. H. Lartigue, who knew the Bois as a small boy, was very impressed by it. See *Mémoires sans mémoire*: "Piétons, cavaliers, automobiles (cinq ou six), beaux équipages mélangés aux fiacres descendent aussi l'avenue du Bois, passent les grilles dorées de la porte Dauphine, tournent à droite devant le Pavillon Chinois

pour se retrouver tous ensemble aux Acacias et commencer une promenade en va-et-vient qui leur permettra de se croiser, de se voir, de se saluer, de se re-croiser, se re-voir, se re-saluer . . . les uns restant dans leur voiture ou à cheval, les autres, surtout s'il y a une jolie robe à montrer, descendant pour marcher dans le 'Sentier de la Vertu' " (p. 80). "Et le dimanche, c'est le contraire de la semaine: ce n'est pas aux Acacias qu'on se promène, c'est avenue du Bois-de-Boulogne. Les actrices et les 'cocottes' ne passent pas. Il n'y a que des parents avec jeunes filles, des parents sans jeunes filles et des jeunes gens seuls. Tout le monde se connaît, ou se reconnaît seulement, et la coûtume voulant que l'on se salue et re-salue chaque fois que l'on se croise et même si l'on s'est déjà croisé, salué et resalué plusieurs fois, au total cela fait énormément de saluts dans la matinée" (p. 161).

72. The later *voitures* pictures brought forward work done for the early *Paris pittoresque* series and renumbered it. The renumbered old pictures were incorporated into the *Paris pittoresque* number series, beginning with no. 61.

73. Marcel Proust, *A la recherche du temps perdu: A côté de chez Swann* (Paris: Pléiade, 1954), pp. 424–25, 427. English translation by C. K. Scott Moncrieff and Terence Kilmartin, *Swann's Way* (New York: Random House, 1981), pp. 459–60, 462.

74. Pierre Merlin, *Les transports parisiens* (Paris: Masson, 1967), p. 15.

75. Grand Palais, Paris, *Lartigue album* (1980), shows both horse-drawn carriages and motorcars. In 1925 a guidebook put out in conjunction with the decorative arts fair, *Paris: Arts décoratifs, 1925* (Paris: Hachette, 1925), explained the tour of the Bois.

76. See Leila Kinney, "Boulevard Culture and Modern Life Painting" (Ph.D. diss., Yale University, forthcoming); Andreas Huyssen, "Mass Culture as Woman," in his book *After the Great Divide: Modernism, Mass Culture, Postmodernism* (Bloomington: Indiana University Press, 1986), pp. 44–62.

77. James Joyce, *Dubliners* (1914; reprint, St. Albans: Panther, 1967), p. 70.

78. On the tradition of the *tableau de Paris*, the inventories of the population according to their occupations, see Karlheinz Stierle, "Baudelaire and the Tradition of the Tableau de Paris," *New Literary History* 11 (1980), pp. 345–61. See also Walter Benjamin, *Charles Baudelaire: A Lyric Poet in the Era of High Capitalism*, trans. Harry Zohn (London: New Left Books, 1973); Louis Chevalier, *Classes laborieuses et classes dangereuses: A Paris pendant la première moitié du dix-neuvième siècle* (Paris: Plon, 1958); T. J. Clark, *The Painting of Modern*

Life: Paris in the Art of Manet and His Followers (New York: Knopf, 1984); Robert Herbert, *Impressionism: Art, Leisure, and Parisian Society* (New Haven: Yale University Press, 1988).

79. Léon Descaves, "Of Open Spaces," in Académie Goncourt, *The Colour of Paris* (London: Chatto & Windus, 1908), pp. 56–57.

80. Gustave Kahn, *La femme dans la caricature française* (Paris: Mericant, 1907), p. v.

81. Lucien Puech, *L'album I–XVIII* (Paris: Tallardier, 1901–02), preface, ellipses in original.

82. Louis Morin, *Le dessin humoristique* (Paris: Laurens, 1913), pp. 16, 26. See also "La gaieté de nos humoristes," *Lectures pour Tous* (1911), pp. 625–33; Camille Bellanger, *L'art du peintre*, pt. 3, p. 30; Emile Bayard, *L'illustration et les illustrateurs* (Paris: Delagrave, 1898), pp. 18ff.; Hector MacClean, *Photography for Artists* (London: 1896), pp. 15–16.

83. F. Berkeley Smith, *How Paris Amuses Itself* (New York: Funk and Wagnalls, 1903), p. 132. See also Montorgeuil, *La vie des boulevards*.

84. Marcel Proust, *A la recherche du temps perdu: La prisonnière* (Paris: Pléiade, 1954), vol. 3, p. 128.

85. Jacques Hillairet, *Dictionnaire historique des rues de Paris*, 5th ed. (Paris: Minuit, 1963), vol. 2, p. 197.

86. Names, as Adrian Rifkin has remarked, become a form of connoisseurship: "In effect, social relations subjected to a connoisseurship of their representation, cease to be relations at all. They are only things to be named, like bird-watching without ecology" ("Musical Moments," *Yale French Studies*, no. 73 [1987], p. 126).

87. My understanding of the *Paris pittoresque* number series owes a very large debt to the work of Maria Morris Hambourg, who has kindly shared her research on its numbering. For the dating of the individual photographs I have accepted the dates written by Atget on the mounts of those prints sold to the Bibliothèque historique de la Ville de Paris. By this time he was also in the habit of noting his own negative number on the back of those mounts.

88. Gabriel Hanotaux, *La Seine et les quais* (Paris: Daragon, 1901), p. 21.

89. Gustave Pawlowski, *Les ports de Paris* (Paris: Berger-Levrault, 1910), p. 41.

90. Ibid., p. 59.

91. Denis Poulot, *Le sublime ou le travailleur comme il est en 1870, et ce qu'il peut être* (Paris: Maspero, 1980).

92. Ibid., p. 120. The song was the sublimes' modification of a known song titled "Travail plaît à Dieu" by Tisserand.

93. Ibid., pp. 124–25. Poulot gave footnotes that glossed the worst of the slang: "tournées de vitriol" (tournée d'eau-de-vie); "contre-coup de la boîte" (le contremaître de l'atelier); "canon" (verre de vin); "de la bouteille" (il y a du vin au litre et du vin à la bouteille; ce dernier est meilleur); "rapointi" (le rapointi est une broche faite avec le déchet de fer; les apprentis forgerons commencent par faire des rapointis).

94. Those sales to libraries help to date the series. See appendix 1 for the full list. The *voitures* group was sold in 1910; the *zoniers* in February 1911; the *métiers* did not enter library collections until later in 1911, but the few legible dates inside them on posters and papers gave away their date of origin. The Morris column on the place St. Sulpice, no. 222, showed three dates for October 1910: the kiosk at the Square Bon Marché, no. 225, showed a copy of *La Vie Heureuse* with a cover by Drian for its special number, "Mode d'Hiver," dated 6 October 1910.

95. See Rosalind Krauss's essays in the catalogue written by Rosalind Krauss and Jane Livingstone, *L'Amour Fou: Photography and Surrealism* (New York: Abbeville, 1985).

Ombres portées

1. Albert de Champeaux and F. E. Adam, *Paris pittoresque* (Paris: Librairie de l'art, 1883), p. 42.

2. E. Goudeau, *Paris qui consomme* (Paris: Béraldi, 1893), p. 267; Guy Tomel, *Le bas du pavé parisien* (Paris: Charpentier, 1894), p. iv. For more on the cabaret Au Père Lunette see: John Grand-Carteret, *Raphael et Gambrinus, ou l'art dans la brasserie* (Paris: Westhausser, 1886), pp. 197ff.; Alfred Bougenier, *Vieilles rues . . . vieilles maisons . . . vieux souvenirs . . . la Place Maubert* (Ivry-sur-Seine: 1909); André Warnod, *Bals, cafés et cabarets* (Paris: Figuière, 1913), pp. 243ff.

3. On the development of the music hall and cabaret see: Jacques Rancière, "Le bon temps ou la barrière des plaisirs," *Les Révoltes Logiques*, no. 7 (Spring–Summer 1978), pp. 25–66; Adrian Rifkin, "Musical Moments," *Yale French Studies*, no. 73 (1987), pp. 121–55, and his "Cultural Movement and the Paris Commune," *Art History* 2 (June 1979), pp. 201–20; Gareth Stedman Jones, "Working-Class Culture and Working-Class Politics in London, 1870–1900: Notes on the Remaking of a Working Class," in his *Languages of Class: Studies in English Working Class History* (Cambridge: Cambridge University Press, 1983), pp. 179–238; Clark, "A Bar at the Folies-Bergère," in *The Painting of Modern Life*, pp. 205–58. And then we have Zola's take on the situation as he found it in the 1890s and wrote about it in *Paris*, trans. Ernest Alfred Vizetelly (New York: Macmillan, 1898),

vol. 1, p. 343. He described a fictional Montmartre club that he called the Chamber of Horrors, which featured a lead singer he called Legras, a thinly disguised Aristide Bruant: "A prelude was played on the piano, and Legras standing there in his velvet jacket sang 'La Chemise,' the horrible song which brought all Paris to hear him. All the lust and vice that crowd the streets of the great city appeared with their filth and their poison; and amid the picture of Woman stripped, degraded, ill-treated, dragged through the mire and cast into a cesspool, there rang out the crime of the bourgeoisie. But the scorching insult of it all was less in the words themselves than in the manner in which Legras cast them in the faces of the rich, the happy, the beautiful ladies who came to listen to him. Under the low ceiling, amidst the smoke from the pipes, in the blinding glare of the gas, he sent his lines flying through the assembly like expectorations, projected by a whirlwind of furious contempt. And when he had finished there came delirium; the beautiful ladies did not even think of wiping away the many affronts they had received, but applauded frantically. The whole assembly stamped and shouted, and wallowed, distracted, in its ignominy."

4. Jean Lorrain, "La tournée des Grands-Ducs," *Je Sais Tout* (June 1905), pp. 720–22.

5. Atget initially brought old numbers forward (4085 and 4087) to make *Paris pittoresque* nos. 201 and 202, then quickly thought better of it and rephotographed the sites. See Szarkowski, *The Work of Atget*, vol. 4, p. 170.

6. Victor Fournel, *Les spectacles populaires et les artistes des rues* (Paris: Dentu, 1863), pp. 371ff. See also Robert L. Herbert, "*Parade de cirque* de Seurat et l'esthétique scientifique de Charles Henry," *Revue de l'Art*, no. 50 (1980), pp. 9–23.

7. Sometime before I began my research, *Métiers, boutiques et étalages* was rebound into a somewhat larger format than was usual for Atget, and the photographs were mounted on new pages. More a folio than a book now, it is not as easily leafed through and read. In the process it has fallen somewhat out of its original order, and its original captions have been lost. The order can be restored almost entirely, thanks to an inventory taken of the album before its demise: in cases where one inventory caption covers two or more photographs in sequence, I have arranged the work in numerical order; when one site is represented at different points in the album, I have made a decision based on the current order of the album. The captions given in the inventory are reduced versions of Atget's, but they stand fairly well as shortened shadows of the first. Their accuracy is probably comparable to that of the contemporary inventory taken of the *Enseignes* album (which has not been rebound), where the captions were given in shorter form.

8. The photographs for pp. 16, 23, 24, 26, and 49 were all taken from the *L'Art dans le Vieux Paris* number series.

9. "Des drôles de marchés," *Lectures pour Tous* (1911), pp. 150–58.

10. Henri d'Ancy, *La science pittoresque: L'abri humaine* (Abbeville: Paillart, 1898), pp. 176–77. Henri Baudin, *L'enseigne et l'affiche* (Geneva: Atar, 1905), p. 65. Amédée Berger, *Les enseignes de Paris* (Paris: Librairie des bibliophiles, 1858), p. 2. Alfred Franklin, *Dictionnaire historique des arts, métiers et professions exercées dans Paris depuis le treizième siècle* (Paris: Welter, 1906); see the entry for "boutique," p. 106. Pierre Giffard, *Les grands bazars* (Paris: Havard, 1882), pp. 276–83. H. Pasdermadjian, *Le grand magasin: Son origine, son évolution, son avenir* (Paris: Dunod, 1948), chap. 2. For modern appreciations of the subjects see especially Jeanne Gaillard, *Paris la ville, 1852–1870* (Paris: Champion, 1977), and Michael B. Miller, *The Bon Marché: Bourgeois Culture and the Department Store, 1869–1920* (Princeton: Princeton University Press, 1981). Walter Benjamin's *Charles Baudelaire* remains useful, especially with regard to the *flâneur*. Roger de la Fresnaye gave a Cubist's sense of it in "L'art dans la rue," *Montjoie!* (April 1914), p. 23.

11. Et. Martin Saint-Léon, *Le petit commerce français: Sa lutte pour la vie* (Paris: Gabalda, 1911), p. 16.

12. Paul Dubuisson, *Les voleuses de grands magasins* (Paris: A. Storck, 1904), p. 53, as quoted by Miller, *The Bon Marché*, pp. 200–01.

13. Léon and Maurice Bonneff, *La classe ouvrière—vol. 2, Les employés de magasin* (Paris: La Guerre Sociale, 1911), p. 33. See also J. Barbaret, *La bohème du travail* (Paris: Hetzel, 1889), pp. 193–94: "A Paris, les commerçants confinent aux deux extrémités de la société. Vous voyez aux magasins du Louvre ou du Bon Marché, tels que M. Chauchard ou feue Mme Boucicaut, des personnages quarante ou cinquante fois millionaires, ayant atteint cette magnifique situation en trafiquant des millions de kilogrammes d'étoffes diverses. Ce sont des commerçants au détail. Puis vous regardez frôler comme des larves les murs de ces magasins par des voitures attelées d'individus à la mine hâlée, aux vêtements sordides et nasillant des cris bizarrement rythmés. Sur ces voitures il y a des légumes, des fruits, des primeurs, des fromages, des poissons, des mollusques, de la charcuterie, des fleurs, que sais-je encore? Les conducteurs de ces voitures ont besoin de réaliser la vente de leur chargement, qui vaut depuis 5 francs jusqu'à 40 francs, pour s'approvisionner le lendemain. Les trois quarts d'entre eux mènent leur fortune sur leur véhicule. Envisagés au point de vue social, ils sont aux antipodes des

splendeurs où se prélassent les sommités du négoce, et cependant, comme ces hauts parvenus, ils font le commerce de détail; comme eux ils achètent en gros, — toutes proportions gardées. Les uns s'approvisionnent dans les premières fabriques, tandis que les autres vont modestement à la criée des Halles centrales."

14. Levasseur, *Histoire du commerce*, pp. 461–63; Miller, *The Bon Marché*, pp. 207ff.; Philip Nord, *Paris Shopkeepers and the Politics of Resentment* (Princeton: Princeton University Press, 1986), especially chap. 2, "*Grands magasins* and small shops."

15. F. Berkeley Smith, *The Real Latin Quarter* (New York: Funk and Wagnalls, 1901), p. 19.

16. Benezit, *Petits métiers*, p. 17.

17. "Etalages en plein air," *Les Amis de Paris* 1 (1911), p. 94. In 1922 J. B. Fonteix and Alexandre Guérin stated the obvious as an axiom for merchandisers: "La clientèle ouvrière se décide uniquement d'après ce qu'elle voit, il faut donc lui présenter une quantité de marchandises et lui donner toutes facilités de 'mettre l'article en main'. Pour lui faire l'article, employer un langage coloré et jovial, parler abondamment, au besoin répéter plusieurs fois les mêmes indications, toujours avec bonne humeur. Dans les quartiers riches, l'étalage doit être discret, sévère, toute surcharge nuirait à l'effet utile et discréditerait la maison. Devant la clientèle élégante, conserver une attitude respectueuse et discrète, parler peu, ne jamais insister. A qui comprends, peu de mots suffisent" (*La publicité méthodique* [Paris: Société Française de Publications, Périodiques et de Publicité, 1922], p. 66).

18. "Etalages en plein air," *Les Amis de Paris* 1 (1913), p. 676.

19. "Etalages et terrasses," *Les Amis de Paris* 1 (1913), p. 624. See also "Les étalages," *Les Amis de Paris* (1913), pp. 676–77, 705.

20. Georges Cain, *Coins de Paris* (Paris: Flammarion, 1905), pp. 175–76.

21. Daudet, *Paris vécu*, p. 182.

22. Halbwachs, *La classe ouvrière et les niveaux de vie*, p. xiii.

23. See Alain Cottereau, "Etude préalable: Vie quotidienne et résistance ouvrière à Paris en 1870," which functions as much more than the introduction to the 1980 Maspero edition of Denis Poulot, *Le sublime ou le travailleur comme il est en 1870, et ce qu'il peut être*. See also Gérard Noiriel, *Les ouvriers dans la société française, dix-neuvième–vingtième siècle* (Paris: Seuil, 1986), especially chap. 1, "A la recherche du prolétariat."

24. The Universités populaires (U.P.) did not keep records of all their speakers, and because the program at each U.P. changed every evening with the lecturer, this is understandable. It is possible, then, to have an idea, but only an idea, of the frequency with which Atget lectured there. I have compiled a list of Atget's lectures from a number of sources, but it is by no means an exhaustive list and is only intended to present the pattern of Atget's work in the U.P. Maria Morris Hambourg has established another such pattern in the second volume of *The Work of Atget*, pp. 33–34. My sources are a set of programs for the U.P. now in the collection of André Fildier, Paris, and the advertisements that appeared in *La Guerre Sociale* and *La Bataille Syndicaliste*.

U.P. programs from the collection of André Fildier: Université Populaire "Emile Zola," 44, Rue Planchat (XXe)

mois d'avril 1904: samedi 30 . . . ATGET: Tartuffe et le Misanthrope de Molière (avec auditions)

mois de novembre 1906: samedi 3 ATGET, Artiste dramatique: On ne badine pas avec l'amour. Alfred de Musset (avec auditions)

Maison du Peuple du 4e Arrondissement, Coopérative Socialiste, 20, Rue Charlemagne, Fédération des Universités Populaires

février 1907: jeudi 21 . . . M. ATGET, artiste dramatique . . . Don Juan, de Molière (avec auditions)

Université Populaire du Faubourg Saint-Antoine, La Coopération des Idées, 157, Faubourg Saint-Antoine

juillet 1908: mercredi 15 E. ATGET, artiste dramatique: Angelo, tyran de Padoue. de Victor Hugo (avec auditions)

janvier 1909: lundi 4 E. ATGET, artiste dramatique: Tartuffe et le Misanthrope (avec auditions). —Cours de mandoline de violon et de français pour les Polonais et les Russes, par M Zielinsky

avril 1909: lundi 5 E. ATGET: Le Foyer. d'Octave Mirbeau (avec auditions). —Cours de mandoline, de violon et de français pour les Russes et les Polonais, par Mme Zielinski.

février 1910: lundi 7 E. ATGET, artiste dramatique: Marie Tudor, de Victor Hugo (avec auditions)

Advertisements from *La Guerre Sociale:*

14 août 1908	La Semaille. U. P. 21 r. Boyer, 20e. Atget. Tartuffe. de Molière (auditions)
9 octobre 1908	La Semaille. Atget, Marie Tudor. de V. Hugo
30 juillet 1909	La Semaille. Atget. La Tour de Nesles, de Dumas père (auditions)
7 janvier 1910	La Semaille. Atget . . . Molière et les médecins
29 mars 1910	La Semaille. Atget: Phèdre. de Racine (avec auditions)

6 juin 1910	La Coopération des Idées. U. P. Atget, artiste dramatique: L'Ecole des Femmes de Molière
6 mai 1911	La Semaille. Hernani de V. Hugo (avec auditions) par Atget

Advertisements from *La Bataille Syndicaliste:*

4 septembre 1911	La Coopération des Idées. M. Atget, artiste dramatique. Le Lion amoureux, de Ponsard (auditions)
2 octobre 1911	La Coopération des Idées. M. Atgel [sic], artiste dramatique, Lorenzaccio d'Alfred Musset. Auditions
31 octobre 1911	La Semaille. M. Atget: Henri III et sa cour (auditions)
2 novembre 1911	La Coopération des Idées. M. Atget, artiste dramatique: Henri I: et sa cour. d'Al. Dumas (auditions)
5 décembre 1911	La Coopération des Idées. M. Atget artiste dramatique. Le fils de Giboyer d'Emile Augier. auditions
23 décembre 1911	U. P. Zola. M. Atget, artiste dramatique. La demi-mondaine, d'Alex. Dumas, fils (Auditions).
2 janvier 1912	La Coopération des Idées. M. Atget, artiste dramatique, La demi-mondaine, d'Alex. Dumas, fils (Auditions)
6 février 1912	La Coopération des Idées. M. Atget, artiste dramatique, Le Gendre de M. Poirer, d'Emile Augier (auditions)
27 février 1912	U. P. Zola, M. Atget, artiste dramatique, Kaen. d'Alexandre Dumas.

On page 65 of his *répertoire*, Atget made the following list:
Conférences

Foyer des Travailleurs du 14ᵉ arr
 Siège Social, 6 Rue Desprez.
Jeunesse Républicaine du 14ᵉ arr
 Siège Social 15 Rue Montbrun – Le président, A. Grandchamp.
Association Philomatique oeuvre gratuite d'Enseignement populaire,
 Siège Social 38 Rue de la Verrerie – Le Secrétaire Général, Fernand Pelletier, Le Président Léonce Dariac.

The list can be dated to 1913 and may well have been copied out of the *Annuaire–Répertoire officiel de l'administration de la Ville de Paris et des Communes du Département de la Seine* (1913). Atget delivered two lectures on Molière at the Ecole des Hautes Etudes Sociales

in 1913. On the handbill he is credited as "Ex-artiste des théâtres de Paris, Conférencier à l'Association Philo-technique, à la Ligue d'Education Sociale et au U. P. de Paris." The Ecole des Hautes Etudes Sociales marked the summit of this kind of lecturing. It had been founded in 1900 to investigate "les différents problèmes de la vie contemporaine—problèmes politiques, problèmes de morale sociale, mouvement artistique et littéraire," and through a series of public lectures one could listen to Georges Sorel on Karl Marx, Lugné-Poe on Ibsen, Emile Mâle on medieval art, Emile Vandervelde on the general strike, Romain Rolland on theater and history, and so on. Atget was in august company (*L'Ecole des Hautes Etudes Sociales, 1900–1910* [Paris: 1910], pp. v–vi, and for the program of courses, pp. 135–78). On the U. P., see Charles Guieysse, *Les Universités populaires et le mouvement ouvrier* (Paris: Cahiers de la Quinzaine, 1901). On this level of public instruction, see the entries for "Association philotechnique," "Association poly-technique," and "Université populaire" in the *Nouveau dictionnaire de pédagogie et d'instruction primaire*, ed. F. Buisson (Paris: Hachette, 1911).

25. André Girard, "L'Université populaire—ce qu'elle est," *L'Effort Sociale*, no. 1 (February 1907), p. 1.

26. L. Dumont-Wilden, "La muse française," *L'Occident* 15 (November 1908), pp. 206–07.

27. Halbwachs, *La classe ouvrière et les niveaux de vie*, p. 420.

28. Aristide Bruant, "A Montmertre," *Dans la rue: Chansons et monologues* (Paris: l'auteur, n.d.), vol. 1, pp. 167–71.

29. Roland Barthes, *La chambre claire: Note sur la photographie* (Paris: Gallimard Seuil, 1980), p. 18.

30. Hans Georg Puttnies, *Atget* (Köln: Galerie Rudolf Kicken, 1980), pp. 36–38.

31. The two other photographs of Atget's studio were numbered 251 and 252, making a kind of branch off the main line of the *Paris pittoresque* series, which has different pictures attached to those numbers. Prints of the studio photographs can be found in the collection of the Museum of Modern Art in New York.

32. A third view of the ceramicist's studio exists, numbered 13, part of the later *Paris pittoresque*, though the view appears to have been made at the same time as the other two. The Museum of Modern Art collection has a print of the picture.

33. Robert Rosenblum, "Picasso and the Typography of Cubism," in *Picasso in Retrospect*, ed. Roland Penrose and John Golding (New York: Praeger, 1973), pp. 49–75.

34. Anne-Marie Thiesse, *Le roman du quotidien: Lecteurs et lectures populaires à la belle époque* (Paris: Chemin Vert, 1984), p. 22.

35. By far the best work on the ragpicker is that by Alain Faure, "Classe malpropre, classe dangereuse? Quelques remarques à propos des chiffonniers parisiens au dix-neuvième siècle et de leurs cités," *recherches*, no. 29 (December 1977), pp. 79–102. Also useful is Comte d'Haussonville, *Misère et remèdes* (Paris: C. Lévy, 1886). For an appreciation of the *métier* at the time of its transformation see: Louis Paulian, *La hotte du chiffonnier*, 3d ed. (Paris: Hachette, 1896); Paul Bory, *La science pittoresque: Les métamorphoses d'un chiffon* (Abbeville: Paillart, 1897); Georges Renault, *Les rois du ruisseau* (Paris: Le livre moderne, 1900); Ministère du Commerce, de l'Industrie, des Postes et des Télégraphes, Office de Travail, *L'industrie du chiffon à Paris*, dir. du travail, Arthur Fontaine (Paris: Imprimerie nationale, 1903); Joseph Durieu, *Les parisiens d'aujourd'hui: Les types sociaux de simple récolte et d'extraction* (Paris: Giard et Brière, 1910); Georges Mény, *Professions et métiers—IX. Le chiffonnier de Paris* (Reims: 48, rue de Venise, 1906).

36. Karl Marx, "Economic and Philosophical Manu-scripts (1844)," in *Early Writings*, trans. Rodney Livingstone and Gregor Benton (Harmondsworth: Penguin, 1975), p. 292. Marx is quoting C. Pecqueur, *Théorie nouvelle d'économie sociale et politique, ou études sur l'organisation des sociétés* (Paris: Capelle, 1842), pp. 418–19, 421ff.

37. Charles Baudelaire, "Le vin des chiffonniers," *Oeuvres complètes* (Paris: Gallimard, 1975), vol. 1, p. 106.

38. Victor Hugo, *Les misérables* (Paris: Pléiade, 1951), p. 682.

39. On the disaffection of the zone see: Roger Guer-rand, *Les origines du logement social en France* (Paris: Editions ouvrières, 1966); Maurice Halbwachs, *Les expropriations et le prix des terrains à Paris, 1860–1900. Thèse pour le doctorat, Université de Paris, Faculté de droit* (Paris: Cornély, 1909); Eugène Hénard, *Etudes sur les transformations de Paris, fasc. 2. Les alignements brisés: La question des fortifications et le boulevard de Grande-Ceinture* (Paris: Champion, 1903); "A la place des fortifications," *Les Amis de Paris* (February 1913), pp. 516–17; Emile Daireaux, *Les fortifications de Paris et le droit des propriétaires de la zone* (Troyes: 1912); Syndicat des Propriétaires et Industriels Zoniers, *La question des fortifications de Paris, 12 janvier 1913* (Paris: Paul Dupont, 1913).

40. A later version of the album exists in a paper album at the Museum of Modern Art in New York. Atget has listed the order of the album inside the back cover of "Album No 2—Chiffonniers" as follows:

1 – 433	11 – 459	21 – 341	30 – 352
2 – 434	12 – 460	22 – 342	31 – 353
3 – 435	13 – 399	23 – 368	32 – 400
4 – 436	14 – 462	24 – 343	33 – 405
5 – 440	15 – 406	24 bis – 344 bis	34 – 407
6 – 441	16 – 336	25 – 345	35 – 408
7 – 442	17 – 337	26 – 346	36 – 430
8 – 443	18 – 338	27 – 347	37 – 431
9 – 457	19 – 339	28 – 351	38 – 397
10 – 458	20 – 340	29 ——	39 – 398

41. Ministère du Commerce, *L'industrie du chiffon à Paris*, p. 3.

42. Ibid., p. 5.

43. Ibid., p. 38.

44. Atget photographed the *chiffonnier* and his *hotte* in 1899, according to the caption on the print at the Bibliothèque historique. It is numbered 3206 and figures into the postcard series.

45. See Faure, "Classe malpropre, classe dangereuse?" for a full discussion of this phenomenon.

46. Bourneville, *Rapport sur l'insalubrité de la Cité Doré et de la Cité des Kroumirs. Préfecture de Police, Conseil d'hygiène publique et de salubrité* (Paris: 1882), p. 10.

47. Ministère du Commerce, *L'industrie du chiffon à Paris*, p. 20.

48. Georges Renault, *Les rois du ruisseau*, p. 18.

49. A. Coffignon, *Le pavé parisien* (Paris: Librairie illustrée, n.d.), p. 31.

50. Privat d'Anglemont, "La villa des chiffonniers," *Paris anecdote* (Paris: Jannet, 1854), p. 218. The article first appeared in *Le Siècle* (30 January 1853).

51. Ministère du Commerce, *L'industrie du chiffon à Paris*, p. 32.

52. Paulian, *La hotte du chiffonnier*, p. 66.

53. Ibid., pp. 65–66.

54. Mény, *Professions et métiers—IX. Le chiffonnier de Paris*, pp. 23–25.

55. Renault, *Les rois du ruisseau*, p. 99. Durieu, *Les parisiens d'aujourd'hui*, pp. 104–05.

56. Renault, *Les rois du ruisseau*, p. 17.

57. Ibid., pp. 17–18; see also p. 6.

58. Durieu, *Les parisiens d'aujourd'hui*, pp. 126–27.

59. B. Tarride, "Rébuts du riche, trésors du pauvre," *Je Sais Tout* (February 1914), pp. 214–22.

60. On the Cité Doré, see: Doré fils, *Notice administrative, historique et municipale sur le treizième arrondissement de la Ville de Paris* (Paris: Dalmont et Dunod, 1860); Doré père, "Réponse à un article sur la Cité Doré signé Pierre Gallie et publié par la Revue Municipale au 10 sept. 1859" (copy at the Bibliothèque Nationale); Privat d'Anglemont, "La villa des chiffonniers"; Comte d'Haussonville, *Misère et remèdes*.

61. Tarride, "Rébuts du riche, trésors du pauvre," p. 218.

62. Ministère du Commerce, *L'industrie du chiffon à Paris*, pp. 5–6.

63. J. Donot, *Manuel du conférencier antialcoolique* (Reims: Action populaire, 1910), pp. 9–10, ellipsis mine.

64. J. Gauvin, *Les métiers* (Paris: Bibliothèque de mes petits, 1914), pp. 14–15.

65. Dr. M. P. Legrain and A. Perès, *L'enseignement antialcoolique à l'école* (Paris: Librairie Fernand Nathan, 1899), p. 177. The adage was the work of one A. Laurent.

66. Susanna Barrows, "After the Commune: Alcoholism, Temperance and Literature in the Early Third Republic," in *Consciousness and Class Experience in Nineteenth Century Europe*, ed. John Merriman (New York: Holmes & Meier, 1979), pp. 205–18. Michael Marrus, "L'alcoolisme social à la Belle Epoque," *recherches*, no. 29 (December 1977), pp. 285–314. J. Lalouette, "Le discours bourgeois sur les débits de boisson aux alentours de 1900," *recherches*, no. 29 (December 1977), pp. 315–48.

67. Lalouette, "Le discours bourgeois sur les débits de boisson," p. 346.

68. Georges Maurange, "Alcoolisme et le parti socialiste," *Revue Socialiste* (April 1912), p. 357.

69. "L'absinthe tueuse d'hommes et d'énergies," *Je Sais Tout* (February 1907), pp. 47–54.

70. Dr. H. M. Menier, *Mon Docteur*, 3 vols. (Paris: Librairie commerciale, 1907). The guide remains in the collection of Valentin Compagnon. Certain sections of it are annotated in Atget's hand.

71. Vandervelde's writings on alcoholism are published in several drafts: *Les facteurs économiques de l'alcoolisme (conférence faite à Lille à l'Assemblée générale de 1901 de l'Union française antialcoolique)* (Paris: 1902); "Les facteurs économiques de l'alcoolisme," *La Grande Revue* 17 (March 1901), pp. 558–76; the last and most complete version appears as a section of his book, *Essais socialistes: L'alcoolisme, la religion, l'art* (Paris: Alcan,

1906). *La Guerre Sociale* sponsored a campaign against alcoholism: "L'alcool, moyen de gouvernement" (1 July 1908); "La victoire des bistrots" (6 February 1912); Un Sans-patrie [Hervé], "Contre l'alcoolisme" (21 February 1912). In addition their press promoted Léon and Maurice Bonneff's book, *Marchands de folie* (Paris: Rivière, 1912). F. Berkeley Smith had this to say about the working-class drunks in his book *The Real Latin Quarter*, p. 129: "Drunkards are not frequent sights in the Quarter; and yet when these people do get drunk, they become as irresponsible as maniacs. Excitable to a degree even when sober, these most wretched among the poor when drunk often appear in front of a café—gaunt, wild-eyed, haggard, and filthy—singing in boisterous tones or reciting to you with tense voices a jumble of meaning-less thoughts. The man with the matted hair, and toes out of his boots, will fold his arms melodramatically, and regard you for some moments as you sit in front of him on the terrace. Then he will vent upon you a torrent of abuse, ending in some jumble of socialistic ideas of his own concoction."

72. Vandervelde, *Essais socialistes*, p. 53. Vandervelde quoted Taine ("L'alcool est la littérature du peuple") and Baudelaire ("il y a sur la boule terrestre, une foule innombrable, innomée, dont le sommeil n'endormirait pas suffisamment les souffrances. Le vin compose pour eux des chants et des poèmes"), but this did not give the cabaret any special cultural value (p. 55). "Paradis artificiel" was not enough, not the real or direct political action that Vandervelde desired.

73. Guillaume Apollinaire, "Zone," *Alcools*, in *Oeuvres poétiques complètes* (Paris: Pléiade, 1956), p. 44.

74. Ibid., pp. 39–40.

75. Charles Fegdal, *Les vieilles enseignes de Paris* (Paris: Figuière, 1913).

76. Warnod's illustrations appeared in *Montjoie!* (April 1914) on pp. 28 and 14, respectively.

77. See also another book on Figuière's list, this one by Warnod himself, *Bals, cafés et cabarets* (Paris: Figuière, 1913). For the poetic view of cabaret life, see also A. t'Serstevens, "II. Les cafés," *Montjoie!* (14 April 1913), p. 5; Grand-Carteret, *Raphael et Gambrinus, ou l'art dans la brasserie*; and Beurdeley, *L'éducation antialcoolique* (Paris: Delagrave, 1905).

78. Jean Muller, "Bars et tavernes," *Montjoie!* (April 1914), p. 28.

79. Fegdal did write about the cabaret in a pair of articles for *La Cité*: "Cabarets et cafés célèbres de la Cité et de ses alentours," *La Cité* 8 (1913), pp. 386–99, and 9 (1914), pp. 395–413. Here he brushed past the sign to examine the historic culture within, culture that he noted was both revolutionary and artistic. The revolutionaries

were, of course, handled with extreme care: in the caba-
ret La Renaissance, closed down by Napoléon III, Fegdal
spoke only of the abstract political discussions of the
students; at the brasserie Saint-Séverin he recounted the
pretentious paramilitary behavior of some leading Com-
munards; at the Cabaret de la Cité near Notre-Dame he
detailed a working-class march on the Hôtel de Ville in
1848, a march to ensure that the new government served
its interests, but Fegdal defused its success in half a sen-
tence—"Mais sa gloire ne fut guère de longue durée, on
l'oublia vite, et il disparut, dans l'indifférence générale,
quand commencèrent les démolitions de la Cité" (vol. 9,
p. 403). By and large he worked to deny the idea of cur-
rent revolution or class presence in the cabaret; as he
said of le Franc Pinot: "En 1830, en 1848, le cabaret du
Franc Pinot eut une grande clientèle de révolutionnaires,
de combattants qui, de là, se rendaient à l'Hôtel de Ville
et y revenaient, après la victoire, boire à la liberté, étan-
cher leur soif et bander leurs blessures. Aujourd'hui le
Franc Pinot, au bas de son antique maison, protégé par
sa solide grille, indiqué par sa vieille et belle enseigne,
est un placide et honnête débit de vins, dont l'archaïque
aspect rappelle les temps enfuis, non sans intérêt ni pitto-
resque" (vol. 9, p. 405). At the hand of a man like Fegdal
the revolution could become picturesque, and with
much the same disregard for popular culture, he ended
his article by claiming that all the drinkers through
the ages were equal: "Mais, les écoliers et les clercs du
moyen âge comme les mousquetaires du Roi; mais, les
seigneurs et les écrivains du grand siècle comme les sans-
culottes de 93; tous, tous se ressemblent fort, car tous
sont venus chercher à la taverne, au cabaret, au café ou
à l'assommoir, le repos joyeux et le prompt oubli de leur
labeur, la gaieté au fond du verre. Plus le cabaret était
célèbre, plus le vin semblait bon, on s'y trouvait en pays
merveilleux: 'Voicy le pays de Cocagne / Où l'on boit le
bon vin d'Espagne, / Le doux hypocras, le muscat, / Et
l'alicant si délicat . . . / Mais où est l'hypocras, où sont
les cabarets d'antan?' " (vol. 9, pp. 412–13). Likewise
the Bibliothèque historique de la Ville de Paris, *La vie
populaire à Paris par le livre et l'illustration (quinzième à
vingtième siècle)* (4 June to 1 October 1907), pp. 10–11,
had had to treat the cabaret and did so very gingerly, as
past culture purely: "Aux tavernes chantées par Villon,
aux cabarets et hôtelleries réglementés par des ordon-
nances royales au XVIᵉ siècle, à la Croix-de-Lorraine,
à la Pomme-de-Pin où se retrouvaient Racine, La Fon-
taine et Boileau, ont succédé, à la fin du XVIIᵉ siècle
et au XVIIIᵉ, les cafés. Une caricature de cette époque
représente le cafetier fumant sa pipe, tenant d'une main
un pot de 'cocolat,' et de l'autre un plateau chargé de ver-
res de liqueur, 'ratafia, coco de caraca, eau-de-vie.' Restif
de La Bretonne promène ses personnages du 'Caffé du
Parnasse' à la boutique d'une belle limonadière (1785).

C'est une belle limonadière encore qu'on retrouve vers
1817, au café des Mille-Colonnes, au Palais Royal. Le
Café des Mille-Colonnes a disparu. Disparus également
le café du jardin des Tuileries adossé à la terrasse des
Feuillants, où se pressaient les élégants du Directoire.
Seul, le café de la Régence, où le neveu de Rameau allait
faire sa partie d'echecs, a survécu."

80. Fegdal, *Les vieilles enseignes*, pp. 97–98.

81. "Formation d'un dossier des enseignes de Paris,"
Commission municipale du Vieux Paris, *Procès-verbaux*
(16 June 1909), pp. 68–69. Etienne Charles, "Au Musée
Carnavalet: Nouvelles salles et nouveaux aménage-
ments," *La Cité* 9 (1914), pp. 340–44. Charles Fegdal,
"Les vieilles enseignes," *Les Amis de Paris* (March 1914),
pp. 58–60. The standard manuals for old signs were:
Edouard Fournier, *Histoire des enseignes de Paris* (Paris:
Dentu, 1884); Edmond Beaurepaire, "Les enseignes de
Paris," *Le Carnet* (October and December 1902), pp. 1–
42 and 321–39, respectively (a third part was promised
but never appeared); Auguste Callet wrote a series of
articles for *La Cité* 1 (1902–03), pp. 81–88, 150–57,
529–38; Fegdal, *Les vieilles enseignes*.

82. Edouard Fournier, *Histoire des enseignes de Paris*,
pp. 276–78.

83. Ibid., p. 138.

84. Ibid., pp. 143–44.

85. Edmond Beaurepaire, "Les enseignes de Paris,"
p. 26.

86. G. H., "Les vieilles enseignes de Paris dessinées par
Jean-Jules Dufour," *La Cité* 6 (1911), pp. 45–47.

87. Cain, *Promenades dans Paris*, pp. 260–61. Ernest
Maindron, *Les affiches illustrées* (Paris: Launette, 1886),
pp. 66–69.

88. *Concours d'enseignes organisé par la Ville de Paris*
(Paris: Guerinet, 1903). Marcel Sembat, "Préface,"
Catalogue du Salon d'Automne, 1913 (1913), p. 56. As
evidence of this see Fernand Léger's essay, "Les réali-
sations picturales actuelles," *Soirées de Paris*, no. 25
(15 June 1914), pp. 349–56.

89. See, for the imitations, Hénard's drawings for Trois
Canettes, Au Dragon, and Au Cherche-Midi, "Les en-
seignes de Paris," pp. 29, 30, 31, respectively. Maria
Morris Hambourg has suggested a probable connec-
tion to Beaurepaire's project, though without citing
the copied photographs; see *The Work of Atget*, vol. 2,
p. 180.

90. The photograph was reproduced on p. 41.

91. There were errors in this Vieux Paris work too: pp.
17 and 36 depict 30 rue du Four; p. 10 is a Louis XV bou-
tique; p. 59 is situated at 98 rue du Bac; and p. 30 does

not depict a cabaret that was later demolished (it still
exists, in fact, at 62 rue de l'Hôtel de Ville).

92. Georges Sadoul, *Lumière et Méliès*, édition augmen-
tée et révisée par Bernard Eisenshitz (Paris: Lherminier,
1985). *Centre culturel international de Cérisy La Salle:
Méliès et la naissance du spectacle cinématographique*,
sous la direction de Madeleine Malthête-Méliès (Paris:
Klincksieck, 1984).

93. Pierre Souvestre and Marcel Allain, *Fantômas*,
2 vols., ed. Francis Lacassin (Paris: Robert Laffont,
1987–88), for a reedition of eight of the stories and criti-
cal documentation. For the way in which black Third
World culture was integrated into French culture and
discourse, see James Clifford, *The Predicament of Cul-
ture: Twentieth-Century Ethnography, Literature and
Art* (Cambridge: Harvard University Press, 1988).

94. Atget had made a photograph of the same cabaret in
1911 as part of the *Topographie de Paris* series, no. 1142.
It showed the cabaret from a greater distance as part of a
sunny street scene.

95. On the modern drunk, see Vicomte d'Avenel, *Le
mécanisme de la vie moderne*, vol. 3, pp. 180–81.

96. Inside the album on the flyleaf, someone, not Atget,
inscribed "Photographies exécutées par Mr Atget phot.
archéologue entre 1900 et 1915" sometime after its
acquisition.

97. Herbert Adams Gibbons, *Paris Reborn: A Study
in Civic Psychology* (New York: Century, 1915), pp.
200–02, dated 6 September 1914.

98. Edith Wharton, *Fighting France: From Dunker-
que to Belfort* (New York: Scribner's, 1915), pp. 41–42.
See also M. E. Clarke, *Paris Waits, 1914* (London:
Smith, Elder, 1915); Rowland Strong, *The Diary of an
English Resident in France during Wartime*, 2 vols.
(London: Eveleigh Nash, 1915; Simpkins, Marshall,
Hamilton, Kent, 1916); and Henri Sellier, A. Brugge-
man, and Marcel Poëte, *Paris pendant la guerre* (Paris:
P. U. F., 1926). The difficulties this posed for culture
have been brilliantly discussed by Kenneth Silver, *Esprit
de Corps: The Art of the Parisian Avant-Garde and
the First World War, 1914–1925* (Princeton: Princeton
University Press, 1989).

99. The full title reads "Album No 3/Les Arbres/Forets
Bois" and includes nos. 414, 415, and 417.

100. Bertout de Solières, *Les fortifications de Paris à
travers les âges* (Rouen: 1906), p. 27. See also J. Flourens,
*Les fortifications de Paris, leur histoire, leur désaffecta-
tion future et ses conséquences. Thèse pour le doctorat,
Université de Paris, Faculté de droit* (Paris: Larose et
Tenin, 1908).

101. E. Pottier took some photographs of the fortifications dated August 1902 and May 1905 and sold them to the Bibliothèque historique. They were described by the card catalogue there as "64 photographies. Portes de Paris (enceinte fortifiée de Louis-Philippe); suite de 64 vues des portes, poternes et passages, prises de Paris vers l'extérieur (sauf les nos. 1, 9 et 45)." Pottier, unlike Atget, emphasized the bastions and the gates.

102. Georges Montorgueil, *Croquis parisiens: Les plaisirs du dimanche; à travers les rues* (Paris: May et Motteroz, 1897), showed prewar photographs of the *zone* and its leisure crowd. Gervais-Courtellemont was credited for the photographs. The *zone* was shown as a barren treeless plain.

103. On this failure, see J. J. Becker, *1914* (Paris: Presses de la Fondation nationale des sciences politiques, 1977); Marc Ferro, *La grande guerre, 1914–1918* (Paris: Gallimard, 1969); Annie Kriegel and J. J. Becker, *1914: La guerre et le mouvement ouvrier français* (Paris: Colin, 1964); Roger Picard, *Le mouvement syndical durant la guerre* (Paris and New Haven: Presses Universitaires de France and Yale University Press: 1928). *La Bataille Syndicaliste* actually ceased publication on 25 September 1915.

104. Gustave Hervé, "A deux doigts de la mobilization," *La Guerre Sociale* (29 July 1914), as cited in Hervé, *La grande guerre au jour le jour: Receuil in extenso des articles publiés dans "La Guerre Sociale" et "La Victoire" depuis juillet 1914* (Paris: Ollendorff, 1917), vol. 1, p. 19.

105. Hervé, "Travail et patrie," *La Guerre Sociale* (1 December 1914), in *La grande guerre*, vol. 1, p. 285.

106. Hervé, "Pour les socialistes anglais," *La Guerre Sociale* (7 September 1915), in *La grande guerre*, vol. 3, p. 91.

107. Reyher notes, p. 42. Jean Leroy, *Atget: Magicien de Vieux Paris* (Joinville-le-Pont: Balbo, 1975), p. 20. M^me Demoulin's memory of Atget reading the *Bonnet Rouge* in the 1920s needs correcting. But both she and her mother remember that Atget did not go out much during the war.

108. For the *Action Française* and the *Bonnet Rouge* confrontation, see Léon Daudet, *Paris vécu*, pp. 73, 181. See also *Histoire générale de la presse française*, vol. 3, pp. 439ff. The editor of the *Bonnet Rouge*, Miguel Almereyda, was associated with *La Guerre Sociale*. He was also the father of filmmaker Jean Vigo. A good summary of Almereyda's work may be found in P. Salles Gomes, *Jean Vigo* (Berkeley: University of California Press, 1971).

109. For a view of how differently the zone was viewed by the illustrated press, see Sergine Dac, "La zone et ses habitants," *L'Illustration* (8 February 1913), pp. 106–08; and A. Gervais, "Paris brise sa ceinture," *Je Sais Tout* (January 1913), pp. 305–15.

110. See, for a good summary, André Billy, *Adieu aux fortifications* (N.p.: St. Eloy, 1930).

111. Ibid., p. 55. Billy gave statistics showing that between 1912 and 1930 the population of the *zone* actually rose from 80,000 to 125,000 inhabitants, and the number of dwellings there went from 9,273 to some 15,000.

112. Lucien Descaves, "Adieu 'fortifs,'" *Les Annales politiques et littéraires*, no. 1548 (23 February 1913), p. 165. See also Gervais, "Paris brise sa ceinture."

113. Guy Debord, *La société du spectacle* (Paris: Buchet-Chastel, 1967).

114. Louis Dausset, *Rapport sur le déclassement total de l'enceinte fortifiée, l'annexion de la zone militaire et sur le projet de convention entre la Ville de Paris et l'Etat* (Paris: Imprimerie municipale, 1912), p. 21.

115. The two volumes were sold via M. Leclerc, rue St. Honoré, on 12 December 1917 and listed in the acquisitions records as " 'L'Affaire Dreyfus'—Recueil d'images par M. Atget"; they sold for one hundred francs. The volumes were rebound into three volumes in 1976 (now Qe 89. fol). Though the acquisition number is nowhere to be found in them, Atget's handwritten annotations identify the clippings. For a different discussion of this material see Maria Morris Hambourg's essay in *The Work of Atget*, vol. 2, p. 24. See also *The Dreyfus Affair: Art, Truth, and Justice*, ed. Norman L. Kleebat (Berkeley: University of California Press, 1987), for the context from which Atget's clippings were selected.

116. Wassily Kandinsky, letter to Franz Marc, 5 June 1913, quoted by Klaus Lankheit in "A History of the Almanac," his preface to *The Blaue Reiter Almanac*, ed. Klaus Lankheit (New York: Viking, 1974), p. 31.

117. Albert Valentin, "Eugène Atget (1856–1927)," *Variétés* 1 (15 Decembér 1928), p. 406.

118. Fernand Léger, "L'esthétique de la machine" (1924), in his *Fonctions de la peinture* (Paris: Gonthier, 1965), p. 57.

119. Louis Aragon, *Paysan de Paris* (Paris: Gallimard, 1926), pp. 29–32. English translation by Frederick Brown, *Nightwalker* (Englewood Cliffs, N.J.: Prentice-Hall, 1970), pp. 15–17.

120. The store occupied space in the buildings numbered 49 and 51 on the avenue des Gobelins and was listed in the Bottin of 1925 as Aux Gobelins, *confections*. The buildings reflected from across the street include the national manufacturer. Marcel Duchamp, *Three Stoppages étalon*, 1913–14. Assemblage: three threads glued to three painted canvas strips, 5 1/4 × 47 1/4" (13.3 × 120 cm), each mounted on a glass panel, 7 1/4 × 49 3/8 × 1/4" (18.4 × 125.4 × 6 cm); three wood slats, 2 1/2 × 43 × 1/8" (6.2 × 109.2 × .2 cm), 2 1/2 × 47 × 1/8" (6.1 × 119.4 × .2 cm), 2 1/2 × 43 1/4 × 1/8" (6.3 × 109.7 × .2 cm), shaped along the edge to match the curves of the threads; the whole fitted into a wood box, 11 1/8 × 50 7/8 × 9" (28.2 × 129.2 × 22.7 cm). Collection, The Museum of Modern Art, New York. Katherine S. Dreier Bequest.

121. Marcel Duchamp, *Duchamp du signe: Ecrits*, réunis et présentés par Michel Sanouillet, nouvelle édition revue et augmentée avec la collaboration de Elmer Peterson (Paris: Flammarion, 1975), pp. 105–06. Translation from the earlier English edition, *Salt Seller: The Writings of Marcel Duchamp* (New York: Oxford University Press, 1973), p. 74.

122. Morris Hambourg itemizes the sign pictures Atget replaced (6224, 6385, 6386) and rephotographed (6376, 6362) in *The Work of Atget*, vol. 2, p. 169.

123. The Bibliothèque Nationale list does not contain the Parc de Sceaux project, whereas it does contain the work from Saint Cloud and Versailles; but the list can be more precisely dated from the names of the places photographed for the *Environs* series. The list does not contain any of the new sites photographed in late 1924 or 1925, which are recorded in the reference paper albums for the series, now in the Atget Archive, MOMA. As of 1923 Atget was careful to furnish dates for that work in the captions he wrote into his reference albums.

124. Fernand Bournon and Albert Dauzat, *Paris et ses environs* (Paris: Larousse, 1925), p. 200.

125. Elie Debidour, "Rapport sur le domaine de Sceaux," Commission municipale du Vieux Paris, *Procès-verbaux* (29 March 1924), p. 52.

126. The classic texts for any discussion of political art in France during this period are: Emile Vandervelde, *Essais socialistes,* and Roger Marx, *L'art social* (Paris: Fasquelle, 1913). See also Eugenia W. Herbert, *The Artist and Social Reform: France and Belgium, 1885–1898* (New Haven: Yale University Press, 1961); Madeleine Réberioux, "Critique littéraire et socialisme au tournant du siècle," *Le Mouvement Social*, no. 59 (April 1967), pp. 3–28, "Avant-garde esthétique et avant-garde politique: Le socialisme français entre 1890 et 1914," in *Esthétique et marxisme: 10/18* (Paris: Union générale d'éditions, 1974), pp. 21–40, and *La république radicale? 1898–1914* (Paris: Seuil, 1975). Also pertinent to Atget's case are: Charles Albert, *Qu'est-ce que c'est l'art?* (Paris: La Guerre Sociale, 1909), and Fernand Pelloutier, *L'art et la révolte* (Paris: Bibliothèque de l'art social, 1896).

127. Walter Benjamin, *One-Way Street and Other Writings*, trans. Edmund Jephcott and Kingsley Shorter (London: Verso, 1979), p. 66; cited by Sandor Radnoti, "The Effective Power of Art: On Benjamin's Aesthetics," *Telos*, no. 49 (Fall 1981), pp. 71–72.

Appendix I

Captions and Negative Numbers for the Albums

Table I. *L'Art dans le Vieux Paris*

Captions have been given as they appear typeset in the Museum of Modern Art version, which included the negative numbers of the photographs. Inconsistencies have been maintained. In the album itself the dates for the images were not given, but when the same prints were sold to the Bibliotheque historique de Vieux Paris (BHVP), Atget dated the captions he wrote for their cardboard mount. Those dates have been listed here. Page numbers are mine.

Page number	Caption	Negative number	BHVP date
1	Hôtel Roualle de Boisgelin (1750) 29, Quai Bourbon (4ᵉ Arrᵗ) – Magnifique porte, style Louis XVI.	3879	n.d.
2	Hôtel Roualle de Boisgelin (1750) 29, Quai Bourbon (4ᵉ Arrᵗ) – Escalier, rampe fer forgé, style Louis XVI, merveille de finesse et de goût.	3880	n.d.
3	(4ᵉ Arrᵗ) Eglise Saint-Louis en l'Ile, Rue Saint-Louis en l'Ile (1664 à 1679) Choeur de 1702 à 1726, Architecture de Levau, G. Leduc et Jacques Doucet. Très belle porte XVIIIᵉ siècle.	3912	mai 1900
4	3, Quai Bourbon (4ᵉ Arrᵗ) – Charmante petite boutique de l'époque de Louis XVI, divisée en arcades finement sculptées, où était établi, paraît-il, le parfumeur de Marie-Antoinette.	3869	mai 1900
5	3, Quai Bourbon (4ᵉ Arrᵗ) – Charmante petite boutique de l'époque de Louis XVI. (Détail)	5630	1909
6	Hôtel de Fieubet, 2, Quai des Célestins (4ᵉ Arrᵗ) – Construit sur l'emplacement de l'hôtel royal de Saint-Paul, par Hardouin Mansart, pour Gaspard de Fieubet, Chancelier de la Reine Marie-Thérèse (1671); acheté en 1850 par M. Lavalette, publiciste qui le restaura: Aujourd'hui, Collège Massillon.	3932	mai 1900
7	Rue Charles V, 12 (4ᵉ Arrᵗ) – Magnifique escalier, ancien Hôtel Daubray, père de la Brinvilliers, habité sous Louis XIV, par la Marquise de Brinvilliers, l'empoisonneuse, aujourd'hui succursale de la communauté des soeurs garde-malades de Troyes.	3934	mai 1900
8	Saint Nicolas-du-Chardonnet, Rue Monge et Boulevard Saint-Germain (5ᵉ Arrᵗ) – Cet édifice, monument historique, a été construit sur les dessins du peintre Lebrun, 1656 à 1690. Très belle porte XVIIIᵉ siècle.	3992	août 1900
9	Impasse de la Poissonnerie, Rue de Jarente. (4ᵉ Arrᵗ) au bas de la Rue de Turenne – Très jolie fontaine construite en 1700. Réédifiée en 1783, sur les dessins de Caron. C'est un joli petit édicule trop ignoré.	3943	juin 1900

Page number	Caption	Negative number	BHVP date
10	Rue Geoffroy-Lasnier, 26. (4ᵉ Arrᵗ) – Hôtel Chalon-Luxembourg (1657) habité par Antoine Le Fèvre de la Borderie Ambassadeur en Angleterre; Très belle porte, chef-d'oeuvre de menuiserie et dont le heurtoir est une merveille.	3528	1898
11	Rue Geoffroy-Lasnier, 26 (4ᵉ Arrᵗ) – Hôtel Chalon-Luxembourg. (1657). Heurtoir.	4589	1902
12	Jardin du Luxembourg. (6ᵉ Arrᵗ) – Remarquable fontaine de Medicis, formée de la réunion de la "Grotte de Vénus" élevée dans le jardin du Luxembourg sur l'ordre de Marie de Médicis (1620), d'après les dessins de Rubens ou de Salomon de Brosse, et de la fontaine qui existait autrefois, au coin de la rue du Regard.	3956	juin 1900
13	Jardin du Luxembourg. (6ᵉ Arrᵗ) – Fontaine qui existait autrefois, au coin de la rue du Regard.	3955	juin 1900
14	Jardin du Luxembourg. (6ᵉ Arrᵗ) – Remarquable fontaine de Médicis.	3018	1898
15	Quai de l'Hôtel-de-Ville, 34 (4ᵉ Arrᵗ) – Très belle grille de cabaret (Disparue en 1902). C'était une des plus curieuses, et aussi celle qui, par ses détails d'exécution, rappelle le mieux la serrurerie du XVIIIᵉ siècle.	3961	juin 1898
16	Rue de Montmorency, 5 (3ᵉ Arrᵗ). Superbe façade sur la cour. Ancien hôtel de Montmorency, construit par le Connétable Mathieu et habité par ses successeurs. Nicolas Fouquet y habita, alors qu'il n'était que procureur général.	4052	août 1900
17	Rue Vieille-du-Temple, 47 (4ᵉ Arrᵗ). Très belle porte, hôtel des ambassadeurs de Hollande construit en 1638, par Cottard, sur l'emplacement de l'hôtel de Rieux.	4076	septembre 1900
18	Rue Vieille-du-Temple, 47 (4ᵉ Arrᵗ) – Hôtel des Ambassadeurs de Hollande. Porte, motif décoratif, chef-d'oeuvre de menuiserie.	4078	septembre 1900
19	Rue Vieille-du-Temple, 47 (4ᵉ Arrᵗ) – Hôtel des Ambassadeurs de Hollande. Dessus de porte, intérieur, cour, bas-relief représentant Romulus et Remus.	5636	1909
20	Rue Séguier, 16 (6ᵉ Arrᵗ) – Hôtel de Moussy, d'Argouges (1695); Marquis de la Housse, ambassadeur de Danemark; Marquis de Flamerens, chancelier de France (1728); le Baron Séguier premier président, y mourent en 1848. Remarquable escalier, rampe fer forgé.	4126	septembre 1900
21	Rue Séguier, 16 (6ᵉ Arrᵗ) – Hôtel de Moussy. Très belle porte.	4115	septembre 1900

Page number	Caption	Negative number	BHVP date
22	Rue de Tournon, 6 (6ᵉ Arrᵗ) – Hôtel de Terrat, marquis de Chantosme, chancelier du Duc d'Orléans; Bugnet, intendant de M. de Creil; Duc de Brancas. Le Docteur Ricerd y habita. Splendide escalier, chef-d'oeuvre de ferronnerie de l'époque de la Règence.	4135	septembre 1900
23	Jardin du Luxembourg (6ᵉ Arrᵗ) – Vase artistique, avec fleurs tombantes, du plus gracieux effet; au fond, le palais du Luxembourg baigné de lumière: le tout compose un délicieux et artistique paysage parisien.	4644	n.d.
24	Quai Conti (6ᵉ Arrᵗ) – Hôtel de la Monnaie, construit en 1771 par l'architecte Antoine. La première pierre de l'édifice fut posée par l'abbé Terray. Entrée sur le quai Conti. Très belle porte dont le heurtoir est de tout beauté.	4141	(BHVP acquires it on 7 mai 1901)
25	Quai Conti (6ᵉ Arrᵗ) – Hôtel de la Monnaie. (Heurtoir.)	4142	"
26	Rue du Four, 10 (6ᵉ Arrᵗ) – Très belle grille de cabaret, XVIIIᵉ siècle, disparue en 1904.	4151	septembre 1900
27	Rue Garancière (6ᵉ Arrᵗ) – Fontaine Garancière, érigée en 1715, aux frais et par ordre de la princesse Palatine. Le mascaron, seule chose intéressante dans cette petite fontaine, est un chef-d'oeuvre des sculpteurs ornemanistes du commencement du XVIIIᵉ siècle.	4152	octobre 1900
28	Rue de Varenne, 65 (7ᵉ Arrᵗ) – Hôtel de la Marquise de Suze (1787): puis de la Rochefoucault Doudeauville. Très belle façade qui fait le plus grand honneur aux architectes du XVIIIᵉ siècle.	4153	octobre 1900
29	Rue de Varenne, 57 (7ᵉ Arrᵗ) – Hôtel du maréchal de Montmorency. Acheté inachevé en 1723 par Jacques de Matignon; Grimaldi, prince de Monaco (1775); Talleyrand, prince de Bénévent (1812). Brogniard le remania; Cavaignac y habita en 1848; Duc de Galiéra en 1878, Comte de Paris en 1884. Aujourd'hui ambassade d'Autriche. Très belle porte.	4157	octobre 1900
30	Rue de Varenne, 57 (7ᵉ Arrᵗ) – Hôtel du Maréchal de Montmorency. Magnifique heurtoir.	4158	octobre 1900
31	Square Monge (5ᵉ Arrᵗ) – Fontaine Childebert, construite de 1720 à 1730, vis à vis du portail de Saint-Germain-des-Prés, réédifiée en 1875 contre le soubassement de l'Ecole Polytechnique, sur le square Monge. Cette merveilleuse petite fontaine, chef-d'oeuvre des artistes du XVIIIᵉ siècle, est presque inconnue des parisiens.	4172	octobre 1900
32	Rue Michel-le-Comte, 36 (3ᵉ Arrᵗ) – Pittoresque enseigne du Bon Puits, fer forgé, aujourd'hui, malheureusement disparue.	5505	1908

Page number	Caption	Negative number	BHVP date
33	Rue Charlot, 83 (3ᵉ Arrᵗ) – Hôtel du Marquis de Mascarani, président à la Cour des Comptes (1750). Aujourd'hui disparu.	4224	avril 1901
34	Rue Charlot, 83 (3ᵉ Arrᵗ) – Hôtel du Marquis de Mascarani (disparu). Splendide départ, fer forgé, de l'escalier de l'Hôtel.	4225	avril 1901
35	Rue de Turenne, 60 (3ᵉ Arrᵗ) – Hôtel du chancelier Boucherat (1713); marquis d'Ecquevilly, grand veneur de Louis XV (1766); couvent de Sainte-Elisabeth jusqu'à la loi contre les congrégations (1901). Ce magnifique hôtel, aujourd'hui livré au commerce, a été entièrement transformé et son superbe escalier a complètement disparu.	4235	avril 1901
36	Rue de Turenne, 60 (3ᵉ Arrᵗ) – Hôtel du chancelier Boucherat. Façade de l'hôtel (disparue).	4236	avril 1901
37	Rue de Turenne, 60 (3ᵉ Arrᵗ) – Hôtel du chancelier Boucherat. Porte de l'hôtel sur la rue de Turenne.	4237	avril 1901
38	Rue de Turenne, 60 (3ᵉ Arrᵗ) – Hôtel du chancelier Boucherat. Heurtoir avec attributs de chasse.	4234	avril 1901
39	Rue de Turenne, 60 (3ᵉ Arrᵗ) – Hôtel du chancelier Boucherat. Magnifique escalier, fer forgé, avec les attributs de chasse du marquis d'Ecquevilly, grand veneur de Louis XV.	4231	avril 1901
40	Rue de Turenne, 60 (3ᵉ Arrᵗ) – Hôtel du chancelier Boucherat. Superbe départ de l'escalier (fer forgé).	4232	avril 1901
41	Rue de Turenne, 60 (3ᵉ Arrᵗ) – Hôtel du chancelier Boucherat. Balcon de l'hôtel sur le jardin.	5511	1908
42	Rue de Turenne, 60 (3ᵉ Arrᵗ) – Très belle boiserie de porte.	4242	mai 1901
43	Rue des Lions-Saint-Paul, 3 (4ᵉ Arrᵗ) – Ancien hôtel des parlementaires. Dans la cour de l'hôtel, très jolie petite fontaine de l'époque de Louis XV, du plus gracieux effet.	4249	mai 1901
44	Rue Béranger, 3 et 5 (3ᵉ Arrᵗ) – Ancien hôtel dit de Vendôme. Bergeret de Trouville, maître des Comptes. Béranger, le célèbre chansonnier, est mort dans cet hôtel en 1857. Très belle porte.	4254	mai 1901
45	Place Saint-Sulpice (6ᵉ Arrᵗ) – Eglise Saint-Sulpice (1646 à 1749), par les architectes Levau, Oppenord, Gitard et Servandoni. Temple de la victoire sous la Convention. On y donna, le 15 brumaire, un banquet au général Bonaparte. Remarquable boiserie de la sacristie: XVIIIᵉ siècle.	4747	1903
46	Place Saint-Sulpice (6ᵉ Arrᵗ) – Eglise Saint Sulpice. Remarquable boiserie (XVIIIᵉ siècle).	4748	1903

Page number	Caption	Negative number	BHVP date
47	Place Saint-Sulpice (6^e Arr^t) – Eglise Saint-Sulpice. Dans une chapelle sous les tours, orgue de Marie-Antoinette provenant du château de Trianon.	4749	1903
48	Place Saint-Sulpice (6^e Arr^t) – Eglise Saint-Sulpice. Dans une chapelle, sous les tours, orgue de Marie-Antoinette (détail) provenant du château de Trianon.	4750	1903
49	Eglise Saint-Sulpice (6^e Arr^t) – Boiserie d'un confessional.	4761	1903
50	Eglise Saint-Sulpice – Remarquable confessionnal (XVIII^e siècle).	4774	1903
51	Eglise Saint-Sulpice – Confessionnal XVIII^e siècle (détail).	4771	1903
52	Quai d'Anjou, 17 (4^e Arr^t) – Remarquable hôtel du duc de Lauzun, mari de la grande Mademoiselle, bâti vers 1617; hôtel de Pimodau (1750). Baudelaire et Théophile Gautier y habitèrent, puis le baron Pichon (1841). Acheté en 1900 par la Ville de Paris pour en faire un musée, et revendu ensuite à la famille du baron Pichon pour la modeste somme de 300,000 francs. Décoration intérieure. Très belles boiseries XVIII^e siècle.	4971	1905
53	Hôtel de Lauzun, quai d'Anjou – Décoration intérieure. Boiseries XVII^e siècle.	4974	1905
54	Hôtel de Lauzun, quai d'Anjou. – Décoration intérieure. Très belles boiseries XVIII^e siècle.	4972	1905
55	Hôtel de Lauzun, quai d'Anjou – Décoration intérieure. Boiseries XVII^e siècle.	4976	1905
56	Hôtel de Lauzun, quai d'Anjou – Décoration intérieure. Boiseries XVII^e siècle.	4978	1905
57	Hôtel de Lauzun, quai d'Anjou – Décoration intérieure. Boiseries XVII^e siècle.	4979	1905
58	Hôtel de Lauzun, quai d'Anjou – Décoration intérieure. Boiseries XVII^e siècle.	4984	1905
59	Hôtel de Lauzun, quai d'Anjou – Décoration intérieure. Boiseries XVII^e siècle.	4985	1905
60	Hôtel de Lauzun, quai d'Anjou – Décoration intérieure. Boiseries XVII^e siècle.	4983	1905

Table 2. *Paysages–Documents divers*, nos. 690–774

Whenever possible the captions and numbers for these photographs have been taken from the prints at the Bibliothèque historique de la Ville de Paris. Otherwise they have been taken from the prints at Lunn Graphics International.

Negative number	Caption	Collection
690	Intérieur de M^r R, artiste Dramatique, Rue Vavin – 1910	BHVP
691	Intérieur de M^r R, artiste Dramatique, Rue Vavin – 1910	BHVP
692	?	
693	?	
694	?	
695	Château de Viarmes	Lunn
696	?	
697	?	
698	?	
699	?	
700	?	
701	?	
702	?	
703	?	
704	?	
705	?	
706	?	
707	Intérieur de M^{me} D, Rentière, B^d du Port Royal 1910	BHVP
708	Intérieur de M^{me} D, Rentière, B^d du Port Royal 1910	BHVP
709	Intérieur de M^{me} D, Rentière, B^d du Port Royal 1910	BHVP
710	Intérieur Rue Montaigne, La Cuisine. 1910	BHVP
711	Intérieur d'un Ouvrier, Rue de Romainville – 1910	BHVP
712	?	
713	?	
714	?	
715	?	
716	?	
717	?	
718	?	
719	?	
720	?	
721	Intérieur d'un employé aux magasins du Louvre Rue S^t Jacques – 1910	BHVP
722	Intérieur d'un employé aux magasins du Louvre Rue S^t Jacques – 1910	BHVP
723	Intérieur d'un employé aux magasins du Louvre Rue S^t Jacques – 1910	BHVP

Negative number	Caption	Collection
724	?	
725	Intérieur d'un employé aux magasins du Louvre Rue St Jacques – 1910	BHVP
726	Intérieur de Mme D, Rentière, Bd du Port Royal – 1910	BHVP
727	Intérieur de Mme D, Rentière, Bd du Port Royal – 1910	BHVP
728	Intérieur de Mme D, Rentière, Bd du Port Royal – 1910	BHVP
729	Intérieur de Mr C, décorateur, Rue du Montparnasse – 1910	BHVP
730	Intérieur de Mr C, décorateur, Rue du Montparnasse – 1910	BHVP
731	Intérieur de Mr C, décorateur, Rue du Montparnasse – 1910	BHVP
732	Intérieur de Mr C, décorateur, Rue du Montparnasse – 1910	BHVP
733	Intérieur de Mr C, décorateur, Rue du Montparnasse – 1910	BHVP
734	Intérieur de Mr R, artiste dramatique, Rue Vavin 1910	BHVP
735	Intérieur de Mme C, modiste, Place St André des Arts – 1910	BHVP
736	Intérieur de Mme C, modiste, Place St André des Arts – 1910	BHVP
737	Le Salon de Mme C, modiste, Place St André des Arts – 1910	BHVP
738	Le Salon de Mme C, modiste, Place St André des Arts – 1910	BHVP
739	Intérieur de Mme C, modiste, Place St André des Arts – 1910	BHVP
740	Intérieur d'un Ouvrier, Rue de Romainville – 1910	BHVP
741	Intérieur d'un Ouvrier, Rue de Romainville – 1910	BHVP
742	Intérieur d'un Ouvrier, Rue de Romainville – 1910	BHVP
743	Chambre d'une ouvrière, Rue de Belleville – 1910	BHVP
744	Chambre d'une ouvrière, Rue de Belleville – 1910	BHVP
745	Intérieur de Mr C, décorateur, Rue du Montparnasse – 1910	BHVP
746	Intérieur de Mr M, Financier, avenue Elisée Reclus, Champ de Mars – 1910	BHVP
747	Intérieur de Mr M, Financier, avenue Elisée Reclus, Champ de Mars – 1910	BHVP
748	Intérieur de Mr M, Financier, avenue Elisée Reclus, Champ de Mars – 1910	BHVP
749	Intérieur de Mr M, Financier, avenue Elisée Reclus, Champ de Mars – 1910	BHVP
750	Intérieur de Mr M, Financier, avenue Elisée Reclus, Champ de Mars – 1910	BHVP
751	Cabinet de Travail, de Mr M, Financier avenue Elisée Reclus, Champ de Mars – 1910	BHVP
752	Intérieur de Mlle Sorel, de la Comédie Française, 99 avenue des Champs-Elisée – 1910	BHVP
753	Intérieur de Mlle Sorel, de la Comédie Française, 99 avenue des Champs-Elisée – 1910	BHVP
754	Intérieur de Mlle Sorel, de la Comédie Française, 99 avenue des Champs-Elisée – 1910	BHVP

Negative number	Caption	Collection
755	Intérieur de M^{lle} Sorel, de la Comédie Française, 99 avenue des Champs-Elisée – 1910	BHVP
756	Intérieur de M^{lle} Sorel, de la Comédie Française, 99 avenue des Champs-Elisée – 1910	BHVP
757	Intérieur de M^{lle} Sorel, de la Comédie Française, 99 avenue des Champs-Elisée – 1910	BHVP
758	Intérieur de M^{lle} Sorel, de la Comédie Française, 99 avenue des Champs-Elisée – 1910	BHVP
759	Intérieur de M^{lle} Sorel, de la Comédie Française, 99 avenue des Champs-Elisée – 1910	BHVP
760	Intérieur de M^r B, Collectionneur, Rue de Vaugirard – 1910	BHVP
761	Intérieur de M^r B, Collectionneur, Rue de Vaugirard – 1910	BHVP
762	Intérieur de M^r B. Collectionneur, Rue de Vaugirard – 1910	BHVP
763	Intérieur de M^r F, Négociant, Rue Montaigne, 1910	BHVP
764	Intérieur de M^r F, Négociant, Rue Montaigne, 1910	BHVP
765	Intérieur de M^r F, Négociant, Rue Montaigne, 1910	BHVP
766	Intérieur de M^r F, Négociant, Rue Montaigne, Atelier de M^{me} Sculpteur amateur – 1910	BHVP
767	Intérieur de M^r F, Négociant, Rue Montaigne, Atelier de M^{me} Sculpteur amateur – 1910	BHVP
768	Intérieur de M^r A, Industriel, Rue Lepic – 1910	BHVP
769	Intérieur de M^r A, Industriel, Rue Lepic – 1910	BHVP
770	Intérieur de M^r A, Industriel, Rue Lepic – 1910	BHVP
771	Intérieur de M^r A, Industriel, Rue Lepic – 1910	BHVP
772	Intérieur de M^r R, artiste Dramatique, Rue Vavin – 1910	BHVP
773	Intérieur de M^r R, artiste Dramatique, Rue Vavin – 1910	BHVP
774	Intérieur Rue Montaigne – La Cuisine – 1910	BHVP

Table 3. *Intérieurs parisiens*

Page numbers are mine. Negative numbers for these photographs have been taken from the prints at the Bibliothèque historique de la Ville de Paris.

Page number	Caption	Negative number
1	Petit Interieur d'un artiste Dramatique M^r R. Rue Vavin	690
2	Petit Intérieur d'un artiste Dramatique – M^r R. Rue Vavin.	691
3	Petit interieur d'un artiste Dramatique M^r R. Rue Vavin.	734
4	Interieur de M^me D, Petite rentière, Boulevard du Port Royal.	707
5	Intérieur de M^me D, Petite rentière, Boulevard du Port Royal.	708
6	Intérieur de M^me D, Petite Rentière, B^d du Port Royal.	709
7	Intérieur de M^me D, Petite rentière, Boulevard du Port Royal	726
8	Interieur de M^me D, petite rentière, Boulevard du Port Royal.	727
9	Intérieur de M^me D, Petite rentière, B^d du Port Royal.	728
10	Interieur d'un employé aux magasins du Louvre Rue S^t Jacques.	721
11	Interieur d'un employé aux magasins du Louvre Rue S^t Jacques.	722
12	Interieur d'un employé aux magasins du Louvre Rue S^t Jacques.	723
13	Intérieur d'un employé aux magasins du Louvre, Rue S^t Jacques.	725
14	Interieur de M^me C. Modiste, Place S^t André des arts.	735
15	Interieur de M^me C. Modiste Place S^t André des arts	736
16	Le Salon de M^me C, modiste, place S^t André des arts.	737
17	Le Salon de M^me C, Modiste. Place S^t André des arts.	738
18	Interieur de M^me C, modiste Place S^t André des arts	739
19	Interieur de Monsieur M, Financier, Avenue Elisée Réclus (champ de Mars)	746
20	Intérieur de Monsieur M, Financier, avenue Elisée Reclus, (champ de Mars.)	747
21	Interieur de Monsieur M, Financier, avenue Elisée Reclus. (champ de Mars)	748
22	Interieur de Monsieur M, Financier, avenue Elisée Reclus, (champ de Mars)	749
23	Intérieur de Monsieur M, Financier, avenue Elisée Reclus (champ de Mars) Cabinet de toilette.	750
24	Interieur de Monsieur M, Financier avenue Elisée Reclus, (champ de Mars)	751
25	Interieur d'un Ouvrier, Rue de Romainville	711
26	Intérieur d'un ouvrier, Rue de Romainville.	740
27	Interieur d'un Ouvrier, Rue de Romainville.	741
28	Interieur d'un ouvrier, Rue de Romainville	742
29	Petite chambre d'une ouvrière, Rue de Belleville	743
30	Petite chambre d'une ouvrière, Rue de Belleville	744

Page number	Caption	Negative number
31	Interieur de M^r F. Négociant. Rue Montaigne	763
32	Intérieur de M^r F, Négociant, Rue Montaigne	764
33	Intérieur de M^r F, Négociant, Rue Montaigne.	765
34	Interieur de M^r F, Négociant, Rue Montaigne. Atelier de Madame, Sculpteur Amateur.	766
35	Intérieur de M^r F, Négociant, Rue Montaigne. Atelier de M^me Sculpteur amateur.	767
36	Intérieur de M^r F, Négociant, Rue Montaigne La Cuisine.	710
37	Interieur de M^r F – Rue Montaigne. La Cuisine	774
38	Intérieur de M^r A. (Rue) Industriel, Rue Lepic	768
39	Interieur de M^r A, Industriel, Rue Lepic	769
40	Interieur de M^r A, Industriel, Rue Lepic	770
41	Interieur de M^r A, Industriel, Rue Lepic	771
42	Interieur de M^r C, Décorateur appartements. Rue du Montparnasse.	729
43	Interieur de M^r C, Décorateur appartements. Rue du Montparnasse.	730
44	Interieur de M^r C, Décorateur appartements Rue du Montparnasse.	731
45	Interieur de M^r C. Décorateur appartements, Rue du Montparnasse.	732
46	Interieur de M^r C, décorateur appartements, Rue du Montparnasse.	745
47	Interieur de M^r C, décorateur appartements, Rue du Montparnasse.	733
48	Intérieur de M^r B, Collectionneur, Rue de Vaugirard.	760
49	Intérieur de M^r B, Collectionneur, Rue de Vaugirard.	761
50	Interieur de M^r B, Collectionneur, Rue de Vaugirard.	762
51	Interieur de M^r R. Artiste Dramatique Rue Vavin.	772
52	Intérieur de M^r R, Artiste dramatique, Rue Vavin.	773
53	Interieur de M^elle Sorel, de la Comédie Française 99 avenue des champs Elysées.	752
54	Interieur de M^elle Sorel, de la Comédie Française, 99 avenue des champs Elysées.	753
55	Interieur de M^elle Sorel, de la Comédie Française, 99 avenue des champs Elysées.	754
56	Interieur de M^elle Sorel, de la Comédie Française, 99 avenue des champs Elysées.	755
57	Interieur de M^elle Sorel, de la Comédie Française, 99 avenue des champs Elysées.	756
58	Interieur de M^elle Sorel, de la Comédie Française, 99 avenue des champs Elysées.	757
59	Intérieur de M^elle Sorel, de la Comédie Française, 99 avenue des champs Elysées.	758
60	Interieur de M^elle Sorel, de la Comédie Française, 99 avenue des champs Elysées.	759

Table 4. *La voiture à Paris*

Page numbers are mine. Negative numbers for these photographs have been taken from the prints at the Bibliothèque historique de la Ville de Paris with the exception of those for pages 9, 23, 26, 35, 41, and 43, which were taken from the prints at the Musée Carnavalet.

Page number	Caption	Negative number
1	Voiture. Maraicher – Marché St Germain – 1910	1
2	Voiture pour le transport des Glaces. 1910	2
3	Compagnie des Voitures de Paris – Fiacre – 1910	3
4	Voiture Blanchisseur – 1910.	4
5	Roulotte d'un fabricant de Paniers – Porte d'Ivry – 1910	5
6	Compagnie de petites Voitures – Caleche – 1910	6
7	Voiture. Cabriolet – 1910	7
8	Voiture de Vidange – 1910	8
9	Omnibus – 1910 –	9
10	Omnibus – 1910	10
11	Tombereau – 1910	11
12	Voiture pour le transport des grosses pierres – 1910	12
13	Voiture pour le transport des grosses pierres – 1910	13
14	Voiture – Balayeuse municipale. 1910	14
15	Voiture – Balayeuse municipale – 1910	15
16	Voiture Arrosage de la Ville de Paris – 1910	16
17	Voiture pour le transport des charbons – 1910	17
18	Voiture Pompes funèbre – 1910. (1e classe)	18
19	Voiture. Pompes funèbres – 1er classe – 1910	19
20	Voiture Pompes funèbres – 1ere classe – 1910 –	20
21	Voiture. Pompes funèbres – 1ere classe – 1910	21
22	Voiture de Laitier – 1910	22
23	Voiture de Laitier – 1910.	23
24	Voiture Maraicher – Les Halles – 1910	24
25	Voiture de Touristes – 1910.	25
26	Tramway – 1910	26
27	Tramway – 1910	27
28	Camion – chemin de fer de l'Etat – 1910.	28
29	Voiture de transport – 1910.	29
30	Voiture pour le transport des eaux Gazeuses – 1910	30
31	Voiture pour le transport des charbons – 1910	31
32	Voiture pour le transport des Platres. 1910	32
33	Voiture des marchés de quartiers de Paris – 1910	33
34	Voiture de Forain. 1910	34

Page number	Caption	Negative number
35	Voitures. marché des patriarches. Rue Mouffetard – 1910	35
36	Brasseur. 1910 –	36
37	Voiture Distillateurs – 1910	37
38	Voiture asphalte – 1910	38
39	Voiture asphalte – 1910	39
40	Voiture à Broyer les pierres – 1910	40
41	Hacquet 1910	41
42	Voiture transport des prisons – 1910	42
43	Voiture. Transport des prisons – 1910	43
44	Voiture voyageurs. (Gares) 1910	44
45	Omnibus voyageurs. (Gares) 1910	45
46	Voiture Déménagement – Grand terme – 1910	46
47	Voiture Déménagement – terme moyen – 1910	47
48	Voiture Déménagement – petit terme – 1910	48
49	Voitures – Bernot – charbons – 1910	49
50	Voiture, Transport des ordures – (Boueux) – 1910	50
51	Transport des facteurs – 1910	51
52	Voiture Bois de Boulogne – 1910	52
53	Petite Voiture – Bois de Boulogne – 1910	53
54	Victoria – Bois de Boulogne – 1910	54
55	Voiture Bois de Boulogne 1910	55
56	Voiture – Bois dé Boulogne – 1910	56
57	Voiturette – Bois de Boulogne – 1910	57
58	Voiture dite Tonneau – Bois de Boulogne 1910	58
59	Le Fiacre, avant les Pneus – 1910	59
60	La Voiture des Postes – Disparue 1910	60

Table 5. *Métiers, boutiques et étalages de Paris*

Page numbers are mine. Captions are from the inventory taken by the Bibliothèque Nationale before the album was rebound, with the exception of the one on page 42. The inventory claims that the photograph in question is an "aggrandissement de la photo précédente," but it is not. Negative numbers for these photographs have been taken from the prints at the Bibliothèque historique de la Ville de Paris with the exception of those for pages 1, 11, 22, 26, 33, 50, and 52, which were taken from the prints at the Museum of Modern Art.

Page number	Inventory caption	Negative number
1	Boutique d'articles de ménage, 340 rue de Vaugirard	219
2	Kiosque à journaux, square du Bon Marché	225
3	Boutique de jouets, 63 rue de Sèvres	224
4	Petit marchand de clefs, quai de la Rapée	227
5	Marchand de glaces, square du Bon Marché	223
6	Kiosque à journaux, Place Saint Sulpice	221
7	Colonne Moris pour les spectacles, Place Saint Sulpice	222
8	Boutique de légumes, 25 rue Charlemagne	217
9	Boutique de légumes, 3 rue Eginhard	218
10	Boutique de légumes, rue Mouffetard	215
11	Petite boutique de friture, rue Mouffetard	216
12	Petite boutique de fleurs, place de la Bastille	212
13	Poissonnier au coin de la rue Daubanton et de la rue Mouffetard	211
14	Petite voiture de légumes à Saint Médard, au coin de la rue Mouffetard	210
15	Petit marché au coin de la rue Mouffetard	209
16	Poissonnier au coin de la rue Daubanton	?
17	"Le brulant Alexandre" cabaret, 100 Boulevard de Clichy	207
18	Boutique de friture, 38 rue de Seine	208
19	Le Moulin Rouge, 86 Boulevard de Clichy	205
20	Brasserie équivoque, 16 rue Blondel	204
21	Cabaret de l'Enfer (façade), 53 Boulevard de Clichy	202
22	Brocanteur rue de Venise	5573 (AVP no.)
23	Boutique de fruits et légumes au coin de la rue Galande	5368 (AVP no.)
24	Boutique de vêtements et cabaret du Père Lunette, rue des Anglais	4638 (AVP no.)
25	Marchand de légumes aux Halles	260
26	Brocanteur, Boulevard Edgar Quinet	3053 (early Pp no.)
27	Brocanteur, 10 avenue Lowendal	232
28	Coin du Marché des Carmes Place Maubert	233

Table 6. *Zoniers*

Page numbers are mine. Negative numbers have been taken from prints at the Bibliothèque historique, the Musée Carnavalet, and the Museum of Modern Art. When Atget has moved a photograph from its 100 number to a 300 number, the old number is given in parentheses. Dates for these photographs have been taken from the prints at the Bibliothèque historique.

Page number	Caption	Negative number	BHVP date
1	Porte d'Ivry – Zoniers (13e arr)	336 (100)	1910
2	Porte d'Ivry – Zoniers – (14e arr) (1912)	337 (101)	1910
3	Porte d'Ivry, Zoniers, 1912 (13e arr)	338 (102)	1910
4	Porte d'Ivry, Zoniers – 1912 (13e arr)	339 (103)	1910
5	Porte d'Ivry. Zoniers – 1912 – 13e arr)	340 (104)	1910
6	Porte d'Ivry. Bd Masséna, chiffoniers – 1912 (13e arr)	341 (108)	1910
7	Chiffonnier Bd Masséna, Porte d'Ivry – 1912 (13e arr)	342 (109)	—
8	Chiffonnier Bd Masséna. 1912 (13e arr)	343 (111)	1910
9	Interieur d'un chiffonnier Bd Masséna. 1912 (13e arr) Porte d'Ivry.	344 (112)	1910
10	Porte de Montreuil, Zoniers, 1912, (20e arr)	345 (120)	1910
11	Porte de Montreuil. Zoniers, 1912 (20e arr)	346 (121)	1910
12	Porte de Montreuil – Zoniers – 1912 (20e arr)	347 (123)	1910
13	Porte d'Italie, Zoniers – 1912 (13e arr)	?	—
14	Porte d'Italie. 1912 (Zoniers) 13e arr	351	1912
15	Porte d'Ivry. Intérieur de chiffonnier, 1912 (13e arr)	352	1912
16	Porte d'Ivry. Intérieur d'un chiffonnier, 1912 (13e arr)	353	1912
17	Porte d'Italie, Zoniers. 1913 (13e arr)	398	1913
18	Chiffonnier. Passage Moret, Ruelle des Gobelins, 1913 (13e arr)	1431 (Top no.)	mars 1913
19	Porte d'Italie, Zoniers – 1912 (13e arr)	397	1913
20	Porte d'Italie, Zoniers. 1913 – 13e arr)	399	1913
21	Porte de Choisy. Zoniers, 1913 (13e arr)	405	1913
22	Porte de Choisy. Zoniers – 1913 (13e arr)	406	1913
23	Poterne des Peupliers, Zoniers – 1913 (13e arr)	425	1913
24	Poterne des Peupliers, Zoniers, 1913 (13e arr)	430	1913
25	Porte d'asnières, Cité Trébert, 1913, 17e arr)	431	1913
26	Chiffonniers, Passage Moret, Ruelle des Gobelins, 13e arr) 1913	1432 (Top no.)	mars 1913
27	Porte d'asnières, Cité Trébert, 1913 – 17e arr) (Chiffonnier).	433	1913
28	Porte d'asnières, chiffonnier, Cité Trébert, 1913 (17e arr)	435	1913
29	Porte d'asnières, Cité Trébert, chiffonnier, 1913 (17e arr)	436	1913
30	Porte de Montreuil, Zoniers, 1913 (20e arr)	440	1913
31	Cité Doré, Bd de la gare 70. 1913 (13e arr) Chiffonnier.	1441 (Top no.)	1913

Page number	Caption	Negative number	BHVP date
32	Porte de Montreuil, Zoniers, 1913 (20ᵉ arr)	443	1913
33	Porte de Montreuil, Zoniers, 1913 (20ᵉ arr)	444	1913
34	Porte d'asnières, Cité Valmy – 1913 (17ᵉ arr) chiffoniers.	457	1913
35	Porte d'asnières, Cité Valmy, 1913 (17ᵉ arr) chiffonnier	459	1913
36	Porte d'asnières, Cité Valmy, chiffonniers, 1913 (17ᵉ arr)	458	1913
37	Porte d'asnières, Cité Valmy, – chiffonniers, 1913 (17ᵉ arr)	460	1913
38	Porte d'asnières, Cité Valmy, chiffonniers, 1913 (17ᵉ arr)	462	1913
39	Porte de Montreuil, Zoniers, 1913 (20ᵉ arr)	122	1910
40	Porte d'Ivry, Zoniers, 1913 (13ᵉ arr)	107	1910
41	Poterne des Peupliers, Zoniers, 1913, 13ᵉ arr)	400	1913
42	Porte d'Italie, Zoniers, 1913 (13ᵉ arr)	407	—
43	Porte de choisy, Zoniers – 1913 (13ᵉ arr)	408	1913
44	Poterne des Peupliers, (Zoniers, 1913 (13ᵉ arr)	429	—
45	Porte d'asnières, Cité Valmy. 1913 (17ᵉ arr) chiffonniers	434	1913
46	Porte de Montreuil, Zoniers, 1913 (20ᵉ arr)	441	1913
47	Porte de Montreuil, Zoniers, 1913, 20ᵉ arr)	442	1913
48	Porte d'Asnières, Cité Valmy, 1913 (17ᵉ arr) chiffonniers	461	1913
49	Poterne des Peupliers, Zoniers, 1913 (13ᵉ arr)	428	1913
50	Un chiffonnier, le matin, dans Paris, avenue des Gobelins.	363 (Pp 3276)	—
51	Cité doré Bᵈ de la Gare 70 – 13ᵉ arr)	4059 (AVP no.)	août 1900
52	Cité Doré, Bᵈ de la gare et Place Pinel – 13ᵉ arr)	4055 (AVP no.)	août 1900
53	Campement de chiffonniers, Bᵈ Masséna, 13ᵉ arr) 1913	110	1910
54	Cité Doré, Bᵈ de la gare 70, 1913, 13ᵉ arr)	1438 (Top no.)	1913
55	Cité Doré, Bᵈ de la gare 70 – 1913 (13ᵉ arr)	1439 (Top no.)	1913
56	Cité Doré, Bᵈ de la gare 70, 1913 (13ᵉ arr)	1440 (Top no.)	1913
57	Chiffonnier, Rue de l'amiral Mouchez, 1913 (13ᵉ arr)	1442 (Top no.)	1913
58	Butte aux Cailles, chiffonniers (Disparu Vers 1900) 13ᵉ arr)	3905 (AVP no.)	mai 1900
59	La Butte aux Cailles, Disparu Vers 1900 – 13ᵉ arr)	3919 (AVP no.)	mai 1900
60	Chiffonnier, Butte aux Cailles, disparue Vers 1900)	3922 (AVP no.)	mai 1900

Table 7. *Enseignes et vieilles boutiques de Paris*

Page numbers are mine. Dates and negative numbers for these photographs have been taken from the prints at the Bibliothèque historique, the Musée Carnavalet, and the Museum of Modern Art. Also included is the date of acquisition for the prints found in the topography file of the Bibliothèque Nationale (BN-Top). Page 43 of the album is a new page, replacing the old one, and the original caption has been lost.

Page number	Caption	Negative number	BHVP date (date acquired for BN-Top file)
1	Cabaret Rue Mouffetard – Demoli en 1907.	3720	1899 (janvier 1900)
2	Au Soleil d'or 84 Rue St Sauveur – Modifié.	?	1899 (10 février 1901)
3	Au Soleil d'or 84 Rue St Sauveur (Modifié)	3725	1899 (janvier 1900)
4	Au Bourdon Rue de Varenne 64 – (fondé 1793)	3738	1899 (no acq. no.)
5	A St Etienne Rue de la Montagne Ste Geneviève	3742	1899 (janvier 1900)
6	Les Canettes, Rue des Canettes 18.	3760	1899 (10 février 1901)
7	Le Dragon Rue de Rennes 50.	3766	1899 (10 février 1901)
8	Le cherche midi 19 Rue du cherche midi.	3770	1899 (10 février 1901)
9	La petite chaise Rue de Grenelle 36.	3771	1899 (10 février 1901)
10	Boutique Louis XVI – 3 quai Bourbon.	3869	mai 1900 (10 février 1901)
11	A L'Enfant Jésus Rue des Bourdonnais 33	3940	juin 1900 (10 février 1901)
12	Cabaret coin Rue Charles V.	3941	juin 1900 (10 février 1901)
13	A la Treille d'or 6 Rue de Condé. (Disparu en 1905)	3957	juin 1900 (10 février 1901)
14	Cabaret 34 quai de l'hôtel de Ville – (Disparu en 1899)	3961	juin 1900 (10 février 1901)
15	A l'homme armé 25 Rue des Blancs Manteaux.	4079	septembre 1900 (10 février 1901)
16	Au Petit Dunkerque 3 quai Conti.	4133	septembre 1900 (10 février 1901)
17	Cabaret Rue du Four 10 (Demoli en 1905)	4151	septembre 1900 (10 février 1901)

Page number	Caption	Negative number	BHVP date (date acquired for BN-Top file)
18	Au Bon Puits Rue Michel Le Comte 36 (Disparu en 1904)	4296	juin 1901 (10 avril 1901)
19	Au Bon Coin Rue des Haudriettes (Disparu en 1908)	4341	juillet 1901 (19 février 1902)
20	Au Lion d'or 16 Rue Volta.	4402	1901 (19 février 1902)
21	Au Franc Pinot, quai Bourbon 1	4448	1902 (20 avril 1903)
22	Au Petit Bacchus Rue St Louis en L'Ile 61.	4449	1902 (20 avril 1903)
23	Cabaret 38 quai de Béthune	4450	1902 (20 avril 1903)
24	A la Grace de Dieu, 121 Rue Montmartre	4459	1902 (20 avril 1903)
25	A la Grace de Dieu, 121 Rue Montmartre	4460	1902 (20 avril 1903)
26	Au deux Pigeons 8 Rue Clément – (Disparu en 1905)	4463	1902 (20 avril 1903)
27	A la Tour d'argent 18 Rue St Germain L'auxerrois.	4483	1902 (20 avril 1903)
28	Au Coq Hardi 18 quai de la Mégisserie.	4492	1902 (20 avril 1903)
29	A la Petite Hotte 1 Rue des Orfèvres.	4493	1902 (20 avril 1903)
30	Cabaret 62 Rue de l'hotel de Ville (Disparu Vers 1905)	4500	1902 (20 avril 1903)
31	Au Griffon 39 quai de l'Horloge.	4555	1902 (20 avril 1903)
32	Boutique empire 21 Fb St Honoré.	4556	1902 (20 avril 1903)
33	Cabaret du père Lunette Rue des Anglais (Disparu en 1908)	4639	1902 (20 avril 1903)
34	Au Port Salut, Rue des Fossés St Jacques.	4678	1903 (no acq. no.)
35	A la Coquille d'or Rue de la Sourdière 42.	4686	1903 (no acq. no.)
36	Cabaret coin Rue du Four et des Ciseaux (Disparu en 1905)	4736	1903 (no acq. no.)
37	Au Reveil matin 136 Rue Amelot.	4780	1903 (no acq. no.)
38	Boutique Empire, 14 Rue de Grammont.	4784	1903 (no acq. no.)

Page number	Caption	Negative number	BHVP date (date acquired for BN-Top file)
39	A la Tour d'argent Rue de Charenton 2	4957	— (no acq. no.)
40	A la Biche Rue Geoffroy St Hilaire.	5002	1905 (no acq. no.)
41	Au Bourdon (1793) 64 Rue de Varenne.	5459	1907 (no acq. no.)
42	Au Tambour 63 quai de la Tournelle.	5521	1908 (no acq. no.)
43	Au Tambour	5522	1908 (no acq. no.)
44	Cabaret de L'ami Jean 8 Rue Thouin	5726	juillet 1908
45	A Ste Geneviève 40 Rue de la Montagne Ste Geneviève.	5727	1908
46	Cabaret 1 Rue Guisarde	5732	1910
47	Boulangerie empire Rue des Blancs Manteaux 28.	5733	1910
48	Cabaret du Gros Pavé Rue du Roi de Sicile 8.	5736	1911
49	A l'agneau Pascal Rue de Valence 11.	5739	1911
50	Cabaret du Petit Maure 26 Rue de Seine.	5747	1911
51	Au Griffon 10 Rue de Bucy.	5752	1911
52	Enseigne 21 Rue des St Pères.	5756	1911
53	Au Vieux chêne 69 Rue Mouffetard.	5757	1911
54	A la Grappe d'or Place d'aligre 4.	5758	1911
55	Cabaret 86 Rue Mouffetard.	5759	1911
56	Le Remouleur Rue des Nonnains d'Hyères.	5760	1911
57	A Jean Bart 38 Avenue Lamotte Piquet.	5767	1911
58	A L'orme St Gervais 20 Rue du Temple (Disparu en 1910)	5768	1911
59	Cabaret 31 Rue du Bac.	5780	1911
60	Cabaret Rue St André des Arts 54 – (Disparu en 1911.	4097	septembre 1900

Table 8. *Fortifications*

Page numbers are mine. Negative numbers have been taken from prints at the Bibliothèque historique, the Musée Carnavalet, and the Museum of Modern Art. Dates for these photographs have been taken from the prints at the Bibliothèque historique.

Page number	Caption	Negative number	BHVP date
1	Porte de Gentilly. Fortifications – 1913. (13e arrt)	141	1910
2	Poterne des peupliers. La Bièvre – Zone des fortifications. 1913 13e arrt	426	1913
3	Poterne des peupliers. Entrée de la Bièvre dans Paris. 1913 13e arrt	427	1913
4	Porte Dauphine. coin des fortifications. 1913. (16e arrt)	421	1913
5	Porte de Bercy. Fossés des fortifications. 1913. (12e arrt)	119	1910
6	Porte Dauphine. Fortifications. 1913. (16e arrt)	419	1913
7	Porte Dauphine. fortifications. 1913. (16e arrt)	464	1913
8	Porte Dauphine. Les Fossés des fortifications. 1913 (16e arrt)	414	—
9	Porte du passage de L'ourcq. Le Bastion 26 Bd Sérurier 1913. (19e arrt)	134	1910
10	Porte du Pré-Saint-Gervais. 1913. 19e arrt.	130	1910
11	Porte Maillot. fossés des fortifications. 1913. (16e arrt)	453	1913
12	Porte Maillot. fossés des fortifications. 1913. 16e arrt	456	1913
13	Porte Maillot. fortifications. 1913. (16e arrt)	451	1913
14	Porte Dauphine. fossés des fortifications. 1913. 16e arrt.	415	1913
15	Porte de Sevres. les fortifications. 1913. 15e arrt	153	1910
16	Porte de Bercy. Fossés des fortifications – 1913 – (12e arrt)	118	1910
17	Porte du passage du Canal de L'Ourcq. Bd Sérurier. 1913. 19e arrt.	132	1910
18	Porte d'Arcueil, Bd Jourdan. La Rentrée de Paris 1913. (14e arrt)	145	1910
19	Poterne des peupliers. Bd Kellermann. fortifications 1913. (13e arrt)	137	1910
20	Porte de Vanves. Fortifications. Bd Brune. 1913 (14e arrt)	149	1910
21	Poterne des peupliers. Bd Kellermann. 1913. 13e arrt	439	1913
22	Porte de Versailles. fortifications – 1913 – 15e arrt	152	1910
23	Porte Maillot. fortifications. 1913 – 16e arrt	454	—
24	Porte Dauphine. fossés des fortifications. 1913. 16e arrt	463	1913
25	Porte d'Ivry. Bd Masséna 18 et 20. fortifications. 1913 – 13e arrt	114	1910
26	Porte de Gentilly. Bd Kellermann. 1913. 13e arrt	140	1910
27	Porte de Bercy. Gare du P.L.M. sur les fortifications. Bd Poniatosski. – 1913 – 12e arrt	116	1910
28	Porte Dauphine. Fortifications – 1913 – 16e arrt	466	1913

Page number	Caption	Negative number	BHVP date
29	Porte de Bercy – Sortie de Paris du P.L.M. B^d Poniatosski – 1913 – 12^e arr^t	115	1910
30	Porte d'Italie. La Bièvre. La Sortie de Paris. 1913 (13^e arr^t)	403	1913
31	Porte d'Italie. La Bièvre à la sortie de Paris. 13^e arr). 1913	402	1913
32	Porte d'Italie. La Bièvre à la sortie de Paris. 1913 – 13^e arr^t	404	1913
33	Porte d'Italie. La Bièvre à la sortie de Paris. 1913 – 13^e arr^t.	401	1913
34	Porte Dauphine. Fossés des fortifications. 1913. 16^e arr^t	468	1913
35	Porte de Bercy. Gare du P.L.M. sur les fortifications. B^d Poniatosski – 1913 – 12^e arr^t	117	1910
36	Porte de Versailles – fortifications – 1913 – 15^e arr^t	151	1910
37	Porte Dauphine. Fortifications – 1913. 16^e arr^t	420	1913
38	Porte Dauphine. Fossés des fortifications. 1913 – 16^e arr^t	465	1913
39	Porte Dauphine. Fortifications. 1913 – 16^e arr^t	413	1913
40	Porte Dauphine. fortifications. 1913 – 16^e arr^t	422	1913
41	Porte Maillot. fossés des fortifications. 1913 – 16^e arr^t	452	1913
42	Fortifications – La Sortie de Paris – B^d Jourdan. Sceaux Ceinture. 1913 – 13^e arr^t	142	1910
43	Porte du passage du Canal de L'ourcq. B^d Sérurier. 1913 – 19^e arr^t	133	1910
44	Porte d'Orléans. Le Bastion 80. le jardin du Bastion 1913 – 14^e arr^t	146	1910
45	Poterne des peupliers. B^d Kellermann. 1913. (13^e arr^t)	138	1910
46	Porte Dauphine. Fossés des fortifications. 1913 – 16^e arr^t	417	1913
47	Poterne des peupliers, B^d Kellermann – 1913 – 13^e arr^t	438	1913
48	Porte Dauphine – Les fossés des fortifications. 1913 – 16^e arr.	416	1913
49	Porte du passage de L'ourcq, B^d Sérurier. 19^e arr – 1913.	131	1910
50	Porte d'Ivry. Impasse Masséna, 18 et 20, sur les fortifications 13^e arr – 1913.	106	1910
51	Porte de Sevres. Bastion. 1913 – 15^e arr^t	159	—
52	Porte d'Arceuil B^d Jourdan. 1913 – 14^e arr^t.	144	1910
53	Poterne des peupliers. B^d Kellermann. Paysage des fortifications – 1913 – 13^e arr^t	139	1910
54	Fortifications. Bastion 87, B^d Kellermann. Porte d'Italie 13^e arr – 1913.	113	1910
55	Porte de Sevres. Fortifications. 1913 – 15^e arr^t	154	1910
56	Porte Dauphine, fossés des fortifications. 1913 – 16^e arr^t	467	1913
57	Porte Dauphine. Les Fortifications. 1913 – 16^e arr^t	418	1913
58	Porte Maillot, un coin des fortifications. 1913 – 16^e arr^t	455	1913
59	Porte Dauphine. Fossés des fortifications. 1913 – 16^e arr^t	423	1913
60	Poterne des peupliers, B^d Kellermann, Paysage des fortifications – 1913 – 13^e arr^t	437	1913

Appendix 2
Records of Atget's Sales to the Paris Institutions, 1898–1928

These lists are based on the entries in the acquisitions records of the various libraries. The entries have been collated and are grouped chronologically. The acquisition number is given first, followed by its date (which was not necessarily the date of the sale), the title given to the lot of photographs, and the price in francs paid for them. Question marks indicate gaps in the records.

1898:

Trocadéro (Musée du Sculpture Comparé)

24273– 24302	n.d.	5 Abbeville 12 St. Riquier 2 Picquigny 9 La Rochelle 1 Angoulins 1 Tours	?

Carnavalet (sold through the agent Danlos)

5001	30 mars	11 types Parisiens	13.75
5013	17 avril	15 types parisiens et vues pittoresques	15.75
5022	3 mai	? types parisiens	17.50
5023	3 mai	19 photos V. P.	(included in the figure for 5022)
5029	? mai	16 types et scènes de Paris	20.
5050	? juin	39 types et vues diverses de Paris	48.75
5060	? juillet	20 vues de Paris (cloître de Billettes, etc.)	25.
5061	? août	13 Photographies – scènes du 14 juillet et vues de Paris	16.25
		12 Vues diverses de Paris	15.x

1899:

Carnavalet (via Danlos)

5277	mai	30 Vues de Paris et types parisiens	?

Bibliothèque historique

32632	16 octobre	100 photographies du Vieux Paris	125.

1900:

Carnavalet (via Danlos)

5537	? juillet	? Vues de Paris et de l'Exposition	30.
5594	? septembre	? sur Paris	196.75

Bibliothèque historique

32786	18 janvier	100 photographies parisiens	125.
32863	25 janvier	100 photographies parisiens	125.
32915	1 mars	100 photographies parisiens	125.
33160	25 mai	100 photographies parisiens	125.

Bibliothèque Nationale (via the agent Rapilly)

| 6100 | ? janvier | 400 photographies 13 × 18 Vues, monuments parisiens inédites et non mises dans le commerce, destinées aux collections topographiques | 305. |

Musée des Arts Décoratifs

| 8608 | 24 mars | 52 Vues du vieux Paris | 52. |
| 8609 | | 80 Plantes et fleurs | 80. |

Ecole des Beaux-Arts

| 29900 | 16 mars | 103 phot^ies du "Vieux Paris" | 128.75 |

1901:

Trocadéro

| 28736– 29035 | ? | [Vieux Paris photographs itemized – 300 phot.] | ? |

Carnavalet (only the first sale was administered by Danlos)

5599	? janvier	? Vues de Paris	135.
5719	? janvier	76 Photographies sur Paris et les environs – 1x 25 et 1x 50 l'un	101.
5759	22 juillet	sur Paris et les environs 47 photo à 1f25 / 44à 1.50	124.75
5810	? novembre	? sur Paris et les environs	111.25
5827	? novembre	39 photographies sur le Vieux Paris et 41 sur les environs	110.25

Bibliothèque historique

| 34510 | 7 mai | 300 Photographies du Vieux Paris | 375. |
| 35537 | 12 août | 191 photographies parisiens | 238.75 |

Bibliothèque Nationale

6245	10 février	404 photographies relatives au vieux Paris, Portes, façades de maisons, intérieurs de cours exécutées par Atget et non publiées	325.
6304	10 avril	142 suite de 142 ép. phot. du vieux Paris, exécutées par Atget et non mises dans le commerce à 1f l'une	142.
6305	10 avril	70 épreuves phot. par le même de monuments des environs de Paris à 1 fr 25 l'une	87.50

Musée des Arts Décoratifs

| 9027 | 21 mars | 143 Vues de Paris | 143. |

Ecole des Beaux-Arts

| 30338 | 15 janvier | 58 photographies du vieux Paris | 58. |

1902:

Carnavalet (only the last sale was administered by Danlos)

| 5958 | ? avril | 43 Photo Vieux Paris 30 Environs de Paris | 98.75 |

6012	? juillet	63 photographies – Vieux Paris à 1x 25	99.75
		14 photo environs de Paris à 1x 50	
6045	? août	44 Vieux Paris	118.
		42 Environs de Paris	
6049	? septembre	44 photo Vieux Paris à 1x 25	115.
		40 photo environs de Paris à 1x 50	
6094	? 1902	44 épreuves sur Le Vieux Paris et les environs	64.

Bibliothèque historique

35741	13 janvier	307 photographies de Paris et environs	428.75

Bibliothèque Nationale

6395	19 février	275 photographies du Vieux Paris	355.

Musée des Arts Décoratifs

9382	20 février	77 Vues du Vieux Paris	77.
9383	20 février	72 Vues des Environs de Paris	90.

Ecole des Beaux-Arts

31102	10 février	3 Vieux Paris	3.
31103	10 février	35 Environs de Paris	43.75

Ecole Boulle

2627–2639	28 janvier	13 Paris [itemized]	13.
2640–2659		20 Versailles [itemized]	25.

1903:

Carnavalet

6148	? mai	49 sur les ancien quartiers de Paris	61.25
6242	9 juillet	37 photos du Vieux Paris	46.25
		38 photos des Environs de Paris	57.
6295	12 octobre	57 sur le vieux Paris	101.25
		20 sur les environs	
6326	7 décembre	32 épreuves Vieux Paris	64.
		16 épreuves environs de Paris	

Bibliothèque historique

36172	3 février	366 photographies (1f50 et 1f25)	495.50

Bibliothèque Nationale (via Rapilly)

6572	20 avril	364 épreuves phot. et vues inédites des vues de Paris	440.

Musée des Arts Décoratifs

9826	18 février	71 Vieux Paris	71.
9827	18 février	35 Environs de Paris	43.75

Ecole des Beaux-Arts

31842	20 février	35 du vieux Paris	80.
		36 des environs de Paris	

Ecole Boulle

3030–3043	3 mars	14 Photographies du Vieux Paris [itemized]	14.
3044–3065		22 Province [itemized]	27.50

1904:

Trocadéro

| 35133–35241 | 1904 | [109 photos itemized, 74 from Paris, 35 from the environs] | ? |

Carnavalet

6433	mai	13 épreuves Vieux Paris 37 épreuves environs de Paris	71.75
6497	4 août	51 épreuves Vieux Paris 11 environs de Paris	80.25
6505	11 septembre	78 épreuves sur Paris 10 sur les environs	112.50

Bibliothèque historique

| 36889 | 29 janvier | 243 photographies collées sur carton et relat. à Paris et environs | 321. |

Bibliothèque Nationale

| 6732 | 15 juillet | 173 photographies du Vieux Paris à 1^{frcs} l'une | 173. |
| 6733 | 15 juillet | 69 photographies des environs de Paris à 1×50 l'une | 103.50 |

Musée des Arts Décoratifs

| 10199 | 20 février | 93 photographies du Vieux Paris | 93. |

Ecole des Beaux-Arts

| 32363 | 20 février | 127 phot. brochés. Vieux Paris | 127. |
| 32364 | 20 février | 39 Environs de Paris (Versailles) | 48. |

Ecole Boulle

| 3425–3437 | 6 février | 13 Photographies [itemized] | 13.75 |

1905:

Carnavalet

| 6744 | 25 juillet | 64 sur le Vieux Paris à 1×25 l'une
8 sur les Environs de Paris | 92. |

Bibliothèque historique

| 37856 | 17 janvier | 243 photographies de monuments du Vieux Paris et des environs de Paris | 329. |
| 38813 | 19 décembre | ? Photographies Paris et environs | ? |

Musée des Arts Décoratifs

| 11470 | 21 janvier | 122 photos de Paris
40 photos de Versailles et St Cloud | 172. |

Ecole des Beaux-Arts

| 32919 | 6 mars | 172 phot. Vieux Paris | 172. |
| 32920 | | 33 phot. Environs de Paris | 41.25 |

Ecole Boulle

| 3762–3769 | 4 février | 8 Photographies. Ornements. Architecture | 9.75 |

1906:

Trocadéro

37324–37451	1906	[128 photographs itemized, 123 being of Vieux Paris and 5 of Beauvais and Sarcelles]	?

Bibliothèque historique

39282	22 octobre	198 vues de Paris et 57 des environs	333.

Bibliothèque Nationale

7035	19 décembre	350 phot. du Vieux Paris	367.50

Musée des Arts Décoratifs

12831	16 janvier	165 photo du Vieux Paris (à 1 fr) et 26 environs de Paris (1,25)	197.50

Ecole des Beaux-Arts

33445	3 février	204 photographies du Vieux Paris	204.
33446	3 février	14 photographies de Fontainebleau	17.50

1907:

Trocadéro

39316–39476	1907	[161 photographs itemized, 142 of Vieux Paris and 19 of Fontainebleau and Senlis]	?

Bibliothèque historique

A161	2 mai	30 épreuves Topographie de Vieux Paris	75.
A162	2 mai	43 épreuves. Documents divers sur le vieux Paris	53.75
A214	24 juin	50 épreuves photographiques. Topographie du Vieux Paris à 2,50 l'une.	125.
A215	24 juin	20 epreuves Documents sur le Vieux Paris à 1 fr 25 l'une	25.
A247	16 septembre	88 photographies du Vieux Paris et des environs de Paris	158.50
A248	16 septembre	60 photographies du Vieux Paris (Topo 48 à 2,50 — Docts à 1,25)	135.

Bibliothèque Nationale (via Rapilly)

7130	17 juillet	303 photographies du Vieux Paris	349.95

Musée des Arts Décoratifs

13937	15 février	135 photo. du Vieux Paris (1 fr.) 43 des Environs de Paris (1,25)	218.75

Ecole des Beaux-Arts

33968	4 mars	146 photographies Vieux Paris	146.
33969	4 mars	54 photographies Environs de Paris	67.50

1908:

Trocadéro

41387–41531	1908	[175 photographs itemized, of Paris and the Tuileries]	?

Bibliothèque historique

A396	22 janvier	108 photos topographie parisienne	270.
A423	10 avril	20 épreuves photogr. Vieux Paris	65.
A424	10 avril	31 épreuves photogr. Vieux Paris	38.75
A446	4 juillet	51 épreuves photog. Topographie du Vieux Paris	127.50
A447	4 juillet	37 épreuves photog. Documents divers	46.25
A472	3 octobre	61 épreuves Topogr. parisienne et documents divers	148.75
A499	29 décembre	88 épreuves topogr. vieux Paris	220.
A500	29 décembre	11 épreuves Documents divers	13.75

Musée des Arts Décoratifs

14990	13 janvier	83 photo Vx Paris (1f) 32 Environs (1,25 fr)	123.

Ecole des Beaux-Arts

35039	6 juillet	65 photographies Vieux Paris	65.
35040	6 juillet	49 photographies Environs de Paris & Province	61.25

1909:

Trocadéro

42808– 42906	1909	[99 photos itemized, 66 of Paris and 33 of Rouen, Houdon, and Etampes]	?

Bibliothèque historique

A527	24 avril	40 épreuves Topographie du Vieux Paris	100.
A528	24 avril	27 épreuves documents divers	46.25
A543	2 juillet	61 épr. topogr. du Vieux Paris	152.50
A544	3 juillet	3 épr. diverses du vieux Paris	3.75
A548	1 septembre	51 photos Topographie Vieux-Paris	127.50
A549	1 septembre	9 photos Documents 1848	22.50
A554	23 octobre	60 Photos Vieux Paris	150.

Ecole des Beaux-Arts

35426	29 mars	64 photographies du Vieux Paris	64.
35427	29 mars	23 photographies des Environs de Paris	27.75

1910:

Trocadéro

43954– 43985	1910	[32 photos itemized, 27 of Paris and 5 of Dammarie-les-Lys, Compiègne, and Vaux de Cernay]	?

Carnavalet

7468	11 juin	67 Vues du Vieux Paris (série de 67 épreuves) Hôtels d'Ecquevilly, Lauzun, Mascarani, de Hollande, Séguier, Boisgelin, Eglise St Sulpice, Fontaines, Cabarets et . . .	100.
7502	27 août	60 Vues du Vieux Paris: Intérieurs parisiens nouvelle série (faisant suite au No E. 7468)	100.

Bibliothèque historique

A603	9 février	120 épreuves photos Topographie du Vieux Paris	300.
A678	9 mars	60 épreuves topographie du Vieux Paris	150.
A805	9 mai	50 photographies Topographie Vieux-Paris	140.
A941	6 juillet	Suite intérieurs parisiens et 36 épreuves Topographie Vx Paris	150.
A1000	5 octobre	69 épreuves photos Paris et environs	151.50
41639	10 novembre	60 photographies représentant des voitures parisiennes	150.

Musée des Arts Décoratifs

| 82 | 5 janvier | 52 photographies du Vieux Paris | 56.75 |

Ecole des Beaux-Arts

| 35967 | 15 mars | 42 phot. Vieux Paris | 42. |
| 35968 | 15 mars | 83 Environs d. Paris et Province | 103.75 |

Ecole Boulle

| 4577–4607 | 10 janvier | Photographies du Vieux Paris | ? |

1911:

Trocadéro

| 51352–51440 | 1911? | [89 photos itemized, of Paris and the Tuileries] | ? |

Carnavalet

7588	21 mars	suite de 60 épreuves: Les Voitures	100.
7614	8 juin	album de 60 photos: Maisons historiques du Vieux Paris	100.
7646	17 août	Les Fortifications de Paris. Série de 60 épreuves en un album.	100.

Bibliothèque historique

A1141 (and 41778)	9 janvier	129 photos vieux Paris	303.50
A1197 (and 41816)	24 février	60 photographies représentant des aspects des fortifications	150.
A1224	10 avril	50 épreuves topographie vieux Paris	150.
41977	30 mai	68 photographies (Paris et environs) collées sur carton	?
42030	10 juillet	60 photographies du vieux Paris	150.
42105	30 septembre	60 photographies (topographie parisienne)	150.
42183	21 décembre	60 photographies représentant des statues parisiennes	?

Bibliothèque Nationale

| 7542 | 16 janvier | Intérieurs parisens 1910 | 210. |
| 7642 | 13 juillet | Les voitures à traction animale. Paris en 1910. | 210. |

Musée des Arts Décoratifs

| 171 | 25 janvier | 33 épr. Vieux Paris (photographies) | 33. |
| 203 | 20 décembre | 77 photos du Vx Paris | 87.75 |

Ecole des Beaux-Arts

37095	5 mai	23 photographies du vieux Paris	23.
37098	5 mai	4 photographies du vieux Paris	4.
37099	5 mai	1 photographie des environs de Paris	1.25

1912:

Trocadéro

| 54187–54398 | 1912? | [212 photos itemized, Paris] | ? |

Carnavalet

| 7677 | 15 janvier | Suite de 60 épreuves photographiques: Coins du Vieux Paris en un album | 100. |
| 7718 | 29 avril | album de 60 épreuves: Vues de Paris | 100. |

Bibliothèque historique

42193	4 janvier	120 photographies du Vieux Paris	?
42213	1 février	60 photographies (statues) monuments des Tuileries	150.
42384	6 mars	60 épreuves photographiques du Vieux Paris à 2 f 50 l'une	150.
42466	26 avril	60 épreuves topographique du Vieux Paris à 2 f 50 l'une	150.
42478	27 avril	6 épreuves photographiques (ligne des boulevards) à 2 f 50 l'une	15.
42504	28 mai	64 photographies du jardin des Tuileries	160. [paid 120.]
42535	10 juin	35 photographies de Paris (jardins du Tuileries, vues, etc)	150. [cancelled]

Bibliothèque Nationale (via Rapilly)

| 7822 | 7 août | Métiers et boutiques et étalages de Paris | 210. |

1913:

Trocadéro

| 57555–57675 | 1913? | [121 photos itemized, Paris and the Bagatelle] | ? |

Carnavalet

| 7853 | 7 avril | album de 60 épreuves: L'Art dans le Vieux Paris | 100. |
| 8083 | 30 juillet | album de 60 épreuves le Vieux Paris | 100. |

Bibliothèque historique

42699	13 janvier	Photographies. Vues de Paris (vases des Tuileries, vues diverses, etc.)	285.
42938	18 mars	64 épreuves photographiques (églises de Paris)	?
43021	2 juin	60 photographies (topographie du Vieux Paris) 15 photographies (2e empire)	171.
43139	15 octobre	53 photographies (hôtels, ports de Paris)	132.50
43154	16 octobre	6 photographies (Vieux-Paris)	15.

| 43155 | 16 octobre | 60 photographies (Vieux Paris) | 150. |

Bibliothèque Nationale (via Rapilly)

| 7915 | 14 mai | Enseignes et vieilles boutiques de Paris | 210. |

Musée des Arts Décoratifs

| 237 | février | 106 photos Vieux Paris | 142.50 |

Ecole des Beaux-Arts

| 38688 | 5 mars | 288 photographies du Vieux Paris | 288. |

1914:

Carnavalet

| 8140 | 3 janvier | album de 60 épreuves sur le Vieux Paris | 100. |
| 8225 | 1 mai | album de 60 épreuves sur le Vieux Paris | 100. |

Bibliothèque historique

43307	27 janvier	116 photographies à 2,50 l'une (Vieux Paris)	290.
43422	20 mars	60 photographies (Topographie du Vieux Paris) à 2,50 l'une	150.
43685	27 mai	60 épreuves (Topographie du Vieux Paris) à 2,50 l'une	150.
43700	20 juillet	60 photographies à 2,50 l'une	150.

Musée des Arts Décoratifs

| 290 | janvier | 96 photos Vieux Paris | 96. |

1915:

Bibliothèque Nationale (via Rapilly)

| 8162 | 10 mai | albums Atget (suite) Les zoniers | 210. |
| 8282 | 15 novembre | albums Atget. Fortifications de Paris | 210. |

1916:

Commission municipale du Vieux Paris

| bon no. 5 | 26 août | 1 épreuve avec droits de reproduction | 10. |

1919:

Musée des Arts Décoratifs

| 393^bis | 1 décembre | 42 archi et sculpture | 63. |

1920:

Trocadéro

| 82563–82620 | 1920 | [58 photos itemized, 52 of Paris and 6 of Sceaux, Taverny, Lucy, and Fontenay-les-Louves] | ? |

Musée des Arts Décoratifs

| 401 | 19 janvier | 41 photos de Paris | 63. |

Monuments historiques

| MH 37421–40020 | 29 novembre | 2621 épreuves et clichés | 10,000. |

1921:

Carnavalet

| 10683 | 4 février | album de soixante épreuves sur Paris | 100. |

Bibliothèque Nationale (via Le Garrec)

| 8702 | 19 janvier | 70 Vues des quais de Paris | 165. |

Musée des Arts Décoratifs

| 416bis | janvier | 14 archi et sculpture | 42. |

1922:

Carnavalet

| 10915 | 30 janvier | album de soixante épreuves: vieilles cours de Paris | 180. |
| 10989 | 4 septembre | aspects du Vieux Paris et notamment du Parc Delessart à Passy. un album, 60 épreuves | 200. |

Bibliothèque Nationale (via Le Garrec)

| 8805 | 1922 | 60 Vues de Paris | 200. |
| 8866 | 12 décembre | 107 Vues de Paris et des parcs des Environs à 3f. | 321. |

1923:

Carnavalet

| 11148 | 9 octobre | Les vieux Hôtels de Paris (nouvelle série) album de 60 épreuves | 200. |
| ? | novembre [according to the receipt left by Atget] | Vieux Paris, Cours Pittoresques Vieux Montmartre 60 épreuves | 200. |

Bibliothèque Nationale (via Le Garrec)

| 8885 | 29 juillet | 111 vues de St Cloud 3 fr. | 333. |

1924:

Bibliothèque Nationale (via Le Garrec)

| 8926 | 5 août | 100 Environs de Paris | 300. |

1925:

Carnavalet

| 11486 | 11 juin | 60 photogr. du Vieux Paris (achat 23 mars 1925) | 200. |
| ? | 21 octobre [dated receipt] | coins pittoresque du Vieux Paris | 200. |

Musée des Arts Décoratifs

| 470 | janvier | 33 photos de monuments | ? |

1926:

Bibliothèque Nationale (via Le Garrec)

8996	mars	148 photographies des environs de Paris	592.
9019	15 octobre	[Environs]	504.

Musée des Arts Décoratifs

477	1926	16 photos de monuments	?

1927:

Bibliothèque Nationale (via Le Garrec)

9037	10 décembre	72 photographies	504.

Monuments historiques

MH 87000– 89000	[after 4 août, Atget's death]	2000 clichés [Paris and environs]	?

1928:

Carnavalet

12140	mars	album Atget	200.

Appendix 3

Atget's Clients, by Profession

Only those clients listed in Atget's *répertoire* are included here. Sources for these professions have been abbreviated as follows:

A Atget's annotation
B Bottin
C Cadastre, Archives de la Seine
LE Listes électorales, Archives de la Seine
P Patentes, Archives de la Seine
TP Tout Paris
VP Membership lists of the Vieux Paris societies
SdA Salon d'Automne catalogues
SI Salon des Indépendants catalogues

If the profession of the client was not available through one of these sources, that client has been listed as part of the "Trade unverified" section, even if the name of the client is well known. Photographic suppliers have been listed in a separate section.

Painters and Illustrators:

Page number of *répertoire*	Client	Profession	Source
20	Alers, L.	dessinateur-artiste	B
81	Altann, Alexandre	peintre-artiste	B
83	Aranjo	académie de peinture	B, P
26	Bac, F.	artiste-peintre	B
80	Baillergeau, Yves	peintre-artiste	B
82	Bailly	dessinateur-artiste	B
15	Barrère, A.	peintre-artiste	B
82	Benito, Edouard-Garcia	peintre	SdA
5	Bideaux, Gaston	peintre-artiste	B
13	Bombled, L.	peintre-artiste	B
19, 50	Bourgain, Gustave	peintre-artiste	B
78, 85	Boutet de Monvel	peintre-artiste	B
25, 51	Brunery, François	peintre-artiste	B
17	Cagniart, Emile	peintre	A
13	Camoreyt, Jacques	peintre-artiste	B
73	Carrey	dessinateur-artiste	B
14	Chabas, Paul	peintre-artiste	B
84	Chabridon, Jean-Joseph	peintre-artiste	SI
67	Chapuis, Pierre	peintre-artiste	B
43	Chartier, Henri	peintre-artiste	B
38	Chauvet, L.	peintre-artiste, peintre-décorateur	B
26	Chiriat, Paul	illustrateur	A
5, 17, 70	Clairin, Georges	peintre-artiste	B

73	Coeuret, Alfred	dessinateur-artiste	B
20	Colas, Louis	artiste-lithographe, dessinateur pour fabrique	B, C
32	Colin	artiste-peintre	A
23	Colin, Paul	peintre-artiste	B
13	Condamy	illustrateur	A
15, 39	Conrad, George	illustrateur, dessinateur-artiste, peintre-artiste	B
13	Damblans	illustrateur	A
9	Daugaud	peintre-artiste	B
13	Datamian	illustrateur	A
9, 42	Detaille, Edouard	peintre-artiste	B
74	Dete, E.	estampes et gravures, graveur	B, A
67	Dethomas, Maxime	peintre	A
13	Dorville, Noel	illustrateur	A
61	Drian	artiste peintre genre Lelong	A
20	Drivon	peintre-artiste	B
13	Dumond	illustrateur	A
69	Dupain, Edmond	peintre-artiste	B
13	Dupuis, Georges	illustrateur	A
69	Dutriac	dessinateur	A
82	Duval, Jean-Charles	peintre	SdA
45	Jobbe-Duval	peintre-artiste	B
81	Edelmann	peintre	A
13	Enjolras, Delphin	peintre-artiste	B
45	Fabiano	illustrateur	A
83	Fanty Lescure	peintre-artiste	B, C
68	Foreau, Henri	peintre-artiste	B
5, 17, 70	Fortuny, Mariano	dessinateur-artiste	B
81	Friesz, Othon	peintre-artiste	historic site marker at address
15	Garat	illustrateur	A
13	Gelibert	illustrateur	A
13	Geoffroy, Jean	peintre-artiste	B
26	Gerbault, Henry	peintre-artiste	B
5	Gervais, Paul	peintre-artiste	B
72	Gil-Baer	dessinateur-artiste	B
24, 50	Giraldon, Adolphe	peintre-artiste	B
26	Gottlob, F.	peintre-artiste	B
5	Grasset, Eugène	peintre-artiste	B

69	Guillaume, Albert	peintre-artiste	B
15, 68, 83	Guillonet, Octave	peintre-artiste	B
26	Helleu, P. D.	peintre-artiste	B
20	Hem, Raoul	dessinateur-artiste	B
73	Henriquez	artiste-dessinateur	B
9, 13	Hernandez, Daniel	peintre-artiste	B
82	Higounet de Villers	peintre-artiste	B
72	Hoffbauer, Charles	peintre-artiste	B
83	Jacques, Lucien Arthur	graveur s / bois	A
26	Jeanniot, Georges	peintre-artiste	B
9, 72	Jouas, Charles	peintre-artiste	B
80	Jouve, Paul	peintre-artiste	B
24, 79	Karbowski, Adrien	peintre-artiste	B
73	Lalauze, Alphonse	peintre-artiste	B
13, 15	Lanos, Henri	dessinateur-artiste	B
63	Laurens, Albert	dessinateur	A
26, 38	Laurent-Desrousseau	peintre-artiste	B
81	Lecomte, Paul Emile	peintre-artiste	B
26	Leguey, Luc	illustrateur	A
5	Leloir, Maurice	peintre-artiste	B
2, 61	Lelong, René	peintre-artiste	B
13	Leroux, Auguste	peintre-artiste	B
13, 26	Loewy	peintre-artiste	B
26	Lourdey	illustrateur	A
13, 15, 23, 50	Macchiati	peintre-artiste	B
13, 73	Mahut	peintre-artiste	B
15, 20, 73	Malteste, Louis	dessinateur-artiste	B
15	Marchetti	peintre-artiste	B
80	Maxence	peintre-artiste	B
74	Mayeur	graveur s/ acier	B
21	Menetrier, Léon Désiré	dessinateur	LE
26	Métivet, Luc	dessinateur-artiste	B
21	Miniot, A.	graveur s/ bois	B
68	Mirande	dessinateur-artiste	B
24	Morand, E.	peintre-artiste	B
68	Myrbach, Félicien de	peintre	SdA
80	Naudin	dessinateur-artiste	B
42	Onfroy de Breville, Jacques (JOB)	artiste-peintre	TP
15	Orazi, Manuel	peintre-artiste	B
13, 15, 26, 50	Paris	peintre-artiste	B
74	Pinet	graveur-artiste, aquafortiste	B

21	Poyet	dessinateur-graveur	B, C
26	Préjelean, René	dessinateur-artiste	B
85	Rapin, Henri	peintre-artiste	B
3	Remond, Georges	peintre	C
13	Rochegrosse, Georges	peintre-artiste	B
25	Rossi, Lucius	peintre-artiste	B
62	Roubille, Auguste	artiste humoristique	A
15, 39	Rudaux, Henri	peintre-artiste	B
2, 13, 71	Sabattier	peintre-artiste	B
27	Scheideker, P. et F.	dessinateurs	B
26	Scoppeta	illustrateur	A
71	Scott, Georges	peintre-artiste	B
64, 79	Serre	artiste aquafortiste	A
23, 26, 38	Simont	illustrateur	A
13	Tavernier, J. L.	peintre-artiste	B
13	Tenré, H.	illustrateur	A
15	Tinayre	illustrateur	A
15, 68	Tofani	peintre-artiste	B
26	Toussaint	dessinateur	A
15	Troncet, Antony	illustrateur	A
19	Vallet	peintre-artiste	B
17	Vayson, Paul	peintre-artiste	B
24	Verneuil	peintre-artiste	B
84	Vignal, Pierre	professeur de dessin	B
13	Vincent, René	illustrateur	A
5, 13	Vogel	illustrateur	A
13, 15	Welly, J.	illustrateur	A
13	Widhopff, D.	dessinateur-artiste	B
84	Zingg	peintre-artiste	B
15	Zo	illustrateur	A

Décorateurs en théâtre. Cinémas:

5, 31, 33, 67	Amable	peintre en décors	B
21	Anselm	peintre en décors	B
3, 67	Bertin, Emile	peintre en décors	B
28	Bin	peintre en décors, ar[te] décorateur	B, A
67	Chambourleron et Mignard	peintres en décors	B
5, 17, 21, 33	Chaperon, Emile	peintre-décorateur	B
11	Cinéma Eclair		
11	Cinéma Halls		
11	Cinéma Lux		

11	Cinéma Pathé Frères		
22	Cornil	peintre-décorateur	B
67	Decassina et Roger	décorateurs en théâtre	B
22, 33	Demongé et Monveau	décorateurs en théâtre	A
22	Diosse	ingénieur constructions théâtrales	B
11	Eclipse et Urban Trading Cie	cinéma	A
12	Gaumont, L. et Cie	cinéma	A
5, 31, 33, 49, 67	Jambon, Marcel	peintre en décors	B
5, 33, 67	Jusseaume, Lucien	peintre en décors	B
23, 33	Karl, Louis	peintre en décors	B
33, 64	Laverdet et Bertin	peintres en décors	B
67	Maréchal, Maurice	peintre en décors	B
22, 33, 67	Maréchal, Olivier	peintre-décorateur	B
21, 33	Menessier, A.	peintre en décors	B
21	Moisson	décorateur en théâtre	A
33, 64, 66, 67, 85	Monveau	décorateur en théâtre	A
67	Numa et Chazot	peintres en décors	B
3, 22, 33, 67	Paquereau	peintre-décorateur en théâtre	B
10, 33, 49, 64	Rochette et Landrin	décorateurs en théâtre	A
21	Rubé et Moisson	peintres en décors	B
22, 33, 51, 67, 70	Simas	peintre en décors	B

The Building Industry:

46	Adda, Charles	architecte-expert	B
85	Andrada	décorateur	B
2	Arfvidson, André	architecte	B
38	Auberlet, E., et G. Laurent	sculpteurs-ornemanistes	B
86	Ausseur	menuisier et fabr. de parquets	B
2, 48, 52	Baguès, Robert	fabr. de bronzes	B
7	Baillet, Ch.	serrurier	B
14	Ballagny	marbrier-sculpteur	B
9	Barbaud et Bauhain	architectes	B
8	Barriol, E.	sculpteur-décorateur	B
79	Bataille, Henri	peintre-décorateur	B
71	Baucaut	sculpteur-décorateur	B
3	Baudet, Donon et Cie	ingénieurs-constructeurs	B
6, 45, 52	Beaudoin, H.	serrurier	B
23	Bellard, Alf.	ingénieur-constructeur, serrurerie d'art	B
66	Benard, Aug. fils	serrurier	B

8	Benezech, H., et fils	marbriers	B
5, 52	Bergeotte, L.	ferronerie et serrurerie d'art	B
30, 51	Bergue, A.	serrurerie d'art	B
1, 2, 48, 56, 66	Bernard	ferronerie d'art	B
14, 16, 50	Berthier	sculpteur-marbrier	B
56	Berthier, E.	architecte-paysagiste	B
55	Bessine, Paul	architecte	B
34, 52	Bettenfeld, L.	ébeniste	B
20, 50	Beylard, Daniel	architecte	B
9, 61	Bigaux, Louis	architecte-décorateur, décorateur pour meubles	B
71	Boignard	peintre-décorateur	B
5, 44	Boileau	architecte	B
34	Boison et E. Bardin réunis	ameublements	B
1, 3	Boisselier, Georges	peintre [pays patente]	P
43	Bonnier, Louis	architecte	B
9, 49, 68	Bontemps	bronzes, meubles et objets d'art	B
32	Borderel et Boyer	serrurier	B
35	Bouhon frères	fabr. de bronzes d'art	B, P
27	Bourdain	architecte	A
29	Bourgeois, François	architecte	B
34	Bouton, Noel	peintre-décorateur	B
8, 22	Bouvier, Henri	sculpteur-marbrier	B
28	Bouwens van der Boyen, Richard	architecte	B
5, 6, 18, 50	Bricard, Jules	serrurier, quincaillerie	B
86	Brunel	serrurier à façon	P
47	Buscaylet, L.	fabr. meubles	B
55	Buvelot, A.	étoffes, objets d'art, décorateur	B, A
1, 44, 71	Carlhian, André	tapissieurs-décorateurs	B
21	Cavaillé-Coll	facteur d'orgues	B
46, 55	Chatenay, Maurice et Rouyre	architectes	B
23, 26	Colin, Paul	ébeniste et tapissier	B
84	Collot	meubles	B
2	Coquantin, V.	tapissier et ébeniste	B
46, 55	Coulomb, A., et Chauvet	architectes	B
7	Crinon	marbrier	C
5, 18	Cruchet, A.	sculpteur-ornemaniste	B
20	Cuvillier	architecte	C
5, 18, 50	D'Albret, Alcime	sculpteur s / bois	B
7	Damon et Colin	ébenistes et tapissiers	B

24, 64, 70	Decour, E., et fils	tapissier	B
29	Deglane, H.	architecte	B
4, 48	Delisle	bronziers et ébenistes	B
5, 18, 50	Destailleur	architecte	B
5, 18	Deveche	sculpteur-ornemaniste	B
67	Deverge	peintre-décorateur	B
4, 44, 48	D'Hière, L.	serrurier d'art	B
28	D'Hont, A., et Lenevé	architectes	B
61	Dondelinger	serrurerie d'art	B
82	Dresa, Jacques	décoration	A
14	Dubosq et Bellenot	décorateur	A
55	Duchene	architecte-paysagiste	B
31	Ducros frères	serruriers	B
45	Dugarric	architecte	A
24	Dumas, P.-A.	meubles	B
83	Dunand, John	ciseleur, sculpteur-décorateur, architecte-décorateur	B
22	Dupuy, A.	sculpteur-ornemaniste	B
35	Epeaux	ameublements	B
27	Fauché	sculpteurs s/bois et meubles anciens	B
81	Felice, Marguerite de	arts décoratifs	SdA
62	Festoc	marbrier-sculpteur	B
5, 37	Flandrin, L.	sculpteur-ornemaniste	B
36, 37	Fontaine	fabr. de quincaillerie, serrures, crémones, etc.	B
1	Forest	tapissier, fabr. de meubles	B
8	Fournier, C.	doreur s/bois	B
30	Gagneau	fabr. de lampes et bronzes pour éclairage	B
2, 48	Gaulet	sculpteur s/bois	B
35	Gauley et Devaux	serrurier	C
34	Gilbert, Félix	menuisier	B
7, 48	Gilis, Ch.	marbrier	B
5, 18, 61	Girault, Ch.	architecte	B
46	Gosset, Bertrand, et Cie	sculpteurs-ornemanistes, décorateurs	B
17	Gouffé	ameublements	B
1	Grandpierre, A.	bronzes et objets d'art, éclairage électrique	B
86	Groult, André	curiosités, meubles art nouveau ou modernes	B
84	Gruber, Jacques	peintre verrier-artiste, vitraux	B
25	Guénot, Emile	architecte	B

25	Pascal, Louis	architecte	B
75	Perin, Louis	architecte	B
6	Petit	ferronnier	A
23, 47	Poisson, Paul	passementier, amateur de Vieux Paris	A
8, 49	Polart, J.	architecte	B
4	Poteau, Edouard	tapisserie, fabr. d'ameublements	B
46	Poulin, Théogen	sculpteur ornemaniste	B
66	Printemps	grand magasin – dessinateurs	A
68	Raulin	ameublements, décoration	B
46, 70, 71	Raynaud	sculpteur-ornemaniste	B
61	Reculon, Louis Jean Baptiste	peintre-décorateur	LE
70, 81	Rémon, G.	architecte-décorateur	B
71	Rémon, P. H.	tapissier-décorateur antiquitiés	B
7	Remond, Henri	tapissier	A
4, 48	Renard	serrurier	B
55	Reveron, C.	architecte-paysagiste	B
31	Rey, Phillippe	sculpteur ornemaniste	A
63	Richard	marbriers	B
66	Riefflin et Regino	serrurerie d'art	A
5, 12	Risler, Ch.	architecte	B
28, 51	Robert et Damon	menuiserie d'art et de bâtiment	B
62	Roubille	dessinateur pour Maison Val Dosne	A
62	Roubille, Paul	architecte	B
29	Rousotte	décorateur en appartement	A
20, 32	Sanson, E.	architecte	B
35	Sarrade, E. fils	menuisier	B
46	Sauvage et Sarazin	architectes	B
27	Scheideker, P. et F.	dessinateurs	B
86	Schenck	artiste-décorateur	B
55	Schultz et Leclerc	tapissiers ameublements	B
2, 48, 66	Schwartz et Meurer	constructions en fer, serrurerie d'art et horticulture	B
63	Seguin	ornemaniste	A
5, 14, 50, 64, 70	Sergent, René	architecte	B
85	Serrière	décorateur	A
23, 28, 44, 95	Sigwalt et Cie	sculpteurs-décorateurs	B
10, 14	Société Marbrière d'Avesnes	marbres en gros	B
30	Sohier, G.	serrurier d'art et de bâtiments	B
8	Suë et Villars	architecte	B
16	Tardif, A.	doreurs-miroitiers	B

5	Ternisien et Dantant	ameublements, décorations	B
35	Tétaz, J.	menuisier	B
1	Tisserand, E.	serrurerie	B
29	Umbdenstock	architecte	B
61, 63	Val Dosne	fondeurs	B
5, 10, 18, 56	Valet	décorateur	A
63	Vanderkelen, V.	marbrier	B
66	Vavasseur, Emile	serrurier	B
66	Vennier	tapissier	A
84	Verdevoye, Léon	décorateur	A
38	Vergnolet et Chauveau	peintre-décorateur	B
5, 55	Vinant, F.	serrurier, ingénieur-constructeur	B
68	Viraut, Lucien	architecte	B
8, 62	Wuiot	marbres historiques, cheminées anciens	B

Amateurs du Vieux Paris, Bibliothèques, Fonctionnaires:

1	Arts Décoratifs (Bibliothèque)		
24, 51	Ecole des arts décoratifs		
77	Benedick	conservateur du Musée Rodin	A
5	Bibliothèque historique de la Ville de Paris		
67	Bibliothèque Nationale		
41	Bibliothèque Sainte Geneviève		
9, 31, 49, 72	Blondel, Paul	amateur du Vieux Paris	A
42	Brot, Charles	miroitier, amateur du Vieux Paris	A
46	Bureau de l'Enseignement	Sous-secrétariat d'Etat des Beaux-Arts, Direction des bâtiments civils et des Palais nationaux	B
87	Cannefroy	Rédacteur principal Hôtel de Ville	A
17	Musée Carnavalet		
29	Chevalier	riche amateur	A
69	Circaud	rentier	LE
14	Custis	spécialités végétariennes riche amateur	B, A
37	Damblemont	directeur de l'Ecole communale de garçons, Place des Vosges	B
42	Delard, Joseph-Eugène	conservateur Musée Galliera	A
16	DeStuers	ministre de Hollande	B

43	Devinck, Baron Carl	amateur de Vieux Paris	A
17, 43	Doucet, Jacques	couturier, amateur de Vieux Paris	A
37	Galli, Henri	conseiller municipal du IVe arrt	
19	Geoffroy, Gustave	administrateur de la manufacture des Gobelins	B
5, 8, 49	Guiffrey, J. J.	administrateur de la manufacture des Gobelins	B
45, 65	Hartmann, Georges	amateur de Vieux Paris	VP
10	Hoche	grand amateur du Vieux Paris	A
78	Bibliothèque du Jardin des Plantes		
39	Lacombe, Paul	amateur de Vieux Paris	B
25, 51	Lambeau, Lucien	membre de la Commission du Vieux Paris	A
43	Marcheix	conservateur Ecole des Beaux-Arts	LE
5	Mareuse, Edgard	membre de la Commission municipal du Vieux Paris	VP
37, 39	Martin, Henri	administrateur de la Bibliothèque de l'Arsenal	B
5	Michel, André	conservateur de la sculpture au Musée du Louvre	B
19	Moustier, Marquis de	amateur de Vieux Paris	VP
75	Pardinel, Charles	employé commerce, amateur du Vieux Paris	LE, VP
23, 47	Poisson, Paul	passementier, amateur de Vieux Paris	A
80	Radius	amateur Palais Royal	A
40	Rothschild, Baron de		
40	Gustave		
40	Edmond		
40	Adolphe		
40	Alphonse	amateurs de Vieux Paris	VP
40	Edouard	bibliothèques	A
41	Albert		
41	James		
41	Henri		
41	Salomon		
5	Sardou, Victorien	de l'Académie Française	B
74, 76	Saunier, Charles	bibliothècaire du sous-secrétariat d'Etat des Postes et Télégraphes	A
16	Tricaud, Auguste	amateur de Vieux Paris	A
17	Vuaflart, Albert	bibliothécaire de Jacques Doucet	A

Editeurs, libraires:

36	American Architect		
64, 73, 75	Les Annales politiques et littéraires		
36	Architectural Record		
72, 76	Art de France		
74, 76, 78	L'Art et les Artistes		
20	Chapellier, Philippe	imprimerie artistique	B
71	Claesen, Charles	libraire	B
65, 75	Colin, Armand	libraires-éditeurs	B
25	Cornély, Edouard	libraire-éditeur	B
74, 76	Firmin-Didot	imprimeurs-typographes et libraires	B
25	Guibert	éditeur	A
65, 75, 77, 87	Hachette		A
	Lectures pour Tous		
	Guides Bleues		
	La Vie à la Campagne		
36	Industrial Publication Co.		A
64, 75	L'Illustration		
77	Je Sais Tout		
5, 43	Lehec	libraire ancienne et moderne	B
31	Neurdein frères	artistes photographes	B
78	La Renaissance		
70	Revue Hebdomadiare		
77	The Studio		
69	Vitry, G.	héliogravure, éditeur de photographies	B

Sculpteur-statuaires:

17, 50	Boulanger, Marcel	sculpteur-statuaire	B
45	Brunat	sculpteur-statuaire	B
62	Damé, Ernest	sculpteur-statuaire	B
84	Gaudissart, E.	sculpteur-statuaire	B
46	Piron	sculpteur-statuaire	B
86	Sandoz	sculpteur-statuaire	B
62	Verion	sculpteur	A
61	Visseaux	sculpteur-statuaire	B

Bijoutiers:

5	Lalique, R.	bijoutier	B
36	Weller	bijoutier	A

Miscellaneous:

72	Fournez, René	de l'Opéra	TP
79	Hermant, Abel	auteur dramatique	B
69	Houdayer, Raymond	étudiant	LE

Suppliers:

inside front cover	Papier Daguerre (dessin) chez Caguelin Craylon – coulé en toile		
12	Mendel, Georges	fournitures photographiques et cinématiques	B
31	Goguin	métreur	P
37	Guerin	dactylographie	B
42	W. M. Spooner et Cie	photographe	A
55	Ruckert et Godde	phototypie	B
69	Vitry, G.	héliogravure, éditeur de photographies	B
70	Papier-berges à voir pour le papier Dble Bulle (80Kil)		A
pages pasted together in the back	Bertreaux Listes Electorales	relieur	A

Trade unverified:

5	Bakès
82	Baudin
7	Beaulieu
5, 31, 53	Bercia-Tourette
27	Boutet, Henri
44	Boutren
pages pasted together in the back	Braciehuret
16	Brossimond
80	Cadol
5, 17, 19	Cancalon
34	Carpentier
52	Chatelier
12	Codman
24	Defeure
9, 49	Dreiger

Appendix 4

The Middle Section of the *Paris pittoresque* Series

The information here has been obtained from a number of sources. Collections have been abbreviated as follows:

BHVP Bibliothèque historique de la Ville de Paris
BN Bibliothèque Nationale
Carn. Musée Carnavalet
MOMA Museum of Modern Art
Ottawa National Gallery of Canada

In some cases the print now holding a *Paris pittoresque* number belonged first to another series. Earlier numbers are given in parentheses. Series other than the *Paris pittoresque* are identified. Numbers 201 and 202 were initially drawn from *L'Art dans le Vieux Paris*, but Atget seems to have thought better of it and rephotographed the sites.

Negative number	Caption	Date	Collection
1	Voiture de Maraîcher, Marché St Germain	1910	Carn.
2	Voiture de Transport de Glace	1910	Carn.
3	Voiture, Fiacre	1910	Carn.
4	Voiture, Blanchisseur	1910	Carn.
5	Roulotte d'un Fabricant de Paniers – Porte d'Ivry	1910	Carn.
6	Petite Voiture, Calèche	1910	Carn.
7	Cabriolet	1910	Carn.
8	Voiture de Vidange	1910	Carn.
9 (Pp 3063)	Omnibus	1910	Carn.
10	Omnibus	1910	Carn.
11	Tombereau	1910	Carn.
12	Voiture de Transport, Grosses Pierres	1910	Carn.
13	Voiture pour le transport des grosses pierres – 1910	1910	BN
14	Voiture, Balayeuse	1910	Carn.
15	Voiture, Balayeuse	1910	Carn.
16	Voiture, arrosage	1910	Carn.
17	Voiture à charbon	1910	Carn.
18	Char de 1er classe	1910	Carn.
19	Char 1er classe	1910	Carn.
20	Voiture 1er classe	1910	Carn.
21	Voiture 1er classe	1910	Carn.
22	Voiture de Laitier	1910	Carn.
23	Voiture de Laitier	1910	Carn.
24	Voiture de Maraîcher	1910	Carn.
25	Voiture de Touristes	1910	Carn.
26	Tramway	1910	Carn.
27	Tramway	1910	Carn.

28	Camion	1910	Carn.
29	Voiture de Transport	1910	Carn.
30	Voiture, Eaux Gazeuses	1910	Carn.
31	Voiture de Transport de charbon	1910	Carn.
32	Voiture de plâtre	1910	Carn.
33	Voiture des marchés de quartier	1910	Carn.
34	Voiture de Forain	1910	Carn.
35	Voitures Marché Mouffetard	1910	Carn.
36	Voiture de Brasseur	1910	Carn.
37	Voiture Distillateurs	1910	Carn.
38	Voiture asphalte	1910	Carn.
39	Voiture asphalte	1910	Carn.
40	Voiture à Broyer les Pierres	1910	Carn.
41	Haquet	1910	Carn.
42	Voiture pour le transport des prissonniers	1910	Carn.
43	Voiture pour le transport des prissonniers	1910	Carn.
44	Omnibus pour Voyageurs (Gare)	1910	Carn.
45	Petit Omnibus pour Voyageurs (Gare)	1910	Carn.
46	Voiture Démenagement, Grand Terme	1910	Carn.
47	Démenagement, Terme Moyen	1910	Carn.
48	Démenagement, Petit Terme	1910	Carn.
49	Voiture Bernot	1910	Carn.
50	Voiture pour Transport des Ordures	1910	Carn.
51	Voiture pour Transport des Facteurs	1910	Carn.
52	Voiturette, Bois de Boulogne	1910	Carn.
53	Voiture, Bois de Boulogne	1910	Carn.
54	Victoria, Bois de Boulogne	1910	Carn.
55	Voiture, Bois de Boulogne	1910	Carn.
56	Voiture, Bois de Boulogne	1910	Carn.
57	Voiture, Bois de Boulogne	1910	Carn.
58	Voiture, Bois de Boulogne	1910	Carn.
59 (Pp 3067)	Le Fiacre avant les Pneus	1910	Carn.
60 (Pp 3218)	La Voiture de Poste en 1905 – Disparue	1910	Carn.
61 (Pp 3071)	?	?	MOMA
62 (Pp 3186)	Voiture de Transport Pierre	?	MOMA
63 (Pp 3260)	?	?	MOMA
64 (Pp 3169)	Voiture fiacre	?	MOMA
65 (Pp 3170)	Station de Voitures	?	MOMA
66 (Pp 3006)	Omnibus	?	MOMA
67 (Pp 3127)	Voiture équipage de luxe	?	MOMA
68 (Pp 3229)	Voiture asphalte 1898	?	MOMA
69 (Pp 3233)	Bitumiers	?	MOMA

70 (Pp 3234)	Voiture bitume	?	MOMA
71 (Pp 3240)	Balayeuse 1910	1910	MOMA
72 (Pp 3066)	Fiacre	?	MOMA
73 (Pp 3062)	Omnibus	?	MOMA
74	?		
75	?		
76	?		
77	?		
78	?		
79	?		
80	?		
81	?		
82	?		
83	?		
84	?		
85	?		
86	?		
87	?		
88	?		
89	?		
90	?		
91	?		
92	?		
93	?		
94	?		
95	?		
96	?		
97	?		
98	?		
99	?		
100	Porte d'Ivry – extra muros – Zone des fortifications 1910 (13e arr)	1910	BHVP
101	Porte d'Ivry – extra muros – Zone des fortifications 1910 (13e arr)	1910	BHVP
102	Porte d'Ivry – extra muros – Zone des fortifications 1910 (13e arr)	1910	BHVP
103	Le Village d'Ivry terasse – Zone des fortifications – Porte d'Ivry extra muros – 1910 (13e arr)	1910	BHVP
104	Porte d'Ivry – extra muros – 1910 (13e arr)	1910	BHVP
105	Porte d'Ivry – Bd Masséna 18 et 20 (13e arr)	?	Carn.
106	Porte d'Ivry – Impasse Masséna – Bd Masséna – 1910 (13e arr)	1910	BHVP

107	Porte d'Ivry – B^d Masséna 18 et 20 – coins pittoresques – 13^e arr (1910.	1910	BHVP
108	Porte d'Ivry – B^d Masséna 18 et 20 – 13^e arr – 1910	1910	BHVP
109	Porte d'Ivry – B^d Masséna 18 et 20 – 13^e arr – 1910	1910	BHVP
110	Porte d'Ivry – B^d Masséna 18 et 20 – 13^e arr – 1910	1910	BHVP
111	Porte d'Ivry – B^d Masséna 18 – 1910 (13^e arr)	1910	BHVP
112	Porte d'Ivry – 18 B^d Masséna – cour d'un chiffonier 1910 (13^e arr)	1910	BHVP
113	Porte d'Italie – B^d Kellermann – Bastion 87 – 1910 (13^e arr)	1910	BHVP
114	Porte d'Ivry – Un coin du B^d Masséna 18 et 20 – 1910 (13^e arr)	1910	BHVP
115	Porte de Bercy – chemin de fer du P. L. M. sortie de Paris – B^d Poniatowski 1910 – (12^e arr)	1910	BHVP
116	Porte de Bercy – la gare des marchandises du P. L. M. – B^d Poniatowski – Vue prise des fortifications – 1910 – 12^e arr)	1910	BHVP
117	Porte de Bercy – la gare des marchandises du P. L. M. – B^d Poniatowski – Vue prise des fortifications – 1910 – 12^e arr)	1910	BHVP
118	Porte de Bercy. Les fossés des fortifications – 1910 – 12^e arr	1910	BHVP
119	Porte de Bercy. Les fossés des fortifications – 1910 (12^e arr)	1910	BHVP
120	Porte de Montreuil – extra muros – Zone des fortifications chiffoniers – 1910 (20^e arr)	1910	BHVP
121	Porte de Montreuil – fortifications extra muros – Zone des fortifications – chiffoniers – 1910 (20^e arr)	1910	BHVP
122	Porte de Montreuil – fortifications extra muros – Zone des fortifications – chiffoniers – 1910 (20^e arr)	1910	BHVP
123	Porte de Montreuil – extra muros – Zone des fortifications – maison d'un chiffonier 1910 (20^e arr)	1910	BHVP
124	Porte de Ménilmontant guinguette	?	MOMA
125	Porte de Ménilmontant – Glacis des fortifications – guinguette 20^e	?	Carn.
126	Porte de Ménilmontant extra muros. guinguette	?	MOMA
127	Porte de Ménilmontant extra muros. guinguette	?	MOMA
128	Ruelle des Mauxins – B^d Serurier 11 – Porte du Pré S^t Gervais (19^e)	?	Carn.
129	Porte du Pré S^t Gervais – Coin du Pré S^t Gervais sur les fortifications (19^e)	?	Carn.
130	Porte du pré S^t Gervais – B^d Serurier – 1910 – 19^e arr	1910	BHVP
131	Porte du passage du Canal de L'Ourcq – B^d Serurier – 19^e arr – 1910	1910	BHVP
132	Porte du passage du Canal de L'Ourcq – B^d Serurier – 1910 (19^e arr)	1910	BHVP

133	Porte du passage du Canal de L'Ourcq – B^d Serurier 1910 (19^e arr)	1910	BHVP
134	Le Bastion N^o 26 B^d Serurier – 1910 (19^e arr)	1910	BHVP
135	Porte de la Villette – Passage du Canal S^t Denis – B^d MacDonald (19^e arr)	?	Carn.
136	Porte de la Villette – Passage du Canal S^t Denis – B^d MacDonald (19^e arr)	?	Carn.
137	Poterne des Peupliers – B^d Kellermann – 13^e arr – 1910	1910	BHVP
138	Poterne des Peupliers – B^d Kellermann – 1910 (13^e arr)	1910	BHVP
139	Poterne des Peupliers – B^d Kellermann. Un paysage des fortifications – 13^e arr – 1910	1910	BHVP
140	Porte de Gentilly. B^d Kellermann et B^d Jourdan 1910 (13^e arr)	1910	BHVP
141	Porte de Gentilly. Un paysage des fortifications 1910 (13^e arr)	1910	BHVP
142	Petite gare de Sceaux Ceinture – B^d Jourdan. La Sortie de Paris – 1910 (13^e arr)	1910	BHVP
143	Petite gare de Sceaux Ceinture sur le B^d Jourdan et le Parc Montsouris (13^e arr)	?	Carn.
144	Porte d'Arcueil – B^d Jourdan – 1910 (14^e arr)	1910	BHVP
145	Porte d'Arcueil – B^d Jourdan. La Rentrée de Paris 1910 (14^e arr)	1910	BHVP
146	Porte d'Orléans – B^d Jourdan – Bastion 80 – Service de carrières de la Ville de Paris – 1910 (14^e arr)	1910	BHVP
147	Porte d'Orléans. Le Bastion 80. Le Jardin du Bastion. 1910 (14^e arr)	1910	BHVP
148	Porte de Vanves. Impasse Vandal. B^d Brune 23 (14^e arr)	?	Carn.
149	Porte de Vanves – les fortifications – Passage à niveau du chemin de fer de l'Etat – B^d Brune – 1910 (14^e arr)	1910	BHVP
150	Porte de Versailles – fortifications (15^e arr)	?	Carn.
151	Porte de Versailles – Paysage des fortifications – 1910 (15^e arr)	1910	BHVP
152	Porte de Versailles. Paysage des fortifications – 1910 (15^e arr)	1910	BHVP
153	Porte de Sevres – Paysage des fortifications – 1910 (15^e arr)	1910	BHVP
154	Porte de Sevres – B^d Victor – Paysage des fortifications – 1910 – 15^e arr)	1910	BHVP
155	Porte de Sevres – Le B^d Victor fortifications (15^e arr)	?	Carn.
156	Point du Jour – Porte du Bas-Meudon B^d Victor (15^e arr)	?	Carn.
157	Point du Jour – Porte du Bas-Meudon sur le quai (15^e arr)	?	Carn.
158	Les fortifications à la porte du Bas Meudon (15^e arr)	?	Carn.
159	Le Bastion 68 sur le B^d Victor – Porte du Bas Meudon (15^e arr)	?	Carn.

160	?
161	?
162	?
163	?
164	?
165	?
166	?
167	?
168	?
169	?
170	?
171	?
172	?
173	?
174	?
175	?
176	?
177	?
178	?
179	?
180	?
181	?
182	?
183	?
184	?
185	?
186	?
187	?
188	?
189	?
190	?
191	?
192	?
193	?
194	?
195	?
196	?
197	?
198	?
199	?
200 (AVP–493?)	Boutique Art Nouveau 45 R St Augustin – 1904 (2e arr) 1904 BHVP

201 (AVP–4085)	Cabaret de L'Enfer Bd de Clichy 53 – 1911 (9e arr)	1911	BHVP
202 (AVP 4087)	L'Enfer Bd de Clichy 53 – 1911 (9e arr)	1911	BHVP
203 (AVP 573?) (Top 865)	Brocanteur 38 Rue Descartes – 5e arr – 1909	1909	BHVP
204	Brasserie équivoque 16 Rue Blondel – 1911 (2e arr)	1911	BHVP
205	Le Moulin Rouge Bd de Clichy 86 – 1911 (18e arr)	1911	BHVP
206	Le Cabaret Alexandre Bd de Clichy 100 – 1911 (18e arr)	1911	BHVP
207	Le Cabaret Alexandre Bd de Clichy 100 – 1911 (18e arr)	1911	BHVP
208	Boutique friture – 38 Rue de Seine (1911) 6e arr)	1911	BHVP
209	Petit Marché Place St Medard – 1911 (5e arr)	1911	BHVP
210	Petit Marché coin rue Mouffetard – 1911 (5e arr)	1911	BHVP
211	Un coin de la rue Daubanton – 1911 (5e arr)	1911	BHVP
212	Boutique fleurs, Place de la Bastille – 1911 – (12e arr)	1911	BHVP
213	Un Brocanteur Place d'Aligre 1911 (12e arr)	1911	BHVP
214	Un coin de la rue de l'arbalète – 1911 (5e arr)	1911	BHVP
215	Boutique fruits 124 Rue Mouffetard – 1911 (5e arr)	1911	BHVP
216	Boutique friture 139 Rue Mouffetard – 1911 (5e arr)	1911	BHVP MOMA
217	Boutique Rue Charlemagne 25 – 1911 (4e arr)	1911	BHVP
218	Boutique 3 Rue Eginhard – 1910 (4e arr)	1910	BHVP
219	Petit Bazar 340 Place de Vaugirard – 1911 (15e arr)	1911	BHVP
220	Boutique de fleurs, Place St Sulpice – 1911 (6e arr)	1911	BHVP
221	Kiosque de journaux Place St Sulpice – 1911 (6e arr)	1911	BHVP
222	Colonne Moris, Place St Sulpice – 1911 (6e arr)	1911	BHVP
223	Boutique Square du Bon Marché Rue de Sevres – 1911 (7e arr)	1911	BHVP
224	Boutique Rue de Sevres 63 (1911 (7e arr)	1911	BHVP
225	Boutique journaux Rue de Sevres – 1911 (7e arr)	1911	BHVP
226	Bouqiniste Place de la Bastille – 1911 (12e arr)	1911	BHVP
227	Petit marchand de clefs quai de la Rapée 1911 (12e arr)	1911	BHVP
228	Petite Boutique, Gâteaux quai de la Rapée 1911 (12e arr)	1911	BHVP
229	Place Valhubert – 1911 (5e arr)	1911	BHVP
230	Maison close 106 Avenue de Suffren – 1911 (15e arr)	1911	BHVP
231	Maison close 106 Avenue de Suffren – 1911 (15e arr)	1911	BHVP
232	Brocanteur 10 Avenue de Lowendal 1911 (7e arr)	1911	BHVP
233	Marché des Carmes, Place Maubert. 1911 (5e arr)	1911	BHVP
234	Marché des Carmes, Place Maubert. 1911 (5e arr)	1911	BHVP
235	Marché des Carmes, Place Maubert, 1911 (5e arr)	1911	BHVP
236	Marché des Carmes, Place Maubert – 1911 (5e arr)	1911	BHVP
237	Boutique de passage. Rue Guillemites, 6.	?	MOMA

238	Boutique Rue Dupetit Thouars (Temple) 1911 (16e arr)	1911	BHVP
239	Boutique 2 Rue de la Corderie (Temple) 1911 (3e arr)	1911	BHVP
240	Boutique 2 Rue de la Corderie (Temple) 1911 (3e arr)	1911	BHVP
241	Petite Boucherie, Marché des Carmes Place Maubert – 1911 (5e arr)	1911	BHVP
242	Brocanteur 4 Rue des Anglais – 1911 (5e arr)	1911	BHVP
243	Un coin de la Rue St Julien le Pauvre au No 12 – 1911 (5e arr)	1911	BHVP
244	Quai de la Tournelle – 1911 (5e arr)	1911	BHVP
245	Un coin du quai de la Tournelle – 1911 (5e arr)	1911	BHVP
246	Un coin du Quai de la Tournelle (5e arr)	?	Carn.
247	Intérieur d'un Céramiste Rue St Jacques – 1911 (5e arr)	1911	BHVP
248	Intérieur d'un Céramiste Rue St Jacques – 1911 (5e arr)	1911	BHVP
249	Intérieur d'un atelier de Relieur Rue Ferou – 1911 (6e arr)	1911	BHVP
250	Intérieur Photographe – 1911 (14e arr)	1911	BHVP
251	Un coin du port des St Pères (6e arr)	?	Carn.
252	Un coin du passage des Patriarches – 1911 (5e arr)	1911	BHVP
253	Un coin du marché des patriarches – 1911 (5e arr)	1911	BHVP
254	Un coin du port des St Pères – 1911 (6e arr)	1911	BHVP
255	l'Ecluse de la Monnaie – Pont Neuf – 1911 (1e arr)	1911	BHVP
256	L'Ecluse de la Monnaie – Pont Neuf – 1911 (1e arr)	1911	BHVP
257	Les Halles – 1911 (1e arr)	1911	BHVP
258	Les Halles, Md de Poissons – 1911 (1e arr)	1911	BHVP
259	Les Halles – 1911 – 1e arr)	1911	BHVP
260	Les Halles – – 1911 (1e arr)	1911	BHVP
261	Md de Vin – 15 Rue Boyer – 1911 (20e arr)	1911	BHVP
262	Intérieur Md de Vin – Rue Boyer 21 1911 (20e arr)	1911	BHVP
263	Quai des Orfèvres – 1911 (1e arr)	1911	BHVP
264	Quai des Orfèvres, 1911 (1e arr)	1911	BHVP
265	Quai des Orfèvres – 1911 (1e arr)	1911	BHVP
266	Pont Neuf – 1911 (1e arr)	1911	BHVP
267	Boutique Boulangerie 48 Rue Descartes 1911 (5e arr)	1911	BHVP
268	Boucherie 42 Rue Descartes – 1911 (5e arr)	1911	BHVP
269	Brocanteur, 38 rue Descartes – 1911 (5e arr)	1911	BHVP
270	Le Ciel et L'Enfer, 53 Bd de Clichy, 1911 (9e arr)	1911	BHVP
271	Le Chat Noir 68 Bd Clichy	?	Carn.
272	Boutique 27 Bd de Clichy. – 1911 (9e arr)	1911	BHVP
273	Terre plein du Pont Neuf – 1911 (1e arr)	1911	BHVP
274	Terre plein du Pont Neuf – 1911 (1e arr)	1911	BHVP
275	Les quais, Terre plein du Pont Neuf – 1911 (1e arr)	1911	BHVP
276	Boutique 9 Rue des Prêcheurs 1911 (1e arr)	1911	BHVP
277	Un coin des Halles Rue Pierre Lescot, 1911 (1e arr)	1911	BHVP

278	Les Halles – 1911 (1ᵉ arr)	1911	BHVP
279	Les Halles – 1911 (1ᵉ arr)	1911	BHVP
280	Terre plein du Pont Neuf – 1911 (1ᵉ arr)	1911	BHVP
281	Les quais au Pont Neuf – 1911 (1ᵉ arr)	1911	BHVP
282	Vue prise sous le Pont Neuf – 1911 (1ᵉ arr)	1911	BHVP
283	Vue prise sous le Pont Neuf – 1911 (1ᵉ arr)	1911	BHVP
284	Boutique 61 Rue Au Maire 1911 (3ᵉ arr)	1911	BHVP
285	Port des Sᵗ Pères – 1911 (6ᵉ arr)	1911	BHVP
286	Port des Sᵗ Pères au Port Port Royal – 1911 (7ᵉ arr)	1911	BHVP
287	Port des Sᵗ Pères au Pont Royal – 1911 (7ᵉ arr)	1911	BHVP
288	Port des Sᵗ Pères – Pont Royal (7ᵉ arr)	?	Carn.
289	Boutique 13 Rue de la Cossonnerie – 1911 (1ᵉ arr)	1911	BHVP
290	Boutique 3 Rue du Jour – 1911 (1ᵉ arr)	1911	BHVP
291	Un Coin Rue Berger – Les Halles. 1911 (1ᵉ arr)	1911	BHVP
292	Boutique boucherie Les Halles	?	Carn.
293	Pont Royal – 1911 (7ᵉ arr)	1911	BHVP
294	Port de Solferino (Pont Royal) 1911 (7ᵉ arr)	1911	BHVP
295	Port de Solferino – 1911 (7ᵉ arr)	1911	BHVP
296	Port de Solferino – 1911 (7ᵉ arr)	1911	BHVP
297	Port des Tuileries – 1911 (1ᵉ arr)	1911	BHVP
298	Port des Tuileries – Pont Royal – 1911 (1ᵉ arr)	1911	BHVP
299	Port du Louvre – 1911 (1ᵉ arr)	1911	BHVP
300	Port du Louvre, Pont Royal – 1911 (1ᵉ arr)	1911	BHVP
301	Boutique, Pêche quai de la Mégisserie 1911 (1ᵉ arr)	1911	BHVP
302	Boutique d'agriculture quai de la Mégisserie 1911 (1ᵉ arr)	1911	BHVP
303	Port de la Mégisserie – Pont Neuf – 1911 (1ᵉ arr)	1911	BHVP
304	Port de la Mégisserie – 1911 (1ᵉ arr)	1911	BHVP
305	Port du Louvre – 1911 (1ᵉ arr)	1911	BHVP
306	Port du Louvre – 1911 (1ᵉ arr)	1911	BHVP
307	Port du Louvre – 1911 (1ᵉ arr)	1911	BHVP
308	Port du Louvre – 1911 (1ᵉ arr)	1911	BHVP
309	Port du Louvre – 1911 (1ᵉ arr)	1911	BHVP
310	Port du Louvre – 1911 (1ᵉ arr)	1911	BHVP
311	Port du Louvre 1911 (1ᵉ arr)	1911	BHVP
312	Port du Louvre – 1911 – (1ᵉ arr)	1911	BHVP
313	Quai d'anjou – 1911 (4ᵉ arr)	1911	BHVP
314	Quai d'anjou – 1911 – 1911 (4ᵉ arr)	1911	BHVP
315	Quai d'anjou, Pont Marie – 1911 (4ᵉ arr)	1911	BHVP
316	Quai d'anjou – 1912 (4ᵉ arr)	1912	BHVP
317	Port des Celestins, Pont Marie – 1912 (4ᵉ arr)	1912	BHVP
318	Port de l'hôtel de Ville – Pont Marie – 4ᵉ arr) 1912	1912	BHVP
319	Pont Marie	?	Carn.

320	Port de l'hôtel de Ville – 1912 (4ᵉ arr)	1912	BHVP
321	Port des Celestins – 1912 (4ᵉ arr)	1912	BHVP
322	Port de l'hôtel de Ville, Pont Marie 1912 (4ᵉ arr	1912	BHVP
323	Port de l'hôtel de Ville Pont Marie – 4ᵉ arr)	1912	BHVP
324	Port de l'hôtel de Ville – 1912 (4ᵉ arr)	1912	BHVP
325	Port du Louvre – Pont Neuf – 1912 (1ᵉ arr)	1912	BHVP
326	Port du Louvre. 1912 (1ᵉ arr)	1912	BHVP
327	Port du Louvre, au pont Neuf – 1912 (1ᵉ arr)	1912	BHVP
328	Port du Louvre. 1912 (1ᵉ arr)	1912	BHVP
329	Port de la Mégisserie – 1912 (1ᵉ arr)	1912	BHVP
330	Port de la Mégisserie – 1912 (1ᵉ arr)	1912	BHVP
331	Port de la Mégisserie, 1912 (1ᵉ arr)	1912	BHVP
332 (PDd 606)	Intérieur d'un Ciseleur. Rue de Sevres – – 1912	1912	BHVP
333	Brocanteur 42 Rue du cherche midi – 1912 (6ᵉ arr)	1912	BHVP
334	Avant l'Eclipse – 17 avril 1912 – Place de la Bastille	1912	BHVP
335 (PDd 891)	Pendant L'Eclipse – 17 avril 1912 Place de la Bastille	1912	BHVP
336 (100)	Porte d'Ivry – extra muros – Zone des fortifications 1910 (13ᵉ arr –)	1910	BHVP MOMA
337 (101)	Porte d'Ivry – extra muros – zone des fortifications 1910 (13ᵉ arr)	1910	BHVP MOMA
338 (102)	Porte d'Ivry – extra muros – zone des fortifications 1910 (13ᵉ arr)	1910	BHVP MOMA
339 (103)	Le Village d'Ivry terasse – Zone des fortifications – Porte d'Ivry. extra muros – 1910 (13ᵉ arr)	1910	BHVP MOMA
340 (104)	Porte d'Ivry – extra muros – 1910 (13ᵉ arr)	1910	BHVP MOMA
341 (108)	Porte d'Ivry – Bᵈ Masséna 18 et 20 – 13ᵉ arr – 1910	1910	BHVP MOMA
342 (109)	Porte d'Ivry – Bᵈ Masséna 18 et 20 (13ᵉ arr)	1910	BHVP MOMA
343 (111)	Porte d'Ivry. Bᵈ Masséna 18 – 1910 (13ᵉ arr)	1910	BHVP MOMA
344 (112)	Porte d'Ivry. 18 Bᵈ Masséna – cour d'un chiffonnier 1910 (13ᵉ arr)	1910	BHVP MOMA
345 (120)	Porte de Montreuil – extra muros – zone des fortifications chiffonniers – 1910 (20ᵉ arr)	1910	BHVP MOMA
346	Porte de Montreuil – fortifications extra muros – zone des fortifications – chiffonniers – 1910 (20ᵉ)	1910	BHVP MOMA
347 (123)	Porte de Montreuil – extra muros – zone des fortifications – maison d'un chiffonnier 1910 (20ᵉ arr)	1910	BHVP MOMA
348	Guinguette sur les fortifs, Porte de Ménilmontant	?	MOMA

349	?		
350	?		
351	Porte d'Italie – Une famille de Romanichels 1912 (13ᵉ arr)	1912	BHVP
352	Une cour de chiffonnier, Bᵈ Masséna – 1912 (13ᵉ arr)	1912	BHVP
353	Porte d'Ivry. Une cour de chiffonnier Bᵈ Masséna – 1912 – 13ᵉ arr)	1912	BHVP
354 (Pp 3000)	Remouleur	?	MOMA
355 (Pp 3250)	Fort de la Halle	?	MOMA
356 (Pp 2997)	Guignol Luxembourg	?	MOMA
357 (Pp 3270)	Boutique aux Halles	?	MOMA
358 (Pp 3198)	Remouleur	?	MOMA
359 (Pp 3075)	Guignol Luxembourg	?	MOMA
360 (Pp 3124)	Joueur d'Orgue	?	MOMA
361 (Pp 3168)	Marché Edgard Quinet	?	MOMA
362 (Pp 3137)	?	?	MOMA
363 (Pp 3276)	Chiffonier	?	MOMA Ottawa
364 (Pp 3211)	Remouleur	?	MOMA
365	Fête des Invalides	?	MOMA
366	Epicerie, Mᵈ de Vin – Bᵈ Masséna – 1912 (13ᵉ arr)	1912	BHVP
367	Epicerie. Mᵈ de Vin, Bᵈ Masséna – 1912 – (13ᵉ arr)	1912	BHVP
368	Epicerie Mᵈ de Vin. Bᵈ Masséna – 1912	1912	BHVP
369	Mᵈ de Fleurs	?	MOMA
370	Marché aux fleurs	?	MOMA
371	?		
372	Quai Conti	?	MOMA
373	Marché aux Fleurs quai de la Cité	?	Carn.
374	Fleurs	?	MOMA
375	Marché aux fleurs du quai de la Cité – 1912 (4ᵉ arr)	1912	BHVP
376	Palais de Justice Marché aux Fleurs	?	MOMA
377	Coiffeur, Bᵈ de Strasbourg – 10ᵉ arr. –	?	BHVP
378	Bᵈ de Strasbourg Coiffeur	?	Carn.
379	Boulevard de Strasbourg Corsets	?	Carn.
380	Boutique Etamage, 3 Rue de la Reynie 1912 (4ᵉ arr)	1912	BHVP

381	Boutique Etamage, 3 Rue de la Reynie 1912 (4ᵉ arr)	1912	BHVP
382	Bassin de la Villette	?	MOMA
383	Quai de la Tournelle 69	?	Carn.
384	Boutique Légumes, 15 Rue Maître Albert – 1912 (5ᵉ arr)	1912	BHVP
385	Vieilles Bornes, Bassin de la Villette – 1912 (10ᵉ arr)	1912	BHVP
386	Ecluse Sᵗ Martin quai de Valmy – 1912 (10ᵉ arr)	1912	BHVP
387	Ecluse Sᵗ Martin, quai de Valmy – 1912 (10ᵉ arr)	1912	BHVP
388	Rue des Lombards	?	Carn.
389	Boutique fruits, 10 Rue des Lavandières Sᵗᵉ Opportune – 1912 (1ᵉ arr)	1912	BHVP
390	A l'Exactitude	?	Carn.
391	Brocanteur 32 Rue Broca – 1912 5ᵉ arr)	1912	BHVP
392	petite épicerie, 22 Rue Tournefort – 1912 (5ᵉ arr)	1912	BHVP
393	Journaux, Rue Mouffetard, coin de l'Eglise Sᵗ Médard – 1912 (5ᵉ arr)	1912	BHVP
394	Intérieur artiste	?	MOMA
395	Intérieur artiste	?	MOMA
396	Intérieur artiste	?	MOMA
397	Porte d'Italie – Zoniers – 1913 – 13ᵉ arr)	1913	BHVP
398	Porte d'Italie – Zoniers – 1913 – 13ᵉ arr)	1913	BHVP
399	Porte d'Italie – Zoniers, 1913 – 13ᵉ arr)	1913	BHVP
400	Porte d'Italie. Zoniers – 1913 – 13ᵉ arr)	1913	BHVP
401	Porte d'Italie, La Bièvre, La sortie de Paris 1913 – 13ᵉ arr)	1913	BHVP
402	Porte d'Italie – La Bièvre. La Sortie de Paris – 1913 – 13ᵉ arr)	1913	BHVP
403	Porte d'Italie, La Bièvre, La Sortie de Paris – 1913 – 13ᵉ arr)	1913	BHVP
404	Porte d'Italie, La Bièvre, La Sortie de Paris – 1913 – 13ᵉ arr)	1913	BHVP
405	Porte de Choisy – zoniers – 1913 – 13ᵉ arr	1913	BHVP
406	Porte de Choisy. Zoniers, 1913 – 13ᵉ arr	1913	BHVP
407	Porte de Choisy. zone des fortifications, Va disparaître Romanichels	?	Carn.
408	Porte de Choisy. Zoniers – 1913. – 13ᵉ arr)	1913	BHVP
409	Fête de Vaugirard. Avenue de Breteuil, Cirque Manfretta – 1913 – 15ᵉ arr)	1913	BHVP
410	Fête de Vaugirard, Avenue de Breteuil, Cirque Manfretta – 1913 15ᵉ arr)	1913	BHVP
411	Fête de Vaugirard. Avenue de Montreuil – 1913 – 15ᵉ arr)	1913	BHVP
412	Fête de Vaugirard, Avenue de Breteuil – 1913 – 15ᵉ arr)	1913	BHVP
413	Porte Dauphine, Fortifications – 1913 – 16ᵉ arr)	1913	BHVP
414	Porte Dauphine – Fortifications – 1913	1913	Carn.
415	Porte Maillot – 1913 – 16ᵉ arr) Fortifications	1913	BHVP

416	Fortifications, Porte Maillot – 1913 – 16e arr	1913	BHVP
417	Porte Maillot Fortifications 1913 – 16e arr	1913	BHVP
418	Porte Maillot – 1913 – 16e arr	1913	BHVP
419	Fortifications, Porte Dauphine – 1913 – 16e arr)	1913	BHVP
420	Fortifications, Porte Dauphine – 1913 – 16e arr)	1913	BHVP
421	Porte Dauphine – Fortifications. 1913 16e arr)	1913	BHVP
422	Porte Dauphine, Fortifications – 1913 – 16e arr	1913	BHVP
423	Fortifications, Porte Dauphine, 1913 – 16e arr)	1913	BHVP
424	Porte Dauphine (16e arr)	?	Carn.
425	Zoniers – Poterne des Peupliers – 1913 – 13e arr)	1913	BHVP
426	Poterne des peupliers – 1913 – 13e) La Bièvre	1913	BHVP
427	Poterne des Peupliers. La Bièvre – 1913 – 13e arr)	1913	BHVP
428	Poterne des peupliers – Bords de la Bièvre 1913 – 13e arr – 13e arr)	1913	BHVP
429	Poterne des peupliers – Zoniers. 13e arr)	?	BHVP
430	Poterne des Peupliers – Zoniers – 1913 – 13e arr)	1913	BHVP
431	Porte d'asnières, Cité Trébert – 1913 – 17e arr)	1913	BHVP
432	Porte d'Asnières Passage Trébert Chiffonniers (17e arr)	?	Carn.
433	Porte d'Asnières, Cité Trébert – 1913 – 17e arr)	1913	BHVP
434	Porte d'Asnières. Cité Trébert – 1913 – 17e arr)	1913	BHVP
435	Porte d'Asnières. Cité Trébert – 1913 (17e arr).	1913	BHVP
436	Porte d'Asnières – Cité Trébert – 1913 – 17e arr)	1913	BHVP
437	Poterne des Peupliers, Bd Kellermann – 1913 (13e arr)	1913	BHVP
438	Poterne des Peupliers – 1913 – 13e arr) Bd Kellermann	1913	BHVP
439	Poterne des Peupliers. Bd Kellermann – 1913 – 13e arr)	1913	BHVP
440	Porte de Montreuil – Zone – 1913 – 20e arr)	1913	BHVP
441	Porte de Montreuil – Zone – 1913 – 20e arr)	1913	BHVP
442	Porte de Montreuil – Zone – 1913, 20e arr)	1913	BHVP
443	Porte de Montreuil, Zone – 1913 – 20e arr)	1913	BHVP
444	Porte de Montreuil – 1913 – 20e arr)	1913	BHVP
445	Port de l'hôtel de Ville 1913 (4e arr)	1913	Carn.
446	Port de l'hôtel de Ville (4e arr)	?	Carn.
447	Port de l'hôtel de Ville (4e arr)	?	Carn.
448	Port de l'hôtel de Ville – 1913 4e arr)	1913	BHVP
449	Port de l'hôtel de Ville – 1913 (4e arr)	1913	BHVP
450	Port de l'hôtel de Ville. Pont Marie – 1913 (4e arr)	1913	BHVP
451	Fortifications, Porte Maillot – 1913 – 16e arr	1913	BHVP
452	Fortifications, Porte Maillot – 1913 – 16e arr)	1913	BHVP
453	Fortifications, Porte Maillot – 1913 – 16e arr)	1913	BHVP
454	Porte Maillot – Fortifications (16e arr)	?	Carn.
455	Porte Maillot – Fortifications – 1913 – 16e arr)	1913	Carn.
456	Fortifications, Porte Maillot – 1913 – 16e arr	1913	BHVP

457	Porte d'asnières, Cité Valmy 1913. – 1ᵉ arr)	1913	BHVP
458	Porte d'asnières, Cité Valmy – 1913 – 17ᵉ arr)	1913	BHVP
459	Porte d'asnières, Cité Valmy – 1913 – 17ᵉ arr)	1913	BHVP
460	Porte d'asnières. Cité Valmy – 1913 – 17ᵉ arr)	1913	BHVP
461	Porte d'asnières, Cité Valmy – 1913 – 17ᵉ arr)	1913	BHVP
462	Porte d'Asnières – Cité Valmy – 1913 – 17ᵉ arr)	1913	BHVP
463	Fortifications, Porte Dauphine – 1913 – 16ᵉ arr)	1913	BHVP
464	Fortifications, Porte Dauphine – 1913 – 16ᵉ arr	1913	BHVP
465	Fortifications – Porte Dauphine – 1913 – 16ᵉ arr	1913	BHVP
466	Fortifications, Porte Dauphine – 1913 – 16ᵉ arr)	1913	BHVP
467	Porte Dauphine – 1913 – 16ᵉ arr) Fortifications	1913	BHVP
468	Fortifications, Porte Dauphine – 1913 – 16ᵉ arr)	1913	BHVP
469	Port Soferino – 1913 – 7ᵉ arr)	1913	BHVP
470	Port Solferino – 7ᵉ arr – 1913	1913	BHVP
471	Port Solferino 1913 (7ᵉ arr)	1913	BHVP
472	Port Solferino 7ᵉ arr 1913 –	1913	BHVP
473	Port Solferino – 1913 (7ᵉ arr)	1913	BHVP
474	Port Solferino – 1913 (7ᵉ arr)	1913	BHVP
475	Port des Invalides – 1913 (7ᵉ arr)	1913	BHVP
476	Port des Invalides – 7ᵉ arr 1913(1913	BHVP
477	Port des Invalides – 1913 (7ᵉ arr)	1913	BHVP
478	Port des Invalides – 1913 – 7ᵉ arr)	1913	BHVP
479	Port des Invalides – 1913 – (7ᵉ arr)	1913	BHVP
480	Port des Invalides – 1913 – 7ᵉ arr)	1913	BHVP
481	Port des Tuileries – 1913 – 1ᵉ arr)	1913	BHVP
482	Port des Tuileries – 1913 – 1ᵉ arr)	1913	BHVP
483	Quai des Tuileries (1ᵉ arr)	?	Carn.
484	Port des Champs Elysées – 1913 – 8ᵉ arr)	1913	BHVP
485	Port des Champs Elysées – 1913 – 8ᵉ arr)	1913	BHVP
486	?		
487	?		
488	?		
489	?		
490	Parc Montsouris	?	MOMA
491	Parc Montsouris	?	MOMA
492	Parc Montsouris	?	MOMA
493	?		
494	Vieille Boutique, Rue des Lyonnais 10 – 1914 – 5ᵉ arr)	1914	BHVP
495	Boutique 12 Rue des Lyonnais – 1914 – 5ᵉ arr –	1914	BHVP
496	Bois charbons, rue des Lyonnais	?	MOMA
497	Fête du Trône	?	MOMA
498	Fête du Trône	?	MOMA

499	Fête du Trône	?	MOMA
500	Fête du Trône	?	MOMA
501	Fête du Trône	?	MOMA
502	Fête du Trône	?	MOMA
503	Fête du Trône	?	MOMA
504	Fête du Trône	?	MOMA
505	Bassin de la Villette – quai de la Loire – 1914 – 19e arr –	1914	BHVP
506	Bassin de la Villette, quai de la Loire, 1914 – 19e arr	1914	BHVP
507	Bassin de la Villette, quai de la Loire – 1914 – 19e arr)	1914	BHVP
508	Bassin de la Villette, quai de la Loire – 1914 – 19e arr)	1914	BHVP
509	Bâteau Parisien – Port de Javel – 1914 – 15e arr)	1914	BHVP
510	Bâteau Parisien – Port de Javel – 1914 – 15e arr)	1914	BHVP
511	Bâteau Parisien – Port de Javel – 1914 – 15e arr)	1914	BHVP
512	Bâteau Parisien – (Intérieur) Port de Javel – 1914 – 15e arr)	1914	BHVP
513	Brocanteur 53 Rue Greneta – 1914 – 2e arr)	1914	BHVP
514	Boutique parapluies 11 rue DuSoubs	?	MOMA
515	Canal de la Bastille	?	MOMA
516	Port Henri IV	?	MOMA
517	Port Henri IV	?	MOMA
518	Bassin de la Villette	?	MOMA
519	Bassin de la Villette	?	MOMA
520	Bassin de la Villette	?	MOMA
521	Bassin de la Villette	?	MOMA
522	Bassin de la Villette	?	MOMA
523	Bassin de la Villette	?	MOMA
524	?		
525	Fête du Trône	?	MOMA
526	Fête des Invalides	?	MOMA
527	?		
528	Fête des Invalides	?	MOMA
529	Quai Bourbon	?	MOMA
530	Intérieur Hetchel	?	MOMA
531	Intérieur Hetchel	?	MOMA
532	Intérieur Hetchel	?	MOMA
533	Intérieur Hetchel	?	MOMA

Selected Bibliography

Abbott, Berenice. "Eugene Atget." *Creative Art* 5 (September 1929): 651–56.

———. *The World of Atget.* New York: Horizon, 1964.

"L'absinthe tueuse d'hommes et d'énergies." *Je Sais Tout* (February 1907): 47–54.

Académie de Rouen. *Quand Atget photographiait Rouen: Photographies de la Bibliothèque municipale de Rouen.* Présentées par Claire Fons. Rouen: CRDP, 1982.

Académie Goncourt. *The Colour of Paris.* London: Chatto & Windus, 1908.

Adam, Paul, et al. *Les rassemblements: Badauderies parisiennes. Physiologies de la rue.* Paris: Bibliophiles indépendants, 1896.

Adeline, Jules. *Les arts de reproduction vulgarisés.* Paris: Quantin, 1894.

Ades, Dawn. *Dada and Surrealism Reviewed.* London: Arts Council of Great Britain, 1978.

Albert, Charles. *Qu'est-ce que c'est l'art?* Paris: La Guerre Sociale, 1909.

"L'album de cartes postales—'les p'tits métiers de Paris' Eugène Atget, 1857–1927." *Guide pratique de la carte postale.* Numéro hors série du *"Collectionneur français"* (1981): 37–40.

Allemand, Hector. *Causeries sur le paysage.* Lyon: Louis Perrin et Marinet, 1877.

Althusser, Louis. *Lenin and Philosophy and Other Essays.* Translated by Ben Brewster. London: New Left, 1971.

Ancy, Henri d'. *La science pittoresque: L'abri humaine.* Abbeville: Paillart, 1898.

Apollinaire, Guillaume. *Chroniques d'art, 1902–1918.* Presenté par L.-C. Breunig. Paris: Gallimard, 1960.

———. *Oeuvres poétiques complètes.* Paris: Pléiade, 1956.

Apollonio, Umbro, ed. *Futurist Manifestos.* Translated by Robert Brain et al. New York: Viking, 1973.

Aradi, Nóra. "Problèmes iconologiques de la représentation de la masse (dix-neuvième et vingtième siècles)." *Actes du Vingtième Congrès, Budapest 1969* 2 (1972): 453–59.

Aragon, Louis. *Les collages.* Paris: Hermann, 1965.

———. *Paysan de Paris.* Paris: Gallimard, 1926.

Les archives biographiques contemporaines. 7 vols., 1905–11.

Archives Nationales. *Le parisien chez lui au dix-neuvième siècle, 1814–1914.* Paris: 1976.

L'armée jugée par les nationalistes. St. Denis: Librairie ouvrière, ca. 1900.

Até. *Méthode sûre, facile et précise de photographie à l'usage des amateurs.* Paris: Mazo, 1897.

Avenel, Vicomte Georges d'. *Le mécanisme de la vie moderne.* 5 vols. Paris: Colin, 1896–1905.

Bakhtin, Mikhaïl. *The Dialogic Imagination: Four Essays by M. M. Bakhtin.* Edited by Michael Holquist. Translated by Caryl Emerson and Michael Holquist. Austin: University of Texas Press, 1981.

———. *Le marxisme et la philosophie du langage.* Preface by Roman Jakobson. Translated by Marina Yaguello. Paris: Minuit, 1977.

Bailly, Arthur, and Hallam De Nittis. *Code des usages professionels: Us et coutumes des métiers (région de Paris).* 2d ed. Paris: Baillière, 1904.

Barberet, J. *La bohème du travail.* Paris: Hetzel, 1889.

Barrès, Maurice. *Pour nos églises.* Paris: Société des Trente, 1912.

———. *Scènes et doctrines du nationalisme.* Paris: Juven, 1902.

Barrows, Susanna. "After the Commune: Alcoholism, Temperance and Literature in the Early Third Republic." In *Consciousness and Class Experience in Nineteenth Century Europe.* Edited by John Merriman. New York: Holmes & Meier, 1979.

———. *Distorting Mirrors: Visions of the Crowd in Late Nineteenth Century France.* New Haven: Yale University Press, 1981.

Barthes, Roland. *La chambre claire: Note sur la photographie.* Paris: Gallimard Seuil, 1980.

———. *Image–Music–Text.* Edited and translated by Stephen Heath. London: Fontana, 1977.

———. *Le degré zéro de l'écriture.* Paris: Seuil, 1953.

———. *Mythologies.* Paris: Seuil, 1957.

Batault, Georges. "Le problème de la culture et la crise du français." *Mercure de France* 92 (1911): 52–81.

Baudelaire, Charles. *Oeuvres complètes.* 1961. Reprint (2 vols.). Paris: Pléiade, 1975.

Baxandall, Michael. *The Limewood Sculptors of Renaissance Germany.* New Haven: Yale University Press, 1980.

———. *Painting and Experience in Fifteenth Century Italy.* Oxford: Oxford University Press, 1972.

———. *Patterns of Intention: On the Historical Explanation of Pictures.* New Haven: Yale University Press, 1985.

Bayard, Emile. *Le bon goût dans le geste, sur soi, dans la maison.* 2d ed. Paris: Garnier, 1919.

———. *La caricature et les caricaturistes.* Paris: Delagrave, 1900.

———. *L'illustration et les illustrateurs.* Paris: Delagrave, 1898.

Beaurepaire, Edmond. "Les enseignes de Paris." *Le Carnet* (October and December 1902): 1–42, 321–39.

Becker, Jean Jacques. *1914.* Paris: Presses de la Fondation nationale des sciences politiques, 1977.

Bellanger, Camille. *L'art du peintre.* Paris: Garnier frères, 1909–11.

Bellanger, Claude, et al. *Histoire générale de la presse française.* Vol. 3, *De 1871 à 1940.* Paris: Presses Universitaires de France, 1972.

Benezit, E. *Petits métiers, petits industries.* Paris: Gaillard, n.d.

Benjamin, Walter. "Central Park." Translated by Lloyd Spencer and Mark Harrington. *New German Critique,* no. 34 (Winter 1985): 32–58.

———. *Charles Baudelaire: A Lyric Poet in the Era of High Capitalism.* Translated by Harry Zohn. London: New Left Books, 1973.

———. *Gesammelte Schriften. Band 5, Das Passagen-Werk.* 2 vols. Frankfurt: Suhrkamp Verlag, 1982.

———. *Illuminations.* Edited by Hannah Arendt and translated by Harry Zohn. New York: Schocken, 1968.

———. "Short History of Photography." Translated by Phil Patton. *Artforum* 15 (February 1977): 46–51.

———. *Understanding Brecht.* Edited and translated by Anna Bostock. London: New Left Books, 1973.

Berger, Amédée. *Les enseignes de Paris.* Paris: Librairie des Bibliophiles, 1858.

Berger, John, and Jean Mohr. *Another Way of Telling.* New York: Pantheon, 1982.

Bergson, Henri. *Le rire: Essai sur la signification du comique.* Paris: Alcan, 1900.

Bertout de Solières, F. *Les fortifications de Paris à travers les âges.* Rouen: 1906.

Bertrand, Louis. *Idées et portraits.* Paris: Plon, 1927.

Berty, Adolphe. *Topographie historique du Vieux Paris.* 6 vols. Paris: Imprimerie Nationale, 1866–97.

Béry, Anatole. *La Bièvre.* Paris: Ficker, 1911.

Besson, George. "Pictorial Photography: A Series of Interviews." *Camera Work,* no. 24 (October 1908): 13–22.

Beurdeley. *L'éducation antialcoolique.* Paris: Delagrave, 1905.

Bibliothèque historique de la Ville de Paris. *Bulletin de la Bibliothèque et des Travaux historiques.* Paris: 1906–15.

———. *Charles Marville: Photographe de Paris de 1851 à 1879.* Paris: 1980.

———. *Constitution d'un patrimoine parisien: La Bibliothèque historique depuis l'incendie de 1871.* Paris: 1980.

———. *La vie populaire à Paris par le livre et l'illustration (quinzième à vingtième siècle).* Paris: 1907.

Bibliothèque Nationale, Paris, and the Metropolitan Museum of Art, New York. *After Daguerre.* New York: 1980.

Bigeon, A. *La photographie et le droit.* Paris: Mendel, 1894.

Billy, André. *Adieu aux fortifications*. N.p.: St. Eloy, 1930.

——. *L'époque contemporaine, 1905–1930*. Paris: Tallandier, 1956.

——. *Paris vieux et neuf: La rive droite*. Paris: Rey, 1909.

Blanchot, Maurice. *L'espace littéraire*. Paris: Gallimard, 1955.

Boime, Albert. *The Academy and French Painting in the Nineteenth Century*. London: Phaidon, 1971.

Bonneff, Léon, and Maurice Bonneff. *La classe ouvrière*. 8 vols. Paris: Guerre Sociale, 1910–11.

——. *Marchands de folie: Cabarets des halles et des faubourgs–cabaret-tâcheron–cabaret-cantinier–cabaret-placeur–cabaret de luxe–l'estaminet des mineurs–au pays du "Petit Sou" sur les quais de Rouen–au pays de l'absinthe–de l'infirmerie spéciale du Dépôt à la Maison de fous*. Paris: Rivière, 1912.

Bonnet, Henri. *Paris qui souffre: La misère à Paris, les agents de l'assistance à domicile*. Paris: Giard et Brière, 1908.

Borcoman, James. *Eugène Atget, 1857–1927*. Ottawa: National Gallery of Canada, 1984.

Bory, Paul. *La science pittoresque: Les métamorphoses d'un chiffon*. Abbeville: Paillart, 1897.

Bouchot, Henri. *Le Cabinet des estampes de la Bibliothèque Nationale: Guide du lecteur et du visiteur, catalogue général et raisonné des collections qui y sont conservées*. Paris: Dentu, ca. 1895.

Bougenier, Alfred. *Vieilles rues . . . vieilles maisons . . . vieux souvenirs . . . la Place Maubert*. Ivry-sur-Seine: 1909.

Bourdieu, Pierre. *La distinction: Critique sociale du jugement*. Paris: Minuit, 1979.

——. *Esquisse d'une théorie de la pratique, précédé de trois études d'ethnologie kabyle*. Geneva: Droz, 1972.

——. *Un art moyen: Essai sur les usages sociaux de la photographie*. Paris: Minuit, 1965.

Bournon, Fernand. *Paris Atlas*. Paris: Larousse, 1900.

——. *La voie publique et son décor*. Paris: Renouard, 1909.

Bournon, Fernand, and Albert Dauzat. *Paris et ses environs*. Paris: Larousse, 1925.

Bouvier, Jean, et al. *Histoire économique et sociale de la France*. Vol. 4, *L'ère industrielle et la société d'aujourd'hui: Siècle 1880–1980*. Paris: Presses Universitaires de France, 1979.

Brassaï. "My Memories of E. Atget, P. H. Emerson and Alfred Stieglitz." *Camera* 48 (January 1969): 4–13, 21, 27, 37.

Breton, André. *L'anthologie de l'humour noir*. Paris: Jean-Jacques Pauvert, 1966.

Brière, Gaston. *Le Château de Versailles, architecture et décoration*. 2 vols. Paris: Librairie centrale des beaux-arts, 1907–09.

Brousse, Paul, and Albert Bassède. *Les transports*. 2 vols. Paris: Dunod et Pinat, 1907–12.

Bruant, Aristide. *Dans la rue: Chansons et monologues*. 2 vols. Paris: l'auteur, n.d.

Bulloz, J.-E. *La propriété photographique et la loi française*. Paris: Gauthier-Villars, 1890.

Burke, Peter. *Popular Culture in Early Modern Europe*. London: Marice Temple Smith, 1978.

Burty, Philippe. "Revue photographique." *Gazette des Beaux-Arts*, ser. 1, vol. 7 (1860): 252.

Cain, Georges. *Coins de Paris*. Paris: Flammarion, 1905.

——. *Nouvelles promenades dans Paris*. Paris: Flammarion, 1908.

——. *Promenades dans Paris*. Paris: Flammarion, 1906.

Callet, Albert. *L'agonie du Vieux Paris*. Paris: Daragon, 1911.

Calmettes, Pierre. *Excursions à travers les métiers*. Paris: Juven, 1904.

Carco, Francis. *Les humoristes*. Paris: Ollendorff, 1921.

Cassagne, Armand. *Guide de la nature chez soi (suite aux modèles à silhouette)*. Paris: Fouraut, 1886.

Caussy, F. "La leçon de Versailles." *Mercure de France* 68 (1907): 460–79.

Centre for Contemporary Cultural Studies, University of Birmingham. *On Ideology*. London: Hutchinson, 1978.

Centre National d'Art et de Culture Georges Pompidou. *Cafés, bistrots et compagnie*. Paris: 1977.

Chabaud, Georges. *Le droit d'auteur des artistes et des fabricants: Législation–Jurisprudence–Projets de réforme*. Paris: Librairie des sciences politiques et sociales, Marcel Rivière, 1908.

Chambre syndicale française de la photographie. Cinquième Congrès national, novembre 1912. Paris: 1913.

Champeaux, Alfred de. *L'art décoratif dans le Vieux Paris*. Paris: Librairie générale de l'architecture et des arts industriels, Schmid, 1898.

——. *Les monuments de Paris*. Paris: Laurens, 1887.

Champeaux, Alfred de, and F. E. Adam. *Paris pittoresque*. Paris: Librairie de l'art, 1883.

Charle, Christophe. "Situation sociale et position spatiale, essai de géographie sociale du champ littéraire à la fin du dix-neuvième siècle." *Actes de la recherche en sciences sociales*, no. 13 (February 1977): 45–59.

Chaussard, Th. *Essai de vulgarisation de principes d'art décoratif et de dessin suivi d'un cours de botanique artistique*. Caudéran: Bissey, 1912.

Chevalier, Charles. *Nouvelles instructions sur l'usage du daguerréotype*. Paris: l'auteur, 1841.

Chevalier, Louis. *Classes laborieuses et classes dangereuses: A Paris pendant la première moitié du dix-neuvième siècle*. Paris: Plon, 1958.

——. *Les parisiens*. Paris: Hachette, 1967.

Chevillard, Valbert. *Itinéraire artistique de Paris*. Paris: Librairie théâtrale, 1908.

Claretie, Jules. *Les piétons de Paris*. Paris: Livre contemporain, 1911.

Clark, T. J. *Image of the People: Gustave Courbet and the 1848 Revolution*. London: Thames and Hudson, 1973.

——. "Preliminary Arguments: Work of Art and Ideology." Papers presented to the Marxism and Art History Session of the College Art Association Meeting, February 1976.

——. *The Painting of Modern Life: Paris in the Art of Manet and His Followers*. New York: Knopf, 1984.

Clarke, M. E. *Paris Waits, 1914*. London: Smith, Elder, 1915.

Clerc, L.-P. *La photographie pratique: Exposé complet de tout ce qu'il faut savoir pour obtenir de bonnes photographies*. Paris: Mendel, 1902.

Clifford, James. *The Predicament of Culture: Twentieth-Century Ethnography, Literature, and Art*. Cambridge: Harvard University Press, 1988.

Clouzot, Henri. "L'Haussmannisation de Paris." *Gazette des Beaux-Arts*, ser. 4, vol. 4 (1910): 349–66.

Coffignon, A. *Paris vivant: L'estomac de Paris*. Paris: Librairie illustrée, n.d.

Coke, Van Deren. *The Painter and the Photograph*. 2d ed. Albuquerque: University of New Mexico Press, 1972.

Cinquième Congrès international de photographie, Bruxelles 1910: Compte-rendu, procès-verbaux, rapports, notes et documents publiés par les soins de Ch. Puttemanas, L. P. Clerc et E. Wallon. Brussels: Bruylant, 1912.

Conrad, Peter. *The Victorian Treasure House*. London: Collins, 1973.

Contet, Frédéric. *Les vieux hôtels de Paris*. 8 vols. Paris: Contet, 1908–14.

Coquiot, Gustave. *Nouveau manuel complet du peintre-décorateur de théâtre*. Paris: Roret, 1910.

Corpechot, Lucien. *Les jardins de l'intelligence*. Paris: Emile-Paul, 1912.

Crow, Thomas. "Modernism and Mass Culture in the Visual Arts." In *Modernism and Modernity: The Vancouver Papers*. Edited by Benjamin H. D. Buchloh, Serge Guilbaut, and David Solkin. Halifax: The Press of the Nova Scotia College of Art and Design, 1984.

——. *Painters and Public Life in Eighteenth Century Paris*. New Haven: Yale University Press, 1985.

Dac, Sergine. "La zone et ses habitants." *L'Illustration* (8 February 1913): 106–08.

Daireaux, Emile. *Les fortifications de Paris et le droit des propriétaires de la zone.* Troyes: 1912.

Dalloz, Désiré, Armand Dalloz, and Edouard Dalloz. "Patente." *Jurisprudence générale: Supplément au répertoire méthodique et alphabétique de législation,* vol. 12. Paris: Bureau de la "Jurisprudence générale," 1893.

Dalloz: Encyclopédie juridique. Répertoire de droit civil. Dirigé par Pierre Raynard et Marguerite Vanel. Paris: Dalloz, 1975.

Dalloz: Encyclopédie juridique. Répertoire de droit commercial. Paris: Dalloz, 1986.

Damisch, Hubert. *L'origine de la perspective.* Paris: Flammarion, 1987.

Daudet, Léon. *Paris vécu.* 2 vols. 1929. Reprint. Paris: Gallimard, 1969.

Dausset, Louis. *Rapport sur le déclassement total de l'enceinte fortifiée, l'annexion de la zone militaire et sur le projet de convention entre la Ville de Paris et l'Etat.* Paris: Imprimerie municipale, 1912.

Davanne, Alphonse. *Le progrès de la photographie.* Paris: Gauthier-Villars, 1877.

Debray, Régis. *Le pouvoir intellectuel en France.* Paris: Ramsay, 1979.

De Certeau, Michel. *L'invention du quotidien.* Vol. 1, *Arts de faire.* Paris: Union générale d'éditions, 1980.

Deleuze, Gilles. *Foucault.* Paris: Minuit, 1986.

Denis, Maurice. *Théories, 1890–1910: Du symbolisme et de Gauguin vers un nouvel ordre classique.* Paris: Occident, 1912.

Descaves, Lucien. "Adieu 'Fortifs.'" *Annales Politiques et Littéraires* (23 February 1913): 165–68.

——. "Les rues débordent." *Je Sais Tout* (15 September 1910): 165–74.

Desnos, Robert. *Nouvelles Hébrides et autres textes, 1922–1930.* Paris: Gallimard, 1978.

Didi-Huberman, Georges. *Invention de l'hystérie: Charcot et l'iconographie photographique de la Salpêtrière.* Paris: Macula, 1982.

Dillaye, Frédéric. *Le paysage artistique en photographie, avec le procédé au gélatino-bromure d'argent.* Paris: Tallandier, 1907.

——. *Principes et pratique d'art en photographie: Le paysage.* Paris: Gauthier-Villars, 1899.

Dimier, Louis. *L'Hôtel Lauzun: Le style Louis XIV. Décorations intérieures.* Paris: Librairie centrale d'art et d'architecture, 1912.

Disdéri. *L'art de la photographie.* Paris: l'auteur, 1862.

Drexler, Arthur, ed. *The Architecture of the Ecole des Beaux-Arts.* New York: MOMA, 1977.

Du Camp, Maxime. *Paris: Ses organes, ses fonctions et sa vie dans la seconde moitié du dix-neuvième siècle.* 6 vols. Paris: Hachette, 1869–75.

Duchamp, Marcel. *Duchamp du Signe: Ecrits.* Réunis et présentés par Michel Sanouillet. Nouvelle édition revue et augmentée avec la collaboration de Elmer Peterson. Paris: Flammarion, 1975.

Dufour, L. V. *Le Vieux Paris: Ses derniers vestiges, dessinés d'après nature et gravés à l'eau-forte par J. Chauvet et E. Champollion.* Paris: 1876.

Du Maroussem, Pierre. *La question ouvrière.* 4 vols. Paris: A. Rousseau, 1891–94.

Dumesnil, Dr. Octave, and Dr. Charles Mangenot. *Enquête sur les logements, professions, salaires et budgets (loyers inférieurs à 400 francs).* Paris: Chaix, 1899.

Dumont-Wilden, L. "La muse française." *L'Occident* 15 (November 1908): 203–11.

Durieu, Joseph. *Les parisiens d'aujourd'hui: Les types sociaux de simple récolte et d'extraction.* Paris: Giard et Brière, 1910.

Duve, Thierry de. *Ecrits datés I, 1974–1986.* Paris: La Différence, 1987.

Eagleton, Terry. *Criticism and Ideology: A Study in Marxist Literary Theory.* London: New Left, 1976.

——. *Walter Benjamin, or Towards a Revolutionary Criticism.* London: New Left, 1981.

L'Ecole des Hautes Etudes Sociales, 1900–1910. Paris: 1910.

Ecole Nationale Supérieure des Beaux-Arts, Paris. *La photographie comme modèle: Aperçu du fonds de photographies anciennes de l'Ecole des Beaux-Arts.* Paris: Ecole des Beaux-Arts, 1982.

Edelman, Bernard. *Le droit saisi par la photographie: Eléments pour une théorie marxiste.* 2d ed. Paris: Bourgois, 1980.

Evans, Walker. "The Re-appearance of Photography." *Hound & Horn* 5 (1931–32): 125–28.

Exposition Universelle de Paris, 1900. *Commission municipale du Vieux Paris, 1897–1900.* Paris: 1900.

——. *Groupe I—Classe III. Ville de Paris. Service des Travaux historiques.* Paris: 1900.

——. *Vieux Paris: Guide historique, pittoresque et anecdotique.* Paris: Ménard et Chaufour, 1900.

Facque, Robert. *Les Halles et marchés alimentaires de Paris.* Paris: Sirey, 1911.

Faure, Alain. "Classe malpropre, classe dangereuse? Quelques remarques à propos des chiffonniers parisiens au dix-neuvième siècle et de leurs cités." *recherches,* no. 29 (December 1977): 79–102.

——. *Choses et gens des Halles.* Paris: Athéna, 1922.

——. "Les vieilles enseignes." *Les Amis de Paris* 2 (March 1914): 58–60.

——. *Les vieilles enseignes de Paris.* Paris: Figuière, 1913.

Fels, Florent. "L'art photographique: Adjet [sic]." *L'Art Vivant,* no. 145 (February 1931): 16, 28.

——. "Le Premier Salon Indépendant de la Photographie." *L'Art Vivant* (1 June 1929): 445.

Ferro, Marc. *La grande guerre, 1914–1918.* Paris: Gallimard, 1969.

Fleury-Hermagis and Rossignol. *Traité des excursions photographiques.* Paris: Rongier, 1889.

Flourens, J. *Les fortifications de Paris, leur histoire, leur désaffectation future et ses conséquences. Thèse pour le doctorat, Université de Paris, Faculté de droit.* Paris: Larose et Tenin, 1908.

Foucault, Michel. *L'archéologie du savoir.* Paris: Gallimard, 1969.

——. *Language, Counter-Memory, Practice.* Edited by Donald F. Bouchard; translated by Donald F. Bouchard and Sherry Simon. Ithaca: Cornell University Press, 1977.

——. *Les mots et les choses: Une archéologie des sciences humaines.* Paris: Gallimard, 1966.

——. *L'ordre du discours.* Paris: Gallimard, 1971.

——. *Surveiller et punir: Naissance de la prison.* Paris: Gallimard, 1975.

Fournel, Victor. *Les rues du vieux Paris: Galerie populaire et pittoresque.* Paris: Firmin-Didot, 1879.

——. *Les spectacles populaires et les artistes des rues.* Paris: Dentu, 1863.

Fournier, Edouard. *Chroniques et légendes des rues de Paris.* Paris: Dentu, 1864.

——. *Histoire des enseignes de Paris.* Paris: Dentu, 1884.

——. *Paris démoli.* Preface by Th. Gautier. 2d ed. Paris: Aubry, Dentu, 1855.

Les français peints par eux-mêmes: Encyclopédie morale du dix-neuvième siècle. 9 vols. Paris: Curmer, 1839–42.

France: Statistique générale. Salaires et coût de l'existence à diverses époques, jusqu'en 1910. Paris: Imprimerie nationale, 1911.

Franklin, Alfred. *Dictionnaire historique des arts, métiers et professions exercés dans Paris depuis le treizième siècle.* Paris: Welter, 1906.

Fraser, John. "Atget and the City." *Studio International* 182 (December 1971): 231–46.

Fresnaye, Roger de la. "L'art dans la rue." *Montjoie!* (April 1914): 23.

Freud, Sigmund. *The Interpretation of Dreams.* Edited and translated by James Strachey. New York: Basic, 1955.

Freund, Gisele. *Photographie et société*. Paris: Seuil, 1974.

Fry, Roger. *Vision and Design*. 1920. Reprint. Oxford: Oxford University Press, 1981.

"La gaieté de nos humoristes." *Lectures pour Tous* (1911): 625–33.

Gaillard, Jeanne. *Paris la ville, 1852–1870*. Paris: Champion, 1977.

Garenc, Paule. *L'industrie du meuble en France*. Paris: Presses Universitaires de France, 1958.

Gauvin, J. *Les métiers*. Paris: Bibliothèque de mes petits, 1914.

George, Waldemar. "Photographie vision du monde." *Photographie*, special number of *Arts et Métiers Graphiques* (15 March 1930): 5–20, 131–61.

Gervais, A. "Paris brise sa ceinture." *Je Sais Tout* (January 1913): 305–15.

Gibbons, Herbert Adams. *Paris Reborn: A Study in Civic Psychology*. New York: Century, 1915.

Giffard, Pierre. *Les grands bazars*. Paris: Havard, 1882.

Ginzburg, Carlo. *The Cheese and the Worms: The Cosmos of a Sixteenth Century Miller*. Translated by John and Anne Tedeschi. Harmondsworth: Penguin, 1982.

Girard, André. "L'Université populaire—ce qu'elle est." *L'Effort Sociale*, no. 1 (February 1907): 1.

Gogh, Vincent van. *The Complete Letters of Vincent van Gogh*. 3 vols. 2d ed. Greenwich: New York Graphic Society, 1959.

Gohier, Urbain. *L'armée de Condé: La revanche des émigrés*. St. Denis: Librairie Ouvrière, 1898.

Gosselin, T. *Le Vieux Paris: Souvenirs et vieilles demeures*. Paris: Eggiman, 1912–14.

Goudeau, Emile. *Paris qui consomme*. Paris: Béraldi, 1893.

Gramsci, Antonio. *Selections from the Prison Notebooks*. Edited and translated by Quinton Hoare and Geoffrey Nowell-Smith. London: Lawrence and Wishart, 1971.

Grand Palais, Paris. *Lartigue album*. Paris: 1980.

Grand-Carteret, John. *Raphael et Gambrinus, ou l'art dans la brasserie*. Paris: Westhausser, 1886.

Grasset, Eugène. *La plante et ses applications ornementales*. Paris: Lévy, 1897–1901.

Greenberg, Clement. *Art and Culture*. Boston: Beacon, 1961.

——. "Four Photographers." *New York Review of Books*, 23 January 1964, 8–9.

Guadet, Julien. *Eléments et théorie de l'architecture: Cours professé à l'Ecole Nationale et Spéciale des Beaux-Arts*. 4 vols. Paris: Aulanier, 1901–04.

Guerrand, Roger. *Les origines du logement social en France*. Paris: Editions ouvrières, 1966.

Guibert, Joseph. *Le Cabinet des estampes de la Bibliothèque nationale: Histoire des collections suivie d'un guide du chercheur*. Paris: Le Garrec, 1926.

Guieysse, Charles. *Les Universités populaires et le mouvement ouvrier*. Paris: Cahiers de la Quinzaine, 1901.

Halbwachs, Maurice. *La classe ouvrière et les niveaux de vie: Recherches sur la hiérarchie des besoins dans les sociétés industrielles contemporaines*. Paris: Alcan, 1913.

——. *Les expropriations et le prix des terrains à Paris, 1860–1900. Thèse pour le doctorat, Université de Paris, Faculté de droit*. Paris: Cornély, 1909.

——. *La mémoire collective*. 2d ed. Paris: Presses Universitaires de France, 1968.

Hallays, André. *Autour de Paris*. 2d ser. Paris: Perrin, 1920.

——. *En flânant: A travers la France*. Paris: Perrin, 1913.

Hambourg, Maria Morris. "Atget: Precursor of Modern Documentary Photography." In *Observations: Essays on Documentary Photography*. Edited by David Featherstone. Carmel: Friends of Photography, 1984.

——. "Charles Marville's Old Paris." In *Charles Marville: Photographs of Paris, 1852–1878*. New York: Alliance Française, 1981.

——. "Eugène Atget, 1857–1927: The Structure of the Work." Ph.D. diss., Columbia University, 1980.

Hareux, Ernest. *Cours complète de peinture à l'huile (l'art, la science, le métier du peintre)*. 2 vols. Paris: Laurens, 1901.

Haussonville, Comte G.-P.-O. d'. *Misère et remèdes*. Paris: C. Lévy, 1886.

Havard, Henry. *L'art et le confort dans la vie moderne: Le bon vieux temps*. Paris: Rouveyre, 1904.

——. *Les arts de l'ameublement: La décoration*. Paris: Delagrave, 1892.

——. *Les arts de l'ameublement: Les styles*. Paris: Delagrave, 1897.

——. *Dictionnaire de l'ameublement et de la décoration depuis le treizième siècle jusqu'à nos jours*. 4 vols. Paris: Quantin, 1887–90.

——. *Histoire et philosophie des styles (architecture, ameublement, décoration)*. 2 vols. Paris: Schmid, 1899–1900.

Heilbrun, Françoise. "The Landscape in French Nineteenth-Century Photography." In Richard Bretell et al. *A Day in the Country: Impressionism and the French Landscape*. New York: Harry Abrams and the Los Angeles County Museum of Art, 1984.

Hénard, Eugène. *Etudes sur les transformations de Paris*. 8 fasc. Paris: Champion, 1903–09.

Herbert, Eugenia W. *The Artist and Social Reform: France and Belgium, 1885–1898*. New Haven: Yale University Press, 1961.

Herbert, Robert. *Impressionism: Art, Leisure, and Parisian Society*. New Haven: Yale University Press, 1988.

——. "*Parade de cirque* de Seurat et l'esthétique scientifique de Charles Henry." *Revue de l'Art*, no. 50 (1980): 9–23.

Hervé, Gustave. *La grande guerre au jour le jour: Receuil in extenso des articles publiés dans "La Guerre Sociale" et "La Victoire" depuis juillet 1914*. 4 vols. Paris: Ollendorff, 1917.

——. *Histoire de la France et de l'Europe pour les grands*. Paris: La Guerre Sociale, 1910.

——. *L'internationalisme*. Paris: Giard et Brière, 1910.

——. *Mes crimes, ou onze ans de prison pour délits de presse, modeste contribution à l'histoire de la liberté de la presse sous la troisième République*. Paris: La Guerre Sociale, 1912.

Hill, Paul, and Tom Cooper. "Interview: Man Ray." *Camera* 74 (February 1975): 37–40.

Hillairet, Jacques. *Dictionnaire historique des rues de Paris*. 2 vols. 8th ed. Paris: Minuit, 1985.

Hobsbawm, Eric. *Workers: Worlds of Labor*. New York: Pantheon, 1984.

Hobsbawm, Eric, and Terence Ranger, eds. *The Invention of Tradition*. Cambridge: Cambridge University Press, 1983.

Hoentschel, Georges. *Exposition internationale de Saint-Louis, U.S.A., 1904, section française: Rapport du groupe 37*. Paris: Comité français des expositions à l'étranger, 1907.

Hugo, Victor. *Notre Dame de Paris*. Paris: Gosselin, 1831.

——. *Les misérables*. 1865. Reprint. Paris: Pléiade, 1951.

Hussey, Christopher. *The Picturesque: Studies in a Point of View*. London: Frank Cass, 1927.

Huysmans, Joris Karl. *Croquis parisiens*. Paris: Vanier, 1886.

——. *Les vieux quartiers de Paris: La Bièvre*. Paris: L. Genonceaux, 1890.

Huyssen, Andreas. *After the Great Divide: Modernism, Mass Culture, Postmodernism*. Bloomington: Indiana University Press, 1986.

"Informations et nouvelles." *La Revue des Beaux-Arts*, no. 98 (6 February 1892): 30.

Jameson, Fredric. *The Political Unconscious: Narrative as a Socially Symbolic Act*. Ithaca: Cornell University Press, 1982.

Jammes, André, and Eugenia Parry Janis. *The Art of French Calotype*. Princeton: Princeton University Press, 1983.

Jammes, Isabelle. *Blanquart-Evrard et les origines de l'édition photographique française: Catalogue raisonné des albums photographiques édités, 1851–1855*. Centre de Recherches d'histoire et de philologie de la quatrième section de l'Ecole pratique des Hautes études. VI. Histoire et civilisation du livre, 12. Geneva: Droz, 1981.

Janis, Eugenia Parry. "Demolition Picturesque: Photographs of Paris in 1852 and 1853." In *Perspectives on Photography: Essays in Honor of Beaumont Newhall*. Edited by Thomas F. Barrow and Peter Walch. Albuquerque: University of New Mexico Press, 1986.

Jaurès, Jean. *La classe ouvrière*. Présenté par Madeleine Réberioux. Paris: Maspero, 1976.

Johnson, William. "Eugène Atget: A Chronological Bibliography." *Exposure* 15 (May 1977): 13–15.

Josse, Etienne. "Les p'tits métiers de Paris d'Eugène Atget." *Le Vieux Papier* (1978): 355–56.

Jour, Jean. *Scènes de la rue et petits métiers parisiens en cartes postales anciennes*. Brussels: Editions Libro-Sciences SPRL, 1979.

Kahn, Gustave. *L'esthétique de la rue*. Paris: Charpentier, 1901.

———. *La femme dans la caricature française*. Paris: Méricant, 1907.

Keller, Ulrich. "The Myth of Art Photography: A Sociological Analysis" and "The Myth of Art Photography: An Iconographic Analysis." *History of Photography* 8 and 9 (October 1984 and January 1985): 249–75 and 1–38, respectively.

Ken, Alexandre. *Dissertations historiques, artistiques et scientifiques sur la photographie*. Paris: Librairie nouvelle, 1864.

Kinney, Leila W. "Boulevard Culture and Modern Life Painting." Ph.D. diss., Yale University, forthcoming.

———. "Genre: A Social Contract?" *Art Journal* 46 (Winter 1987): 267–77.

Kleebat, Norman L., ed. *The Dreyfus Affair: Art, Truth, and Justice*. Berkeley: University of California Press, 1987.

Klingsor, Tristan. *La peinture*. Paris: Rieder, 1921.

Koechlin, Raymond. "L'art décoratif moderne." *Journal des Débats* (22 May 1910).

Kracauer, Siegfried. *Orpheus in Paris: Offenbach and the Paris of His Time*. Translated by Gwenda David and Eric Mosbacher. New York: Knopf, 1938.

Krauss, Rosalind. *The Originality of the Avant-Garde and Other Modernist Myths*. Cambridge: MIT Press, 1985.

———. "Photography's Discursive Spaces: Landscape/View." *Art Journal* 41 (Winter 1982): 311–19.

———. "Re-presenting Picasso." *Art in America* 68 (December 1980): 90–96.

Krauss, Rosalind, and Jane Livingston. *L'Amour Fou: Photography and Surrealism*. New York: Abbeville, 1985.

Kriegel, Annie, and Jean Jacques Becker. *1914: La guerre et le mouvement ouvrier français*. Paris: Colin, 1964.

La Blanchère, H. de. *L'art du photographe*. Paris: Amyot, 1859.

Lambeau, Lucien. *Exposition Universelle de 1900: Ville de Paris. Commission municipale du Vieux Paris, 1897–1900*. Rapport. Paris: Dubreuil, n.d.

Lartigue, Jacques Henri. *Mémoires sans mémoire*. Paris: Laffont, 1975.

Lalouette, J. "Le discours bourgeois sur les débits de boisson alentours de 1900." *recherches*, no. 29 (December 1977): 315–48.

Laurent, Jeanne. *Arts et pouvoirs en France de 1793 à 1981: Histoire d'une démission artistique*. 3d ed. St. Etienne: CIEREC, 1983.

Le Corbusier. *L'art décoratif d'aujourd'hui*. Paris: Crès, 1925.

———. *Les plans Le Corbusier de Paris, 1956–1922*. Paris: Minuit, 1956.

Lecoq de Boisbaudran, Horace. *The Training of the Memory in Art and the Education of the Artist*. Translated by L. D. Luard. London: Macmillan, 1911.

Léger, Fernand. *Fonctions de la peinture*. Paris: Gonthier, 1965.

———. "Les réalisations picturales actuelles." *Soirées de Paris*, no. 25 (15 June 1914): 349–56.

Legrain, Dr. Maurice Paul, and A. Perès. *L'enseignement anti-alcoolique à l'école*. Paris: Fernand Nathan, 1899.

Lenoir, Albert. *Statistique monumentale de Paris*. 2 vols. Paris: Imprimerie impériale, 1867.

Léon, Paul. "La beauté de Paris." *La Revue de Paris* 6 (November 1909): 280–302.

———. *Les monuments historiques: Conservation, restauration*. Paris: Renouard, 1917.

———. *La vie des monuments français: Destruction, restauration*. Paris: Picard, 1951.

Leroy, Jean. *Atget: Magicien du Vieux Paris*. Joinville-le-Pont: Balbo, 1975.

Levasseur, Emile. *Histoire du commerce de la France*. 2 vols. Paris: Rousseau, 1912.

Levin, Miriam R. *Republican Art and Ideology in Late Nineteenth Century France*. Ann Arbor: University of Michigan Press, 1986.

Levy, Julien. *Memoir of an Art Gallery*. New York: G. P. Putnam's, 1977.

Libonis, Léon. *Les styles enseignés par l'exemple*. 3 vols. Paris: Laurens, 1897–98.

Liébert, Alphonse. *La photographie en Amérique: Traité complet de photographie pratique par les procédés américains*. Paris: Leiber, 1878.

Lipstadt, Hélène. *Architecte et ingénieur dans la presse: Polémique débat conflit*. Paris: CORDA, 1979.

Londe, Albert. *Album de chronophotographies documentaires à l'usage des artistes*. Paris: Mendel, 1903.

———. *La photographie moderne: Pratique et applications*. 2d ed. Paris: Masson, 1896.

Longuet, D. A. "De la protection des oeuvres photographiques." Rapport présenté à la huitième session du Congrès International des Editeurs. Budapest, June 1913. Paris: Chaix, 1913.

Lorrain, Jean. "La tournée des Grands-Ducs." *Je Sais Tout* (June 1905): 717–26.

Louis, Paul. *Histoire de la classe ouvrière en France de la révolution à nos jours: La condition matérielle des travailleurs, les salaires et le coût de la vie*. Paris: Rivière, 1927.

Loyer, François. *Paris, dix-neuvième siècle: L'immeuble et la rue*. Paris: Hazan, 1987.

Lumet, Louis. "Notes sur l'art industriel." *La Revue Socialiste* 35 (1902): 690–97.

Lyotard, Jean-François, et al. *Les immatériaux*. Paris: CCI, 1985.

McCauley, Elizabeth Anne. *A. A. Disdéri and the Carte de Visite Portrait Photograph*. New Haven: Yale University Press, 1985.

———. "Of Entrepreneurs, Opportunists and Fallen Women: Commercial Photography in Paris, 1848–1870." In *Perspectives on Photography: Essays in Honor of Beaumont Newhall*. Edited by Thomas F. Barrow and Peter Walch. Albuquerque: University of New Mexico Press, 1986.

———. "Photographs for Industry: The Career of Charles Aubry." *J. Paul Getty Museum Journal* 14 (1986): 157–72.

MacClean, Hector. *Photography for Artists*. London: 1896.

Macherey, Pierre. *Pour une théorie de la production littéraire*. Paris: Maspero, 1966.

MacOrlan, Pierre. *Atget: Photographe de Paris*. Paris and Leipzig: Jonquières, 1930; New York: Weyhe, 1930. The German edition was titled *Atget Lichtbilder* and contains a preface by Camille Recht.

Magne, Emile. "L'esthétique de la rue." *Mercure de France* 56 (1905): 161–81.

Magny, Charles. *La beauté de Paris: Conservation des aspects esthétiques*. Paris: Tignol, 1911.

Maindron, Ernest. *Les affiches illustrées: Ouvrage orné de vingt chromolithographies par Jules Chéret et de nombreuses reproductions en noir et en couleur d'après les documents originaux*. Paris: Launette, 1886.

Mallarmé, Stéphane. *Oeuvres complètes*. Paris: Pléiade, 1945.

Man Ray. *Self Portrait*. Boston: Little Brown, 1963.

Mannheim, Karl. *Ideology and Utopia: An Introduction to the Sociology of Knowledge*. London: Kegan Paul, Trench, Trubner, 1936.

Marcel, Henry, Henri Bouchot, Ernest Babelon, Paul Marchal, and Camille Couderc. *La Bibliothèque Nationale*. 2 vols. Paris: Laurens, 1907.

March, Lucien. *Influence des variations des prix sur le mouvement des dépenses ménagères à Paris*. Nancy: Berger-Levrault, 1910.

Mareshcal, Georges. *Les voitures de place: Etude de la réglementation parisienne de la circulation*. Thèse pour le doctorat, Université de Dijon. Dijon: Mareschal, 1912.

Marnata, Frangoise. *Les loyers des bourgeois de Paris, 1860–1958*. Paris: Colin, 1961.

Marrus, Michael. "L'alcoolisme social à la Belle Epoque." *recherches*, no. 29 (December 1977): 285–314.

Martial, A. P. *Paris intime*. 1874.

Martin, Alfred. *Etude historique et statistique sur les moyens de transport dans Paris*. Paris: Imprimerie nationale, 1894.

Martin, Henri-Jean, and Roger Chartier. *Histoire de l'édition française*. Paris: Promodis, 1985.

Martin, Jean-Baptiste. *La fin des mauvais pauvres: De l'assistance à l'assurance*. Seyssel: Champ Vallon, 1983.

Martin-Sabon, F. *La photographie des monuments*. Troyes: 1914.

Martin Saint-Léon, Et. *Le petit commerce française: Sa lutte pour la vie*. Paris: Gabalda, 1911.

Marx, Karl. *Capital*. Translated by Ben Fowkes. 3 vols. London: Penguin and New Left Review, 1976.

——. *Early Writings*. Translated by Rodney Livingstone and Gregor Benton. Harmondsworth: Penguin, 1975.

——. *Grundrisse: Foundations of the Critique of Political Economy*. Translated by Martin Nicolaus. Harmondsworth: Penguin and New Left Review, 1973.

Marx, Karl, and Friedrich Engels. *The Communist Manifesto*. Harmondsworth: Penguin, 1967.

Marx, Roger. *L'art social*. Paris: Fasquelle, 1913.

——. *Les maîtres de l'affiche*. 5 vols. Paris: Chaix, 1896–1900.

Maurange, Georges. "Alcoolisme et le parti socialiste." *Revue Socialiste* (February, April, June 1912): 219–26, 352–62, 523–32.

Mayer, Arno. *The Persistence of the Old Regime: Europe to the Great War*. New York: Pantheon, 1981.

Melot, Michel. "La notion d'originalité et son importance dans la définition des objets d'art." In *Sociologie de l'art: Colloque international. Marseille, 13–14 juin 1985*. Sous la direction de Raymonde Moulin. Paris: La documentation française, 1986.

——. "La pratique d'un artiste: Pissarro, graveur en 1880." *Histoire et Critique des Arts*, no. 2 (June 1977): 14–38.

Mény, Georges. *Professions et métiers*. Vol. 9, *Le chiffonnier de Paris*. Reims: 48, rue de Venise, 1906.

Merlin, Pierre. *Les transports parisiens*. Paris: Masson, 1967.

Meyer, Alain, and Christine Moissinac. *Représentations sociales et littéraires: Centre et périphérie. Paris, 1908–1939*. Paris: I.A.U.R.I.F., 1979.

Michaels, Barbara. "An Introduction to the Dating and Organization of Eugène Atget's Photographs." *Art Bulletin* 61 (September 1979): 460–68.

——. "Behind the Scenes of Photographic History: Reyher, Newhall, and Atget." *Afterimage* 15 (May 1988): 14–17.

Michelson, Annette. " 'Man with the Movie Camera': From Magician to Epistemologist." *Artforum* 10 (March 1972): 60–72.

Michel, André. *Histoire de l'art depuis les premiers temps chrétiens jusqu'à nos jours*. 8 vols. Paris: Colin, 1905–29.

Miller, Michael B. *The Bon Marché: Bourgeois Culture and the Department Store, 1869–1920*. Princeton: Princeton University Press, 1981.

Ministère de l'Instruction Publique et des Beaux-Arts. *Archives de la Commission des Monuments historiques*. 9 vols. Paris: Gide et Baudry, 1855–72; Renouard, 1898–1903.

——. *Les archives photographiques d'art et d'histoire: Catalogue des clichés photographiques des monuments de Paris et du département de la Seine*. Paris: Palais Royal, ca. 1927.

——. *Catalogue illustré des clichés photographiques des Archives de la Commission des Monuments historiques*. Paris: Neurdein, 1904.

——. *Inventaire général des richesses d'art de la France*. 3 vols. Paris: Plon, 1879.

Ministère des Finances. Direction générale des contributions directes. Contribution des patentes. *Législation et tarifs*. Paris: 1905, 1923.

——. *Statistique des patentes par professions*. Paris: 1904.

Ministère du Commerce, de l'Industrie, des Postes et des Télégraphes. *Exposition Universelle à Paris, 1900: Rapports du jury international. Classe 12—Photographie*. Paris: 1901.

——. *Office de Travail: L'industrie du chiffon à Paris*. Directeur du travail, Arthur Fontaine. Paris: 1903.

Ministère du Travail et de la Prévoyance Social. *Statistique générale de la France: Résultats statistiques, 5 mars 1911*. Vol. 2. Paris: 1915.

Mithouard, Adrien. *La perdition de la Bièvre*. Paris: Bibliothèque de l'Occident, 1906.

Un modèle olympien. "Carnet de la curiosité—petit bleu de modèle." *Art et Critique*, no. 89 (13 February 1892): 78–79.

Monckhoven, Désiré van. *Traité générale de photographie comprenant tous les procédés connus jusqu'à ce jour, suivi de la théorie de la photographie et de son application aux sciences d'observation*. 4th ed. Paris: Masson, 1863.

Montorgueil, Georges. *Croquis parisiens: Les plaisirs du dimanche; à travers les rues*. Paris: May et Motteroz, 1897.

——. *La vie des boulevards, Madeleine—Bastille*. Paris: May et Motteroz, 1896.

Morin, Louis. *Le dessin humoristique*. Paris: Laurens, 1913.

Mousseigne, Alain. "Surréalisme et photographie: Rôle et place de la photographie dans les revues du mouvement surréaliste, 1929–1939." In *L'art face à la crise, 1919–1939*. St. Etienne: CIEREC, 1980.

Moutier, L. *Traité pratique et simplifié de la peinture à la détrempe appliquée aux décors de théâtre, et conseils pour l'application d'une scène*. Orléans: Jeanne d'Arc, 1911.

Muller, Jean. "Bars et tavernes." *Montjoie!* (April 1914): 28.

Musée Carnavalet. *Atget. Géniaux. Vert. Petits métiers et types parisiens vers 1900*. Paris: Musée Carnavalet, 1984.

——. *Atget: Intérieurs parisiens*. Paris: Musée Carnavalet, 1982.

Néagu, Philippe, et al. *La mission héliographique: Photographies de 1851*. Paris: Inspection générale des musées, 1980.

Needham, H. A. *Le développement de l'esthétique sociologique en France et en Angleterre au dix-neuvième siècle*. Paris: Champion, 1926.

Nesbit, Molly. "The Use of History." *Art in America* 74 (February 1986): 72–83.

——. "What Was An Author?" *Yale French Studies*, no. 73 (1987): 229–57.

Neudin, Joelle, and Gérard Neudin. *L'argus international des cartes postales de collection*. Paris: 1979.

Neveux, Marcel. *Le dépôt légal des productions des arts graphiques*. Thèse pour le doctorat, Université de Paris. Paris: Pedone, 1934.

Nietzsche, Friedrich. *The Use and Abuse of History*. Translated by Adrian Collins. New York: Bobbs-Merrill, 1949.

Niewenglowski, Gaston-Henri. *Traité complémentaire de photographie pratique*. Paris: Garnier frères, 1906.

——. *Traité élémentaire de photographie pratique*. Paris: Garnier frères, 1905.

Nogaro, B., and W. Ouladid. *L'évolution du commerce, du crédit et des transports depuis 150 ans*. Paris: Alcan, 1914.

Noiriel, Gérard. *Les ouvriers dans la société française, dix-neuvième–vingtième siècle*. Paris: Seuil, 1986.

Nolhac, Pierre de. *Les jardins de Versailles*. Paris: Manzi-Joyant, 1906.

Nora, Pierre, ed. *Les lieux de mémoire*. T. 1, *La République*; t. 2, *La Nation*: v. 1, *Héritage. Historiographie. Paysages*; v. 2, *Le territoire. L'état. Le patrimoine*; v. 3, *La gloire. Les mots*. Paris: Gallimard, 1984–86.

Nord, Philip. *Paris Shopkeepers and the Politics of Resentment*. Princeton: Princeton University Press, 1986.

Normand, Charles. *Nouvel itinéraire-guide artistique et archéologique de Paris*. Paris: L'Ami des monuments et des arts, 1889–1903.

Normand, Charles, and Lucien Leblanc. *Projet de reconstitution de Paris à travers les âges: Exposition Universelle de 1900 à Paris*. Paris: 1894.

"Nos artistes et leurs modèles." *Lectures pour Tous* (April 1910): 639–47.

O'Neal, Hank. *Berenice Abbott: American Photographer*. New York: McGraw-Hill, 1982.

L'oeuvre de la nouvelle majorité à l'Hôtel de Ville: Un bilan victorieux, 1900–1904. Paris: Bureau de "La Patrie Française," 1904.

Oppler, Ellen. *Fauvism Re-examined*. New York: Garland, 1976.

Pare, Richard. *Photography and Architecture, 1839–1939*. Montreal: Canadian Centre for Architecture, 1984.

Pasdermadjian, Hrant. *Le grand magasin: Son origine, son évolution, son avenir*. Paris: Dunod, 1948.

Paulian, Louis. *La hotte du chiffonnier*. 3d ed. Paris: Hachette, 1896.

Pawlowski, Gustave. *Les ports de Paris*. Paris: Berger-Levrault, 1910.

Pelloutier, Fernand. *L'art et la révolte*. Paris: Bibliothèque de l'Art Social, 1896.

Pératé, André, and Gaston Brière. *Collections Georges Hoentschel*. 4 vols. Paris: Librairie centrale des beaux-arts, 1908.

Perrot, Marguerite. *Le mode de vie des familles bourgeoises, 1873–1953*. Paris: Colin, 1961.

Perrot, Michelle. *Les ouvriers en grève (France, 1871–1890)*. 2 vols. Paris: Mouton, 1974.

——. *L'impossible prison: Recherches sur le système pénitentiaire au dix-neuvième siècle réunies par Michelle Perrot*. Paris: Seuil, 1980.

Pessard, Gustave. *Nouveau dictionnaire historique de Paris*. Paris: Rey, 1904. New edition in 1908.

"Pétitions par M. le Président. De M. Atget proposant l'acquisition par la Ville d'un receuil photographique du Vieux Paris." *Bulletin Municipale de la Ville de Paris* 1 (1902): 1109.

Photographies. Colloque Atget. Actes du colloque. Collège de France, 14–15 juin 1985. *Photographies* (March 1986).

Picard, Roger. *Le mouvement syndical durant la guerre*. Paris and New Haven: Presses Universitaires de France and Yale University Press, 1928.

Pinsard, Jules. *L'illustration du livre moderne et la photographie*. Paris: Mendel, 1897.

Planat, P., and E. Rümler. *Le style Louis XIV*. Paris: Librairie de Construction Moderne, ca. 1912.

Poe, Edgar Allan. *Histoires grotesques et sérieuses*. Translated by Charles Baudelaire. Paris: Lévy, 1864.

Poëte, Marcel. *Leçon d'ouverture du cours d'introduction à l'histoire de Paris professé à la Bibliothèque de la Ville*. Paris: Pichon et Durand-Auzias, 1904.

——. *La promenade à Paris au dix-septième siècle: L'art de se promener. Les lieux de promenade dans la ville et aux environs*. Paris: Colin, 1913.

——. "Le Service de la Bibliothèque et des Travaux historiques de la Ville de Paris: Exposé historique sur le service. Etat actuel." *Bulletin de la Bibliothèque et des Travaux historiques de la Ville de Paris* 1 (1906): v–xxviii.

——. *Les sources de l'histoire de Paris et les historiens de Paris*. Paris: Editions de la Revue politique et littéraire (Revue bleue) et de la Revue Scientifique, 1906.

——. *Une vie de cité: Paris de sa naissance à nos jours*. 3 vols. and album. Paris: Picard, 1924–31.

Porte, Marcel. *Budgets de familles et consommations privées*. Grenoble: Allier, 1913.

Poteau, Edouard. *Exposition internationale de Milan, 1906: Section française. Papiers peints, tapis, décoration, meubles: classes 68 à 71*. Paris: Comité français des expositions à l'étranger, 1910.

Potu, M. E. *La protection des oeuvres photographiques: Extraits de la* Revue Trimestrielle de Droit Civil. Paris: Sirey, 1912.

Pouillet, Eugène. *Traité théorique et pratique de la propriété littéraire et artistique et du droit de représentation*. 3d ed. Paris: Marchal et Billard, 1908.

Poulet-Allamagny, Jean-Jacques, and Philippe Néagu. "Caisse nationale des Monuments historiques et des sites: Les Archives photographiques des Monuments historiques." In *Monuments historiques de la France*, no. 110 (1980): 53–67.

Poulot, Denis. *Le sublime, ou le travailleur comme il est en 1870, et ce qu'il peut être*. Introduction by Alain Cottereau. Paris: Maspero, 1980.

Pour bien tenir sa maison. Paris: Lafitte, 1911.

Privat d'Anglemont, Alexandre. *Paris anecdote*. Paris: Jannet, 1854.

Protol, Eugène. *Une révolution dans l'habitation*. Paris: Sevin et Sarrat, 1909.

Proust, Antonin. *L'art sous la république*. Paris: Charpentier, 1892.

Proust, Marcel. *A la recherche du temps perdu*. 8 vols. Paris: Grasset, 1914; N.R.F., 1918–24; Gallimard, 1924–27.

Provensal, Henry. *L'habitation salubre et à bon marché*. Paris: Schmid, 1908.

Puech, Lucien. *L'album I–XVIII*. Paris: Tallardier, 1901–02.

Puttnies, Hans Georg. *Atget*. Köln: Galerie Rudolf Kicken, 1980.

Rajchman, John. "Foucault's Art of Seeing." *October*, no. 44 (Spring 1988): 89–117.

——. *Michel Foucault: The Freedom of Philosophy*. New York: Columbia University Press, 1985.

Rancière, Jacques. "Le bon temps, ou la barrière des plaisirs." *Les Révoltes Logiques*, no. 7 (Spring–Summer 1978): 25–66.

——. "The Myth of the Artisan: Critical Reflections on a Category of Social History." *International Labor and Working Class History*, no. 24 (Fall 1983): 1–16.

——. *La nuit des prolétaires: Archives du rêve ouvrier*. Paris: Fayard, 1981.

Réberioux, Madeleine. "Avant-garde esthétique et avant-garde politique: Le socialisme français entre 1890 et 1914." In *Esthétique et marxisme*. Paris: Union générale d'éditions, 1974.

——. "Critique littéraire et socialisme au tournant du siècle." *Le Mouvement Social*, no. 59 (April 1967): 3–28.

——. *La république radicale? 1898–1914*. Paris: Seuil, 1975.

Receuil sur la Bièvre: Envoi de la Commission du Vieux Paris. Ex libris: L'Esprit. Unique copy in the collection of the Bibliothèque historique de la Ville de Paris.

Reff, Theodore. "Cézanne and Poussin." *Journal of the Warburg and Courtauld Institutes* 23 (1960): 150–74.

Rémond, René. *La droite en France*. 2 vols. 3d ed. Paris: Auber, 1968.

Renault, Georges. *Les rois du ruisseau*. Paris: Le livre moderne, 1900.

Révoltes logiques, collectif. *Esthétiques du peuples*. Paris: La Découverte et Presses Universitaires de Vincennes, 1985.

Reyner, Albert. *Manuel pratique du reporter photographe et de l'amateur d'instantanés*. Paris: Mendel, 1903.

Riat, Georges. *Paris*. Paris: Renouard, 1900.

Richard, Elie. *Paris qui meurt*. Paris: Figuière, 1923.

Rifkin, Adrian. "Cultural Movement and the Paris Commune." *Art History* 2 (June 1979): 201–20.

———. "Musical Moments." *Yale French Studies*, no. 73 (1987): 121–55.

Rifkin, Adrian, and Roger Thomas, eds. *Voices of the People: The Politics and Life of "La Sociale" at the End of the Second Empire*. Translated by John Moore. London: Routledge and Kegan Paul, 1988.

Robert, Karl. *Leçons pratiques de dessin au fusain appliqués aux modèles du cours de paysage de A. Allongé*. Paris: Goupil, 1876.

———. *La photographie aide du paysagiste ou photographie des peintres: Résumé pratique des connaissances nécessaires pour exécuter la photographie artistique: Paysage, portrait, genre*. Paris: Laurens, 1890.

———. *Traité pratique de la peinture à l'huile (portrait et genre)*. 4th ed. Paris: Laurens, 1910.

Robinson, Henry Peach. *Photography as a Business*. Bradford: Percy Lund, 1890.

Rochegude, Félix, marquis de. *Guide pratique à travers le Vieux Paris: Maisons historiques ou curieuses, anciens hôtels pouvant être visités en trente-trois itinéraires détaillés*. Paris: Hachette, 1903. New editions in 1903, 1905, and 1907.

———. *Promenades dans toutes les rues de Paris par arrondissements: Origines des rues, maisons historiques ou curieuses, anciens et nouveaux hôtels, enseignes*. 20 vols. Paris: Hachette, 1910.

Roger-Milès, L. *Comment discerner les styles du dix-huitième au dix-neuvième siècle*. 2 vols. Paris: Rouveyre, 1896–97.

Roth, Lisa Horvitz, ed. *J. Pierpont Morgan, Collector. European Decorative Arts from the Wadsworth Atheneum*. Hartford: Wadsworth Atheneum, 1987.

Rougerie, Jacques. "Remarques sur l'histoire des salaires à Paris au dix-neuvième siècle." *Le Mouvement Social*, no. 63 (April 1968): 71–108.

Rouillé, André. *La photographie en France, 1839–1870. Textes et controverses: Une anthologie, 1816–1871*. Paris: Macula, 1989.

———. "La photographie française à l'Exposition Universelle de 1855." *Le Mouvement Social*, no. 131 (April–June 1985): 87–103.

———. "Les images photographiques du monde du travail sous le Second Empire." *Actes de la recherche en sciences sociales*, no. 54 (September 1984): 31–43.

Rouillé, André, and Bernard Marbot. *Le corps et son image: Photographies du dix-neuvième siècle*. Paris: Contrejour, 1986.

Rudhardt, Ch. *La peinture à l'huile simplifiée: L'art de la peinture, lois, métier, pratique*. Paris: Laurens, 1913.

Sagne, Jean. *L'atelier du photographe, 1840–1940*. Paris: Presses de la Renaissance, 1984.

Salles Gomes, P. *Jean Vigo*. Berkeley: University of California Press, 1971.

Sanborn, Alvan Francis. *Paris and the Social Revolution*. London: Hutchinson, 1905.

Sandoz, G. Roger, and Jean Guiffrey. *Exposition française d'art décoratif de Copenhague 1909: Rapport général précédé d'une étude sur les arts appliqués et industries d'art aux expositions*. Paris: Comité français des expositions à l'étranger, 1912.

Scharf, Aaron. *Art and Photography*. 2d ed. Harmondsworth: Penguin, 1974.

Schéfer, Gaston. *Catalogue des estampes, dessins et cartes composant le Cabinet des Estampes de la Bibliothèque de l'Arsenal*. Paris: Aux bureaux de "l'Artiste," H. Leclerc, et Société pour l'étude de la gravure française, 1894–1929.

Schiff, Richard. *Cézanne and the End of Impressionism*. Chicago: University of Chicago Press, 1984.

Sedeyn, Emile. "Le faubourg Saint Antoine." *La Renaissance* 4 (1921): 585–642.

Sekula, Allan. "The Body and the Archive." *October*, no. 39 (Winter 1986): 3–64.

———. *Photography Against the Grain*. Halifax: The Press of the Nova Scotia College of Art and Design, 1984.

———. "Photography between Labour and Capital." In *Mining Photographs and Other Pictures, 1948–1968: A Selection from the Negative Archives of Shedden Studio, Glace Bay, Cape Breton*. Edited by Benjamin H. D. Buchloh and Robert Wilkie. Halifax: The Press of the Nova Scotia College of Art and Design, 1983.

Sellier, Charles, and Prosper Dorbec. *Guide explicatif du Musée Carnavalet*. Paris: Librairie centrale des beaux-arts, 1903.

Sellier, Henri, A. Bruggeman, and Marcel Poëte. *Paris pendant la guerre*. Paris: Presses Universitaires de France, 1926.

Silver, Kenneth E. *Esprit de Corps: The Art of the Parisian Avant-Garde and the First World War, 1914–1925*. Princeton: Princeton University Press, 1989.

———. "Purism: Straightening Up after the Great War." *Artforum* 15 (March 1977): 56–63.

Silverman, Debora Leah. *Art Nouveau in Fin-de-Siècle France: Politics, Psychology, and Style*. Berkeley: University of California Press, 1989.

Simmel, Georg. *On Individuality and Social Forms: Selected Writings*. Edited by Donald Levine. Chicago: University of Chicago Press, 1971.

Simon, P. *Statistique de l'habitation à Paris*. Paris: Librairie Polytechnique, Baudry, 1891.

Simond, Charles. *La vie parisienne à travers le dix-neuvième siècle: Paris de 1800 à 1900 d'après les estampes et les mémoires du temps*. 3 vols. Paris: Plon, Nourrit, 1900–01.

Singer-Kérel, Jeanne. *Le coût de la vie à Paris de 1840 à 1954*. Paris: Colin, 1961.

Sitte, Camillo. *L'art de bâtir les villes*. Notes translated and completed by Camille Martin. Geneva: Atar, 1912.

Smith, F. Berkeley. *How Paris Amuses Itself*. New York: Funk and Wagnalls, 1903.

———. *The Real Latin Quarter*. New York: Funk and Wagnalls, 1901.

Sohn-Rethel, Alfred. *Intellectual and Manual Labor: A Critique of Epistemology*. London: Macmillan, 1978.

Sorel, Albert. *Vues sur l'histoire*. Paris: Plon, 1898.

Sorel, Cécile. *Les belles heures de ma vie*. Monaco: Rocher, 1946.

Sorel, Georges. *Réflexions sur la violence*. 3d ed. Paris: Alcan, 1912.

Souvestre, Pierre, and Marcel Allain. *Fantômas*. Présenté par Francis Lacassin. 2 vols. Paris: Robert Laffont, 1987–88.

Stedman Jones, Gareth. *Languages of Class: Studies in English Working Class History*. Cambridge: Cambridge University Press, 1983.

Stein, Sally. "Making Connections with the Camera: Photography and Social Mobility in the Career of Jacob Riis." *Afterimage* 10 (May 1983): 9–15.

Stierle, Karlheinz. "Baudelaire and the Tradition of the Tableau de Paris." *New Literary History* 11 (1980): 345–61.

Strong, Rowland. *The Diary of an English Resident in France during Wartime*. 2 vols. London: Eveleigh Nash, 1915; Simpkins, Marshall, Hamilton, Kent, 1916.

Sutcliffe, Anthony. *The Autumn of Central Paris: The Defeat of Town Planning, 1850–1870*. London: Edward Arnold, 1970.

Syndicat des Propriétaires et Industriels Zoniers. *La question des fortifications de Paris, 12 janvier 1913*. Paris: Paul Dupont, 1913.

Szarkowski, John. *Atget: A Limited Edition of New Prints from Twelve Negatives by Eugène Atget*. New York: MOMA, 1978.

———. "Atget's Trees." In *One Hundred Years of Photographic History: Essays in Honor of Beaumont Newhall*. Edited by Van Deren Coke. Albuquerque: University of New Mexico Press, 1975.

———. *Looking at Photographs*. New York: MOMA, 1973.

Szarkowski, John, and Maria Morris Hambourg. *The Work of Atget*. Vol. 1, *Old France*; vol. 2, *The Art of Old Paris*; vol. 3, *The Ancien Regime*; vol. 4, *Modern Times*. New York: MOMA, 1981–85.

t'Serstevens, A. "II. Les cafés." *Montjoie!* (14 April 1913): 5.

Tagg, John. "The Currency of the Photograph." *Screen Education* 28 (Autumn 1978): 45–67.

Taine, Hippolyte. *Philosophie de l'art*. Paris: Baillière, 1865.

Ternisien, Eugène. *Exposition universelle et internationale de Liège, 1905: Section française. Classe 71. Décoration mobile et ouvrages du tapissier*. Paris: Comité français des expositions à l'étranger, 1906.

Thierry, Henry, and Lucien Graux. *L'habitation urbaine: Chambres de domestiques, cuisines et loges de concierges*. St. Denis: Bouillant, 1909.

Thiesse, Anne-Marie. *Le roman du quotidien: Lecteurs et lectures populaires à la belle époque*. Paris: Chemin Vert, 1984.

Tomel, Guy. *Le bas du pavé parisien*. Paris: Charpentier, 1894.

Valentin, Albert. "Eugène Atget (1856–1927)." *Variétés* 1 (15 December 1928): 403–08.

Vandervelde, Emile. *Essais socialistes: L'alcoolisme, la religion, l'art*. Paris: Alcan, 1906.

———. "Les facteurs économiques de l'alcoolisme." *La Grande Revue* 17 (March 1901): 558–76.

———. *Les facteurs économiques de l'alcoolisme (conférence faite à Lille à l'Assemblée générale de 1901 de l'Union française antialcoolique)*. Paris: 1902.

Varnedoe, Kirk. "The Artifice of Candor: Impressionism and Photography Reconsidered." *Art in America* 68 (January and Summer 1980): 66–78 and 96–110.

Véra, André. "Le nouvel style." *L'Art décoratif* 27 (1912): 21–32.

Vidal, Léon. *Absence d'un texte légal réglant les droits d'auteur afférents aux oeuvres des arts mécaniques de reproduction. Diversité d'opinions relatives à cette question. Solution qui semble la plus rationelle. (Extrait des Mémoires de l'Académie de Marseille)*. N.p.: n.d.

Vigneau, Jules. *Les Halles centrales de Paris autrefois et aujourd'-hui*. Paris: Duruy, 1903.

Ville de Paris. *Concours d'enseignes organisé par la Ville de Paris*. Paris: Guerinet, 1903.

———. *Receuil des lettres patentes, ordonnances royales, decrets et arrêtés préfectoraux concernant les voies publiques*. Paris: Imprimerie Municipale, 1886–1902.

Walter Benjamin et Paris: Colloque international, 27–29 juin 1983. Paris: Cerf, 1986.

Warnod, André. *Bals, cafés et cabarets*. Paris: Figuière, 1913.

———. *La brocante et les petits marchés de Paris*. Paris: Figuière, 1914.

Weber, Eugen. *Action Française: Royalism and Reaction in Twentieth Century France*. Stanford: Stanford University Press, 1962.

———. *France: Fin-de-Siècle*. Cambridge: Harvard University Press, 1986.

———. *The Nationalist Revival in France, 1905–1914*. Berkeley: University of California Press, 1959.

Wechsler, Judith. *A Human Comedy: Physiognomy and Caricature in Nineteenth Century Paris*. London: Thames and Hudson, 1982.

Werkmeister, O. K. "Marx on Ideology and Art." *New Literary History* 4 (Spring 1973): 501–19.

Wharton, Edith. *Fighting France: From Dunkerque to Belfort*. New York: Scribner's, 1915.

White, Hayden. *Metahistory: The Historical Imagination in Nineteenth Century Europe*. Baltimore: Johns Hopkins University Press, 1973.

Williams, Raymond. *Marxism and Literature*. Oxford: Oxford University Press, 1977.

———. *Problems in Materialism and Culture*. London: New Left, 1980.

Wolf, Peter. *Eugène Hénard and the Beginning of Urbanism in Paris, 1900–1914*. Paris: Centre de recherche d'urbanisme, 1968.

Zeldin, Theodore. *France, 1848–1945*. 2 vols. Oxford: Clarendon, 1973–77.

Zola, Emile. *Les trois villes: Paris*. Paris: Fasquelle, 1898.

Index

Photo Credits

L'ART

DANS LE

VIEUX PARIS

E. ATGET

AUTEUR-ÉDITEUR

17bis, Rue Campagne-Première, 17bis

PARIS

1 Hôtel Roualle de Boisgelin (1750) 29, Quai Bourbon (4ᵉ Arrᵗ) – Magnifique porte, style Louis XVI.

2 Hôtel Roualle de Boisgelin (1750) 29, Quai Bourbon (4ᵉ Arrᵗ) – Escalier, rampe fer forgé, style Louis XVI, merveille de finesse et de goût.

4 3, Quai Bourbon (4ᵉ Arrᵗ) – Charmante petite boutique de l'époque de Louis XVI, divisée en arcades finement sculptées, où était établi, paraît-il, le parfumeur de Marie-Antoinette.

3 (4ᵉ Arrᵗ) Eglise Saint-Louis en l'Ile, Rue Saint-Louis en l'Ile (1664 à 1679) Choeur de 1702 à 1726, Architecture de Levau, G. Leduc et Jacques Doucet. Très belle porte XVIIIᵉ siècle.

5 3, Quai Bourbon (4ᵉ Arrᵗ) – Charmante petite boutique de l'époque de Louis XVI. (Détail)

6 Hôtel de Fieubet, 2, Quai des Célestins (4ᵉ Arrᵗ) – Construit sur l'emplacement de l'hôtel royal de Saint-Paul, par Hardouin Mansart, pour Gaspard de Fieubet, Chancelier de la Reine Marie-Thérèse (1671); acheté en 1850 par M. Lavalette, publiciste qui le restaura: Aujourd'hui, Collège Massillon.

7 Rue Charles V, 12 (4ᵉ Arrᵗ) – Magnifique escalier, ancien Hôtel Daubray, père de la Brinvilliers, habité sous Louis XIV, par la Marquise de Brinvilliers, l'empoisonneuse, aujourd'hui succursale de la communauté des sœurs garde-malades de Troyes.

8 Saint Nicolas-du-Chardonnet, Rue Monge et Boulevard Saint-Germain (5ᵉ Arrᵗ) – Cet édifice, monument historique, a été construit sur les dessins du peintre Lebrun, 1656 à 1690. Très belle porte XVIIIᵉ siècle.

9 Impasse de la Poissonnerie, Rue de Jarente. (4ᵉ Arrᵗ) au bas de la Rue de Turenne – Très jolie fontaine construite en 1700. Réédifiée en 1783, sur les dessins de Caron. C'est un joli petit édicule trop ignoré.

10 Rue Geoffroy-Lasnier, 26. (4ᵉ Arrᵗ) – Hôtel Chalon-Luxembourg (1657) habité par Antoine Le Fèvre de la Borderie Ambassadeur en Angleterre; Très belle porte, chef-d'oeuvre de menuiserie et dont le heurtoir est une merveille.

11 Rue Geoffroy-Lasnier, 26 (4ᵉ Arrᵗ) – Hôtel Chalon-Luxembourg. (1657). Heurtoir.

12 Jardin du Luxembourg. (6ᵉ Arrᵗ) – Remarquable fontaine de Medicis, formée de la réunion de la "Grotte de Vénus" élevée dans le jardin du Luxembourg sur l'ordre de Marie de Médicis (1620), d'après les dessins de Rubens ou de Salomon de Brosse, et de la fontaine qui existait autrefois, au coin de la rue du Regard.

13 Jardin du Luxembourg. (6ᵉ Arrᵗ) – Fontaine qui existait autrefois, au coin de la rue du Regard.

14 Jardin du Luxembourg. (6ᵉ Arrᵗ) – Remarquable fontaine de Médicis.

15 Quai de l'Hôtel-de-Ville, 34 (4ᵉ Arrᵗ) – Très belle grille de cabaret (Disparue en 1902). C'était une des plus curieuses, et aussi celle qui, par ses détails d'exécution, rappelle le mieux la serrurerie du XVIIIᵉ siècle.

16 Rue de Montmorency, 5 (3ᵉ Arrᵗ). Superbe façade sur la cour. Ancien hôtel de Montmorency, construit par le Connétable Mathieu et habité par ses successeurs. Nicolas Fouquet y habita, alors qu'il n'était que procureur général.

17 Rue Vieille-du-Temple, 47 (4ᵉ Arrᵗ). Très belle porte, hôtel des ambassadeurs de Hollande construit en 1638, par Cottard, sur l'emplacement de l'hôtel de Rieux.

18 Rue Vieille-du-Temple, 47 (4ᵉ Arrᵗ) – Hôtel des Ambassadeurs de Hollande. Porte, motif décoratif, chef-d'oeuvre de menuiserie.

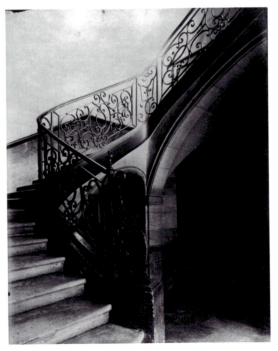

19 Rue Vieille-du-Temple, 47 (4ᵉ Arrᵗ) – Hôtel des Ambassadeurs de Hollande. Dessus de porte, intérieur, cour, bas-relief représentant Romulus et Remus.

20 Rue Séguier, 16 (6ᵉ Arrᵗ) – Hôtel de Moussy, d'Argouges (1695); Marquis de la Housse, ambassadeur de Danemark; Marquis de Flamerens, chancelier de France (1728); le Baron Séguier premier président, y mourent en 1848. Remarquable escalier, rampe fer forgé.

21 Rue Séguier, 16 (6ᵉ Arrᵗ) – Hôtel de Moussy. Très belle porte.

22 Rue de Tournon, 6 (6ᵉ Arrᵗ) – Hôtel de Terrat, marquis de Chantosme, chancelier du Duc d'Orléans; Bugnet, intendant de M. de Creil; Duc de Brancas. Le Docteur Ricerd y habita. Splendide escalier, chef-d'oeuvre de ferronnerie de l'époque de la Règence.

23 Jardin du Luxembourg (6ᵉ Arrᵗ) – Vase artistique, avec fleurs tombantes, du plus gracieux effet; au fond, le palais du Luxembourg baigné de lumière: le tout compose un délicieux et artistique paysage parisien.

24 Quai Conti (6ᵉ Arrᵗ) – Hôtel de la Monnaie, construit en 1771 par l'architecte Antoine. La première pierre de l'édifice fut posée par l'abbé Terray. Entrée sur le quai Conti. Très belle porte dont le heurtoir est de tout beauté.

25 Quai Conti (6e Arrt) – Hôtel de la Monnaie. (Heurtoir.)

26 Rue du Four, 10 (6e Arrt) – Très belle grille de cabaret, XVIIIe siècle, disparue en 1904.

27 Rue Garancière (6e Arrt) – Fontaine Garancière, érigée en 1715, aux frais et par ordre de la princesse Palatine. Le mascaron, seule chose intéressante dans cette petite fontaine, est un chef-d'oeuvre des sculpteurs ornemanistes du commencement du XVIIIe siècle.

28 Rue de Varenne, 65 (7e Arrt) – Hôtel de la Marquise de Suze (1787): puis de la Rochefoucault Doudeauville. Très belle façade qui fait le plus grand honneur aux architectes du XVIIIe siècle.

29 Rue de Varenne, 57 (7ᵉ Arrᵗ) – Hôtel du maréchal de Montmorency. Acheté inachevé en 1723 par Jacques de Matignon; Grimaldi, prince de Monaco (1775); Talleyrand, prince de Bénévent (1812). Brogniard le remania; Cavaignac y habita en 1848; Duc de Galiéra en 1878, Comte de Paris en 1884. Aujourd'hui ambassade d'Autriche. Très belle porte.

30 Rue de Varenne, 57 (7ᵉ Arrᵗ) – Hôtel du Maréchal de Montmorency. Magnifique heurtoir.

31 Square Monge (5ᵉ Arrᵗ) – Fontaine Childebert, construite de 1720 à 1730, vis à vis du portail de Saint-Germain-des-Prés, réédifiée en 1875 contre le soubassement de l'Ecole Polytechnique, sur le square Monge. Cette merveilleuse petite fontaine, chef-d'oeuvre des artistes du XVIIIᵉ siècle, est presque inconnue des parisiens.

32 Rue Michel-le-Comte, 36 (3ᵉ Arrᵗ) – Pittoresque enseigne du Bon Puits, fer forgé, aujourd'hui, malheureusement disparue.

33 Rue Charlot, 83 (3ᵉ Arrᵗ) – Hôtel du Marquis de Masca-
rani, président à la Cour des Comptes (1750). Aujourd'hui
disparu.

34 Rue Charlot, 83 (3ᵉ Arrᵗ) – Hôtel du Marquis de Mas-
carani (disparu). Splendide départ, fer forgé, de l'escalier de
l'Hôtel.

35 Rue de Turenne, 60 (3ᵉ Arrᵗ) – Hôtel du chancelier
Boucherat (1713); marquis d'Ecquevilly, grand veneur
de Louis XV (1766); couvent de Sainte-Elisabeth jusqu'à
la loi contre les congrégations (1901). Ce magnifique
hôtel, aujourd'hui livré au commerce, a été entièrement
transformé et son superbe escalier a complètement disparu.

36 Rue de Turenne, 60 (3ᵉ Arrᵗ) – Hôtel du chancelier
Boucherat. Façade de l'hôtel (disparue).

37 Rue de Turenne, 60 (3ᵉ Arrᵗ) – Hôtel du chancelier Boucherat. Porte de l'hôtel sur la rue de Turenne.

38 Rue de Turenne, 60 (3ᵉ Arrᵗ) – Hôtel du chancelier Boucherat. Heurtoir avec attributs de chasse.

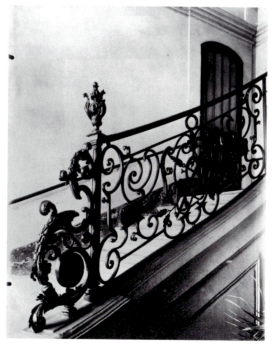

39 Rue de Turenne, 60 (3ᵉ Arrᵗ) – Hôtel du chancelier Boucherat. Magnifique escalier, fer forgé, avec les attributs de chasse du marquis d'Ecquevilly, grand veneur de Louis XV.

40 Rue de Turenne, 60 (3ᵉ Arrᵗ) – Hôtel du chancelier Boucherat. Superbe départ de l'escalier (fer forgé).

41 Rue de Turenne, 60 (3ᵉ Arrᵗ) – Hôtel du chancelier Boucherat. Balcon de l'hôtel sur le jardin.

42 Rue de Turenne, 60 (3ᵉ Arrᵗ) – Très belle boiserie de porte.

43 Rue des Lions-Saint-Paul, 3 (4ᵉ Arrᵗ) – Ancien hôtel des parlementaires. Dans la cour de l'hôtel, très jolie petite fontaine de l'époque de Louis XV, du plus gracieux effet.

44 Rue Béranger, 3 et 5 (3ᵉ Arrᵗ) – Ancien hôtel dit de Vendôme. Bergeret de Trouville, maître des Comptes. Béranger, le célèbre chansonnier, est mort dans cet hôtel en 1857. Très belle porte.

45 Place Saint-Sulpice (6ᵉ Arrᵗ) – Eglise Saint-Sulpice (1646 à 1749), par les architectes Levau, Oppenord, Gitard et Servandoni. Temple de la victoire sous la Convention. On y donna, le 15 brumaire, un banquet au général Bonaparte. Remarquable boiserie de la sacristie: XVIIIᵉ siècle.

46 Place Saint-Sulpice (6ᵉ Arrᵗ) – Eglise Saint Sulpice. Remarquable boiserie (XVIIIᵉ siècle).

47 Place Saint-Sulpice (6ᵉ Arrᵗ) – Eglise Saint-Sulpice. Dans une chapelle sous les tours, orgue de Marie-Antoinette provenant du château de Trianon.

48 Place Saint-Sulpice (6ᵉ Arrᵗ) – Eglise Saint-Sulpice. Dans une chapelle, sous les tours, orgue de Marie-Antoinette (détail) provenant du château de Trianon.

49 Eglise Saint-Sulpice (6ᵉ Arrᵗ) – Boiserie d'un confessional.

50 Eglise Saint-Sulpice – Remarquable confessionnal (XVIIIᵉ siècle).

51 Eglise Saint-Sulpice – Confessionnal XVIIIᵉ siècle (détail).

52 Quai d'Anjou, 17 (4ᵉ Arrᵗ) – Remarquable hôtel du duc de Lauzun, mari de la grande Mademoiselle, bâti vers 1617; hôtel de Pimodau (1750). Baudelaire et Théophile Gautier y habitèrent, puis le baron Pichon (1841). Acheté en 1900 par la Ville de Paris pour en faire un musée, et revendu ensuite à la famille du baron Pichon pour la modeste somme de 300,000 francs. Décoration intérieure. Très belles boiseries XVIIIᵉ siècle.

53 Hôtel de Lauzun, quai d'Anjou – Décoration intérieure.
Boiseries XVIIᵉ siècle.

54 Hôtel de Lauzun, quai d'Anjou. – Décoration intérieure.
Très belles boiseries XVIIIᵉ siècle.

55 Hôtel de Lauzun, quai d'Anjou – Décoration intérieure.
Boiseries XVIIᵉ siècle.

56 Hôtel de Lauzun, quai d'Anjou – Décoration intérieure.
Boiseries XVIIᵉ siècle.

57 Hôtel de Lauzun, quai d'Anjou – Décoration intérieure. Boiseries XVIIe siècle.

58 Hôtel de Lauzun, quai d'Anjou – Décoration intérieure. Boiseries XVIIe siècle.

59 Hôtel de Lauzun, quai d'Anjou – Décoration intérieure. Boiseries XVIIe siècle.

60 Hôtel de Lauzun, quai d'Anjou – Décoration intérieure. Boiseries XVIIe siècle.

INTÉRIEURS PARISIENS

DÉBUT DU XXᴱ SIÈCLE

ARTISTIQUES

PITTORESQUES & BOURGEOIS

E. ATGET

AUTEUR-ÉDITEUR

17ᵇⁱˢ, Rue Campagne-Première, 17ᵇⁱˢ

PARIS

1 Petit Interieur d'un artiste Dramatique M^r R. Rue Vavin

2 Petit Intérieur d'un artiste Dramatique – M^r R. Rue Vavin.

3 Petit interieur d'un artiste Dramatique M^r R. Rue Vavin.

4 Interieur de M^{me} D, Petite rentière, Boulevard du Port Royal.

5 Intérieur de M^{me} D, Petite rentière, Boulevard du Port Royal.

6 Intérieur de M^{me} D, Petite Rentière, B^d du Port Royal.

7 Intérieur de M^{me} D, Petite rentière, Boulevard du Port Royal

8 Interieur de M^{me} D, petite rentière, Boulevard du Port Royal.

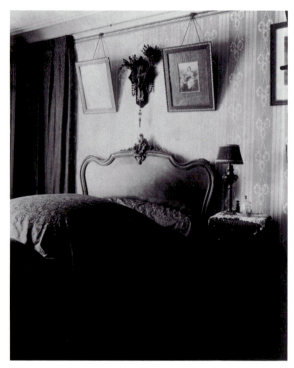

9 Intérieur de M^{me} D, Petite rentière, B^d du Port Royal.

10 Interieur d'un employé aux magasins du Louvre Rue S^t Jacques.

11 Interieur d'un employé aux magasins du Louvre Rue S^t Jacques.

12 Interieur d'un employé aux magasins du Louvre Rue S^t Jacques.

13 Intérieur d'un employé aux magasins du Louvre, Rue S^t Jacques.

14 Interieur de M^me C. Modiste, Place S^t André des arts.

15 Interieur de M^me C. Modiste Place S^t André des arts

16 Le Salon de M^me C, modiste, place S^t André des arts.

17 Le Salon de M^me C, Modiste. Place S^t André des arts.

18 Interieur de M^me C, modiste Place S^t André des arts

19 Interieur de Monsieur M, Financier, avenue Elisée
Réclus (champ de Mars)

20 Intérieur de Monsieur M, Financier, avenue Elisée
Reclus, (champ de Mars.)

21 Interieur de Monsieur M, Financier, avenue Elisée Reclus. (champ de Mars)

22 Interieur de Monsieur M, Financier, avenue Elisée Reclus, (champ de Mars)

23 Intérieur de Monsieur M, Financier, avenue Elisée Reclus (champ de Mars) Cabinet de toilette.

24 Interieur de Monsieur M, Financier avenue Elisée Reclus, (champ de Mars)

25 Interieur d'un Ouvrier, Rue de Romainville

26 Intérieur d'un ouvrier, Rue de Romainville.

27 Interieur d'un Ouvrier, Rue de Romainville.

28 Interieur d'un ouvrier, Rue de Romainville

29 Petite chambre d'une ouvrière, Rue de Belleville

30 Petite chambre d'une ouvrière, Rue de Belleville

31 Interieur de M^r F. Négociant. Rue Montaigne

32 Intérieur de M^r F, Négociant, Rue Montaigne

33 Intérieur de Mʳ F, Négociant, Rue Montaigne.

34 Intérieur de Mʳ F, Négociant, Rue Montaigne. Atelier de Madame, Sculpteur Amateur.

35 Intérieur de Mʳ F, Négociant, Rue Montaigne. Atelier de Mᵐᵉ Sculpteur amateur.

36 Intérieur de Mʳ F, Négociant, Rue Montaigne La Cuisine.

37 Interieur de M^r F – Rue Montaigne. La Cuisine

38 Intérieur de M^r A. (Rue) Industriel, Rue Lepic

39 Interieur de M^r A, Industriel, Rue Lepic

40 Interieur de M^r A, Industriel, Rue Lepic

41 Interieur de Mr A, Industriel, Rue Lepic

42 Interieur de Mr C, Décorateur appartements. Rue du Montparnasse.

43 Interieur de Mr C, Décorateur appartements. Rue du Montparnasse.

44 Interieur de Mr C, Décorateur appartements Rue du Montparnasse.

45 Interieur de M^r C. Décorateur appartements, Rue du Montparnasse.

46 Interieur de M^r C, décorateur appartements, Rue du Montparnasse.

47 Interieur de M^r C, décorateur appartements, Rue du Montparnasse.

48 Intérieur de M^r B, Collectionneur, Rue de Vaugirard.

49 Intérieur de M r B, Collectionneur, Rue de Vaugirard.

50 Interieur de M r B, Collectionneur, Rue de Vaugirard.

51 Interieur de M r R. Artiste Dramatique Rue Vavin.

52 Intérieur de M r R, Artiste dramatique, Rue Vavin.

53 Interieur de M^elle^ Sorel, de la Comédie Française 99 avenue des champs Elysées.

54 Interieur de M^elle^ Sorel, de la Comédie Française, 99 avenue des champs Elysées.

55 Interieur de M^elle^ Sorel, de la Comédie Française, 99 avenue des champs Elysées.

56 Interieur de M^elle^ Sorel, de la Comédie Française, 99 avenue des champs Elysées.

57 Interieur de M^elle Sorel, de la Comédie Française, 99 avenue des champs Elysées.

58 Interieur de M^elle Sorel, de la Comédie Française, 99 avenue des champs Elysées.

59 Intérieur de M^elle Sorel, de la Comédie Française, 99 avenue des champs Elysées.

60 Interieur de M^elle Sorel, de la Comédie Française, 99 avenue des champs Elysées.

La Voiture à Paris

1 Voiture. Maraicher – Marché St Germain – 1910 2 Voiture pour le transport des Glaces. 1910

3 Compagnie des Voitures de Paris – Fiacre – 1910 4 Voiture Blanchisseur – 1910.

5 Roulotte d'un fabricant de Paniers – Porte d'Ivry – 1910

6 Compagnie de petites Voitures – Caleche – 1910

7 Voiture. Cabriolet – 1910

8 Voiture de Vidange – 1910

9 Omnibus – 1910 –

10 Omnibus – 1910

11 Tombereau – 1910

12 Voiture pour le transport des grosses pierres – 1910

13 Voiture pour le transport des grosses pierres – 1910

14 Voiture – Balayeuse municipale. 1910

15 Voiture – Balayeuse municipale – 1910

16 Voiture Arrosage de la Ville de Paris – 1910

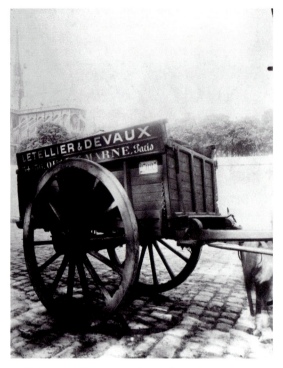

17 Voiture pour le transport des charbons – 1910

18 Voiture Pompes funèbre – 1910. (1e classe)

19 Voiture. Pompes funèbres – 1er classe – 1910

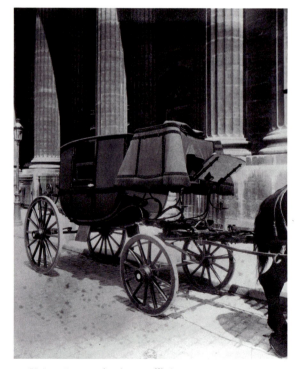

20 Voiture Pompes funèbres – 1ere classe – 1910 –

21 Voiture. Pompes funèbres – 1^{ere} classe – 1910

22 Voiture de Laitier – 1910

23 Voiture de Laitier – 1910.

24 Voiture Maraicher – Les Halles – 1910

25 Voiture de Touristes – 1910.

26 Tramway – 1910

27 Tramway – 1910

28 Camion – chemin de fer de l'Etat – 1910.

29 Voiture de transport – 1910.

30 Voiture pour le transport des eaux Gazeuses – 1910

31 Voiture pour le transport des charbons – 1910

32 Voiture pour le transport des Platres. 1910

33 Voiture des marchés de quartiers de Paris – 1910

34 Voiture de Forain. 1910

35 Voitures. marché des patriarches. Rue Mouffetard – 1910

36 Brasseur. 1910 –

37 Voiture Distillateurs – 1910

38 Voiture asphalte – 1910

39 Voiture asphalte – 1910

40 Voiture à Broyer les pierres – 1910

41 Hacquet 1910

42 Voiture transport des prisons – 1910

43 Voiture. Transport des prisons – 1910

44 Voiture voyageurs. (Gares) 1910

45 Omnibus voyageurs. (Gares) 1910

46 Voiture Déménagement – Grand terme – 1910

47 Voiture Déménagement – terme moyen – 1910

48 Voiture Déménagement – petit terme – 1910

49 Voitures – Bernot – charbons – 1910

50 Voiture, Transport des ordures – (Boueux) – 1910

51 Transport des facteurs – 1910

52 Voiture Bois de Boulogne – 1910

53 Petite Voiture – Bois de Boulogne – 1910

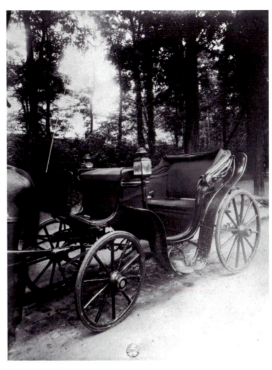

54 Victoria – Bois de Boulogne – 1910

55 Voiture Bois de Boulogne 1910

56 Voiture – Bois de Boulogne – 1910

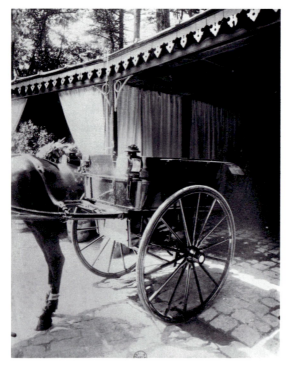

57 Voiturette – Bois de Boulogne – 1910

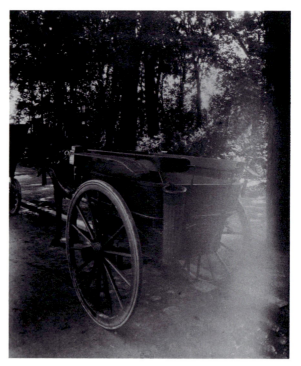

58 Voiture dite Tonneau – Bois de Boulogne 1910

59 Le Fiacre, avant les Pneus – 1910

60 La Voiture des Postes – Disparue 1910

Métiers, boutiques et étalages de Paris

1 Boutique d'articles de ménage, 340 rue de Vaugirard

2 Kiosque à journaux, square du Bon Marché

3 Boutique de jouets, 63 rue de Sèvres

4 Petit marchand de clefs, quai de la Rapée

5 Marchand de glaces, square du Bon Marché

6 Kiosque à journaux, Place Saint Sulpice

7 Colonne Moris pour les spectacles, Place Saint Sulpice

8 Boutique de légumes, 25 rue Charlemagne

9 Boutique de légumes, 3 rue Eginhard

10 Boutique de légumes, rue Mouffetard

11 Petite boutique de friture, rue Mouffetard

12 Petite boutique de fleurs, place de la Bastille

13 Poissonnier au coin de la rue Daubanton et de la rue Mouffetard

14 Petite voiture de légumes à Saint Médard, au coin de la rue Mouffetard

15 Petit marché au coin de la rue Mouffetard

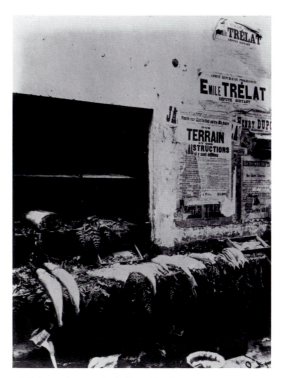

16 Poissonnier au coin de la rue Daubanton

17 "Le brulant Alexandre" cabaret, 100 Boulevard de Clichy

18 Boutique de friture, 38 rue de Seine

19 Le Moulin Rouge, 86 Boulevard de Clichy

20 Brasserie équivoque, 16 rue Blondel

21 Cabaret de l'Enfer (façade), 53 Boulevard de Clichy

22 Brocanteur rue de Venise

23 Boutique de fruits et légumes au coin de la rue Galande

24 Boutique de vêtements et cabaret du Père Lunette, rue des Anglais

25 Marchand de légumes aux Halles

26 Brocanteur, Boulevard Edgar Quinet

27 Brocanteur, 10 avenue Lowendal

28 Coin du Marché des Carmes Place Maubert

29 Coin du Marché des Carmes Place Maubert

30 Coin du Marché des Carmes Place Maubert

31 Coin du Marché des Carmes Place Maubert

32 Boutique d'articles pour hommes, 16 rue Dupetit Thouars (Temple)

33 Marchand de légumes

34 Costumier, 2 rue de la Corderie

35 Costumier, 2 rue de la Corderie

36 Brocanteur, rue des Anglais

37 Boucherie, Marché des Carmes, Place Maubert

38 Un coin de la rue Saint Julien le Pauvre

39 Un coin du passage des Patriarches, rue Mouffetard

40 Intérieur de photographe

41 Etalage de poissons aux Halles

42 Etalage de poissons aux Halles

43 Marchand de vin, rue Boyer

44 Etalage de poissons aux Halles

45　Boulangerie, 48 rue Descartes

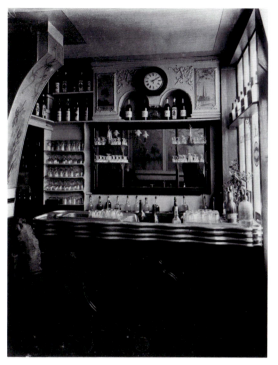

46　Marchand de vin 21 rue Boyer

47　Boucherie 42 rue Descartes

48　Marchande de gâteaux, quai de la Rapée

49 Boutique de meubles au coin de la rue des Ciseaux et de la rue Gozlin

50 Boutique Art Nouveau, 45 rue Saint Augustin

51 Cabaret de l'Enfer, 53 Boulevard de Clichy

52 Brocanteur 38 rue Descartes

53 Cabaret Alexandre, 100 Boulevard de Clichy

54 Bouquiniste, place de la Bastille

55 Entrée d'une maison close, 106 avenue de Suffren

56 Intérieur d'un céramiste, rue Saint Jacques

57 Intérieur d'un céramiste, rue Saint Jacques

58 Intérieur d'un relieur, rue Férou

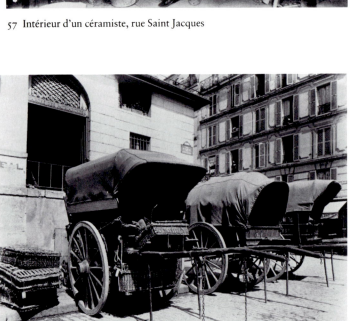

59 Un coin du marché des Patriarches

60 Marchande de fleurs, Place Saint Sulpice

Enseignes et vieilles boutiques de Paris

1 Cabaret Rue Mouffetard – Demoli en 1907.

2 Au Soleil d'or 84 Rue Sᵗ Sauveur – Modifié.

3 Au Soleil d'or 84 Rue Sᵗ Sauveur (Modifié)

4 Au Bourdon Rue de Varenne 64 – (fondé 1793)

5 A Sᵗ Etienne Rue de la Montagne Ste Geneviève

6 Les Canettes, Rue des Canettes 18.

7 Le Dragon Rue de Rennes 50.

8 Le cherche midi 19 Rue du cherche midi.

9　La petite chaise Rue de Grenelle 36.

10　Boutique Louis XVI – 3 quai Bourbon.

11　A L'Enfant Jésus Rue des Bourdonnais 33

12　Cabaret coin Rue Charles V.

13 A la Treille d'or 6 Rue de Condé. (Disparu en 1905)

14 Cabaret 34 quai de l'hôtel de Ville – (Disparu en 1899)

15 A l'homme armé 25 Rue des Blancs Manteaux.

16 Au Petit Dunkerque 3 quai Conti.

17 Cabaret Rue du Four 10 (Demoli en 1905)

18 Au Bon Puits Rue Michel Le Comte 36 (Disparu en 1904)

19 Au Bon Coin Rue des Haudriettes (Disparu en 1908)

20 Au Lion d'or 16 Rue Volta.

21 Au Franc Pinot, quai Bourbon 1

22 Au Petit Bacchus Rue Sᵗ Louis en L'Ile 61.

23 Cabaret 38 quai de Béthune

24 A la Grace de Dieu, 121 Rue Montmartre

25 A la Grace de Dieu, 121 Rue Montmartre

26 Au deux Pigeons 8 Rue Clément – (Disparu en 1905)

27 A la Tour d'argent 18 Rue Sᵗ Germain L'auxerrois.

28 Au Coq Hardi 18 quai de la Mégisserie.

29 A la Petite Hotte 1 Rue des Orfèvres.

30 Cabaret 62 Rue de l'hotel de Ville (Disparu Vers 1905)

31 Au Griffon 39 quai de l'Horloge.

32 Boutique empire 21 Fb St Honoré.

33 Cabaret du père Lunette Rue des Anglais (Disparu en 1908)

34 Au Port Salut, Rue des Fossés St Jacques.

35 A la Coquille d'or Rue de la Sourdière 42.

36 Cabaret coin Rue du Four et des Ciseaux (Disparu en 1905)

37 Au Reveil matin 136 Rue Amelot.

38 Boutique Empire, 14 Rue de Grammont.

39 A la Tour d'argent Rue de Charenton 2

40 A la Biche Rue Geoffroy St Hilaire.

41 Au Bourdon (1793) 64 Rue de Varenne.

42 Au Tambour 63 quai de la Tournelle.

43 Au Tambour

44 Cabaret de L'ami Jean 8 Rue Thouin

45 A Sᵗᵉ Geneviève 40 Rue de la Montagne Sᵗᵉ Geneviève.

46 Cabaret 1 Rue Guisarde

47 Boulangerie empire Rue des Blancs Manteaux 28.

48 Cabaret du Gros Pavé Rue du Roi de Sicile 8.

49 A l'agneau Pascal Rue de Valence 11.

50 Cabaret du Petit Maure 26 Rue de Seine.

51 Au Griffon 10 Rue de Bucy.

52 Enseigne 21 Rue des Sᵗ Pères.

53 Au Vieux chêne 69 Rue Mouffetard.

54 A la Grappe d'or Place d'aligre 4.

55 Cabaret 86 Rue Mouffetard.

56 Le Remouleur Rue des Nonnains d'Hyères.

57 A Jean Bart 38 Avenue Lamotte Piquet.

58 A L'orme S^t Gervais 20 Rue du Temple (Disparu en 1910)

59 Cabaret 31 Rue du Bac.

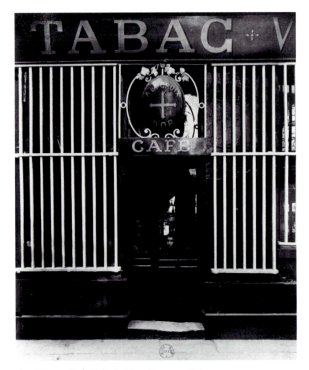

60 Cabaret Rue S^t André des Arts 54 – (Disparu en 1911.

Zoniers

1 Porte d'Ivry – Zoniers (13ᶜ arr)

2 Porte d'Ivry – Zoniers – (14ᶜ arr) (1912)

3 Porte d'Ivry, Zoniers, 1912 (13ᶜ arr)

4 Porte d'Ivry, Zoniers – 1912 (13ᶜ arr)

5 Porte d'Ivry. Zoniers – 1912 – 13ᵉ arr)

6 Porte d'Ivry. Bᵈ Masséna, chiffoniers – 1912 (13ᵉ arr)

7 Chiffonnier Bᵈ Masséna, Porte d'Ivry – 1912 (13ᵉ arr)

8 Chiffonnier Bᵈ Masséna. 1912 (13ᵉ arr)

9 Interieur d'un chiffonnier B^d Masséna. 1912 (13^e arr) Porte d'Ivry.

10 Porte de Montreuil, Zoniers, 1912, (20^e arr)

11 Porte de Montreuil. Zoniers, 1912 (20^e arr)

12 Porte de Montreuil – Zoniers – 1912 (20^e arr)

13 Porte d'Italie, Zoniers – 1912 (13ᵉ arr)

14 Porte d'Italie. 1912 (Zoniers) 13ᵉ arr)

15 Porte d'Ivry. Intérieur de chiffonnier, 1912 (13ᵉ arr)

16 Porte d'Ivry. Intérieur d'un chiffonnier, 1912 (13ᵉ arr)

17 Porte d'Italie, Zoniers. 1913 (13ᵉ arr)

18 Chiffonnier. Passage Moret, Ruelle des Gobelins, 1913 (13ᵉ arr)

19 Porte d'Italie, Zoniers – 1912 (13ᵉ arr)

20 Porte d'Italie, Zoniers. 1913 – 13ᵉ arr)

21 Porte de Choisy. Zoniers, 1913 (13ᵉ arr)

22 Porte de Choisy. Zoniers – 1913 (13ᵉ arr)

23 Poterne des Peupliers, Zoniers – 1913 (13ᵉ arr)

24 Poterne des Peupliers, Zoniers, 1913 (13ᵉ arr)

25 Porte d'asnières, Cité Trébert, 1913, 17e arr)

26 Chiffonniers, Passage Moret, Ruelle des Gobelins, 13e arr) 1913

27 Porte d'asnières, Cité Trébert, 1913 – 17e arr)
(Chiffonnier).

28 Porte d'asnières, chiffonnier, Cité Trébert, 1913 (17e arr)

29 Porte d'asnières, Cité Trébert, chiffonnier, 1913 (17ᵉ arr)

30 Porte de Montreuil, Zoniers, 1913 (20ᵉ arr)

31 Cité Doré, Bᵈ de la gare 70. 1913 (13ᵉ arr) Chiffonnier.

32 Porte de Montreuil, Zoniers, 1913 (20ᵉ arr)

33 Porte de Montreuil, Zoniers, 1913 (20ᵉ arr)

34 Porte d'asnières, Cité Valmy – 1913 (17ᵉ arr) chiffon-
niers.

35 Porte d'asnières, Cité Valmy, 1913 (17ᵉ arr) chiffonnier

36 Porte d'asnières, Cité Valmy. chiffonniers, 1913 (17ᵉ arr)

37 Porte d'asnières, Cité Valmy, – chiffonniers, 1913 (17ᵉ arr)

38 Porte d'asnières, Cité Valmy, chiffonniers, 1913 (17ᵉ arr)

39 Porte de Montreuil, Zoniers, 1913 (20ᵉ arr)

40 Porte d'Ivry, Zoniers, 1913 (13ᵉ arr)

41 Poterne des Peupliers, Zoniers, 1913, 13ᵉ arr)

42 Porte d'Italie, Zoniers, 1913 (13ᵉ arr)

43 Porte de choisy, Zoniers – 1913 (13ᵉ arr)

44 Poterne des Peupliers, (Zoniers, 1913 (13ᵉ arr)

45 Porte d'asnières, Cité Valmy. 1913 (17^e arr) chiffonniers

46 Porte de Montreuil, Zoniers, 1913 (20^e arr)

47 Porte de Montreuil, Zoniers, 1913, 20^e arr)

48 Porte d'Asnières, Cité Valmy. 1913 (17^e arr) chiffonniers

49 Poterne des Peupliers, Zoniers, 1913 (13ᵉ arr)

50 Un chiffonnier, le matin, dans Paris, avenue des
Gobelins.

51 Cité doré Bᵈ de la Gare 70 – 13ᵉ arr)

52 Cité Doré, Bᵈ de la gare et Place Pinel – 13ᵉ arr)

53 Campement de chiffonniers, B^d Masséna, 13^e arr) 1913

54 Cité Doré, B^d de la gare 70, 1913, 13^e arr)

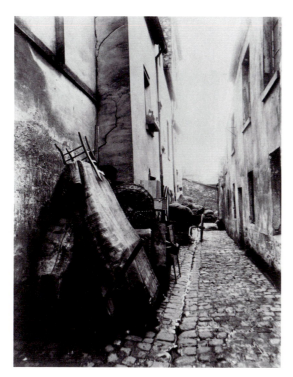

55 Cité Doré, B^d de la gare 70 – 1913 (13^e arr)

56 Cité Doré, B^d de la gare 70, 1913 (13^e arr)

57 Chiffonnier, Rue de l'amiral Mouchez, 1913 (13e arr)

58 Butte aux Cailles, chiffonniers (Disparu Vers 1900) 13e arr)

59 La Butte aux Cailles, Disparu Vers 1900 – 13e arr)

60 Chiffonnier, Butte aux Cailles, disparue Vers 1900)

Fortifications de Paris

1 Porte de Gentilly. Fortifications – 1913. (13ᵉ arrᵗ)

2 Poterne des peupliers. La Bièvre – Zone des fortifications. 1913 13ᵉ arrᵗ

3 Poterne des peupliers. Entrée de la Bièvre dans Paris. 1913 13ᵉ arrᵗ

4 Porte Dauphine. coin des fortifications. 1913. (16ᵉ arrᵗ)

5 Porte de Bercy. Fossés des fortifications. 1913. (12ᵉ arrᵗ)

6 Porte Dauphine. Fortifications. 1913. (16ᵉ arrᵗ)

7 Porte Dauphine. fortifications. 1913. (16ᵉ arrᵗ)

8 Porte Dauphine. Les Fossés des fortifications. 1913 (16ᵉ arrᵗ)

9 Porte du passage de L'ourcq. Le Bastion 26 B^d Sérurier 1913. (19^e arr^t)

10 Porte du Pré-Saint-Gervais. 1913. 19^e arr^t.

12 Porte Maillot. fossés des fortifications. 1913. 16^e arr^t

11 Porte Maillot. fossés des fortifications. 1913. (16^e arr^t)

13 Porte Maillot. fortifications. 1913. (16ᵉ arrᵗ)

14 Porte Dauphine. fossés des fortifications. 1913. 16ᵉ arrᵗ.

15 Porte de Sevres. les fortifications. 1913. 15ᵉ arrᵗ

16 Porte de Bercy. Fossés des fortifications – 1913 – (12ᵉ arrᵗ)

17 Porte du passage du Canal de L'Ourcq. Bd Sérurier. 1913. 19e arrt.

18 Porte d'Arcueil, Bd Jourdan. La Rentrée de Paris 1913. (14e arrt)

19 Poterne des peupliers. Bd Kellermann. fortifications 1913. (13e arrt)

20 Porte de Vanves. Fortifications. Bd Brune. 1913 (14e arrt)

21 Poterne des peupliers. B^d Kellermann. 1913. 13^e arr^t

22 Porte de Versailles. fortifications – 1913 – 15^e arr^t

23 Porte Maillot. fortifications. 1913 – 16^e arr^t

24 Porte Dauphine. fossés des fortifications. 1913. 16^e arr^t

25 Porte d'Ivry. B^d Masséna 18 et 20. fortifications. 1913 – 13^e arr^t

26 Porte de Gentilly. B^d Kellermann. 1913. 13^e arr^t

27 Porte de Bercy. Gare du P.L.M. sur les fortifications. B^d Poniatosski. – 1913 – 12^e arr^t

28 Porte Dauphine. Fortifications – 1913 – 16^e arr^t

29 Porte de Bercy – Sortie de Paris du P. L. M. B^d Poniatosski – 1913 – 12^e arr^t

30 Porte d'Italie. La Bièvre. La Sortie de Paris. 1913 (13^e arr^t)

31 Porte d'Italie. La Bièvre à la sortie de Paris. 13^e arr). 1913

32 Porte d'Italie. La Bièvre à la sortie de Paris. 1913 – 13^e arr^t

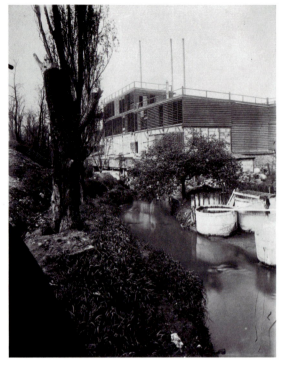

33 Porte d'Italie. La Bièvre à la sortie de Paris. 1913 –
13ᵉ arrᵗ.

34 Porte Dauphine. Fossés des fortifications. 1913. 16ᵉ arrᵗ

35 Porte de Bercy. Gare du P.L.M. sur les fortifications. Bᵈ Poniatosski – 1913 –
12ᵉ arrᵗ

36 Porte de Versailles – fortifications – 1913 – 15ᵉ arrᵗ

37 Porte Dauphine. Fortifications – 1913. 16ᵉ arrᵗ

38 Porte Dauphine. Fossés des fortifications. 1913 – 16ᵉ arrᵗ

39 Porte Dauphine. Fortifications. 1913 – 16ᵉ arrᵗ

40 Porte Dauphine. fortifications. 1913 – 16ᵉ arrᵗ

41 Porte Maillot. fossés des fortifications. 1913 – 16ᵉ arrᵗ

42 Fortifications – La Sortie de Paris – Bᵈ Jourdan. Sceaux Ceinture. 1913 – 13ᵉ arrᵗ

43 Porte du passage du Canal de L'ourcq. Bᵈ Sérurier. 1913 – 19ᵉ arrᵗ

44 Porte d'Orléans. Le Bastion 80. le jardin du Bastion 1913 – 14ᵉ arrᵗ

45 Poterne des peupliers. B^d Kellermann. 1913. (13ᵉ arrᵗ)

46 Porte Dauphine. Fossés des fortifications. 1913 – 16ᵉ arrᵗ

47 Poterne des peupliers, B^d Kellermann – 1913 – 13ᵉ arrᵗ

48 Porte Dauphine – Les fossés des fortifications. 1913 – 16ᵉ arr.

49 Porte du passage de L'ourcq, B^d Sérurier. 19^e arr – 1913.

50 Porte d'Ivry. Impasse Masséna, 18 et 20, sur les fortifications 13^e arr – 1913.

51 Porte de Sevres. Bastion. 1913 – 15^e arr^t

52 Porte d'Arceuil B^d Jourdan. 1913 – 14^e arr^t.

53 Poterne des peupliers. B^d Kellermann. Paysage des fortifications – 1913 – 13^e arr^t

54 Fortifications. Bastion 87, B^d Kellermann. Porte d'Italie 13^e arr – 1913.

55 Porte de Sevres. Fortifications. 1913 – 15^e arr^t

56 Porte Dauphine, fossés des fortifications. 1913 – 16^e arr^t

57 Porte Dauphine. Les Fortifications. 1913 – 16e arrt

58 Porte Maillot, un coin des fortifications. 1913 – 16e arrt

59 Porte Dauphine. Fossés des fortifications. 1913 – 16e arrt

60 Poterne des peupliers, Bd Kellermann, Paysage des fortifications – 1913 –
13e arrt

770.924 A864N458 178317

Nesbit, Molly

Atget's seven albums

DATE DUE		
APR 10 1997		
OCT 28 97		
DEC 09 1997		
OCT 0 4 2000		
MAR 1 2006		
MAR 0 9 2006		
3/30 @ 11 pm		